The Rebirth of Painting in the Late Twentieth Century

The Rebirth of Painting in the Late Twentieth Century examines the continued validity and variety of painting in the postmodern era. Bringing a psychological perspective to the subject, Donald Kuspit argues that painting remains the premiere medium of the visual arts, in terms of its potential for innovation and influence on other modes of art making. Discussing a range of representational and abstract painting in the United States and Europe by artists such as Gregory Amenoff, Vincent Desidiero, and Odd Nerdrum, Kuspit also examines works by Picasso, Mondrian, Pollock, Johns, and Soutine, among others, with an eye to reevaluating their art historical significance. This study also includes psychosocial studies of various cultural issues that affect painting, including feminism and Jewish identity.

Donald Kuspit is one of America's most distinguished art critics. A recipient of the Frank Jewett Mather Award for Distinction in Art Criticism from the College Art Association, he has received honorary doctorates in the fine arts from Davidson College and the San Francisco Art Institute, and an honorary doctorate of humane letters from the University of Illinois at Urbana-Champaign. The National Association of the Schools of Art and Design cited him for Distinguished Service to the Visual Arts. Dr. Kuspit is the author of numerous books, articles, exhibition reviews, and catalogue essays on aspects of contemporary art.

The **Rebirth** of **Painting** in the **Late Twentieth Century**

DONALD KUSPIT

CAMBRIDGE
UNIVERSITY PRESS

PUBLISHED BY THE PRESS SYNDICATE OF THE UNIVERSITY OF CAMBRIDGE
The Pitt Building, Trumpington Street, Cambridge, United Kingdom

CAMBRIDGE UNIVERSITY PRESS
The Edinburgh Building, Cambridge CB2 2RU, UK http://www.cup.cam.ac.uk
40 West 20th Street, New York, NY 10011-4211, USA http://www.cup.org
10 Stamford Road, Oakleigh, Melbourne 3166, Australia
Ruiz de Alarcón 13, 28014 Madrid, Spain

First published 2000

Printed in the United States of America

Typeface Stone Serif 9.5/13.5 pt. *System* QuarkXPress™

A catalog record for this book is available from the British Library

Library of Congress Cataloging-in-Publication Data

Kuspit, Donald B. (Donald Burton), 1935–
 The rebirth of painting in the late twentieth century / Donald
Kuspit.
 p. cm.
 Includes bibliographical references.
 ISBN 0 521 66218 4 (hardback). – ISBN 0 521 66553 1 (pbk.)
 1. Painting, Modern – 20th century. 2. Painting, Modern – 20th
century – Psychological aspects. I. Title
 ND195.K87 2000 99-16265
 759.06 – dc21

ISBN 0 521 66218 4 hardback
ISBN 0 521 66553 1 paperback

For Judith

Contents

II. Animadversions

Prefatory Note

Broadly speaking, there are two ways (at least) of practicing art criticism. Lawrence Alloway endorses one, that of Apollinaire, who "wrote from straight journalistic motives, describing a complex art scene," of which "he was a participant." Being "a friend of artists improved his access and extended his subject matter but did not tempt him to elaborate acts of interpretation."[1]

The problem with this approach is that the critic tends to become the mouthpiece of the artists with whom he is friends. Why be tempted by an act of interpretation that extends beyond their ideas when they supposedly have the last word about their art? Why declare one's intellectual and emotional independence from them when one can hide the limits of one's empathy and understanding behind one's dependence on them?

I prefer Baudelaire's idea, which is based on the belief that the interpretation of art – the determination of its meaning and value – is too important to be left to artists. They clearly have a vested interest in it, for it will decide their fame and place in art history. Genuine criticism must not serve the artist's narcissistic obsession with immortality, but address the significance of art for all human beings.

The only way to do this is by writing from "a point of view that opens up the widest horizons," as Baudelaire said.[2] This can be done only through elaborate acts of interpretation – of empathic understanding. Better their riskiness than the safety of reporting the obvious. Journalism is a first step, but hardly adequate to the art it acknowledges. It misses what Baudelaire said is the primary issue of art: ethics – psychoethics, as I would say.

Baudelaire endorses Stendhal's view that "painting is nothing but a construction in ethics!"[3] "You can say as much of all the arts," Baudelaire states, and declares that ethics means that art is the medium for "the feeling, the passion and the dreams of [the] man." For the artist is a man before he is an artist, and his art conveys his humanity and general sense of what it means to be human.

Baudelaire asserts that criticism must always be "in contact with metaphysics" to understand the humanity involved in art and its relevance to humanity at large. By metaphysics he means psychology: a metaphysical criticism does not

examine the art in "a cold, mathematical" way, as though performing an autopsy on a corpse to determine how it died, but tries to understand, however poetically, the love and hate or "temperament" that give it life. A metaphysical criticism is psychophysical or psychoethical rather than strictly physical – "technical" or "positivist," as Baudelaire says – and thus indifferent to the "mysterious processes" of the mind.[4]

The criticism in this book is written in a Baudelairean spirit, and the psychometaphysics involved, however poetic, is hopefully more sophisticated than the Romantic metaphysics with which Baudelaire tried to understand what he called the "mode of feeling" which art is. Hopefully this gives my acts of interpretation at least as much legitimacy as his, and greater credibility.

Acknowledgments

Special thanks to Gregory Amenoff, Elizabeth Baker, Vincent Desiderio, Nan Goldin, Anselm Kiefer, Wlodek Ksiazek, Odd Nerdrum, Archie Rand, Pierre Soulages, May Stevens, and Miles Unger, and, as always, to Beatrice Rehl.

Introduction

WHY PAINTING?

For, after many years of waiting, I had finally found people to teach me who did see that the essence of painting is that every mark on the paper should be one's own, growing out of the uniqueness of one's own psychophysical structure and experience, not a mechanical copy of the model, however skilful.

Marion Milner, *On Not Being Able to Paint*[1]

Our aesthetic forms explore the void, the blank freedom which come of the retraction (*Deus absconditus*) of the messianic and the divine. If the "hallowed precision" of Georges de la Tour's *Job Mocked by his Wife* at Epinal or of a Giorgione landscape enact the epiphany of a real presence, if they proclaim the kinship of art with the calling on mystery in the matter of the world and of man, a Malevich, an Ad Reinhardt reveal, with no less authority, their encounter with a "real absence."

George Steiner, *Real Presences*[2]

WHY NOT? THE ATTACKS AGAINST PAINTING PROLIFERATE, BUT IT PERSISTS, endures, flourishes, leaving the theorists who would legislate it out of existence in its wake. They have declared it to be obsolete, but the grounds on which they do so are completely beside its human point: its power to evoke and convey what is subjectively fundamental in human experience. It is because painting does so that it remains, and will continue to remain, the primary visual art: the matrix in which visual possibilities can spontaneously generate. It is no accident, as Frank Gehry realized, that "Corbusier's stunningly original forms came out of his paintings."[3] As Gehry said, "there's another freedom out there, and it comes from somewhere else." Painting is that other freedom, for it can put us in touch with that somewhere else.

According to "advanced" theorists, painting ought not to exist because it is made an old-fashioned way – by hand.[4] Photography is more appropriate to the machine age – it is a more progressive technology than painting – and does what painting used to do, and does it better: capture likenesses. Photography even seems to have become the imaginative equal of painting, creating illusions that are magically charged with aura.

Moreover, a painting has become the commodity par excellence – a venal symbol of the commercial degradation of art. The more sublime and autonomous a painting the more readily the wealthy buy it, reducing it to "pure wall decoration."[5] It is elitist entertainment, a status symbol, an investment property – everything except the sacred object it purports to be.

Indeed, painting symbolizes power and wealth at their most subtly arrogant and irresponsible – power and wealth so self-confident that they feel no need to rationalize and excuse themselves. Painting is their ideological disguise, the transcendental veil with which they disguise themselves. It is proof of their claim that they are means to a glorious end, rather than ends in themselves: they exist to encourage and support the higher things in life, things of intrinsic value – surely art, epitomized by painting, is one. How can power and wealth be criticized if they exist in the service of personal creativity, of which painting is the most direct expression? Painting adds to their lustre and seductiveness. It is the sign that their cup runneth over with goodness and mercy. Appropriating pure value, their value becomes unquestionable.

But perhaps the most ironic "advanced" argument against painting is that it is emotionally stultifying – furtively perverse and degenerate. Marcel Duchamp's experience of it as "olfactory masturbation"[6] says as much. Paint is the smelly liquid of lonely sexual discharge, and to paint is the "handy" means of bringing about the discharge. Painting condenses the sticky cause and result of sexual self-stimulation. "Genital masturbation," Charles Brenner observes, "ordinarily constitutes the child's sexual *activity*" during the Oedipal phase. "Both the masturbatory activity and the fantasies which accompany it substitute in great part for the direct expression of the sexual and aggressive impulses which the child feels toward its parents. ... The substitution is inevitable, because in the last analysis it is forced on the child by his biological immaturity."[7]

The readymade is no doubt Duchamp's way of overcoming his sexual immaturity, if only because, unlike a painting, it is machinemade rather than handmade. But in forsaking olfactory masturbation Duchamp forsook something else: the body (in the symbolic form of the painting).[8] It is the body – its rhythms, activities, growth, materiality – that is implicated in painting, as Duchamp uncomfortably implies. In rejecting painting, Duchamp is rejecting the body, and in rejecting the hand in particular he is rejecting the spontaneity and expressivity of the body, for the hand has the power of spontaneous movement and is inherently expressive. (Photographers also distrust the hand, because it is too spontaneous and expressive to record the world accurately, which is to create the illusion that one is in control of it.) Similarly, and even more profoundly, sexual activity is a spontaneous "expression" of the body. Duchamp, as is well known, de-organicized sexual activity, that is, treated it as a mechanical event, and also de-organicized the body, regarding it, in Cartesian fashion, as a kind of machine – a chess piece on a grid, as in the *Bride Stripped Bare by Her Bachelors, Even*, 1917–21. Rejecting the hand as a source of creativity – not simply a passive instrument of

creativity that can be manipulated at will, but spontaneously creative in its active engagement with and "grasp" of the world – Duchamp in effect rejected his own spontaneity. In a sophisticated statement of "ironic indifference," he reduced sexual activity and the body to intellectual travesties of organic life. But this apparent indifference to life, which seems to rise above it by reducing it to mechanical terms, reflects Duchamp's impotence – intellectualized as irony, to hide the terror and despair in it – when he experienced his own living body, whether in sexual activity or when he used his hands to paint. Unable to control the organic life of the body, he renounced it completely in the fantasy of his art to create the illusion of superiority to it in his mind.

This suggests a larger issue: vitality – physical and above all psychic aliveness. When Gehry states that he "threw away the grid system" he had been taught after experiencing the original forms and freedom of Corbusier's painting, he is in effect saying that the mechanical uniformity of the grid system is devitalizing and inhibiting, while painting is disinhibiting and thus revitalizing, and as such a necessary condition for originality, in the deepest sense of that term.[9] "In our culture," Erich From writes, "education too often results in the elimination of spontaneity and in the substitution of original psychic acts by superimposed feelings, thoughts, and wishes."[10] "Original," he writes, means that "an idea … originates in the individual, that it is the result of his own activity and in this sense is his thought." Painting at its best is the space of individuality and spontaneity, and as such affords the possibility of original psychic acts. It is the nonconformist subjective alternative to the objectifying conformist grid. When Gehry threw away the grid system, he threw away the superimposition and impingement of the collective on his individuality, thus liberating his spontaneity. More broadly, he recovered a sense of himself as an active subject, rather than a passive part of a collective system. While there seems little reason to doubt, as Max Horkheimer wrote, that "we are seeing the last of the person in the full sense of that word … the nothingness of the individual,"[11] painting at its best can become an expression of personhood and individuality – perhaps their last refuge – to the extent it becomes an original psychic act. (Thinkers who believe that the collective is more important than any individual that constitutes it, and who argue that subjectivity is nothing but a social construction and as such lacks a dynamic of its own, cannot help but reject painting. Does their ideology rationalize the fact that the collective necessarily suppresses individuality and spontaneity in the modern instrumental-administrative world, which attempts to include everyone in a total, comprehensive system? Painting has to be historically discredited and devalued if only because it is produced by individuals, and as such implies what Peter Gay calls "privacy," however much it involves collective culture and craft.[12])

The spontaneity necessary to make a convincing painting is hard to achieve; disinhibition – the shedding of collective ideals and expectations – does not come easily, especially after spending so many years of one's life learning to obey them. Spontaneity is possible only when there is a return to the lived body – even in the

perverse form of "masturbation," which however compulsive an activity affords a sense of spontaneous, vital release. The grid represents not only the inhibition of individual spontaneity by collective demands, but perhaps more crucially the inhibition of the body. The grid conquers it by dividing it into intellectual parts, denying its organic integrity. Reduced to an automaton – a machine that performs as it is supposed to – the body seems more dead than alive.[13] That is, with its devaluation comes its devitalization, psychic as well as physical: the machine body is emotionally as well as corporally deficient. The most convincing modern painting is a symbolic attempt to revitalize the body, that is, to make it, and with it the psyche inseparable from it, feel alive again. As Marion Milner writes, "what the painter does conceptualize in non-verbal symbols is the astounding experience of how it feels to be alive, the experience known from inside, of being a moving, living body in space, with capacities to relate oneself to other objects in space."[14]

If his art is any testimony, Duchamp seemed to lack this last capacity, but he does seem to struggle to symbolize the feeling of being alive, however contaminated by the feeling of being dead. The readymade is ambiguously both: a dead object invested with artistic life, in a kind of Frankenstein joke. Was Duchamp's masturbatory painting his last serious effort to make himself feel alive, however much this was done in a mechanical way that symbolized the fact that unconsciously he felt dead? And however much it resulted in an image of the body as a bizarre machine, simultaneously dead and alive? Duchamp's intellectualization of art expressed his feeling of being psychically dead even as it masked this feeling. Or rather it gave him a feeling of being ironically alive – a self-defeating way of feeling alive that was no doubt better than feeling completely dead. In modern times, the aliveness of the psychosoma can no longer be taken for granted; it is no longer self-evident, as it was in traditional art and painting. Perhaps nowhere is this more evident than in Duchamp's art.

Milner writes: "the sense of inner 'beingness,' of 'dead' material acquiring a life of its own, is the fundamental test of the goodness of a work of art; for a good picture is one in which every mark on the canvas is felt to be significant, to be suffused with subject. Similarly a good dancer gives the impression that there is a maximum intensity of being in every particle of the living flesh and muscle and skin, the body itself having become the objective material suffused with subjectivity; and in good sculpture the whole mass of 'dead' metal or stone has been made to irradiate the sense of life."[15] All of this is an attempt to recover a sense of true selfhood, as D. W. Winnicott called it. Modern painting at its best is the ideal medium in which to articulate true selfhood, because in striving for absolutely "spontaneous gesture" and unapologetically "personal idea" modern painting conveys the most salient characteristics of the true self.[16] Authentically modern painting is radically individual and existential, and as such sets the model for modern art of all kinds, that is, for art which is a matter of psychic life and death, in that it aims to defend the true self against exploitation by instrumental-administrative society, "which would result in its annihilation."[17]

Paradoxically, in preserving a sense of psychic vitality and true selfhood in a society that threatens them, painting becomes mystical, confirming that they have become mystical – numinous – states of mind in modernity. That is, they are known more by their absence than presence, which makes them seem all the more rare and sacred. They exist in imaginative form, which suggests that they are possible if never quite actual, however much they may now and then seem to become magically manifest in the lives of isolated individuals. If, as William James writes, the mystical state of mind is ineffable – "defies expression" – and at the same time is a transient state of "insight into depths of truth unplumbed by the discursive intellect" that occurs only when the will is "in abeyance,"[18] then the best modern painting presents the mystical states of psychic aliveness and true selfhood as though they are gifts of grace from an existence superior to one's own. The perception of modern painting is thus a process of conversion to a consciousness of life and self that is otherwise absent and unavailable in everyday life and may seem illusory from its perspective, however much they may be intimated – never with any great certainty – by some lives and selves. As such, modern painting preserves the impulse to transcendence – indeed, satisfies, however mystically, the basic human need for transcendence[19] – in a secular society that denies that there is any.

PAINTING: PAST AND PRESENT

Charles Burchfield

APOCALYPSE NOW

For in those days there will be such a tribulation as has not been seen from the beginning of the creation which God created until now, and never will be. And if the Lord had not shortened the days, no human being would be saved; but for the sake of the elect, whom he chose, he shortened the days.

<div align="right">Mark 13:17–18</div>

For behold, I create new heavens and a new earth; and the former things shall not be remembered or come into mind.

<div align="right">Isaiah 65:17</div>

Anxiety is therefore on the one hand an expectation of a trauma, and on the other a repetition of it in mitigated form.

<div align="right">Sigmund Freud, "Inhibitions, Symptoms and Anxiety," 1936</div>

CHARLES BURCHFIELD HAS LONG BEEN RECOGNIZED AS A VISIONARY, BUT I think the content of his visionary outlook has been misunderstood. He has been regarded as an essentially nineteenth-century American naturalist who happened to be working in the twentieth century. His vision of nature has been associated with that of Ralph Waldo Emerson, Henry David Thoreau, and Walt Whitman, especially with their peculiar mix of romanticism, transcendentalism, and pragmatism; that is, ecstasy and simplicity. Like them, he is supposedly an individualist who identifies with an idealized nature, conceived as a space of emotional freedom and free expression, and what today would be called alternative lifestyle, in contrast to that prevailing in a society enslaved by corrupting, constricting, antilife conventions. This is, of course, an American version of the old Rousseau paradigm, with a touch of Germanic *Weltschmerz* thrown in. Or, if one wishes, it is an American Scene artist with a moralizing touch.

But none of this gets to the core of Burchfield: to the introspective essence of his art, symbolized by the self-probing journals he kept throughout his life. His art and journals form a seamless whole that add up to a picture of an extraordinarily self-observant, self-analytic man. None of this quite explains the peculiar religiosity of his art, whose twists and turns have been described by J. Benjamin Townsend.

Townsend thinks the thrust of Burchfield's art is fundamentally religious: it begins in the "apostasy" of "anti-Christian agnosticism, develops into a vision of a pantheistic communion with God," and, finally, culminates in a "mystical view of nature" in which Burchfield's "earlier monotheism and pantheism are reconciled with Protestant Christianity and blended with neoprimitive animism, School of Concord transcendentalism, and twentieth-century vitalism."[1] This again saddles Burchfield with a nineteenth-century mentality, whatever the vitalistic touch. Moreover, one can only exclaim in wonder at Townsend's cast of doctrines and theories: did Burchfield really conceive of his art as a battlefield of conflicting ideologies? Nonetheless, Townsend's point is well taken: Burchfield is at heart a spiritual artist – a man of faith, however bizarre and sometimes manqué. All his life he was haunted by religion – rarely to his emotional benefit[2] – and, as Nancy Weekly suggests, his nature clearly has a certain sacred aura.[3]

But the conception of Burchfield's art as a kind of religious *Bildungsroman* – a kind of pilgrimage to the shrine of nature, as though in perpetual search of a redemption that was not unequivocally forthcoming – peculiarly misses the point. Burchfield never had much use for religion as such – for this or that belief system, this or that church, however much he may have outwardly conformed to one or the other in acknowledgment of the importance of churchgoing in the provincial environment of his upbringing. Religion was of consequence for him only insofar as it was a vehicle for his emotions. It was the medium of his innermost self. His was a pragmatic religiosity: like the converts William James describes in the *Varieties of Religious Experience*, religion was Burchfield's way of experiencing, expressing, and changing himself.[4] It was Burchfield's curiosity about the troubling emotions that seemed to constitute the self at its deepest that gave him what could be called a religious identity. For Burchfield came to realize that the emotions he experienced were not particular to him but universal, and that religion signaled this universality of emotion. Perhaps most important, religion, by reason of its ritual evocation of emotions, suggested that they had a certain independent logic: they were neither isolated, arbitrary phenomena nor blind responses to events, but occurred in certain basic patterns whatever the circumstances that triggered them. That is, properly perceived, they articulated what was fundamental to the psyche.

It was an attempt to perceive the emotions properly – to gain a certain detachment from and understanding of them – that led Burchfield to devise his "Conventions for Abstract Thoughts" (Fig. 1). They attempt to code, even reify the emotions in pictographic form in order to master them. The bad emotions, "such as fear, morbidness, imbecility, fascination of evil, dangerous brooding, and insanity"[5] – all indicative of profound suffering – were of special importance to Burchfield. All threatened the integrity of the self; they were symptoms of its decline and fall, indeed, self-defeat. As his journals show, Burchfield experienced all of them intensely; his determination to articulate the bad emotions in artistic form was a defense against what they implied: irreversible mental disintegration –

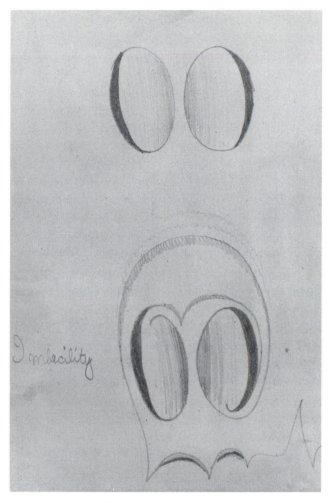

1. Charles Burchfield, *Conventions of Abstract Thought: Fear and Morbidity,* 1917. Watercolor, graphite. 8 $^1/_2$ × 5 $^1/_2$ inches. Courtesy of Kennedy Galleries, New York.

going completely mad. It is as though, if he could nail them down in visual form – see the enemy, as it were – he would be spared the madness that was his greatest fear.

It is no accident that Burchfield began to devise these Conventions – normally speaking, abstract expressive motifs – in 1917, "his golden year," as he called it. It was not only his most prolific year, but the year in which he established the formal fundamentals of his art: creatively worked them out in the Conventions. They were his basic innovation – the source of his expressive uniqueness. In a sense Burchfield was forced to be innovative, for there is no one, approved, completely reliable, and satisfactory way of communicating emotions – of representing them, and, above all, presenting their force and subtlety. Burchfield used the Conventions – simple, ecstatic pictographs – again and again in his art, endlessly

varying them but never changing them essentially. They were its unchanging essence and point of departure, its building blocks.

The Conventions make it clear that Burchfield was first and foremost a psychological artist – an expressionist and subjectivist as it were. And that is why he is relevant today, for expressionism has once again shown its durability – indeed, its centrality in twentieth-century art, even the core avant-garde "position" – as the new subjectivism of postwar German expressionism indicates. Thus, like Vincent van Gogh, Burchfield believed that art existed to articulate, in as transparent, direct, and immediate a way as possible, "fundamental emotions,"[6] or, as Oskar Kokoschka said, "the most intimate self where fear lodges,"[7] fear being the prevailing emotion for him.

This "turn inward" occurs, as Vasily Kandinsky said, "when religion, science, and morality are shaken … and when outward supports threaten to fall."[8] It is then that society becomes traumatic and seems to subvert the individual it is supposed to support. It threatens the individual's mental health and even physical survival, for it is no longer a facilitating environment. It becomes indifferent to the selfhood of the individual, who must learn to survive on his own, by means of the turn inward. This partly involves recognition and monitoring of the anxiety society arouses. Most of all the turn inward implies a critique of society from the perspective of inner life. Society is certainly not interested in the individual's self-understanding for it is a threat to its manipulation of him. Thus he can no longer trust society; he has to distance himself from it, and it has to be outwitted. The turn inward is not a gratuitous gesture of radical individualism, but is forced on the individual by a society that no longer supports him, but rather uses him. Simply to endure, he must have the illusion that his self can triumph over society. Burchfield's turn to nature was part of his turn inward. It was his way of distancing himself from, criticizing, and ultimately rejecting a society that offered him little or no emotional support, which is why it tends to look barren and gloomy in his pictures of it – all the more so in contrast to the richness of his representation of nature. Apart from his mother, nature was his only support, and it was his mother transfigured.[9]

Fear – above all, a traumatic sense of abandonment and isolation – is the basic response to a situation of lack of support or deprivation. Fear is the most fundamental emotion in Burchfield's art, the emotion that all the Conventions adumbrate one way or another. It is the most draining emotion of all, and the most difficult to master. Fear can never be controlled completely. It is no coincidence that Burchfield's Conventions were conceived in 1917, when America entered World War I. Whatever his personal emotional problems, the young Burchfield had good reason to turn inward, good reason to fear society: it threatened him with death. His depressions were a form of emotional death, but now he literally had death to fear.[10]

Burchfield's fear was no doubt intensified by the fact that he was born and raised in a small Ohio town, which offered religion – certainly not artistic expression – as the only public outlet for emotions. And, however much it acknowl-

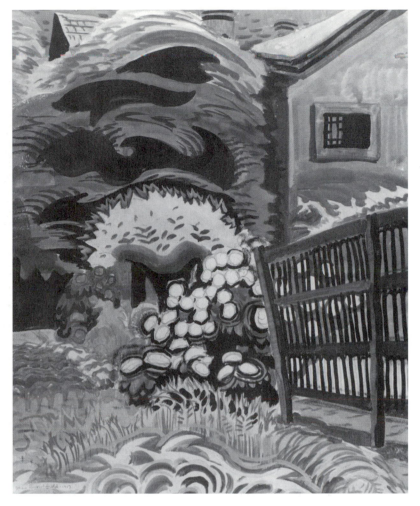

2. Charles Burchfield, *Noontide in Late May,* 1917. Watercolor and gouache on paper. 22 × 17 ¹⁵/₁₆ inches. (55.9 × 45.6 cm.) Collection of Whitney Museum of American Art. Photograph Copyright © 1999, Whitney Museum of American Art. Photograph by Geoffrey Clements.

edged them, religion tended to regulate them ruthlessly, for it prescribed a socially proper – in effect, procrustean – form for their expression. Thus it repressed emotions as much as it expressed them, for it was as rigid as they were fluid. Religion is not only the opium of the masses, as Karl Marx said (although I think the media now have replaced it), but particularly of the provincial masses. It is a vehicle of self-expression, but it dulls – indeed, insidiously undermines – the emotions it gives voice to, because it channels them through anonymous collective forms that ritualize and depersonalize them. Thus it stifles individual autonomy and authentic self-expression. Burchfield's problem was to find a personal form for the emotion of fear he felt in any collective situation, however independent of them it ultimately was.

But Burchfield's art is full of delirious elation as well as terror and fear. His excited pleasure at being alone in the presence of some tidbit of nature is palpable in his journals. He claimed that he felt at home – "perfect peace" – in the "midst of nature"[11] (Fig. 2). In fact, his deepest experiences of nature – peak experiences, to use Abraham Maslow's term – were highly ambivalent. At their most intense, they show a complex emotional process that amounts to a kind of conversion – the passage from an abject, anxious frame of mind to the joyous one of a person who has barely escaped death – as in a famous 1930 entry from his journal: "A tall dark pine tree stands by – I raise my eyes to the sky, fling wide my arms and pray to God to forgive me my sins, my lusts, my hideous thoughts, my cheapness … I fall on my knees – it is not enough – I fall on my face – press my forehead to the snow – at last the tears come – the wind roars past – I grow cold and I rejoice in being cold – I come away in peace."[12]

Burchfield clearly projects his feeling of guilt onto the ominous pine tree, which seems to overwhelm him, forcing him to his knees and finally flattening him on the cold earth. But when he is completely fallen, as though dead – when he feels completely at a loss, utterly futile – his spirit not only rebounds and rises up but his feeling completely changes. He is, in effect, emotionally reborn: he seems to become a fundamentally new person. It is this experience that is embodied in the form of the Conventions, that is, conveyed in and through their construction of contradiction. They show, with ecstatic simplicity, both the bad feeling and the good feeling, and the transformation of the former into the latter. In other words, the Conventions are emblems of Burchfield's apocalyptic mentality. We see it in action in his pine tree experience. It is this mentality that makes Burchfield's art freshly contemporary – eternally timely, not simply topically American.[13] Viewed through the lens of the apocalyptic expressionism of the German art that became prominent in the 1980s, Burchfield not only becomes relevant again – relevant beyond the provincial American Scene artists with whom he is usually associated – but all along seems to have had his finger on the pulse of modernity, which is through and through apocalyptic in its mentality, however subliminally.

Indeed, the violent yet subliminally utopian social revolutions that can be said to inaugurate and sustain modernity are apocalyptic thinking in action – massive evidence for an apocalyptic understanding of historical change. And so is authentically avant-garde art. In a sense Burchfield is, if not the very first avant-garde American artist – but who could be called authentically avant-garde in America before 1917 (even with the influence of the 1913 Armory Show)? – then the quintessentially American avant-garde artist.[14] For he seems to have instinctively understood – driven by whatever private suffering and need for personal expression – that to be original in modernity, art must turn inward to psychic reality, and that art was essentially apocalyptic in character.

Burchfield's Conventions – his avant-garde contribution – signal his recognition of this, that is, of the peculiarly conflicted, contradictory way the psyche worked. They show him tracing its apocalyptic pattern: frustrating, depressing, life-threat-

ening, annihilative bad emotion spontaneously changing into gratifying, joyous, life-affirming, self-renewing good emotion. The tension between the opposing emotions is never lost, even though one seems to disappear into the other, in an endless, apparently cyclic oscillation between the two. Thus, Burchfield came to understand, accept, and even welcome the apocalyptic rhythm of the psyche and embody it, by way of nature's pattern of temporal change, in what seems like religious metaphor: one must die to this world – it, in fact, emotionally crucifies or mortifies you – to be resurrected in a heavenly feeling.

To put this another way, one must be completely laid low emotionally to rise up confidently, "transcendentally." One's spirit must die completely to be re-created stronger and more determined to survive than ever. One must die to the alien world to recover a sense of self that seems independent of it to the extent of transcending it. This is the essence of the apocalyptic experience – apocalyptic self-transformation. Burchfield never lost his awe at its mysteriousness, even though he was convinced that he had grasped its contradictoriness in concentrated form in the Conventions. Indeed: they seem to intellectualize, even stereotype, apocalyptic change, even as they worship it.

The seemingly self-conflicted works of art based on the Conventions shred the obvious unity traditionally demanded of art and as such seem, at times, absurd and manic, beyond their distorted, even exaggerated expressivity. They are absurd from the everyday point of view, for it is blind to the apocalypse within and often enough without. The apocalyptic experience is at the core of authentic expressionistic art, and Burchfield is the first authentic American expressionist artist.

The apocalypse is perennial subject matter of religious art – "sacred" subject matter, because it bespeaks an immanent emotional logic – but secular modernity has stripped it of its religious trappings, in the process repressing consciousness of it while sociopolitically behaving in terms of it. The repressed does not have to return; for all practical purposes, it never left. It is in fact inescapable: the line from Albrecht Dürer's Apocalypse series to Burchfield's apocalyptic images of nature is more or less straight, whatever the difference in their mode of articulation – and, if one looks carefully, the details of Dürer's images are not dissimilar to those of Burchfield's Conventions. But the important point is that Burchfield's art not only links up with the apocalyptic mainstream of twentieth-century art, but dramatically began what became climactically self-evident in the paintings of Barnett Newman, Mark Rothko, and Clyford Still: the projective representation of the apocalyptic mentality in the starkly basic terms appropriate to its contradictoriness. (The apocalyptic mainstream sprang from van Gogh and Edvard Munch, and became a torrent in early and late German Expressionism and American Abstract Expressionism. In fact, apocalyptic experience, unconscious or conscious, inspires every avant-garde innovation, from Cubism through Robert Smithson's earth art. The hedonism of most French art is a defense against the potentially overwhelming, disintegrative feeling of apocalypse, which is why French art is generally preferred and regarded as "superior" to German art.)

If Newman's *Stations of the Cross* are the ultimate abstract statement of apocalypse – despite their regressive, biblical title (for to be genuinely modern means to articulate every truth of the emotions without mythologizing them and without cultural crutches, in acknowledgment of Kandinsky's insight that society is no longer supportive and credible) – then Burchfield's representations of nature are the seminal, inaugural American statement of the apocalyptic mentality. (To my mind, they seem more authentically and spontaneously apocalyptic than Newman's works, which tend to look manufactured and all too stylized or aestheticized.) Apocalyptic, annihilative anxiety and the wish for rebirth lurk within the sublimity of nature as well as the abstract sublime. Indeed, Anselm Kiefer's apocalyptic landscapes, which ironically fuse annihilative anxiety about both nature and society and the wish for their rebirth with the nothingness of the abstract sublime, share with those of Burchfield and Newman belief in the problematic future of the human figure. All three eschew it – in Kiefer the human figure tends to be a token of self-representation – as beside the point of the ongoing apocalypse in the human psyche, and in the world.

Burchfield's method of articulating the apocalyptic experience – it is the formal method of the Conventions – bespeaks its character: his works are constituted by a more or less rapid oscillation, which at first glance looks like an interpretation, but in fact is a dynamically stark contrast – between light and dark and sharp, tight angle and long, sweeping curve. For example, the formal center of *Starlit Woods* is the angle formed by the converging black tree trunks and the light that floods it, as well as, secondarily, the star it points to. This abrupt contradiction in the background is matched by that of the foreground growth and, perhaps most transparently, the ground-level opening in the large middleground tree. The pinnacle of the curved black opening – it looks like a dead volcano – is a sharp angle, and its blackness is fringed with light. The Manichaean play of light and dark, curve and angle – the former emblematic of manic elation and erotic, integrative life-affirmation; the later of trauma and anxiety (an angle is a break, confirming the brokenness, indeed, "emotional" rottenness of the tree, which is a kind of living death) – is an obsessive constant in Burchfield's art. The more compulsively repeated, the more intensely expressive his works. And he is compulsively repetitive: on the micro level, every one of his works of any expressive consequence has an amazingly consistent structure, although I haven't the space to demonstrate that here. I can only note that as late as 1951, as *Wind-blown Asters* indicates, Burchfield's clouds and terrain in general are constituted of more or less rapidly alternating curves and angles, ritualistically integrated into an almost ornamental, decorative pattern, suggesting its staying power and inevitability – eternal verity. Even though this work is more light than dark, the flashes of dark are foreboding and violent, suggesting the imminence of an apocalyptic storm – a seeming psychotic break with reality that allows access to what has been called the psychotic core of the psyche.

Nature, then, is the objective correlative of Burchfield's apocalyptic emotions, that is, the emotions that are traces of the apocalyptic "conversion" experience of the self. This has been conceived religiously – Burchfield himself does so – because it is eschatological in import, but that is misleading, for the eschatology involved has to do with perennial psychoexistential issues, as Daniel Bell suggests.[15]

We are ripe for a rethinking of Burchfield's art, because at the *fin de siècle* – indeed, at the end of a millennium, in which civilization has more or less survived (haphazardly and less rather than more) – our mind tends to turn to the apocalypse, as both an idea and feeling. The expressionist artists of this century, particularly the German ones, have let us know that, in fact, the apocalypse has always been in process. It is always occurring: it is now. We are always neurotically moving between bad and good emotions: fear seems to return as fast as it becomes joy. That is, there is always an apocalypse in the psyche. Perhaps Freud is right: we should be striving for the in-between state of normal unhappiness. But Burchfield didn't think so – even though, for a short while, he represented it in his industrial landscapes – or else couldn't abide it, perhaps constitutionally. He was made for the apocalypse, and he survived it numerous times, as his images of nature, at every season of the year and in every mood, indicate.

Burchfield did not inflate nature with his personal apocalypse, but experienced nature as testimony to it. He seemed to have endured a daily apocalypse and experienced it in nature. No doubt this unconsciously made him feel one of the elect Mark alludes to in the first of this essay's epigraphs: one of those sensitive human beings who made the apocalypse more bearable for others. And perhaps even more remarkably, a person who could remember the old heaven and earth even as he experienced the new ones: a person who could never forget. Perhaps this made Burchfield feel like God, destroying and creating heaven and earth in a single, cosmic picture. The German Expressionists and the avant-garde masters in general no doubt developed similar delusions of grandeur as they endlessly repeated their traumatic sense of apocalypse triggered by modernity. It probably made them feel less victimized by their apocalyptic sensibility. But Burchfield was the first to realize that the attempt to master and mitigate the apocalypse inside oneself and in the world is a Sisyphean repetition, which makes it all the more ironically emphatic.

Soutine's Shudder

JEWISH NAIVETÉ?

Sophisticated reflection is what art requires. Art can do without *naiveté*. Or can it? Aesthetic consciousness must not allow its experience to be regimented by what happens to be the cultural norm. Rather, it must preserve the faculty of spontaneous response, including response to avant-garde schools. No matter how deeply the individual mind may be mediated by society and the prevailing objective spirit, it is still the only organon of self-reflection and expansion available to spirit. Thus, while a totally ingenuous person ends up being blind to art, the perfect sophisticate is even more narrowminded in that he invariably accepts what is foisted upon him.

<div align="right">T. W. Adorno, Aesthetic Theory</div>

O NE SEES, IN A SOUTINE PICTURE, THE SAME INTIMATE THING, OVER AND OVER again: an ordinary object – the human figure but also, famously, a dead animal, its bowels sometimes exposed, or else a landscape or still life – precariously set in space. The object itself seems a precarious space – inwardly unstable, as its distorted appearance, latently grotesque, suggests. It holds its own, however unestablished it is in itself. We are claustrophobically close to it, and it threatens to impinge upon us, sometimes seems to erupt or thrust toward us, as though determined to impress its presence on us – to force us to engage its being with the depths of our being. Whatever it is, it wants to make itself felt. The picture is painted with vigorous, often slashing strokes, making the object all the more tangible and dissonant. It is painted with a turbulent intensity and "intuitive power," with "seemingly uncontrolled but immensely descriptive brush gesture," which has led H. H. Arnason to claim that Soutine "is closer than any artist of the early twentieth century to the abstract expressionists of the 1950s."[1]

The existential character of the image and the expressionistic vehemence with which it is painted – the apocalyptic excess, at times verging on lurid extravagance, which outdoes in "violence," as Arnason said, "anything produced by the fauves or the German expressionists" – converge, creating a sense of what T. W. Adorno calls "shudder": "Shudder is a kind of premonition of subjectivity, a sense of being touched by the other."[2] And, more crucially, "without shudder consciousness is trapped in reification. ... The subject is lifeless except when it is able

to shudder in response to the total spell." What we see in a Soutine picture is the subject's shuddering – or a symbol of the subject, be it animal, landscape, or still life, shuddering in recognition of its isolation, forced back on a desperate minimal expression of being subjectively alive. Shudder is unsophisticated, involuntary, uninhibited by reflection, a kind of signal anxiety, as Freud called it, indicating the subject at its wit's end, almost at a complete loss: shudder is the witless life-affirmation that is the subject's last defense against depression, a prelude to psychic death.[3] Shudder is the least, the most basic form of spontaneity, and as such the ultimate naiveté – *defiant* naiveté – in the face of the spell.

"The spell," Adorno writes, "is the subjective form of the world spirit, the internal reinforcement of its primacy over the external processes of life."[4] It is "the basic stratum of unfreedom" that exists in each of us, and our submission to that unfreedom as our destiny – the acceptance of the negation of our subjectivity as unavoidable. We internalize the objective world spirit, identifying with it – "men become that which negates them, that with which they cannot cope" – and carry it forward in our own existence, and at the expense of our existence. But if we did not do so – if we did not accept the yoke of "social mediation," the collective's definition of us – we would have no existence, no definiteness: we would be rank subjectivity – rank naiveté. We would be nothing but shudder if we did not become what D. W. Winnicott calls compliant false selves.[5] At their best, Soutine's expressionistic paintings are nothing but shudder.

Their shudder – their unembarrassed naiveté and spontaneity, for all the museum "learning" that supposedly went into them – is Jewish. The uniqueness of Soutine has to do with his rendering of this Jewish shudder, at once acknowledging the yoke of the world spirit on the Jew – indeed, the Jew embodying all the restraints, or negation, imposed on subjectivity by the objective world spirit (a literal embodiment, for Soutine shows us how the world spirit's distorted view of the Jew's body – the first ego, as Freud reminds us – has damaged it, threatened its very existence, and how this annihilative distortion has been internalized and re-externalized by the Jew). Soutine also shows us the Jew throwing off the world spirit, in a desperate attempt to restore a sense of the body's subjective aliveness, and ultimately its capacity for what Gilbert Rose calls "feelingful awareness," the integration of "affect with thought and perception" that alone "makes experience 'come alive' with fresh sensuousness and emotion."[6] Soutine gives us fresh sensuousness and emotion – bodies and beings full of feelingful awareness – but he also gives us the shuddering of the body that is on the verge of being destroyed, subjectively if not yet literally – but sometimes already literally destroyed, as though Soutine was a prophet of the Holocaust, reading in the Delphic entrails of his animals or in the catastrophic aura of his landscapes (Fig. 3) the dead future that his death in 1943 seemed to signify.

How, in detail, does Soutine construct his expressionist shudder, the Jewish shudder? And why should we call it Jewish – indeed, an especially miserable sign of outcast Jewishness? Why can one say, without hyperbole, that Soutine pictures,

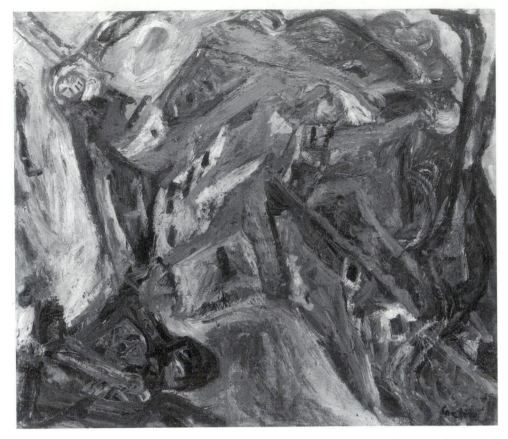

3. Chaim Soutine, *Village Square, Céret,* ca. 1921. Oil on canvas. 29 $^1/_8$ × 33 $^3/_4$ inches. Henry and Rose Pearlman Foundation, Inc. Photograph by Bruce M. White.

metaphorically, the Jew at psychic death's door, shuddering in the ghetto – the symbol of Jewish unfreedom, of Jewish negation by the world spirit, which takes the form of exclusion from it?

Soutine was a shtetl Jew, born in the Lithuanian village of Smilovitchi, "the tenth of eleven children of a pitifully poor Jewish mender" (as distinct from a tailor), at the bottom rung of the shtetl "social ladder," as Maurice Tuchman tells us.[7] This already was to be something of an outcast – within the Jewish world itself as well as in the collectivity of the world spirit. But Soutine was also an outcast because, naively, he wanted to be a painter, and, as two of his older brothers told him: "A Jew must not paint." Soutine was beaten over and over again by them, and ridiculed by his family, for the "crime" of wanting to be a painter. He was a Jew, guilty not only because he belonged to the people who killed Christ – which is presumably what excluded them from the world spirit – but because in wanting to paint he was un-Jewish. And, yet, all he could paint was his experience of Jewish being – the "sadness, misery and suffering" of being a Jew. Indeed, "he staged a Jewish burial," shrouding a friend with a white drape and surrounding him with candles, and drew the scene.

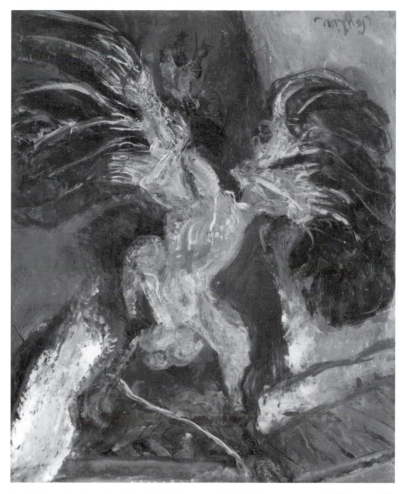

4. Chaim Soutine, *La Dinde Perdue*, ca. 1926. Oil on canvas. 37 $^3/_4$ × 28 $^3/_8$ inches. Henry and Rose Pearlman Foundation, Inc. Photograph by Bruce M. White.

Soutine's "shtetl conditioning," as Tuchman calls it, shows itself explicitly in his "famous images of hanging, splayed fowl," apparently in motion (Fig. 4). They derive from "a shtetl custom with which Soutine would have been familiar," *kappores,* or the so-called "whirling of the fowl," in which a "psychological scapegoat" is used in a "ritual of absolution" that took place "on the morning of the Eve of Yom Kippur – the Jewish Day of Atonement." Tuchman quotes Mark Zborowski and Elizabeth Herzog: "The fowl ... is whirled about the head of the penitent, with an appropriate prayer" and "consumed by the family at the [post–] Yom Kippur feasts," presumably a more civilized (and less wasteful) event than sending the goat originally used in the ceremony out into the desert to die after it was beaten. Tuchman thinks that "the uniformed domestics and servants Soutine began painting during the same time he painted the fowl" were also scapegoats, not just of society but of shtetl society: "servants ... were regarded with disdain in

the shtetl." Their meaning was even more complexly Jewish for Soutine: like Jews, "their identity is determined by their social role [place] rather than through their individual personalities." Tuchman argues that Soutine's early *Dog and Forks* painting reflects shtetl superstitition and sadism; that Soutine's pictures of food – or of animal carcasses on the way to becoming food – reflects shtetl fear of hunger, which gave food a sacramental meaning; that even Soutine's choice of such tabooed Christian subjects as "choir boys, page boys, communicants," however rebellious and provocative, reflect shtetl paranoia; and that Soutine's "emotional expressiveness" in general and "expressions of vitality" in particular reflect the "high value" placed on them in the shtetl. As Tuchman writes, "Soutine was twenty years old before he fully left behind him the culture of the shtetl." It cannot have helped but leave its ambivalent mark on him: ambivalent because of its own ambivalence toward life – the strange synthesis of life-instincts with death-instincts that pervaded it – and because of its rejection of Soutine because he was a painter as well as the member of a family from the lowest "class" in the shtetl.

What instinct – what will to self-preservation and individuality – made him want to become a painter and escape the shtetl, even if he could never do so emotionally? It was clearly spontaneous and life-affirming, and yet it reflected the double shock of living in the shtetl and being a pariah in it – being rejected by social rejects. Soutine's shudder is a sublimation of the trauma of being born a lowly shtetl Jew and becoming an absurd Jew – not a real Jew – by becoming a painter, which, after all, expressed the wish to escape the shtetl. He became something that it was impossible for a Jew to become, especially a shtetl Jew, and thus dared express the Jew's most secret and forbidden wish – secret and forbidden because it could never be granted: the wish to live in and be respected by the non-Jewish world, where life was presumably more positive than it was in the shtetl. Soutine was socially damned as a Jew, damned within the ghetto as the lowest kind of Jew, and damned for being a Jew who painted and so was not quite kosher. (Did Soutine get carcasses in kosher butcher shops?) Trauma compounded is living death intensified, and Soutine's shudder is his desperate transcendence of living death – about as successful as he could subjectively be in expressing his instinct for life. He was caught in a quicksand of contradictions: he had only his art – a spontaneous, massive shudder at the folly of his Jewish existence and Jewish existence as such – to comfort him, but it threw Jewish existence back in his face, as though to punish him for attempting to undo it, at least externally. Soutine's expressionistic shudder shows him conflicted about being a Jew – caught between Jewishness, which was oppressive in itself and doubly oppressive in the shtetl, and artistic spontaneity, which was liberating, even if a kind of naive reaction formation against Jewishness.

Soutine remained an expressionist to the bitter end – long after expressionism had been domesticated (occurring as early as Matisse's schematic, calculated, almost formulaic *Luxe II,* 1909, which has lost the naive, spontaneous, intuitive look of *Luxe I,* 1907[8]) – because he inwardly remained Jewish to the bitter end.

Adorno has argued that it is "mistaken ... to classify expression as an aspect of subjectivity," for what "dwells in expression is externalization, the non-I, ultimately the collectivity," that is, the domineering world spirit.[9] Expression acknowledges its absolute power. At the same time, "expression already points to the existence of a rupture" in the collectivity, a limitation of its power, and with that to the "self-consciousness" of the subject – to the subject's consciousness of his place in the collectivity, and of its disastrous effect on his subjectivity. Expression is thus, after all, not only a sign of abject dependence on and submission to the objective world spirit, but also "independent, i.e., an expression of the subject," more particularly of its cathartic attempt to deny the collectivity complete power over itself.

This, ultimately, is why expression is naive, and why at its most extreme expression is a shudder on the verge of becoming a scream.[10] The scream represents complete subjective rupture from the collectivity – a demonstrative moment of helpless autonomy – while the shudder marks the more covert rupture initiated by the subject's spontaneous recognition of the collectivity's objective power over it. Shuddering consciousness is already informed with the subject's determination to maintain its vitality despite the deadening effect of the objective world spirit on it, that is, the world spirit's power to objectify the subject entirely in collective terms. The subject registers that power of objectification as depression, but also resists it with elemental spontaneity: the shudder contains both the depression and the saving grace of spontaneity, in whatever tangled form. Where screaming consciousness is a kind of last-ditch, all but exhausted spontaneity, and unwittingly surrenders to the collectivity – its outrage expresses its sense of futility, and thus is a kind of self-abandonment – shuddering consciousness, which contains in itself the possibility of a more expansive, joyous spontaneity, is a cunning form of will power. The subject's spontaneous shudder demonstrates its refusal to be self-defeating, however much the objective world spirit, in the form of collective ideology, may in historical fact defeat it.

Soutine's paintings are somewhere between shudder and scream – the alpha and omega of spontaneity – sometimes more one, sometimes more the other. They are in constant pursuit of what Clement Greenberg called the "maximum of expressiveness," which is, among other things, what bothered him about them.[11] They were too subjective, "dreamlike": their "unimpeded expression of feeling" made them "more like life itself than like visual art." As such, they were naive – radically naive – for they confused and mingled different orders of reality, assumed continuity between life and art when art, to be itself, had to be discontinuous with life. For Greenberg this meant that Soutine's paintings were "exotic and ... futile": "only an outsider could have thought it possible" to "overpower the medium" for the sake of "expressiveness," that is, in order "to move us" even more deeply than we are ordinarily moved in life. However much Soutine's paintings had "the directness of 'pure' painting," they lacked the discipline necessary to practice it properly – to achieve "reassuring unity" and "decorative ordering." The word "reassuring" is telling. Soutine's paintings are not reassuring; indeed, they were disturbing to

Greenberg. They were simply too evocative: their "vehement, almost brutal, yet always eloquent, hardly ever less than completely felt touch" was simply too heart-felt – unrepressed, egoless (aesthetic unity was the sign of ego control) – for him. Soutine was simply too emotionally unsafe and unsavory for Greenberg.

Paradoxically, Greenberg also thought that Soutine was "a victim of the museum," that he "turned his back on Cubism and refused ... to like anything but the Old Masters" (whatever his debt to Van Gogh). One would have thought that meant Soutine had some sophistication and discipline, however much it was not the most up-to-date sophistication and discipline – however much "Old Master pathos and naturalism" did not suit Greenberg's programmatic, not to say tendentious, sense of art history. But, of course, as Greenberg reluctantly realized, Soutine, however much he may or may not have learned from Old Master painting, never lost his naive spontaneity. The Old Masters had nothing to teach him about the expression of feeling. In fact, he could teach them a thing or two: he was freer and deeper – more intense – than they were, because he was Jewish. That is, he had directly experienced the world spirit's power to negate subjectivity – it made no secret of its hatred of Jewish subjectivity – and thus had been forced to become aware of his subjectivity. This subjectivity had to be defended and preserved, and to do so all its secrets – feelings – had to be known, as if they were places in which he could hide from the world spirit. Thus Soutine was wary of the world spirit, if subliminally thankful to it for making him aware of his subjective existence, while the Old Masters took it for granted that their art spoke for the world spirit, and that their subjectivity correlated with its objectivity.

Moreover, the art of the Old Masters suffered from socially mandated stylistic and narrative inhibitions, which limited feeling in the act of containing it for the sake of propriety. Pathos and suffering were more signaled than expressed – lived – in their pictures. Soutine could show them depths of feeling they were hardly aware of, or only hinted at perfunctorily. For Soutine, the Old Masters became, at most, a new opportunity and vehicle for spontaneity. At best, they suggested expressive heights still to be scaled, expressive possibilities still to be explored, expressive nuances still to be developed. In short, they could catalyze but not instruct Soutine's spontaneity. Tintoretto and El Greco, Rembrandt and Courbet changed nothing fundamental. They did not make Soutine more of a master – less naive; in fact, it was the intuitive core of their art that he appreciated. Soutine may have been regressive from the perspective of Greenberg's conception of artistic progress, but his expressive art was more radical and fresh than any that preceded it, and as such was humanly progressive.

Elie Faure speaks of Soutine's "instinctive virulence" – typically Jewish for Faure – and of his "tragic vision," connecting his work to the ghetto and describing him as a "religious" painter.[12] Similarly, Waldemar George speaks of the "stamp of melancholy" on the "emaciated faces" of the "children of the ghetto" Soutine paints.[13] More extravagantly, Maurice Raynal describes Soutine's art as:

the expression of a kind of Jewish mysticism through appallingly violent detona-
tions of color ... all those distorted, devastated ... landscapes, all of those appalling,
inhuman figures, treated in a stew of unheard-of colors, must be regarded as the
strange ebullition of an elementary Jewish mentality which, weary of the yoke of its
rigorous Talmud, has kicked over the tables of the Law, liberating an unbridled tem-
perament and indulging at last in an orgy of criticism, destruction and reconstruc-
tion of Nature – cursing the while, and cursing very copiously, its Creator.[14]

What Andrew Forge saw as a failure of "the classical" – "distinguishing clearly
between one thing and another"[15] (which meant to recognize and accept their
separateness) – and thus as hopelessly romantic, Raynal saw as appallingly Jewish.
Soutine's whirlpool of paint and distorted figures signified for Raynal Jewish self-
conflict, exasperation with God, and martyrdom at the hands of the world spirit.
But also the refusal not to be restrained by it.

The Jew is, indeed, appalling to the world spirit, because he embodies its neg-
ativity – its power to distort existence. Its violent wind bends the lone pine until
it can no longer grow straight. It shows the violence in its distorted shape. The
Jew is appalling because he is depressed – "melancholy," to use the polite word
the genteel critics use – and distorted. Depression and distortion go together:
the Jew is distorted by depression, and depressed by the world spirit's distortion
of his existence – the violence it does his existence. Society deceives itself into
believing the distortion is objective: after all, it is apparent in the face and body
of the Jew. Thus, the Jew has good reason to be depressed: he was born mis-
shapen – a natural "misfit." The world spirit did not inflict anything on him he
did not deserve. It is ultimately Soutine's "tragic" distortion of the body,
whether human or animal or vegetable, that Greenberg, Raynal, George, Faure
find appalling – depressing – and repugnant. (Greenberg no doubt all the more
so because he doesn't like the body in art, for it invariably reminds one of the
body in life.)

When Raynal repudiates Soutine's painting – while finding its energy and dis-
tortions fascinating, almost irresistible – because it does not follow "French tradi-
tion," that is, "defies all measure and control," he asserts that French tradition
represents the world spirit in art, that is, that it has objective, authoritative power
within the scope of art history. For Raynal, it is inherently superior to Soutine's
Jewish painting, which to him is some grotesque anomaly, little realizing that it is
French tradition – self-described as "classical" – that created Jewish painting by
default, for it declared that Jewish existence by definition is distorted, that is, lack-
ing measure and control. Because the Jew lacks rationality by nature, Jews and
their art in this view are necessarily irrational – virulently irrational – which
makes him all the more cursed and unwholesome. The Jewish Soutine is in touch
with his instincts – which seem immeasurable and uncontrolled – in a way a
French artist could never be, and would never want to be, for measure and control
are automatically part of what it means to be French.

Similarly, Werner Haftmann writes that Soutine "belongs to the tradition repre-
sented by Nolde in Germany, Kokoschka in Austria, De Pisis in Italy, and the early
Vlaminck in France ... but what clearly distinguished him from [them] is the spe-
cial 'tonality' of his vision – the unmistakable Jewish strain."[16] Haftmann asserts
that Soutine's expressionism is anomalous because it is Jewish, while mainstream
expressionism, essentially Germanic in spirit, is the real thing. "The manifesta-
tions of decline and decay" that Haftmann professes to find in Soutine's paint-
ings, and that supposedly "disclose a new, strangely melancholy beauty," are in
his view symptoms of Jewishness. They contrast with the vigor of Germanic
expressionism; whatever melancholy it may have is overcome by aggression,
while Jewish melancholy is a sign of passivity – acceptance of fate, which leads to
decline and decay.

Whichever way he turns, the Jew is out of it, signaling something abhorrent,
negative: for Raynal the Jew is all too instinctive, for Haftmann all too melan-
choly, and both are the wrong thing to be. Neither has any sense that Soutine's
"instinctive" distortion and "melancholy beauty" have anything to do with the
world spirit's effect on him – with French and Germanic negation of the Jew.
Haftmann does not realize that to call Jewish melancholy beautiful is to white-
wash and justify the world spirit that made the Jew melancholy, and Raynal does
not realize that to call the Jewish temperament unbridled is to excuse the world
spirit's attempt to bring measure and control to it – to humble it – by confining it
in the ghetto. Neither realizes that his analysis of Soutine's paintings is anti-
Semitic.

The term *peintre maudit,* as applied to Soutine as well as Chagall, Modigliani,
Pascin, and Moise Kisling, is a condescending lie and evasion, showing little
understanding of what it labels. Christian art historians have no comprehension
of the Jewish suffering behind it. To call it "questioning melancholy," as
Haftmann does, is to whitewash that suffering, and ignores the fact that the
melancholy was created by Christian anti-Semitism and that the questioning is a
self-questioning induced by virulent anti-Semitism as well as a questioning of the
professed compassionate Christians who practice it. "The breakdown of the regu-
lation of self-esteem [is] a universal feature in depression," according to psycho-
analytic theory, and it is this breakdown that we see in Soutine's figures, who are
all Jews, actual or honorary. Depression involves self-criticism – the feeling that "I
am a failure" – and guilt – the feeling that "I am bad and deserve to be punished."
"Depression follows a narcissistic blow" – world history administered it to the Jew
– that can "evolve to a mood state."[17] It is this complex mood of depression that
is responsible for the so-called "melancholy beauty" of Soutine's paintings. It is
beautiful only for Christians, who want to deny their responsibility for it – who
want to rationalize it away, turn melancholy into a modifier of beauty rather than
a substance in itself.

In short, Soutine's figures convey a sense of failing themselves – a distorted
sense of self – when it is world history that has failed and distorted them. From

the 1921 *Praying Man* (a lot of good his prayer will do him), the 1922 *Little Pastry Cook,* and the 1923 *Self-Portrait,* to the many portraits of women and children, Soutine paints a human panorama of depression and its distorting effect on the self. The Céret landscapes are also consistently distorted, but in them, as in many other images of nature, distortion becomes manic. They represent a manic denial of depression, however much they show the depression the mania defends against.[18] Through a process of projective identification, Soutine transfers the substance of his subjectivity to nature. His explicitly dead – tortured, torn – animals show this identification at its most urgent and desperate, as if his sacrifice of these animals on the altar of his art meant that he might not have to sacrifice himself. What Raynal calls unbridled temperament, detonation, and destruction – what might be called wildly "polymorphous perverse" painting – is essentially manic. It is the Jewish "shudder" carried to a manic extreme – the shudder that cannot be stopped, because the Jew cannot stop being a Jew. (He may want to, by becoming a painter, but the Jewish shudder informs his painting.)

Soutine's subject matter is, in fact, depressing. There is no doubt an element of persecutory guilt in both the subject matter and the painterly shudder that seems to shape it, and perhaps also a touch of depressive guilt – a sense of "reconstruction," to use Raynal's word, or of "resurrection," to use Arnason's religious word. But, to my mind, the death-instinct and mourning (expressed through persecutory guilt) dominate the life-instinct and libidinous rebirth (expressed through depressive guilt), in Soutine's painting.[19] Soutine's exciting colors may be profoundly libidinous in import, but the bodies they embellish are not altogether enlivened by them. The bodies are dead, whether ostensibly alive or not; the animals are ostentatiously dead, however much they flourish with colors. It is as though the colors distract us from the depressing character of the bodies, however evident that depression is in their inertia – their advanced state of entropy, whether physical or emotional. The manic colors struggle to change them, to bring the bodies to life, but they remain essentially static and unchanged.

What is the significance and value of Soutine today? If, as Max J. Friedländer wrote, "the rule of theory always rises in proportion as creative power falls,"[20] then Soutine's visionary painterliness shows us how much higher than theory creative power can rise. If, as Arthur Danto writes, progress in art means that "the objects [of art] approach zero as their theory approaches infinity"[21] – a clear signal of art's pathetic dependence on philosophy, and philosophy's arrogant claim that "art is really over with, having been transmuted into philosophy"[22] – then Soutine shows us that it is possible to make works of art that approach infinity, materially and emotionally, and thus have no need of theory to justify their existence. If this means they are regressive from the point of view of philosophy, they are progressive from the point of view of the imagination. Soutine's paintings are maximal rather than minimal – expansive rather than reductive: theory does not censor or co-opt imagination in them. As Gaston Bachelard writes: "The imagination does not want to end in a diagram that summarizes acquired learning. It

seeks a pretext to multiply images, and as soon as the imagination is interested in an image, this increases its value." The result is an "absolute image that is self-accomplishing" rather than "a post-ideated image that is content to summarize existing thoughts,"[23] which is what art under the rule and thumb of philosophy – it, like Christianity, claims to speak for the world spirit – becomes. It may be that Soutine turned to the Old Masters because their images seemed absolute and self-accomplishing, proof of their roots in spontaneity – in the shudder.

In short, Soutine proposes that we revalue imaginative painting, which has been devalued by philosophy. In an age of repressive theory – philosophical sophistication – they hold up the ideal of expressive spontaneity – radical naiveté. "A philosopher," writes Bachelard, "often describes his 'entry into the world,' his 'being in the world,' using a familiar object as symbol. He will describe his ink-bottle phenomenologically, and a paltry thing becomes the janitor of the wide world."[24] The result will be words "tarnished through over-frequent philosophical use." In Soutine's painting a very different kind of paltry thing gives us entry into the world – shows us what it really means to be in the world: the shtetl Jew, whose suffering and spontaneity, condensed into a violent shudder, can never be reduced to theory. The shudder always remains fresh beyond the stale words of philosophy. Thus Soutine's paintings show that Jewishness can be an important resource for art, since art can objectively be itself only when it is full of negation and subjectivity, as Adorno argued, and Jews have long experience with negativity, that is, with the subjective effect of being negated by the world spirit. Through his Jewish powerlessness, implicit in his subject matter and explicit in his crazed painterliness, Soutine understood the world spirit's power better than it understood itself.

THREE

Picasso's Portraits and the Depths of Modernism

CONSENSUS HAS IT THAT PICASSO IS THE GREATEST ARTIST OF THE TWENTIETH century, and that his portraits – especially his early Cubist portraits – are among his greatest works. As though to confirm this judgment, now that the century is drawing to a close, the Museum of Modern Art in New York has staged "Portraiture and Picasso: Representation and Transformation." It is a truly stunning exhibition of the range of Picasso's portraits over the course of his long development – a selection of 130 paintings, 100 works on paper, and a plaster relief, all testifying to his creative rendering of the self. But the daunting grandeur of the exhibition – its almost overwhelming abundance of works, testifying to Picasso's seemingly limitless capacity for innovation and metamorphosis – should not blind us to the problem it raises about Picasso and above all modernist portraiture: was he really sufficiently interested in others to render their inner life – sufficiently related to empathically comprehend them – or were they simply an excuse to make art, that is, simply another subject matter to be conquered and colonized by style?

William Rubin, the exhibition's curator, notes that "Picasso's tendency, from Cubism onward, to represent men and women as generic types only intermittently particularized by the addition of individual traits might be taken to reflect more general psychological attitudes. To some extent, he may have seen actual men and women as actors who could be cast in one role or another of his private psychodrama." But is Picasso's seemingly effortless "oscillation between Neoclassicism and Cubism" – sometimes within the course of producing one work, as in the case of *Woman in an Armchair* (Olga), July 29, 1920 – the result of unconscious psychodrama, or does it demonstrate Picasso's acute consciousness of the drama of style, that is, the different, seemingly infinite variety of formal possibilities and expressive effects that can be achieved with each and every style?

Picasso is always stretching the limits of seemingly limited styles by bringing alien styles into them: heightening the contrast, tension, and battle between seemingly incommensurate, polarized styles, in an effort to resolve as well as

exploit their differences, seems to be his main ambition. He is determined to show that parallel stylistic lines can meet in the infinity of his limitless creativity. Creativity can bring together what is separated in and by history: Picasso may have been the avant-garde enemy of tradition in his early Cubist period – which increasingly seems like a brief moment in the totality of his development – but thereafter he tried to reconcile tradition, represented by Neoclassicism, and avant-garde art, be it Cubist, Expressionist, or Surrealist. This was not simply a matter of traditionalizing avant-garde art, or avant-gardizing traditional art, but of integrating the two in a new, seemingly incomprehensible unity – of striking a balance between them which would create a new sense of the wholeness of art, and, one might add, give it a new kind of wholesomeness, to replace the wholesomeness and wholeness it lost in modernity. This was the Herculean feat Picasso attempted, and at times appeared to have achieved.

Picasso's tendency to dramatize, then, has more to do with his concern to articulate and resolve the drama that lurks within every style than with his recognition of the inner drama of human life. Thus, his portraits stage different styles, not different people. Paradoxically, they tend to get reduced to undifferentiated – generic – types, while the styles in which they are rendered become more and more differentiated and complex. For it is the styles that are being rendered and explored, not the people. It is the styles that are being treated in a human way, while the people are being treated inhumanly – as nothing but examples of different styles. I think Picasso renders the styles in an all too human way to allow him to "operate" on them – work them out – in greater detail and ease, as though each style had the complexity and familiarity of the human body and person. He transposes that complexity and familiarity into the style, while at the same time, by demonstrating style on a human scale, shows its mysteries and dynamics more clearly. The basic point is to show the drama of style, not of people: by reducing people to the terms of style, and, simultaneously, dressing style in human form – by giving artistic form human form and vice versa – Picasso neither humanizes style nor stylizes humanity, but brings "transcendent" style down to earth. In his portraits Picasso in effect personifies style, so that it seems less mythical and more accessible.

I am suggesting that Picasso's obsession with style overrides his use of other people to express his private feelings. The case the exhibition wants to make is that Picasso transformed the portrait "from a purportedly objective document into a frankly subjective one," in part reflecting his own particular sexual issues, in part reflecting twentieth-century awareness of depth psychology. But depth psychology respects the humanity and particularity of the individual, however much it understands him or her in terms of certain dynamic universals, while Picasso, in using other people as tropes for his own feelings, shows little understanding or respect for their humanity and individuality – or, for that matter, his own feelings, which he simply enacts through his portraits, stereotyping both his feelings and their subjects in the process. Thus, on January 21, 1939, he painted

two portraits, one of Dora Maar, the other of Marie-Thérese Walter, both of whom he was involved with at the time. The portraits contrast not only two types of women, but two styles and two attitudes, to the extent of typecasting – "generi-cizing" – all three: one has a sense that the women are simply occasions for the articulation and elaboration of the styles and attitudes, as though Picasso was more interested in nailing them down than rendering the women, whatever his feelings toward them are.

But, paradoxically, this genericizing tendency shows his depth and greatness, and the depth and greatness of modernism at its best – Picasso's modernism – is capable of: it dispenses with the individual, and his or her particular humanity, in order to get at the psychologically inevitable and fundamental, which it trans-poses to stylistic terms. The greatness of Picasso is that he was able to work in both the protean terms of primary process, which is represented by the variety of avant-garde styles – full of the false reconciliations of metaphoric condensation and ironic displacement, and tending to render human being as a composite of part objects – and simultaneously the rational terms of secondary process, which is represented by Neoclassicism, which conveys stability, wholeness, and integrity, that is, human being at its most ideal. More particularly, Picasso is able to work both – often simultaneously – from the paranoid–schizoid and depres-sive positions, in Melanie Klein's terminology. That is, sometimes he enviously – destructively – scoops out, devours, and pathologizies the being of those he por-trays, regressively reducing them to a bizarre agglomoration of part objects in the process, and sometimes he restores them to wholeness and self-containment. The former is associated with a de-idealizing avant-garde process and method of art making (Fig. 5), the latter with a traditional, "classical" process and method of idealization (Fig. 6). Picasso is in effect representing or illustrating the paranoid-schizoid and depressive positions – the fundamental attitudes of our being – by way of his intense engagement with his female objects. In the former position he destroys that object, in the latter position he renews it – "neoclassicizes" it, as it were. *Seated Bather* (Olga), 1930, and *Portrait of Olga,* 1921 – the back and front images on the exhibition catalogue – are, respectively, examples of the former and latter positions, while such buoyant images as Marie-Thérese as *Bather with Beach Ball,* 1932, reconcile traditional and avant-garde styles under the auspices of the depressive position, and *Seated Nude* (Jacqueline), 1959, reconcile them under the auspices of the paranoid-schizoid position. The body is the inescapable site of the oscillation between the positions, and it is always, simultaneously, the body of art, which is style. Picasso's feelings for those he portrays are avenues into the depths of the psyche and style, whose universes mysteriously and seam-lessly converge in his art. Defying all expectations, the psychic depths and the artistic heights are the same in Picasso's art, which is what makes it so baffling and engaging.

I don't think he himself realized this: he was simply another human being struggling with his feelings – trying to use his art to exorcise them, as he said.

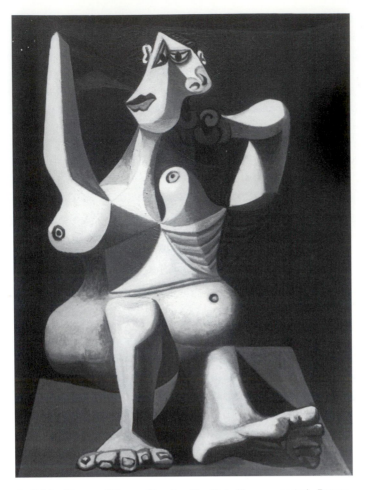

5. Pablo Picasso, *Woman Dressing Her Hair* (Femme assise), Royan,
June 1940. Oil on canvas. 51 $^1/_4$ × 38 $^1/_4$ inches. (132 × 97.1 cm).
Museum of Modern Art, New York. Louise Reinhardt Smith Bequest.
Photograph © 1998, Museum of Modern Art, New York. © 1999,
Estate of Pablo Picasso/Artists Rights Society (ARS), New York.

However, as he was doing so, the art became more important than the feelings,
and became a problem in its own right. And he must have realized, however sub-
liminally, that in trying to solve the problem of art he was, in some strange way,
fathoming what was deepest in human nature: he must have intuited that in try-
ing to bring all the contradictory resources of the history of art to bear on his per-
sonal problem – on his contradictory, highly ambivalent, virtually split attitude
toward everyone he ever dealt with – he was struggling with the basic human con-
dition. He was struggling to reconcile the hate-love relationships we have with
each other and ourselves. He must have known that the split that informs the his-
tory of style is the split that informs human nature, and that it makes both
uncanny: it is this uncanniness that he has ultimately captured in his portraits.

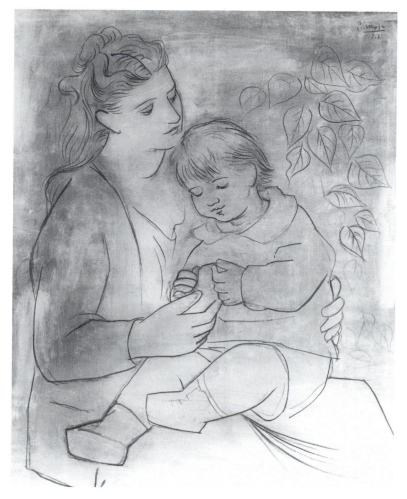

6. Pablo Picasso, *Mother and Child,* 1922. Oil on canvas. 100 × 81 cm. Baltimore Museum of Art: Cone Collection, formed by Dr. Claribel Cone and Miss Etta Cone of Baltimore, Maryland. (BMA 1950.279) © 1999, Estate of Pablo Picasso/Artists Rights Society (ARS), New York.

He also must have known that neither split can ever be completely and convincingly worked through or healed – the wounding contradiction can never be more than temporarily resolved, in this or that work – which is why he continued to work at them, compulsively, all his life.

A Shameful Cultural Sham?

WILLEM DE KOONING'S LAST PAINTINGS

THE EXHIBITION OF WILLEM DE KOONING'S LATEST AND PRESUMABLY LAST paintings at the Museum of Modern Art is not only a personal tragedy for de Kooning but a collective tragedy for the artworld. The issue is not that de Kooning, suffering from Alzheimer's disease and, more broadly, the feebleness of extreme old age, made works that document the decline of his once major oeuvre, but that a major museum exhibits them as a triumphant late style.

They are nothing of the sort: they lack the unconditional freedom and search for the unknown that characterize such style – the sense of abandoning conventions for an introspective style that seems to reach to the depths, whether of human existence, as in Rembrandt's last self-portraits, or of art, as in Matisse's last collages. Above all, an authentic late style synthesizes the artist's experience of life and art in a kind of wisdom about both that conveys their interconnection. An aging artist has two options: repeat and refine and reify his earlier ideas – the ones that first brought him critical recognition and worldly success – as though to validate them and consolidate his historical position (indeed, he imagines he understands himself as history will, which, unwittingly, is to treat himself as though already dead – reproducing himself, he in effect mummifies himself – which no doubt spares him a lot of creative anxiety); or to renew what Keats called "negative capability," in his words, the capacity of "being in uncertainties, Mysteries, doubts, without any irritable reaching after fact and reason." It involves, as has been said, "the capacity to give free rein to the imagination," which means to accept "the disparate, absurd, inchoate, illogical, impossible" rather than restrain them. One no longer cares what the world thinks, as Matisse said in his old age; all that matters is what one's imagination – one's unfettered creative process – makes possible. One gives oneself completely to that incomprehensible process, regardless of the world's judgment of its products.

The earlier de Kooning, who worked, as Harold Rosenberg said, "on the borders of the act," (Fig. 7) no longer exists. The spirit of the painter who "court[ed] the undefined" – kept "his art and his identity in flux," viewing them as an unsafe terra incognita to be explored at risk, and who, like "the mountain climber or the boxer," had a

7. Willem de Kooning, *Untitled,* Summer 1961. Ink on paper. 23 ³/₄ × 18 ¹³/₁₆ inches. Hirshhorn Museum and Sculpture Garden, Smithsonian Institution. Gift of Joseph H. Hirshhorn, 1966. Photograph by Lee Stalsworth.

"trained sense of immediate rightness," for he often had to invent new methods on the spot (spontaneously) not just to win his goal but to survive – has become a dead letter in the late paintings. Flux has been fixed in them – gesture has become a trophy and relic (Fig. 8), the flaccid banner of a country that no longer exists displayed on a canvas that remains as blank and unforgiving as an empty museum wall – and the absurd has become well-defined: negative capability, arousing anxiety – a crisis of identity – has been replaced by matter of fact, reasonable – emotionally irrelevant, however nominally capable – painting. All sense of immediacy has been lost; only a dull rightness remains. What we see is a punchdrunk boxer relying on his training to get him through one more round of painting, a mountain climber keeping fit by climbing molehills. De Kooning used to saturate his canvas with ambivalently charged gestures, but they now lack ambivalence, charge, energy. They are sad, fea-

tureless ghosts of themselves, precipitates of faded glory, altogether without nerve and charisma: de Kooning's fabled lyricism has become pseudo-epic. At best, de Kooning's late paintings are a species of mannerist abstraction – abstraction parodying itself (unwittingly?) in search of any new, stray expressive effect.

In short, the old intensity and density, emblematic of depth and freshness of experience, have disappeared: a new shallowness – a new superficiality of feeling and pseudo-subtlety of handling – prevails. The bright colors – largely red and blue, with hints of yellow and green, and sometimes purple – are deceptive. They are filler: the often rigid, emphatic contours are what count in the late paintings – the framework that holds the gesture together and in place. It has become an empty shell with a kernel of stale color. The contours are all that remains of the visceral painterliness of de Kooning's earlier works. Indeed, no figures – bodies – appear, neither male nor female, and there is no excited texture: only flat epicene gestures, that seem to spend themselves in the very act of being produced – that seem inherently dissolute even as they remain stiff and inflexible (that is, stylized in their flexibility). What we see in the late paintings is the dried bones of gesture, with a bit of thin painterly flesh – flayed color-skin – attached to them: painterly abstraction mocks itself in these paintings.

Why, then, were they exhibited? Because they are by de Kooning, the last survivor of a great age of painting. But also because they are the equivalent of money: by virtue of the reputation of his earlier paintings, everything he touches is automatically of economic if not esthetic value. Culture needs its myths – idols – and de Kooning is one, but the point is that culture has become a cash cow, and de Kooning continues to give milk, however much it is about to turn sour. The museum these days has become as much of a gambling place as the stock market, and the Museum of Modern Art has taken a gamble with de Kooning not just out of nostalgia but because he seems a safe bet. Behind this is a familiar cynicism about what will be accepted, what sells: a name brand, not a particular product. The prominence of the name counts, not the products it represents. Indeed, the priorities reverse in our decadent culture: the products represent the valuable name, rather than valuable products giving a name value, as traditionally was the case. Time may have made "de Kooning" an empty signifier, but it still has enough significance to make his paintings seem significant, even though their significance can't be clearly stated: it resides in the aura the name emanates, rather than in the painting. That is, we are in a tautological situation: the paintings are important because they were made by an officially important painter. Already in the pantheon of painters, his name can spare some of its transcendence without seeming to lose any.

But because de Kooning's last paintings live off the borrowed capital of his reputation, they are living on borrowed time: we see them lying in state, waiting to be sent to the morgue of the museum, that is, its basement, along with other archival curiosities, which are no doubt testimony to a certain history, but don't make history in the present.

Indeed, their sensibility seems borrowed from the past: they live off the capital of de Kooning's past eccentricities, as the stylized oddity of his planar fragments –

8. Willem de Kooning, *Untitled*, 1985. Oil on canvas. 77 × 88 ¹/₈ inches. Hirshhorn Museum and Sculpture Garden, Smithsonian Institution, Holenia Purchase Fund. In Memory of Joseph H. Hirshhorn, 1991. Photograph by Lee Stalsworth.

some of them seem directly lifted from his black paintings of the late forties, with flat color replacing the vivid black – suggests. What may redeem them is that they do convey, with their flat affect and dessicated intensity, an inner body experience, which is what I think Abstract Expressionism, on one level, is about: the projection of the experience of the body ego – the experience of the self at its most fundamental, before it has a social identity (and so seems indefinite and uncannily vital). If that is so, then de Kooning's paintings serve to remind us of the crippling depression – the sense of threat to the self, that is, anticipation of loss of the body ego – that often accompanies old age. They convey the inner experience of losing one's true, spontaneous self – it alone is creative, as D. W. Winnicott said, for it is rooted in the creativity of the body, that is, its power of renewal – and becoming a false, compliant self, that is, conforming entirely to social expectations. As Winnicott ironically notes, the false self invariably has more worldly success than one's true self, which is why de Kooning's late paintings are regarded, in certain quarters, as jewels. But then the crystalline jewel is a petrified process – an illusion of life, or, if one wishes, a climactic product of life that betrays it.

Jackson Pollock

LIVELY ART, ARTLESS LIFE

CAN ONE SEPARATE THE LIFE AND THE ART?: THAT'S THE QUESTION THAT HAUNTS Jackson Pollock's paintings. From a formalist point of view – still common enough among Pollock interpreters – the miserable life (that of an aggressive alcoholic) is incidental to the art, which, as art is supposed to do, stands alone on the heights above life. Supposedly autonomous pure painting, Pollock's all-over drip paintings of 1947–50 – commonly regarded as the apex of his achievement – have nonetheless been celebrated for their "quintessentially American … virility and rawness," as Kirk Varnedoe notes. These are terms borrowed from life, and they suggest the expressive quality – constantly overlooked by the formalists – of Pollock's paintings. Virility is a masculine quality and rawness is a state of matter. Both terms convey the conspicuous physicality of Pollock's paintings. To simply describe it as "tactile," as Pepe Karmel does, with no further examination of the implications of touch, is to miss its bodily import – the visceral character of Pollock's paint.

Pollock's paintings in general have been noted for their energy and air of violence. This is conspicuous enough in the turmoil of the early imagery – figures are embroiled with one another, embracing through conflict – but it is also evident in the all-over paintings. They are not simply "free form," as has been said, but full of endless crisscrossings. They are not simply meandering lines "freed at last from the job of describing contours and bounding shapes," as Michael Fried described them, but irregular lines that dispute one another, and that become blotches of color forming a fragmented surface – an eerie terrain, perhaps a fantasy of an eroded landscape. In other words, Pollock's all over paintings are not simply unstructured, but full of contradictory movements, colors, and lines. They are not simply optical, but physically irritating. To what emotional point, one can't help ask? The black lines that seethe across the surface of *Alchemy* (Fig. 9), 1947, together with the often straight white lines, and the general air of grayness, however disrupted by sudden splatters of red, yellow, and orange, evoke a certain mood – a far from ordinary feeling, which, as Wassily Kandinsky said, is what abstract painting at its best should do. But what mood, what unusual feeling? Out

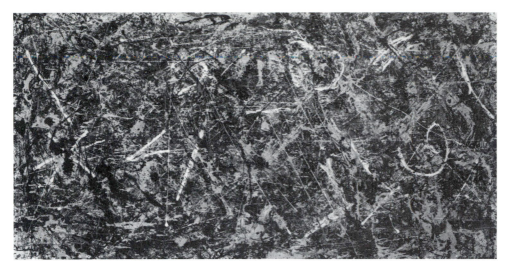

9. Jackson Pollock, *Alchemy,* 1947. Oil, aluminum (and enamel?), paint, and string on canvas. 45 ¹/₈ × 87 ¹/₈ inches (114.6 × 221.3 cm). Solomon R. Guggenheim Foundation, New York, Peggy Guggenheim Collection, Venice, 1976. Photograph by Robert E. Mates, © Solomon R. Guggenheim Foundation, New York. (FN 76.2553 PG 150)

of what inner necessity – to again use an idea of Kandinsky – do Pollock's all-over paintings arise?

Let us free associate to them – no doubt not the orthodox art-historical way to approach a painting, but a common enough one, and, with respect to an abstract painting, an all too human one, for such paintings seem to resist humanization even as they evoke feelings that are inseparable from being human. Free associations are not arbitrary, nor free, but as Freud said, determined by the subject's relationship to a certain object as well as by the object. (The essays by Varnedoe and Karmel in the catalogue accompanying the Pollock retrospective are prime examples of the true and tried if also somewhat tired and limited orthodox approach. It is essentialist, in that it thinks it possible not only to identify the essential qualities of a work of art – all others are regarded as contingent – but to find the significance of the work in these essential qualities. The essays are full of useful information – they discuss the art-historical importance and reception of Pollock's paintings [contingent], and describe in elaborate detail how he made them, suggesting that the authors toe the partyline of formalist [essentialist] thinking about them – but they offer no fresh insight into them.[1])

Now Pollock's all over paintings are like a swamp, or a Sargossa Sea, or the turbulent surface of a stormy ocean. Even Varnedoe relates them to Monet's "oceanic art." Clearly what Varnedoe calls "the transporting expansiveness of [Pollock's all-over] paintings" has something to do with what Freud called "oceanic feeling." Annie Reich associates it with the *unio mystica* and ecstasy of orgasm, which involves "the flowing together of self and … primary object … a temporary relinquishment of the separating boundaries" between them. Michael Balint goes one

step further: "environment and individual penetrate into each other, they exist together in a 'harmonious mix-up.'"[2] But the mix-up of elements in Pollock's oceanic paintings hardly seems harmonious, however rhythmic. Even their rhythms are broken and shaky. Pollock's lines seem to suffer from vertigo. In *Comet*, 1947, a straight white one streaks diagonally across the canvas, but it is a piecemeal construction of painterly splotches – as broken and erratic as any Pollock ever made. In *Number 8, 1949*, 1949, black lines restlessly circumnavigate the canvas, as though to form a cocoon, but the result is abortive. Pollock's lines are too unpredictable – they keep changing direction and form – to reliably hold together and merge. However much they may overlap and interpenetrate, they do not exactly suggest unity, mystical or physical. They do not converge, but convey hostility.

They are in fact the residue of the hostile figures of Pollock's earlier paintings. Their hostility has been abstracted into gestures, which devour the space like locusts. The gestures don't fit together, suggesting the dissolution of harmony. They thrash around in empty space, suggesting their futility by falling through it. It is this that we witness in the all-over paintings: the destruction of harmony, and the desperate but unsuccessful effort to restore it. What is signaled is not the oceanic harmony of individual and environment, but the disturbing trace of it left in the emptiness that signals its loss.

Pollock is enacting his basic fault, as Balint calls it. "The basic fault may be traced back to a considerable discrepancy in the early formative years of the individual between his bio-psychological needs and the material and psychological care, attention, and affection available during the relevant times. This creates a state of deficiency whose consequences and after-effects appear to be only partly reversible." The "lack of 'fit'" between Pollock and his mother has been well-documented. The disintegration – finalized in suicide – that resulted from it has also been documented. Pollock's addiction to both alcohol and painting are attempts to establish "a feeling that everything is now well" between himself and his maternal environment – the ocean that once engulfed him. As Balint says, "the yearning for this feeling of 'harmony' is the most important cause of alcoholism or, for that matter, any form of addiction." Pollock's all-over paintings enact – all at once – feelings of discrepancy (incoherence, lack of cohesion), deficiency (emptiness), lack of fit (unfittingness, fitfulness, faultiness), yearning for fit (harmony, faultlessness, cohesion, coherence). They seem orgasmic when they suggest harmony, and violent when they suggest its impossibility. They seem to deny it even as they imply it. Their greatness is a psychological greatness, in that they express what remains inexpressible – apparently unfathomable – in a great many people.

Pollock performed an emotional miracle, in that he was able to use the inarticulate gesture to articulate the fundamental truth of his life. In the process he performed an artistic miracle, recreating the expressionistic gesture from the ground up. But for all his effort to make it more exciting and moving – more supple and resonant than it had ever been – his gesture remained the pleading of a drowning man.

Jasper Johns and Ellsworth Kelly

THE DEADEND OF MODERNISM

A RETROSPECTIVE IS A FORM OF APOTHEOSIS, BUT ALSO AN OPPORTUNITY FOR evaluation: for a hard look at what has been accomplished by the artist over a long period of time – in the cases of Jasper Johns and Ellsworth Kelly, almost a lifetime. A retrospective gives us a chance to survey an artist's development – his history in the making – but also to put it in historical perspective: to understand his place in art history – giving him a retrospective assumes that he has a significant one – as well as his particular achievement. Thus a retrospective brings an artist's fame into question even as it acknowledges it. This is not to deny that the artist is entitled to his glory, but to ask how he earned it. It is really unfair to an artist to take his importance on faith: it leaves his art in the limbo of naive appreciation, which is to make its face value its true value. His fame is only legitimate when a convincing case can be made for the historical inevitability of his art.

Thus, I want to argue that Johns and Kelly, for all their undeniable uniqueness, are critically important because they represent the end – even deadend – of modernism. They have been privileged since the beginning of their careers because they seemed to advance modernism, but I think they bring it to a tragic end. They epitomize its decadence, its last grand stand, more precisely, its entropic grand climax: in manufactured enigma and obscurity, in Johns's art – a deadend, diluted dadaism, with a strong surrealistic accent; and in ultrarefinement, in Kelly's art – a deadend, atrophied abstraction, full of pseudosublimity. Their art gives modernism its final museum form, as it were, suggesting that it is no longer capable of formal "breakthroughs," that is, has nothing more to teach us about the possibilities of art (however many more novelties and curiosities it may come up with); and, perhaps more crucially, that it has nothing new to tell us about modern life – that it has lost its sense of the "heroism of modern life," to use Baudelaire's notion, and of the artist as a hero of modern life, indeed, the exemplary modern self.

Johns and Kelly share an acute historical consciousness – an awareness of modernist predecessors – but their art is an elegant reprise of modernist assumptions about art rather than an extension and deepening of insight into the most basic ones: art's subjective point of departure in unconscious content, and the difficulty

of objectifying it for consciousness, an idea directly relevant to Johns's work; and art's tendency toward what might be called noncommittal form, that is, its objectification in disinterested space and color, completely effacing its subjective significance, making it look like an impersonal product, a view directly relevant to Kelly's "objects."

Taken together, Johns and Kelly share a Solomonic wisdom: they are unable to strike a satisfying balance between the subjective and objective poles of modernism. They divide modernist art, separating what the pioneering modernists struggled to keep together, while quintessentializing them. The objective gives the subjective its necessary form – gestural or geomorphic – and the subjective gives the objective its emotional resonance, just as necessary for the integrity of the art. Split apart and pursued as goals in their own right, the subjective and objective – the evocative and formal – are not so much quintessentialized or "radicalized" as reified – absolutized into absurdity. Johns in his way, and Kelly in his, are one dimensional. Slowly but surely, their art loses its dialectical tension: Kelly increasingly eschews evocative incident, leading him toward the deadend of thematizing objectivity (purity, paradoxically, leads to a manufactured look); and Johns, failing to find an adequate objective outlet for his subjective tensions, arrives at the deadend of self-quotation, historicist manipulation (the past under erasure), and pictorial gamesmanship – ironic reversal as an end in itself.

Each does struggle with the opposite, and ingeniously integrates it, but the final result is ineffective, indeed, peculiarly self-defeating: the dominant pole absorbs and neutralizes its opposite, making for an ironically impoverished whole – the dialectic does not succeed in its enriching purpose, however much it complicates things. It is peculiarly abortive. Thus, Johns's paintings subsume many objective, "marginal" "devices," from body parts to household objects, their self-evident givenness and axiomatic intelligibility "foiling" the subjective, "obscure," "difficult" painterly process – the dominant pole of Johns's art – indirectly suggesting the possibility of controlling it. For example, *Painting with Two Balls*, 1960, involves a geometrical insertion in a gestural painting (between two canvases, and thus on the margin of both), whatever the ironical metaphorical (sexual) meaning. This procedure – operational integration of opposites – reaches a climax of sorts in the so-called "cross-hatch" pattern paintings, for example *Scent*, 1973–74. More or less painterly parallel lines form eccentric geomorphic units, converging in an ironic all-overness. Similarly, coming from the other direction, gestural incidents seem to disappear from Kelly's oeuvre, but they are in fact transformed: subtly integrated as the "impulsive," singular (mis)shapes of his paintings. They are in effect controlled – overcontrolled? – impulses. Indeed, both Johns and Kelly struggle to control what seems inherently uncontrollable – the unconscious in Johns's case, space and color in Kelly's case. For me, this confirms the fact that they represent the domestication of modernism: they are not really revolutionaries, but refiners and stylizers – decadents. They are the last traditionalists of the new, rather than discoverers and conquistadors of a new world of art, as the pioneering modernists were.

This is why, despite the fact that they attempt to use abstraction to do what it does best – generate enigmatic meaning – they do not exactly succeed, without clearly failing. Kelly's autonomous canvases may form a total perceptual environment, manipulable at will, but it lacks evocative depth, and does not sustain the initial excitement generated by bringing the individual canvases together, for on their own they lack energy. It is only the friction between them that sparks a certain amount of it, which quickly fades. Moreover, there is something fraudulent about their terseness and autonomy, in contrast to that of the concentrated, self-contained canvases of Malevich and Mondrian, which intervene in the social environment, contradicting it, rather than functioning comfortably – almost like decorative punctuation – within it, as Kelly's do. Equally decadent, such works as Johns's *Target with Four Faces* and *Target with Plaster Casts,* both 1955 – to name only the most famous examples – not only manufacture enigma, packaging it as an intellectual product (incomprehensible incongruity "rationalized" as preinterpreted juxtaposition), but estheticize it. This falsifies its meaning: Johns reduces the enigmatic or unknowable – impenetrable, unfathomable, permanent mystery – to the merely unknown. With a little interpretative effort, it becomes the known. Thus the emotional intensity that ordinarily builds up in an encounter with the enigmatic – the irreducibly, intractably incomprehensible – finds an easy outlet. Johns suggests that it is possible to master what can only be acknowledged with awe, thus betraying it.

But Johns's decadence is most evident in his narcissistic pathology, which is, I think, the basic subject matter of his art. The two *Souvenir* paintings of 1964 (Fig. 10) and the four *Season* paintings of 1985–86 show the poles of his problematic sense of self. The former are clearly self-portraits: the youthful Johns appears, looking arrogant and stubborn, and glaring contemptuously – corrosively scowling – at his audience. The latter are also self-portraits, if less obviously: the slim, frail figure that appears in them is also the youthful Johns – the same Johns that appears in various 1950s photographs, but now reduced to a pale, ghostly memory. I want to suggest that the arrogance and defiance evident in the *Souvenir* paintings is a defense against the vulnerability – latent sense of narcissistic injury – made mysteriously visible in the four *Season* paintings. It was always there, which is why Johns needed the character armor of his arrogance from the beginning. Arrogance is not simply pride in achievement; Johns had it before he achieved anything. It is, as Wilfred Bion suggested, imbued with a death wish toward the world, more particularly, transforms dissatisfaction with oneself into dissatisfaction with the world, in effect making one feel superior to it, and thus forgetful of one's feeling of inferiority. Arrogance is a kind of inflexible, self-defensive attitude, and it is evident in Johns's physical stiffness and fixed stare. It seems uncompromising, but it is, unconsciously, a way of compromising with oneself. This is very unlike genuine pride in achievement, which is full of generous libido and narcissistic satisfaction and tranquility. It feels no triumph over the world, but pleasure at having given it something of positive value.

Johns's art ruthlessly negates – aggressively mocks – the world and defensively elevates – monumentalizes – himself, as though by destroying the world he could create himself. But in showing its vulnerability and nothingness he unwittingly discloses his own. Thus, he mocks the United States, turning its flag and map into a painterly Duchampian joke, and, more crucially, uses Duchampian painterliness to render letters and numbers – the building blocks of language and communication – meaningless, in effect destroying them. They are reduced to hollow, formal signs – occasions for making seemingly pure art. They lose their objective function and meaning; but in doing so they acquire, no doubt unexpectedly, subjective function and meaning. Thus the esthetically "ruined" flag, map, letters, numbers, and so on, become, ironically – and this is the real irony of Johns's art – symbols of Johns's own sense of being ruined. Indeed, his is a kind of ruined, anti-abstract expressionism. Unwittingly, he has disclosed the feeling he most wanted to hide with his arrogant negativity: his innermost feeling of being nobody in particular – a kind of ghostly presence, haunting, but to no clear purpose, and thus all the more tragic. But he is tragic not because of anything the world did to him, but because of what he has done to himself – tragic heroes, from Oedipus to Hamlet to Willy Loman, are always their own victims, which is what their tragedy is. Johns is tragic because he is, underneath his self-protective arrogance, "a weak, crumbling, precariously coherent self," in the words of Heinz Kohut. His precarious sense of self extends to his sense of the body: it is a sum of parts that do not add up to a cohesive whole. It is fragmented to the point of complete disintegration; it cannot be reconstituted, for, literally, all its parts do not add up. It is this feeling that the parts of Johns's works do not add up that is the source of their so-called obscurity. The fragments of the so-called Tantric works are perhaps the most telling, and suggest one source of Johns's problematic, insecure, inhibited sense of self: the juxtaposition of testicles and death's-head suggest unconscious guilt about being gay. (Tantrism involves the ritualistic performance of sex; Johns's voyeuristic dissection of sexuality is a subtext of his art.) To connect sex with death – an old convention – is to punish oneself for libidinous pleasure in the act of enjoying it. In general, fragmentation, whether of the body or the picture as a symbol of the body, is a consistent feature of Johns's work to the present day: pursued as an end in itself, the fragment is the ultimate decadent form.

Johns's decadence shows itself in yet another way: his work is a manipulative reprise of modernist ideas, from Cubism and Dadaism through Surrealism and Abstract Expressionism. In later work, everyone from Grunewald to Picasso is manipulatively quoted and dismembered. Johns, in other words, is a "pastist" rather than Futurist; indeed, he suggests one can no longer look to the future of art, for there is nothing new on its horizon. Duchamp is his special hero, as indicated by Johns's Mona Lisa images, readymade devices, and appropriation method, and by his Duchampian sense of ironical indifference (a form of arrogance and contempt), described by Johns as a kind of "hilarity" in an essay in homage to Duchamp. But it is all secondhand – secondhand Duchamp, second-

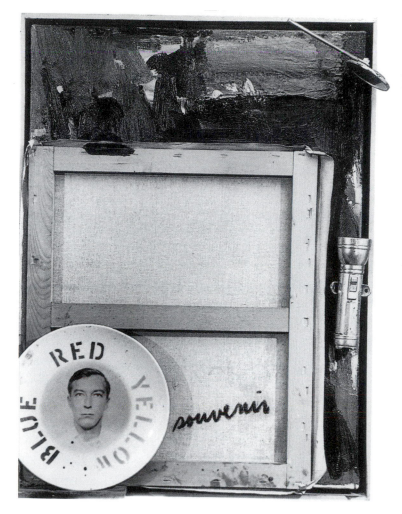

10. Jasper Johns, *Souvenir 2*, 1964. Oil and collage on canvas with objects. 28 ³/₄ × 21 inches (73 × 53.3 cm). Collection of Sally Ganz, New York. Licensed by VAGA, New York.

hand modernism – the dregs of modernist "defiance," risk-taking, subversiveness. I think this is particularly evident in Johns's bronzing – monumentalizing, immortalizing – of found or appropriated ordinary objects. The ideology of immortality comes to the rescue of the Dadaist gesture; bronzing is hardly a subversive art act, however ironical it may be to bronze an ordinary object. Instead of intellectualizing the object so that it becomes "poetic" rather than banal, as Duchamp did, Johns confirms that it is immortal art by bronzing it – making it materially permanent. This is clearly a more modest ambition than Duchamp's.

Johns, then, is into history, and from the beginning treats himself as a historical, even legendary figure: he memorializes and bronzes himself, as though he could stop time – the passage of the seasons, including the seasons of modernist

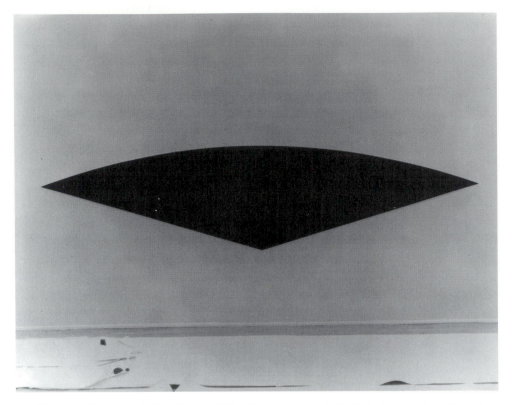

11. Ellsworth Kelly, *Dark Blue Curve,* 1995. Oil on canvas. 3 ft 10 inches × 15 ft 10 inches. Solomon R. Guggenheim Museum, New York. Photograph by Jerry Thompson, © Solomon R. Guggenheim Foundation, New York.

art. Neither it nor Johns are supposed to grow old; we are to remember them as they once were, heroes to themselves. But this poster mythologization compensates for the feeling of narcissistic vulnerability – the strange sense of hurt that pervades Johns's art, and makes it authentic. And yet it, too, is part of his decadence, his position as an epigone of modernism – a necessarily tragically injured, secondhand modern self: a self that points to the fact that heroism is no longer possible in modern life (which is no doubt why it must be monumentalized).

Kelly's endgame abstraction also suggests that he, even more profoundly than Johns, is narcissistically injured: in monumentalizing abstraction he hides from the emptiness it has become, confirming the emptiness he has perceived in himself. He empties abstraction of useful meaning the way Johns rendered letters, numbers, and American society meaningless and useless. In fact, from the beginning, Kelly's art was about emptying what seemed full, as though to make his own inner emptiness – the feeling of emptiness that is the ultimate emotional effect of narcissistic injury – indirectly manifest, and thus confirm that fullness was, all along, an illusion. This is what Kelly accomplishes in his eloquent drawings of empty leaves: he empties nature of organic content, reducing it to an abstract

ghost, not unlike Johns's figure in the four *Seasons*. Like that empty figure – a presence that is also an absence – Kelly's ghostly, empty abstraction implies a self-emptying self, one that denies the possibility of fullness of being. Bion has spoken of "the pure note in music, devoid of undertones or overtones," and as such lacking in associations, and thus "meaning nothing at all," that is, empty of meaning: this is exactly the way Kelly's pure colors and shapes are, which is why they are unfulfilling (Fig. 11).

In both Johns and Kelly, then, modernist art and the modern self have lost their Faustian drive and inner necessity – their Faustian power of innovation – and become ironic, peculiarly stale shadows of themselves, wittingly in the case of Johns, unwittingly in the case of Kelly. There is no doubt a certain pathetic charm in this double decadence, but one cannot help wondering why it is so privileged – why regressive epigone should be elevated into the pantheon of progressive modernism. But of course their art speaks to our current postmodern, fin de siècle situation, to which retrospection is an appropriate, superficially fulfilling response.

Ivan Albright

ANACHRONISTIC CURIOSITY OR THE ULTIMATE MODERN ARTIST?

S THE METROPOLITAN MUSEUM OF ART'S RETROSPECTIVE SUGGESTS, THE moment seems propitious for Ivan Albright: here we are nearing the death of the century and the millennium, and Albright's pictures are death-obsessed, more so than any others in modern art. His ambition was, as he said, to make the "darkness" of death "visible," more particularly, to make the "decay" and "dissolution" latent in the body vividly self-evident. Thus his instantly recognizable signature material: the notorious "corrugated mush" of disintegrating flesh that constitutes his figures. It is an insidious creeping crud that corrodes and eventually consumes them: a catastrophe subversively scribbling itself on their bodies, erupting from within like a brazen cancer but also secretly in the air they breathe. It is the paradoxical epitome of a life-threatening disease: the parasitic rot within that dares outrageously blossom with a life of its own, fatally undermining and displacing the life of its host. Indeed, life and death – growth and decay – become confused and inextricable in Albright's pictures: while they seem to render the triumph of death, they also seem to show death as a kind of growth or living process. *Into The World There Came A Soul Called Ida,* 1929–30, is the classic example, but *Fleeting Time, Thou Has Left Me Old,* 1928–29, and *And Man Created God In His Own Image (Room 203),* 1930–31 (Fig. 12), also make the living death of human flesh offensively explicit.

Albright has no embarrassment in the face of death, which after all is the most embarrassing fact of life. A good part of the sensational, traumatic effect of his pictures is that he draws no veil of modesty over death, as one is supposed to in our society. He doesn't bury his corpses-to-be quickly, but perversely dwells on the details of their disintegration, magnifying them out of all proportion. Indeed, he spent years getting them literally right, until each became a revelation in itself. Just as birth is a biological truth of life, like childhood sexuality and the appetite for life it expresses, and as such is subject to amnesia – all fundamental truths of life are, because they are too traumatic for consciousness to consistently bear – so death, the other great inescapable truth of life, is subject to a kind of amnesia, along with the depression – the loss of appetite for life – it unconsciously causes,

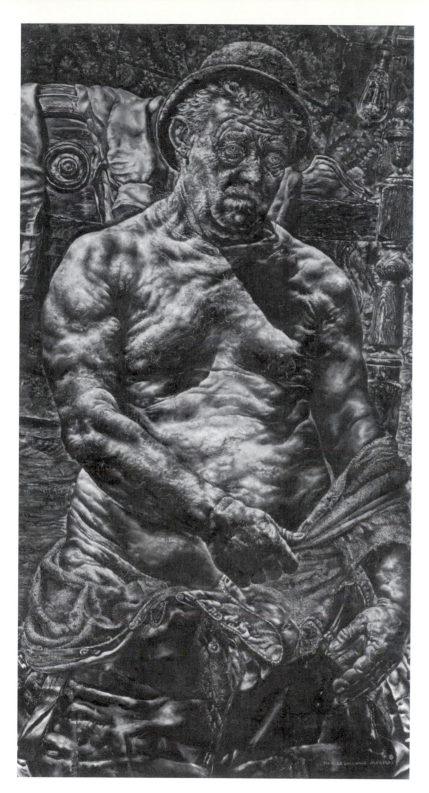

12. Ivan Albright, American, 1897–1983, *And God Created Man in His Own Image,* 1930–31. Oil on canvas. 121.9 × 66 cm. Gift of Ivan Albright (1977.36). Photograph © 1998, Art Institute of Chicago. All Rights Reserved.

for it too is too difficult to face consciously. But Albright deliberately strips away this amnesia – this radical denial of death – dropping us into the abyss of depression it hides. Albright is in fact a master of psychological as well as physical truth; indeed, the latter is a symbol of the former for him. His paintings were introspective from the beginning, their shocking, unwholesome physical surface signaling their profound emotional depth. Thus, already in *The Lineman,* 1927 – the first work that brought Albright notoriety – physical rot was the expression of emotional rot. Appearing on the cover of the magazine *Electric Light and Power* in May 1928, Albright's exhausted and depressed worker – he has lost his will to live and, in an act of self-recognition, seems to be turning inward, as though realizing that his daily life is living death – raised a storm of public controversy because he contradicted the idealistic myth of the vigorous, invincible American worker, grateful for a job and performing it joyously.

Jean Dubuffet, who admired and met Albright, and whose violent, tortured surfaces are related to his, however indirectly, regarded him as one of those artists who, like himself, inhabited an "anticultural position." For "former ideas of beauty ... is substituted a howling tumult ... a Gehenna of forms entirely delivered to delirium," and, one might add, dementia. As Albright said about the famous *Poor Room – There Is No Time, No End, No Today, No Yesterday, No Tomorrow, Only the Forever and Forever Without End (the Window),* 1942–43, 1945–55, 1957–63, which Dubuffet saw in his studio, "some objects are falling, others are rising," creating an effect of unresolved "tension and conflict" – of dangerous lack of balance, all the more so because of the irreconcilable perspectives from which the objects are seen. Dubuffet, who was also taken by the equally horrific *That Which I Should Have Done I Did Not Do (The Door),* 1931–41, thought that Albright's pictures were among the most "alarming" ever made.

Part of Albright's strategy is to overwhelm us with objects as well as details, and it is a theatrical – indeed, very stagey – strategy. I want to suggest that it is one of the basic methods of modern art, derived, no doubt, from Renaissance art and the Neue Sachlichkeit – major inspirations for Albright, as the exhibition catalogue points out – and that the other and its opposed method involves the stripping away of details and objects to a precious and increasingly irrelevant few, climaxing in a Minimalist mocking of detail. I propose the following: that the two most representative works of modern art are Albright's *Picture of Dorian Gray,* 1943–44 – featured in the Hollywood film of Oscar Wilde's story, it is a perfect example of the expansionist/additive technique at its most confident – and Picasso's *Les Demoiselles d'Avignon,* 1907, incomplete because Picasso was not prepared to carry its reductionist/eliminationist technique to its logical conclusion, namely, the stripping of the figures of all human attributes and of the scene of all allegorical implications. Both works are equally absurd, grandstanding, and humanist – or rather inhumanist – in their implications, but I want to suggest that Albright's rotted figure is a more reliable guide to the devastating emotional truth about modern life than Picasso's rebuilt figures. The latter defend against the human truth by

proposing an artistic alternative to it, namely, a space of pure art in which suffering and emotional collapse have no place. (There is more to Picasso's assertion that the *Demoiselles* was an "exorcism.") Picasso's Cubism is the decisive beginning – Cézanne's labored late Impressionism was its prophet – of the invention of a realm of eternal, seemingly self-created and self-nuancing forms, in which neither inner decadence nor outright death leave any trace: a realm in which there is only the interplay of esthetic absolutes, in which any human "hangover" is slowly but surely purged.

Now it is because Albright's figure transparently registers, in whatever theatrical, spectacular way, the inner rot and outer destruction that our century has perpetrated on human beings (it has come to be regarded as the greatest nightmare in history) – and spectacle is the collective mode which tries to contain them, theater the collective way of making them intelligible and palatable to the survivors, as well as of establishing a certain distance (not without stoic potential) from them – that I think Albright is *the* artist for our fin de siècle, millennial times. Fraught with apocalyptic potential, they are desperately in need of the eschatological awareness Albright offers to counterbalance modernity's scientific triumphs as well as its esthetic feats. Indeed, it is at the fin de siècle and millennium that spectacle truly comes into its own, for it is the only mode of "representation" that creates the illusion of satisfying collective needs, and Albright is a confident master of convincing spectacle. Of all the modern masters, his works cannot help but whet the collective palate for spectacular excess. They successfully compete with Hollywood, however much Hollywood horror films, with their images of crawling flesh, may have preempted him.

More simply and art historically, Albright is the fountainhead of the Chicago "monster roster," as it has been called. (Leon Golub, for example, is inconceivable without Albright, and in fact Golub's figures look like awkward reprises of Albright's figures. They indecisively balance Albright's abundance – spectacle – of details with reductionist esthetics ["purifying" flatness], thus compromising both by carrying neither to an extreme.) Am I suggesting that (typically) mimetic Chicago art is preferable to (typically) abstract New York art, in that upfront Chicago art rather than devious New York art tells us the emotional truth about modernity – a depressing truth that is far from hidden today, indeed, that has become a kind of collective spectacle – while New York art evades and obscures it? Not exactly, for while the horrors of modern life are more spectacularly conspicuous in Chicago art than in the esthetic heroics of New York art, the latter is just as – if not more – necessary than the former. It is necessary to be untrue to and defend against one's times, not simply to reflect them in abject submission. Why should one be consumed by them – be their victim? Sublime esthetics suggests that one need not be – one can transcend them, at least emotionally. This may have more minority than majority appeal – may be a minority rather than majority possibility. It may seem like an esthetic ostrich hole in which one foolishly hides from the truth – which will take one from behind because one is not look-

ing it in the face – for such Chicago truthtellers as Albright. But it still remains a programmatic possibility for life as well as art. Albright, after all, is a crowdpleaser, and the problem finally is to please oneself, that is, to maintain and protect one's sense of self despite being in a crowd – despite being part of the spectacle of its suffering. Starry-eyed esthetics may, after all, be the best insulation against isolation in the crowd, not Albright's recognition – however cleareyed and authentic – of the death instinct that controls it.

Jiri Georg Dokoupil

REAL HALLUCINATIONS AND
ANAL ABSOLUTES

Latino and caribbean sex is ... more natural than petty bourgeois central european "sexual intercourse." ... there sex is more strongly "asshole orientated": the tongue plays a more honorable role than in our latitudes.

<div align="right">

Jiri Georg Dokoupil[1]

</div>

My hypothesis is that perversion represents a ... reconstitution of Chaos, out of which there arises a new kind of reality, that of the anal universe. This will take the place of the psycho-sexual genital dimension, that of the Father.

<div align="right">

Janine Chasseguet-Smirgel[2]

</div>

Traces of hallucinations are found on every page of history.

<div align="right">

Bierre de Boismont[3]

</div>

TO PUT A TONGUE WHERE A PENIS COULD – SHOULD? – BE, AS IN DOKOUPIL'S *Cunt-licker* and *Ass-licker* pictures of 1996: that's perverse, however playful. It's just not talked about, let alone depicted, in polite society. To put a bouquet of fresh flowers in a woman's anus, as though it was fertile soil for life – we see this in two other works of the same year – is even more perverse and playful, even more upsetting to the petty bourgeois sense of proper sex, not to say the petty bourgeois sense of esthetics. Similarly, Dokoupil ends his film *No pasa nada*, 1994–95 with a scene of two gangsters masturbating, devotes part of a diary entry to an account of a woman's masturbation,[4] and another to an account of his "sex meditation" with a girlfriend.[5]

Clearly Dokoupil is sex crazy – obsessed with sex – and regards it as transgressive of petty bourgeois morality. But more than simple sexual machismo and épater le bourgeois are involved, although Dokoupil's pride in his sexual performance is evident in his account of how he and one of his many women – he describes himself as "polygamous"[6] – "scarcely left the bed for a week."[7] (Dokoupil is competitive with "quickie" petty bourgeois "virtuous" sexuality, that is, sexuality strictly for the purpose of reproduction, and thus sexuality that is not as pleasurable as it could be, if only because it has a "higher purpose" in mind and thus shuns – repudiates as disgusting and distracting, not to say "inefficient" for reproductive purposes – the

pleasure that really low part of the body, the anus, can give.) His wish to be a "sexual tidbit"[8] is complicated by a more "metaphysical" wish: his use of polymorphous perversity to continually reconstitute – in effect rejuvenate – his life "by a certain kind of freshness."[9] In other words, Dokoupil is a classic sexual visionary.

He is caught up in an old North European myth, indeed, the age-old wishful thinking of aging men: the belief that indiscriminate, extravagant, guiltless sexuality with foreign, exotic women – ostensibly more open about sexuality and its possibilities, and supposedly enjoying it more than European women, who view it as a social chore and duty rather than a spontaneous natural act (and thus don't experience it as particularly pleasurable, indeed, are frigid rather than passionate) – is the way to everlasting freshness, the way to maintain youthful vigor. Faith in sex as the panacea for aging and death: Dokoupil describes himself as "europeansocialized-touched by a dying Christianity-at the 40 and upwards stage."[10] In other words, he is conscious of his mortality. Whether Ponce de Leon knew it or not, sex was the fountain of youth he searched for in Florida – in the tropical South, with its perpetually fertile, abundant nature, the South that is as organically hot as an animal in heat.

Dokoupil's Latino woman is a contemporary, trendy version of the proverbial "looser," freer Southern woman. Gauguin went in search of her in Tahiti, and the anthropologist Margaret Mead thought she existed on Samoa, and Dokoupil thinks he has found her on Tenerife, where he lives a good part of the year. His fantasy is that she exists everywhere: he conceives of "a world-wide interconnected 'commune' with no fixed abode"[11] – "a number of locations" where free, exploratory love, celebratory of the body in all its aspects, is practiced. In short, just as Goethe had his first and presumably best – most uninhibited – sexual experience in Italy, so Dokoupil has his best if not first sexual experience in the always sunny sexual South, wherever it technically is – Tenerife, New York, Berlin, Africa, the Caribbean, to mention some of the places in which he has discovered it.[12] Whoever goes South becomes young again – Arnulf Rainer, for example, "on holiday in playa de santiago … looks 20 years younger"[13] – and presumably more virile.

For Dokoupil, then, compulsory and compulsive sex – above all, the Southern kind of sex (sex the Southern way, using the "Southern" entrance to the body) – is the magic that will restore a man to youth, and keep him young. (In this Dokoupil resembles Norman Mailer, who in a famous short story advocated anal intercourse as a general cure for inhibition and the path to mental and physical health, and also Wilhelm Reich, who regarded orgasm as a panacea and guarantee of everlasting mental and physical health.) To understand Dokoupil, one only has to recall that the first thing the aging Doctor Faustus asked from the devil was youth, so that he could enjoy everlasting sex with Helen of Troy, that most consummate of Southern belles (after dispensing with Margarete, the Northern girl who believed in marriage and motherhood).

All the orifices and their products are of equal value in the practice of sexual alchemy. Thus, the living sperm of the penis and the dead shit of the anus are

interchangeable – equivalent – for Dokoupil. He was "born out of a single mole-
cule of dried shit,"[14] and in his film – "actionistically staged passion illuminated
with feeling,"[15] like all his art – the character Soledad notes that "models and stars
in Hollywood are now having sperm injected into their breasts instead of sili-
con."[16] It is as though organic life would make them more erect and substantial –
revitalize them, so that they seemed to grow organically rather than artificially –
than the dead matter of inorganic silicon. Dokoupil piles up bananas as though
they were so many penises and oranges and apples as though they were so many
breasts. Are they trophies – fetishes – of successful sex, just as deer antlers
mounted on a wall are trophies of a successful hunt? Is the banana a symbol of a
good erection and orgasm – Dokoupil notes how one of his lovers "'interiorized'
his orgasm for days"[17] – and the orange and apple symbols of the breasts of the
well-endowed Latino women he has copulated with (they appear in photographs
in his 1996 catalogue)? Is Dokoupil's egg a symbol of the child "hatched" by cop-
ulation – its ideal, indeed, perfect fruit? (Leda, we may recall, gave birth to eggs,
after copulating with Zeus the swan.) We are in the zone of Baudelaire's myth-
making correspondences, now sexualized. Everything organic in Dokoupil's art –
and he regards it as an organic art – is pregnant with sexual meaning. But the bot-
tom line is that polymorphous perversity – in effect the fetishization of all eroge-
nous zones and their secretions – is the way to physical and emotional renewal.
That, I think, is what the eggs ultimately symbolize: the artist's own new life will
hatch out of them, again and again – with every new orgiastic sexual relationship.
Life totalized as sex is life that will never die.

Dokoupil's pictures are polymorphously perverse in technique as well as con-
tent. It is playfully perverse to make pictures of soap bubbles (surrogate sperm?)
and mother's milk (the inner abundance of abundant breasts) and candle soot
(substitute shit) and tire tracks (another useless residue). These are hardly the
materials conventionally used to make paintings – ironical action paintings
(Dokoupil yearns to be an American artist, as he has said[18]) – but they are the raw
and gross materials of life. Indeed, if water is the source and medium of life, then
Dokoupil's watercolors are, in a sense, his most vital materials. Dokoupil's
"organic painting methods" and his use of his hand and brush "in a similarly
organic manner"[19] no doubt have an artistic point. In a typical avant-garde way,
Dokoupil blurs the distinction between the spontaneous, improvised drawing and
the deliberate, polished painting. Indeed, like all good modernists he reverses the
priorities, preferring risk to perfection: organic execution takes precedence over
the traditional inorganic result – dynamic action infiltrates and subverts the pas-
sive product. The opposites finally converge, and become indistinguishable.

This is especially evident in the soot paintings (Fig. 13). The black texture, a
residue of the process of natural and artistic combustion, becomes the inner grain
of the picture, bringing the petrified wood of the photograph – the painting's
point of departure – to haunting if depressing life. The result is socially bizarre if
ironically introspective – a dialectical corrosion of the photograph, implying that

the information in it is old news. What was clear has become blurred with time – what was vivid has become decadent and stale and ghostly – what was historical has become hallucinatory – what was self-evident has become obscure – what was known has become unknowable – what was objective has become subjective. But Dokoupil's soot painting is depressing not only because it plunges us into darkness and indeterminacy, but because it seems to decompose in the process of being composed. That "conceptual" darkness is more anxiety-arousing than its perceptual darkness. The soot painting seems visionary and "insightful" because it dissolves the conventional consciousness capsulated in the photograph, but its crumbling of reified photographic perception becomes an avalanche that buries the very idea of a picture. At the least, it conveys the frustration of trying to make a picture adequate to an anxiety-arousing reality. It is impossible to picture reality adequately – to convey its urgency convincingly. In the soot paintings reality crumbles to dust – it becomes a kind of shit, along with the painting. It conveys transience with a vengeance, all the more so because it is the desperate product of an exhausted process, indeed, an exhausted idea – the idea of painting. Art is the shit that is left from life, Dokoupil seems to be saying, that can never do justice to life, which may also be shit.

In short, Dokoupil's decadent, perverse method of painting turns the picture into a terra incognita of irreality – into a limbo between reality and unreality. Paradoxically, because Dokoupil's pictures demonstrate the inherent inadequacy of representation to the process of life, they seem to have the uncanny knack of representing feelings that seem inherently unrepresentable – feelings that can only be suggested by pictures that seem as "off," and thus as uncanny, as they are. Unstable representations of unstable – constantly changing – reality, Dokoupil's pictures are emotionally unsettling or destablizing. His organic method of picture-making is a Sisyphean struggle to reach a goal that is technically out of reach, yet inwardly within reach. At the same time, because his neo-automatist paintings never become finished pictures, Dokoupil ends up picturing the picture-making process – the action of painting – itself. That alone gives painting emotional as well as esthetic credibility.

I think Dokoupil yearns to be an American artist because it was in postwar American art that this union – indeed, disappearance – of opposites was accomplished with particular vehemence and élan, first, decisively, in Pollock's all-over abstract paintings, and then in Rauschenberg's combine paintings. The latter extended Pollock's method to representation: Rauschenberg integrated images that had their origin in social process – photographs that seemed to fix the transient social scene for all eternity, so that it seemed fated and determined – into violently dynamic, chaotically indeterminate painterly process. What once looked straightforward and simple became subliminally ambiguous and overdetermined, until it seemed like a deception. Dokoupil's description of his own works as "combination pictures" acknowledges a debt to Rauschenberg, and he is clearly aware of Pollock. And one can't help thinking that he knows Robert

13. Jiri Georg Dokoupil, *Badende III, 1991. Bathers III.* Candle soot on canvas. 94 $^1/_2$ inches × 98 $^1/_2$ inches (240 × 250 cm). Courtesy of Tony Shafrazi Gallery, New York.

Morris's tire track "drawings," where process and product achieve a particularly ironical reconciliation: they can no longer be differentiated – they are all but simultaneous – but the difference between them is never lost. Similarly, in Dokoupil's untitled black-and-white tire painting of 1992, the tire track is at once process and product, and yet the process of execution of the work by rolling the tire, dipped in white paint, across the black canvas, remains distinct from the representation of the tire track – a symbol of modern time relentlessly on the move.

But for all its avant-garde credentials Dokoupil's polymorphous technical and imagistic perversity has a larger, more aggressive point: the task of perverse art is to create an anal universe, in which everything genital – everything to do with the Father, who is the creator of historical reality – is turned into a hallucination, that

is, comes to seem unreal, and as such a piece of shit. As Chasseguet-Smirgel writes, "to replace genitality [represented by the Father] by the [anal-sadistic] stage that normally precedes it is to defy reality. It is an attempt to substitute a world of sham and pretence for reality."[20] But there is a crucial difference in Dokoupil's case: he intends to show that the reality the Father has created is in objective fact – not just in unconscious fantasy – a nightmare. He is not just slandering the Father, but revealing the emotional truth about him. In this Dokoupil follows avant-garde tradition: from Max Ernst through Richard Prince the attack on the Father has been a sanctioned ritual.[21] To show that reality is not what it seems – to show that it is an anal hallucination rather than genital triumph, which is what Dokoupil does in the soot paintings that picture Vietnamese in the process of leaving their homeland for the West, is to tell the depressing truth about the Father's reality: to tell the truth that the Father botched creation. (He was drawn to the theme no doubt because it reminded him of his adolescent trauma of having to leave Czechoslovakia for the West after the Soviet occupation. Does the fact that his exile occurred during his adolescence explain his "adolescent" attitude to sex?)

To largely replace reality by hallucination, almost block it out, is not necessarily a "thought disturbance," as psychiatrists from Kraepelin and Eugen Bleuler to Harry Stack Sullivan believe,[22] but can be, as I think it is in Dokoupil, a justifiable, ironical expression of rage at the Father – a way of discrediting a Father who has clearly failed in his creation of reality, as history shows. To replace the photograph which represents reality in the Father's straightforward, matter-of-fact way with a devious, hallucinatory painting that makes the nightmarishness of the scene self-evident – makes clear the inner feeling of depression the exiled Vietnamese experience – is not only to contradict and criticize the Father, but to rebel against and overthrow the reality that he stands for. The photograph is a deception, not the hallucination that seems like one, because the photograph betrays the inner meaning of the exile by rendering it in a routine way, as just another everyday event, while the hallucination that "mystifies" the photograph reveals the emotionally disgusting truth it hides. The hallucinatory painting is a kind of mnemonic trace of the repressed suffering of the Vietnamese. Thus Dokoupil's hallucinatory images are a kind of inner exile from the Father's reality, as well as a kind of revolutionary critical consciousness of it. Dokoupil does not simply use contradiction and chaos to castrate the Father – his "negative dialectic" of *agere contra* is not gratuitously transgressive, an antisocial adolescent declaration of independence from and irreconcilability with the Father – but to declare his own adult recognition of reality.

Dokoupil's vision of reality looks mystifying and immature only because most so-called adults are blind about the reality of the world they live in. He seems to cast a hallucinatory veil over reality, but in fact he is stripping away the veil of everydayness that obscures its inner nature. It should be noted that this is a time-honored avant-garde pursuit, and in fact the ultimate justification of hallucinatory abstraction, which in effect declares that the everyday representation of reality – indexed by the photograph – is fraudulent, while hallucinatory abstraction is a

genuine representation of it. The former is an inauthentic, the latter an authentic hallucination of reality. Dokoupil's hallucinatory abstraction reintegrates avant-garde innovation and critical purpose, not only because of his "incessant search for new expression,"[23] served by his perverse materials, but because he fuses everyday and abstract representations of reality in a way that makes it impossible to tell which is which. His imagery is uncanny to the extent that it seems at once repressive and expressive – as repressive as everyday representation and as expressive as abstract "representation." Thus the traumatic feelings repressed or expressed – the traumatic feelings induced by the Father's reality – seem to pervade the whole picture, while being unfathomable and unnamable. Even "depression" does not do justice to the tangled emotions of the Vietnamese soot pictures.

The tire is a sign of the Father's reality – it alludes to the manly automobile, always on the move, running over everything, conquering the earth – but there are two works in which the Father is addressed openly by Dokoupil. One is an undated photograph of a marble bust of the philosopher Pythagoras defaced by blue paint – a wild, willful, colorful gesture that bleeds all over it. It is as though the wounded thinker shed blue blood, indicating his inherent superiority if also hurt. Above his noble name, a girl's name – the anonymous graffiti "Lisa" – is impudently scrawled, in big, bold letters – bigger and bolder than the letters of the philosopher's name.[24] One can't help wondering whether Dokoupil staged the photograph – hurled paint in the philosopher's face, crudely inscribed the name of some current girlfriend – just to mock the manly philosopher, whose famous theorem Dokoupil tattoos on his shoulder in a coy 1987 self-portrait. The other work is "Lyotard's nose," a full-scale glass model of the famous philosopher's real nose. Lyotard was "not very happy" with it, and apparently wrote Dokoupil a letter in which he pointed out that Freud had already noted "the similarity between a man's nose and his penis."[25] (It was actually Freud's friend and "confessor" Wilhelm Fliess who had equated the two.)

Clearly, the works are big jokes for Dokoupil, but they are also meant to really hurt – serious attacks on intellectual authority. (His comic sensibility has been much noted – aggressive personal comedy to counteract social tragedy and intellectual stagnancy.) They have a certain moral irony. The great philosophers, above it all, pretentiously constructing Reality in their own manly images – with their manly minds – epitomize the Father, and Dokoupil is out to castrate them – cut them down to size. Dokoupil once said: "I want pure nature. I want nature against ideas, formalism, academicism. Against politics."[26] To which we might add "against philosophy" – but it is already on the list, for it is the formal activity that generates ideas and is practiced in the academy. (Indeed, for philosophy ideas are academic formalisms rather than the vital stuff of life.) So Dokoupil hurls nature – in the form of raw paint and a woman – at Pythagoras, suggesting that he is a bad joke, a farce, who perhaps needs a good fuck, to make him less pompous and rigid – philosophical. Pythagoras was a mathematician, and mathematics is anti-organic and even inorganic – all the more reason why Dokoupil must give him

the organic treatment. Similarly, Dokoupil reminds Lyotard that he has a penis, which, big or small, shows that he's part of nature – that he has a lower part as well as higher mind, a natural organ as well as anti-organic ideas. Dokoupil inflicts physical pain on a surrogate Pythagoras, emotional pain on the real Lyotard, as punishment for their intellectual lordliness. He turns both into comic creatures – clowns, like the clown he painted when he was a boy. His clowning, like his in-your-face advocacy of the Latino woman, polymorphous perversity, and, above all, anality, is his Slavic, third-world way – and the Latino woman represents the marginalized, exploited third world, which is partly why he associates with and finally identifies with her – of taking revenge on the triumphant, self-centered West, represented by the hegemony of its intellectuals. The outsider Dokoupil in effect declares these insider intellectuals assholes and fools.[27]

His coy childlike clowning is evident in his many self-portraits. In *Sardinen erwachtet, ich male,* 1984, he mischievously peers out from behind a canvas. In an untitled 1986 self-portrait he sardonically – malevolently – glares at the viewer, his face ironically labeled with his qualities, the most prominent of which, above his erotic lips and below his phallic nose, is "Geschlechtsrenheit." In another untitled self-portrait of 1986 he shows himself as a brooding, melancholy – black, naked (has he gone native, become a primitive?) – thinker with three big, bright erections, each in a primary color. The primary color penis shows the way Dokoupil at once mocks and uses esthetic fundamentals to emotional advantage. It is this overgrown child, full of mischievous fun yet dead serious, that takes accurate potshots at the philosophers, even if he is, as he realizes, a kind of philosopher – an antiphilosophical philosopher – himself.

Philosophers are perhaps the ultimate fathers, for they are the fathers of mind – the mind with which we construct reality – and as such must be reminded, as forcefully as possible, that their higher reality betrays nature, and thus must be damned by it, which is what Dokoupil does: he acts in the name of Mother nature to overthrow the philosophers who have fathered our reality and given us a false understanding of our nature. Indeed, in elevating mind over matter – consciousness over unconsciousness – the philosophical Fathers destroy our inner organic relationship with Mother nature, thus alienating us from ourselves.

It seems to me no accident that Dokoupil's 1996 catalogue contains two letters from his mother, but none from his father. Unconsciously, he probably regards himself as an Oedipal winner. At the same time, in his mythical family romance, he implicitly gives himself a Tartar father – just like Joseph Beuys, whose spirit of social criticism and material innovation he emulates. This suggests that in his artistic family romance Beuys is his father. In fact, the art of both is grounded in historical trauma, ambiguously mastered or healed by immersion in [Mother] nature. Also, the fantasy fathers of both are warriors rather than philosophers or intellectuals – doers rather than thinkers. Finally, to complete his resemblance to Beuys, Dokoupil also is absorbed in the organic, and regards it as healing – for him as for Beuys nature liberates us from history, cures us of the diseases of society,

politics, and highmindedness. His 1987 untitled self-portrait, in which his face in effect becomes that of Beuys, and in which he wears Beuys's trademark hat, completes his identification with Beuys. There is no doubt an element of ironic idealization – detachment as well as admiration – in it, but Beuys nonetheless is the hero Dokoupil would like to be. Dokoupil does not simply render homage to Beuys, but endorses his ideals and shares his values.

To go against the official philosophers – the official view of reality – and return to and live according to nature was the ambition of Diogenes, the founder of Cynicism, and Dokoupil's "favorite philosopher, the great grandfather of anarchism and viennese actionism."[28] Just as Diogenes copulated in public, to show that coitus was a natural act – the Cynics could not understand why sex could not be satisfied in public the way hunger is, since both were natural appetites – so, in effect, does Dokoupil, by way of his erotic, body-based pictures. The *Cunt-licker* and *Ass-licker* pictures are an even more audacious display of sexuality. Like a good Cynic, sexual desire is "reasonable" for Dokoupil, and like Diogenes he advocates free love and a community of wives. This return to nature – to sexual nature – is, as Peter Sloterdijk suggests, at the core of the "kynical impulse,"[29] and Dokoupil's polymorphous perversity – our sexual nature at its most fundamental – is nothing if not impulsive.

Thus, sexual anarchism is used to overthrow systematic philosophy: unself-conscious instinct thumbs its nose at self-conscious intellectuality – especially at feelingless mathematics, that most formal, epicene of intellectual activities, which more than any other turns organic life into inorganic ideas. Lacking any feeling for nature, Pythagoras murdered nature to dissect it into number, regarding it entirely as an academic matter. If woman is the symbol of nature, then the philosophers in effect murder and "mathematize" woman, as though pure mind alone could overpower her. To do so, they must first castrate themselves – destroy their sexuality to devote themselves completely to the higher life of the mind.

In complete rebellion against this fraudulent masculinity of the mind, Dokoupil, not unlike Picasso – and in his versatility he is like Picasso – identifies with women, the younger the better (like Picasso). As he says on the back cover of his 1996 catalogue, as though it was the goal of all his artistic efforts, "I'm growing into a pubescent girl" – the prelapsarian Eve, a girl who is just discovering and excited by her sexual nature yet still remains innocent. If art today has become all too conceptual (unfeeling, academic, indifferent to nature) – all too philosophical (pseudophilosophical?, mock intellectual?, quasi-theoretical?) – then Dokoupil's playful perversity, pansexual idealism, and militant naturalism are a vital, major challenge and provocative alternative to conceptualism. Mimicking philosophy has made art absurd and self-defeating. In the end, philosophy lets art down – looks down on art – for philosophy thinks it is superior to art. But its higher consciousness, as Dokoupil suggests – and his art is in part a critique of philosophy and so-called higher consciousness – comes at an enormous cost of life. Art exists to affirm it. Only Dokoupil's instinct for the sexual jugular can restore art to vitality and human use.

Abstract Painting and the Spiritual Unconscious

I THINK THE WORD "SPIRITUAL" IS SUSPECT IN OUR SOCIETY, OR RATHER HAS BEEN made suspect by our society, very much the way, according to Kandinsky, the word "mood" became suspect. Both words indicate something similar, as Kandinsky said, namely, "the poetical strivings of the living soul of the artist." For "poetical" we can substitute "spiritual" without much loss of meaning, indeed, with a greater precision of meaning, for "spiritual" explicitly conveys the idea of transcendence that "poetical" only implies. In any case, for Kandinsky such words tend to be "misused" and "discredited," as he said, because they go against the grain of the prosaic materialistic understanding of the lifeworld. The poetic transcends the prosaic the way the spiritual transcends the material, but conventional collective understanding does not want transcendence. It in fact finds the poetic and spiritual incomprehensible, and prefers the more readily comprehensible prosaic and material. "Was there ever," Kandinsky asked in despair, knowing the answer in advance, "any great word that the masses have not instantly sought to desecrate?"[1]

This collective desecration – nullifying reification – of great words forces us to refine and clarify them, more particularly, to recover the personal dialectic implicit in them – the self-transformative process they imply. The masses resist this process, for it involves a recovery of individual experience from collective experience, and with that a radical change in orientation and attitude to the lifeworld. It comes to be understood from a different perspective than the collective perspective, allowing for a certain critical consciousness of it, without, however, sacrificing one's ability to negotiate it, indeed, enhancing one's effectiveness in it. Paradoxically, one sees the lifeworld more clearly, and thus can have greater mastery of it, than when one blindly accepts its supposedly natural and normal point of view, that is, mindlessly assumes it has the wisdom to prescribe the way life should be lived. Such change – personal revolution – is always suspect to the masses, which prefers to play it safe with the known and thus presumably true and tried. They prefer conformity to what seems painful isolation or at least insecure aloneness. The crowd's version of sanity is comforting compared to the insanity of going it alone, however supported by higher, spiritual powers.

Now I want to suggest that art at its best embodies such an individualizing self-transformative process, and proposes it to the spectator. As Rilke concluded in his early poem "Archaic Torso of Apollo," the work of art declares: "You must change your life" ("Du musst dein Leben ändern"), presumably for the better. What I will argue is that this change is what has been traditionally called a spiritual conversion, and that in the modern world abstract painting has become the instrument and embodiment of spiritual conversion. It is, so to speak, not only inspirational, but itself inspired. Hence my title: abstract painting, not representational painting. Like traditional religious painting, pure abstract painting is meant to lead the spectator to conversion, that is, catalyze a conversion experience, in which the spectator sees the light, as it were, in and through the painting, the same flash of light that is so often literally represented in religious painting. Pure abstract painting is in and of itself an act of conversion, that is, it conveys, in a seemingly cryptic, subliminal way, the process of change called conversion. It begins the process by eschewing the mediation of the material world in conventional terms, and brings it to climax by replacing representation with what Alfred North Whitehead calls presentational immediacy or pure "sense presentations,"[2] which I will argue, no doubt paradoxically, are mystical in import. It is the ripeness of the immediate that is at stake in pure abstract painting, and the transcendental function of that ripeness.

Now this dialectical process of conversion occurs in – or rather is instigated by – what is here called the "spiritual unconscious." What I want to try to do is to describe this unconscious spiritual process in psychodynamic rather than religious terms, with the hope of once again reconsecrating it, or at least restoring it to credibility. I will do this by analyzing statements by abstract artists that to my mind testify to the conversion experience. These statements suggest the process implicit in the experience. I will try to make it explicit.

Its basics have already been analyzed by William James in *The Varieties of Religious Experience,* but they need psychoanalytic elaboration. James described the effect of conversion on consciousness, but he did not analyze its unconscious dynamics, however much he acknowledged that conversion involved what he called a "subconscious" factor. While James's account of conversion stays largely on the surface, it nonetheless remains helpful for a preliminary understanding of the artists' remarks. James's account is not only a supportive context for the artists' statements, but the point of departure for my own psychoanalytic remarks. For James, "To be converted, to be regenerated, to receive grace, to experience religion, to gain an assurance, are so many phrases which denote the process, gradual or sudden, by which a self hitherto divided, and consciously wrong, inferior and unhappy, becomes unified and consciously right, superior and happy, in consequence of its firmer hold upon religious realities. This at least is what conversion signified in general terms, whether or not we believe that a direct divine operation is needed to bring such a moral change about."[3]

This conception of conversion occurs in the context of James's analysis of the "two ways of looking at life," corresponding to two kinds of human character:

the healthy-minded, who need to be born only once, and ... the sick souls, who must be twice-born in order to be happy. The result is two different conceptions of the universe of our experience. In the religion of the once-born the world is a sort of rectilinear or one-storied affair, whose accounts are kept in one denomination, whose parts have just the values which naturally they appear to have, and of which a simple algebraic sum of pluses and minuses will give the total worth. Happiness and religious peace consist in living on the plus side of the account. In the religion of the twice-born, on the other hand, the world is double-storied mystery. Peace cannot be reached by the simple addition of pluses and elimination of minuses from life. Natural good is not simply insufficient in amount and transient, there lurks a falsity in its very being. Canceled as it all is by death if not by early enemies, it gives no final balance, and can never be the thing intended for our lasting worship. It keeps us from our real good, rather; and renunciation and despair of it are our first step in the direction of the truth. There are two lives, the natural and the spiritual, and we must lose the one before we can participate in the other.

As James notes, the sick soul is made sick by awareness of "evil as a pervasive element of the world we live in," and "the pessimistic elements" of evil – "sorrow, pain, and death," that is, destructiveness or negation of life, mental and physical – are inherent to natural life. Thus renunciation of natural life is renunciation of the "disease" of evil, which includes, as James says, "worry over [the] disease ... itself an additional form of disease, which only adds to the original complaint." Renunciation is in part accomplished by repentance for the natural evil in one-self, and in part by deliberately affirming goodness, consciously struggling and willing to be good, and even happy, that is, full of *joie de vivre*. For James, this is clearly an unnatural if not impossible effort – a kind of supernatural effort, from the religious point of view. In other words, one mourns the death of one's own nature – the old Adam – and labors to give birth to a new nature – the new Adam. This whole process of change induced by mournful renunciation, which is a kind of self-transcendence, and the toughminded resolve to be good and happy, is experienced, very personally, as a spiritual conversion. One's whole being seems at stake; life and death ride on the outcome of the conversion. The renunciation of the sickness and evil of the natural is a spiritual death which makes spiritual birth – the second birth of the twice-born – and healthy-mindedness possible. After a successful conversion, the self is no longer divided against itself – no longer divided between its actual evil and its potential goodness – but, having accepted its evil and vigorously struggling to actualize its goodness, becomes rec-onciled to itself, and thus dynamically at peace with itself.

With these statements as background, let me foreground statements by Kandinsky and Mondrian on the one hand, and Rothko and Motherwell on the other. The former are among the first practitioners of abstract painting in Europe, and the latter helped pioneer it in the United States. I group them not only in

14. Piet Mondrian, *Broadway Boogie-Woogie*, 1942–43. Oil on canvas. 50 × 50 inches (127 × 127 cm). Museum of Modern Art, New York. Given anonymously. Photograph © 1998, Museum of Modern Art, New York.

chronological order, but to highlight the difference in their attitudes and their conception of the spiritual significance of abstract art. Their ideas and feelings converge, but for Kandinsky and Mondrian spirituality means overcoming modern materialism, while for Rothko and Motherwell it means overcoming modern alienation. No doubt Kandinsky and Mondrian felt alienated from the modern materialistic society in which they found themselves, but it was the society's materialism that disturbed them more than their alienation from it. They took alienation for granted; it came with spiritual superiority. They wanted to save materialistic society through their spiritual example, as Mondrian makes clear in his assertion that "the 'painting' of purely abstract art … prepare[s] the realization of pure equilibrium in

society itself," that is, in the "material environment." "Only then will art become life ... We then see more clearly manifested the force that animates the joy of living – which says almost all that need be said concerning purely abstract art."[4] (Fig. 14) Similarly, for Kandinsky the "new [spiritual] wisdom ... inaudible to the masses, is first heard by the artist." His spiritual art communicates it to the increasing "number of people who set no store by the methods of materialistic science in matters concerning the 'nonmaterial.'" "The artists who seek the internal in the world of the external" do so not only for their own edification, but for the benefit of everyone. They make the "effort of pulling ... the cart of humanity" up "the spiritual triangle that will one day reach to heaven."

In contrast, for Rothko and Motherwell, there was no artistic way of coming to terms with modern materialistic society. Art could not transform it for the better, either by suggestion or practice. The artist was always alienated from it, and it was always hostile to his best emotional interests. Rothko and Motherwell never reconciled themselves to modern materialistic society, and they did not try to educate it for its own good. The did not try, in Kandinsky's words, to have "a direct [transformative] influence on [its] soul." It was beyond redemption. All that a mere painter could do was to transcend it by means of his abstract painting. The more pure – unrepresentational, unworldly, immaterial – the more transcendent the painting seemed. Indeed, for Rothko and Motherwell pure abstraction transformed the claustrophobic feeling of alienation into the liberating feeling of transcendence. In short, where for Kandinsky and Mondrian abstract painting was a response to an objective problem, which undoubtedly had subjective consequences, for Rothko and Motherwell it was a response to a subjective problem, however objective its cause. Where Kandinsky and Mondrian wanted to save materialistic society, Rothko and Motherwell wanted to save their own souls.

Kandinsky writes: "Our souls, which are only now beginning to awaken after the long reign of materialism, harbor seeds of desperation, unbelief, lack of purpose. The whole nightmare of the materialistic attitude, which has turned the life of the universe into an evil, purposeless game, is not yet over. The awakening soul is still under the influence of this nightmare. Only a weak light glimmers, like a tiny point in an enormous circle of blackness. This weak light is no more than an intimation that the soul scarcely has the courage to perceive, doubtful whether this light might not itself be a dream, and the circle of blackness, reality" (Fig. 15). Mondrian writes, somewhat more hopefully: "Well executed, works of purely abstract art will ... always remain fully human, not 'although' but precisely 'because' their appearance is not a naturalistic one. Is art nearing its end? There is nothing to fear. What is this – still distant – end of art but humanity's liberation from the dominance of the material and physical, thus bringing us closer to the time of *'matter-spirit'* equivalence?"

Shifting to Rothko and Motherwell, the emphasis is less on nightmarish materialism than on nightmarish alienation – less on materialistic society than on its devastating effect on the self, although it also turns out to be – or by force of will can be turned into – a spiritual opportunity for the self. Rothko states: "The unfriendliness of society to his activity is difficult for the artist to accept. Yet this

15. Wassily Kandinsky, *Painting with White Border,* May 1913. Oil on canvas. 140.3 × 200.3 cm (55 ¹/₄ × 78 ⁷/₈ inches). Solomon R. Guggenheim Museum, New York. Gift of Solomon R. Guggenheim, 1937. Photograph by Robert E. Mates, © Solomon R. Guggenheim Foundation, New York (FN 37.245).

very hostility can act as a lever for true liberation. Freed from a false sense of security and community, the artist can abandon his plastic bankbook, just as he abandoned other forms of security. Both the sense of community and of security depend on the familiar. Free of them, transcendental experiences become possible"[5] (Fig. 16). In a related way, Motherwell writes:

"The emergence of abstract art is one sign that there are still men able to assert feeling in the world. Men who know how to respect and follow their inner feelings, no matter how irrational or absurd they may first appear. From their perspective, it is the social world that tends to appear irrational and absurd ... I think that abstract art is uniquely modern – not in the sense that word is sometimes used, to mean that our art has 'progressed' over the art of the past ... but in the sense that abstract art represents the particular acceptances and rejections of men living under the conditions of modern times. If I were asked to generalize about this condition as it has been manifest in poets, painters, and composers during the last century and a half, I should say that it is a fundamentally romantic response to modern life – rebellious, individualistic, unconventional, sensitive, irritable. I should say that this attitude arose from a feeling of being ill at ease in the universe, so to speak – the collapse of religion, of the old close-knit community and family may have something to do with the origins of the

16. Mark Rothko, *Green and Tangerine on Red,* 1956. Oil on canvas. 93 $^1/_3$ × 69 $^1/_8$ inches. Acquired 1960. Philips Collection, Washington, D.C.

feeling. ... But whatever the source of this sense of being unwedded to the universe, I think that one's art is just one's effort to wed oneself to the universe, to unify oneself through union. ... For make no mistake, abstract art is a form of mysticism[6] (Fig. 17).

The following seems clear.

1. For all the nightmarishness of modern materialistic society, Kandinsky and Mondrian are optimistic that it can be awakened to the spiritual truth by means of abstract painting, while Rothko and Motherwell have no such expectation or illusion. For them abstract painting has no social power and influence, for better or worse. In a letter to Pfister, Freud wrote that "my pessimism seems a conclusion, while the optimism of my opponents seems an *a priori* assumption."[7] Similarly, the social pessimism of Rothko and Motherwell was a conclusion based on their experience of modern materialistic America, while the social optimism of Kandinsky and Mondrian was an *a priori* assumption based on their belief in the

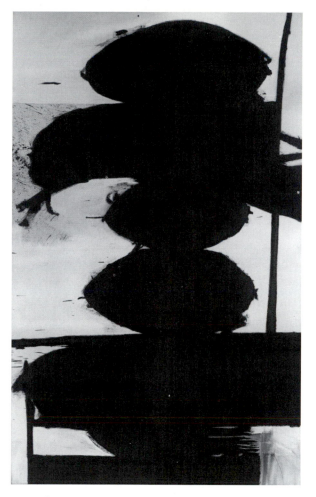

17. Robert Motherwell, *Elegy to the Spanish Republic,* 1961. 69 × 114 inches. Metropolitan Museum of Art. Anonymous Gift. Dedalus Foundation. Licensed by VAGA, New York.

power of art. It is hard to decide whether this idealistic belief was narcissistically healthy or defensive, even insane and delirious, but in retrospect it seems absurd and naive – a wish-fulfilling fantasy, falsifying hope as all such dreams do. It is the echo of the good old times when art was integrated in society – had its place, if often as an instrument of the powers that be, spreading their ideology as though it were the gospel truth. Art was a mode of esthetic support and esthetic dogmatization in the service of so-called higher powers, and unconsciously Kandinsky and Mondrian wanted it to continue to be, however different the higher powers.

In contrast, the realism of Rothko and Motherwell is refreshing if also depressing. It holds out no false hope of art's reintegration in society. No longer of direct use to society – however much it may be appropriated by society – art can be of indirect use to the individual. It can also become an esthetic end in itself, realizing its full potential as art. Seemingly self-sufficient, it becomes a beacon of subjective

intensity, integrity, and intimacy in a dismal, disintegrative, cold society – a sign of empathy in a peculiarly abstract society. Indeed, in a sense the abstract painting of Rothko and Motherwell reconciles empathy and abstraction, in Worringer's sense. It is a very personal painting, that is, painting that evokes a sense of person, organically and psychically alive in a peculiarly inorganic, death-infected technocratic/bureaucratic society – an anonymous society of indifferent administration. Adorno argued that modern art reflects such social "negativity" in its tendency to inorganic structure – the grid in particular, the emblem of universal administration, imposing its universality and uniformity on everything, geometrically dividing things irrespective of their differences, intellectually homogenizing them despite their heterogeneity – but the abstract painting of Rothko and Motherwell breathes organic life into the inorganic without denying its dominance.

2. The mood – in Kandinsky's sense of the term – of all four artists is remarkably similar, once one gets beyond the difference in their attitude to society. Kandinsky speaks of "desperation, unbelief, lack of purpose." For Mondrian, "our disequilibrated society" is a threat to *"joie de vivre."* For Rothko, society is unfriendly and "hostile." For Motherwell, it is "irrational and absurd." He feels "ill at ease" and disconnected in it. In all four we see depression and isolation, verging on self-loss and meaninglessness. That is, all four are what James called sick souls. They have been sickened by the evil in the modern world, which they experience, variously, as materialistic, unbalanced, alien, and unsupportive – all evil qualities.

3. For all four, abstract art is a fantasy of religious rescue from unavoidable evil: from cynical social and scientific materialism for Kandinsky, from lack of social and personal balance and joy for Mondrian, from a crippling sense of separation and alienation, resulting from a sense of the lack and impossibility of community, for Rothko and Motherwell. Abstract art gave them faith, hope, and charity – faith in themselves, hope for the future of the world, and a freely given gift to the community of humanity regarded as a whole, from which they expected nothing material in return – in a society where they do not seem to exist. In short, for Kandinsky, Mondrian, Rothko, and Motherwell abstract art offered meaningful selfhood and relationship in a world where neither seemed to exist, and seemed all but impossible to achieve. Abstract art made them feel less like failures as human beings and more equal to the world. All four artists had deep narcissistic and relational problems, and pure abstract art was a pure, abstract way of relating to others, that is, feeling a sense of community with them, with no sacrifice of selfhood, especially important because they didn't have much self to spare.

Pure abstract painting was clearly an integrative activity for them, that is, it gave them a sense of being whole, significant individuals and of being a significant, even indispensable part of the community. The integration and sense of wholeness achieved on a purely abstract or formal level in painting, where it is a matter of balancing primordial visual elements of color, gesture, and space, led, on a psychic level, to feelings of self- and world-communion, in whatever fantasy form. Such a surge of positive feelings involve the fantasy of leaving all one's conflicts behind

forever, and of experiencing a happy, harmonious – nonconflictual – relationship with the world and humanity at large (if not the people in one's society in particular). No longer divided against oneself, one no longer feels at odds with – irreversibly separate from – society. Indeed, the equilibrium and unity of the abstract painting, however hard-won – it is a constant struggle to achieve it, and it always seems on the verge of breaking down, confirming its precariousness and fragility – creates the utopian illusion of a statically tranquil, stable self and society – a well-ordered social pyramid, as Van Gogh said, in which everyone has his happy place.

In other words, for Kandinsky, Mondrian, Rothko, and Motherwell, to paint abstractly was to be healthy-minded. It involved recognition of the evil of the self and the world – acceptance of the fact that they are evil by nature. Renunciation of representation of that world was renunciation of evil. The self's resulting joie de vivre, evident, however subliminally, in the dynamics of color, gesture, and space, is not only a consequence of transcendence of the world, but the discovery of the self's spiritual nature made possible by that transcendence, that is, recognition of the self's potential for goodness, bringing with it faith in the real possibility of goodness in the world beyond the self. No doubt the joie de vivre is ambivalent, as indicated by the mournful gloom of many of Rothko's and Motherwell's paintings, and the desperate surges of blackness in many of Kandinsky's. I think that when Mondrian removed gray from his painting he rose above his melancholy, but black was only eliminated in his late New York paintings, that is, at the end of his life. Even then, the beating pulse of colors the black line became in those last works had its entropic regularity – always a danger for Mondrian, who skirted entropy by asymmetry, thus conveying a lyric effect of "inner freedom," as Meyer Schapiro called it.[8] Such entropic regularity overtook Rothko and Motherwell's late works, and Mondrian only avoided it by a kind of private irony. This ambivalence – the tense fusion of death-instincts and life-instincts, for Léon Grinberg the substance of ego – signals the ongoing struggle against evil which is the sign of authentic conversion. Without that struggle, conversion is facile, Pollyannalike, and unconvincing, indicating that the convert was once-born all along, that is, incapable of engaging evil, especially the evil in the self, inevitably turning it against itself – splitting it at the root – and of imagining any attitude other than the natural attitude, to misuse Husserl's idea.

The problem with conversion is that, however authentic, it is premised on a fantasy of psychic escape that does not preclude capture and hanging by society. There is a serious failure of reality-testing in it. Much the way the Ambrose Bierce soldier who was being hung by his captors fantasized that he freed himself just as the trap opened beneath him – the Civil War story is told from the point of view of his conviction, so that we don't realize the truth until the end, when there is a sudden shift to an external observer's point of view – the abstract painter may be deceiving himself into believing that he is free when he is not. And yet without the absurd, even psychotic fantasy of liberation and transcendence that is at the core of conversion there is no way Kandinsky, Mondrian, Rothko, and Motherwell could begin to do the psychic work, that is, the actual work of conversion, which involves a working

through of evil, in the form of art-work, to use Fairbairn's term – I accept Arnheim's idea of isomorphism, which proposes, in the words of Gilbert Rose, that "the structure of art and the emotions are homologous"[9] – necessary to remedy their misery, let alone pretend to change the mood of the world. Pure abstract painting is a space of conversion in which the emotional ideal of peace, which hovers over the painting as a whole, competes with the esthetic reality of conflict and struggle that is the nitty-gritty of the painting's structure, with the whole enterprise catalyzed by the artist's unconscious omnipotent belief in his revolutionary ability to fundamentally change his life, and even that of the whole world.

It should be noted that the convert abstract artist's isolation does not necessarily help his self-work. The usual religious convert enters a community of like-minded believers, who help him sustain his new-found faith in himself and God, with its accompanying belief in the possible – indeed, eventual – conversion of the whole world, so that it will be one grand community of true believers. But the conversion of the abstract painter does not bring him into a community of like-minded believers – an alternative society of the faithful. He remains at odds with other abstract painters, a victim of the credo of individualism that at once motivates and hobbles the avant-garde artist. Indeed, uncompromising individualism is supposedly a badge of honor that confirms vanguardism. Even the Blaue Reiter group had its conflicts – differences of opinion, to put it politely – and eventually broke up, and not only because of the first world war. The pure abstract artist remains profoundly alone – his purity and self-esteem depend on it – however much he may now and then associate with other abstract artists. It is as though they would interfere with his development rather than encourage it – interfere with his spontaneity rather than support it. One only has to read Hans Hartung's skepticism about the ideas of Kandinsky and the deceptive personality of Mondrian to realize how tenuous and spiteful the relationship between artists that seem to have an affinity can be. What Freud called the "narcissism of small differences" seems to be involved. The pure abstract artist wants to go his own way, whatever the social and, more insidiously, hidden personal cost. For going it alone in the desert – recall that Malevich metaphorically described his abstract Suprematist painting as a "desert experience"[10] – is no guarantee that one will experience conversion. It may just prolong one's agony.

4. For all four painters, pure abstract painting is a mystical-spiritual enterprise, independent of religious dogma and ritual. It is a mode of transcendence that works in terms of immediate sensation rather than symbolism, however subliminally symbolic the pure abstract painting may be. Indeed, the problem was to transcend traditional spiritual symbolism by means of purely "sensational" painting, whether conceived in terms of geometrical space, as in Mondrian's and Rothko's case, or gesture, as in Kandinsky's and Motherwell's case. Not exclusively, of course: Mondrian's color planes become color gestures in his late New York work, as though recapitulating and refining the gesturalism of his early works, especially of the so-called plus and minus paintings – the New York work is

a kind of regression in the service of an ego that had reached a geometrical dead-end – and Rothko's color planes are an intricate matrix of intimate gestures. Similarly, Kandinsky and Motherwell attempted to fuse spontaneous gesture and geometrical space in their later work. They wanted to loosen axiomatically inflexible geometrical space by means of energetic gesture, and give free gesture an intellectual dimension by imbuing it with geometrical deliberateness. As Plato said, geometry is eternal, and their Platonization or classicizing of gesture harks back at least to Cézanne's wish to paint like Poussin, that is, to synthesize geometrical structure and Impressionist sensation – to eternalize sensation, which is inseparable from painting, as Boccioni said.[11] No doubt Ehrenzweig's distinction between gestalt and gestalt-free forms, and their convergence, helps explains this synthesis. Pure abstract painting invites one to meditate on the feelings aroused by and associated with primordial sensations – whether geometrically or gesturally evident – rather than to read a narrative of supernatural life and otherworldly society to prepare one for them.

In pure abstract painting primordial visual sensation is enriched by what Deikman calls "the phenomenon of 'sensory translation,' through which psychic actions such as conflict, repression, and problem-solving are perceived through relatively unstructured experiences of light, color, movement."[12] Every sensory experience of them is heightened or enhanced – radically transformed – by such sensory translation, which involves projection into them, even projective identification with them. I think that Kandinsky's color symbolism – his attempt to correlate particular colors and particular feelings – is implicitly a matter of sensory translation, ultimately the dialectical fusion or cross-pollination of sensations and psychic actions. It is what makes the sensations and feelings afforded by pure abstract painting seem more "refined" than everyday sensations and feelings, as Kandinsky said.

Sensory translation is in effect the content, as it were, of pure abstract painting. The abstract painting we perceive as great – experience as spiritual – appears to make this translation spontaneously, right in front of our eyes. It is experienced as unquestionably and profoundly subjective – imbued with psychic actions ("psychic gestures") of all kinds and an externalization of psychic space ("psychic geometry"), both necessarily abstract, for the psyche is not physical, however rooted in the body it may be. It invites our instant subjective participation, that is, instantly makes us aware of our own psychic activity – of our so-called stream of consciousness. We unconsciously retranslate light, color, movement back into psychic actions, just as the abstract painter unconsciously translated psychic actions into light, color, movement. We unconsciously experience pure abstract painting as pure psychic action, and through it we seem to experience our own psychic activity in apparently pure form. This is what Harold Rosenberg meant when he described it as action painting and an arena of self-creation.[13]

Sensory translation affords an enriched sensory immediacy. It generates a ripeness of immediacy that seems to tear the veil of representation open, irreparably, as Yves Bonnefoy says. According to him, it is in pure abstract painting that

"one imagines that … the immediate exists," that it is "easily verified," and that it seems "nothing short of miraculous."[14] It may be, as Bonnefoy argues, that the abstract painter's refusal of and need to replace and defeat "conventional readings of the world … keeps them alive, and in the end … merely adds to the complexities of the sign as it works on being." Nonetheless, for however brief an enchanted experiential moment, the immediacy of surface and space achieved in pure abstract painting seems to "transcend perception" in the very act of being perceived. Bonnefoy finally declares that "there is no immediacy, there is only the desire for the immediate, which so many feel." But in the pure abstract painting of Kandinsky, Mondrian, Rothko, and even Motherwell – of all four, the last relinquishes symbolism the least – the immediate mystically emerges through the intensity of the desire to be rescued from and transcend – relieved of – the perceived world, with its emotional as well as material crudity and constraints. In short, this sudden flash of immediacy – of intense and all-encompassing immediate sensation – is the instrument and "proof" of conversion. Baudelaire referred to it, unknowingly, when he compared the freshness of vision in an imaginative work of art to that of a child looking at the world for the first time, and to the intense oceanic sensations he experienced using opium. Similarly, what James called the "subliminal uprush" in the exceptional mental state of genius, and what Kandinsky described as the experience of walking through color, articulates, in however metaphorical a way, a phenomenology of pure immediacy. The gist of the conversion experience is this feeling of pure immediacy – of pure presence, with nothing familiar and communal present, an absence which confirms its mystical character. The experience of pure abstract painting is optimally one in which the experience of timeliness conveyed by the feeling of pure immediacy is at the same time an experience of timelessness, which is why it can be called mystical. The timely and the timeless merge in pure immediate sensation, bespeaking the sense of merger with the divine – being wedded to the universe as a whole, as Motherwell says – in which time is altogether transcended.

Now the question is: where did the turn to pure abstract art – modern spiritual art – originate? No doubt in the spiritual unconscious: it is a direct expression of the spiritual unconscious. I want to suggest that the spiritual unconscious only makes itself felt and known, unpredictably, when the self seems to have reached the point of no return from narcissistic and relational injury – when it seems wounded with no hope of recovery or repair. That is, the self is wounded by its internal perception of itself – more particularly, of its own evil tendencies and character, that is, its destructiveness and destroyed state – and of the external world, which is also experienced as thoroughly evil. No healing seems possible in either direction. Both perceptions are accurate, and so is the perception of incurability – the impossibility of healing. It is then that the spiritual unconscious becomes manifest: it is the sudden promise of magical healing and health in a situation of terminal mental illness and absolute isolation – of complete hopelessness and helplessness. It is some neglected aspect of the unconscious

spontaneously rising to the occasion of total defeat by life and the world. It is the visionary moment of truth that ends the seemingly endless dark night of the soul. It is a mirage, containing in itself all the meaningfulness of life, that unexpectedly arises in the meaningless desert of the self and the world, indeed, the worldly self and the selfless world. This promise takes the form of the wish to change one's life entirely – to convert to a new way of life. And also to convert the world – to change it for the better, once and for all time. The paradox is that the impulsive utopian promise can be fulfilled, in an emotionally concrete way, in art-work – abstract and otherwise – which can offer moments of healing and health to both the serious artist and the serious spectator, that is, those who are seriously creative, or rather, to use the term Winnicott uses in "The Location of Cultural Experience," who actively "create into" something rather than passively take it for granted. They attempt to make it good rather than see it simply as another material, existing for no apparent reason and growing boring by the minute.

I think the simplest way of understanding the paradoxical character of the spiritual unconscious, which is the unequivocal wish for total healing and health, is by way of a quotation from Winnicott. Writing of a rather "depressive individual" he once knew, a poet who "seemed to spend most of his time in bed, lolling in a regressive state" – stagnating, as it were – Winnicott recalled his presence at "a discussion on health [in] a company of doctors, all committed to the elimination of disease." Shocking the doctors, the poet declared: "I find health disgusting! ... He went on ... to describe ... a friend of his [who] got up early in the morning and had a cold bath and started the day full of glee; he himself, by contrast, was lying in bed in a deep depression, unable to get up except on the basis of a fear of the consequences."[15] What was missing was the fantasy of self-help or self-rescue, bringing with it true faith in health and happiness, that the spiritual unconscious could supply, which in practice would mean taking poetry seriously. Winnicott's poet friend had not yet discovered his spiritual unconscious, and may never have. There is no guarantee that it will ever appear, and no necessity that it does. The paradox is completed by the fact that it is a saving grace only likely to appear, in a seemingly miraculous way, when the poet is actively writing poetry, or actively studying the work of other poets. It is only then that he might begin to take poetry as such seriously, and realize that it is hard work, rather than just a way to pass the time – to escape the world's work yet perhaps gain some social acclaim. It is worth recalling that Rosenberg said the "test" of painting is its "seriousness – and the test of seriousness is the degree to which the act on the canvas is an extension of the artist's total effort to make over his experience," his "experience of transformation."[16] If and when this change in attitude and transformation of experience decisively occurs, the spiritual unconscious will already have done its work. It will have disappeared as quickly as it appeared, confirming that it was an illusion all along, visible or invisible in situations of extreme, incurable suffering.

The Pathos of Purity

PIET MONDRIAN REASSESSED

E VERYONE CELEBRATES THE TRIUMPH OF NONOBJECTIVITY IN MONDRIAN'S ART: his steady evolution, with seeming inevitability whatever its difficulty, toward "purely abstract expression." His legendary perfectionism, his subtle manipulation of primary colors, the noncolors of black and white, and geometry – the latter are also equally primary or fundamental – to achieve an effect of dynamic equilibrium, overcoming contradiction without forcing reconciliation, have been hailed as a revolutionary new model for art. Even more decisively than Malevich, he declared the work of art's autonomy, symbolizing the transcendent autonomy of the artist. Mondrian understood his own development as a process of "denaturalization," which he regarded as "one of the essential points of human progress." "To denaturalize is to abstract," and to abstract is to essentialize; Mondrian was an essentialist: he thought there was an essence of art, and that his "genuine abstract painting," in which "both constructive elements and the manner of composing them" had been "denaturalized," had reached it. The genuine abstract painting was something more: a scientific painting. Essentialization was progressive – modern – because it was scientific: "Why should universal beauty continue to appear in art under a veiled or covert form, while in the sciences, for instance, the trend is toward the greatest possible clarity? Why should art continue to follow nature when every other field has left nature behind?" Mondrian took his confidence from science: he thought he was emulating it in making "non-natural" painting, because he thought science existed in a hermetically abstract space of its own, from which it could dominate and control nature, like a deus ex machina deciding the fate of mere mortals.

It seems appropriate, on the occasion of the Mondrian retrospective at the Museum of Modern Art in New York, to say that Mondrian's art is not what it seems to be and what he thought it was: time to recast it in other – more critical – terms, in an effort to reassess it, and above all determine its relevance today, when abstraction is past its prime, and no longer novel. Clement Greenberg once said that Minimalism was a gain that was not worth the effort, and I want to suggest that while Mondrian's nonobjectivity – his totalization of art in entirely abstract

terms – was worth his effort, it is no longer worth ours. The gains of abstraction are diminishing, and they even came to be for Mondrian, which doesn't mean there are none, and were none for him, but that they are not what they seem to be. Total abstraction is no doubt a hard path to take, and often seems too slippery to stay on – to avoid distraction by nature, especially one's own nature, one may finally have to completely blank them out, as Ad Reinhardt did in his black paintings, which by his own testimony were "mindless" and "selfless" – but even when successfully maintained the ingenious simplicity and apparent austerity that result are less than they seem to be, not, as has come to be thought, more.

I want to suggest that the high point of Mondrian's art was in fact the time when it was most in trouble, most "experimental" and uncertain: the time of transition from naturalism to nonobjectivity – the time when there was as much nature as non-nature in it – when it was not clear to Mondrian that denaturalization really worked, or rather, that he really wanted to denaturalize. From this point of view, the most exemplary – because most conflicted – works in his oeuvre are his tree and sea paintings, in which nature had not yet been sacrificed on the altar of purity. The pure paintings were anticlimactic to the struggle evident in the tree and sea paintings, and became increasingly so. Indeed, there are no climaxes in the former – their elements are equilibrated to the point of seeming self-regulating – while the latter are full of climaxes, as though their dynamics were too explosive to be completely controlled. Nature, in the process of being sadistically attacked and disintegrated, released more energy than Mondrian could handle and, when he finally learned to do so, the result was a sense of passive mastery, if not without scars of the violence that had been done to nature (broken edges, ambiguously resolved tensions). Like the superego formed by the resolution of the Oedipus Complex, Mondrian's pure paintings have an air of superiority that verges on the authoritarian. The violent lyricism of the nature paintings has been replaced by the pseudo-omnipotence of purity.

But I think this hard-won purity eventually became sterile drudgery for Mondrian, a procrustean bed from which he struggled to escape in the forties, when he came to New York, and was freshly inspired by "nature" – an environment of some sort. It was sufficiently different from the European "nature" he grew up with – and much more inartistic – to make a difference in his work, that is, to give him a way out of total abstraction, without abandoning it completely. But who knows if *Broadway Boogie-Woogie*, 1942–43, and above all the erratic, even fitful *Victory Boogie-Woogie*, 1943, and unfinished at Mondrian's death in 1944, were not the dernier cri of Mondrian's purity, and already sufficiently impure – dynamically unbalanced, their elements imperfectly integrated – to signal a crisis that would have led him, as it led Malevich, to return to the representation of nature, in whatever quasi-abstract form?

The issue is, what was sacrificed – repressed – in the tree and sea paintings, among others of the time? What was Mondrian fleeing from – struggling with? He himself tells us: the self, that is, the "psychology of man," "untidy minds," and

above all woman. All are tragic, and to expunge the tragic was Mondrian's explicit purpose. "Neo-plasticism agrees with the futurists in desiring to eliminate the *self* from art," he writes. Moreover, the "futurist ... proclamation of hatred of woman (the feminine) is entirely justified. It is the Woman in Man that is the direct cause of the dominance of the tragic in art." To paint purely seems to have meant to be all-Man – to have completely eliminated the female in oneself, and woman as such, that source of so much tragedy. (A Pandora's box of evils, with its token of hope – hopeful orgasm – at the bottom.) It is not clear whether Mondrian made a so-called "homosexual solution" to the conflicts of sexuality we must all suffer, but it seems clear that his "nature," like ours, is Mother Nature. Like everyone, he initially identified with and eventually had to separate himself from her. Like everyone, he had to resolve his psychic bisexuality; he fantasized he did by making epicene paintings (if one neuters the Woman in oneself, one also neuters the Man). The result eventually became all too tidy, and it was this tidiness that Mondrian was fleeing at the time of his death in New York, a supurbly untidy city.

In the end, Woman signaled instinct for Mondrian – his own conflicted desire for her – and instinct is untidy and tragic. Mondrian's abstract paintings are an intellectual defense against it, as his appeal to science suggests; it, too, does battle with nature through abstraction. What Charles Hanly wrote of Plato and Descartes also seems true of Mondrian: "some personal intensification of anxiety precipitated a regression that withdrew drive energy from objects resulting in an intensification of narcissism that constructed intellectual defenses against painful realities ... In Plato's thought the dread of animality, of the material and instinctual, is pervasive." In Descartes, thought defends against reality by "depersonalization and derealization." In Mondrian's thought – his paintings – there is a progressive process of intellectual depersonalization and derealization of nature: purity defends against matter, instinct, animality, under the illusion they can be completely mastered. The tree and sea paintings are full of drive energy and anxiety, while the pure paintings are a successful defense against – intellectualization of – them. (It seems significant that Mondrian never painted an animal, only vegetation, even though some of his trees snarl like animals and the plus and minus marks he reduces his sea to are a kind of animal language [yes and no, the most primitive vocabulary].)

When he saw death approaching in New York – and death invariably arouses anxiety, unconscious or conscious – Mondrian's instincts flared up again, in a last efflorescence of life. He was on the verge of losing intellectual control. Perhaps, with the end of his life approaching, he no longer saw any need for it. His drive energy, which had survived in the idiosyncratic construction of his pure paintings – their elements are never conclusively integrated – threatened to erupt and become free-floating, which is the way it was in his tree and sea paintings. Mondrian in effect was rebelling against himself – against the mastery that made him a mature, pure, laconic painter. He was, I think, on the verge of achieving a synthesis of instinct and intellect, rather than using the latter to defend against

the former. The ruptured tidiness, if not untidiness, of the late paintings gives them an uncanny gracefulness, which Mondrian never had before, except in the paradoxical tree and sea paintings. There, the strangeness that is said to be inseparable from beauty, adding a note of intimacy and urgency to its universality, came to the fore.

The lesson of Mondrian's development is that the self – psychology, woman, drive – can never be eliminated from art, however hard it tries. Greenberg thought that the paintings of Van Gogh and Soutine were failures because they had, conspicuously, not mastered their instincts and feelings. Their paintings lacked esthetic integrity, however much they had personal integrity. They were all too energetic and "informal," and as such not superior to life. Above all, they did not escape – even try to escape – nature. If this is so, then Mondrian's tree and sea paintings, and his freshly insecure and troubled last ones, must also be formal failures – inadequately abstract and transcendent. But such failure is the only real success in art, which can never escape human nature.

Negatively Sublime Identity

PIERRE SOULAGES'S ABSTRACT PAINTINGS

Using the term "abstract" in its loosest sense for a moment, we can say that abstractness in art signals a withdrawal from the objective world at a time when nothing remains of that world save its *caput mortuum*. Modern art is as abstract as the real relations among men. Such notions as realism and symbolism have been completely invalidated.

T. W. Adorno, *Aesthetic Theory*[1]

The question is: how to be isolated without having to be insulated?

D. W. Winnicott, "Communicating and Not Communicating Leading to a Study of Certain Opposites"[2]

Dialectics is the consistent sense of nonidentity.

T. W. Adorno, *Negative Dialectics*[3]

1

THERE IS NO ART THAT IS MORE SUBJECT TO HUMILIATION – NEUTRALIZATION, objectification, conventionalization – than abstract painting: "the non-representational is perfectly compatible with the ideas affluent members of society have about decorating their walls."[4] Through its reduction to decoration –" wallpaper patterns capable of being extended infinitely"[5] – it is brought into the collective, which is to take revenge on it for the fact that it has a certain "power of resistance" to the world, because it cannot be objectified in its terms (unlike realism and symbolism).[6] Moreover, "radically abstract painting" is "lonely and exposed," which makes it a critique of the objective world, for it reminds it of the subjective reality it repudiates – the subjective reality lurking within its objectivity:[7] this is another reason radically abstract painting must be neutralized, degraded, trivialized, almost annihilated. Adorno has argued that we live "in an age of total neutralization of art,"[8] an overstatement which nonetheless makes it clear that the "compact majorities" of modernity, as he calls them, must defend themselves against the emotional recognition radical art brings with it, even as they endorse and objectify it as commodified civilization. For art at its most radical is full of too many unwelcome, dark truths about modernity and its effect on the self – too much contradictory enlightenment.

From the start of his career, with a kind of heroic tenacity and singlemindedness, Soulages has struggled to maintain abstract painting's power of resistance – its "critical bite."[9] Indeed, the critical bite of his blackness – initially eschatological in import, and then, in his later works, a luminous gnostic revelation in itself – not only subverts the decorative, but restores a sense of the subjective rebellion which abstract painting at its most radical is. Soulages uses blackness, aroused and dramatized, and finally transparent and infused with light, to finesse uniformity dialectically – to defeat the wallpaper effect of redundant flatness, emotional as well as literal, that is the instrument of neutralization, de-radicalization, in the very act of acknowledging it. But it is above all the tenacious isolation of his blackness that re-radicalizes the abstract painting: loneliness has become blatant and intransigent – overexposed and assaultive, violent and stubborn – in Soulages's blackness, making it utterly incompatible with the sociality represented by the decorative. It has the force of irreconcilability: the transcendence of negation.[10]

The abstract painting must contradict, even seem to abandon the wall: to float free of it, or to stand out from it, as though levitating at a deliberate distance from it, and thus become untouchable, and beyond simple placement, social or esthetic – beyond embeddness in any decorative scheme. The wall, in losing necessity, makes the abstract painting seem self-grounding – an autonomous if insecure architecture. Thus the radically abstract painting reacts to the wall's dull stability and clear identity with the ironic instability of its own identity. Such irreverent detachment is one of the things Soulages's blackness accomplishes: it is an ecstatic presence – a levitating force that slowly ferments a negative freedom, once again giving the abstract painting a negative identity, thus renewing its radicality, its lonely exposure.

<div align="center">2</div>

"Abstract pictures" may no longer be able to escape being subsumed as "one element in a purposive arrangement," but they can be a discomforting element.[11] Unsettling because unsettled in themselves, they are only superficially compatible with luxury. Society may think it has grown wise in no longer resisting the abstract painting that once resisted it, and try to swallow it whole without blinking. But the most radical abstract painting remains indigestible – peculiarly "out of sight," unseeable, ironically invisible. It is too hard for ordinary perception, which seeks comfort before insight, to swallow.[12] Radical abstract painting does not accommodate to decor, does not fit in, despite every effort to metabolize it into a "place setting." Indeed, it always seems oddly out of place, no matter how well one places it. No matter how glamorous its presence, it adds an odd tone of absence. No matter how much it communicates, it seems incommunicado. Thus it can never be completely neutralized into decoration, the power of its difference drained from it, because it does not submit to the usual processes of perception designed to foreclose on radical difference, subsume the uniqueness that is evident in irreconcilability. Decoration symbolizes the comfort that denies the anxi-

ety aroused by the irreconcilably isolated self, so radically different from the self that falsifies itself by glorifying itself as an ornament of the world.

When it was unexpected, abstract painting forced itself on us like a bizarre eruption from the unconscious, breaking through the defensive everyday blindness we achieve through selective inattention, as Harry Stack Sullivan called it, of which decoration is a major instrument, leveling as it does whatever strangeness invades attention. Now that abstract painting has become expected, an academic category, its contemporary problem is to reassert its difference – not to restore the old sense of difference, but to test the authenticity of its difference and irreconcilability, its resistance to the sameness that decorative neutralization instigates in the name of society. It must show that the difference of radical abstract painting is not a gratuitous act of social defiance, but ontologically inherent. It is inherently nonconformist, because it is conforming to its own anxiety.

The task that Soulages has set himself, and that he sustains throughout his development, is to establish and define this radical difference. The absence and invisibility embodied in blackness – the apotheosis of absence and invisibility through blackness – is its major mode and instrument: the blackness of his abstract paintings is irreconcilable with decor, resists decor with all the power of its nothingness, even when, as in the later works, it sometimes seems more elegant than existential. It is through blackness that Soulages's abstract paintings articulate the social truth of their outsiderness, their nonidentity in a society that posits its own mythical self-identity – also symbolized by the uniformity of the decorative. Soulages's abstract black paintings do something more: they reveal the negation inherent in the forced social march to self-identity, a negation articulating the truth that abstraction informs all real relations among men, as Adorno said. It is this ironical revelation of the ambiguity of abstraction – the fact that it is as much an instrument of conformity as of uniqueness, that it establishes the compact majority as well as the difference of the outsider individual – that makes Soulages's abstract black paintings truly radical.

But they are even more extraordinarily radical: they reveal that to be unconditionally negative is to become conditionally positive. That is, their victory over decoration is more than Pyrrhic because they affirm, in the very act of making the negation implicit in abstraction explicit and uncompromising, the subliminal, attenuated feeling of being an incommunicado subject, which is to be an autonomous if isolated self. It is this feeling that the collectivization represented by the decorative is determined to destroy. In reaching, through their negativity, the truth that "by slaying the subject, reality itself becomes lifeless," Soulages's abstract black paintings restore a kind of dialectical life to the "powerless subject," thus showing that "reality" is not as "all-powerful" as its abstractness makes it seem.[13] "Annihilating reality" is revealed in all its self-annihilation, which does not mean the subject has the power to undo the annihilating effect of abstract reality on it – the feeling that it is unreal – but does give it the courage to recognize itself in the black mirror of its emaciation,[14] to face the fact that continuous

abstract relations have reduced it to a shadow of itself. But recognition of the fact that in everyday collective existence one has become an abstract, inwardly lifeless shadow of oneself, is to begin to recognize one's true self, for it is ironically mirrored by – hidden in – one's shadow. Such ironical recognition of one's shadowy reality gives one the courage to survive and feel real and emotionally full, rather than unreal and emotionally emaciated. For by admitting the truth to oneself, one becomes true to oneself, in however small a way, and thus transcends one's feeling of being annihilated – profoundly falsified and diminished in one's being – by the abstract collective. Perhaps such dialectical self-recognition is no more than an artistic kind of survival, but it nonetheless testifies to the subject's will to live.

The subject's emaciation becomes negatively sublime – a blackness that is too extreme to become the site of human fantasy, an infinity too black to be idealized into a decorative cornucopia, to be compromised in its stubborn immediacy. Soulages's blackness may seem to reverse, may seem to become "light" (luminous and less of a burden), may seem to become the color Soulages thinks it is, and indeed he often suggests that it is full of color, or hides color[15] – but it never disappears: it remains insidiously absolute, omnipresent and omnipotent, a fearless negative transcendence, a symbol of his insight into nothingness, and acceptance and mastery of the anxiety it arouses.

Soulages's blackness is the complete abstraction from reality that represents the unreality it has become, and thus allows the subject a certain reality, a certain right to exist, without guaranteeing it concrete existence, a home in the world, an end to its feeling that it is unreal, an empty abstraction.[16] Soulages may seem to reify blackness, but he uses it to re-radicalize abstract painting, to make it, once again, nonaccommodating and heroically homeless – a refusal to play the decorative game of symbiotic belonging, the imaginary return to a world that gives one the illusion of being a significant part of it, and as such a radical statement of the nonidentity that is the only identity in a reality full of readymade, abstract identities. The architecture of identity that Soulages constructs with his blackness – an architecture that changes the moment it stabilizes into self-identity, for it must maintain "the proportions of the interior,"[17] and to be completely self-identical is to become an exterior – is always on the verge of collapse, always risks declaring its own nothingness, which confirms its subjective power as nonidentity and self-absence. In displacing his identity to art – it was "the only thing worth spending one's life on," he discovered early in life – he acknowledged the slipperiness of both, and the fact that life is only worth living when one does not try to earn one's identity the way one earns a living.[18]

3

Soulages has said that "there was nothing negative in [his] choice" of black,[19] but in origin his choice was not without a certain unconscious melancholy, as his remark that his first paintings were of "trees in winter, without their leaves" – trees

… painted in black on a brown background"[20] – suggests. Black remains "a very violent color" for Soulages, a "very intense color, more intense than yellow, capable of giving rise to violent reactions and contrasts,"[21] like a dead winter landscape. In fact, it is incandescent yellow that mitigates the futility of blackness in many of the early brown gouaches and paintings – they are to my mind an adult, abstract transposition of his bleak adolescent landscapes – along with Soulages's ambiguous attempt to architect blackness into an enigmatic emblem, an almost picturesque pictograph. While Soulages seems to agree with Matisse that "black is a color" – that it is "absurd to make a distinction between black and color," that in choosing black one is "not rejecting the other colors"[22] – unlike Matisse he disinters it from nature, as though to render it as a nonobjective feeling, to use Malevich's term. In fact, Soulages discovered Malevich's desert in the barren winter landscape, and Soulages's subsequent abstract paintings are the esthetic equivalent of both, or rather abstract the emotionally rich barrenness of both.

In the history of modernist painting, blackness has two faces – a split identity. On the one side, it serves symbolism – emotional realism. Kandinsky described it as:

a totally dead silence … a silence with no possibilities. … Black is something burnt out, like the ashes of a funeral pyre, something motionless like a corpse. The silence of black is the silence of death. Outwardly black is the colour with least harmony of all, a kind of neutral background against which the minutest shades of other colours stand clearly forward.[23]

At the other extreme, the noncolor of black epitomized art-as-art for Ad Reinhardt – the ultimate nonrepresentational purity.[24] Art-as-art – art as only itself, with a certain grand if perverse simplicity – is pure negation, pure absence. It is totally inexpressive – untranslatable. Reinhardt's radical abstract black paintings cancel the mundane and herald transcendence, without giving it a content, for it has none. Their polished blackness shuts the world out, and makes them hermetically true to themselves. But that self – art – is unnamable; their blackness signifies that art is "selfless" as well as nonworldly. It does not mime internal or external reality (symbolism and realism). They are certainly not informed by any signs of Reinhardt's everyday self and desire, and in fact represent his personal achievement of selflessness and repudiation of desire. They are beyond experience and history, personal and collective, and as such timeless and spaceless. Thus his abstract black paintings convey art's unintelligibility to itself as well as its incomprehensibility to ordinary worldly, "realistic" consciousness. His irreducible blackness is the blank such consciousness draws on art's transcendence as well as the "form" of that transcendence. It establishes meaninglessness, but also a kind of alternate meaning. Reinhardt has been called the ultimate artist mystic: a kind of "anesthetic" – self-anesthetized – fundamentalist.[25]

Soulages's development can be understood as a movement from Kandinsky's evocative use of blackness to Reinhardt's exhibition of it, in all its presentational

immediacy, to use Alfred North Whitehead's concept, as a cul de sac absolute. But there is a crucial difference between Soulages and both Kandinsky and Reinhardt: the exquisite sensitivity of Soulages's brushwork, which he never stops refining, and the austerity of his constructions, which, unlike those of Reinhardt and the later Kandinksy, depend not on readymade geometry, but on "powerful buttresses," Soulages's basic invention. They are "heavy bars" and "elementary gestures" in one, as Werner Haftmann says.[26] The result is "a complete, self-contained monumental icon" composed of "ponderous movements" and conveying "archaic strength," even when, in the later works, the movement becomes more systematic, repetitive, suave – ritualized, and thus intensified. Soulages does not fall between Kandinsky and Reinhardt; he ultimately transcends both, however much, initially, he may have been tempted by their methods and perhaps had similar ideas: the hypersensitive – ultrasensuous – surface of his later paintings is neither altogether expressive nor simply an assertion of art-as-art, but radically esthetic. If Kandinsky's surfaces tend to be manic, and Reinhardt's surfaces look anesthetized, then Soulages's surfaces are unabashedly esthetic. For they offer sensory elements that seem too intense to contain, and thus seem to spread infinitely, yet are self-contained: a self-grounding architecture of sensation. Soulages's later paintings architect their own containment – this is what his earlier paintings were struggling toward – without sacrificing their sensitivity, indeed, while growing in sensitivity, that is, incommunicado sensory quality. One might say, in Wilfred Bion's terms, that they have learned to perform the alpha function for themselves, which they could not initially do, however much they tried, for they were too full of tragedy, willingly or not.[27]

However much Soulages might deny it, his early gestures are explosive traces of the tragedy that World War II was for France – residues of a belated, risky action as well as a mourning for its failure, and the loss of self-respect or narcissistic wound this failure brought in its postwar wake. Soulages's early paintings are informed by an existentialist mentality if not existentialist doctrine, and like French existentialism they are an all too delayed and muted assertion of autonomy and declaration of freedom – a gestural emblem of the action and self-assertion that might have been. The subtle morbidity of Soulages's abstract black paintings of the late forties is evidence, as Bernard Ceysson writes, of "the profound effect" that "the moral and intellectual shock caused by the French defeat in 1940 and the German occupation of France" had on "the conscience of the individual."[28] They are works of conscience, and, as I will argue, conscience never left Soulages's work.

4

Soulages's account of the formative influences on his development is brief but telling. Two moments seem of particular importance. When he was about ten, he drew a "snow landscape," as he called it: "a series of lines in black ink on white paper," in effect an abstract "landscape under snow." He "was trying to recapture

the brightness of light. The white paper began to shine like snow by contrast to the black lines." A few years later, he "learned to look at Romanesque art, the cathedral of Conques for example, where [he] was overwhelmed by the proportions of the interior."[29] The Romanesque aspect of Soulages's paintings is unmistakable. They convey a very Romanesque sense of strength, solidity, and solemnity – of an inexhaustible reserve of titanic power waiting to be released – in their architecture. They have the same enclosed appearance as a Romanesque interior. They are, I suggest, an abstraction of it. At the same time, bright light informs Soulages's black planes – as it does the dark Romanesque interior – and struggles to break through them, as well as to purify itself, to become more like the brilliant white light of the stars or freshly fallen snow than the yellow light of the sun or the reddish light of sunset. In fact, the black planes overlay and obscure the light, the way the black ink lines of his youthful snowscape overlaid the white paper. Is it simplifying Soulages's abstract paintings to say that their whole point is to find light in the dark – more particularly, the light that dwells in the darkness, and that, at the moment of revelation, is secreted by it, as it were? Soulages is a gnostic, however unwittingly: he searches for the saving revelation of light, which seeps out of the darkness like sap out of bark.[30]

I am suggesting that the Romanesque interior is the model of self for Soulages, and that what he paints is the self at its most extreme and emaciated, to use Adorno's term again, and desperate for the light that can transfigure it. Again and again, in innumerable ways, light breaks through, onto the surface of Soulages's paintings, transfiguring it. The light that is always latent in the self, concealed within its blackness, suddenly becomes manifest – a kind of grace. Soulages paints this moment of breakthrough – of unexpected revelation, this sudden contradiction of darkness by light – again and again. He tries to recover his feeling of being overwhelmed by the abstract architecture of the Romanesque interior, and to architect esoteric abstract paintings that overwhelm us the same way. But he also offers us the same relief he experienced: light suddenly seems to invade the oppressive, massive black space, giving us a new sense of interiority. In his later paintings Soulages seems to have descended to the very crypt of the self, where the darkness is complete, and yet even there a certain thin, fragile light filters through the gloom. The dark lines he added to his youthful snowscape came from within him: the light was already there, outside him, in nature's snow, symbolized by the plane of white paper. In a sense, he taints it with his own interiority. That was not a given; it was something he had to discover. But in his later painting the black is already there, omnipresent, engulfing: he adds the lines of light. Soulages's dialectic – interior – has changed: blackness is now no longer the end that must be urgently expressed, but the starting point for subtle, almost inexpressible light.

5

In such works as *1948-2, 1948-4* (Fig. 18), and *1948-6*, Soulages struggles to organize his blackness, to give it shape, as though he could reconstruct a world out of

18. Pierre Soulages, *1948-4,* 1948. Brou de noix sur papier. 100 × 75 cm. Courtesy of the artist.

its cinders. He is not entirely successful – the result looks more like a tattered emblem than a grand architecture, the fragment of an idea of form rather than a solid content – but he doesn't want to be successful. The sense of wreckage, the ironical incompleteness of a ruin, the feeling of a fragment that is a structure in itself, is more important than any rebuilding. The grid of *1948-2* is unresolved however self-enclosing, the curved gesture of *1948-4* is inconclusive, however mysterious and cabalistic, and the firm verticals and decisive curves of *1948-4* do not add up to a stable architecture. Everywhere there is light, but it is unrecognized – a secondary and atmospheric rather than a primary presence. Indeed, through the early fifties, structure remains unstable, however dramatic – a zone of conflict and contradiction, in which thick bar-gestures, of various densities of black (a broad, thinly painted, atmospheric underlayer; a more, thickly painted overlayer), tend to shoot off in opposite directions, at odds with each other, however much they seem like blocks from the same building, as in *1951-14*. There is

more conspicuous organization to this forceful painting than the earlier ones mentioned – it seems to be an enigmatic, aggressive escutcheon, the mandala of a defiant self – but the resulting construction has no ground to stand on, however self-grounding it may be. In all these works the abstract black figure floats on a ground of impure light, which sometimes informs the figure as a kind of gesture, giving its blackness a reddish brown or dark orange cast, adding to its dimensionality and negative sublimity. It is as though Soulages is trying to give shape to the feeling of death that has infected him, in an attempt to exorcise it by making it "definite," but the forcefulness of the black suggests that it cannot be expunged.

2 June 1953 has a similar asymmetrical, opaque black, cross-like structure in its center, dividing the work into four atmospheric quadrants of less intense black. The vertical and horizontal borders of the central structure are marked by streaks – outbursts – of light that form a kind of broken halo. The sophisticated, nuanced handling of the surface contrasts oddly with the stark, weirdly primitive icon in the center. *20 November 1956* is a grid of bar-gestures, not unlike *1948-2,* but arranged in tiers on a white ground, with strong elements of orange in the central tier. One of the most dramatic of Soulages's disturbing, eccentric "crosses" is the climactic *6 January 1957:* the intense, confrontational black structure that seems to project beyond – hover above – the yellow ground it rests on, has an uncanny resemblance to the so-called papal cross. Its "finials," and the "panels" on the ends of several of the horizontals, give it a "medieval" look. All these works, to my mind, have, however obliquely, a reluctant, peculiarly angry, even bitter religiosity.

Soulages suddenly smashes the structural mold he has struggled to establish: the pieces scatter, if still taking the shape of a grid-frame, in *27 August 1958,* and *28 December 1959* is a kind of pile-up of the bar-gesture fragments. Figure and ground already began to integrate into a single, ominous plane in *22 May 1959,* and the works grow larger and larger, as *24 November 1963* and *5 February 1964* indicate. They become oppressively black environments, if with startling "interruptions" – ruptures or rips – of light. Blackness seems to lose its footing on a plane of light in *6 November 1964,* but in general dominates, filling the canvas, as in *22 November 1967,* the light lapping around its edges, sometimes biting at its corners, as in *25 May 1967,* and sometimes filled with an inner orange illumination, made of similar bar-gestures, as in *20 October 1967.* In other works, such as *21 September 1967, 25 September 1967,* and *29 September 1967,* it becomes more calligraphic than iconic – a kind of dense, incomprehensible glyph, twisted in on itself.

Broadly painted, mural-sized works such as *14 May 1968* and *4 January 1974,* with their trans-human scale and eloquent vertical cleavages or seams of light-fragments – in *17 January 1970* the broad, softly curved black and white verticals balance each other – can undoubtedly be compared to the similar, uniformly colored field paintings of Barnett Newman and Clyfford Still, who also use a residual gesturalism, but Soulages remains much more economical in his means, leading to a more concentrated result. Soulages's field, however broad, seems more focused and, simultaneously, more ingeniously constructed. Also, he does not make transcendental claims for it; his field is not the product of a God-like "Act" of creation,

19. Pierre Soulages, *Painting*, March 1986. Polyptych, oil on canvas. 162 × 727 cm. Courtesy of the artist.

as Still grandiosely thought his field paintings were – a mystification of the artist as well as the work of art – nor is each bar-gesture, however narrow or broad, thick or thin, a metaphysical signifier, as Newman's zips are supposed to be. Soulages's abstract painting is not a form of preaching, an attempt to save our souls, like that of Newman and Still. His paintings are not philosophy and religion in simplistic disguise – a disguise that simplifies them – as Still's and Newman's are. Soulages, then, does not pretend to be dividing the Red Sea when he divides his canvas, only creating a certain tension of light and darkness, sometimes with a mediating zone of primary (yellow, red, blue) or complementary (orange) color between. Mind (but not God) exists in the concreteness of this tension – a precarious if self-conscious balancing act between black and white, in which the former claims to have priority and all the power, a claim the latter subtly refutes – not as a deus ex machina supervising the tension, as in Still's and Newman's paintings. The tension of black and white may have a gnostic dimension, as I think, but Soulages has no intention of intellectually or for that matter emotionally and rhetorically exploiting their difference – whatever its evocative, persuasive power – only of exploring its possibilities. Still and Newman want to rewrite the Gospel with their painting, but Soulage is simply purifying his experience of radical contrast until it becomes epiphanic. There is no anthropomorphic or picturesque residue in Soulages's paintings, as there is in those of Newman and Still, only a pure tension.

As though to insist on this point, Soulages simplifies – radicalizes – his paintings even further in the late seventies and eighties. The process can be studied in three works made around the same time: *27 February 1979, 19 March 1979,* and *14 April 1979.* An opaque black bar and a uniform gesture of luminous lines – a reversal of the black lines of Soulages's early snowscape – oppose each other, like substance and luminous shadow, even though they constitute the same plane. The grand triptych *30 May 1979* is a climactic statement of this mode, with the gestural field more luminous, and the bar more resistant, than before. In the equally gigantic *7 February 1985,* the luminous linear gesture has made a clean sweep of the field, with the black bar now reduced to a thin divider, as light once was. In a number of other 1985 and 1986 works Soulages integrates the black bar and luminous gesture in what might be called an intuitive seriality. These works are peculiarly ritualistic as well as driven. *March 1986* is a particularly striking example (Fig. 19). The severity yet strange vitality of this work – opaque bar and luminous gesture alter-

nate vigorously in an irregular rhythm, sometimes stumbling over each other yet maintaining their dignity – achieves a remarkable sense of nonidentity within self-sameness. In *18 February 1990* white reappears, a rectangle that takes the measure of the vertical work, which can be intuitively divided into rectangles of the same size. Its pendant, *23 February 1990,* has black in the same place. Proportion is crucial in both these "classical" works. Like *28 December 1990, 30 December 1990, 5 January 1991, 14 January 1991, 29 January 1991, 7 February 1991,* and *19 February 1991,* they are modular constructions, however irregular – diagonal – their divisions. The diagonal becomes dominant in *11 December 1991,* but the same principle holds.

Adorno has argued that expression and construction are the poles of twentieth-century avant-garde production, and that each makes the most radical esthetic sense when it has nothing to do with and in fact makes nonsense of the other. But Soulages's late constructions, at once uncannily "minimalist" and emotionally insinuating, suggest that in the current decadent, so-called postmodernist situation of art, in which both expression and construction have become reified and exhausted their possibilities, only a crafty hybrid of the two can make fresh esthetic sense. Indeed, the split between expression and construction must be healed for art to grow, and Soulages attempts to accomplish it on the most fundamental level: that of gesture and geometry, figure and ground. In the late paintings they seem to converge and constitute each other, an achievement that was Soulages's ambition from the beginning. But even though figure and ground and geometry and gesture become identified with each other – form a subliminal unity or at least a concordance – they maintain their autonomy, and thus remain nonidentical, even subtly discordant. Thus the paintings of the eighties and nineties are Soulages most radical, daring works, for they carry his ambition to its logical, and simultaneously illogical, conclusion.

They are also radical because black and white radiate with equal intensity and brilliance in them – in his youthful snowscape he wanted to capture the total "brilliance" of the scene – however different their textures and form, which in fact they repeatedly exchange. It is as though they have become the same substance. To call Soulages's late paintings abstract seems a misnomer, in view of the fact that black and white, and expression and construction, line and space, have become irreducibly concrete. Each has become unmistakably itself, while remaining inseparable and contradictory of each other. Thus the late paintings establish an irreducible solitude: a peculiarly agonizing solitude, for despite their determined attempt to heal the primitive splits in the self they never succeed in doing so, however much they actually seem to. For the splits are too deep, being the very fundament of the self, and yet there are few artists who have articulated them, and the self's core unity, as incisively and consistently as Soulages.[31]

Unconscious and Self-Conscious Color in "American-Type" Painting

The strife of colors, the sense of balance we have lost, tottering principles, unexpected assaults, great questions, apparently useless striving, storm and tempest, broken chains, antitheses and contradictions, these make up our harmony.

<div align="right">Wassily Kandinsky, Concerning the Spiritual in Art, 1911[1]</div>

The simultaneity of colors through simultaneous contrasts and through all the (uneven) quantities that emanate from the colors, in accordance with the way they are expressed in the movement represented – that is the only reality one can construct through painting.

<div align="right">Guillaume Apollinaire, "Reality, Pure Painting," 1912[2]</div>

<div align="center">1</div>

AD REINHARDT IS NOT USUALLY THOUGHT OF IN THE SAME BREATH AS Clyfford Still, Barnett Newman, and Mark Rothko – masters of "American-Type" painting, as Clement Greenberg called it. But without Reinhardt's black paintings the subliminal import of their color paintings would be missed. In fact, Reinhardt completed, in his development from what he called his "bright-colored painting"[3] to paintings with "no-contrasting (colorless) colors,"[4] the neutralization – denaturalization – of color, and then its cancellation (Fig. 20). He made his last "bright-colored paintings" in 1953. Reinhardt went further than they intended to go, but what he accomplished was already in the making in their painting, unknown to them. The "darkened, value-muffling warmth of color in the paintings of Newman, Rothko and Still"[5] is thus an unwitting prelude to Reinhardt's black paintings, as well as the ironical climax of the modernist tradition of simultaneous color contrasts.

All three concluded their careers with paintings that more or less abandoned color, if not contrast: Reinhardt overthrew both in a single revolutionary renunciation. What was for them an uncertain process, a slow, insecure, unsteady evolution toward a recognition – that the candid use of color for its own sake is not of the essence of modernist purity, as had been dogmatically supposed – became, in Reinhardt, a self-conscious vision of painting-beyond-color, truly absolute painting. For, free of relative perceptual effects – an indication of the ambivalence cre-

ated by contrasted colors, the uneasy balance of attraction and repulsion between them – Reinhardt's steady state, entropic colorlessness achieved an effect of space-lessness and timelessness. Free of the perceptual vicissitudes responsible for the sense of space and time, the black paintings seemed eternally constant. Only the complete absence of mutually conditioning colors made such completely pure – seemingly unconditional – presence possible.

Reinhardt's black paintings also make clear that modernist emphasis on color contrasts and light, evident since Impressionism, is only in part an attempt to quintessentialize reality. For the abstraction of color contrasts and light begins a journey of separation from reality. Reinhardt's great insight was the realization that complete transcendence – complete autonomy of painting and mind – can be achieved only when they are completely eliminated, for, however independently cultivated and abstractly individuated, they remain vestiges of reality, an imma-nent expression of it. Still, Newman, and Rothko unconsciously tended – "drifted" is perhaps the best word – toward the goal of transcendent colorlessness while consciously believing they were articulating the depths of subjective reality through their refinement of color contrast. They were in subtle self-contradiction: unconsciously de-differentiating colors – moving toward the obviation of con-trast – while consciously re-differentiating them. They were not able to make Reinhardt's daring leap of faith into the holy land of colorlessness, but they saw it from afar, like a mirage in the desert. (Even more inconceivable to them was the abandonment of irregularity for serial regularity, gestural atypicality for geometri-cal typicality. Neither Rothko's nor Newman's "suggestive," peculiarly aborted geometry come close to Reinhardt's unwavering, ascetic geometry.) Thus, while they tended toward monochrome painting, it was in unwitting anticipation of colorless painting.

Reinhardt's black paintings are in effect a fresh application of the ruthless "law of modernism," namely, that "the conventions not essential to the viabil-ity of a medium be discarded as soon as they are recognized."[6] But they are much more. For in showing that the convention of color (and light) is not essential to the viability of painting – that painting is more itself without color (although light invariably infiltrates any surface, being inseparable from its visi-bility) – Reinhardt made us aware that modernist painting, from the start, was a dialectic of color and colorlessness. Colorlessness was its repressed term – a term that it vigorously repressed, as though it was a threat to the integrity of paint-ing. (Thus the reconception of colorless black as a color by many modernist painters.)

By ending the repression – by making colorlessness omnipresent and omnipo-tent, the very substance of painting – Reinhardt not only made clear that lively, light-filled color was the instrument of that repression rather than an end in itself, but that modernist painting's anxiety about static, inexpressive colorlessness masked a fascination with it. Indeed, Reinhardt showed that colorlessness is not modernist painting's self-loss, but the true sign of the "selflessness" it secretly

20. Ad Reinhardt, *Black Paintings*. Installation for an exhibition at the Jewish Museum, 12/23/66–1/15/67. © 1999, Estate of Ad Reinhardt/Artists Rights Society (ARS), New York. © COPYRIGHT ARS. Jewish Museum, New York. Jewish Museum, NY/Art Resource, NY.

desired – the transcendence that implied a radically different sense and source of self than perception of the material world afforded. Modernism's advocacy of color, then, denied colorlessness – invisible, dematerialized color, as it were – but unconsciously looked to it as the conceptual fundament of color. The pursuit of pure color – the perceptual hunger for the energy of color – kept the void of colorlessness out of sight and mind while acknowledging it. In fact, the void proved inescapable in modernist painting, becoming visible by means of a visual parapraxis, as it were – the colorless blank canvas spontaneously breaking through the color contrasts that overlaid and denied its existence, as in many of Cézanne's late paintings. Like an unexpected snake under a garden stone, this manifestation – veritable epiphany of colorlessness – proved that the void was alive and well under the surface of even the most vitally colorful modernist paintings. Reinhardt's black paintings made it an intense surface in its own right. In contrast, the modernist paintings of Still, Newman, and Rothko anxiously grasp at straws of color as they sink into colorlessness. To put this another way, they use color to wall off the void, as though it was a monster to be kept out of sight. Only when Reinhardt made the void explicit did it become clear that it had invisibly existed all along, guiding the painting into presence.

According to Greenberg, "the most radical of all the phenomena of 'abstract expressionism' – and the most revolutionary move in painting since Mondrian – consists precisely in an effort to repudiate value contrast as the basis of pictorial design."[7] Clyfford Still, whose "paintings were the first serious abstract pictures … almost entirely devoid of decipherable references to Cubism,"[8] was the leader of this revolution (Fig. 21). "Still's great insight was to recognize that the edges of a shape could be made less conspicuous, therefore less cutting, by narrowing the value contrast that its color made with the colors adjacent to it."[9] Newman and Rothko were "stimulated and influenced" by Still, without losing their independence. Newman's color functioned "more exclusively as hue [than Still's], with less help from difference of value, saturation or warmth," and thus was more "progressive." Rothko was regressively independent, as it were, for he retained "certain [insinuating] contrasts of warm and cool … learned from Matisse."[10]

Now the point is that by renouncing color contrast Reinhardt took the difficult step toward iconoclasm – completely imageless painting, painting that was not even latently or secretly imagistic – implicit in Still, Newman, and Rothko.[11] They could not take it because they were imagistic in intention, however unwittingly. They wanted to "picture" interiority: they thought of abstract painting as the best means of presenting subjective states without adulteration and compromise – not simply evoking them by association with color, but articulating them in a direct way, as at were, as though the play of color in the abstract painting was the self-imaging of the subjective state. For them, abstract painting symbolized the subject liberated from the objective world it is usually immersed in and obscured by. Abstract color contrasts did more than symbolize the tension of the liberated subject's inner life: such "artistic," irrational contrasts were its visible form. For them, the seemingly adjectival – and thus dispensable – coloring subjective reality gave to objective reality, is the true, indispensable substance of modern painting. The shift from representation to abstraction inseparable from modernism – the liberation of nonobjectivity – is in effect a shift from the articulation of objective reality to the articulation of subjective reality.

The painting of Still, Newman, and Rothko is not only residually imagistic, but figural, however obliquely – they articulate the subjective figure as an abstract landscape in which fluid, sometimes grand, ultimately indecipherable "gestures" spontaneously erupt – in a way Reinhardt's is not, for all his acknowledgment of the figural size of his black paintings.[12] Indeed, while Reinhardt, from the start of his career, was committed to abstract purity, they began as painters of surreal figures in a surreal landscape. When they became completely nonobjective, they transformed the picture itself into a surreal landscape-figure. That is, the picture itself, as a physical whole, became the subjective figure – an abstract analogue of the figure. It was constituted by color contrasts, bringing figure and ("landscape") ground together in a common, if not unified, field, as Greenberg called it.[13] Thus, by eliminating any and every color contrast in order to make an "inexplicable icon" – "a clearly defined object, independent and separate from all other objects

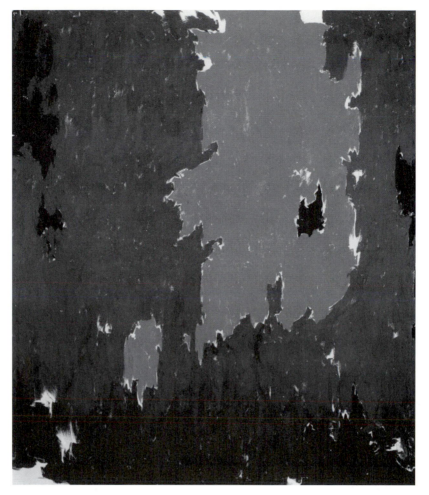

21. Clyfford Still, *1950-A No. 2,* 1950. Oil on canvas. 108 $^3/_4$ × 92 inches. Hirshhorn Museum and Sculpture Garden, Smithsonian Institution. Gift of Joseph H. Hirshhorn, 1972. Photograph by Lee Stalsworth.

and circumstances, in which we cannot see whatever we choose or make of it anything we want, whose meaning is not detachable or translatable"[14] – rather than a picture or image, Reinhardt abandoned the expressionistic, existential, and human import of painting, as he acknowledged.[15] By bringing color into question – which is what colorlessness does – he declared a transreality. Not only does it stand opposed to the abstract articulation of inchoate subjective life through the strife and tension of simultaneous colors, but eschews imagistic intention. Reinhardt's colorless paintings subvert the color paintings of Still, Newman, and Rothko. They claim to offer an altered consciousness of subjective reality, but Reinhardt's black paintings offer a more profoundly altered consciousness, beyond subjectivity and objectivity. Reinhardt scours consciousness completely clean, rooting out even the most abstract images of life.

2

Reinhardt himself formulated the difference between Still, Newman, Rothko, and his own paintings, in effect distinguishing between two modernist uses of color – the symbolic-unconscious and the transcendental-self-conscious. The former is represented by Surrealism and Abstract Expressionism, the latter by Reinhardt's own art-as-art. By implication, the positivistic-interactive use of color, however sophisticated, as in Hans Albers and Ellsworth Kelly, betrays both.

Following Reinhardt's lead, there is a "poetic or dramatic or literary or musical" – "musical being the cleanest," "poetic being the dirtiest" – use of color in Still, Newman, and Rothko, and a "rational ... and self-conscious" use of color in Reinhardt.[16] For Reinhardt, color in general is "illusionistic," and the combination of "calligraphy and color"[17] in Still, Newman, and Rothko creates the illusion of subjective presence. Reinhardt admits to feeling "uncomfortable with the mixture of both abstraction and expressionism" in the painting of Still and Rothko.[18] While they superficially tend toward "an architecture of colors," they represent, in an American context, what Gauguin and van Gogh did in a European one, namely, the "disorder and insecurity" – irrationality – below the surface of bourgeois capitalist society.[19] In their own abstract surrealist way – their abstract color contrasts have a surrealist effect, or what Hans Hofmann called a "higher 'surreal' ... [or] mystic overtone"[20] – Still, Newman, and Rothko articulate "chaos, confusion, individual anguish, terror, horror," while Reinhardt stresses "unity, totality, connectedness" through his rationalistic use of repetition, symmetry, and colorlessness.[21] Reinhardt deduces a painting, while they infer it from their intuition of the "underworld."

The distinction between the symbolic use of color to articulate emotion, by way of disjunctive, discordant color relationships, and the pure use of color in conjunctive, concordant rhythmic relationships implying transcendence and transreality, goes back at least to the difference between Kandinsky's characterization of color as spiritual – which means, in Hofmann's words, color as "the emotional and intellectual synthesis of relationship perceived in nature"[22] – and Delaunay's description of simultaneous color as rhythmic essence. Perhaps Reinhardt's fullest, if most ironical, statement of the difference is in his statement that:

The painting leaves the studio as a purist, abstract, non-objective object of art, returns as a record of everyday (surrealist, expressionist) experience ("chance" spots, defacements, hand-markings, "accident-happenings," scratches), and is repainted, restored into a new painting painted in the same old way (*negating the negation of art*), again and again, over and over again, until it is just "right" again.[23]

For Reinhardt color is the epitome of chance experience, perceptual accident, surreal-expressive happening. To self-consciously repaint the colorful painting until it is colorlessly right is to restore it to transcendental significance – to locate it beyond experience, ordinary perception, emotional import and importunity. In a sense, Reinhardt cancels out the conventional aim of art – in Hofmann's words,

"the blending of experience gained in life with the natural qualities of the medium," creating an effect of spirituality.[24] Reinhardt suggests an alternative, even higher aim: the communication – through an effect of some communication being held incommunicado, leading to a sense of inward or self-communication – conveyed by colorless, rationally controlled painting, of a transcendent dialectic of being and nothing. Such painting does not reify the dialectic into a theory, that is, turn it into yet another passing hypothesis of experience, spiritual or otherwise. Indeed, in Still, Newman, and Rothko the sense of passage is of the perceptual essence, while in Reinhardt what Alfred North Whitehead calls a "conceptual feeling" of stasis – its constancy – subsumes all inconstant perceptual experiences. For them, color partakes in erratic passage, while for Reinhardt colorlessness is as much of the sensation embodying the transreal – transexperiential – dialectic of being and nothing as it is possible to have.

Rothko has said that:

I am not interested in relationships of color or form or anything else ... I am interested only in expressing the basic human emotions – tragedy, ecstasy, doom, and so on – and the fact that lots of people break down and cry when confronted with my pictures shows that I communicate with those basic human emotions. The people who weep before my pictures are having the same religious experience I had when I painted them. And if you, as you say, are moved only by their color relationships, then you miss the point![25]

But it is in fact the color relationships in Rothko's paintings – relationships made conspicuously emphatic by the isolation of colors in discreet, if blur-edged, rectangles, as in *Green on Blue*, 1956 – that generate the sense of "basic human emotions." Similarly, the psychodramatic effect of Newman's centralized vertical zip, as in the *Onement* series (1948 on), is as much a matter of the contrast of its dense color with the thinner, if related, color of the ground it is on, as it is of its sublime spatial – and, one might add, obliquely figural – effect. Like Still, both work with emblematic color and form to achieve, in Still's word, the sense of a primary "act" of genesis – spontaneous generation, a timeless art of timeliness, bringing time into being. They create a basic act of contrast which seems simultaneously to subjectify and objectify the painting, giving it both indeterminate expressivity – an unnamable surplus of expression – and elementary determinate form.

I am modifying Reinhardt's assessment of Still and Rothko (and by implication Newman), or rather, regarding their ambiguity – their fusion of abstraction and expression – as a virtue rather than vice, as he does. They never even attempt to distinguish, let alone separate the two, because for them abstraction is the profoundest, most concentrated and distilled, expression of subjective experience. Reinhardt does, of course, sharply separate abstraction from expression; for him the former implies transcendence of experience, be it subjective or objective, while the latter is blindly bound to it. Still, Newman, and Rothko want to satiate

the senses with abstract color, expressing the unconscious – color that seems mystically libidinous, an emotionally resonant sensuality. Reinhardt wants to transcend the unconscious and ordinary consciousness by renouncing color and establishing complete geometric control, thereby denying the expressionist character of abstract painting. Reinhardt's colorlessness and orderliness bespeak superego perfection, while the subtle color contrasts of Still, Newman, and Rothko bespeak id tempered by ego, or rather id and ego in uneasy "equivalence."

Still's forties pictures are muddy colored, as though to avoid the issue of color, or at least direct color. They are overtly figural, even if the figure is stripped to bare bones, or intestinal coils. By the fifties, the figure is diffused into the field, and Still's famous "spaceless space" appears. But the sense of muddy color remains, even when it is brightly toned, as in *Untitled,* 1975. That is, Still's color remains peculiarly opaque – in contrast, say, to the transparent color of Matisse, especially in his Fauvist phase and cut-outs. Greenberg once made a distinction between the "coarse brushwork and muddy color" of American painters in contrast to the "soft and harmonious" hues of European painters."[26] Even though such American "mud" was "provincial, uncultured," it was preferable to the elegance of postwar French painters, who were "empty" in the "liveliness and knowingness" of their color. Indeed, "bright, hot … warm colors … crowded close to one another – sometimes at dangerously close intervals that threaten to turn the effect into mud," was one of the "tensions and dramatic virtues" of modernist painting, as Greenberg suggested, alluding to Bonnard – the exception to the French rule.[27] Pollock's painting is a particularly climactic instance for Greenberg. But Pollock's dense, muddy color is lyric and volatile, while Still's is epically inert, moving at a glacial pace. It is line – the rough, irregular edge of the monumental color plane – that moves in Still's painting, and that lends his color its dynamic.

I think muddy color is of the essence of American-Type paintings; even Reinhardt's colorlessness is a variant of it. Muddy color is a constant of the most significant American painting. It is evident in Ryder – an acknowledged influence on Pollock – and triumphant in Abstract Expressionism. Close-packed, muddy color, almost opaque – perceptually impenetrable – but now and then affording a conceptual glimpse of the colorless void behind it, an intuition of the infinitely open nothing that the something of color obscures, even seems to deny, is the essence of American-Type color. To name the void – as the general sensation of hovering, more particularly, the free-floating, eternally suspended, unresolved geomorphic forms and erratic edges in Rothko, Still, and Newman do – would be to lose sight of it. This is why it is kept hidden by – sometimes seemingly dissolved into – the excess fullness of muddiness. (In Reinhardt, geometrical resolution – the "rationalization" of the void – is muted by the blackness or colorlessness, creating a similar [if hardly the same] muddy look.)

I think the meaning of American muddy color is not readily reducible to American nature, abstractly rendered, as has been thought. It is not a sign of nature before the creation – the nature of elemental chaos – nor of nature at the

moment of creation, when elementary differences (night and day, land and ocean) are articulated.[28] (Still's paintings are usually understood as conveying the former, Rothko's – and especially Newman's – the latter.) Rather, if we take the subjective intentions of Still, Newman, and Rothko seriously, then the smoldering, muddy color must be the sign of unconscious ambivalence: an unholy mix of life and death instincts, affirmation of existence and recognition of the nothingness it will come to – the most basic inner conflict. Reinhardt's colorless geometry does not imply a resolution of that conflict, as seems at first to be the case, but rather its intensification: colorless geometry is muddiness in an advanced, irreversible state – the ultimate muddiness. In Reinhardt's black paintings both color and geometry seem to have suffered entropic reduction – atrophy. That is, both the ego's organizing, interpreting power and the id's expressive, energizing power have been sharply diminished. In the black paintings the colors of the id – colors suggest its drive – are banished, and the geometrizing ego, seemingly triumphant, has in fact become simple-minded, producing simplistic, "minimal" geometrical structure. The ego has become geometrically rigid, exercising minimum, dumbly basic control. It is in effect as depleted as the id. (Reinhardt's colorless serial geometry was paradoxically both a prelude to and epitomization of Minimalism, and more transcendentally effective – experientially neutral – than it. In general, Minimalism involves a sense of reduction or minimalization of artistic function masquerading as renunciation of experience.) Reinhardt's black paintings, apparently eschewing expression for abstraction – with eternal geometry being conceived as the only authentic abstraction – in fact perversely levels both without ending their conflict. Thus, however much Reinhardt disliked the muddy mix of abstraction and expression in Still, Newman, and Rothko, his "metaphysical" mix of geometrical being and colorless nothing is equally muddy, indeed, more extreme in its murkiness.

In a sense, color is always local, and geometry always cosmic. Still, Newman, and Rothko made color cosmic and geometry – or its representative, line or edge – local, indeed, profoundly local: subjectively relative (Fig. 22). This does not mean their muddy color loses its subjective resonance and complexity, but rather that, through the geometry or its linear symbol the subjectivity discloses itself as self-differentiating. In a sense, the geometry or would-be geometry of their paintings suggests the urge toward differentiation – contrast – inherent in undifferentiated muddy color. Thus when color is clear and distinct in American-Type painting, it remains latently muddy and turgid, as its insistent, peculiarly seductive texturality – whether harshly grating as in Still's case, smoothly scumbled as in Rothko's, grandly uniform as in Newman's – suggests. That is, their color never becomes ingratiating, for it seems about to negate itself, which is what happens in Reinhardt's colorless paintings.

To the two categories of psychosymbolic and transcendental-pure color, we must add the category of empirically neutral or positivistic – matter-of-fact – color. It is the color that historically followed, and attempted to overthrow, the other two categories of color. The paintings of Kelly and Stella best exemplify it, although they are by no means alone. In a sense, their positivistic assertion of color announces

22. Barnett Newman, *Onement IV,* 1949. Oil and casein on canvas. 33 × 38 inches. Roush Fund for Contemporary Art, with additional funds from the National Endowment for the Arts Museum Purchase Plan and an anonymous donor. Allen Memorial Art Museum, Oberlin College, Oberlin, Ohio.

the death of "significant" color. This is not simply because their color does not signify or have the metaphoric power generated by incongruous contrasts – their color relationships are sheer congruity – but because they regard color contrast as mechanical interaction rather than dynamic action. Their paintings are robotic rather than organic in their color relationships. It makes all the difference whether a color is presented as dependent upon another color or as independent yet in creative relationship with other colors. Colors assumed to be in dependent, scientifically exact relationship, are subjectively indifferent and irrelevant – overly objectified, as though in causally efficacious aesthetic relationship. In contrast, independently conceived colors are intransitive in their presentational immediacy. Brought together in an ingenious clash, they seem to articulate the expressive urgency of the subject. As such, they sidestep easy aesthetic characterization.[29] The postwar history of American color, which begins with the fruitful color tensions between Still, Newman, and Rothko, ends in the prolonged whimper of positivistic color, that is, color that has lost both its psychodynamic and transcendental bang.

THIRTEEN

Relics of Transcendence

CRITIC JACK KROLL ONCE DESCRIBED RICHARD POUSETTE-DART AS A "TRANS-cendental expressionist,"[1] and, more elaborately, art historian Stephen Polcari has argued that "Pousette-Dart's paintings reveal the utter secular religiosity at the heart of much Abstract Expressionism. Whether the sacred is routed into ritual, vitalist dynamism, or illumination, the cultivation of the ineradicable, intangible, all-powerful life force beyond human power is its greatest statement."[2] This may be well and true – Pousette-Dart himself thought of art as a "transcendental language" conveying "universal eternal presence,"[3] and apparently was imbued with the ideas of American transcendentalism and Eastern mysticism[4] – but the question remains, just how is "the urgency of transcendental experience"[5] realized in and through the rather mundane, particular material of paint?

How, after all, did Richard Pousette-Dart, with no more than human power, make the all-powerful evident in paint? How did he make the intangible tangible? For all the transcendental mumbojumbo associated with his art – for all the transcendental mystique in which it is cloaked – just what, concretely, did he achieve in painting? What can we say about the quality and character of his painting: its vigor and subtlety are at issue, not the life force, when it comes to determining his contribution to the history of Abstract Expressionist painting. Pousette-Dart may have thought of art as a higher, spiritual calling, but just exactly why should we pay attention to his painting – as painting? At a time (roughly, 1940–60) when American painting seemed at the height of its expressionist power, and ambitiously – innovatively – abstract, what difference did Pousette-Dart's paintings make? What did they add to that surge of energy and intricacy of image that goes under the rubric of Abstract Expressionism, for many the movement that carried American art over the avant-garde top?

In 1945, Clement Greenberg, that great connoisseur of painting, described Richard Pousette-Dart as "a young painter" of "considerable promise. Working away from an ornamental, too heavily elaborated style, pushed along by the kindred influence of Jackson Pollock and that – strangely enough – of Mark Tobey, he tries for boldness, breadth, and the monumental." Greenberg observed that Pousette-

Dart "has not attained them yet … but he is travelling in the right direction." "American painting is much in need of all three qualities," Greenberg wrote, and Pollock, "though he had been before the public hardly more than a year," already "manifests all three," thus "exert[ing] an influence" on Pousette-Dart.[6] This, from the beginning to the end of his long career, was his problem: his painting seemed to exist in the shadow of Pollock's, which was the model to be emulated, although, however hard one might try to, it was by definition impossible to make painting as consummate and innovative as his. Pousette-Dart was only four years younger than Pollock, and lived more than three decades longer than he did, but he always seemed a perpetually promising rather than fully realized painter in comparison to Pollock. After an initial celebration of the potential of his "over-elaborated oil,"[7] Greenberg never again wrote about him, ignoring Pousette-Dart's later paintings, which, from the point of view of Polcari, fulfill the ideal of sacred luminosity.

But from the point of view of art historian David Anfam they were anticlimactic. Compared to *Blood Wedding,* 1950 – with its "impressive incandescent totems," the climax of "the mythic, ideographic and biomorphic trends of the 1940s" – the "lapidary effects meant to evoke the cosmic" in Pousette-Dart's later paintings "betray a lack of impetus."[8] Implicitly, the boldness, breadth, and monumentality – the cosmic effect – Pousette-Dart finally achieved in such paintings as *Presence, Ramapo Horizon,* 1975, *Presence, Circle of Night,* 1976, and the particularly striking *White Circle, Time,* 1979–80, lacked the explosive grandeur and insidious dynamics of Pollock's presumably incomparable all-over paintings of the late forties.

But I think all this represents a misunderstanding of Pousette-Dart's complexity. Greenberg had an agenda, a vision of the direction abstract painting must take, out of art-historical necessity: it must cancel its debt to "surrealist 'biomorphism'" – to the "'poetry' and 'imagination'" of Arp and Miró – and "continue the flatten-ing-out, abstracting, 'purifying' process of cubism."[9] Greenberg admired the breadth and monumentality that resulted from this process – the sense of con-centration that resulted from the inhibition of the natural tendency to make images and tell stories, whether surreal or real – but he never convincingly argued why the renunciation of representation, in whatever form, was historically neces-sary. Why should art split into poetic and pure parts, and why should the latter be more "modern" than the former? Why is flatness more to the point of modernity than a well-rounded imagination?

Ironically, in Anfam, just the opposite holds: poetic totems count for more than cosmic sweep – than the pulsating flatness of *Radiance Number 8,* 1974 (Fig. 23), for example, which was as far as Pousette-Dart carried the purifying process, no doubt not very far from Greenberg's point of view. And yet the circular red center, which forms a kind of "figure" in the gestural field, thereby compromising its all-overness, epitomizes or condenses its vibrancy, bringing it to a head, as it were. This poignant, concentrated center remains firmly embedded in the more diffuse flatness.

The purifying process has a paradoxical result in Pousette-Dart. It leads not to an unstructured all-overness, as it does in Pollock, but to the sudden, seemingly

23. Richard Pousette-Dart, *Radiance Number 8,* 1974. Acrylic on linen. 90 × 90 in. (228.6 × 228.6 cm). Metropolitan Museum of Art, Promised Gift of Evelyn Pousette-Dart.

spontaneous emergence of a basic geometrical structure, which exists in tension with the diffuse, chaotic surface. In *The Square of Light,* 1978–80, and *Time Is the Mind of Space, Space Is the Body of Time,* 1979–82, several such structures appear, simultaneously embedded in and sharply differentiated from the turbulent field of gestures. Some are animated and free floating, and apparently accidental, while others are more deliberate and fixed. Linked in rhythmic repetition, these form boundaries, which the rush of protean gesture does not entirely respect.

Eternal geometry is freshly imagined, as though it was a perceptual epiphany, even unexpected revelation, in Pousette-Dart's two paintings. Like the biblical

burning bush, the monumental square, circle, and triangle of *Time Is the Mind of Space, Space Is the Body of Time* have unusual presence. For all their typicality, they seem singular. The very intensity of their materiality gives them an aura. Indeed, their vigorous, painterly contours make them seem like so many nimbi, dramatically fixed in space like omens of an approaching apocalypse. In *The Square of Light,* contour builds on contour: Pousette-Dart's square of light – it clearly derives from Malevich's white square – is framed by a black square, cleanly cut out of the surrounding black-and-white chaos, and that black square is in turn framed by a crudely painted white one. Black and white neatly divide, as on the first day of creation, yet remain tensely dependent upon each other. Geometrical security is established, holding its own against the restless fluidity of transient gesture.

In both paintings, geometrical coherence germinates out of gestural chaos: Pousette-Dart's triangle, square, and circle are miraculous, abstract flowers growing in a quicksand of gesture – holding their own where no hold seems possible. Elementary building blocks of the cosmos, and embodiments of order and stability, they seem to have just formed out of formless space. They may dissolve back into the hectic flux of gestures, but for the visionary moment they exist they seem to rise above and rule it. Indeed, they are sanctuaries – sacred territory – within its slipperiness. Pousette-Dart makes us believe we are experiencing geometry for the first time, and convinces us that it can be exciting and enigmatic.

I am suggesting that where, for Greenberg, Pollock is central because he carried the purifying process to its logical conclusion, eliminating imagination – the process of producing images, which is always expressive as well as abstractive – from his painting for the sake of flatness and pure painterliness, Pousette-Dart is determined to remain imaginative as well as pursue purity, and, more crucially, to establish a correspondence between them. He attempts to blend the purifying process, which demands immersion in the medium of paint (absorption in and "exploitation" of its properties), and the imaginative process, which treats paint in a "poetic" way. That is, its fluidity becomes a visionary spawning ground, engendering inchoate images and, ultimately, riper symbolic structures. There is an urgent symbolism in Pousette-Dart's work, which goes along with the urgency with which he invests paint.

Why develop purity at the expense of poetry? Why can't you have both – why can't purity be poetic, and poetry be, however peculiarly, pure? That's the issue Pousette-Dart's painting raises, and the question is whether his late cosmic works finally unite, seamlessly, the visionary potential of paint with its literal impact. Or do they remain in conflict – peculiarly at odds? It is the uncertainty of the answer that makes Pousette-Dart's paintings intriguing, beyond any theory of what painting should be, or any study that divides his development into early dynamic, vitalist works and sublime later ones.

I venture to say that Pousette-Dart's ambition to reconcile what Greenberg's Solomonic wisdom about modern painting regarded as irreconcilable is truer to the spirit of Abstract Expressionism than the purifying process. Indeed, Greenberg misconceived Pollock, who never abandoned imagination for purity (however

much imagination went underground in the all-over paintings). The Abstract Expressionist painters did not want imagination at the expense of purity, or purity at the expense of imagination: visionary revelation and "insight," indifferent to the medium in which it occurred, or exclusive devotion to the medium, its every nuance refined and refined yet again. Rather, to reiterate, they wanted an amalgam of poetry and purity, even though, unwittingly, they may have shown the friction – explored the terra incognita – between them. For Pousette-Dart, painting was simultaneously an end in itself and the medium in which he could most accurately express his poetic vision of life. Paint's plasticity made it the ideal medium, for the vision involved an attempt to articulate the inwardly plastic character of matter – the "electrical reciprocities" of its "molecular structure," as he said.[10]

Pousette-Dart's painting is convincing because it avoided any facile solution to the modern problem of the unity of pure painting and poetic imagination. His imagination remained gothic to the end: the late *Illumination Cross,* 1982–83, as well as *The Peacock Has Not Yet Asked Me* and *Summer Sung Orange Down,* both 1985–89, are as gothic as the early *Shadow of the Unknown Bird,* 1955–58, and *Illumination Gothic,* 1958. This is not for iconographic reasons, but because of their oppressive, claustrophobic ornamentalism, a *horror vacui* that is a basic feature of the gothic, as Wilhelm Worringer as argued.[11] Similarly, from the start, Pousette-Dart was determined to purify his painting, an ambition most evident in his "presence" paintings. As early as *Sky Presence (Morning),* 1962–63, he showed his concern with the quality of paint as such. His touch became "grainy" or "pointillist," in a deliberate effort to articulate texture for the sake of texture.[12] The cosmic or oceanic effect of the "presence" paintings has to do with the repetitiveness of the "atoms" of paint – paint as pure and absolute as Pousette-Dart could make it – which form a seemingly infinite field of dancing ions.

Pousette-Dart, then, had a raw, unregulated, chaotic side – a dark gothic expressiveness, making for crowded, tormented painting – side by side with a sophisticated sensitivity to paint as such. For him, the purifying process was a clarifying process, which led, as it did for other Abstract Expressionists, for example, Adolph Gottlieb, toward the emblematic gestalt. It was in the geometrical gestalt, given presence by reason of its "pure" handling, that Pousette-Dart sought to reconcile his gothic and modernist sides – the side that held that imaginative expression was inherent to painting, and the side that held that paint could transcend imagination and become simply optical. The former led him toward sensual overelaboration of surface, the latter toward sensuous understatement, with a philosophical touch of melancholy.

It is hard to decide which is more dominant in his oeuvre, and whether his integration of them always worked. But their simultaneity suggests that Pousette-Dart's spirituality was peculiarly Sisyphean. I think that his geometrical forms are the ruins – relics – of transcendence rather than its substance. His circles, however strong their presence, do not so much ascend as hover statically in space; they have more to do with self-containment than spiritual aspiration. They are sym-

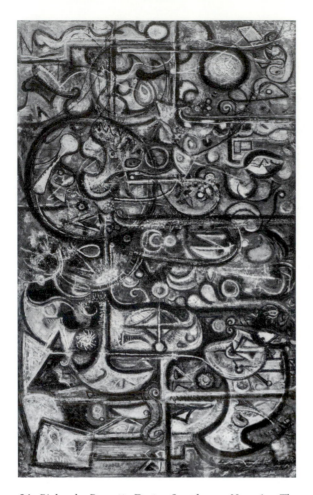

24. Richard Pousette-Dart, *Symphony No. 1. The Transcendental,* 1941–42. Oil on canvas. H. 86, W. 140 $^1/_2$ inches (218.4 × 356.9 cm). Metropolitan Museum of Art, Purchase, Lila Acheson Wallace Gift, 1996.

bols of loneliness rather than of transcendence. We may see, as Polcari has argued, echoes of medieval stained glass in Pousette-Dart's paintings,[13] but we do not see any pointed Gothic arches. There are strong verticals, but they do not converge at the heights, forming a spiritual climax – the miracle of parallel lines meeting in infinity. And the stained glass seems shattered, its radiance – purity – pulverized.

To my eye and mind, Pousette-Dart never overcomes the aborted transcendence of the grim *Figure,* 1944–45, and *Fugue Number 4,* 1947. *Symphony Number 1. The Transcendental,* 1941–42 (Fig. 24), is far from harmonious and not transcendental. Pousette-Dart's paintings are never completely harmonious, or their harmony is opaque, to refer to *Opaque Harmony,* 1941–43; even the pure "presences" are peculiarly out of joint with the surrounding atmosphere. It is this disjointedness that gives Pousette-Dart's paintings their brooding power.

Gregory Amenoff

RENEWING ROMANTIC MYSTICAL NATURE PAINTING

Every natural fact is a symbol of some spiritual fact. Every appearance in nature corresponds to some state of the mind, and that state can only be described by presenting that natural appearance as its picture.

Ralph Waldo Emerson, "Nature," 1836

Shall we say then that Transcendentalism is the Saturnalia or excess of Faith…? Nature is transcendental, exists primarily, necessarily, ever works and advances, yet takes no thought of the morrow.

Ralph Waldo Emerson, "The Transcendentalist," 1842

'What', it will be Question'd, 'When the Sun rises do you not see a round disc of fire somewhat like a Guinea?' O no, no, I see an innumerable company of the Heavenly host crying 'Holy, Holy, Holy is the Lord God Almighty'. I question not my Corporeal or Vegetative Eye any more than I would question a window concerning a Sight. I look thro' it & not with it.

William Blake, 1810

I now affirm of Nature and of Truth, Whom I have served, that their Divinity Revolts, offended at the ways of men.

William Wordsworth, "Excursion," 1814

The sense of the freedom, spontaneous, unpolluted power of nature was essential … Wordsworth's "haunted me like a passion" is no description of it, for it is not *like,* but *is,* a passion; the point is to define how it differs *from* other passions, – what sort of human, pre-eminently human, feeling it is that loves a stone for a stone's sake, a cloud for a cloud's.

John Ruskin, describing his love of nature at age 18

1

WHAT A FUNNY WAY TO BEGIN AN ESSAY ON A FIN DE SIÈCLE POST-AVANT-GARDE twentieth-century painter: with a pile of quotations from nineteenth-century poets and thinkers. And yet the seemingly old-fashioned idea they express – their moral romance with nature – remains as fresh and relevant to our lives as it did when it was first enunciated. Indeed, more relevant, for the ways of

men seem more offensive than ever. And the ways of art have become offensive: the prevailing conceptual orthodoxy of neo-avant-garde art has left art emotionally bankrupt. Neo-avant-garde art claims to carry the banner of avant-garde art, but it has none of its spirit, if all of its hubris, which is one definition of decadence. This is part of what it means to say that it is avant-garde art petrified – avant-garde art without the fragile balance between heuristic method and archaic emotion that underlay its innovations: neo-avant-garde art reifies innovation into novelty and upsets the balance, leaving a disspirited intellectuality in its wake. In contrast to neo-avant-garde art, the romantic belief in the healing, restorative power of nature, and in art's capacity to distill and convey that power – mediate it in a so-called therapeutic landscape, emotionally resonant with the possibility of self-renewal – seems the only adequate response to such decadence.

Amenoff's paintings pick up on a seemingly marginal aspect of modernism, one that has been regarded as beside the main thrust of its development, supposedly the conceptual purification of art, yet that flourished unapologetically in the United States, from the nineteenth-century Luminists and Albert Pinkham Ryder to Charles Burchfield, Arthur Dove, and Marsden Hartley in the twentieth century, to name only artists with whom Amenoff feels affinity. This strongly suggests that their nature mysticism – their spontaneous passion for unpolluted nature, and evocation of it as a Divinity, in Wordsworth's sense – has inner necessity. Nature mysticism continues to have appeal because it speaks to a need that has become impossible to satisfy in the modern urban world, that is, in the same claustrophobic cities, full of pseudo-humanity and rank artificiality, in which it originated. Amenoff's paintings attempt to satisfy it, and, like the best romantic nature painting, reach toward mysticism to do so, for only at the orgasmic extreme of mysticism can there be complete satisfaction of a need that has been systematically repressed.

In Amenoff's paintings, modern romantic nature mysticism makes one of its strongest, most defiant statements, coming into its own again, and, perhaps most crucially, offering itself as the healthy fin de siècle alternative to neo-avant-garde decadence. They offer a way out of the impasse of self-styled progressive conceptual modernism by regression to modernism's earliest, most romantic "theory" of the function of art: art is to serve humanity by distilling and mediating a sublime image of nature, presenting it as a beacon of hope in a dehumanizing society. This gave art faith in itself – a brave, new, modern sense of purpose in a brave, new, modern world which threatened to dismiss it as the relic of an old, obsolete, traditional world. In Amenoff, sublimity commemorates – mourns – a nature that has come to seem doomed: no doubt it will continue to exist "technically," in the attenuated, ghettoized form of gardens and parks, where it is preserved but subtly devalued, but it will never again be the force it was for the nineteenth-century romantics. That force can now only live in art – in Amenoff's paintings, where his gesturalism communicates and idealizes it. They make it clear that nature's phenomenal appearance no longer matters, only its numinous meaning, which is what must be preserved. There is no nostalgia – no facile historicism – in this, only emotional necessity.

Thus Amenoff's saturnalian gesturalism mystifies Ruskin's stone and cloud – and pine tree and ocean, sunlight and starlight – completely undermining their conventional appearance, which remains evident, however distorted, in traditional romantic nature painting. In Amenoff's paintings natural phenomena are barely recognizable, not because they have been altogether distorted, but because they have been completely transformed: they exist as aura rather than substance. They have been transcendentalized – spiritualized – to the extent that they can no longer be thought of or even seen as natural phenomena. Amenoff has carried the romantic project of revelation – the project of Blake, Emerson, Ruskin, and Wordsworth, among other romantic thinkers – to a climactic conclusion: natural phenomena are stripped of their materiality to reveal their innate "supernatural" character. For Amenoff, as for all the romantics, nature is a sacred reality that seems profane to mundane eyes, which is why one needs the eyes of art to see it. The transcendentalist ambition is to display the inner divinity of nature, and to show that it can only be grasped in and through passion, and that once passionately experienced it radically changes human life for the better: it answers one's deepest need for change – the need to change oneself.

Amenoff transcendentalizes nature not only because it is inherently worthy to do so, as well as the subliminally basic task of modern art, but in response to the modern need for nature, as I have suggested. This need has grown stronger than ever, as though to undermine the foundation of modernity, which involves a Faustian will not only to master nature, but ultimately to eliminate it. Replaced by a world totalized by technology, nature becomes a mirage. Thus, while it is hard to know what is special about nature in our increasingly unnatural world, and to recognize that we remain part of it however removed from it we think we are, we continue, however unconsciously, to feel the need for a passionate, unpressured relationship with it as an antidote to the daily pressure of our lives. The need is too strong for traditional representational romantic nature painting to satisfy: simply to describe nature, however lovingly, and assume that the contemporary viewer will get the spiritual point – to experience natural fact as spiritual fact – is no longer enough to establish an intense, convincing, consummate relationship with it. In our secular world nobody believes such symbolic correspondence: nobody has a direct spiritual relationship with nature, as the first romantics did, and it seems naive to have the faith necessary for such a relationship. In our time, the point must be forced, as Amenoff does, by carrying it to a seemingly extravagant, even absurd artistic extreme, where the passion for nature becomes inalienable, thus ending our alienation from our own nature.

We have then, ironically, come to the emotionally decadent point where only art can acknowledge and satisfy our profound need for a "peak experience," to use Abraham Maslow's term, of nature. Amenoff's art, which affords such experience, is no doubt socially and artistically maladapted. But it speaks to something more important than conceptually advanced modern art and technologically advanced modern society: what Erich Fromm calls the psychic need for transcendence,

which bespeaks the fact that "man transcends all other life because he is, for the first time, life aware of itself." Thus Amenoff's modern nature painting represents modern life's deepest self-awareness, indeed, secret self-criticism.

Amenoff is an important painter not only because he is heir to the great tradition of romantic nature painting, but because he renews faith in nature without sentimentalizing it – renews it with a certain rugged, almost harsh, and peculiarly tragic undertone, which seems specifically American, as the paintings of Burchfield, Dove, and Hartley indicate. It is this tragic ruggedness that radicalizes their paintings, and that Amenoff carries to an extreme from which there seems no return to the matter-of-fact representation of nature. Indeed, the tragic vehemence of his image of nature is an aggressive critique of the sterile, matter-of-fact appearance to which it has been reduced in photography, which has become the commonplace, even puerile (as Baudelaire suggested) means of representing – and commodifying – it. Thus Amenoff's mystical nature paintings are not only an important alternative to avant-garde art – a way of underlining the fact that it has become academic, redundant, and commercial, that is, decadent – but to the mechanical standardization of natural appearance. Where photography tends to make nature look inorganic, artificial, mummified – as static as a clothes dummy – Amenoff's painterliness restores living process to its appearance – the same organic process that Pop art mocked and denied. Pop art, by reason of its capitulation to urban industrial imagery and commodity photography – clearly for the sake of capitalist success – was the beginning of the end of avant-garde art, its self-destructive handwriting on the wall, and Amenoff's elated gestural painting can be read as a rebuttal of it and all it stands for.

Thus Amenoff's mysticism is a form of social and artistic subversion and resistance, all the more so because it signals the possibility of "an original relation to the universe," as Emerson called it, in a society in which it seems impossible, a society too disillusioned and faithless – scientifically enlightened – to believe such a relation is possible, or even meaningful. "Why should we not enjoy" such a relation, Emerson asked, never realizing that it would come to be regarded as an escapist illusion and social construction, rather than a spontaneous necessity, born out of a desperate passion. Never did he realize that it would one day be regarded as a decadent response to social progress, rather than a healthy response to social pathology. But Amenoff's paintings convince us that even in our technological society it is possible to have an original, inspired relation with the universe. Indeed, they suggest that it is something we should consciously strive for – a romantic vision of the universe that may seem absurd from an everyday perspective, but that ultimately makes more emotional sense.

<div align="center">2</div>

As their Blakean titles suggest – they come from Blake's *Songs of Experience* – Amenoff's series of nature paintings range far and wide, reaching high into the sky and deep into the sea: on the one side *The Starry Floor* (all 1994), and *The Starry*

Pole (1994–95), on the other *The Wat'ry Shore* (all 1995). But whatever their ostensible site, the same mystical, visionary point is made again and again: the primordial sky above and the primordial earth and sea below are linked, indeed, all but one, whatever their apparent differences. The sky has roots of light in the earth and sea: one sees them reaching down, no doubt deep below the surface, in *The Wat'ry Shore* and *The Wat'ry Shore II*. In *The Wat'ry Shore III*, a tree of light is suspended above the earth, as though uprooted from it. In *The Wat'ry Shore IV*, dazzling circles of light are set within a sky that seems to be raw terrain, as the earth color mixed with its blue suggests. Light suffuses the earth in *The Wat'ry Shore VI*: Blake's holy light dematerializes the earth, turning it into a sacred substance. In *The Wat'ry Shore I*, striations of light echo the curve of the shore, as though they were partners in a dance, the movement of one reciprocated in the shape of the other. In *The Wat'ry Shore V*, triangular shapes, presumably pines, are tinged with light from the circular stars above – stars that, however remote, seem to exist on the same plane as the trees.

In all these works Amenoff seems to view the earth and sky and sea from an infinite distance above them – *sub specie aeternitatis*. This universal point of view sets their finitude in bold, dynamic outline: their form is all force, their material is excited energy. *The Starry Floor* and *The Starry Pole* series make the perspective of revelation explicit: the stars are larger and more glowing – fiery – than ever, as though we are viewing them up close rather than from a distance, as in *The Wat'ry Shore* series, and a climactic, crucial new element is added – the starry pole, a sturdy vertical, as thick as the trunk of a large tree, that directly links heaven and earth. It is in effect a Jacob's ladder – a visionary pathway along which the stars move, more mysterious than ever, like Blakean angels in abstract disguise. This vertical appears, already outsize and burning bright – glowing with extraordinary presence – in *The Starry Floor IV* and *The Starry Floor VI*. Growing out of the earth – indeed, seeming to shoot out of it like a rocket – it spreads to form a heavenly platform, a kind of launching pad for angels. It is the centerpiece of all the works in *The Starry Pole* series, generally sky blue in appearance, although one is the color of radiant sunlight. In *The Starry Pole I* and *The Starry Pole III*, it seems to be accompanied by the tangle of a burning bush – the same volcanic burning bush out of which the pole seems to grow in *The Starry Floor IV* and *The Starry Floor VI*, and a huge bush which seems to have burnt itself out, becoming a charred root, in *The Starry Floor I*. There are other omens – heavenly and elemental signs, full of foreboding and intimidating in *The Starry Pole* works, as there are in all of Amenoff's images, but in *The Starry Pole* works they seem more abstract. However derived from geomorphic heaven or biomorphic earth, and gesturally intense and tangled, they belong to neither: they have become universal. An original relation to the universe transforms its appearances so that they become transcendental symbols – enigmatic emblems that bespeak the universe's own mysterious originality. Amenoff's visionary paintings are about the problem of origin, not as a concept or a literal moment, but as a certain kind of experience of being.

All Amenoff's paintings are a compound of dark earth and illumined sky, which seem to be locked in a Manichean struggle as well as loving embrace. This paradox – "mystification" – is crucial: the sense of transformation – and transvaluation – in process is crucial to the visionary effect. A certain tendency toward extremes – apparently irreconcilable opposites – is also necessary: broad planar handling, as in the smoldering dark blue lower section of *The Starry Pole IV* and the upper section of *The Starry Floor III*, contrasting with violently busy, dense, raw – gritty – gesture, as in *The Starry Pole I* and, in a different tone, *The Starry Pole III*. The calm and tranquility – relatively – of *The Starry Floor V*, with its balance of bright blue sea, luminous pines, and dark sky, with red stars, is rare. *The Wat'ry Shore V* is another example of a relatively balanced work – a stablized scene, in which all the natural elements are at peace, however uneasily. In fact, balance is always precarious in Amenoff's pictures, and lack of balance – a sense of the impossibility of balance, in the midst of what seems like a struggle to achieve balance – reigns in most of them, as the stunning disproportion between earth, water, sky, and light in *The Wat'ry Shore* indicates. Again and again such disproportion between the elements manifests itself – *The Starry Floor II* is another stunning example (Fig. 25) – suggesting that Amenoff is more interested in conflict than its resolution, which at best occurs fitfully. For all the apparent coherence of Amenoff's pictures – a scene, however strange to ordinary eyes, is clearly recognizable – they are a sum of wild fragments that do not add up to an integral whole. No doubt this contributes to their visionary character: the ordinary world of appearances is shattered, and the fragments become luminous with mysterious significance.

Art historically, Amenoff's paintings belong to the American transcendentalist tradition of visionary landscape, as I have argued, and specific influences can be traced. But Amenoff never simply takes them over and touches them up; he is not just another postmodernist historicist, adding an ironical twist to what he appropriates. On the contrary, he is anti-ironical, and realizes that the past had a certain vision of reality that must be recovered, however irrecoverable and unrealistic it seems today. It must be taken seriously, for our own good, for it has something to give us that we have forgotten how to give ourselves. The credibility of Amenoff's appropriations comes from the fact that he renders them dynamically and abstractly, thus ending their art-historical petrification and estrangement. They become dialectical structures rather than sanctimonious reifications. Unresolved dialectic is in fact at the core of Amenoff's paintings, as I have suggested, and it is operational in his relationship to his sources. *The Wat'ry Shore IV* is a case in point. It is derived from Ryder's famous marine landscapes, but luminous sky and dark sea are more fused and confused in Amenoff's marine landscapes: in Ryder they remain clear and distinct – puritanically separate, while in Amenoff they are set in dialectical motion – erotically interpenetrate. The same thing happens in the works derived from Munch: the sky in Munch's *The Scream* reappears in tattered, almost chaotic form, less fixed and more beside itself than anything Munch dared imagine. Similarly, Amenoff's phantom-like forms have a more sinister intensity

25. Gregory Amenoff, *The Starry Floor II,* 1984. Oil on canvas. 86 × 64 inches. Courtesy of the artist.

than those of Munch, and spread like a tumorous growth – the earth brown sky, with its morbid black aura, in *The Starry Floor I* and the amoeba-like form in *The Starry Floor III,* are good examples. Amenoff's starry sky is wilder than that of Van Gogh; so is his light. In general, Amenoff's abstract naturalism is the most intense and dramatic of the entire tradition, which, on its abstract side, culminates with Arthur Dove, whose *Sunrise* series, 1937, seems to be the springboard of Amenoff's work.

Amenoff seems to recapitulate the history of abstraction, but he takes it back to its beginnings, when it was an expression of revelation, walking a fine line between pure expressive form and visionary experience of nature, and the picture was neither all immanent form nor blind emotional response to external nature, but an equivocal compound of both. Where Kandinsky saw through Monet's haystack to the luminous abstract pentagon it was, discarding its naturalness in

the process, Amenoff sees its organic truth – luminous vitality – through its abstract form. But he does not so much reverse the process, as struggle to balance precarious truths – the equally endangered truths of radical abstraction and radical concreteness, truths that are equally impossible to grasp in an ordinary state of mind, and slip out of sight as soon as we intuit them in an extraordinary state of mind – all the while knowing that they can never be completely reconciled, for they derive from different, if obliquely related, orders of experience. Each can aid the revelation of the other, but neither by itself is a revelation – this is Amenoff's ultimate point. He suggests that only by renewing the friction between them can each cast serious light on the other.

Thus, where Kandinsky and Mondrian dispensed with and finally destroyed the image of nature for the sake of artistic truth, Amenoff shows that its true image can only be recreated with abstract means. Their fusion makes clear, in an awesome imagistic revelation, that nature is emotionally indispensable. Successfully synthesizing them, Amenoff overcomes the bifurcation of sensibility endemic to modernism, as T. S. Eliot observed. Formalist abstraction and photographic representation are its polar opposites. Both secularize art, by undermining its aura and resonance – the aura and resonance of Amenoff's stars – which can catalyze a transvaluative, even sanctifying experience of existence. Amenoff's neo-transcendentalism, as I suppose art historians will call it, convincingly restores aura and resonance to art, suggesting that, however much art's only purpose seems to be to advance and refine style, it can still have a sacred purpose. Artist and viewer may still have to pass through the needle's eye of style, but beyond that the horizon is infinite.

Modern History Painting in the United States

URING THE SUMMER OF 1997 THERE WAS, IN BERLIN, AN EXHIBITION CALLED "The Age of Modernism: Art in the 20th Century." The works in the exhibition were organized in four categories: "reality-distortion"; "abstraction-spirituality"; "language-material"; and "dream-myth."[1] Whether or not I agree that these are the fundamental categories of twentieth-century modernism, what was startling about the exhibition is that there was no category for history painting, not even in the attenuated form of "Art and Society: Protest and Propaganda," to mention the category Peter Selz uses in his book *Art in Our Time: A Pictorial History 1890–1980.*[2]

In the nineteenth century the situation was quite otherwise. Charles Baudelaire, in his review of "The Salon of 1859," has two sections devoted to "religion, history, fantasy." While remarking on the deficiency of religious painting, and its difficulty – it is hard to make painting that is equal to religion, which he calls "the highest *fiction* of the human mind"[3] – he notes the vigor of history painting, particularly "military pictures."[4] Baudelaire is sharply critical of them, dismissing them as predictable spectacles, but nonetheless he gives them a great deal of attention, and even celebrates one, which he describes as "an idyll shot through by war."[5] Similarly, Théophile Gautier, in "The A.B.C. of the Salon of 1861," devotes a section to modern "battle pictures," which he distinguishes from those "painted in former times," in which "the artists did not strain for a historical and military accuracy."[6] He thinks it is "no small thing" to achieve such descriptive precision,[7] and goes on to declare that "a grand, irresistible war maneuver [is] admirably suitable to painting," in that it affords an opportunity for unusual "harmonies or contrasts."[8]

Also in 1861, there was a National Exposition in Florence, and the Italian critic Pietro Selvatico divides the art shown into two categories, historical painting and sacred painting. Like Baudelaire and Gautier, Selvatico singles out "battle pieces" as the most important kind of historical painting, criticizing the classification of such works as genre paintings.[9] Also, he distinguishes between war pictures that "give a stamp of individuality to these legal massacres of humanity"[10] – Selvatico

thought Horace Vernet's images of war were the first to do so[11] – and those that serve the purposes of propaganda, singling out the works of the "demagogue" painter Jacques Louis David, as Selvatico calls him.[12] It is worth noting that Edmond and Jules de Goncourt also thought that "no one understands large military machines better than" Vernet,[13] whom they regarded as somewhere between "a circus director and a painter."[14]

Now the point of these brief introductory art-historical remarks is to highlight the collapse of history painting as an official category in the twentieth century, and the comparative dearth of history painting in this century. The devaluation of history itself is one of the "achievements" of modernism. When the modernist American critic Clement Greenberg asserted that art as such is more significant than politics and religion,[15] he in effect declared the irrelevance of history painting and religious painting, the two basic categories of art in the nineteenth century. The Goncourts, in 1852, already insisted that "religious painting is no longer possible today,"[16] and thought that "the historical school is dying"[17] and being replaced by the landscape school. For them "landscape [is] the greatest glory of the modern paintbrush,"[18] that is, the vehicle of painting as such – painting which does not "put an idea in a line" or "symbols in the living domain of art," but allows it its autonomous vitality.[19]

The Berlin exhibition had certain famous examples of modern history painting – mostly German, for example, Kirchner's *Artillerymen,* 1915, from the first world war, and Kiefer's *Operation "Sea Lion,"* 1975, dealing with Hitler's plan to invade England in the second world war – but they were a distinct minority of the works exhibited. I think this is because modernism is antithetical to history painting, indeed, deeply antihistorical and finally ahistorical, in that it posits a religion of art that can transcend the nightmare of history, as James Joyce called it. Modernist art is a kind of ostrich hole in which one thinks one can hide from history, even though it is, as I will argue, a sign of the overwhelming power of history, and the particularly inhuman character it has acquired in modernity. Indeed, the paradox of history as it is experienced in modernity is that it seems to be made less by human beings than by abstract forces beyond human control, and as such seems fated, however much, like the proverbial genii in the bottle, human beings let the inhuman forces loose.

I submit that genuine history painting has nothing to do with the so-called spectacle of history, or with the empirical description of supposedly historical events such as battles, which is what the nineteenth century thought history painting was – spectacle and description are superficial and secondary aspects of history painting – but rather tries to show the connection between "life history and the historical moment," as Erik Erikson calls it,[20] that is, between the concrete life of the individual and collectively important events. In modernity, this means that history painting conveys the way collective events determine individual destiny, as though human beings had no power of self-determination. This is the latent meaning of the best history painting of whatever period, for example,

Poussin's *Rape of the Sabines,* which shows human beings doing things to other human beings that change the destiny of both. The Roman men are blindly driven to overpower and rape the Sabine women, although, no doubt, the former think they are acting out of their own free will. But both the Romans and Sabines are victims of the abstract force of collective destiny – an obscure force greater than them, and that uses them for its own purpose.[21] History painting seems to show individuals "making" history, but it subliminally conveys the feeling that they are its victims – that history is beyond their control, however much they may think they are in control of it. The Roman soldiers certainly thought they were making history rather than being made by it. Genuine history painting subverts the idea that history is voluntarily made by autonomous agents with the idea that history is an impersonal collective force manipulating and molding individuals, who are so much passive clay in its hands. Genuine history painting presents the familiar idea that individuals are not the master of their destiny, however much they think they are, but rather the "expression" of collective forces, which are hard to fathom and abstract. Poussin's lucid, crystal clear style, which seems to rise impersonally above the collective event it clothes and expresses – indeed, which appears to regard the history it represents from the perspective of eternity – conveys the sense that the collective event is foreordained, that is, the signature of a mysterious transhuman power, which alone (and ironically) makes the human event meaningful. The question is, what is this abstract, nonhuman yet collective fate and force? How can it be characterized? This is the question genuine history painting must answer.

I want to examine a few examples of modern American history painting with the intention of demonstrating that it offers an important characterization of this abstract collective force. That is, I believe it offers a suggestive encoding of the reasons why history, ideally an account of the human effort to resist and overcome natural fate by creating civilization – optimally a space in which human beings care for one another and flourish as individuals, that is, a social space in which tooth and claw are forbidden and life is not short, nasty, and brutish as it is in nature – has in modernity come to seem, surprisingly, not the story of civilization but the representation of collective fate – a new kind of fate. I will suggest that in modernity technological fate has replaced natural fate, and that we are beginning to realize that the former is just as terrifying as the latter, but in a different way.

W. Brian Arthur, in an article titled "How Fast Is Technology Evolving?", remarks that the "correspondence between biology and technology is striking," but that "technology is evolving at roughly 10 million times the speed of natural evolution." Arthur writes that this seems "frightening," until we realize that we use all the technology "at our disposal for simple, primate social purposes." "Technology," he argues, "is merely an outer casing for our inner selves. And these inner selves, these primate souls of ours with their ancient social ways, change slowly. Or not at all."[22] I think Arthur is wrong about the last point: his distinction between external technology and inner self ignores the fact that our external environment

has an effect on our inner self, and that the technological environment we have created has profoundly changed our sense of self. The technological environment is so all-encompassing that the self cannot help but internalize it – cannot help but feel as impersonal and mechanical and peculiarly abstract as technology, however unconsciously.

This feeling of depersonalization is only the beginning of technology's subtly debilitating effect on the self, however facilitative technology may be on a material and practical level – in the external world. The emotional effect of technology climaxes in unconscious feelings of helplessness, vulnerablity, and inadequacy, all the more so because most of us do not understand how technology works, however much we may use it. Its principles and structure are incomprehensible except to the technocratic elite. In doing this – in taking over our inner self and making us experience ourselves as inferior and even worthless victims of life – technology functions as fate, that is, becomes as inhuman as fate. Thus, not only has technology surpassed nature in evolutionary power, but technological necessity has become the core of historical necessity, and as such human necessity. Human beings conceive themselves as necessary only to the extent they conceive themselves in technological terms, but to do so is to be subtly inhuman.

I will argue that modern American history painting, such as it is, deals with technological necessity and its dehumanizing effect. However unwittingly, modern American history painting conveys the idea that technology, no matter how domesticated and everyday, is ingeniously self-alienating. It deals with what might be called the "technological unconscious" and its power over self-consciousness.[23] I will also suggest the reason why this technologically oriented modern history painting developed in America rather than elsewhere, however quickly it was emulated by other technologically advanced countries. I will also argue that the "pop abstract style" of modern American history painting, as I call it – a paradoxical style that combines an ironic version of modernism with the illustration of popular stereotypes – symbolizes the intellectual abstractness yet social accessibility of technology. Both the latent abstraction and manifest stereotypes of modern American history painting – which is what I think Pop art implicitly is – are technologically contrived. In general, in its emphasis on technique, modernism shows that it is inspired by technology, however much it enlists technique in the service of the religion of art. But strange as it may seem to say so, the modern religion of art, with its idea of transcendence of history through pure technique, is derived from the religion of technology. Technological idealism is the modern religion par excellence; like all religions, it promises salvation, that is, freedom from suffering. Today we believe that technology can give us that freedom and transcendence. Indeed, it already has, in more ways than one, saved us from ourselves, even as it brings with it a new kind of self-alienation or suffering. Internalizing technology we have, ironically, lost our sense of inner self, even as we have transcended ourselves. American Pop art is the symbolic demonstration of this.

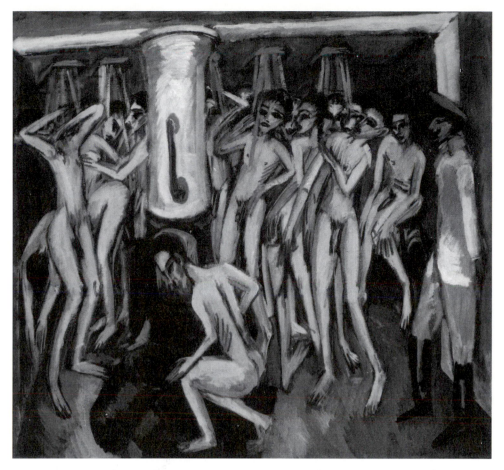

26. Ernst Ludwig Kirchner, *Artillerymen,* 1915. Oil on canvas. 140 × 153 cm (55 ¹/₈ × 59 ¹/₈ inches. Solomon R. Guggenheim Museum, New York. By exchange, 1988. Photograph by Robert E. Mates, © Solomon R. Guggenheim Foundation, New York.(FN 88.3591.)

I want to begin my discussion of modern American history painting in what may seem a strange way – with an analysis of the modern German history paintings by Kirchner and Kiefer. For their paintings implicitly deal with the technological issues that the American paintings deal with explicitly. Kirchner's *Artillerymen* (Fig. 26) is a good history painting because it is an allegory of the conflict between the power of history, symbolized by the officer, that is, social authority at its most absolute and inescapable, and the helpless, vulnerable individual, symbolized by the soldiers, whose helplessness and vulnerability are made all the more emphatic by their nakedness. Indeed, it suggests that they are stripped naked of any civilized identity, and endure a ritual cleansing, in preparation for their sacrifice to the merciless god of war. The picture is a perfect representation of Hegel's dialectic of master and slave. Also, there is an important technological dimension to the scene. More or less in the center of the room is a stove. It has been argued that the soldiers resemble primitive natives performing a ritual dance

of worship around the totem-like stove, but it is just as important to note that it is a symbol of technology. The showerheads the soldiers stand under are also a symbol of technology – a more advanced technology than the stove. These showerheads, which cover the ceiling above them, suggest that the soldiers are completely under the rule and dominance of technology – as naked as the day they were born, and baptized or born again in a stream of water supplied by a machine that symbolizes the ruthless authority of society. After their shower, they will put on their uniforms and become cogs in the war machine. Many of them will die at its hands.

Kiefer's *Operation "Sea Lion"* (Fig. 27) is also a good history painting because it shows the same dialectic, in even more extreme terms. The bathtub with its toy battleships plays the same role as the officer in Kirchner's painting, and the empty chairs on the distant horizon play the same role as the naked soldiers. But there is a crucial difference between the paintings: in Kirchner's painting human beings are quite visible – humanity is under pressure, but still holds its own – while the scene in Kiefer's painting is completely dehumanized, that is, there is only the symbolic, abstract suggestion of human presence, in the form of the empty background chairs. (The middleground figures are the ghosts of German soldiers killed in the war.) And they are not as prominent as the foreground battleships – the war machines, that is, inhuman killing machines, signifiers of the advanced technology of war. Also, crucially, war has become an abstract children's game in Kiefer's painting, watched over by indifferent, absentminded parents, as it were.

In modern American history painting, the technology indirectly acknowledged by Kirchner and Kiefer, and their subtle evocation of the schizoid mood technology induces, become self-evident. Warhol's *128 Die in Jet,* 1962, Lichtenstein's *Blam,* 1962, Rosenquist's *F-111,* 1965, all show airplanes – triumphs of technology (although it is hardly triumphant in Warhol's picture) – and are all executed in what I have called a pop abstract style – a slick, impersonal populist yet also somewhat stilted abstract style that emulates what has been called the machine look. The utilization of pop abstract style is of the essence of these works, and signifies their collective as well as technological character, which is what the airplanes also do. (Those by Lichtenstein and Rosenquist are the latest – for the sixties – in high-tech fighter planes, but they are abstracted from any battle scene. This makes their pictures very different from nineteenth-century war pictures.)

The pop abstract style also subtly conveys ambivalence and anxiety about machines, that is, reflects their everydayness yet threatening remoteness. They are commonplace yet strange, which has to do in part with their inorganic character and in part with the fact that most people do not understand how they work, as I have mentioned. Equally important, pop abstract style symbolizes the appropriation of high abstraction by popular culture. High abstraction is vulgarized in pop art, which means that it is reified – reduced to a visual slogan, a petrified shell of itself. It becomes a form of what Bernd Schmitt and Alex Simonson, in their book on *Marketing Aesthetics,* call "aesthetic management."[24] Indeed, I think that Pop

27. Anselm Kiefer, *Operation Sea Lion I*, 1975. Unternehmen "Seelöwe." Oil on canvas. 86 $^5/_8$ × 118 $^1/_8$ inches (200 × 300 cm). Collection of Norman and Irma Braman, Miami Beach. Courtesy of Marian Goodman Gallery, New York, and the artist.

art is the first example of the strategic management of an existing style to achieve a brand identity – an artistic identity that is regarded as a brand name, rather than as the expression of a self. It is the difference between postmodern and modern art, and it makes Pop art the first completely postmodern art (although the late Dali establishes a certain precedent). The important point in the context of this paper is that abstraction is stripped of its transcendental connotations and turned into an instrument of populist illustration. Abstraction becomes a standard stylistic device, that is, an everyday technology of art. There is more to Warhol's idea of painting like a machine than he realizes. In short, technology completely determines the subject matter and style of modern American history painting, which is what the best pop art is, as I have suggested. Pop art is the most socially representative and historically accurate American painting, in that it represents America as a country whose modern history has been determined by technology more than anything else.

The twentieth century has been called the American century, and the United States seems particularly important because history seems written large in American life – not so much modern military history, but the history of modern mass technological society. As Jacques Ellul writes in his book on *The Technological Society,* we all live in a standardized society which tries to function with "mathematical precision."[25] War is secondary to technology in shaping modern society, and war itself has become technological and mathematically precise; even soldiers

are taught to behave like programmed machines. Americans especially live in a technological society, and American warfare has become heavily dependent on technology, as Lichtenstein's and Rosenquist's pictures suggest. The United States is fortunate in that it has never had a war, with a foreign enemy, on its own territory, and never been the victim of total war. The American Civil War has been called the first modern technological war, but it was the senseless slaughter of soldiers that interested those who visually recorded it – the most famous photographs of the Civil War focus on dead bodies, as in Timothy H. O'Sullivan's *Field of Death*, July 1863 – not its technological character. It was only in the twentieth century, when modern technology began to dominate the battlefield, and determine the outcome of war, that American war imagery became obsessed with technology and technologized its aesthetics. Indeed, so important and fascinating is the technology that it is represented independently of the war – which is what Lichtenstein and Rosenquist do. The technology of photography becomes basic, to the extent of becoming the underpinning of painting, indeed, the source of its imagery and surface, as Pop art makes clear.

Thus, even such an old-fashioned painter of battle pictures as Leon Golub – he is essentially a nineteenth-century painter, in that he focuses on soldiers, that is, human agency rather than technology – relies on photography. Golub, it should be noted, is also old-fashioned in his emphasis on primitive aggression; he is as much interested in the social production of death as any nineteenth-century painter of war pictures. His brutal realism, as he calls it, misses the technological and thus peculiarly innocent, impersonal character of modern aggression – Golub humanizes and personalizes it – as a comparison of his Vietnam pictures with Rosenquist's *F-111* (Fig. 28) makes clear. The little girl who pilots the fighter is the naive spirit of America, happily riding high on its advanced technology. Golub's history painting is as obsolete and wide of the historical mark – shows as little understanding of what really makes history in modernity – as Ben Shahn's equally humanistic painting of Sacco and Vanzetti. They were sent to their deaths because they supposedly threatened to bomb society – that is, use technology to victimize it – not because of their anarchistic ideology and politics.

Indeed, I happen to think that Rosenquist's painting, as a history painting, is more authentically modern, by reason of its representation of technology, than Picasso's *Guernica,* supposedly the greatest history painting of the twentieth century. Where are the bombs the airplanes dropped on Guernica, and where are the airplanes? In fact, the only piece of modern technology in Picasso's painting is a rather primitive electric light. Without modern technology, one can't have a modern history painting. Picasso's *Guernica* is in fact the grand climax of nineteenth-century romanticized, humanistic, and allegorized history painting, going back at least to Gericault's *Raft of the Medusa*. Picasso's figures – the human presence is clearly greater than the technological presence in his painting – may be more abstract than those of Gericault, but they are still far from the cute little girl – an American stereotype – who pilots the F-111.

28. James Rosenquist, *F-111*, 1965. Detail. Oil on canvas with aluminum. 10 × 86 feet (3.05 × 26.21 m). Private Collection. Licensed by VAGA, New York.

Rosenquist's *F-111* is also a more authentically modern history painting than Motherwell's *Homage to the Spanish Republic* series, and for the same reason: Rosenquist gives us a representation of technology – symbol of American society – while Motherwell's representation of the Spanish Civil War romanticizes it in abstract expressionistic terms. Like Picasso, Motherwell ignores the fact that the Spanish Civil War was won by German technology. They may make a certain artistic point – show the power of abstraction – but that does not mean they are making adequate history paintings.

Indeed, the point is that because history has become so much a matter of technology it is hard to view it in romantic terms – to see it from any kind of subjective perspective. If technology is historical destiny, it is hard to think of history in human terms. Human beings become alienated from their own history because it is mediated by – indeed, seems contrived by – technology. They cannot help thinking of themselves as machines, badly or well functioning. Ludwig von Bertalanffy, in his book *General System Theory*, writes that in modernity the robotic and organic models of the human being – the idea that a human being is a closed homeostatic system and the idea that a human being is an open system receiving feedback from the environment – are at war.[26] While von Bertalanffy thinks that the robotic model is demonstrably wrong, in the United States it has carried the day. While such proto-Pop works as Jasper Johns's flag paintings fuse organic gesture and mechanical image, suggesting an ironical American humanity, full-fledged Pop works, such as those I have shown, are totally mechanical in character, in both their representational manner and formal structure. When they render human beings, as in Warhol's portraits and Lichtenstein's females, they show them as inorganic machines. They are reduced to the terms of media technology, further confirming their robotic character. Clearly, in modern American history painting, the world historical is no longer conceived of as a hero on horseback, the way he was in the nineteenth century – Hegel described Napoleon as the world historical on horseback – but as a machine on the move. This is what we see in Lichtenstein and Rosenquist. The people who make these machines move also move like machines.

Where traditional history painting was once an extension of the Triumph of Death, or else showed a hero trying to triumph over death, usually unsuccessfully, modern history painting is about the Triumph of Technology over man, who no longer has the possibility of being a hero. In modernity, machines perform heroically, not human beings. Nowhere is this more clearly suggested than in modern American history painting, which is why it is history painting at its most exemplary. Indeed, there are neither heroes nor dead bodies – no sign of organic humanity – in it. There is little of it not only because twentieth-century America has not experienced war firsthand, but because war is only an incidental part of technology. Technology is the social reality of America – at least since the time of Edison, America has defined itself by its technology – not war. In general, whenever an American painter shows robotic, peculiarly wooden figures, for example, Philip Pearlstein, he is in effect being a social realist. In fact, Pop art is more authentically

social realist than thirties social realism, in that Pop art presents, in a fairly straight-forward way, for all its theatricality and consumer symbolism, the social reality of technological America. Thirties social realism still saw technology as a means to a human end, as in Benton's romantic painting of a threshing machine, rather than as an end in itself, which is what American history has shown it can be.

Finally, it should be noted that in what I call modern American history painting history is beyond politics – which is another reason why modern American history painting is peculiarly abstract or modernist. For in this apoliticality it carries the modernist "idea of *l'art pour l'art*," that is, "the principle of 'pure,' absolutely 'useless' art" to a kind of ironic climax. For this idea originated in France, as Arnold Hauser says in *The Social History of Art*, "from the opposition of the [nine-teenth-century] romantic movement to the [eighteenth-century] revolutionary period as a whole," which "enlists the services of art" in the politics of change.[27] Modern American history painting is a kind of technological art for the sake of technological art, and as such implies that technology is beyond politics, indeed, more important than politics. Technology is destiny, and determines history, while politics is pseudo-destiny – pseudo-history. In fact, the technological revolution is the only one that seems to have been genuinely successful, and is still going on, while political revolutions tend to become abortive, turning into reigns of terror, as the French Revolution showed.

The technology-dominated pictures of Pop art tend to deify as well as reify technology, which is to confirm our subservience to it. It should be noted that there is a precedent for this in the works of Charles Sheeler, a so-called Precisionist, who in effect illustrates the mathematical precision Ellul regards as characteristic of the technological society. Finally, to return to the beginning of my paper, both Sheeler and the Pop artists imply that we have abandoned our inner selves to technology – become so identified with it that we no longer know what it means to have an inner self. Warhol's historical figures, from Jacqueline Kennedy to Marilyn Monroe, have no inner life. They are as mechanical as the airplane, if less advanced and intricate in their technology. They are social constructs, that is, media inventions – the products of a certain kind of technology, just like any of the products Warhol mechanically renders.

It is the appropriation of humanity by technology that is the disturbing under-side of modern American historical painting, whose alias is Pop art. This disturb-ing underside seems to express itself in such technological disasters as Warhol's jet airplane crash, and in Robert Arnason's *Fragment of Western Civilization*, 1972, an image of the rubble of Western civilization after a nuclear disaster, which is a demonstration of the triumph of technology over the civilization that produced it. History painting necessarily takes strange forms in modernity and America, because history painting is the history of the failures and successes of technology.

Mourning and Memory

WLODEK KSIAZEK'S ABSTRACT PAINTINGS

For make no mistake, abstract art is a form of mysticism.

Robert Motherwell[1]

THERE ARE NEW EPIPHANIES AND INTRICACIES OF TEXTURE IN WLODEK KSIAZEK'S paintings. It is like an eccentric avalanche: sometimes layers of paint coagulate in bizarre bulges; sometimes they flow down the canvas smoothly, as though wishing to span it in an instant, only to end suspended in its space, their energy spent; and sometimes they gouge out trenches of space that form, as though by chance, a primitive, often irregular and incomplete, if more or less stable, geometric pattern. It has the graphic look of an incision or inscription – a sudden formation of intelligibility in the midst of an unintelligible, headlong process. Suddenly, there is the miraculous, abrupt appearance of control in an uncontrollable flux. It is these strange trenches – stranger, in the context of the gestures, than the erratic gestures themselves – that give Ksiazek's paintings their edge. Or rather it is the way the orderly pattern exists in the volatile mix of gestures that gives the paintings their enormous evocative power. The pattern is monumental yet peculiarly ephemeral, the gestures indeterminate yet forceful; it is their ambiguous intimacy – the sense that at any moment the pattern could be engulfed by the gestures, suddenly disappear in the renewed rush of its fluidity, and, at the same time, that it completely transcends their flux, however marked by it – that gives the paintings their poignancy.

Thus, in one grand, gloomy, resonant painting, four windowlike shapes, arranged in pairs, one above the other, and marking the corners of a rectangle, stand out like precious icons, all the more so because of their subdued yet intense luminosity. They are oases in a desert: unexpected openings to the infinite beyond, breaking through the densely packed surface of finicky, finite gestures. But one window has been partially eaten away by the surrounding murkiness, and all are infected by it: all are dying from the enveloping gloom, as though from a cancer, and they will all eventually become shadows of themselves, indeed, as empty and lightless and opaque as the similar ghostlike shapes in the rows

29. Ksiazek, Woldzimiercz, *Untitled,* 1990–97. Oil on canvas, 80 × 100 inches. Courtesy of the artist and Marisa del Re Gallery, New York.

between them. Or has Ksiazek excavated the four windows from the void, rescuing them from oblivion, reminding us of a grandeur that once was? Are they the residue of a structure that was more magnificent than any our world could conceive? It is hard to say, and the ambiguity is a crucial part of the enigma the paintings engage: the enigmatic presence of ambiguous signs of life in a scene of loss and ruin – or mourning and memory – of catastrophic, efflorescing decay. Ksiazek is an archaeologist, lifting our collective amnesia, but he is also a master of the enigma of presence, all the more intense because it is always mixed with absence, and thus inherently apocalyptic (Fig. 29).

A more eccentric pattern, spreading horizontally across the canvas, emerges in a darkly blue painting, and the linear remnants of a regular pattern are lightly streaked with blue – as though to lend them the life of the dynamic sky – in another, blacker painting. Some patterns are triangular, some involve rows of rectangles, and sometimes a square appears; all seem partial, incomplete, and compressed – truncated, to the extent that it is hard to imagine what the structures they imply might be like. Ksiazek has said that they are architectural plans, and as such are mental constructs rather than physical realities. And yet they are given stark physical presence by their embeddedness in the tumult of the paint. We may

not be able to imagine the buildings that were once constructed on their basis, but they themselves have the aura of expressive constructions.[2] They are the foundational signs that are left after the buildings have been razed: they are in effect memento mori – reminders of death.

Of what death? Of what death do we always have to be reminded in the modern world? Of the death of the sacred. This is the death that I think Ksiazek's paintings engage – and, in a sense, why they must be abstract, for in our world the sacred has become a distant abstraction rather than a concrete, immediate presence.[3] There is indeed a sense of being at an enormous temporal and physical distance from some mystery – still glowing with embers of life – in Ksiazek's paintings. Archaeology tries to overcome such distance, which is emotionally immeasurable – a feverish sense of the immeasurable lurks in Ksiazek's space – in order to give us a sense of the life that once was and has been forgotten. Archaeology cannot help but evoke its life in the act of recovering its signs. There is a terrible pathos in archaeological excavation, especially in the excavation of a concept that has died, and the idea of art as the archaeological excavation of such a concept suggests its affinity with death. Indeed, Ksiazek's conception of his painting as the "archaeological exploration of pictorial space" implicitly acknowledges that it is dead. Art was once able to picture the sacred in imaginary space – bring it to vivid life in a picture comprehensible by all – but now it is only able to evoke it by acknowledging its death. Ksiazek's esoteric paintings engage the abstract ghost of the sacred. The friction between the surface formed by the gestures and the depth suggested by the pattern – the tension between them remains, however much they seem "dialectically" reconciled by their interplay – generates a vague, numinous feeling of the sacred, for its substance is no longer available for human use. To use Thomas Sebeok's language, Ksiazek's averbal semiotic system of gestures is in effect the disintegrated flesh of the sacred, while his geometric patterns – a language that can be verbalized – are in effect its bones.[4] Nonetheless, it can be said that in mourning for the sacred, Ksiazek's paintings preserve the idea of it, for archaeology – which is a kind of mourning – is in effect a way of preserving, even resurrecting, in however attenuated a form, the idea of something that was once necessary to life, and may still secretly be, which is why it is excavated and its ruins cherished. It may only be an appearance – a grand illusion – but it still has emotional reality.

László Fehér

MEMORY AND ABANDONMENT

L ÁSZLÓ FEHÉR'S PAINTINGS HAVE A SUBTLY STARK INNOCENCE. AGAIN AND AGAIN one sees the same core image, as though witnessed by an inner eye – a vision slowly brought into focus as it emerges from the unconscious: transparent, almost invisible figures – often only one, a child – reduced to their contours, and alone in a flat void, usually black and gray, that is, colorless, but sometimes, iron-ically, bright yellow, as though the deserted scene was bathed in the light of a sun that would never set. The image is grim, yet it is also oddly comical: the figures are ghosts in a barren landscape – an ironic Elysian field – but do ordinary things in an innocent way. They play with toys (*Junge with Luftballon* and *Kreisel,* both 1991), float on rubber mattresses (*Auf dem Wasser,* 1990), have a swim (*Im Wasser,* 1990), embrace on a bridge (*Paar,* 1991), have a smoke in private (*Der Raucher II,* 1991), walk in a park (*Steinvase,* 1990), and feed the bird that swims in its lake (*Swan,* 1994). They are altogether relaxed and unself-conscious. Little good their innocence does them: it is threatened by their bleak environment. They may be unaware of it, but it holds them in its deadly grip.

There is an aura of nostalgia to the scene, and nostalgia always means we are in the presence of something dead, if not yet emotionally over with – something that endures in memory, and, while it no longer shapes the living moment, unconsciously influences the sense of a life as a whole. Nostalgia is a way of pro-cessing the past without ever letting go of it. In other words, Fehér's figures are endowed with absence rather than presence, and they are experienced as if in a glass, darkly. They convey the melancholy of the past, a melancholy that seems as eternal as the figures, fixed in form and space like timeless statues. The static char-acter of the scenes – their concentrated stillness – seems fatalistic. Fate has indeed overtaken Fehér's figures, but they have no idea that it lay in wait for them.

The incongruity between the everyday figures and the abstract wasteland they inhabit makes for a weird tension and anxiety. There is another tension, inducing another kind of anxiety: the incongruity between the elusive figures and the things they share their space with, which are also rendered schematically, but are more conspicuously concrete, for they are opaque rather than transparent, mater-

ial rather than immaterial, solid rather than porous. Thus, there is a double para-
dox. On the one hand, the figures are as disembodied as the space, and invaded by
its abstract emptiness. They are simple, fragile outlines inscribed in its flatness –
transient, finite apparitions within its infinite extension. We see through them to
the nothingness, suggesting their own nothingness: they are whimsical hallucina-
tions, on the verge of dissolving into space, confirming their illusory nature. On
the other hand, they are comfortably ensconced in a very modern, functional
world. They live in modern houses (*Freunde,* 1991), which have modern chairs
and modern coffee tables *(Raucher II),* and live in a society that builds modern
bridges (*Paar* and *Vor der Brücke,* 1989). All these modern things are as flat – one-
dimensional – and abstract as the picture plane, confirming that Fehér paints
modern pictures, if with an emotional catch.

But there is yet another incongruity – contradiction, even absurdity – in Fehér's
pictures: within the functional modern world there are old-fashioned monuments
belonging to another, more ancient world – classical monuments more timeless
and memorable than the figures themselves, and even more material than they
are. These grand, sacred monuments are made of stone, indicating that they will
last forever. They symbolize eternal spiritual values, suggesting that there is more
to life than being fashionably up-to-date and efficient. The unmodern monu-
ments have greater authority and autonomy than the modern artifacts. If, for all
their apparent material indestructibility, the monuments should someday become
historical ruins, the spiritual reality they signify will remain intact and unchanged.
But the style of furniture and architecture will change, suggesting that the values
they represent are not only far from eternal, but completely relative – altogether
historical and secular. The classicism of the monuments stands opposed to both
the memory out of which the figures arose and the banal modernity that consti-
tutes their habitual world. The unresolved conflict between these three elements –
the bizarre pictorial reality that they exist in the same space – conveys the essen-
tial emotional theme of Fehér's pictures: alienation, and with it an overwhelming
sense of abandonment, emptiness, and absurdity. Fehér's figures are literally
empty, and in their own way his traditional monuments and modern environ-
ment – even the trees that appear in *Brüder,* 1990, and the clouds that appear in
Ballspieler, 1991 – are empty. They are token forms, weightlessly floating in the
abstract void. Everything in a Fehér picture is permeated by an abstractness that
announces the tentativeness of its givenness, or rather the odd hopelessness of its
existence.

And yet, for all the metaphysical aura of Fehér's alienation, it is historically
grounded. His scenes of abandonment and memory – scenes that convey the
memory of abandonment as well as a sense of being lost in memory (not to say
betrayed by life) – have a social meaning. For the classical monuments, which
seem to transcend time and space – however dated and ornamental, they imply
an existence beyond this one – also signify absolute social authority and power.
Classicism is the style of the state, and the classical monuments symbolize it. The

more totalitarian the society or absolutist the state – the more it wants to control every aspect of social and private life – the more it conceives of itself as "classical." It is the absolute state that is the hidden fate in Fehér's pictures, totalitarian society that subtly dominates his figures – that determines their fate. It is the state that makes them seem irrelevant and inconsequential, more apparent than real – mere toys of thought that can disappear at the whim of fate, figments of the imagination that can be blotted out as though they had never existed – as though they were nothing to begin with. Every last one of Fehér's figures, and his whole modern world, exists at the sufferance of the absolute, all-encompassing state.

Its implacable power, authority, and glory are implicit in the giant monument that dwarfs the figures that stand in front of it in *Vor dem Denkmal,* 1990, in the majestic giant monument that dwarfs the boy who sits on it in *Steinerne Welle,* 1991, and in the conventionally beautiful larger-than-life fountain that dwarfs the figure in *Der Wartende,* 1990. These pictures are as political as they are introspective. To put a little boy on a giant baroque scroll – a piece of a grand palace, as it were – is to make a political statement as well as to dream of one's unhappy childhood. It is to represent unrelieved social alienation as well as the misery of self-alienation. Indeed, it is to suggest that the latter is the consequence of the former. Fehér's pictures are, then, however subliminally, profoundly political as well as intensely introspective. His depressed – stoic? – little boy communicates the inner state of all the children that appear in his pictures, but the boy – implicitly Fehér – also represents every person who has ever been oppressed by an absolute state and totalitarian society. So does the equally isolated adult man sitting on the diagonal in *On The Pier,* 1992 – a kind of Munch *Scream* without the scream, or rather with the scream internalized, or perhaps projected in the form of the relentless blackness – indicating that Fehér means to signal a universal, unchanging condition. The only escape is to jump off the pier into oblivion.

The absolute state is the abstract gray eminence – the ostensibly indifferent yet omnipresent, dangerous background atmosphere – in Fehér's pictures, and the apparently transcendental, classical monument is the absolute state made ironically visible, as well as the insidious instrument of its power. In Fehér's pictures, the classical monuments are a kind of conquering occupation force: they alone hold their own in the space of the picture – the ground does not permeate the figure they cut, nor are they of any practical service to the human figures represented – and sometimes threaten to monopolize it. It is they who make the space inhospitable, even inhuman – remote and abstract, that is, alien – even to those who grew up in it, like the little boy in *Steinere Welle* and in such childhood pictures as *Behind a Tree,* 1992, *Step II,* 1993, *Kneeling, Puddle,* and *On the Road II,* all 1994.

Fehér's classical monuments, then, are far from innocent decoration. They are more solid, durable, sensuous, and knowing than the figures. Indeed, they even have more "personality" than the figures. Compared to the dull, mirage-like figures, the monuments are rich, visionary oases. The anonymous, drab man who

glances at the stone vase in *Steinvase* has almost completely disappeared into the gray mist, but the vase makes a strong, distinctive appearance. The state controls even the senses; it must make a more spectacular appearance than the human beings whose lives it controls. Fehér's stately monuments are permanent, while his human beings are temporary, which is partly why they seem far from real. Sooner or later they will fade away completely, but the state will survive in its monuments. Human beings are on the verge of oblivion in Fehér's pictures, but the monuments of the state endure forever. The eternal absolute state is the basic subject matter of Fehér's pictures, not simply human life. The state appropriates all higher, "classical" values because it claims to transcend life, indeed, be even more important than life – because it is higher and mightier than any human being who happens, by chance, to live in it. The state is death, and Fehér's pictures are about living death in an emotionally oppressive environment. Fehér's figures are phantoms in a society ruled by absolute authority, which makes itself felt in and through the threatening abstract environment it creates. The absolute state is technically invisible in Fehér's pictures, but it is "theoretically" visible – intuitively known – by its devastating effect on life: it makes life seem abstract and inorganic rather than tangible and organically vital.

Fehér's paintings are dependent on photographs – many of the figures are clearly posing to have their picture taken – but they win their independence by reason of their abstraction, that is, their esthetic fundamentalism. His figures themselves become ironically abstract, which makes them seem all the more abandoned, indeed, all the more like memories. Thus, the splitting of *In the Light,* 1993, into dark and light halves (more or less) serves to make the gray female figures that bridge the extremes all the more isolated and fragile, like memories. A torn, faded photograph – and every photograph reifies something already old, indeed, whatever is photographed becomes instantly old and petrified – has been turned to esthetic advantage. At the same time, by becoming entangled in what is implicitly a gnostic conflict between light and dark, the figures acquire a certain esthetic majesty, not unlike that of the little boy in *Steinerne Welle*. He is as black as the space he inhabits, but his contours are as white as the stone wave on which he sits, suggesting that he too is caught up in a gnostic struggle – a struggle to the death between elemental forces, at once moral and esthetic. Virtually all of Fehér's figures are constructions of light and dark, giving them an expressive edginess. Indeed, the tension between radical luminosity – Fehér's yellow is light at its most intense and incandescent – and absolute black in his pictures symbolizes the conflict between the forces of good and evil – between grace and destruction.

Black and white may blend into gray in many of the pictures, as though a truce was called, or good and evil fought each other to a standstill, or neutralized each other, but there are always signs, however slight, of gnostic intensity and contradiction in Fehér's pictures – traces of oppressive darkness and liberating light, in whatever unexpected form and situation. The rubber mattresses in *Auf dem Wasser* are mysteriously luminous, the metal fence in *Am Becken,* 1990, is dramatically

dark, the engulfing gray of *Weisse Treppe,* 1990, is marked by devilish contrasts of whiteness and blackness in the lampposts. Gnostic esthetics are evident everywhere in Fehér's pictures, if one knows how to look. Fehér uses black, white, and gray allegorically, in an occult balance of forces. Whole scenes are built of them, and acquire an occult character by reason of them. They lose their ordinariness, and become enigmatic. *Auf der Strasse,* 1991, is a case in point – a point that has as much to do with the unconscious from which Fehér's images spring as from his conscious gnostic/expressionistic esthetics.

Fehér is an altogether hybrid, paradoxical artist – a postmodernist artist in the best sense of the term. If, as Julia Kristeva says, the task of postmodernism is to synthesize what was separate in modernism[1] – not to cynically reify modernist ideas, as many think, but to use them to new effect by bringing them together in unexpected ways (which, even if it does not seem to succeed, will generate expressive friction) – then Fehér shows his postmodernism by synthesizing abstraction and symbolism, formalism and narrative, photography and painting, empathy and irony. The last conjunction may reflect Fehér's deepest purpose: his pictures, explicitly as well as implicitly, deal with the irony of Jewish existence in an anti-Semitic society – a society with no empathy for the Jews: a society that oscillates between indifference to and hatred of them, and subliminally believes they should not exist. Thus Fehér's abstractness has another meaning: it is the abstractness of Jewish life in an alien society. Indeed, he offers us modern Jewish pictures – pictures in which the modern sense of alienation and the Jewish sense of alienation converge – another postmodern achievement.

Tashlich, 1990, is explicitly Jewish. It ostensibly deals with a ceremony involving the symbolic purging of sins that occurs on the Jewish New Year. But to me the "Jewish feature" of the work is the great band of yellow that separates the figure – as in so many other works, a white outline on a dark field – from the sky above. This band divides the work into incommensurable realms. A similar division occurs in *An der Mauer,* 1990, and *Ballspieler,* 1991. *Vor einem Feiertag,* 1989, is another explicitly Jewish picture, and while the division between foreground and background space is not as expressively important as it is in *Tashlich,* the stark difference between the black bureau and the yellow surroundings is. In an attempt to explain "The Genius of the Jew in Psychiatry," Karl Menninger argues that the Jew's psychological sensitivity comes from the feeling of insecurity that results from the Jew's religious separateness, which translates into social separateness, which both the self-preservative Jew and prejudiced society insist upon.[2] I believe that Fehér renders this separateness as such, and the insecurity and self-sensitivity that come with it. But he does so indirectly: insecurity translates into transparency, self-sensitivity into isolation, and separateness into gnostic abstraction – the abstraction of conflict.

The Jew, Max Horkheimer said, knows "that no degree of conformism was enough to make one's position as a member of society secure." Thus, the Jew "experience[s] the tenacity of social alienation."[3] Virtually all of Fehér's adult fig-

ures are conspicuously bourgeois – social conformists in appearance and behavior. And yet they are alienated – isolated, insecure. They feel abandoned by society, however hard they try to belong to it – to blend in, to look like everyone else does. But the Jews can never belong: they are marked by their separateness. Separateness is the rock-bottom existential issue of Fehér's pictures. It is separateness confirmed by the state as well as society – by the absolute state that insists on conformity, yet finds one dispensable, as well as by a totalitarian society that barely tolerates one despite one's conformity. Separateness is everywhere in Fehér's pictures, and it strongly suggests that their fundamental issue is the problem of Jewish identity – all the more of a problem in an absolute state or totalitarian society, that is, a world in which conformity, inwardly and outwardly, is mandatory. In other words, in Fehér's Hungary, before the so-called revolution. Identity, Harold Rosenberg once said, was the modern "metaphysical" problem par excellence, and no one, he added, understood the problem of identity – the difference and separation between personal and social identity, and the difficulty of having a secure sense of identity – as well as the Jew.[4] Fehér's postmodern paintings show that the problem of identity, as a metaphysical ideal, a social perception, and something given to one by history, has become more acute than ever, not only for Jews, but for the ordinary conformist.

Odd Nerdrum, Perverse Humanist

While we cannot bear to be fully conscious of the disappointments and tragedies, the injuries to our narcissism which reality causes us to suffer, they are revealed to us by the artist. His sensitivity reflects experiences of which we have only been dimly aware, and he makes us face them. In our time, he shows us not only the images of a machine-dominated world which pervades our existence and confronts us with unimaginable dangers, but above all the world's rejection of our humanity – our impotence and sense of futility in a world which happens without us and takes no notice of our judgments and aspirations. He shows us just how dispensable we have become.

George Frankl, *Civilisation: Utopia and Tragedy*[1]

LOOKING AT ODD NERDRUM'S RECENT PAINTINGS, ONE IS TEMPTED TO SAY THAT he is a special sort of contradiction: an existential humanist and morbid pervert in one. That is, his art affirms the constancy of humanity in an inhuman world – in Frankl's words, "the human self-image" in "a world in which the human being had disappeared"[2] – but it does so in a way that reflects the perverse effect of the world's indifference on the human self-image.

If, as Robert Stoller writes, perversion is "the erotic form of hatred ... a fantasy ... primarily motivated by hostility" that "portray[s] itself as an act of risk-taking,"[3] then Nerdrum's risky figures embody the world's cruel indifference in their crippled flesh, even as their bodies are erotically excited by that cruelty. It is as though being emotionally crippled – Nerdrum translates it into physical crippling – makes one more sensual than one would otherwise be. Perversely, his figures are aroused by their own ruined state, however much their arousal confirms their self-hatred, an ironic version of the world's hatred.

The desert that pervades Nerdrum's pictures symbolizes the world's hostile indifference – the destructive abandonment of human being to the nothingness – and Nerdrum's figures are often reduced to nothing but their flesh, that is, the bare minimum of existence. They are as naked as the day they were born, yet about to die, or haunted by death. Often missing one or more limbs, their bodies are already on the verge of disappearing forever: no vision of resurrection in Nerdrum's desert, only sickness unto absolute death. Yet, however severely injured

by the world – Nerdrum's figures are irreparably damaged – and however much their narcissistic injury is visible in their flesh, they experience it as sensually gratifying – a masochistic triumph over the sadistic world. After all, they have to find pleasure somewhere: Nerdrum's figures are existentially tortured, but they are forced to enjoy it.

Thus, in a remarkable self-portrait, *Self-Portrait in Golden Gown* – truly unique in the history of artists' self-portraits – we see Nerdrum exhibiting an erection. It is a risky, hopeful display, pointing skyward like the finger of John the Baptist in Leonardo's strange painting of the saint. The erection is a defiant act of self-assertion, yet there is something futile, even self-defeating about it. It occurs in a dark vacuum – in the solitude of the studio. The artist is aged and alone; his sexuality can release itself only in the masturbation of his art. It alone gives him real pleasure. Dressed in an archaic robe, as gold as any king's – it reminds one of the theatrical robes that Rembrandt, another King of Art, affected in many works, even the most introspective, existential ones, as though the wearing of the robe signaled that he had not completely lost his mind to his art but still had a social identity and place – Nerdrum lifts its cloth to show not only his erection but his peculiarly unsullied yet heavy flesh. Like the erection, it is about to sag: both are subject to the downward pull of gravity, which is the secret subject of the picture. The ironic secret of the picture is that the erection is about to collapse of its own weight. After all, it cannot be held forever; it has to give, like any flesh, and fall down, its seed spent, futilely or not. Perhaps more futilely than joyously, as the dark background, emblematic of mortality and entropy, suggests. And yet there is a certain joy in the light that falls on Nerdrum's belly and erection, picking them out of the darkness as though they were freshly born, in a way that seems to leave his aging face behind.

The very figure we look at undercuts the voyeurism of our look. The reclining odalisque in *Pissing Woman* may be voluptuous and seductive – her eyes invite us to enjoy the sight of her nakedness – but she has also lost all her limbs and is urinating. Indeed, the luridly luminous stream of her urine is surrounded by a halo, while her face is in darkness. It is a startling image, full of contradiction. One cannot help but recall the poem in which Jonathan Swift expresses his shock and incomprehension at the fact that his beloved, a beautiful woman, also defecated – a perverse contradiction for him, indeed, a Gordian knot that not even his poem could cut. The standing one-armed man who accompanies Nerdrum's perverse heroine – they are a truly odd couple, she passive and immobile on the barren ground, while he raises his one arm in an angry gesture – adds to the contradiction, making it all the more unresolvable and terrifying. He is hardly the sexual companion she may desire – she seems to prefer some person looking at the picture, as the direction of her glance suggests – yet they are emotionally compatible, for together they form a single state of misery.

Another oddly complementary naked couple appears in *Old Man with a Dead Maiden* (Fig. 30). The beautiful young woman is stretched out on an animal skin,

30. Odd Nerdrum, *Old Man with Dead Maiden,* 1997. Oil on canvas. 104 $^1/_2$ inches × 126 $^3/_4$ inches. Courtesy of the artist and Forum Gallery, New York.

while the ugly, old and somewhat demented man sits up, his red cloak absurdly flowing behind him, his sword – symbolically unused in its scabbard – beside him. She is in fact dead, and he all but dead. They ironically represent two different stages of life and different states of mind, but like all opposites they stay together, however much they can never be reconciled, not by sexual intimacy nor any other human exchange. Nerdrum pictures human beings and human relationships in all their unfathomable intimacy – a compound of absurdity and sterility, as fated as the bleak world they inhabit.

Nerdrum's three paintings are existential allegories. They epitomize his art, which is a peculiarly medieval psychomachia – even a contemporary version of miracle play – that deals with the conflict between the life-instincts and the death-instincts, subtly evident in the body, and taking their toll on it. The very grain of Nerdrum's pictures is fraught with the gnostic battle between biophilia and necrophilia, as his tenebrism indicates. He has in fact revitalized, even quintessentialized, what has become an Old Master cliché – the subtle oscillation and tension between light and dark that structures emotional life – showing that

nothing in art is obsolete, so long as it can still be put to human use. Showing that Old Master methods are still fresh and meaningful is Nerdrum's way of indicating that however much human beings are subject to the terror of annihilation anxiety, whether for individual or social reasons, the consummate artistry with which their suffering can be represented triumphs over it. Nerdrum's human beings endure, however injured by the inhumanity of the world and their own inadequacy, just as his art will endure, however much it perversely drops us into the abyss of existence.

Vincent Desiderio

POSTMODERN VISIONARY PAINTING

T HE FLOOR PICTURED IN THE OUTER WINGS OF VINCENT DESIDERIO'S TRIPTYCH *Transmigration* (1994) is strewn with a virtually infinite number of picture books. Every last one is open to a reproduction of a famous painting, some by Old Masters, others by major avant-garde painters. Viewed from an indeterminate height – a kind of provocative distance – they look small and blurred, indeed, nothing more than geometrical patches of bleached color, with an image now and then decipherable. Their significance is reduced, however much we are engulfed by them. A similar assortment of open art books surrounds the male figure sleeping on the floor in *The Interpretation of Color* (1997) as well as the sleeping male figure in the painting within the painting *Theoretical Study* (1995). Are they artists or art historians, who have fallen asleep, fatigued by the futility of deciding which of the works pictured is the best (most important, original, perfect, etc.), by whatever standard? Clearly, no one image matters more than any other – the postmodern state of affairs, in which all hierarchies and models of value have collapsed, leaving in their wake numerous towers of artistic Babel, each as marginal as the other.

These scenes are intimate, but even more intimate are the bedroom scenes in *Insight* and *History Painting* (both 1997). Desiderio is a Neo-Intimatist, it seems: he pictures privacy, with great sensibility and masterful craft. We eavesdrop, as it were, on secluded situations. As in all good Intimatist painting, outer reality becomes emblematic of inner reality; appearances become moody and enigmatic, to the extent that they no longer seem securely anchored in everyday reality. They become as abstract as memories – screen memories, lived in the present but belonging to a dead past. In *Insight, History Painting,* and many other works, nakedness resonates with interiority, even symbolizes it. The phantom scenes on the wall in *Insight* are clearly the projected fantasies of the half-naked (ironically blind?) woman. (Another wall is covered with blurred reproductions of art – mechanical memories of a different kind of fantasy.) Similarly, the naked lovers in *History Painting* are on the verge of dissolving into phantoms, at least at their lower extremities, suggesting that the whole scene is a fantasy.

Desiderio's paintings, then, are as apparitional as they are realistic, and as urgent by reason of their brilliant chiaroscuro and sudden gestural storms as by reason of their disturbing imagery. Desiderio is not just a painter, but what Baudelaire called a "poet-painter" – a painter who is able to condense into a single hallucinatory work a contradictory variety of emotions and ideas, in a way that makes it clear that painting has a unique power of subliminal, imaginative communication. Desiderio's mastery of the Old Master manner of oil painting, which cannot help but engage us deeply, confirms this. Absorbing light, the oil surface creates the illusion of seeing into mysterious depths, evoking a feeling of empathic communion with the subject matter pictured.

But for all their Old Master brilliance, Desiderio's paintings convey a very postmodern ambivalence about art. It is the combination of these incommensurates that makes him the consummate postmodern painter. On the one hand, his Intimatism communicates a certain skepticism about art's mimetic power, in the deepest sense, that is, in terms of its adequacy to lived experience – its ability to rise to the occasion of deeply felt life. Desiderio's Intimatism desperately tries to mediate such experience, but suggests its own failure to do so by signaling that it is, after all, only art – not "art as experience," to use John Dewey's famous phrase. Thus, Desiderio brings art into serious question by discovering it to be nothing but art. He implies that his vision of life reduces to the visual tricks of the trade, of which he clearly has many. On the other hand, he never abandons his intention of using art – an encyclopedic range of art, indicating his extensive knowledge of the languages of art (represented by the reproductions that proliferate in his works) – to communicate an intimate, intense, consummate vision of his very personal experience of life. His paintings are theoretical: they show art as a reproduction of a reproduction of a reproduction, in infinite if ironical regress to a utopia of its own – an esthetic utopia far from the reality of life. At the same time, they are profoundly personal: Desiderio clearly regards art as a unique means of sounding the emotional depths of his own life – of exploring his own private hell, including the hell of being an artist.

In other words, Desiderio has both a postmodern and Old Master notion of art, and puts it to postmodern and Old Master use. This contradiction – unresolvable dialectic – is responsible for his sense of the Sisyphean futility of art, which converges with his sense of the Sisyphean futility of life. He has a tragic vision of both, each vision reinforcing the other and fusing in a general feeling of ambivalence – a kind of malaise of ambivalence. Thus, virtually every one of his paintings shows, somewhere in it – sometimes quite centrally – an uneasy truce or standoff between the experience of art and the experience of life. This suggests their irreconcilability, even as it reconciles them in the same picture. This hypothetical reconcilation is in fact the truly visionary element within Desiderio's vision of the postmodern experience of art and his Old Master vision of suffering (the human condition). Denying a neat fit between art and experience, Desiderio implicitly denies his own art's ability to articulate his experience of life convincingly, however explicit his attempt to make it do so, and however much he believes that art – traditional, Old Master art – is especially suited to do so.

31. Vincent Desiderio, *Elegy,* 1995. Oil on canvas. 56 × 82 ³/₈ inches (142.2 × 209.2 cm). © Vincent Desiderio. Licensed by VAGA, New York. Courtesy of Marlborough Gallery, New York.

It is the postmodern predicament: one has all the languages of art at one's command, but none of them quite works to make a human point – none of them seems to reference human experience satisfactorily – resulting in what might be called Sisyphean mimesis: mimesis that undoes itself in the process of perfecting itself. It is mimesis that comes to seem like the futile gesture of art to life, even as it seems to be immediate with experience, resulting in a memorable image. It fails in the very act of succeeding, for it cannot help but call attention to its method, that is, the fact that it is just another language of art, existing first and foremost in and for itself. Its significance is contained in itself, so that whatever it signifies in the lifeworld beyond itself seems beside its fundamental point. This sense of failure occurs even when Desiderio pulls out all the stops on all the languages of art he knows – indeed, occurs all the more completely, for one can't help but be aware that he is a highly educated, historically self-conscious artist, which comes to seem more significant than his experience of life, however painful. After all, everyone suffers, but not everyone is so knowledgable – such a virtuoso rhetorician of styles. In the end, one admires Desiderio's pictorial intelligence more than one empathizes with his suffering, for one has enough of one's own.

Desiderio's paradoxical, Sisyphean attitude is embodied in the tense contest between art and life – always ending in a draw, however intricate their intimacy – that is pictured again and again in his paintings. *Elegy* (1995) (Fig. 31) shows their difference clearly: the adult male figure is an artist, as the art books on the floor next to his bed suggest, and the suffering boy by his side is implicitly his son – in

actuality a victim of hydrocephaly, needing a respirator to breathe. This reference to real life is not essential for an understanding of the picture's story, for the boy's suffering is self-evident. He appears again in *The Travellers Log* (1996) and *Adieu* (1997), and is implicitly contrasted with the healthy boy playing the flute in Manet's painting, reproduced in several of Desiderio's works. The point is that the reality of life is at odds with the reality of art in both pictures. No attempt is made to reconcile them, even as Desiderio uses all his great skill to give both emotional meaning.

Thus, the adult male in the central panel of *The Travellers Log* is clearly an artist, as the apparatus on the floor indicates. Even more striking is the contrast between the cuckoo clock, ticking off the time of life, and the reproduction of Rodin's bust of Baudelaire – a poet who more successfully than most artists reconciled his art and experience of life, even though today his poems seem to have more to do with art than life (like the book reproductions) – in a side panel of *Adieu*. The chimes in the cuckoo clock toll for the boy in the central panel, and the side panel forms an art/life contradiction with the central panel. For both kitsch cuckoo clock and reproduction of avant-garde sculpture, however at odds, are both popular art. (The strategy of a contradiction within a contradiction occurs frequently in Desiderio's paintings.) The modernist building – a museum? – in the other panel also represents art, while the nightsky above it conveys the melancholy of life, and the panel as a whole also forms an art/life contrast with the central panel.

Perhaps the most telling art/life contradiction Desiderio sets up appears in the central panel of *Redux* (1995), where a hook – a symbol of the brutality and cruelty of life – dangles above a Matisse mural of blue nudes. The two are visually reconciled within the abstract geometrical composition they form, but they are emotionally irreconcilable. The shock of their juxtaposition never quite disappears, however much the mural and hook are formally integrated. But the uneasy occult harmony they establish only confirms that each holds its own: neither submits to the other – each is emotionally as well as pictorially as strong as the other. (Several metaphors seem to suggest themselves, including that of aggression against the female nude, a subtext that recurs in other Desiderio works.)

The hook appears again in a side panel of *Target Practice* (1996), also juxtaposed with art, in this case the Baudelaire bust and Velazquez's *Philip IV*. And, perhaps most strikingly, it appears in the narrow central panel of *Emblematic Narrative* (1996), flanked by two famous works of ancient art, the dome of the Pantheon and a bronze sculpture of a maenad (itself juxtaposed with a Suprematist square and bull's-eye). In *Transmigration,* the hostile, toothy monkey – its mouth is wide open, as though to bite – and the art books form another striking life/art juxtaposition. In *Couple* (1997), the bright, smiling woman and the dull brown palette form yet another. (There is also a bit of an art book in the lower area, next to a bowl of food.) The juxtaposition of a lustful couple (doctor and patient) with Manet's *Execution of the Emperor Maximilian* in one panel of *Ocular Complicity* (1993) (Fig. 32) is particularly dramatic. In the other panel, the picture frames and modernist building on

32. Vincent Desiderio, *Ocular Complicity,* 1993. Oil on canvas. Rt./left panel: 36 × 49 $^3/_4$ in. (91.44 × 126.37 cm). Center panel: 36 × 49 $^3/_4$ inches (91.44 × 126.37 cm). © Vincent Desiderio. Licensed by VAGA, New York. Courtesy of Marlborough Gallery, New York.

the one hand, and the crouching male nude on the other, form a more subtle contrast. Life/art tensions abound in *Theoretical Study* (1995), epitomized by the kneeling nude, who is life and art together, as her mirrored buttocks suggest.

Desiderio uses many of the spatial tricks of traditional painting, particularly the picture – or is it mirror? – within a picture idea of Velazquez's *Las Meninas.* *Theoretical Study* uses it – the buttocks may be painted rather than mirrored – as does *Academy* (1997). The indeterminate space also suggests the uncertain difference between art and life, reaffirmed when the eyes of Desiderio's painted figures meet those of the spectator, as they sometimes do. Again and again he shows art that, however consummate in itself, is no help in living, and in fact seems beside the point of life, however much it may point to it.

The three fragments whose juxtaposition constitutes *Mimetic Composition* (1995) epitomize the issue. In one panel, painted in light tones, a plaster cast of a madman (Messerschmidt?) rests on the floor, and is seen close up. In another panel, also in light tones, a family dinner table is seen from above. (The mounted video-camera is a means of recording family life, that is, of turning it into "entertaining" art. The art-as-entertainment theme recurs, as the video cassettes that appear in other paintings indicate. They also suggest the picture-within-a-picture. Indeed, many of Desiderio's paintings are Chinese boxes of pictures.) Between them, painted in black, a gray, melancholy face – it could be one of Gericault's portraits of the insane – stares at us. This living face contrasts sharply with the sculptural rendering of suffering, which seems to express the agony underlying it: the face is more of a mask than the mask, which has more life than any face. It is indeed a life-mask, suggesting that the suffering of life can only be experienced when it is masked, in every sense of the term. The family table is off by itself – the scene of the crime showing no traces of suffering. There is no way to put the pieces of this puzzle together, however much they subliminally hang together. But they also hang together because they suggest the paradox and futility of representing inner life in art, even though there is no other way to represent it in a memorable way.

ANIMADVERSIONS

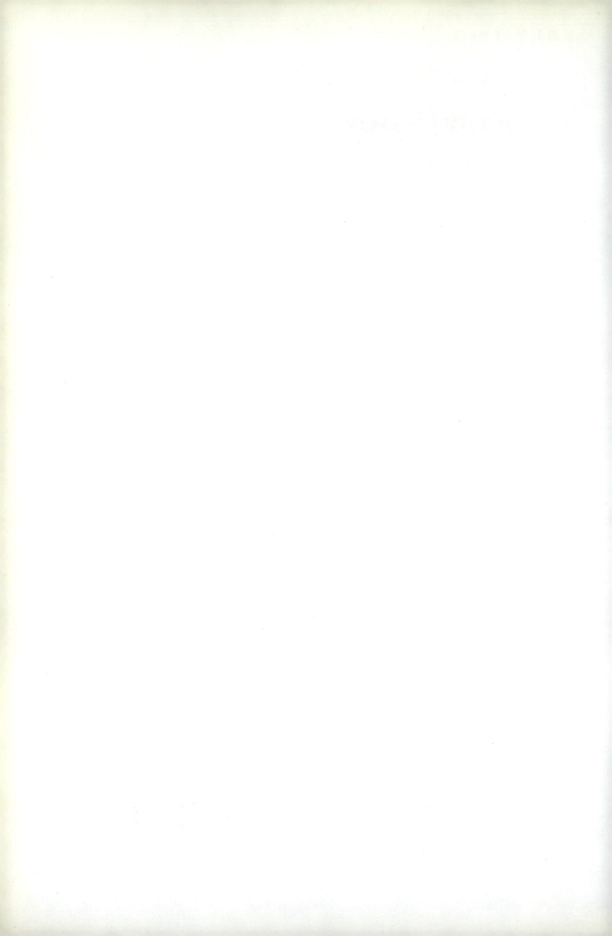

Avant-Garde, Hollywood, Depression:

THE COLLAPSE OF HIGH ART

N O DOUBT IT'S ALWAYS BEEN HARD TO BE AN ARTIST, ESPECIALLY WHAT USED TO be called a "fine artist," but it is particularly hard in the modern world. In part this is due to the uncertainty of patronage; the loss of church and state as reliable sponsors brought with it dependence on the whims of the market. But it is mostly science and technology that make life hard for art; they are able to alter the world in reality not just in fantasy. Freud pointed out how easy it is to do the latter, and how hard to do the former. As he suggested, science and technology offer knowledge and mastery of reality, while art extends the old wish-fulfilling "mysticism" of magical thinking. The devotion we accord art is religious in character, in that it is grounded in the wish for a more perfect life and world, and the illusion that esthetic rituals can bring the change about, in lieu of any realistic way of doing so. The religion of art is no different in character from any other religion in that it traffics in the grand illusions of the pleasure principle.

Perhaps more than any of them, it promises more than it delivers – this is the gist of seduction and glamour – for it promises it in the here and now rather than hereafter. No doubt this is why art seems the most consummate and enjoyable of all communications. Indeed, however absurd its claims, the aura of infinite promise that emanates from the most exciting art is especially satisfying – however shortlived the excitement, that is, however quickly the sense of expanded vitality the art affords shrinks and withers – because it conveys a sense of omnipotence, the profoundest and most magical of all feelings. Art restores the infantile sense of omnipotence and grandiosity – absolute mastery and self-belief – that inhabits all deep satisfaction, whether grounded in fantasy or actual experience. But science and technology, with their commitment to the reality principle, are disillusioning killjoys. They puncture the balloon of omnipotence and grandiosity, showing art (and religion) to be filled with emotional hot air, that is, the toxic exhaust of intolerable frustration.

So the modern public, increasingly aware of science and technology, and attracted to them – why not, since they improve its lot concretely, if by increments rather than in the grand fell swoop promised by religion and art – is some-

what more skeptical of art than the traditional public, however still teased by its promise of transcendence and transformation, that is, its mystical *promesse du bonheur,* to use Stendhal's famous expression, picked up and expanded ironically by Adorno. Certainly art helps ameliorate the anxiety aroused by the scientific demystification of the world. The modern public no longer trusts art – I think this, not simply reluctance to accept stylistic change, was responsible for nine-teenth-century resistance to avant-garde art – but it allows itself to be seduced by it. That is, the enlightened new public sees through art's grandiosity and magic in the act of savoring them. As though in acknowledgment of this, art itself has come to see through itself by deconstructing itself, that is, showing its own method of construction (Cézanne, Cubism) – the art behind the art – and claim-ing that disillusioning enterprise to be the real art. (Ironically, nineteenth-century resistance was greatest when art pretended to be science rather than art. Thus, the new realism or materialism of Manet and the Impressionists, with its quasi-scien-tific observation, detachment, and desublimation of nature, struggled longer for acceptance than Symbolism, which did what art always does – mystify and emote. Why accept mock science when one could have the real thing? In short, it was a growing disillusionment with art, when contrasted with science and technology, that was responsible for resistance to the avant-garde, not simply its rebellion against traditional art. I think the avant-garde called itself "advanced" to imply – defensively – that art could compete with the "advances" of science and technol-ogy. But avant-garde innovation is hardly of the order of technological innova-tion. The latter has enormous, inescapable social impact, while the former makes no essential difference in society, however much it may make an existential dif-ference for a particular individual.)

The modern public, then, believes and disbelieves in art, with disbelief having the last word. Art may be sincere, but grandiosity is an illusion, however pleasur-able. Disbelief is suspended for the sake of pleasure, but disbelief is the inner truth of the modern enlightened attitude to art. Moreover, a truly modern public is so enlightened that it understands its own need and wish for art – it relates to art through its own self-consciousness – and thus has as much doubt about art as it has about itself. It expects to be disenchanted after the experience of enchant-ment, which it knows is grounded in its own subjectivity rather than intrinsic to art. This expectation is basic to being modern – part of a "scientific" attitude to art, that is, part of critical consciousness, which assumes that any "higher" and "deeper" experience is a form of mystification, a veil over raw subjective truth. Thus, however subliminally necessary, art is suspect in modernity, for its *promesse du bonheur* looks delirious and irresponsible in comparison to the more cautious promises of science and technology, which depend on objective truth.

I think that art has become completely suspect and problematic in the post-modern world. It has become so questionable that only philosophers are inter-ested in finding answers to the questions it poses. What was unconscious skepticism in modernity has become conscious cynicism in postmodernity. Art no

longer seems worth even the emotional trouble. It may remain as status symbol and market property, but its magic and promise have disappeared, or at least become so attenuated as to seem nominal. Science and technology shook our faith in art, but our belief in its emotional relevance remained intact. But now this too has been destroyed; indeed, art has destroyed itself from within, for it has abandoned its pretense to be "high." We are living at a time when the reign of "high" or "fine art," correlate with the idea that art can offer us a special "esthetic experience," has come to an end. What began with Kant has ended with the decadence of Duchamp. Art has lost its subjective value as it has become a "theoretical" enterprise. It has become so much of a theoretical question that it has lost human interest. It has been bifurcated – objectified – into material and idea, losing its character as a sign and expression of the subject in the process.

Moreover, the idea of a "high artist" has become increasingly absurd. There are more artists than existed in the past, not only because there are more people, but because anyone can declare himself to be an artist and not be questioned. There are no standards by which to determine whether or not the person is actually an artist, because the concept of artist has become so flexible that it can cover a multitude of activities and identities. The old distinction between a calling and a career has broken down, because the difference between working out of inner necessity and working to establish a social persona has broken down. Kandinsky looks inauthentic from the perspective of Warhol, and Warhol looks inauthentic from the perspective of Kandinsky, but it is no longer clear which perspective is authentic. It does seem clear that it is easier to be a Warhol – a postmodernist – than a Kandinsky – a modernist – because it is easier to make copies than to struggle to be original. It is easier to perversely replicate than to master a meaning. It is easier to simulate than to imagine.

Perverse replication, á la Warhol et al., has become the modus vivendi of postmodern art. It is the gist of the Hollywoodization of art. It confirms its cynicism, and the postmodern rejection and destruction of high art. It is disillusionment with art by "artists." Perverse replication is a form of nihilism, in that it pulls the support of tradition out from under art in a way the avant-garde never did. Avant-garde artists felt compelled to take a stand to tradition, whether that meant to master it enough to modify it or to work it through to an ostensibly liberated, independent creativity. In contrast, postmodern artists are indifferent to tradition; they see no point in struggling with it to achieve autonomy, for both tradition and autonomy are irrelevant in a postmodern world, in which current appearance is all, at whatever cost to reality testing. Tradition has no presence in the postmodern world, for history has been Hollywoodized – perversely replicated for mass consumption. Tradition is not a bedrock but a hangover.

Perverse replication is a way of bringing down what was once regarded as high, in the sense of offering a perspective on a lifeworld ordinarily unavailable in it, which is what art worthy of becoming canonical – tradition at its best – achieves. In postmodernity, there is no higher perspective; all perspectives are leveled in the

name of ready accessibility. There is no possibility of an original perspective on an unoriginal world, only the basic unoriginality of all perspectives, that is, the inability to rise above the world, to be more than a material and social part of it. Perverse replication is the ultimate reductionism, in that it denies the imaginative possibilities of art. It is passive and fatalistic; resistance to the world, by way of imaginative transformation of it, implying spontaneous transcendence of it for the sake of subjective survival, is a futile illusion. All the artist can do is replicate the world, giving it a perverse twist, which is the sign of subjective presence. In postmodernity subjectivity is marginalized to a perverse "angle," while in modernity it becomes the major perspective on the world, the imaginary center from which it can be surveyed and comprehended as a whole, as well as in its least detail. In modernity, the subject resists the world, proudly declaring its autonomy and outsiderness, registering the world's impingements on its existence while shrugging them off. In postmodernity the subject submits to the engulfing world and exists only as a twitch on its impassive face. In modernity the subject wrestles with the world, while in postmodernity it lets itself be overpowered by the world, for it lacks the conviction and confidence in itself to do otherwise.

I prefer the term "perverse replication" to the more conventional "quotation art" or "appropriation art," for the latter miss the point: there is nothing innocent or neutral about the postmodern subsuming of original art. What at first seems to be a dialectical act of homage and admiration turns out to be an envious and contemptuous act of castration, indeed, an insidious annihilation of originality. Mike Bidlo's shoddy quotations of Picasso and Pollock, and Sherrie Levine's truncated quotations of Walker Evans and Malevich, attack the originals they acknowledge. The shoddiness and cropping – the sense of something "off" in what initially seems matter of fact – gives the game away: quotation cuts the originals down to everyday, manageable size, so that they seem mindlessly reproducible and thus mindless in themselves. The perversity of appropriation art consists in the fact that it treats authentic art in an everyday way, so that it becomes impossible to take it seriously as high art, that is, the imaginative and mythic encoding of a new perspective on the human condition, affording unique insight into it. Appropriation art devalues – trivializes – original art by turning it into an everyday phenomenon of no special significance. Perhaps this is most explicit in Cindy Sherman's "takes" on Old Masterpieces. Nastily reduced to vaudeville constructions, they lose all credibility. What starts out as an act of de-origination turns into a total rout – complete destruction of the meaning and structure of the original. It is not only discredited as a model, but as an individual achievement. Sherman's works are beyond satire, which usually suggests an alternative to what it ridicules. Sherman's deidealization leaves us with no alternative ideal, only vacuous laughter – dumb hilarity amid the ruins.

The perverse replicator has little or no understanding of the original "ironically" replicated. Its culturally privileged position is denied, and even its right to exist. If, as Joyce McDougall suggests, the psychotic feels she has no basic right to exist,

then the perverse replicator projects her feeling of the illegitimacy of her existence onto the authentically existing original. Such psychotic nihilism is the core of appropriation art. We are inured to its Hollywoodization of authentic art – the treatment of high art as everyday spectacle, transparently pretentious – because Hollywoodization is standard practice in public space. Indeed, it has taken it over completely, to the extent that public space exists only as transparent spectacle. (The irony of the Hollywood movie is that one can see right through it with one's everyday understanding – this confirms its democratic, unthreatening character – even as it lulls one into losing oneself in its mystification of everyday life, which supposedly demonstrates its artistic authenticity. Mystification – the everyday understanding of what high art is about – and common sense, which is supposed to prevail in everyday life, exist side by side in the Hollywood movie, reconciled by the fact that they are equally routine, that is, formulaic in character.)

I think perverse replication is a desperate last-ditch attempt to make something resembling art, but that in fact is less than art, for it involves no imaginative transformation of the lifeworld for the sake of emotional transcendence but rather a cannibalistic attitude to other art to deny feelings of emptiness and meaninglessness – depression. Perverse replication reflects the radical uncertainty and directionlessness of the artist – not to say failure or at least crisis of creativity – in postmodernity. Consciously or unconsciously, the postmodern artist sees no future for herself and for art as such. It is given over to philosophers, who willingly take it over, vitiating it with their "death of art" theory, that is, projecting their own lack of creativity and imagination – the living death which philosophy is – into art. The postmodern artist has bought into this theory, whether because of creative impotence and helplessness, or out of an exaggerated sense of the significance of philosophy, which looks more intimidating than it is – which is a paper tiger. (To change the metaphor, philosophers are vampires, eagerly sucking the life force out of the things they fasten on, reducing them to empty shells, which the philosophers then move into with their theories. Philosophers know only how to appropriate and deconstruct life spaces – necessarily built with originality and great difficulty, in creative adaptation to circumstances – rather than how to construct them. In short, philosophy has no space of its own because it has no life of its own. It is parasitism at its purest.)

No doubt there are social reasons for this – for the fact that, as Max J. Friedländer said, "The rule of theory always rises in proportion as creative power falls."[1] Among them is the prevailing Hollywoodization of society, but more crucial, perhaps, is the Hollywoodization of creativity itself. It has been identified with spectacle, more precisely, information made spectacle. The Hollywoodization of creativity shows itself with particular clarity in the fact that creativity has become the ultimate value in our society – more important than morality, more important than kindness, more important than happiness. In line with this comes the idea that it is easy to be creative. I think this is why so many people want to be artists; they think that by calling themselves artists they confirm their creativity, and

indicate how easy they find it to be creative. Postmodernism believes in creative chic, if not originality. Universally desired, creativity is the sweet perfume life is supposed to smell of, and like perfume our society thinks it can be chemically synthesized. Thus, everyone can have a bit of artificial creativity, courtesy of the bargain-basement counter of socially sanctioned self-love. Creativity has become confused with narcissism and exhibitionism. People who vomit on famous paintings are regarded as creative artists, and so are people who hand out ten-dollar bills to illegal Mexican immigrants crossing the border into the United States. The concept of "creative artist" has been used to rationalize and justify all kinds of behavior, which suggests how empty it is – as empty as the many self-styled creative artists.

Creativity has been democraticized – become an inalienable right. This has brought with it confusion about what it is, which is in part why it has become a hot topic of psychological and sociological research. Supremely valuable, it has become less and less comprehensible and specifiable. A consequence of this is that the difference between significant and insignificant creativity – and art – has been blurred, to the extent that no one knows what it is. There are no longer any reliable criteria – so-called standards of judgment – for determining the difference. Even the most intricate interpretation of a supposedly creative art avoids passing judgment on it, because there are no means of doing so. The art is either "in" or "out," depending on the whims of "fashion," which achieve its currency and "credibility" by contagion. These days there is no art, however fashionable, that is more authoritative than its media presentation.

Passing judgment on an art, or at least challenging its "ideas," is regarded as a slander on its creativity, not to say a questioning of its integrity. To criticize is to insult creativity, perhaps inhibiting it, which is the ultimate sin in this age of everyman-an-artist. Few critics dare approach the art they care about with reasoned skepticism, or dare examine it from an unfashionable point of view. Postmodern critics censor themselves, stunting their intellectual and emotional growth to survive on the "scene." Playing it safe, they confirm their own banal creativity. Criticism was anathema to the modern artist, who arrogantly treated the critic as a fool who had to be instructed in the new truth of art. This is the way Gauguin treated André Fontainas and Rothko and Gottlieb treated Edward Alden Jewett. Fortunately this is no longer the case. These postmodern days artist and critic get along famously, for the critic serves the artist whether or not he intends to. The critic is a publicist despite himself; critical argument – all the more so when it is controversial – has become a publicity stunt, however unwittingly. Properly publicized, the artist can become famous, even if it is no longer clear what fame means, other than, tautologously, to become a seemingly necessary fact of social life, sufficiently visible to be regarded as universally significant. As Leo Braudy writes in *The Frenzy for Renown,* and Gladys and Kurt Lang write in *Etched in Memory: The Building and Survival of Artistic Reputation,* fame requires the distribution that only publicity can achieve, but the value of what is publicized is

not unequivocally clear. (The Langs also point out that the myth that the artist is a "superior" human being is another reason everyone wants to be an artist.) The critic thus also plays his part in the Hollywoodization of art and fame, but more crucial is the fact that the artist and art have become self-Hollywoodizing, as it were. The critic simply puts the final cosmetic touch on what has become an unavoidable postmodern process of spectacle making.

High social visibility has become the basic aim of the postmodern artist. Only this quiets her fear of insignificance – only this seems to confirm value. The audience confers aura; none is built into the art. It no longer matters whether the art is kitsch or avant-garde, whether it flatters or violates the public, whether it lives up to expectations or contravenes them. Being postmodern, it probably does both, which tempts one to say that it does neither well. But such distinctions – basically the difference between nonconformist, "outsider" art that seems to oppose, critique, or transgress the status quo and "insider" art that seems to conform to and thus ratify it – have become moot and passé in postmodernity. Today neither artist nor critic are pariahs, for both serve the same social system – a system that socializes or administers even the most outrageous outsider artist into an institutional cliché before she can complete her identity, thus nipping her maturity in the bud, as it were. Ripeness is not all in the postmodern world; institutionalized immaturity is.

My ulterior motive is to suggest why this is so. It ultimately has to do with a fact I have already begun to circle around: the idea of high or fine art – avant-garde art was its last flourish and fling – has broken down. It has eroded into inconsequence, however much lipservice it is still given. It continues to be important, but for reasons that have nothing to do with it. Even though the fine artist is a disappearing breed, the idea of the fine artist remains socially privileged, however nostalgic. But the postmodern repudiation of the idea of high art – the attempt to treat it as inwardly "low" – is nothing new. As I have suggested, it is a standard enlightened modern approach to art and culture in general. Thus, in a letter to Ludwig Binswanger, Freud wrote: "I've always lived in the *parterre* and basement of the building. You claim that with a change of viewpoint one is able to see an upper storey which houses such distinguished guests as religion, art, etc. You're not the only one who thinks that; most cultured specimens of *homo natura* believe it. In that you are conservative, I revolutionary. If I had another lifetime of work before me, there is no doubt that I could find room for these noble guests in my little subterranean house."[2] This statement encapsulates with particular straightforwardness the modern ambition of reducing the higher to the lower – the mature to the immature, the civilized to the primal, the self-conscious to the unconscious. It is supposedly demystifying and disillusioning, but it in fact remystifies and creates another illusion: that high art and culture are oblique expressions and blind projections of basic instincts, and as such of no help in dealing with reality. They leave it unchanged and misunderstood, however much they claim to represent it truthfully. But in fact it is always filtered

through an unself-enlightened subjectivity, and as such far from objective. The Marxist understanding of art and culture as ideology – the reification of class interests – does something similar, however much Marxist theory has come to understand ideology as a kind of dialectical feedback shaping rather than simply reflecting the reality of social production. Class plays the same primal role as instinct, and has the same reductive function vis-à-vis art and culture. To believe in them – to experience them in and for their own sublime selves, that is, trust the idea of transcendence they convey – is to be unenlightened about social reality, just as from a Freudian point of view it is naive to regard them as anything more than sublimated and socialized expressions of instinctive needs and conflicts. For both Freud and Marx, the fundamental is more important than what is built on it; neither seems to realize that without the upper storeys the basement is only a hole in the ground. The issue is what is built on the foundation, not that there is a foundation.

The breakdown of high art occurs not only because modern intellectuals emphasize what is below rather than what is above, but because postmodern society has swallowed high art whole, with no fear of indigestion. Avant-garde art – the dernier cri of high art, as I have suggested – becomes simply another mark of novelty in a society in which novelty is mass produced, another token of individuality in a society in which individuality is a boring cliché. Avant-garde revolution seems small potatoes in a society in perpetual change. Also, the abundance of competing avant-gardes has led to the belief that "anything goes" in art. Every art comes to seem worthy of attention if not absolutely convincing. Baudelaire's idea of being passionate and partisan about some particular art no longer makes sense, indeed, seems naive. No art fights to the death with any other art – however much some artist may declare his hatred of another artist (for example, Judd of Baselitz, that is, pure abstraction of figurative expressionism) – because all are assimilated into a kaleidescopic pluralism. No art has historical dominance, for there is no privileged history. There is no longer the divisive, agonizing either/or, but the ecumenical, lazy both/and.

But all is not blissful artistic sisterhood in postmodernity. Depression lurks behind its apparent liberality, and within its Hollywood idea of art. Warhol turns human beings into imposters of themselves, mannequins of their own meaninglessness. Reifying social appearance, he abolishes subjective presence. Human substance is reduced to redundant shadow. The human figure becomes the empty shell of an isolated appearance (no doubt ready to be filled with theory, making the figure all the more ghostlike and unreal). This is perhaps the ultimate self-defeat, but for Warhol it is a readymade social irony. For him, the schizoid state of depersonalization and derealization is socially normal, indeed, altogether "natural" – an accurate perception. Warhol's version of anything goes – everybody's fifteen minutes of fame (anybody's portrait) – is on social target, but Warhol implies it is more farce than tragedy, which is no doubt his way of distancing himself from his own schizoid state of nonexistence.

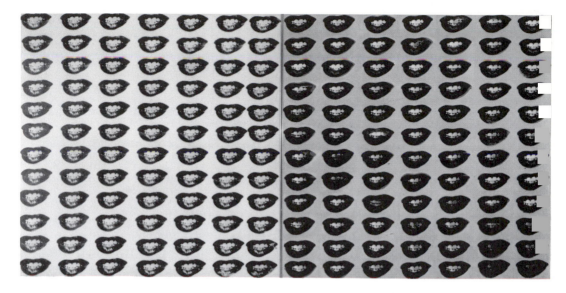

33. Andy Warhol, *Marilyn Monroe's Lips*, 1962. Silkscreen ink on synthetic polymer paint and pencil on canvas; two panels, 6 ft 10 in. × 6 ft 8 ³/₄ in., 6 ft 11 ³/₈ inches × 6 ft 11 inches. Hirshhorn Museum and Sculpture Garden, Smithsonian Institution. Gift of Joseph H. Hirshhorn, 1972. Photograph by Lee Stalsworth.

Warhol demonstrates (unwittingly?) the depressing character of Hollywoodization: reduced – but some people think elevated – to pure social spectacle, one becomes unpersonal and unreal to oneself, that is, forfeits one's sense of being a subject and self to be "immortalized" as a socially recognizable identity (Fig. 33). Socially objectified, one becomes subjectively meaningless. The social objectification of avant-garde art (and high art in general) has made it subjectively meaningless – useless as an instrument of subjective change and personal growth. It no longer affords insight into the self nor instinctive pleasure. In short, where avant-garde art was a metaphor for the self and its vicissitudes, neo-avant-garde art is "selfless." It is an entropic deadend of the self as well as creativity. (Warhol's Hollywood envy, however ironical – but irony is a form of destructive envy – is overt, as is, more subtly, that of Sherman, Longho, Salle, and Schnabel. The latter's film about Basquiat is one in a long line of Hollywood films in which the artist's life is treated as a spectacle, which is always designed to prevent a close look at the subjective truth. Spectacle is inherently shallow, however much its mystification of the subjective truth – the obscurantism that comes with social objectification – makes the self seem more "mysterious.")

Perverse replication is the method of all "neologistical" art, be it neo-abstract or neo-expressionistic, neo-conceptual, or neo-narrative. If there are four basic models of avant-garde art, as I think – instinctive painting; the use of an object to mediate an idea (the object becomes "art" by virtue of this mediation); pure art or form as such; and art that takes the street as its point of origin (Breton thought one found more interesting things in the street than in the museum) – then the

subjective newness of all four has become the arch neoness achieved by perverse replication, which is at the core of every process of objectification. (For example, compare Kirchner's avant-garde instinctive painting with that of the neo-avant-garde Baselitz; compare Duchamp's avant-garde use of found objects in the service of the mind with that of the neo-avant-garde Haim Steinbach; compare Mies van der Rohe's avant-garde architectural purity with that of the neo-avant-garde Richard Meier; and compare Kaprow's avant-garde vision of 42nd Street to that of the neo-avant-garde 1993 Times Square show.) More unequivocally and archly than any neo-avant-garde artist, Warhol shows the power of perverse replication to turn presence into absence, the authentic into the inauthentic, the revolutionary into the reactionary, the subjective into the objective, in a way that implies there is no difference between them, thus nihilistically confusing them. This voiding of the visionary is the ultimate symptom of depression.

The depressive objectification of high art, and with it subjectivity and selfhood, is irreversible. The postmodern process of decadence is irreversible, because depression is endemic in and inseparable from postmodern society. This was made clear in the December 1992 issue of the *Journal of the American Medical Association*. In the words of the *New York Times* summary, titled "A Rising Cost of Modernity" – it should have added postmodernity, in which the cost is rising even faster – crosscultural evidence was presented that depression, which is "not just sadness, but a paralyzing listlessness, dejection and self-deprecation, as well as an overwhelming hopelessness," is the one mental ailment which has grown exponentially the last half century, to the extent that it has become worldwide. The causes are not clear, but the symptoms are. I want to suggest that this epidemic of depression has a good deal to do with the relentless processes of objectification that are inseparable from modern enlightenment. They climax in postmodernity, where they achieve complete dominance, becoming virtually totalitarian, that is, afford an ostensibly "total" objectification and thus control of subjectivity, selfhood, and culture, as well as of social production in general. Modernity was more concerned with the latter than the former, but in postmodernity we think we are completely enlightened about the former as well as the latter. We know how everything works – how everything is constructed – which is depressing. More particularly, subjectivity, selfhood, and culture react to the unempathic objectification and understanding of them by becoming depressing, that is, not working. Or rather working but finding the work meaningless and purposeless, for the self that does the work thinks little or nothing of itself.

The question that faces us is whether a new form of high art can rise to rescue us from our depression. Depression, as Otto Kernberg writes, can have "the quality of impotent rage, or of helplessness-hopelessness in connection with the breakdown of an idealized self concept," that is, a vision of a "higher self." At its most extreme, it can have a "disorganizing effect upon all ego functions," leading to "'depersonalization' and severe withdrawal from emotional relationships with reality."[3] Neo-avant-garde art reflects a depressed state of mind in its relative lack

of emotional expression and depersonalization, correlate with subliminal impotent rage and a denial of ideality; Warhol's strained "coolness" and ironic realism, reflecting a narrowing of the sense of ego – irony is invariably deidealizing and immobilizing, and as such an expression of helplessness and hopelessness – is the model.

The only alternative is "true art," as Bruno Bettelheim calls it. "In a strange dialectical process unique to it – just because it stands for the deepest personal statement made universal by disciplined effort – [high art] becomes one of the greatest forces binding people together without lessening what is uniquely personal to them. Art permits them to share with others what all consider something higher – something that lifts them out of everyday experience to a vision greater than themselves." "Art's unique role," he argues, is "that of guiding the individual to a personal vision of the world, and of his place in it... Art is always a vision, an attempt to express visibly – I am tempted to add: and tangibly – what a particular age, a particular society, a particular person has viewed as the true nature and essence of reality, the essence of both man and his relations to significant aspects of the world."[4] Such a vision affords a perspective on given existence, inviting one to change it. Thus art creates "a visual image of the hidden aspiration of man," so that "perhaps man will be able to shape reality in the image of his inner artistic vision." That is, art can catalyze human progress: "human progress was achieved when reality began to imitate art."

Avant-garde art offered a new vision of instinct, mind, purity (form as such), and reality (represented by the street). Neo-avant-garde art objectified that vision, in the process destroying its inwardness. The loss in inner necessity became a gain in social spectacle. What remains after social spectacle? What can move us beyond our fascination with and seduction by social spectacle? Unexpectedly, the liquidation of avant-garde art by neo-avant-garde art clears the way for another vision: ethical vision – for art that struggles with ethical issues. What is needed today are artists who are ethical visionaries – who have an inner artistic vision of man's ethical possibilities. Such a critical vision offers the prospect of progress in human ethics. It is sadly lacking, as is evident in every area of our depressing society. Indeed, ethical failure – widespread indifference to the difference between good and bad, in whatever area of human endeavor, and however difficult to determine – is partially responsible for the individual's depression, that is, her sense that her life makes no difference. Life is not worth taking seriously when there is no serious, public discussion of the difference between a good and bad life (and of the role of art and culture in both). Society no longer needs an artistic avant-garde, but an ethical and existential avant-garde, and unless artists join it, and show themselves to be the visionaries in its forefront, art will become more humanly irrelevant than it already is.

Failure of Identity?

ON BEING HALF AN ARTIST

Thus, the nature of the identity conflict often depends on the latent panic or, indeed, the intrinsic promise pervading a historical period. Some periods in history become identity vacua caused by three basic forms of human apprehension: *fears* aroused by new facts, such as discoveries and inventions (including weapons), which radically expand and change the whole word image; *anxieties* aroused by symbolic dangers vaguely perceived as a consequence of the decay of existing ideologies; and, in the wake of disintegrating faith, the *dread* of an existential abyss devoid of spiritual meaning.

Erik H. Erikson[1]

I have totally separated my political and social life from my moral and poetic one and in this way I feel at my best... Only in my innermost plans and purposes and endeavors do I remain mysteriously self-loyal and thus tie my social, political, moral and poetic life again together into a hidden knot.

Johann Wolfgang von Goethe[2]

S INCE IT HAS COME INTO ITS OWN, WITH ABSTRACT EXPRESSIONISM, THE PROBLEM of identity has haunted American art: nothing has changed in the last quarter of the century, except that the problem has become more urgent and exasperating. As the art in this exhibition suggests, there are too many artistic identities, each of them claiming to be authentic. It is as though we are faced with the twenty-two Jesus Christs of Ypsilanti, each of them claiming to be the real Jesus Christ.

Which work is more authentic: Barbara Kruger's *Untitled (We Will No Longer Be Seen and Not Heard)*, 1985, with its feminist ideology and self-righteousness, or Keith Haring's witty untitled graffiti work of 1983–84, with its horror vacui and perverse, nihilistic figurines – a work which, ironically, has the "spread-hide" appearance that Clement Greenberg attributed to the "American-type" abstract painting of Clyfford Still?[3] Both are graphic and populist, but altogether different in mood and method. Does Carl Andre's *Twenty-Ninth Copper Cardinal*, 1975, with its detached simplicity and pristine geometry – its pretentious purity and hermetic perfection – speak the artistic truth, or does Glenn Ligon's seemingly personal statement, *Untitled (I Am Not Tragically Colored)*, 1990, speak a more

important psychosocial truth? The former is all art – depends for its very sub-stance on a certain notion of artistic integrity; the latter uses art – the increasingly blurred, infinitely repeated text – to communicate a complicated consciousness of self, arising in response to the social reality of racism. Which are more to the artis-tic point: the repetitive squares of Andre's work or the repetitive words of Ligon's work? Or are both simply a subtly hollow, unwittingly self-mocking rhetoric – the "singular" terms of an artistic discourse nullified by their own repetition, their meaning neutralized and aborted by their redundancy?

As Theodor Adorno once said, works of art don't live in comfortable closeness, but compete with each other to the death, each asserting its difference at the expense of the other – each declaring its authenticity, and the other's inauthen-ticity. I recall quite vividly a major conceptual artist sweepingly dismissing all of eighties art as "boutique estheticism," while upholding his own politically correct art as the real thing. Who is to say his self-promotion is wrong? Partisanship and self-advertisement are necessarily rampant in the artworld, because values and standards are unclear. Can one really decisively come down on one side or the other of the many divides that unbalance the artworld?

There is no clear answer, no sword to cut the twisted Gordian knot of contem-porary American art – and that's just the point I want to make: taken as a whole – a no-doubt clumsy, unwieldy whole – it is the conflicts, indeed, irreconcilable dif-ferences, that are important, not this or that artistic position. It is the splits in atti-tude that count – between Kruger's dead seriousness and Haring's carnival humor, between Andre's formalistic grandeur and Ligon's ironical pathos – not the hierar-chical ranking of the artists in some imaginary history. Even differences in tech-nique reflect differences in attitude: the ironically rough-and-ready paint of Robert Colescott's *The Three Graces: Art, Sex and Death*, 1981 (Fig. 34), and the slick, glossy magazine look of the paint in David Salle's *Splinter Man*, 1982, speak very different emotional languages. The social sycophancy evident in Jeff Koons's commodity exhibitionism – he displays his *New Hoover Convertibles, Green, Blue; New Hoover Convertibles, Green Blue; Double-decker*, 1981–87, just the way they would be dis-played in a department store for the consumer – is at odds with the exhibitionism of Jack Pierson's *Will You Still Love Me Tomorrow?*, 1994, with its more intimate objects. His towels seem clean and new and unused, but they are implicitly conta-minated by personal use, as the worn case they are locked in suggests.

Catherine Opie's *Mike and Sky*, 1992, are altogether different people – have an altogether different attitude to the world – than Anna Mendieta, buried alive, as it were, in the untitled 1977 photograph that forms a part of her series *Fetish*, and Jimmie Durham, who stands exposed to the world in his 1986 *Self-Portrait*. The Cuban-born Mendieta and the Native-American Durham are victims and American outsiders, the lily pure white Mike and Sky are bullies and American insiders: within the abundant figuration of the exhibition there are startling dif-ferences in attitude, major contradictions, which reflect the contradictions in American life. The distance between the killers in Leon Golub's *White Squad I,*

1982 – they could be Mike and Sky in uniform – and the isolated figure in Susan Rothenberg's *Holding the Floor,* 1985, and in Charles Ray's *Puzzle Bottle,* 1995, seems enormous, yet they are both representative of American experience. On the one side, the painful reality of Chris Burden's *America's Darker Moments,* 1994, and the gun of Mel Chin's *HOMEySEW 9,* 1994, and on the other side, the bizarre decorative facades of Lari Pittman's *Untitled (A Decorated Chronology of Insistence and Resignation)* and Fred Tomaselli's *Octotillo Nocturne,* both 1993, their ironic glamor, subliminally lurid, hiding the suffering just under the surface of American life. Violence and isolation, grim reality and pleasurable illusions, are the substance of American society, along with compensatory consumerism.

Similarly, there are decisive differences within the abundant abstraction of the exhibition: the distance between the delicate, introspective grid of Agnes Martin's untitled 1977 work, with its subtle chiaroscuro, and the blatant colors and manufactured-looking geometry of Peter Halley's *The Acid Test,* 1991–92 – the whole work has a hi-tech designer's look – seems unbridgable, yet they are both characteristically American. The poetry of the former points to America's earlier inner-directedness – the piety and search for inner freedom that motivated the first American settlers (together with the wish for wealth) – while the latter acknowledges its contemporary outer-directedness, that is, an America in which spectacle has become substance. Halley shows us that even the esoteric substance of abstract art has become facile spectacle.

Does the grid in Ellen Gallagher's *Afro Mountain,* 1994, with its ironic inlay of African lips (making it oddly aggressive, if passively), displace the asocial, transcendent grid of Agnes Martin's work, making it seem outdated? For Gallagher, the grid is a springboard to a social meaning – an ironical foil to it – not a higher end in itself. Does the messy linearity of David Hammons's untitled 1992 sculpture – the flexible lines are like so many (African?) hairs – make the clean geometrical lines of Sol LeWitt's wall piece seem old-fashioned, a historical relic from a past, already remote epoch of art, that from Hammon's ideological perspective seems inconsequential because of its apolitical character? Do Gallagher and Hammons debunk – discredit – Martin and LeWitt? Does the social awareness and ideological symbolism one finds in much recent American postmodernist art make it more important than earlier American modernist art, with its more strictly esthetic, insular, transcendent concerns? Are Gallagher and Hammons expressing disillusionment with esthetic transcendence or do they find it both "impossible" and beside the point in the current social situation of America?

Has formalist, esoteric art seen its heyday – from a long-term perspective it seems like an elitist interlude in American art – and been replaced by a socially engaged art? Its "social realism" is more traditionally American, however much the new postmodernist art of social engagement incorporates seemingly unconventional – but they have become academic – abstract methods. It may appear unusual, but it is typically American in its social concern – its reference to a troubled society.

34. Robert Colescott, *The Three Graces: Art, Sex and Death,* 1981. Synthetic polymer on canvas. 84 × 71 ⁷/₈ inches (213.4 × 182.6 cm). Collection of Whitney Museum of American Art. Gift of Raymond J. Learsy. Photograph Copyright © 1999. Whitney Museum of American Art.

I am suggesting that there is a serious split in American art – a serious difference in opinion about what is artistically credible, and even about the purpose of art. I think the split has always been there, implicitly or explicitly: American art has been in a perpetual identity crisis from the start. If one follows out Erikson's psychologic, this means that it has always been more adolescent than adult – more

concerned with enactment than autonomy. It is no accident that Harold Rosenberg, in his famous essay, "The American Action Painters," describes the abstract expressionist canvas "as an arena in which to act ... what was to go on the canvas was not a picture but an event."[4] And it is no accident that the alternative to an act of raw action is, as he says, art in the service of a social cause or art "from the standpoint of The Community,"[5] which, as Rosenberg writes, is "an ideological substitute for [individual] experience," a collectively "Ready-Made" belief system or dogma "suitable for packaged distribution."[6] Action – blind externalization – is the adolescent way out of inner conflict; and ideological commitment – the uncritical (and unself-critical) commitment to fixed, unquestioned beliefs – is the adolescent idea of adulthood, indeed, the adolescent idea of taking a considered stand.

Adolescence involves "enactments midway between the play of children and the ritualized aspects of adult society,"[7] enactments which involve the expression and projection of "a newly mobilized and vastly augmented id" – this is what occurs in action painting – experienced as both "a hostile innerworld" and "an inner outerworld."[8] The enactments end – one might say stablize – in headlong, blind, unthinking engagement with an ideology, regarded as a panacea and ego identity – a panacea because it gives the adolescent a conflict-free ego identity. Instead of being enacted, id energy is projected into a readymade ideology, which – along with its representatives – seems radiant with charisma: instinctive intensity becomes intensity of belief and conviction, making ideology the ideal, consummate object of adolescent gratification. Id energy is subsumed in the ritual expression of ideological faith. The apparent transcendence of enactment through ideology is in effect reenactment under the auspices of ideology: id energy is channeled into ideologized purposiveness, bringing a gratifying sense of ego identity in its wake – almost as a kind of epiphenomenon or mirage. Ideology, then, becomes a way out of adolescence – an adolescent way of seeming to escape adolescent enactment, but really a transformation and socialization of it – and of entering pseudo-adulthood. What we see in American art is an oscillation between "sudden impatience," as Rosenberg calls it – "a gesture of liberation" and "grand crisis" in one, involving a "private myth" of "true identity" – and a "code to obey."[9] In other words, it oscillates between grand adolescent gestures, misread as critical nonconformity, and pseudo-adult conformity, misread as falseness to oneself.

Erikson describes ideology as "a *system of commanding ideas* held together ... more by totalistic logic and utopian conviction than by cognitive understanding or pragmatic experience."[10] Its values seem universal, and it is worn like a uniform: instant, simplistic collective identity becomes a substitute for the difficult achievement of individual identity and complexity. Even more subtly, adolescent enactment is misunderstood as individuation, which is what Rosenberg does. In any case, the distinction between the improvisational stylelessness of authentic American art and the uniformity and stylization of inauthentic, un-American art – but it also flourishes in America, as he acknowledges – is basic to Rosenberg's

thinking, as "The Parable of American Painting" makes clear. American Coonskiner art "springs from the tension of ... singular experiences," while in British Redcoat art ostensibly universal ideology controls artistic identity, thus obliterating individuality.[11] Indeed, the individual artist is sacrificed to a collective idea of art – to the belief that art exists to mirror collective ideals and concerns. Art is totalized, and becomes a ritual practice.

For Rosenberg, the ideal American artist works "on the borders of the act," "court[ing] the undefined ... keep[ing] his art and identity in flux."[12] He is not "governed ... by rule," but weaves a "web of energies ... between his painting and his living [which] precludes the formation of any terminal idea."[13] The American "actor-artist," as Rosenberg calls him, regards any terminal idea as ideological, which is why the definite identity it brings seems like the kiss of death, a sign of personal and artistic failure, a fatal loss of energy. The hyperactive adolescent artist cannot imagine that a definite identity might not be ideological and entropic, but the result of a decisive commitment to a perspective or position, based on cognitive understanding or pragmatic experience, to recall Erikson's words. This, of course, goes against the grain of adolescent enactment. To enact – to put one's energy before one's mind – is adolescent, while to take a stand, after critical thought and calm reflection, is adult. But then the adolescent inevitably confuses ideological belief – unconditional commitment to a comprehensive system of thought that claims to be able to solve all problems – with critical and self-critical thought. Rosenberg once wrote that identity was the issue of modern art, but in modern and postmodern American art identity has become immature and problematic – permanently split and adolescent.

If we look at the artists in this exhibition, we see that they seek their identity on one side or the other of the great divide: some, like Mike Kelley, Sue Williams, and Jean-Michel Basquiat, are heavily into adolescent enactment, which, however ironical, still makes a regressive point, while others, like Nicole Eisenman and Martha Rosler, turn their enactments into ideological statements, ostensibly critical but in fact predetermined in their damnation of existing society. Unlike Goethe, none of the artists in the exhibition successfully integrates, on the innermost level, their social, political, and moral concerns with their poetic, esthetic, and formal concerns. This is not to say they don't try – Gallagher's ironically understated application of socially symbolic lips to a poetic surface and Golub's appropriation of the red color field of Barnett Newman's *Vir Heroicus Sublimis*, 1951, as an esthetic background for his politically charged scene are two examples – but they do so in a superficial, token way. Gallagher's lips are moralistic ornament, Golub's red background, meant to underscore the ironic heroism of his macho figures, is quasi-esthetic ornament. Their pictures offer the facade rather than substance of formal subtlety: what was poetic in Newman and Martin – the color field and grid, respectively – has become pseudopoetic, almost farcical, in the politically correct art of Golub and Gallagher. In both cases we see a facile dialectic: the nominal assimilation of a rejected pole – the disdained opposite –

that does nothing to heal the split. Thus, we are left with the appearance rather than the reality of a whole art. Both remain partial artistic identities – each has only half of what would make for a complete artistic identity – for all their efforts to be artistically whole. Not only is the attempt to integrate the sociopolitical and formal – to make an art that is at once poetic and moral – unconvincing when it occurs in this exhibition of American art, but it seems to compromise rather than illuminate the partial artistic identity there is.

Why, then, are these American artists only partial artistic identities – why are they artistically unbalanced? Why are they, artistically speaking, adolescents: why do they offer an adolescent esthetics and an adolescent view of the world? Why is there so much fun and games, so much easy irony, whether formally, as in Elizabeth Murray's *Children Meeting*, 1978, or conceptually, as in Shigeko Kubota's *Meta-Marcel: Window*, 1976, and Sherrie Levine's *"La Fortune" (After Man Ray: 4)*, 1990? Why is there so much labored playfulness – the ironical presentation of art as children's play, as in Dennis Oppenheim's *Lecture No. 1*, 1976–83, Nicholas Africano's *Sprained Ankle*, 1977, and Christian Schumann's *Hoot (Crit)*, 1995 – when, subliminally, the artists clearly find nothing to laugh about?

I think the answer has to do with American society: it is impossible to have an art that envisions unity – that is at once esthetically sublime and socially telling, artistically and experientially adequate – in a society wracked by fears, anxieties, and most of all by existential dread of emptiness. It is impossible to make an art that is spiritually adequate in a society that is spiritually inadequate. The adolescent youth culture that dominates American society and the youth culture of modern art – already in 1925 José Ortega y Gasset observed that "all modern art begins to be comprehensible ... when it is interpreted as an attempt to instill youthfulness into an ancient world"[14] – converge in contemporary American art. To be young is to be both quintessentially American and quintessentially modern, which is why America, with its perennial pursuit of youth, is thought of as the ultramodern society, and why American art struggles to always be new, that is, young and modern, which means to never build or build on a tradition. My thesis is that this doubly young art – this art desperate to be as eternally young as America and modern art are supposed to be – is at once a symptom of the fears and anxieties that unavoidably pervade American society (and of the spiritual void that underlies them), and a defense against them.

America, as Erikson wrote, "subjects its inhabitants to more extreme contrasts and abrupt changes during a lifetime or a generation than is normally the case with other great nations."[15] It is a country of "contradictory slogans" – "outgoing internationalism and defiant isolationism; boisterous competition and self-effacing co-operation," for example – that bewilder the individual, and never allow him more than a tentative, incomplete, and thus invariably insecure identity. "As the heir of a history of extreme contrasts and abrupt changes," the American is always in some kind of identity crisis: he struggles to integrate "dynamic polarities," but he can only combine them tentatively.[16] One or the other pole tends to

dominate, and the American often vacillates indecisively between them. Thus the American's identity always seems contingent and in-the-making, never essential and definite. It is always in anxious flux and forced to face new fears, which make it spiritually unsustainable.

Behind the American celebration of pluralism and multiculturalism – it is apparent in the art of this exhibition – lurks uncertainty about what is the correct identity to have. America's motto is "one out of many," but it is unclear which one. In such a situation, one feels young – there is always a new opportunity for a new identity (it is no accident that the concept of the protean self developed in America) – and hopeless at once. One is always threatened as well as lured by possibility; one doesn't know what to believe in, or else one defiantly clings to one's beliefs. This is the adolescent way of identifying oneself. One either insists on one's absolute identity, or one has no identity.

America, then, is a hard place to grow up in – a difficult place to be an adult in. One may become older, but not necessarily wiser. The flux of identity that Rosenberg celebrated as a sign of authenticity in art is the flux – indecisiveness – of identity that exists in American society. Whether the artists in this exhibition identify themselves through their formal or social concerns, their identity is unconsciously informed by the concern they never adequately developed, which often exists in vestigial, marginal form in their art. Social concern, for example, exists in atrophied form in the public wall on which LeWitt's displays his drawing, and formal concern is residual in the coloration of Komar and Melamid's *A Suite in Chrome Yellow. A Suicide in Bayonne,* 1993. The artists know that, whatever identity they have created for themselves, they have somehow failed to find the proper identity, because they are surrounded by alien identities, which are abortively incorporated because they seem to have the really right stuff. In America, the identity one does not have always seems younger and fresher and more vital and ideal than the identity one has. In America, change has been reified, which is why it seems easy to change one's identity; all it requires is artistic magic.

Of the Immature, By the Immature, For the Immature

KEITH HARING AND CINDY SHERMAN

HERE WE ARE IN A COUNTRY IN WHICH MORE AND MORE PEOPLE ARE LIVING longer and longer, and here we are with an art still oriented to youth – dubiously golden, far-from-innocent youth, as the images of Keith Haring and Cindy Sherman suggest. Have we come to the point where art exists only for the young and is made only by the young – or rather, the immature? Is this perhaps why it's so dissatisfying to everyone else, except market speculators, fetishists, and professional art historians and critics? The counterculture once declared that no one over thirty was worth the trouble, which is perhaps why Jean-Michel Basquiat overdosed at twenty-seven. I am suggesting that the proper perspective from which to examine the work of Haring and Sherman is that of their subject matter – the immature human being, who, moreover, is determined to remain immature.

In the case of Sherman's "Untitled Film Stills," 1977–81 – the series that established her reputation – immaturity exists in the form of a young woman, on the verge of adulthood but still adolescent in her attitude, trying out various roles in search of an identity she does not believe in, that is, a womanhood she is skeptical of even as she playacts it. Sherman seems to be exploring a labyrinth of exciting female identities, but all are stale, predetermined, and somewhat tarnished clichés, as indicated by the fact that they are the products of Hollywood convention and artifice (Fig. 35). All clearly have the aura of make believe, suggesting that none are convincing, however "representative." One pose is as good as another, one role as pretentious as another, which is why all are interchangeable, suggesting that Sherman's young woman is unable to establish or decide on an identity, however hard she tries. And I don't think she tries very hard; she likes the promiscuity of possibilities, none of which can really be actualized. After all, they're all excerpts from a film – so many manufactured fantasies.

Sherman's film stills are usually understood as a feminist critique and caricature of socially prescribed female roles, but I want to suggest that they are a compulsively repetitious sequence of adolescent enactments desperately attempting to keep adulthood at bay – to forestall growing up. They show a directionless young woman militantly determined to remain "loose," as though that was freedom

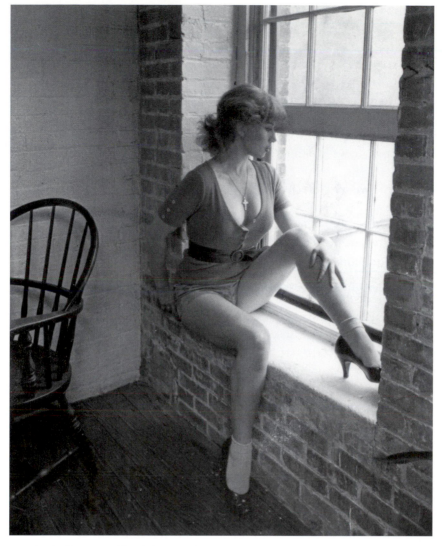

35. Cindy Sherman, *Untitled Film Still #15,* 1978. Gelatin silver print. 9 $^1/_2$ × 7 $^1/_2$ inches. Courtesy the artist and Metro Pictures.

rather than inadequacy. She daydreams her way through life as though that would keep her from awakening to the reality of her particularity. There are no hard choices in Sherman, because to make a hard choice would be to forgo fantasy and self-deception, become real, and grow up – grow old. Sherman's female is as unreal, impersonal, and unchanging as any paper doll or mannequin – any female blank slate – wearing various outfits in a game of femininity, each familiar outfit a "strategy" of female identity confirming the nothingness of woman as such. Moreover, this seemingly infinite variety of female identities are all conformist, and however much Sherman may disdain and mock them she inhabits them comfortably, because she has no alternative to them. It is no accident that

Madonna – another fake female who toys with conventional female roles, that is, another case of arrested development in the youth culture – sponsored Sherman's exhibition at the Museum of Modern Art.

Individuality has no meaning for her, not only because it is a media joke, but because to accept it would mean to accept her own limitations – which would mean she would have to give up the omnipotence that allows her to pretend she is everywoman. The immature cling to the belief in their omnipotence – the omnipotence that allows one to believe one is able to become anything one wants to become – and Sherman clings to it with a vengeance, which is to refuse to mature, that is, accept the fact that one is this limited historical person rather than any other. I think that Sherman has a horror vacui, that is, a horror at the emptiness of not having any secure sense of self, which is why she heaps false identity upon false identity, as though that might afford a sense of fullness of being and truth to oneself. She thus hopes to achieve through a facile process of pseudo-individuation what can only be achieved through difficult, uncertain experience. Sherman's "model" woman is what the psychoanalyst Helene Deutsch called an "as if" personality, a chameleon masking her feelings of empti-ness and meaninglessness by constantly changing her appearance – the typically superficial metamorphosis of the immature. Indeed, they are quick-change artists, masking their inability to change essentially by numerous changes in appear-ances. They attain complete control of their appearances – a kind of omnipotence – to compensate for their lack of any real self. Nonetheless, however pseudo-exis-tential, Sherman's images bespeak the existential crisis of the frightened adoles-cent: her recognition that she can only come into her own by facing the reality of the world rather than playing with herself in front of an "artistic" mirror, yet her realization that all she knows are narcissistic games.

In our society age may not mean wisdom but it does confer the distinction of survival against all odds, but in Haring's art there is neither age nor wisdom nor survival, only colorful, cavorting infantile figures, stripped of all distinguishing signs, including those of gender. They are ageless figurines full of energy, existing for its own utopian sake (Fig. 36). Haring also has a horror vacui, as though by fill-ing his canvases with his blank figures – compulsively repeated ad nauseum, in a tumbling chaos – he will confer on them an individuality they can never have. Ironically, their blankness – they are all labile contour, with simple surface divi-sions into colored planes – confirms their emptiness. That in fact is the immature point of his cartoon – immature – art: to establish a paradise of plenty in which no one grows old – and, God forbid, die – because no one can grow, period. It is an Arcadia of the eternally immature, with a few toy demons thrown in for good measure. The Whitney exhibition shows a drawing and journal description of what Haring (a homosexual) regarded as the most beautiful penis he had ever seen, and notes his preoccupation with armpits. But the point is that they are what the psychoanalysts call part objects, suggesting his inability to conceive of whole, substantial persons – confirmed by the undifferentiated, rather simple,

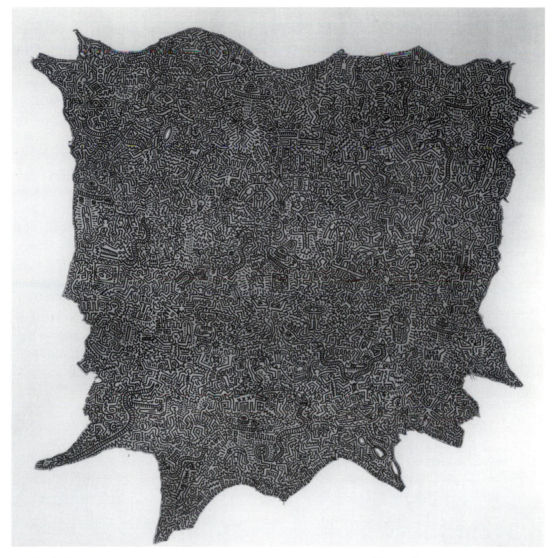

36. Keith Haring, *Untitled,* 1983–84. Felt-tip pen on leather. Irregular: 87 $^1/_2$ × 85 $^5/_8$ inches (222.3 × 217.5 cm). Collection of Whitney Museum of American Art. Purchased with funds from the Drawing Committee. Photograph © 1999, Whitney Museum of American Art. Photograph by Geoffrey Clements.

flimsy abstractions his flat figures are – which indicates a certain emotional immaturity. As does his unenlightened fascination with the body at the expense of self-aware identity.

In 1925, in his essay on "The Dehumanization of Art," José Ortega y Gasset remarked that "all modern art begins to be comprehensible ... when it is interpreted as an attempt to instill youthfulness into an ancient world." I think youthfulness has outlived its value, all the more so because it has become self-stereotyping and self-glamorizing, which is what I think occurs in Sherman's and Haring's

work. We saw youthfulness in operation in the Cultural Revolution of Mao's Red Guards, to name only one of many glaring sociopolitical examples. Its destructiveness motivates all the attempts at new beginnings, fresh starts, wiping the slate clean, returning to fundamentals, and so on, that have caused so much havoc in the twentieth century. We see the destructiveness of youth in operation in the artist who goes around vomiting on modern masterpieces by Malevich and Mondrian – ironically, themselves avant-garde artists who attempted to destroy tradition and wipe the slate clean by getting down to "fundamentals." What would the avant-garde be without the destructiveness that it thinks makes it young – the destructiveness that, these days, brings with it pseudo-freshness and pseudo-spontaneity rather than real vitality? We see the dregs of the youth revolution in art – the revolution called avant-garde art – in the art of Sherman and Haring, which suggests that, after all, youth has become more decadent and "ancient" and tired than the society it damns and mocks. In fact, modern society, with its dynamic technology and innovative capitalism, is hardly as "ancient" as Ortega thought it was. Thus, what we see in Sherman's interminable crisis of female identity and Haring's rabid infantilism is the pathology of self-infatuated, subtly self-defeating youth – callow youth trapped by its inability to grow, and trying to convince itself that to remain young is to have the best of life, when in fact it is to be blind to it, not to say stupid about it. Ripeness is all, not youthfulness.

Heroic Isolation or Delusion of Grandeur?

CHUCK CLOSE'S PORTRAITS OF ARTISTS

In contrast to the meagerness of art, the artist is blown up to gigantic proportions.

Harold Rosenberg, "On the De-definition of Art"

CHUCK CLOSE'S *BIG SELF-PORTRAIT*, 1967–68 (107 $^1/_2$ × 83 $^1/_2$″) (FIG. 37), AND equally big *Self-Portrait*, 1997, are a long way from Rembrandt's 1650 and 1661(?) *Self-Portraits*. The former reveals the Old Master's "double disposition to romanticism and to psychological penetration."[1] The latter, probably made in the year of his beloved Hendrickje's death, exposes Rembrandt's "precarious emotional balance." Close's portraits are an even longer way from Albrecht Dürer's 1498 "portrait of himself in the guise of a *gentilhuomo*," and 1500 "portrait of himself in the guise of Christ."[2] In the former Dürer presents himself as a "homo liberalis atque humanus," and in the latter he mystically identifies with – "imitates" – Christ. Close's arrogant self-assurance and inhumane hauteur are altogether alien in spirit to the "uneasiness" and sense of "inner crisis" evident in Rembrandt's self-portraits, which "relates his own experience [of loss] to the universal insecurity of human existence," and even more alien to the noble humanism and Christian compassion of Dürer's self-portraits.

There is little sense of "inner suffering" in Close's self-portraits – little sense of sharing and communicating the common lot of humanity, and virtually no sense of belonging to the human community and being subject to the vicissitudes of life[3] – and certainly nothing Christlike. The question is, why is this so – why has the artist's sense of himself changed so radically? It is the answer to this question that makes Close's self-portraits, and his equally grandiose portraits of his artist friends, interesting, rather than their esthetics, which is a tired, if also true and tried, modernism. Close's style, from its routine dependence on the photographic close-up (with its air of intimacy) and the impersonal grid (with its distancing effect) to the belabored, ostentatious coloristic and gestural detail of the later portraits (their flamboyance also reveals itself as coldly mechanical when examined up close), amounts to a decadent, petrified, anticlimactic, facile summary of institutionalized modernist methods.

What we have in Close's portraits is a bombastic elevation of the artist above the human condition – a glorification of the artist carried out by means of a monstrous enlargement, indeed, grotesque monumentalization, of his appearance. This is supposed to intimidate the viewer into submissive belief and acquiescence in what is in effect a big lie: it is a quantitative inflation – mystification by way of magnification and overstatement – that is supposed to pass for qualitative proof of the artist's superior existence. The spectator is supposed to look up in awe at the artist looking down at him in contempt. I submit that Close's crude deification of the artist as a one-dimensional megalomaniac – the emotional reality behind the artist's vision of himself as a divine genius – is a last desperate fetishization and justification of the avant-garde artist, whose cult, if not entirely defunct, continues to exist by reason of economic necessity. Society is complicit in Close's hyperbole and self-adulation: it has to believe that the artist is inherently bigger than the nonartist – larger than life, more extraordinary than everyone else – if it is to pay unrealistically big prices for his art. And one has to think that megalomania is the source of artistic creativity when one no longer quite knows its human point. When art seems to be nothing but a speculative gamble on novelty, one has to believe that the gambler is a god who secretly knows what he is doing.

The lack of introspection – the inward look, so evident in Dürer's and Rembrandt's self-portraits (which do not so much privilege the artist's self as search for insight into the all-too-human self) – of Close's artists is striking. They defend their emotional shortcomings – I venture to say their failure as human beings – with their aggressive megalomania. Indeed, the characteristic emotional tone of the portraits is that of in-your-face – confrontational – "pugnaciousness." As the exhibition catalogue notes, the "pugnacious visage" of Richard Serra appears in one of Close's earliest portraits. It in effect sets the emotional tone for all the portraits.

Pugnaciousness – pointless belligerence – is nothing to be proud of; it is human stupidity at its worst. It supposedly suggests the artist's toughmindedness – or at least physical toughness and staying power – but belligerence, with its threat of violence, is all too commonplace in our society, suggesting that after all the artist is as uncivilized and crude – emotionally primitive – as everyone else. Pugnaciousness is a serious character flaw, however much it may be idolized in the movies – Serra is after all just another Schwarzenegger or Stallone – as a sign of strength and virtue. Serra, of course, is notorious for the intimidating – all but overwhelming – macho character of his sculpture, which seems to get larger with each new work, as though to distract from its limited, "minimalist," redundant character, that is, Serra's rather limited power of innovation – the poverty of his creativity. Something similar occurs in Close's works; they belong to the same generation of anti-expressionistic artists (Serra and Close were in fact classmates in Yale's graduate art program) who hide their emotional vacuousness behind a facade of grandeur – a pretentious largeness (which always seems glamorous in our bigger-is-better society). (Both tried to become "expressive" late in their

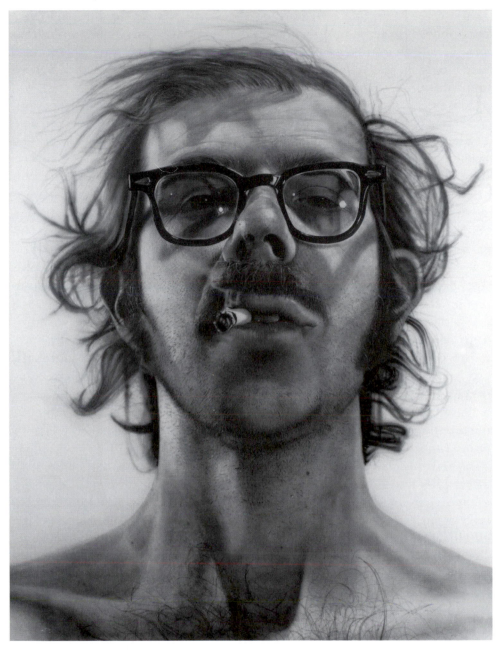

37. Chuck Close, *Big Self-Portrait,* 1968. Acrylic on canvas. 107 $^1/_2$ × 83 $^1/_2$ × 2 inches. Collection Walker Art Center, Minneapolis. Art Center Acquisition Fund, 1969.

careers; Close's turn to colorful gesture and Serra's turn to the sweeping curve were supposed to accomplish that. But the expressivity that resulted was unconvincing, for their works remained fundamentally simplistic and static. Underneath their ostensible drama – the pseudo-Sturm-und-Drang – they remained naively minimalist.)

Close's works are important documentation of the mentality of the late avant-garde artist in more ways than one. They strongly suggest that he has to be a hero to himself because he feels isolated and alienated, however economically and socially successful he may be. I want to suggest that this is not just because he has to defend his creativity at all costs, but because he subliminally realizes that his art lacks humanity. Close's artists have sacrificed their humanity to their art: where the dehumanization of art occurs, as Ortega y Gasset called it, the inhumanity of the artist is not far behind, if not already implicit. Ironically, the disintegration of the artist's appearance that occurs in many of Close's late portraits – its final dehumanization, under the cover of a technical tour de force – acknowledges his inhumanity. It is as though the artist's pugnaciousness backfired, annihilating him rather than his public. Alienated belligerence is no doubt the prevailing mood in modern society, but the late avant-garde artist seems to reify it in his person, as though to suggest its immutability. For Close the dehumanization of art and the inhumanity of the artist are one and the same, as his robotic faces – his late portraits in particular have the constructed look of impassive machines, oiled by technique into the semblance of organic animation – indicate. In Close's portraits artists are nothing but artists, while Dürer and Rembrandt are human beings before – and after – they are artists. For them, making art was not a raison d'être, but a means of exploring the reason for being.

The desperate machismo of Close's late avant-garde artist is a testimony to the futility and deadend of being an artist today, especially because the artist has become a rebel without a human cause. Indeed, his rebellion and belligerence have become another social posture and cliché of "radical chic." Nonetheless, the fashionable inhumanity of Close's portraits bespeaks the inhumanity of our age, which make them emotionally telling despite their spectacular character. They are publicity posters for famous artists – artists who make spectacles of themselves as a way of becoming famous – legitimating advertisements for their rather inflated sense of themselves. But their publicity character, and the deluded narcissism of the artists, are symptomatic of the indifference – a strange compound of empathic failure and naive absorption in spectacular appearances, which correlates with and is partly responsible for that failure – that makes our society as subliminally monstrous as they are.

Nan Goldin

PICTURES OF PATHOLOGY

The exhibitionist knows he was humiliated, knows it was traumatic, knows it was a repetition, knows he is vulnerable to that humiliation, knows that in the humiliating attack on him are statements about himself he has always known, knows he wants revenge, knows he must pick strangers, knows the social rumpus is important. His aesthetic task is to keep knowing what he knows and yet to not know. (Freud called this "splitting.") So then we get mysteries and secrets and illusions and scripts. We get details that are thrown in not by chance but because they speak. And we get risks that are pseudorisks. The actor knows that.

We really do know that perversion is theater. If there were no mystery, secrets, and illusions, there would be – God forbid – insight. For perversion, insight is the death of excitement. It would require one to come to terms with the trauma and develop the ability to enjoy intimacy with someone else rather than deny it with a manic outburst, the perversion.

<div align="right">Robert Stoller, "Perversion and the Desire to Harm"[1]</div>

It is the lack of self-esteem of the unmirrored self, the uncertainty about the very existence of the self, the dreadful feeling of the fragmentation of the self that the addict tries to counteract by his addictive behavior.

<div align="right">Heinz Kohut, *The Restoration of the Self*[2]</div>

AGAIN AND AGAIN, NAN GOLDIN PHOTOGRAPHS THE SAME PERSON, WEARING whatever body and gender: a victim, whether of AIDS, drugs, violence, the opposite sex (however unwittingly, the latter include Goldin's transvestites[3]). Some are visibly pathetic, others defiantly upbeat. All are unapologetic: there's an in-your-face aggressiveness to their appearance, however miserable or vulnerable. No doubt they blame their plight on society – no doubt Marxists will read them as symptoms of social pathology – but, in emotional fact, they are victims of themselves: the "purposeful bleakness" of the Lower East Side[4] where they lived their alternative, ostensibly countercultural lifestyle in the late 1970s – so they rationalized it, self-deceptively – objectified their own bleak outlook and lack of purpose, their premature weariness and decadence.

Luc Sante, an intimate of Goldin, who was a participant observer in their world – it modeled the world as such for her, and she has been searching for similar

deadend worlds ever since – describes the lifestyle: "The pace of life alternated between headlong urgency and seemingly infinite stretches of mental wallpaper. One took drugs for fun, or maybe to stop up grief or despair, but most often to build a personality that could be taken out into the night."[5] It was at night that one really came alive, compulsively going from party to party – club to club – to escape the loneliness and longing and emptiness of the day in between. The social rumpus of the parties temporarily alleviated the loneliness, but one could not escape the emptiness, nor satisfy the longing, which became more and more urgent and vague and excruciating, and used anybody – any flesh or stranger – to try to satisfy itself. But the satisfaction was never more than skindeep, and the relationship never endured.

The unconscious point was to obscure one's real need: one's longing for a self one didn't have, and that it was too late to have – already, in one's teens, much too late in life. The frustrated need to secure a sense of self masqueraded as a wish for excitement: hid from itself in the compensatory excitement of partying and taking drugs. One was addicted to both, each was supposed to synergistically enhance the other, but when one came down from the forced, addictive high, one realized one was left with nothing but one's soiled youth, and one's fear of growing up and old – one's transience and immaturity. The synergy was an illusion: one had oscillated between Sisyphean frustrations to avoid facing up to the emotional truth, but in the end it caught up with one, telling one that all the drugs and partying could not put one's Humpty Dumpty self back together again. A public "personality" was no substitute for a private self. One was left with the recognition that one had no purpose in life, not the least reason for truly being, which is why one could not bear being alone with what little sense of self one had. One's life was, peculiarly, over before it began: compulsory partying and drugs were a substitute life – a makebelieve way of feeling alive and real – the one creating the illusion of intimacy, the other of intense selfhood. Each exaggerated what was not there, leaving one with a feeling of purposeless bleakness – face to face with the underlying emptiness – after their effect had worn off.

Thus there was a kind of guilelessness – a quasi-innocence – to the fatalistic antisociality of Goldin's partygoers and drug takers, which her apparently artless – anti-art? – photographs emulated. It was not a matter of choice but the result of uncertainty and ultimately lack of self. In other words, their delinquency was an expression of annihilation anxiety. They were completely deficient in selfhood, not simply defective selves. Their feeling of being nothing and no one in particular was so intense it undermined and devalued the small sense of self afforded by partying and taking drugs: so intense it denied the very value of selfhood – saw no point in even trying to be a self. Thus, their annihilation anxiety left them adrift in the lonely, stupefied crowd. Their self-deprecation could not help but lead to self-destruction, as though at last to confirm their lack of self, and also ridicule the very idea of selfhood – the absurdity of any sense of self, however insignificant and unstable, thus, ultimately, the impossibility of truly being

a self. They were neither true nor false to themselves, because they had no self to be true or false to.

Luc de Sante: "We were all on the train to death, as we simultaneously knew and didn't want to know. Already people were dropping, of ODs and suicide and choking on their vomit, and then AIDS began taking out the very ones who seemed most alive to the moment."[6] These people seem tragic, but they were far from being tragic heroes in the traditional sense, or for that matter anti-heroes – rebels and revolutionaries – in the modern sense: they were simply acting out their annihilation anxiety – the humiliating pathology of being "selfless." They seem to carry Rimbaud's "disordering of the senses" to its logical, fatal, entropic conclusion – they made explicit the disillusionment and dementia implicit in its idealization of sense experience – but they left nothing of artistic value behind them, as he did. Except for Goldin's photographs. In a sense, these are the quasi-visionary, anti-climactic result of their self-destructiveness – as much of a vision-ary result as Goldin's naive empiricism allows. In fact, her photographs, like the people she photographs, show the naivete and bankruptcy of Rimbaud's visionary idealism. They did not become seers, nor did Rimbaud – his art may be visionary, but he did not live wisely, as an authentic seer tries to do (life is more important than art for him or her) – but rather disclose, in the least detail of their bodies and living quarters, the chaotic consequences of – the irreversible disorganization, internal and external, that results from – living for the moment. One never learns from experience by doing so – accumulates no wisdom – and neither Rimbaud or Goldin's people had the wisdom to learn from experience, to gain a perspective on their own lives and life as such, which would have saved them from suicide and living death.

Goldin was and remains one of these people – she too took drugs and was a par-tygoer – but she had an advantage over them: her camera. It helped her sidestep the death they had all chosen, consciously and unconsciously. Like a blind person feeling her way with a cane, she used the camera to "see" the world she inhabited while maintaining a certain mental distance from it. She, too, was a somnambu-list, but not as deeply asleep and self-destructive as the others: her camera kept her from being blind to herself, and represented her wakefulness. It gave her a reality principle in the midst of all the desperate, self-destructive pleasure-seeking around her. Seeing others through its lens gave her the sense of self they lacked – the self-consciousness and ego strength to fight her own morbid tendencies. It was a shield defending her from those she portrayed. But for the grace of the cam-era, she would have shared their fate – succumbed to their dementia. The camera was between her and others, and as long as it was she was safe. She used it to avoid their fate, used it as a crutch of consciousness, as it were – a means of gaining con-sciousness of her condition, an instrument of self-understanding, however incomplete. Her addiction to photography – a quasi-art – saved her from their fate. (Perhaps Rimbaud, who managed to kick the habit of art – poetry in his case – but could not kick the drug habit, would have been saved from his drug addic-

tion and its devastating consequences by continuing his addiction to art, the latter substituting for the former, as I think became the case with Goldin.)

But the issue is not only what Goldin's camera did for her self-esteem, but what it did for that of the people she photographed (Fig. 38). Was it really as friendly as she thought – an implicit "caress," as she claimed – or did it, however indirectly, encourage their self-destructiveness? The answer is hidden in Goldin's wish to mirror them with her camera – a seemingly neutral, noncommittal, "scientific," documentary attitude, but in fact one fraught with indifference. Goldin is in fact consciously emulating Warhol (who unconsciously emulated Duchamp, who treated people like things, the ultimate crime against humanity, for it gives one absolute power over them[7]: "I'll be your mirror" was the motto, as it were, of Warhol and the Velvet Underground. But mirroring, as Kohut suggests, can be a form of attunement and empathy – a way of satisfying a primitive narcissistic need we all have.[8] Is Goldin's camera the concerned, empathic, insightful, would-be therapeutic mirror she believes it is, or is it in cold complicity with the self-destructive tendencies of her friends, luring these tendencies out the way Warhol's sinister, blind camera-mirror did? Does her camera undo the traumatic humiliation of her friends, or does it in some sense exploit it? I think more the latter than the former, or the latter as much as the former. That is, Goldin was, however unconsciously, highly ambivalent about the company she was keeping.

She loved her friends – she thought of the people she photographed as extended family – but also found them frustrating and disturbing, and, as the famous self-portrait of her battered face indicated (wearing her make-up, that is, cosmetically adorned and crowned, as it were), some of them gave her as much pain, emotional and physical, as pleasure. I think this self-portrait is a perfect symbol of Goldin's ambivalence, and the problems – artistic as well as human – it caused her: on the one hand she is posing, just like all the people she photographs – more particularly, pretending to be a movie star[9] – but on the other hand she is revealing "real life" suffering. There is a profound confusion here: it is as though one could escape one's pathology by acting it out for the camera, but the camera only confirms its inescapability – shows how completely marked by it one is.

Goldin's camera brings out the exhibitionist in everyone, including herself. And in doing so it reveals the reason why the people she photographs, including herself, have no real sense of self: the celebrity is their model of selfhood. The wish to be a celebrity is the real pathology of modern and especially postmodern life, for the charisma of celebrity is a creation – projection – of other, uncelebrated people's unfulfilled longing to be a self. Celebrity is thus inauthentic, false selfhood: the mirror image of other people's profoundly frustrated wish to have a self. Moreover, it is a self that can never disintegrate – that is too famous and thus seemingly ideal, even perfect to disintegrate – for it is enshrined and immortalized in the movies, indicating that it is unconditionally loved and treasured by society. The celebrity has no real self – has not earned his or her fame the hard way, by achieving a purposeful existence that is of value to society – but rather is an iron-

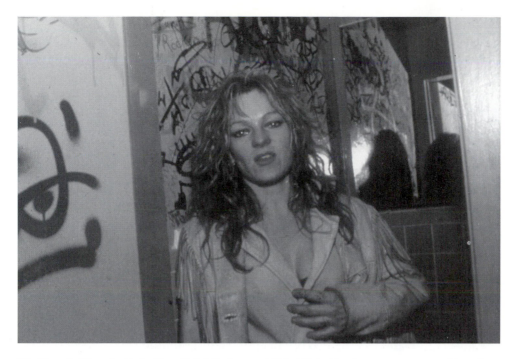

38. Nan Goldin, *Cookie in Hawaii 5-0 Bathroom, NYC,* 1986. Cibachrome print, 16 × 20 inches. Courtesy of the artist.

ical reflection of other people's lack of self. This is why the celebrity is more cele-brated than anyone who has made a genuine contribution to society: the celebrity embodies its frustrations, which are always profounder and more enduring than its triumphs. I think Goldin shows her wish to be a celebrity, and the fact that she is, to an extent, a kind of poseur, like everyone she photographs – follows a script laid down by popular culture – by the fact that she puts on make-up before she photographs her battered face. This make-up functions as a seductive veil, at once dissembling and revealing: one glimpses Goldin's bruises through it, but they seem as much illusion as reality – a particularly dramatic part of her make-up, indeed, a way of dramatizing herself, giving herself added presence. She is just another actor playing a role – even when she is playing the biggest role of all, her own unhappy life.

The theatrical dimension of Goldin's photography becomes explicit in *The Ballad of Sexual Dependency,* which is more about infantile dependency than adult sexuality. Stringing together many of her photographs and projecting them in the form of slides, she creates a peculiarly arch simulation of an old-fashioned movie (the slides are not seamlessly synchronized), complete with popular background music. Thus she turns human suffering into a spectacle, ambiguously avant-garde and Hollywood, that is, a typical postmodern panoramic synthesis of kitsch and avant-garde "visions," suggesting the decadence of both.[10] Paradoxically, this undermines, or at least compromises, her major "technical" achievement: indi-

vidually, each photograph seems to reinstate the old-fashioned idea of the camera as an honest, truthful, clinical record of reality – knowledge of something that is unmistakably the case, even when it is posed.[11] Nonetheless, in incorporating her friends in a sensational, ingratiating, covertly sentimental narrative (not to say sideshow) – manipulating them like puppets rather than presenting them in a straightforward way, as though they were autonomous, which is what the individual photographs do – she shows that she is indeed an artist, for they are completely reduced to illusions. They are no longer simply case histories, but part of culture, for the movie is a standard form of culture. That is, she becomes a director, not simply purveyor of information. In actively shaping the subliminally tedious, openly disastrous lives of her friends into a lively, fast-paced narrative, she acts as though she was in control of events rather than their passive, helpless recorder, unable to change the reality of what she records. Indeed, she implies, omnipotently, that she could reverse the course of events, prevent catastrophe, just as a movie can be reversed from end to beginning. If the camera gives its user the illusion of omnipotence, a pseudo-*sub specie aeternitatis* view of the world, as well as the illusion of immunity to existence that comes with it, then the movie compounds that double illusion by seeming to recreate the world according to one's deepest wishes. Thus, lifted out of context and exploited for dramatic effect, Goldin's human information forfeits its objectivity and becomes subjectively resonant, which is the achievement of all art.

The question in her case is how authentically subjective the human information really is: does she or does she not tell us the emotional truth about her friends? But their subjectivity was formed by the movies, which is why they never understood the emotional truth about their lives, indeed, why they emotionally betrayed themselves. And why they had no individuality, but were simply true to type. Borrowing their sense of self from a banal cultural representation of self, they became merely representative. This is the real pathos of their lives: that they lived it in movie terms. They lived to be seen by the camera – to make an appearance, to be photogenic (cosmetically desirable) – which is why, in the end, they turned themselves inside out, as though that could really hold the camera's attention, really make them exciting and different. But it only showed how little they had on the inside. Lacking introspection, they became completely external – the ultimate emptiness. Why should we expect Goldin to understand this any more than they did, since her life and art – half documentary, half mythmaking, like every camera creation implicitly is – were also formed by the fantasies of the movies? They were all, after all, the victims – slaves – of a collective fantasy of the liberated, uninhibited life – the truly lived life – that, unfortunately, had personal, real consequences. Living a lie – lying to themselves – they never really lived, as their early deaths confirm. Romanticizing and popularizing pathology like the movies, Goldin's *Ballad of Sexual Dependency* is an object lesson indicating how far down they let us.

David Wojnarowicz

THE LAST RIMBAUD

T HERE'S NO QUESTION ABOUT IT: DAVID WOJNAROWICZ HAD A HARD LIFE. IT was a kind of loss leader for his art, which reads like a surreal case history documenting it.

Wojnarowicz's artistic career seriously began with *Arthur Rimbaud in New York,* 1978–79, a series of twenty-four black-and-white gelatin silver prints in which a friend, wearing a mask of Rimbaud, was photographed in a variety of New York settings, all more or less sordid and "underground." Wojnarowicz's identification with Rimbaud is clear, and there is a startling resemblance between their lives, and even their art.

Wojnarowicz was born in 1954, exactly a century after Rimbaud, and died in 1992, living one year longer than Rimbaud, who died in 1891. Both were the products of broken homes and abusive parents, both ran away from provincial homes to the big city, both traveled widely, both were gay. Both needed a loving relationship with an idealized father figure and artistic mentor to stimulate and support their own art – Paul Verlaine in the case of Rimbaud, the photographer Peter Hujar in Wojnarowicz's case – and both were violent personalities – Rimbaud eventually shot Verlaine, and death and destruction run rampant in Wojnarowicz's imagery, most famously in *Untitled (Falling Buffalo),* 1988–89. (In one film bodies are mutilated and torn apart.) Both had a certain arrogance, evident in Wojnarowicz's videotaped "performances" as a gay activist. Rimbaud was rejected by the Parisian literati as an arrogant, boorish drunk. At one time or another both lived beyond the social pale, Wojnarowicz as a child prostitute, Rimbaud as a gun runner. The criminal or outlaw experience gave them pleasure – their art in fact is a kind of homage to the pleasure principle, celebrated as illicit – as Wojnarowicz's writings – as intense and eloquent as Rimbaud's – indicate. They felt they could get away with being exceptions to the rules everyone else must follow, and they paid a human price for doing so, whatever the artistic results of doing so. Both died horrible deaths, Rimbaud after having his cancerous right leg amputated – he apparently suffered from syphilis – and Wojnarowicz died from AIDS related illness.

Perhaps most crucially, Wojnarowicz's imagery pursues the same hallucinatory effect as Rimbaud's poetry – both attempt to break the mold of artistic stereotypes by suggesting a complete derangement of the senses, as Rimbaud called it – and like Rimbaud he tried to transform his suffering into seerdom. They failed to do so, as the fact that both lived lives that were a prolonged "season in hell" – altogether unwise – indicates. For both, art became a way of life when no other worked, or seemed possible, because each chose to be an outsider, or had become one by virtue of an unhappy experience of life. However hard they tried to escape from their lives and feelings by transmuting them into art – turn the sordid raw material of their life into sublime art – they could not completely do so: their images attained a certain vigorous purity, but continued to vent suffering and dissatisfaction. Their art did not save them; it permitted them to cope, temporarily. Rimbaud abandoned art when it could no longer do so, and in a sense Wojnarowicz abandoned art by using it to make political statements, which blamed the world for his troubles and stopped his development. Indeed, he may have turned to politics because it had run his course, and he had nothing more to say about his life. The ruins of their lives washed up on the shores of art, to our benefit, but not clearly to theirs.

But the resemblance between them breaks down: Rimbaud was an avant-garde innovator, Wojnarowicz an avant-garde decadent. Both were brilliant, but Wojnarowicz ended – brought to an ambiguous populist conclusion – what Rimbaud began: the idea of the artist as an experimental visionary. Wojnarowicz brought down to everyday earth what for Rimbaud was a mystical way of ascending to psychic heaven. Wojnarowicz standardizes and stereotypes Rimbaud's unusual techniques and puts Rimbaud's surreal expressionist aesthetics to antiesthetic use. He in effect makes exoteric what was once an esoteric art with an esoteric purpose. In short, he conventionalizes what was once unconventional, and does so with a casual ease that betrays its difficulty. Surrealism is vernacularized in the juxtaposition – however momentarily startling the incongruity – of monkey, money, and tornados in *Fear of Evolution,* 1988–89, and expressionism is vernacularized in the untitled series of sculptured heads made in 1984. In both collage – Wojnarowicz's major technique – is routine, however lively, mechanical, however novel its content.

The visionary impulse was intact in Wojnarowicz, but his experiments – and he was relentlessly experimental, as his restless movement between painting, sculpture, printmaking, music, film, video, and numerous collaborations indicate – are not as ingenious and radical as those of Rimbaud. They are more clever than subtle, more blatant than intimate. Wojnarowicz lacks the emotional breadth, complexity, and depth of Rimbaud, tending instead to harp on one emotional note – usually rage, as he acknowledges. This is partly because of his populism – evident in his use of collective imagery, comic strip style, and such social materials as supermarket posters as points of departure – and partly because he wants to make a political point – put his firsthand experience to social use – which requires that one write one's ideas large and simplify them. Mass consumption always involves

reduction to a common denominator, and Wojnarowicz was torn between the wish to make high art and to influence the indifferent masses. Moreover, if his political imagery did not incorporate his personal narrative, which involved self-mythologizing, his activism would have lost its cutting edge and poignancy.

Having said all this, Wojnarowicz remains a major figure and symbol, largely because of his existential fundamentalism, evident particularly in his death-inspired photographs. I am not thinking of the famous masochistic image of him with his lips sewn shut that appeared in the video *Silence = Death,* 1990, nor of the frequently sadistic character of his imagery, in which hostility often climaxes in murder. Rather, I am celebrating his sophisticated, nuanced use of black and white, suggesting the closeness and even mutuality of death and life, in his *Ant Series* and *Sex Series,* both 1988–89, and *Dust Track I* and *II,* 1990. Black and white intertwine the way life and death do; Wojnarowicz's demonstration of this is his true visionary achievement. Prosaic images become sheer poetry – the stuff of life is at last transformed into art that transcends it – art that is deathdefying even as its entire atmosphere is funereal. As has been said, there is nothing like death to concentrate the mind. And there is nothing like death to bring an art to ripeness.

Hujar died from AIDS in 1988, and Wojnarowicz, discovering that he was HIV positive, realized that he also would probably die soon. In his last works he faces his death: social critique and homosexual explicitness are embedded in brooding on death. No doubt his social engagement – inseparable from his self-acceptance – was an attempt to be adult, but he was never more adult than when he dealt with death. It was then that he finally came to terms with his lot in life. There is a subliminal solemnity and intensely mournful quality to Wojnarowicz's last works which is more heroic than their in-your-face aggression. In them he struggled to integrate his death and life instincts to achieve and maintain a sense of ego. He succeeds in doing so: we admire the strength of ego which allows him to face his own death and life. He was not, in the end, the vulnerable frog with whom he identified in some images.

Both Rimbaud and Wojnarowicz died midway through life, at the age when Dante became depressed enough to begin his voyage to heaven – to take salvation seriously. In contrast, they never left hell, but they were able to endure it with dignity. Perhaps there was even something more to Wojnarowicz's art – something that made it even more authentically existential than Rimbaud's. If, as Milton said, "the Mind … can make a Heaven of Hell, a Hell of Heaven," then Wojnarowicz, while not able to make the adolescent hell of his mind into the consummate artistic heaven Rimbaud did, nonetheless used art to arrive in purgatory. Perhaps he was able to do so because he continued to make art to the bitter end of his life – it was a kind of lifeline to which he desperately held – while Rimbaud abandoned art early in life, suggesting it was an adolescent trifle. To reach purgatory is certainly a step beyond hell and the next best thing to heaven, and brought Wojnarowicz closer to salvation than Rimbaud. The lesson of Wojnarowicz is that if one persists in pushing the Sisyphean wheel of art uphill – it always falls back, and one has to start pushing again – one may not only get further in life, but in the afterlife.

Woman at Risk

THE REPRESENTATION OF THE FEMININE IN MODERN AND POSTMODERN ART

All women have vaginas, but only in a few of them are they properly connected to their heads. Don't ever confuse vocal chords with brains.

Max Ernst[1]

Every therapist ought to have a control by some third person, so that he remains open to another point of view. Even the Pope has a confessor. I always advise analysts: "Have a father confessor, or a mother confessor!" Women are particularly gifted for playing such a part. They often have excellent intuition and a trenchant critical insight, and can see what men have up their sleeves, at times see also into men's anima intrigues. They see aspects that the man does not see. That is why no woman has ever been convinced that her husband is a superman!

C. G. Jung, *Memories, Dreams, Reflections*[2]

I have had three lives. One for Robert, one for my son and grandsons, and one, all too short, for myself.

Sonia Delaunay[3]

"Two Lives," a man's and a woman's, distinct yet invisibly joined together by mutual attraction, grow out of the earth like two graceful saplings, side by side, straight and slender, though their fluid lines undulate in unconscious rhythmic sympathy, as they act and react upon one another ... But as the man's line broadens or thickens, with worldly growth, the woman's becomes finer as it aspires spiritually upward, until it faints and falls off sharply – not to break, however, but to recover firmness and resume its growth, straight heavenward as before, farther apart from the "other self," and though never wholly sundered, yet never actually joined.

Henry Tyrrell, describing a "symbolistic" drawing by Georgia O'Keeffe[4]

THIS EXHIBITION EXPLORES THE REPRESENTATION OF WOMAN IN MODERN AND postmodern art. There are works by male and female artists – works that illustrate the so-called male gaze, and works that convey female self-understanding, in effect subverting the male contemplation of the female body. That body is in fact at the center of the exhibition, in the images of both male and female artists. Sometimes it appears ironically, as in Sue Williams's *Irresistible*, 1992, a

sculpture of a pin-up – the populist form of the eternal female – curled up on the floor. Her voluptuous flesh is neutralized into oblivion: ghostly white, as though she was a corpse, and overwritten – one might say overridden – by text, interfering with any lustful male gaze at it. Williams's feminist work is a mocking version of the cliché of the reclining odalisque. The antithesis to it is John Kacere's *Caroline*, 1984, an idealized, erotically available young woman, the sheet veiling her body making it more enticing, adding to her allure. Here woman is the object of eternal male desire, and so eternalized – eternally young – herself.

Sometimes this is overt, as in the classical torso in Rene Magritte's *La Lumiere de Coincidences*, 1946, and the contemporary torso in Robert Graham's *Figure 1-B* and *Figure 1-G*, both 1989–90: in both cases woman has lost her head, becoming all beautiful, ageless body. Nude rather than clothed – one thinks of Freud's remark about the displacement of sexual desire from the erogynous zones to the body as a whole, and about the repressing and civilizing effect of clothing – she is always available for pleasure. Seeing, as Freud also said, is, after touch, the major medium of libidinal excitement, and the bodies Magritte and Graham present can be touched in fantasy after being seen. Indeed, in making themselves visually available, they become emotionally tactile. Completely exposed to the male eye, they loom large in the male mind.

However, even when she is clothed, as in Alexej Jawlensky's *Schokko mit Tellerhut*, 1910, desire for her is symbolically evident in the artist's method. The flaming red of the ground and of the figure itself – her dress is even more intensely red – as well as her hat, convey the male artist's passion for his female model. Although her clothing binds her to a certain historical time and place – locates her socially and culturally, in a way the eternal nude of Magritte and Graham can never be, whatever its style – Schokko too, however obliquely, is a version of the eternal feminine, that is, the idealized object of male desire.[5] (Her hat fuses the reds of the ground and dress. The red fruit on it suggest the abundance of Schokko's breasts, and the tissue-like blue curves that frame the fruit turn the whole round hat into an abstract symbol of the vagina.) In all three male cases art, indeed, is substitute gratification, while in the female case male desire is thwarted and satirized.

It may also be, to pursue a Jungian idea, that Magritte, Graham, and Jawlensky unwittingly represent their generative anima or muse – the truly eternal, ideal, inescapable female and creative part of themselves, disguising her divinity in the form of external, particular woman. But Williams does not want to be any part of the male mind, however honorific and innate. She wants to escape the clutches of male creativity and imagination. Does this suggest that her own are reactive rather than primary? Must she free herself from the male view and appropriation of woman to be herself? And who is that self? Woman has a clear erotic identity for Magritte, Graham, and Jawlensky, but Williams puts that identity in question, and in doing so hopes to discover woman's authentic identity. But it is not clear what that is. Williams's woman resists her irresistibility in man's eyes – negates

her seductiveness to man – but it is not clear what she is without it. What would she be like if she was not seductive, irresistible, desirable? Who is she without the sugarcoating of male desire that makes her mysterious, and turns her body into a luxury rather than platitude? Is it psychosocial progress for woman to shrug off man's desire for her, even violently strip it away, or simply part of the ironical process of being a woman? Is her identity grounded in resentment of man? Can she only assert her existence when she denies his? Is she most authentic when she denies the authenticity of man's desire, viewing it as the instrument of his will to power rather than an irrational drive – a slyly rational means of control rather than an uncontrollable force sweeping both man and woman before it? Who is she apart from her relationship, good or bad, with man? Williams leaves these questions unanswered, but not every woman artist in the exhibition does.

Clearly there is a contradiction between the male and female renderings of the female – a difference of outlook and emotion that reflects a difference in social role and status, and in biology. Generally speaking, the postmodern works, especially those made by women, grapple with this difference, while the modernist ones, especially those made by men, seem to accept it. After all, it is to their benefit to do so, since it gives them artistic rights and power over women. It is worth asking ourselves, for a moment, how grounded and essential that ostensibly hierarchical difference is, particularly in view of the postmodernist critique of essentialism. Is there a female essence, as Magritte, Graham, and Jawlensky seem to think? The psychoanalyst Jessica Benjamin notes that Foucault

contended that identities are not derived from essences but constructed by discourse. This position requires us to delineate the way in which discursive systems of knowledge actually "produce" the categories by which we recognize ourselves to *be* the containers of such identities. Here the point is not only to reject the biological, transhistorical foundations of sexuality and gender – even to deconstruct the very category of "nature" – which rationalized masculine claims to power in traditional thought. It is also to rebut all claims from the feminist side, which might deploy and defend a naturalized female identity; to critique not only any natural foundation of Man's prerogatives but also the notion of "Woman." Thus it has been said that Woman is a "name" that makes woman appear to be the same kind of unitary subject as was the male subject of philosophical and political discourse and that works to suppress all other differences (race, class, sexual choice). It uses the frame of gender to create a false identity.[6]

So that when *Homo sapiens* and Neanderthal men spent a good deal of their time raping each others' women, as Jean M. Auel fantasizes they did in her best-selling novel, *The Clan of the Cave Bear,* this had more to do with dominating woman than satisfying biologically ordained sexual desire. And when Magritte, Graham, and Jawlensky use the discourse called the eternal feminine, they idealize woman as the consummately unitary being in order to deprive her of any right to complex, autonomous becoming. Presumably the difference between man and

woman is historical and cultural rather than biological and generic: it is not innate or essential, but a matter of social power and conditioning, pretending to be knowledge. Presumably there is neither female nor male nature – both Woman and Man are simply names, and as such lack inherent identity.

And yet, as Sally E. Shaywitz tells us, there is experimental proof that male and female brains function differently.

It turns out that in men phonological processing engages the left inferior frontal gyrus, whereas in women it activates not only the left but the right inferior gyrus as well. These differences in lateralization had been suggested by behavioral studies, but they had never before been demonstrated unequivocally. Indeed, our findings constitute the first concrete proof of gender differences in brain organization for any cognitive function. The fact that women's brains tend to have bilateral representation for phonological processing explains several puzzling observations: why, for example, after a stroke involving the left side of the brain, women are less likely than men to have significant decrements in their language skills, and why women tend more often than men to compensate for dyslexia.[7]

Is it absurd to ask, on the basis of this information, whether the brains of female artists process the language of art – the basic elements of form – in a different way than the brains of male artists? Does the difference between male and female phonological processing offer a biodynamic basis for distinguishing between feminine and masculine sensibility – an issue that has haunted feminist literature on art from the start?[8] Perhaps these questions are too speculative to answer, but they suggest that the difference between the male and female representations of women are more essential – less socially constructed – than they may seem at first glance. They suggest that there is a natural functional difference between man and woman – a subtle gender difference, not explicitly sexual – and that this difference appears in the way they picture woman. Does man show woman as all body and no brains because of the limitations of his own brain? Does he have a greater fear of her brains than of her vagina?[9] Or is his fear of her vagina the ostrich hole in which he hides his fear of her brains? Does woman show her brains in revolting against this conception of her, and declaring her dialectical integration of body and brain – a rare achievement – as suggested by William's inscription of language on woman's body?

Can the difference be traced to the fact that, as Arlene Kramer Richards writes, "women are no longer who they used to be,"[10] but men would like them to remain – and so depict them – as they were? As she observes, "women in the West no longer die in childbirth in the second or third decade of their lives. We also have fewer children, so that rather than spend almost all of our adult lives in pregnancy or lactation, we experience at most five or six years of that as against five or six decades of adulthood with childbearing."[11] This has "consequences for psychic reality," as Richards notes. "Contemporary women" seem to have "a new set of wishes, fears, and dreams," which are not easy to understand. Motherhood is at

the center of many of them. "Women in the nineties" are able "to separate female identity from motherhood," indeed, "fulfill their feminine personalities without motherhood," Mardy S. Ireland argues in *Reconceiving Women* (1993).[12] It is possible "to value a child-free life as a goal rather than a second best settlement." Indeed, it is possible to argue, as some feminist thinkers have, that "the ideal of motherhood as an exclusive lifelong preoccupation is destructive to both women and children. It does not allow for the mother's need for social and intellectual stimulation and satisfaction any more than it accommodates the child's need for those things."[13]

If motherhood is no longer sacred – if to be a mother is no longer the top priority in woman's life – why should female artists bother to represent mothers, except ironically? Do men cling to the image of ideal motherhood more than women, for whom it has become an obstacle to self-fulfillment, indeed, a form of self-denial? Cindy Sherman mocks the regal Madonna of Christian tradition in her untitled 1989 image of a Madonna and Child. The Madonna's exposed breast is a peculiarly abstract, prosthetic device, only nominally attached to her body. It is a ripe, rather overblown – disproportionately large – piece of fruit, no doubt full of nourishment. But the Madonna seems rather detached from it, just as it seems to exist apart from her. Indeed, she does not so much lovingly give the breast to the infant as allow it to offer itself to him, as though it had a mind and will of its own. All this suggests that it is not an integrated part of her person, which in turn implies that her role as mother – even mother of the savior – is not an integral part of her identity. She has split her role off – expelled it, as it were – into her breast. It is the only part of her that she intends to give – it would be an overstatement to say "devote" – to the ordeal of mothering. She has, in a kind of ironic triumph over motherhood, given her breast an independent life to maintain her own independence.

Sherman's Madonna is a heavenly queen who has been distracted by the duties of motherhood – had the role of motherhood thrust on her by the male God. Fallen from her state of narcissistic glory by the need to care for her unwanted infant, she remains aloof from her own motherhood in order to maintain her majesty, spiritlessly if dutifully – it is part of her royal duties – giving (with an attitude of noblesse oblige) only that part of herself ordained by nature for the task of nourishing the infant. She sacrifices her empathy to keep up her stateliness – sacrifices her milk of human compassion to uphold her regal integrity and dignity. Sherman has clearly captured, with a kind of grotesque humor, the repressed moment in the narrative of the Immaculate Conception: God forced himself on the Virgin Mary – another case of a father's sexual abuse of his daughter? – making her a mother against her will. As mentioned, her reluctance to be one is evident in her emotional detachment from the infant, which is registered in the almost literal detachment of her breast. It is worth noting, although it is not relevant to Sherman's image – but it is to the larger discussion – that there is a class of image of the young Mary that shows her reading, that is, having an intellectual

life (the so-called Education of Mary iconography), indicating what she had to give up to become the holiest of mothers. The paradigmatic exchange is not clearly worth it from a feminist point of view: Mary lost her mind to become a mother. Forced to use her body to nourish another being, she was forced to betray and finally forfeit her intelligence, or rather use it in the service of her baby, ideally a male, like the Christ child.

Thus, through a deceptively simple manipulation of the Madonna's breast, which becomes an autonomous and peculiarly artificial part object, indirectly invoking Melanie Klein's ideas about the infant's phantasies of its power for the good and bad in his life, Sherman ingeniously brings the traditional idea of the sacredness of motherhood into question. She attacks, with revolutionary daring, the supposedly most inviolable image of motherhood in our society, conveying its dubiousness. Breaking the taboo against parodying sacred images, her tragicomic picture suggests the absurdity of motherhood for woman, indeed, the ugly old sexual truth the idealization of motherhood – the concept of the mother as an irreproachable queen – hides. Motherhood is, conventionally, a sacrifice of youthful freedom and independence, but, as Sherman implies, it also threatens – all but eradicates – woman's selfhood, and neither loss is worth the gain. There is, simply, no longer any time for reading – for an intellectual life. In postmodernity, motherhood is not a necessity, not even a worthwhile choice, but self-defeat on a grand scale.

May Stevens's equally grim, polemical, mournful *Forming the Fifth International,* 1985 (Fig. 39), shows the useless, private waste her mother's life was in contrast to the rich, socially useful life of the Marxist revolutionary Rosa Luxemberg. Indeed, Stevens seems to imply that her mother's schizophrenia and dehumanization resulted from her unquestioning acceptance of the roles of mother and housewife – neither particularly conducive to self-development for Stevens – while Luxemberg's social activism and humanitarian intellectuality were made possible only by her repudiation of motherhood and domesticity. Luxemberg and Stevens's mother are seated in separate spaces, as though to make their incommensurateness palpable; the former figure is gray and stern, the latter is colorful, in deceptively feminine pink, accentuating their difference. The distance between them is immense – the former was a brilliant German intellectual and leader, the latter an obscure American housewife, banal except for her madness – and unbridgable, except in the fantasy of the picture. Even there the conflict they represent – it is has as much to do with the difference between their times and worlds as their lives – is far from resolved.

There is an emotional as well as intellectual asymmetry between them: Stevens's mother turns in on herself, while Luxemberg – Stevens's spiritual mother? – boldly faces the viewer, as though to challenge her (Stevens's works are addressed to women). "What kind of life – lifework – have you chosen?", Luxemberg seems to be asking. "Have you followed my lead or that of Stevens's mother?" Of course, both came to a bad end – Luxemberg was murdered for her revolutionary beliefs

(she was one of leaders of the Sparticist revolt in Berlin), and Stevens's mother was a kind of suicide – suggesting the futility of woman's life for Stevens. Woman ends up either assassinated by man or in a madhouse. Her life is death-infected from the start, for it is lived in the shadow of man. In an ironic way, the painting recapitulates, in modern terms, the traditional distinction between the vita activa, represented by Luxemberg, and the vita contemplativa, represented, strangely enough, by Stevens's mother. I think Stevens uses her mother to symbolize the contemplative life to suggest that it is "insane" for women to look inward to understand their problems, for they are caused by male society, which in fact is epitomized in Stevens's earlier "Big Daddy" series, a nasty attack on her father. All the introspection in the world will not solve her problems, for they are not of her own making.

On a more personal note, I think Stevens is expressing her ambivalence toward her mother: she wishes her mother had been a revolutionary thinker like Luxemberg, but she wasn't. Indeed, Stevens paints her critical picture, and others like it, to try to understand what exactly it was that her biological mother gave her. The figures, then, represent female alternatives – the painting is an allegory of woman's life, indeed, a kind of Hercules at the Crossroads idea transposed to woman's situation. The point in this context is that motherhood comes off badly in Stevens's painting, however much both women are idealized (they're in an amorphous heaven of evergreen nature). Stevens, like Sherman, vehemently disputes the significance of motherhood. For both it is unequivocally oppressive. "Anonymous is not a woman," Stevens seems to be saying, except to the extent she is a mother.

So we have two resolute, theoretically advanced female artists showing motherhood in disgrace – an obstacle to woman's self-realization. But the male artist John Ahearn's *Maria and Her Mother,* 1987, represents the mother as a supportive, loving person, indeed, a kindly rock of Gibralter for her fragile, needy daughter. Ahearn's mother is emotionally ideal if physically realistic. Is she only a male fantasy of the warm, compassionate mother, the epitome of humanity and fertile, nurturing earth goddess in one? Or is she, as the presence of her daughter suggests, also the unconscious object of woman's worship, a model and projection of possible selfhood, however old-fashioned? Ahearn's sculpture suggests that, however secularized, indeed, vernacularized, the archetype of motherhood remains alive and well in both the male and female psyche. No doubt Sherman and Stevens would dispute this, but in fact their works show them obsessed with motherhood, however skeptical of it they are.

If liberated nineties woman can no longer take her definition as woman from motherhood – if it is no longer a culturally readymade, reliable source of female identity – then woman seems to have become undefinable, or rather has lost any need to define herself as specifically and essentially female, that is, to clearly differentiate herself from man. The need for social and intellectual stimulation and satisfaction that Ireland emphasizes – and that Stevens's picture indirectly deals with – is not particular to woman, but generally human. For woman to insist on her right to such stimulation and satisfaction, and to put them before mothering,

39. May Stevens, *Forming the Fifth International,* 1985. Oil on canvas. 78 × 115 $^1/_2$ inches. Courtesy of the artist and Mary Ryan Gallery.

is for her to assert her humanity and personhood before all else in her life. And for man to accept woman's need for social and intellectual stimulation and satisfaction – a need whose satisfaction was traditionally his prerogative and privilege, and a source of his supposed superiority to woman – means that he can no longer define her according to his biological and emotional needs: he realizes that splitting her into a glamorous sexual animal and the guiding muse of his heroism – simultaneously less and more than human, thus deprecating and idealizing her in the same breath – denies the authenticity and particularity of her existence. It renders her insignificant, even while apparently giving her absolute significance. Demythologized into vulnerable, mortal humanity, as concerned with self-fulfillment as man, and with the same social and intellectual needs, she loses her magical ambiguity – the expression of man's ambivalence toward her – and the ecstatic old satisfactions it brought with it. But man's new realism about woman makes a new, more mature, and unexpectedly deeper kind of satisfaction possible: recognizable as a person and individual, and treated as an equal partner – a friend and companion as well as lover and idol – a new sense of mutuality and intimacy – dialectic – with her emerges.

But it is hard to give up old mental habits, particularly if that means giving up power and privilege. Man continues to prevent woman from satisfying her social

and intellectual needs, particularly when her satisfaction would impinge on his apparent need for power over her. Thus the computer artist Teresa Wennberg describes how her need for intellectual and creative satisfaction was frustrated again and again by male experts.

Upon further advancement into the computer world, I was – and am – rather amazed to see that it was and still is very male oriented. Computer science and its related tools, be they software or hardware, have been developed mainly by (male) technicians, mathematicians and military scientists, and seldom by artists. Suddenly, here was an unexpected barrier: the belief that an artist, and especially a female one, would not know about technical matters. In every computer lab or institution that I visited, I have invariably been greeted with disdainful comments about my intellectual capacity to understand a program or make any interesting use of it... There is another catch to the masculine fascination with machinery and games: in computer graphics, it is hard to validate a more feminine view of things. The market is brimming with karate fighters, kick-boxers and war games – perhaps due to the never-ending quest for power. Most of these games are rather void of artistic qualities other than a good sense of timing for where and how to place scary "enemies."[14]

Wennberg faces a double problem: patriarchal skepticism about woman's intellectual abilities, and about artists as such, for from the patriarchal point of view they are female, and as such unable to do man's work – work with machines, for example. In a sense, James Rosenquist's allegorical *House of Fire II*, 1982, stages the conflict between man and woman in terms of the difference between woman's cosmetic art, represented by the lipsticks, and man's technological knowledge, represented by the gears that seem about to crush them, or at least impinge on them. If man and woman have different skills and different arts, their representation of woman has to be different.

All this implies that the difference between male and female representations of woman – between man's vision of woman as the absolute, supreme Other, onto which his contradictory fantasies of himself can be projected, and woman's belief that she can become authentic by repudiating these projections, whether by ironicizing them or bluntly negating them – is not only an expression of the social inequality between man and woman, but of their different needs, which are in a sense the expression of their radically different assumptions about and psychosocial experience of each other. For man, woman is nourishment, and nothing else – spiritual and material nourishment conveniently in one being. For woman, man is the universal model of unitary selfhood – the culturally approved ideal of integrated identity. Paradoxically, woman can actualize this ideal only by becoming completely independent of man, which in practice means refusing to nourish him, whether by playing the role of glorified mother or vulgar sex object, both equally ready to serve him. Reciprocity with him, asymmetrical to begin with, must be abolished, in part because it is disappointing, in that man himself seems to lack the capacity to nourish woman in return, and in part to call his bluff about

his integrity: either he lives up to the ideal self he pretends to be – overcomes his divided conception of woman – or else, by realizing that he is unable to do so and thus less than ideal, learns to nourish her as much as she nourishes him. Woman's rejection of man's ideality will either make or break him humanly. However, it may be too late for them to establish a genuinely reciprocal relationship of mature dependence, as W. R. D. Fairbairn calls it. The irony of many man-made works in the exhibition is that they project the unitary, integrated selfhood that man ideally has onto woman, whether in her mythical character as holy mother or profane sex object. The irony of many woman-made works is that they reject man's double vision of her as the principle of nourishment, but without the expected result of independent identity. The exhibition suggests that neither man nor woman live up to their belief in themselves.

We are left with the ironies of the "negative dialectic" and misunderstanding between man and woman. Man devalues woman's mind so that she will be available as sublimated maternal body – the eternal feminine goddess or omniscient muse – and desublimated sexual body. She affords emotional support for his "higher" intellectual pursuits, and animal satisfaction for his "lower" biological body. She is thus at once refined and raw, spiritual and material, ideal goal and realistic point of departure. Her contradictoriness points to her omnipotence: a utopian presence, she reassures man, for she guarantees that nothing basic is lost of life – that neither mind nor body exist at the other's expense. Thus woman embodies the paradoxical ambition of intellectually transcending the human condition while gratifying animal needs – of becoming all mind with no sacrifice of body. She is the perfect nourishment: food for thought as well as feeling. But man's devaluation of woman's mind – her supposed mindlessness, however much she may symbolize the aspirations of his mind – and overvaluation of her body – its supposed irresistibility and seductiveness – deprives her of the possibility of self. She overcomes this dehumanization of herself, resisting and rejecting man's aggrandizement of her, by asserting her intellectuality, which is what we see in the feminist images of Sherman and Stevens – in the thoughtfulness of the Madonna reluctantly contemplating the child and the detachment of Rosa Luxemburg quizzically contemplating the viewer. Woman supposedly exists only to serve and satisfy man, and she must get her satisfaction from doing so, but in thinking for herself she finds another, more rewarding – and rehumanizing – way of satisfying herself.

This separates her from man, and isolates her – the sense of isolation and abandonment is palpable in Stevens's figures. Isolation is not exactly independence, and certainly not full humanness. Indeed, it falls short of showing woman's will to be human: to be free of the influence of man's idea of her is not necessarily to have any clear idea of who she is humanly. In fact, many of the images in the exhibition show woman as passive and willless, even when removed from man. Whether the object of the male gaze, or existing in her own right, she remains peculiarly incomplete. It is as though her being has been worn out, whether from

being repeatedly appropriated or struggling to escape appropriation. In none of these images do we have a clear sense of what it means for woman to be herself, or to be human in general, in the sense in which that means "to face the infinity which … symbolic cognitive power presents … in the form of thoughts."[15] Woman has been too busy emancipating herself from man's paradoxical, dehumanizing conception of her to think about anything but herself. Even when she presents herself as a goddess, as in the early work of Mary Beth Edelson[16] – a militantly spiritual, autonomous being – or as a dancing, healthy figure, as in the later imagery of Nancy Spero, she is conceiving herself in male terms, or celebrating her liberation from the male – Spero's later works follow upon her "Torture of Women" imagery, which deals resentfully with women's victimization by man, and is full of hatred for him – and thus remains isolated and inadequately human and self-identified.

In short, where the male artists are trapped by their own pathological clichés of woman, the female artists struggle to cure themselves of the contagious clichés. I think that the heart of their effort is the attempt to counteract the myth of woman's seductiveness, which supposedly makes her charismatic. From a male point of view the essence of woman is her seductiveness, whether to a spiritual or sexual purpose. It means that man cannot conceive her apart from the paradox of his desire for her. Any image of her as unseductive, that is, undesirable – plainfaced, even ugly, as in the grotesque renderings of her in many late Sherman images (for example, with a pig's snout) – violates that preconception, and becomes liberating: no longer having to worry about physical appearances, woman can become herself, which at the least means becoming intellectual, that is, full of the thoughtfulness or reflection man thinks she is constitutionally incapable of.

Man's experience of woman as seductive is inseparable from his conception of her as an irrational "child of nature," as in Niki Saint Phalle's allegorical image of her as *Temperance (Guardian Figure),* 1984–85. This is why she needs to be ruled by man, who is inherently more adult (intellectual, reasonable). If woman can break the spell of her seductiveness, she can realize a measure of autonomy from man, for she can no longer be associated with childhood and nature (both of which are implicated in her "mysterious" biological capacity to give birth), and thus irrationality. Man is irrationally tempted to return and surrender to nature – it is invariably seductive, a siren song it is hard to resist, both spiritually and sensuously – and thus forfeit his sense of superior intellectual identity; surrender to woman, whether conceived as transcendental being or common animal, is the "natural" means of such a return, which is why she is simultaneously welcomed and guarded against by man. But if she is neither transcendentally nor sexually seductive – if there is no irrational reason for a relationship with her – but simply socially and humanly given, then man may be dissuaded from imposing his desire upon her.

He may lose interest in her, indeed, become disillusioned with and finally indifferent to her: male indifference to woman is her only hope of freedom from him,

that is, for discovering her own indifference to him, namely, finding the strength of will to refuse to nourish him. Indifference is even liberating for man. No longer seductive – no longer having to satisfy male desire – she is free to develop herself – her sociality and intellect. And, man free of the blinders of his desire, can see her in a new light. They gain the opportunity to form a new kind of relationship, transcending the oscillation between spirituality and sexuality: more equal and trusting, less dangerous and defensive, less deceptive and self-deceptive, more rational and realistic, mutually nourishing and supportive rather than exploitive and predatory. (No doubt this is an impossibly utopian relational goal.) We all of course eventually return to nature through death, but for man to conceive of woman as an irrational child of nature is to deny her the possibility of adulthood. Indeed, denying that she can ever grow up, she can be treated as though she was already dead and inconsequential – except insofar as she becomes compelling by reason of becoming the object of his transcendental and sexual fantasies, that is, his split personality.

Hegel wrote, with philosophical pomp and circumstance: "In its metamorphosis, the Earth-Spirit has developed, partly into a silently energizing Substance, partly into a spiritual fermentation: in the first case it is the feminine principle of nourishment, in the other the masculine principle, the self-impelling force of self-conscious existence."[17] But this is a man's smug point of view – an intellectualization and reification of age-old, hidebound male clichés – and projects the unconscious split in his psyche. It is man who reduces woman to the principle of nourishment and elevates himself as the self-impelling force of self-conscious existence. Until he becomes conscious of this, and realizes that he has no monopoly on self-consciousness, and that woman is not simply nourishing substance (and fundamentally seductive because of this), but as self-impelling or self-determining as he is, at least until thwarted by him, he will have as little right to existence and self-satisfaction as he allows woman. It is, ultimately, this aggressive point that the feminist pictures of woman make.

There are many of them in this exhibition. Janine Antoni's ironical *Lick and Lather* self-portrait busts mock the ideal female body, with its smooth, perfect skin, and the contrary male demands imposed on it. It is at once as pure as soap and as sensual as chocolate – virginal and erotic – suggesting male ambivalence about it. Carrie Mae Weems's sequence of photographs show three women, two black and one white, engaged in a dialogue that excludes man, as though to imply that their presence would detract from – indeed, interfere with – the women's individuality and intimacy. Woman's plight is clearly expressed in Shirin Neshat's photograph of a Muslim woman, her head veiled, on her knees praying. Such women are among the most oppressed in the world. Their inferior status is confirmed by religion, which fixes them forever in place: on their knees, pleading for mercy, or else of sexual and reproductive service in the bedroom. We are a long way from the voluptuous houri of the male-conceived Muslim heaven in this photograph.

In their different ways, these woman-made images of woman stand opposed to the man-made images of brainless, all-vagina woman – woman as inert mindless flesh. She is sometimes idealized into an exotic fantasy, as in John DeAndrea's *American Polynesian,* 1990, and, in a different way, his *Clothed Artist and Seated Model,* 1976, Henri Matisse's *Odalisque au Fautenuil Noir,* 1942, and Giulio Paolini's reprise of ancient statues of Venus (the erotic antithesis of Athena, the symbol of mind, suggesting that ancient man also split woman). This idealization can sometimes be ironical, suggesting man's conflicted attitude to woman, but she nonetheless remains a superior, even transcendent being. Such ironical idealization seems self-evident in Dali's sardonic *Venus a la Giraffe,* 1972, Joel Otterson's threatening *Venus, The Iron Maiden,* 1992, Mel Ramos's wittily populist *Miss Liberty – Frontier Heroine,* 1962, Arman's equally witty allegory *Victoires San Limite,* 1993, and Tom Wesselman's ongoing series on the All-American odalisque, all of which picture the phallic woman – the ultimate goddess. More often, she is vulgarized into a cheap spectacle,[18] as in John Corrin's *The Living Room,* 1995, Eric Fischl's *The Visit II* and *Untitled (Two Women in Bedroom),* 1982, Lyle Ashton Harris's *Hot En Tot,* Dario Morales's *Nude on a Sofa,* 1987, David Salle's *Untitled,* 1981, and *Woodsmoke,* 1985, all of which take as their point of departure the pornographic representation of woman.[19] Woman-as-flesh – implicitly raw and meaningless, that is, mindless and feelingless flesh – is as much celebrated as mocked by Vito Acconci's colossal bra sculptures, 1990–91, which, like Lucian Freud's *Big Sue,* 1995, suggest just how overwhelming and intimidating female flesh can be from a puny, not to say infantile, male point of view. The woman in Georg Baselitz's *Malekopf wie Blumenstraub II,* 1987, and in Willem de Kooning's untitled drawing of ca. 1957–60 may be more avant-garde in style than Freud's gross female, but she is just as much all flesh, however comically dumb. That is, however much man tries to diminish her – and control his desire for her – by laughing at her, even trying to laugh her off. Oil painting in fact was invented to render woman's awesome flesh, according to De Kooning's speculative fancy.

Andy Warhol's *Four Marilyns,* 1962, pictures, as a garish spectacle, the woman who, more than any other today, has come to epitomize woman-as-flesh. Marilyn Monroe flaunts her flesh, its lush sensuality confirming her mindlessness. She is all manipulative seduction, which, no doubt, suggests that she has a kind of intelligence – the proverbial intelligence of the "dumb blonde," whose greed confirms her instrumentality. Even when she is sad, as in Roy Lichtenstein's image of her, the blonde remains stupid, and above all an actress – a fake, that is, more apparent than real – which, paradoxically, makes her seem all the more seductive: her flesh is all the more appetizing for being a mere if glamorous appearance. Ida Applebroog's *Beulahland (For Marilyn),* 1987, More Fleury's *Glamour May '93 (Better Butt Fast),* a quotation of a Glamour magazine cover of yet another pretty face (there seems to be an infinite social supply of them, and indeed, they are mass produced on an image assembly line), Robin Kahn's *Taming of the Shrew,* 1995, Zoe Leonard's *Beauty Calibrator, Museum of Beauty, Hollywood,* 1993, Cindy Sherman's

Untitled Film Still #15, 1978, and Hannah Wilke's *Venus,* show woman artists' ironical efforts to undermine the seductive glamor girl image of woman, but they seem to confirm its power – its hold even on the female imagination, which seems obsessed with it, indicating how deeply it has been internalized. Dorothea Tanning's *Woman Artist, Nude, Standing,* 1985–87, confirms this: even the autonomous woman artist must submit to the ritual of naked self-display, showing off her flesh, as though her body – rendered in a painterly way that makes it all the more emphatically flesh – was more important than her art and mind. Ironically, Robert Mapplethorpe's *Lisa Lyon,* 1982, comes closest to subverting the representation of woman as seductive flesh, for her nakedness conveys strength, and her confrontal glance challenges and threatens the male gaze. So does Nan Goldin's *Christmas on the Other Side, Boston,* 1972, which also turns the tables on the male gaze. But the larger social issue remains the same: the woman gazes at a glamorous, vacuous male figure – as much an attractive appearance and illusion as any pretty female face – suggesting that both are trapped in a world of fantasy, and commercialized fantasy at that. That is, neither can escape the status of being the product that the other consumes. Consumer products all, one no longer knows what their reality is.

Existing apart from that appropriative gaze – standing on her own, without the support of man's desire for her – woman seems peculiarly limited and bereft, and more isolated than independent. Even empathic, or at least empirical, male artists recognize this, as Duane Hanson's *Seated Woman,* Robert Longo's *Untitled,* 1980, Alex Katz's *Ada in a Red Coat,* 1954, and *Ada, Ada,* 1959, and Currin's *Ramona,* 1992, indicate. This puzzled isolation is evident in Elaine de Kooning's *Self-Portrait #1,* ca. 1942, and epitomized in Catherine Murphy's subtle *Persimmon,* 1991. The smeared lipstick and wrinkled lips and above all their inexpressivity – the discrepancy between the expressiveness of the lipstick and the firmly closed mouth is especially telling – convey a woman who is one thing to herself, another to the male world, focused exclusively on her alluring lips. For the purposes of male desire, they are the gateway to her body. But while she may be kissed, she refuses to open her mouth in intimacy, in effect keeping herself to herself, and declaring that she has an interior life which has nothing to do with her sex appeal, epitomized by her lips. Audrey Flack's introspective *Gambler's Cabinet,* 1976 (Fig. 40), and *Queen* are perhaps the exhibition's most serious efforts by a woman artist to assert her autonomy and articulate her identity, but even then it is entangled with man's idea that woman is all seductive appearance, as Flack's dazzling cosmetic colors suggest. Also, being a woman is implicitly a game, which also confirms man's view of woman as deceptive – the other side of the coin of her seductiveness. Of course, Flack is dealing with the hand that life dealt her, and trying to find good fortune in the cards that tell her fate, but the overall effect of these brilliant pictures is of a woman with an uncertain sense of identity, for all her introspection. In a sense, who she is depends on a throw of the social dice. The playing cards show Flack's mind in action – they are emblematic of reflection, and she is

40. Audrey Flack, *Gambler's Cabinet*, 1976. 83 × 78 inches. Oil over acrylic on canvas. Courtesy of Louis K. Meisel Gallery, New York. Photograph by Steven Lopez.

in effect playing solitaire – which no doubt is better than displaying her body, but they confirm her complex bewilderment and isolation. Louise Bourgeois's *Totem*, 1949–50, and *Figure*, 1960, suggest that she responds to woman's feeling of isolation in a male world by becoming, in effect, the omnipotent phallic woman, but that is an infantile fantasy, and implies identification with man – the very being that Bourgeois feels victimized by, as other works, such as the vengeful *Destruction of the Father*, 1976, indicate. In the end, as Annette Messager's *Stories of the Dresses*, 1990, implies, woman remains bound to and gets her identity from her clothing, and what it hides, her victimized body, as Anna Mendieta indicates.

Man takes his revenge on woman for her power over him by victimizing her – battering her, as in Hans Bellmer's *La Poupee* photographs, 1935/83, and Nan Goldin's 1991 self-portrait of her battered face. Her significance must be reduced, which is what I think also occurs, however unwittingly, in Robert Wilson's minimalist symbols *Bessie Smith's Breakfast Chair*, 1988, *Esmeralda's Bed*, 1989, and *Chair for Marie Curie*, also 1989. They are not much of a tribute to their female subjects – their bareness (not to say barrenness) seems to trivialize the important, indeed heroic achievements of Bessie Smith and Marie Curie – and in fact confirm the cliché that an intelligent woman is undesirable. Whatever else it is about, minimalism tends to expunge sensuality from art – to give us the bare "intellectual" bones of form without its mucky flesh – and Wilson's symbolic minimalism does nothing to reverse this tendency. He supposedly presents woman as mind rather than matter – all concept and no body – but this concept is as prejudiced, falsifying, and inhumane as the view of her as all matter and no mind. Nowhere do we see a genuinely integrated view of woman as simultaneously body and mind – that is, a view that regards woman the same human way man regards himself. No wonder that she must fall back on motherhood – implicitly on her vagina – as in Kathe Kollwitz's *Lovers (Mother and Child)*, ca. 1913, and Alfred Leslie's *Constance Pregnant*, 1985. She may not want to abort the infant, which Sherman's Madonna seems to wish she had done, as her harsh gaze at it suggests, but she has aborted herself, at least according to nineties feminist thinking.

Unconsciously, Always an Alien and Self-Alienated

THE PROBLEM OF THE JEWISH-AMERICAN ARTIST

CHRISTIAN SOCIETY CAN HARDLY BE AWARE OF THE NARCISSISTIC INJURY IT HAS inflicted on the Jew: through its persecutions and killings it has forced the Jew to internalize its hatred of him or her, at once strengthening the resolve to maintain Jewish identity while making it seem problematic. The ultimate alien in Christian society – the enemy against which all Christians can unite, burying their differences to make common cause against the Jewish threat (all the more insidious because it seems to arise from within Christianity, which, ironically, is built on a Judaism that never accepted it) – alienation cannot help but become part of Jewish identity, however much it is resisted. The encroaching margin against which the Christian center must hold, the Jew cannot help feeling marginal, however centered he or she is in himself or herself.

The split in the Jewish community represents this tension and oscillation – Jewish self-contradiction: the religious Jew proudly proclaims his or her faith, the secular Jew accepts it because he or she knows Christian society will not let him or her forget it. But in the minds of both genocide is always in the offing. The former turns inward at the thought of the Holocaust, as though praying at the Wailing Wall, while the latter openly curses the hostile world, as though to preempt its cruelty, and turn its threat back on itself. But for all their differences, they are inwardly united; they know Christian society regards them as one and the same, and has prepared a common grave for them.

American Christian society is ostensibly a different place: persecution takes the insidious form of prejudice rather than the overt form of pogroms. For example, the Christian minister Jesse Jackson's description of New York City as "Hymie town," and the murder of the Orthodox Jew Yankel Rosenbaum by another African-American, seem like isolated instances of hatred that, however outspoken, hardly amount to a program of liquidation. But they have the same depressing effect as one; America, after all, is not so different for the Jew. If blacks, who also have been the victims of prejudice and persecution, feel free to heap contempt on Jews, then not even American society is completely safe for them. Blacks are Christians, and America is a Christian society, and thus blacks are implicitly more

American than Jews, and like every Christian they are entitled to project their discontent onto Jews. The Christian does so with a self-righteousness that broaches no appeal to conscience: so long as Jews are bad, Christians can feel good, whatever their lot in life.

The recent disclosure that Secretary of State Madeleine Albright, raised a Catholic, was born a Jew – that her family repudiated its Jewishness to escape anti-Semitic persecution – is sure to affect Christian society's attitude to her. She is no longer really part of it: she got where she got because she's a "smart Jew," to allude to Sandor Gilman's account of that stereotype,[1] not because she's just plain smart, or, more subtly, because her ambition was supported by her identification with her father, also a diplomat. Should American foreign policy fail, she is the ready-made scapegoat: it had to fail because it was secretly "Jewish," not because it was misguided. Regarded as superior, the Jew is set up to take the fall as the scapegoat for Christian society's failures and problems. Especially the social and economic ones to which there seems no solution short of revolution: being stateless and classless in the popular mind the Jew can be blamed for the state's oppressiveness and class conflict.

Thus, the Jew is always vulnerable, because he or she never really belongs to Christian society: when Linda Nochlin examines her features in the mirror to see how "different" she really is, she is in emotional fact acknowledging her vulnerability – her feeling of inadequacy, which she necessarily blames on herself.[2] It's built into her appearance – so who else is too blame if she feels bad about herself, however smart she may be? She ought to hate herself, because to be Jewish is to be inherently hateful, and to show it in one's face. To be a Jew is to be ontologically the case, not simply to have a cultural identity. There has been much talk recently of the power and influence Jews have in Christian American society, but the important point is that it is Jews that have the power, not just ordinary Americans. In singling out the "special case" of the Jews, American Christian society, however ostensibly goodwilled, shows that it is inwardly suspicious of the Jews, and unconsciously never accepts them, however much it uses them.

"Jewish art" is also a special case – art outside the mainstream (whoever decides what that is), and barely art – certainly not very significant art – at that. As Harold Rosenberg wrote, when the prominent German Christian art historian Werner Haftmann divided twentieth-century painting into a "Mediterranean mode ... characterized by rationality, harmony, sensibility" and a "profoundly subjective, metaphysical, speculative ... Northern or Germanic mode," such Jewish artists – so Haftmann characterized them – as Chagall, Modigliani, and Soutine were all but squeezed out of art history.[3] Haftmann gave them a "small off-track confine" of their own, despite the fact that, as Rosenberg notes, "there is very little resemblance" between them, and despite the fact that Haftmann could not "explain what it was in their art that made it Jewish." Indeed, as Rosenberg says, "each stems from a different tradition and underwent a highly individual development," and to call them Jewish is to shortcircuit understanding of them, just as to

characterize the work of "Rothko, Newman, Guston, Saul Steinberg and dozens more" as Jewish is to misrepresent and ostracize it. All the more so because they are American, compounding their outsiderness, and thus, by definition, unable to truly understand what it means to make Mediterranean or Germanic art, however much they may attempt to do so. It is thus impossible for them to be authentic, let alone have a significant place in twentieth-century painting.

Haftmann was accused of anti-Semitism by one reviewer, but I think he is a European chauvinist. His book was written at a time when it was perhaps necessary to be one: Europe had just finished destroying itself in the second world war, and it needed something to restore its belief in itself – to rebuild its morale. Haftmann attempted to do so by pointing out that it had produced great art during the first half of the twentieth century, which ought to give it the pride and confidence necessary to go forward in the second half; the world wars were a temporary demoralizing interlude. Haftmann regenerated, as it were, the European avant-garde art that Hitler had labelled degenerate and almost liquidated. Restored to credibility and vitality, it could become the rallying point for a new Europe – the spiritual basis for the new greatness of Europe. Moreover, Haftmann hoped that by recognizing its split artistic identity – parallel artistic paths that were equally valid – Europe would, paradoxically, heal itself: if France and Germany realized that the Mediterranean and Germanic modes complemented rather than conflicted with each other, they could become reconciled.

However, Haftmann's establishment of a European in-group of complementary Mediterranean and Germanic artists – opposite sides of the same European coin – depends upon his exclusion of Jewish artists. Their seclusion in a small section of his book – in effect a ghetto – is unexpectedly pivotal for his conception of twentieth-century European painting. What is crucial for Haftmann, however unconsciously, is that Chagall, Modigliani, and Soutine were "wandering Jews": foreign parasites on Parisian painting. Their dependence on it testified to its greatness – to the basic necessity of the Mediterranean mode. They were not even authentically European, even though Chagall came from Russia, Modigliani from Italy, and Soutine from Poland. These were peripheral, secondary places – marginal to the spiritual centers, France and Germany. They sustained European art; for Haftmann, twentieth-century Russian, Italian, and Polish art became irrelevant after brief "advances," which were themselves derived from – dependent on – advanced French and German art.

Rosenberg argues that Haftmann's reluctance to accept Jewish artists is premised on the idea of "the Jewish mind's ... incapacity for art," a view he finds hidden in Sartre's *Anti-Semite and Jew*. It is "the raw material out of which anti-Semitism has been formed": Sartre, despite his conscious intentions to the contrary, is unconsciously an anti-Semite. Rosenberg writes: "From the image of the man limited to abstract ideas, it is but a step to that of the man dedicated to cash, since the chief abstraction in the modern world is, of course money. The explanation of why the Jews don't have art and the conception that they are devoted to

money fit together and provide a description of a kind of unlikable people." Of course, the Christians forced the bad Jews to handle "dirty lucre" so that they, the good Christians, could remain pure (Calvinism put an end to that illusion), as well as by excluding them from the "higher" professions. (The moneygrubbing of Shylock and Fagin was a defense and matter of survival, not choice.) Art was one of those higher, finer professions, and the Jews were kept from becoming artists because art was concrete not abstract, and superior to money, which worships it.

Nonetheless, the twentieth-century raised, in a big way, a problem Jews had plenty of experience with: "the most serious theme in Jewish life is the problem of identity," and it became the major theme "in the chaos of the twentieth century" and, inevitably, in twentieth-century art. Simply stated, the problem was how to maintain one's identity and individuality and authenticity in a society that had no models for them, and in fact disputed their significance. Collective identity counted more than individual identity – one was understood to be a member of a certain society before one was understood to be an individual – and authenticity was beside the point, and in fact a critical thorn in the side of the collective. It had to be plucked out, and if Jews symbolized authenticity they also had to be plucked out. But splinters always remained: individuality continued to flourish despite social oppression – the indifference of the collective, which threatened to wilt individuality before it could ripen into authenticity.

For Rosenberg, Jewish artists signaled the survival of authentic individuality against the social odds: "American Jewish artists ... began to assert their individual relation to art in an independent and personal way ... help[ing] to inaugurate a genuine American art by creating as individuals." The Jew had long been "inspired by the will to identity" and "engaged with the ... self": modern art became a natural venue, as it were, for working out one's identity in a secular world, an acceptable place in which to assert and explore the self – an empathic environment in which the self could freely breathe and flourish. Thus, as Rosenberg says, the "need to ask ... whether a Jewish art exists or can exist" was eliminated. It was beside the point: to be an artist was in effect to be a Jew, and to be a Jew was to be a kind of artist – an individualist in a collective world, and thus, implicitly, a criticism of it. The Jew became the hero of modern life, to refer to Baudelaire's idea.

This modern dialectic, in which art is used to make an individual point, indeed, even used against the collective, or at least to create a kind of emotional sanctuary within society – an oasis within the collective desert – no longer exists in postmodern art. On the contrary, it is completely determined by collective concerns – a collective mentality; individuality does not exist for it, and it is as though individuality never existed. Nowhere is this more ironically evident than in postmodern Jewish art, as evidenced by the "Too Jewish?" exhibition at New York's Jewish Museum (1996). The artists no doubt believe they are asserting Jewish individuality and authenticity, but, however unwittingly, they show the American Jew to be as much of an inauthentic stereotype – taking his or her identity from the collec-

tive representation of it – as any other American. There is no questioning of the cultural cliché of Jewishness, but implicit acceptance of it, suggesting the meaninglessness of Jewish individuality. It is as bankrupt as any other idea of individual difference in America.

The exhibition demonstrates that the stereotype of the Jew has become an acceptable, conventional part of American Christian society. But this hardly means the end of Jewish alienation and self-alienation; rather, it means their institutionalization. The Jew remains the ultimate alien, but the critical consciousness Jewish alienness once meant – and Jewish self-alienation once generated – has been neutralized. The Jew remains a thorn in the side of Christianity, but the thorn has lost its sting. Hitler was wrong: one doesn't have to literally liquidate the Jews to get rid of them, one has only to appropriate them – to keep the illusion or simulation of the Jew, without his or her substance.

Thus, alienated Jewish critical consciousness has become part of the media spectacle, as Kenneth Goldsmith's *Bob Dylan,* 1995, Deborah Kass's *Four Barbras (the Jewish Jackie Series),* 1992, and Rhonda Lieberman's *Barbra Bush,* 1994, suggest. Jewish difference affords vulgar comic relief, as Neil Goldberg's *Shecky,* 1992 – a display of famous Jewish-American comedians – indicates. Its cutting, ironically self-deprecating mockery has become a media event – a transient amusement, that no one takes seriously – the ultimate American accolade, a sign of banal belonging, of mindless assimilation. The so-called "politics of identity" has become apolitical. Or else the Jew is another good American consumer of luxuries, as Cary Leibowitz and Rhonda Lieberman's *Chanel Hanukkah,* 1991, implies. Adam Rolston's *Untitled (Manischewitz American Matzos),* 1993, makes the point succinctly: there is no longer anything uniquely Jewish about the American Jew. Matzo is as American as pizza: Jewish identity has been completely preempted by American identity, such as it is. The Jew is expected to Christianize – "normalize" – his or her name, as Ken Aptekar's *Albert. Used to be Abraham,* 1995, shows. The Jew preempts himself or herself, as it were, so eager is he or she to be an ordinary member of American society, rather than an extraordinary individual. The Jew no longer knows Hebrew, as the blurred pages of Helene Aylon's *The Liberation of G-d,* 1990–96, imply. It is mechanically recited as part of religious ritual on official Jewish holidays, but it is otherwise not much of a sacred language. The "prominent" Jewish nose has become a fixture of American society, but it is no longer sniffing out the truth: Dennis Kardon's *Jewish Noses,* 1993–95, have little resemblance to those of Marx, Freud, and Einstein. They are simply stereotypical Jewish signifiers, rather than symbols of independent critical minds. We are left with the *Complex Princess* of Nurit Newman, 1995, Hannah Wilke's *Jewish Pareve,* 1982–84 – Venus turned into another Jewish princess – and Archie Rand's expressionistic archaeology of Jewish symbols in *The Chapter Paintings,* 1989 – all equally pathetic, cliché-ridden dregs of Jewish identity (Figs. 41–43). The irony of this art doesn't come through: what does is a standard idea of Jewishness, and a certain narcissistic fascination with it. It is reified rather than brought into question by its "artistic" presentation. That is,

41. Archie Rand, from *The Chapter Paintings* (54), 1989. Acrylic and mixed media on canvas. Each 36 in. × 24 inches. (1)*B'rashit*. Collection of the artist.

it is not transformed, but dogmatized. It is not changed to make an individual point, but presented as a changeless collective icon.

And that's just the tragic point: there's very little artistic transformation of the collective image of Jewishness – can one call its glamorization "artistic transformation?" – suggesting that for these postmodern artists art is no longer an instrument of individuation, as it was for the Jewish modernists Rosenberg mentions, but a means of conformity and confirmation of the status quo. Art exists passively rather than actively in their work. It is a secondary rather than primary concern. Rona Pondrick's *Swinger,* 1992, is the only example of radical transformation – a brilliant surreal-conceptual composite of bloody victim and blackbooted victimizer – but it is the exception that proves the rule. This, I think, is because the art exhib-

42. Archie Rand, from *The Chapter Paintings* (54), 1989. Acrylic and mixed media on canvas. Each 36 inches × 24 inches. (27)*Tazriah*. Collection of the artist.

ited is media-based – newspapers play a prominent part in Pondick's hanging sculpture – rather than Mediterranean or Germanic, that is, rather than grounded in historical tradition. The media is the premier American art mode, and the media neutralize whatever they mediate into a formula. They deal only in stereotypes – stereotypes so fixed and rigid they are hard to bend to the purposes of individuality. Stereotypes establish sameness rather than difference, or else they turn difference into sameness by making it seem uniform and predictable. The stereotype is a mock individual, with no authenticity, however much it apes real appearances. What we see in this exhibition is the Hollywoodization of the Jew, and the confusion of Hollywoodization and artistic transformation – the achievement of individuality through art.

43. Archie Rand, from *The Chapter Paintings* (54), 1989. Acrylic and mixed media on canvas. Each 36 inches × 24 inches. (53)*Haazinu*. Collection of the artist.

This postmodern Jewish art is, I think, symptomatic of a larger sociocultural issue in America: the pressure to homogenize. Multiculturalism – the exhibition in effect declares that Jewish culture is an indispensable part of multicultural America – masks this pressure, but the media keeps it up, indeed, shows the way: shows us how we can all become stereotypes of ourselves – standardize ourselves into identity packages. Multiculturalism is paradoxical: it maintains the facade of heterogeneity while homogenizing it, that is, totalizing diversity so that individual difference is standardized. The Jew had an identity advantage, as it were, when he or she was persona non grata ontologically; now that Jewish difference is merely cultural, the Jew has become part of the identity spectacle of American society.

The Jewish-American is another hyphenated identity, taking its place alongside the African-American, Italian-American, Hispanic-American, and so on, and

embodying as little substantial difference as any of them. The hyphen is a residue of immigrant status, and all Americans were once immigrants – eager to become part of the modern New World and leave the traditional Old World behind them – but to be an immigrant has become another American stereotype. But without the hyphen it would not be clear what it means to be an American – without the qualification of an alien identity American identity would not have much point. Indeed, the existential emptiness of "being-American" would become self-evident: the uncertainty of what it means to be an American is built into American hyphenated identity. The "American" part depends on the foreign part for its credibility. American individuality, which Rosenberg defined as resistance against European stereotypes or "uniforms of identity," has also become a uniform and stereotype. American particularity, like Jewish particularity, has been lost – so generalized that it no longer makes individual sense.

This, ultimately, is why Jews have adopted a multicultural – hyphenated – identity: they want to be as American as anyone else, as the "Too Jewish?" exhibition indicates, but like everyone else these days they don't want to be completely American or too American – even though, by accepting a stereotypical media Jewish identity they become completely American – for then they wouldn't have any identity at all. (The artists do not realize that to accept the stereotype as one's true identity is to be profoundly alienated from oneself – more self-alienated than one becomes from internalizing anti-Semitic hatred of one's Jewishness.) In other words, the postmodern hyphenated or hybrid American identity has given up the struggle to be individual and authentic, and makes it clear that the independent new American artist-self Rosenberg envisaged has become an old, time-honored cliché. Thus Americans must return to their immigrant roots to have viable identities, even if those roots have become petrified artifacts in a depressing part of the museum of the American mind.

American Jews have an especially vested interest in declaring their Jewish identity in hyphenated form – making them as much American as Jewish – because the Christian world has never let them take root anywhere for long. Having a hyphenated identity is a way of playing it safe. (Apart from the fact, as the "Too Jewish?" exhibition suggests, that there's great narcissistic satisfaction in having a double identity – that one can never be Jewish or American enough – however cliché-ridden both are.) Although they seem rooted in Christian America – seem to be comfortably integrated, to the extent that many of them have married Christians and abandoned their religion, in fact if not in principle – their history has taught them, with paranoid precision, that one never knows what persecution and ostracization the future will bring.

TWENTY-EIGHT

Meyer Schapiro's Jewish Unconscious

I N 1994, MARGARET OLIN, REVIEWING THE FOURTH VOLUME OF MEYER SCHAPIRO'S *Selected Papers,* observed that Schapiro "only seldom addressed [his] Jewish heritage."[1] Surely, she suggests, it must have influenced his practice of art history and criticism. But she is at a loss to say how. Olin notes that Schapiro's neglect of the issue is all the more conspicuous in view of the fact that his contemporaries, the Jewish-American art critics Clement Greenberg and Harold Rosenberg, openly viewed modern art from a Jewish perspective. While it was one among several heuristic gambits, they often privileged it as the most revelatory: the perspective that could disclose what is most at stake or immanent in modern art.

Thus, Rosenberg argued that anxiety about identity is "the most serious theme" – indeed, the ultimate "metaphysical theme" – in both Jewish life and modern art.[2] Such anxiety was at its height after World War II, which is why many Jews became artists then. Art allowed them to work through their ambivalence about being Jews. They experienced Jewish identity as increasingly problematic in the modern world, yet inescapable – even in the modern world. But it is modern to be alienated from one's received identity, which made the modern Jewish artist exemplary.

Greenberg declared that "Kafka's Jewish self ... tests the limits of art":

When did a Jew ever come to terms with art without falsifying himself somehow? Does not art always make one forget what is literally happening to oneself as a certain person in a certain world? And might not the investigation of what is literally happening to oneself remain the most human, therefore, the most serious ... of all possible activities?[3]

Could Franz Kafka reconcile the Jew and artist in himself? Did he use his art to understand his situation as a Jew in a Christian world? If a Jew turns to art to strengthen his sense of self – to survive emotionally in a world in which he is always suspect – isn't he turning away from God? Doesn't art help one remember – indeed, embody – what emotionally happens to one in the world, and isn't that more essential than what literally happens to one?

Modern art in particular raises such questions for Greenberg, for it tends to be alienated from the world it represents. And the modern Jewish artist – most noteworthily, Kafka – has a certain ironical advantage or head start, for he or she can graft the alienation inescapable in modern life onto the alienation built into Jewish existence, the alienation that is the Jew's birthright. Thus, contrary to all expectations, the Jew is in a position, by reason of his or her emotional if not religious heritage, to become the exemplary modern artist, which is what Kafka was for Greenberg. While "the Jewish truth, or the truth of [Kafka's] Jewishness … accounts for some of the frustrations of his art,"[4] it also reminds us that "one of the functions of art [is] to keep contradictions in suspension, unresolved."[5] Thus, the artist is entitled to "inconsistency," however much "the triumph of art lies – as always – in [the] reconciliation" of "contradictory impulses."[6] Kafka's stories are a major test of art, for in them the impulse to make art is in conflict with Jewish awareness of menace, even as they ingeniously use art to bring the reader to full, excruciating consciousness of it, and to transpose it to the modern world: Kafka's triumph is to make its menace unmistakable – traumatic and overwhelming.

The question as to whether Jewish identity and artistic identity can be reconciled – whether the apparent contradiction between them can be overcome – seems very far from Schapiro's thinking about modern art, and art in general. And yet, as I hope to show, it is as important for him as it is for Greenberg and Rosenberg, but much more subliminally. Like them, Schapiro was an early, forceful advocate of Abstract Expressionism. And like them, he thought that selfhood or identity was the central issue of modern art, as his studies of Cézanne and van Gogh indicate. But this rarely involved Jewish identity, at least overtly, as it tended to in the thinking of Greenberg and Rosenberg.

Only in Schapiro's essay on Marc Chagall's Illustrations for the Bible does he explicitly deal with an artist's Jewishness. And there its effect on his art is remarkably positive. It was because of his Jewishness that Chagall "surmounted … the limits of his own and perhaps all modern art," Schapiro writes.[7] Jewishness kept him in touch with "the full range of his emotions and thoughts," unlike other modern painters, whose "enthusiasm for new and revolutionary possibilities of form and … desire for an autonomous personal realm" led them "to exclude large regions of experience from their work." Jewishness gave Chagall's art a broad humanity not always in evidence in modern art. Schapiro's essay is the only place I know of where he criticizes modern art; he usually praises the modern artist's preference for "the spontaneous, the immediately felt,"[8] indicating his "remarkable inner freedom."[9] Thus, while Chagall "owes much to the happy conjunction of his Jewish culture – to which painting was alien – and modern art – to which the Bible has been a closed book," he is a "rare," virtually unique phenomenon. In more ways than one: he is the only consciously Jewish artist, modern or otherwise, Schapiro deals with, apart from the anonymous artist who created The Bird's Head Haggada: An Illustrated Hebrew Manuscript of ca. 1300.

The absence of sustained, explicit engagement with the question of Jewish iden-
tity in Schapiro's oeuvre is all the more surprising in view of the fact that he never
denied his Jewishness, unlike the great connoisseur Bernard Berenson, who
actively repudiated his Jewishness by converting to Christianity. Berenson ini-
tially became an Episcopalian – the thing to be at Harvard and in the world of
Boston Brahmins that Berenson moved in – and then converted to Catholicism,
supposedly out of love for the woman who became his wife, but also because it
was the thing to be in Italy, where Berenson settled. Sounding like an anti-Semite,
Berenson in fact once wrote that "the puzzling character of the Jews ... and their
interests are too vitally opposed to *ours* [my emphasis] to permit the existence of
that intelligent sympathy between *us* [my emphasis] and them."

I am quoting from "Mr. Berenson's Values," Schapiro's notorious 1961 essay on
Berenson.[10] Schapiro's title clearly suggests his determination to separate his val-
ues from those of Berenson. Berenson's disavowal of his Jewishness – his identifi-
cation of himself as a Christian – is completely alien and repugnant to Schapiro.
Olin focuses on the essay, correctly regarding it as essential for understanding
Schapiro. It not only reveals, as she writes, "the complexities of the experience of
Jewish art historians and critics,"[11] but the Jewish thread in Schapiro's labyrinthine
writing about art. To use Henry James's phrase, the essay strongly suggests that a
Jewish figure can be deciphered in the carpet of Schapiro's consciousness of art, if
one cares to look carefully. Jewish identity is the irrepressible issue of Schapiro's
discussion of Berenson, leading one to suspect that it must be inherent to his out-
look, if usually unconscious. It is as though, dealing with Berenson, Schapiro
could no longer repress himself, for Berenson's denial of his Jewish heritage – a
temptation for many assimilated Jews, indeed, a confirmation of their assimila-
tion. And yet, as Schapiro subtly shows, it was a peculiarly Jewish achievement:
Berenson's Jewish identity gave him the strength of character and cunning to sur-
vive and flourish in alien circumstances. Schapiro's essay is a remarkable tour de
force: a vigorous, if ironical affirmation of the benefits of a Jewish identity. More
crucially, Berenson forced Schapiro to show his hand – to signal, decisively if only
once, the important, even crucial role Jewish identity played in his view of art.
Indeed, I will argue that for Schapiro the most innovative artists were Jewish in
spirit – that he believed authentic innovation was only possible from a "Jewish
position" in society.

Schapiro deals with Berenson's Jewish identity at great length. However, inter-
estingly enough, the index to volume 4, in which the essay is reprinted, does not
mention Jewishness. In general, there are few references to it in any index in any
volume of Schapiro's *Selected Papers*. In the index to volume 3, devoted to *Late
Antique, Early Christian and Mediaeval Art*, mention is made of "Jewish art,"
"Jewish literature and folklore," and the (good) relations between Jews and
Christians in the Carolingian Empire. But apart from that, only the first volume,
on Romanesque Art, discusses "Jewish beliefs." Two of the five references are to
footnotes. The relative paucity of reference to things Jewish is no doubt pre-

dictable in the context of an analysis of Christian art. But, as I will argue, it is the fact that they occur in this context that gives them peculiar weight.

Berenson and Schapiro had a certain amount in common. Both were Lithuanian Jews, born almost forty years apart, Berenson in 1865 and Schapiro in 1904. Yiddish was their first language. But Schapiro never changed the surname that identified him as a Jew, while Valvrojensky became Berenson. And Berenson's birthplace was no longer Butremanz but Vilna, which is the way it is still listed in the *Encyclopedia Britannica*. Thus, Berenson falsified his identity, while Schapiro remained true to his. Noting these facts, Schapiro observes that Berenson, "through his interest in old Italian art ... was able to surmount" the "troubling" question of his Jewish identity and origin by "transposing the questions: Who am I? Where did I come from? to the challenging problem of the identity of artists, creative personalities known by their first names" and widely admired "but often mistaken for others in the labeling of works."[12] Berenson created a new identity as a connoisseur of Italian art out of an early identity as a specialist in Oriental languages. (At Harvard, he studied, apparently with rabbinical diligence and fervor, Arabic, Assyrian, Hebrew, and Sanskrit.) It paralleled his change of religious (and social) identity from Jew to Christian. These self-transformations clearly interest Schapiro as creative solutions to the problem of identity. For Schapiro, Berenson's self-creation suggests a kind of artistic resourcefulness.

In fact, for all his skepticism about Berenson, Schapiro is not without a certain admiration for him, especially because of his ability to survive in an alien, inhospitable world. Even though Berenson was a Jew from the "uncouth ghetto," Schapiro writes, he was able to force "the New England patricians [to] meet him on the higher ground of culture, in his personally created establishment in the land of the great Renaissance painters."[13] "A frail little man, an aesthete dreaming of Pater's Marius, [Berenson] had the will and energy and intelligence to achieve authority and a social position,"[14] as well as to make a fortune. Indeed, Schapiro remarks, not without a certain respect and perhaps surprise, that "through all dangers [Berenson] landed on both feet, even under Fascist anti- Semitism and with Hitler's army in Italy during the Second World War." Berenson in fact was once a role model for Schapiro, until a moment of disillusionment, which he describes in his essay. Certainly their paths were different, yet Schapiro identified with Berenson as a Jew making his way in a Christian world openly prejudiced against Jews. Berenson's will to survive and even flourish, materially and intellectually, against all odds, testifies to his Jewish pride for Schapiro. Thus, Berenson remained a Jew on the inside, however much, on the outside, he denied that he was one.

In his Berenson essay, Schapiro makes it clear that he is deeply concerned with Jewish identity and, more crucially, its relationship to artistic creativity. But this concern is, paradoxically, not generally visible on the surface of his writing (perhaps because it is deep). Nonetheless, it is possible to infer, and demonstrate, that for Schapiro the creative, paradoxical way Jews – Jews like Berenson – survive and

establish an identity in a world that barely tolerates their existence is the model for the way artists achieve their creative identity. That is, the paradox that art becomes when it is most creative exemplifies what might be called the Jewish Paradox. I will offer a reading of Schapiro to prove my point. I will even attempt to explain why the Jewish truth in Schapiro necessarily remains hidden, however profoundly his thought is informed by it.

For Schapiro, all authentically creative art – which is not every art – is subliminally Jewish, not in a doctrinaire sense but in attitude. This holds for modern art, which Schapiro regards as a particular triumph of creativity, but also for the remarkable sculptures of the Romanesque abbey church of Souillac. Both show the Jewish Paradox in action. For Schapiro, the achievement of creative art, in whatever society it occurs – and he studied it primarily in medieval Christian society and modern Capitalist society – is Jewish in a generic sense. Thus, while Schapiro doesn't use the word "Jewish," the negative social experience out of which artists make something esthetically positive through their creative mastery of it, is fundamentally Jewish. The Jew's social role is to represent creative survival against great odds, which is why, however persecuted, Jews are never completely exterminated: they represent society's need to believe in its survival, indeed, immortality. The Jews have been called the "eternal people" for good reason: they carry the austere banner of eternity for society. But this is also why they are regarded ambivalently: the requirements of eternity often interfere with those of the moment. Eternity is fairly demanding; it doesn't accept half-measures. The creative artist is also a survivor – that is, a person who can establish an identity and sense of self and individuality against great odds. The artist also represents a possible immortality; truly creative art is not just made for the moment. The Jewish Paradox is cross-cultural and verges on being an historical paradigm for Schapiro, but the important point is that it signals a common problem artists face wherever and whenever they live, especially if they want to be original. The Jewish Paradox is, then, the root paradox of art for Schapiro. He understands its history through this paradox and at least two other paradoxes that follow from and, in a sense, explicate it. Schapiro uses them to make art at its most creative and innovative intelligible. I emphasize that while Schapiro is thoroughly familiar with the history of art, he concentrates on works of art that show the most originality. Carefully analyzed, as Schapiro does in great empirical detail, they make it clear that originality is a peculiarly paradoxical achievement.

A *paradox*, according to the *Oxford Universal Dictionary*, is "a statement or tenet contrary to received opinion or belief." It can also be "a statement seemingly absurd or self-contradictory, though possibly well-founded or essentially true." The prefix *para* signifies "by the side of," often implying "amiss, faulty, irregular, disordered, improper, wrong," as well as "subsidiary relation." To what? To the orthodox, which the dictionary tells us means "right in opinion," "holding correct, i.e., currently accepted, opinions, especially in theology." Paradox, then, has a certain resemblance to heterodox, which means "not in accordance with estab-

lished doctrines or opinions, or those generally recognized as orthodox," "originally in religion and theology," that is, in the theory and practice of spirituality. But paradox is not just discordant; in contradicting established doctrine, it establishes self-contradiction. It carries difference to the point of absurdity. More precisely, it goes against received opinion and belief, but it does not offer a different opinion and belief. Rather, it signals the absurdity of all opinion and belief. It frees us from any and every existing opinion and belief. That is, paradox offers us spiritual liberation. It releases us from our bondage to *doxia*, to use the Greek word. Instead of doctrine, it gives us a certain sense of spirit.

Thus, in a paradox, opposites unite to creative, spiritual effect. What looks absurd and incoherent from the aspect of ordinary logic, has a spiritual logic: the logic of transcendence of received doctrines of any kind, leaving one with a sense that no opinion is fixed forever, indeed, that belief is beside the point of spirit. Rather than dismissed as a deadend logical puzzle, the paradox can be experienced as a form of play and, as such, a sign of spontaneity and freedom. Schapiro is obsessed with them. Again and again, he celebrates them as characteristic of truly original art. Indeed, they are art's ultimate gift to us.

Let me bring this down to earth. The Jew is by definition heterodox within an orthodox Christian world. That is, the Jew has different received opinions and is in the minority. In a world of Christian orthodoxy, the Jew is radically Other. Jews are by definition outsiders, not only "within the bourgeoisie," as Max Horkheimer said,[15] but because they have a "basic common experience ... that no degree of conformism was enough to make one's position as a member of society secure," that is, a long "experience of the tenacity of social alienation."[16] The question is how the heterodox minority can survive the domination of the orthodox majority without being submissive and without surrendering its beliefs. The answer is by becoming creative. What does it mean to be creative? It means to establish what Schapiro calls a "chiasmic, antithetic"[17] or "discoordinate"[18] relationship with orthodoxy. How does one do this? By treating its beliefs spontaneously, which affords a certain sense of freedom from them – and unwittingly undermines them or forces them to change. Spontaneity is rebellion within a system of orthodoxy and conformity, only the conforming orthodox do not realize this until it is too late for them to do anything about it – to inhibit or censor it.

Similarly, the artist is heterodox within an orthodox world of conformity, be it Christian or Capitalist. He has to work with its received opinions, but he can treat them in a spontaneous, creative way, which liberates him from them. If he is a good Abstract Expressionist painter, he produces a painting that conveys a sense that there are no received opinions – a giddy sense of spontaneity and freedom, which undoubtedly looks like anarchy to the orthodox and doctrinaire. If the artist is a sculptor working on Souillac, the artist produces a self-contradictory work of art that, by reason of its interplay of sacred and profane elements, seems to undermine the official hierarchy of being. In the case of both Jew and artist, the way of responding to the dominant, deadening, doctrinaire orthodoxy is para-

doxical, and the result is a vital spiritual paradox – the core of a sense of identity. For Schapiro, art is the individual's creative solution to the problem of oppressive orthodoxy that demands conformity. The individual's nonconformist, unorthodox resources of spontaneity and inner freedom can resist and replace it.

Schapiro is acutely aware that the original work of art that embodies the individual's unorthodox solution to the problem of survival and identity in an orthodox world is likely to be aggrandized by it as a subsidiary identity. Ironically, the work becomes proof of orthodoxy's own survival power, as well as a demonstration that, after all, it is not so oppressive. Orthodox society honors unorthodox art to show its tolerance of nonconformity and insubordination, but it does so only after the fact, that is, after it created an oppressive world that made unorthodox originality – "insurgent convictions"[19] – necessary for survival.

Thus, Capitalism, the dominant orthodoxy of the modern world, turns unorthodox art into a commodity. In a famous passage, Schapiro deplores the commodification of art, which exploits its essential spirituality, to use his own word.[20] Paradoxically, it is only as a commodity that art survives – just as, paradoxically, it was only as a Christian that Berenson survived and was able to devote himself to eternal art. Similarly, Christianity, the dominant orthodoxy of the medieval world, assimilated Romanesque art, which is only nominally Christian. As Schapiro wrote, Romanesque art was "a new sphere of artistic creation without religious content and imbued with values of spontaneity, individual fantasy, delight in color and movement, and the expression of feeling that anticipate modern art."[21] For Schapiro, such qualities suggest that Romanesque art, like "much of the best art of our day ... [was] strongly critical of contemporary life," that is, the dominant Christian orthodoxy.

Romanesque art and modern abstract art are the poles of Schapiro's interest. They converge: in a sense, what Romanesque art began climaxes in modern abstract art, which, "more passionately than ever before, [is] the occasion of spontaneity or intense feeling. The [abstract] painting symbolizes an individual who realizes freedom and deep engagement of the self within the work."[22] Such deep engagement is a criticism of society. Intense feeling, ostensibly religious, but issuing in a new aesthetic, is implicitly critical of orthodoxy. As Schapiro argues in his brilliant analysis of the socioeconomic basis of early modernist art, the spontaneity of "early Impressionism ... had a moral aspect ... its unconventional, unregulated vision ... [is] an implicit criticism of symbolic social and domestic formalities."[23] It was an antidote to "a sense of helpless isolation in an anonymous, indifferent mass." But within a decade "the enjoying individual becomes rare in Impressionist art," and in Neo-Impressionism even "the private spectacle of nature" disintegrates. What is left is "the social group" broken up "into isolated spectators, who do not communicate with each other," as in Georges Seurat's masterpiece *La Grand Jatte* (1884–86), and the representation of "mechanically repeated dances submitted to a preordained movement with little spontaneity," as in Seurat's *Study for Le Chahut* (1889) and Toulouse-Lautrec's *Moulin de la Galette*

(1888). The art of Gauguin and van Gogh is a "groping to reconstitute the pervasive human sociability that capitalism had destroyed" – to not suffer the fate of the listless, numbed, ironically dispassionate figures we see in Seurat and Toulouse-Lautrec. "But since the artists did not know the underlying economic and social causes of their own disorder and moral insecurity, they could envisage new stabilizing forms only as quasi-religious beliefs or as a revival of some primitive or highly ordered traditional society with organs for a collective spiritual life."

In other words, the Impressionists, Neo-Impressionists, and Symbolists were faced with the Jewish Paradox. They were forced to use their creativity in a life-threatening situation over which they had no control. Schapiro dissects various artistic solutions to life-threatening Capitalism and, implicitly, Christianity. The solutions, which are the result of a desperate struggle for emotional survival in an objectively oppressive society, as Schapiro emphasizes, involve the same spontaneity and inner freedom. The artist has the courage of his spontaneity and projects his inner freedom into his art. His artistic solution to his psychosocial problems is personal, but it clearly has social import, which is why society eventually enshrines it, without necessarily understanding it. Indeed, society has to forget the reason for originality – rebellious criticism of it – to "recognize" an original art. Such a recognition invariably involves a falsifying reconceptualization of the art as a purely formal matter.

For Schapiro, the dialectic or paradox of originality or genuine creativity involves a heterodox individual who criticizes and contradicts an orthodox system of opinion and belief with his own spontaneity and inner freedom in order to survive and establish his or her independent identity or autonomy, a word Schapiro frequently uses. The irony of originality is that the individual has to identify partially with orthodoxy to defeat it or, rather, transform it into a symbol of himself or herself. Vestiges of orthodoxy – that is, orthodox iconography, indicative of received social opinion, and orthodox style, indicative of a received conception of creative art (as though it was simply a mimicry and reiteration of received ideas) – survive within the artist's unorthodox representation of it, which not only reveals its underlying truth but symbolizes the artist's opposition to it. Basically, what the artist wants and creates is breathing space: the work of art is an unorthodox space in which it is possible to breathe in an emotionally stifling orthodox society. The highest accolade Greenberg could give a work of art was to say that it "breathed." Schapiro says something similar – spells out what it means to breathe, and in fact at one point uses the same language Greenberg does.

The Jew needs breathing space in the Christian world, just as the artist needs breathing space in the Capitalist world. Both represent strange breathing spaces – perversely healthy alternatives to stuffy orthodoxy. Like the Jew, then, the artist constantly monitors a threatening environment – an environment that asks him to sacrifice his creativity to some orthodoxy and, if he refuses, tries to impose it on him. Like Berenson, the artist may, on the surface, give in to survive. (It is worth noting that the conception of art as a mode of health is Nietzschean, but

Nietzsche didn't realize as fully as Schapiro its ironical character and social place. It should also be noted that, unlike Greenberg, Schapiro believes, and demonstrates, that Jewishness, as an inescapable state of mind for the sensitive individual, and art, as a creative escape from it, are not only compatible but inseparable.)

Spontaneity and inner freedom show themselves through what Schapiro calls "discoordination" and chiasmic dialectic – paradox in action, as it were. Discoordination, Schapiro writes, is "a grouping or division such that corresponding sets of elements include parts, relations, or properties which negate that correspondence."[24] Chiasmic or negative dialectic is the root of discoordination, that is, it results in a discoordinated or negative esthetic. According to *Webster's Dictionary, chiasm* is a term derived from anatomy; it means "intercrossing or decussation." The optic chiasma is "the optic commissure or decussation of the fibers of the optic nerve." More directly relevant to the idea of dialectical creativity is chiasmatypy, a term from genetics that designates "the supposed spiral twisting of homologous chromosomes about each other during parasynapsis, with fusion and possible crossing over at the points of contact." Put this another way: the heterodox and orthodox, which are homologous except for one gene of belief – the crucial difference – conjugate to paradoxical effect. Schapiro explicitly asserts that this dialectical process of ironic doubling is the method of individualization or individuation. Actually, he is obsessed with the structure of opposition and its dialectical resolution in paradox. He is always disclosing the paradoxical doubleness of the artistic phenomena he investigates, be they works of art or such critics as Eugene Fromentin and Denis Diderot, who are, in their different ways, role models for him, because of their awareness of doubleness.

Thus, Schapiro speaks of the "calculated ambiguity" of art,[25] Champfleury's "double attitude ... to the events of 1848 and 1849,"[26] the "double character of the mousetrap ... as domestic object and theological symbol" in Robert Campin's Merode Altarpiece,[27] the "double process" whereby religious authority becomes humanized and realism spiritualized in that same altarpiece[28] – a process basic to the most creative religious art – and a "double gesture ... not merely designed to represent a more complex interaction, but ... an element of a style which promotes contrasts and movement," and "constitutes an expressive form as well as an expressive symbol."[29] Important images always have a "double character," particularly in Romanesque art, and particularly images of force, which Schapiro shows a special interest in. He repeatedly analyzes "counterpart elements," "counter movements," "counterpart patterns," "counterpart symmetrical gestures,"[30] contrasts of color[31] and direction,[32] as when legs vigorously cross in a stark X form.[33] He loves paradoxes of meaning, as when he notes "that just as two unlike words (or syntactical forms) may have a common ancestor, so in different languages two similar words with the same meaning may be independent of each other."[34] Thus, the paradoxical import of *saltimbanque* and *banker,* which both derive from the same bank or bench of the fairs. But the former symbolizes the impoverished yet independent artist, in theory a person of free, spontaneous,

deeply feeling spirit, and as such heterodox, whereas the latter names an author-ity on and priest of money, a pillar of the Capitalist orthodoxy.[35]

Schapiro is taken with juggling and any kind of juggling with words and visual forms, with the way new art negates old art while "the old may persist beside the new in affirming an opposed or declining culture,"[36] and with Augustine's dialec-tical conception of beauty – "God is an artist who employs antitheses of good and evil to form the beauty of the universe, and ... where beauty is a compound of opposites, including ugliness and disorder."[37] He loves, as he says St. Bernard did, "striking contrasts, violent and astounding oppositions, ... the antithetic and inverted."[38] He admires Piet Mondrian's "asymmetry of unequal lines."[39] Van Gogh's paintings achieve their agonizing quality by means of "counter-goals," "competing centers," and "competing directions."[40] Their power derives from "crossing diagonals," their "strain" or tension from "self-conflicted" forms.[41] Cézanne's art engages us, emotionally and intellectually, because of his "practice of the other pole,"[42] his attempt to overcome the "polarity" between color and line as well as self and nature, and in general his use of "counterpart shapes"[43] and "color contrasts."[44] Schapiro speaks of the "stress of contrasts" in Cézanne's paintings[45] and the "contradictions" in those of van Gogh.[46] In the *Wheatfields,* van Gogh "is caught up across the yellow fields from the chaos of the paths and the dread of approaching birds and carried to the deep blue sky, the region of the most nuanced sensibility, a pure, all-absorbing essence in which at last subject and object, part and whole, past and present, near and far, can no longer be dis-tinguished."[47] Romanesque art makes similar use of chiasmic form to achieve an effect of sublimely nihilistic indistinguishability and ironical totality. "Expressive dualities," "polar forms," "polar ideas," acquire their particular weight "within a prevailing system of (social) values,"[48] just as the doubleness of the Jew's existence has its weight because of its ironical place in the prevailing system of social values. Schapiro's sense of dialectic is derived from his reading of Hegel and Marx, who offer "an explanation of active historical process," and from Alois Riegl, who examines "possible latent internal conditions" of development by analyzing the "oppositions within a style" (or society) that render it "unstable and hence sug-gested fresh changes and solutions."[49]

But it is also derived from his feeling of being a Jew in the opposition, forced either into submission or independence, or dialectically, some creative compro-mise between the two, such as Berenson in his way – and Schapiro in his way – achieved. It has been said that psychoanalysis is a Jewish science. I would rather call it the Jewish revenge, its revenge consisting in its demonstration that there is conflict behind even the most sanctimoniously orthodox, socially unctuous facade. One might say that Schapiro devoted a good part of his career to Christian art in order to demonstrate that it is highly – indeed, violently – conflicted and full of awkward compromises, that is, contradictions and bizarre syntheses of opposites, which give the lie to the Christian profession of universal reconcilia-tion. In doing this – in going right to the center of traditional art history, namely,

the study of Christian iconography and classical or classicizing style – Schapiro subverts traditional art history, in the process turning it into what might be called a Jewish science, that is, a science of esthetic and moral paradoxes. Art is a matter of unbalanced psychosocial forces brought into precarious, unpredictable balance, not of divinely foreordained harmony, a preconceived unity whose historical and formal exemplification in different styles is ultimately beside the point. Also, in showing that the most dynamic Christian art is implicitly modern, he shows that art history cannot help but be modern itself – that is, the study of dynamic dialectical process – rather than the reification of existing modes of art into ideal, absolute models, which is what occurs under the guise of classification.

Schapiro needs modern art to come to his aid – which in part is why he supports it and identifies with its oppositional spontaneity and inner freedom – because he is taking on the traditional art-history establishment, which is heavily invested in traditional art, and thus supports Christian orthodoxy whether it wants to or not. One only has to realize that many traditional art historians think modern art was an experiment that went awry to appreciate the courage of Schapiro's conviction. And one has to realize that Schapiro wrote next to nothing about Renaissance Christian art, which is the stronghold of traditional art history, to realize how unorthodox an art historian he is. (His most "Renaissance" essay is his response to Freud's essay on Leonardo.[50] There, with his usual irony, he goes against psychoanalytic orthodoxy with an orthodox art-historical approach.)

Schapiro's vision of art stands in paradoxical opposition to traditional art history not only because it unites traditional Christian and modern Capitalist art at their most critical and intense, but because in doing so it contradicts two of the most basic tenets of traditional art history: namely, that the esthetic and the moral have nothing to do with each other, and that traditional art must be understood in its own terms, without reference to modern art and modern ideas. The first assumption is equivalent to saying that spontaneous form and social content have nothing to do with each other, a view Schapiro fiercely combats in his critique of Jurgis Baltrusaitis's conception of Romanesque art[51] and in his critique of Alfred Barr's conception of the development of abstract art.[52] The second assumption amounts to asserting that there is no continuity of human issues in art history, so that the art of the past cannot live in the present, a view he attacks in his critique of Berenson's attitude toward modern art, among other places. For Schapiro, both assumptions reduce the living art of the past and present to irrelevance and inhumanity. They do this by denying the enduring human, subjective purpose of formal innovation.

Formal innovation is always motivated by the desperate wish to maintain the feeling of being emotionally alive and autonomous, as he argues in his essay "On the Humanity of Abstract Art" (1960). Abstract art, he writes, reflects "the pathos of the reduction or fragility of the self within a culture that [is] increasingly organized through industry, economy and the state," a potentially fascist situation that "intensifies the desire of the artist to create forms that will manifest his lib-

erty."[53] Orthodoxy carried to an extreme becomes fascist, squeezing out, even obliterating the sense of selfhood, which turns to art to rescue and preserve itself. In general, Schapiro's essays on modern art are an implicit critique of the totalitarian and authoritarian tendencies of Capitalist orthodoxy, just as his essays on early Christian art, particularly Romanesque art, are a critique of the totalitarian and authoritarian tendencies of Christian orthodoxy. This is part of their creative Jewishness. Genuinely creative art, like creative Jewishness – the Jewishness of Schapiro and, to a lesser extent, Berenson – is a mode of adaptation to an oppressive society, and as such a declaration of independence and liberty, which is why, as Schapiro says, it moves us deeply. It reminds us that even in the most impossible circumstances we can survive and even have autonomy, if only inwardly.

The two paradoxes through which Schapiro understands art history are variations of the Jewish Paradox. The first paradox, that one can only understand the sociomoral issues implicit in an art by understanding its esthetic character, is capsulated in his assertion that "aesthetic feeling … [can] be a starting point of radical thought."[54] "The aesthetic … [can] sublimate the imperfections of the world," and in doing so criticizes it. If esthetics is not a spiritual transformation of "common experience," and if it does not address "the problems of mankind," then art "risks becoming empty and sterile."[55] For Schapiro, the contradiction between esthetic spontaneity and moral content first appeared, in its modern form, in Diderot's thought. He resolved it by imagining an art of "passionate morality."[56] While being "an ethics of altruism" and an "implicit critique of egoistic indulgence," it nonetheless conveyed "the general principle" that "art in modern society requires for its life the artist's spontaneity."[57] According to Schapiro, Diderot was among the first to recognize this principle and regard spontaneity as a moral, indeed, altruistic matter. Of course, Schapiro, with his usual wary irony, cannot help but note that Diderot's vision of "the artist's independence" was subsumed, in our century, by his vision of art as "a moral and civic agent," leading to its use as "an instrument of despotism and a support of mediocrity"[58] by such totalitarian and authoritarian societies as Nazi Germany and the USSR. Perhaps Schapiro's most probing formulation of this paradox is his view that the doubleness or contradictoriness or precariousness of form in the best art is a sign of "searching conscience,"[59] as he calls it. Creative originality is a form of searching conscience.

Schapiro's second paradox is that one can only understand the past through the present, a notion that he regards as a cliché of understanding. Nonetheless, it is suspect among traditional art historians, because they do not see the spiritual continuity between the best traditional and the best contemporary art. Schapiro's attitude is that of Fromentin, one of his critic heroes: "Studying the works of the past, he strives to make himself contemporary with them as actions of a spiritual moment and a mood."[60] This is why, like Fromentin, Schapiro "can speak … of the execution or colors or arrangement" of a work of art "as noble, generous, passionate, or candid," that is, "as possessing … the attributes of a superior humanity."[61] In other words, art can embody a "full humanity." Indeed, it can be more

human than human beings, for they displace the hopes and aspirations they cannot realize onto it.

Schapiro's conception of the spiritual exchange that occurs between past and present art – an exchange that allows us to understand both more comprehensively and deeply than the traditional division of art history into disconnected and incompatible periods – is perhaps at its clearest in his argument that "modern practice disposes us to see … prehistoric works as a beautiful collective palimpsest."[62] Schapiro believed that Berenson "failed to grow" "as a theorist and critic"[63] because of his contempt "for contemporary taste in art"[64] – he denounced "the whole of contemporary art as degenerate,"[65] not unlike the Nazis – even though "Berenson's aesthetic, with its categories of 'Form, Movement, and Space,' and his stern insistence on the highest values of art, seems in the line of thought which produced modern painting."[66] (They are the basics of visual art. The question for Schapiro is whether they are realized spontaneously and paradoxically, thus serving and symbolizing inner freedom, or whether they conform to some current orthodoxy's fixed conception of selfhood and society.) This is ultimately why Schapiro thinks Berenson is ridiculous as a mind and even inauthentic as a connoisseur. Schapiro in fact cites several examples of major errors of attribution made by Berenson, casting doubt on his famous eye and his motivation for making the attribution. Many of the Renaissance works involved are not by the master's spontaneous hand, even to a novice eye. But in proclaiming that they were, Berenson increased their economic value and his profit enormously.

At its most literal, Schapiro's Jewish Paradox asserts that Christian art can only be understood through Jewish spirituality and spontaneity. In fact, Christian art reifies the Jewish Bible into a dogmatic iconography. Even the idea of Christ is a reification of the Jewish idea of the Messiah, a hopeful, spontaneous wish fulfillment. Christian art historians do not sufficiently realize the Jewish truth at the core of Christian art. It has to be emphasized that Christian art has been the dominant art of the West. It has absorbed every style and moral idea into its orthodoxy. Modern art, with its unorthodox emphasis on spontaneity and inner freedom rather than on blind faith in orthodox ideas, is a passing episode compared with orthodox Christian art. This is why Schapiro defends modern art, and unorthodox Christian art, so strongly.

Finally, consistent with himself, Schapiro is against Jewish orthodoxy – "the demands of [Jewish] ideological conformity"[67] – as much as he is against Christian and Capitalist orthodoxy. This is why there is relatively little explicit mention of Jewishness in his writing. Jewishness is as conflicted as Christianness; that is, Jewishness is not a unified position, but a precarious balance of convictions. It is split in its vision of God: on the one hand, he is a wrathful if judicious patriarch and, on the other hand, pure abstract creative spirit, able to manifest itself spontaneously in a flaming bush or a pillar of smoke. Schapiro preferred the latter conception: God's power was manifested neither in the punitive authority of patriarchy nor matriarchy, but in the pure grace of spontaneous creativity.

Now in this Schapiro is like Spinoza. One of the most interesting parts of Schapiro's essay on Berenson occurs when Schapiro expresses his disgust at the "grotesque comparison"[68] Berenson makes between himself and Spinoza and St. Paul. In contrast to Berenson, they were, Schapiro writes, "two deeply dedicated and uncompromising Jews who, like himself, broke with the religion of their ancestors. But theirs was an act of courageous conviction, while for him the change of religion was a short-lived conversion that helped to accommodate him to a higher social milieu." I believe that Schapiro, in his conception of art as a zone of spontaneity and inner freedom, was essentially a Spinozist. That is, like Spinoza, he broke with Jewish orthodoxy out of courageous spiritual conviction in a creative God, even as, in his rabbinical habits of scholarship and his belief that art at its best is a kind of spiritual creativity – dare one say creation of spirit? – he showed that he was a dedicated and uncompromising Jew.

Like Spinoza, he was a heterodox Jew who had a paradoxical conception of art – a conception that went back to Genesis, not to the orthodoxy of mosaic law. Like Jewishness, art can be reduced to orthodoxy, ritual, rules, and materialism. But, at its best, it is divinely – spontaneously and freely – creative and inward in import. For Schapiro, art is the realm in which the one true God becomes manifest: for him, as for many critic-esthetes, art is a religion – a spiritual enterprise. It replaces traditional religion, which has lost its spirituality as it has become more and more orthodox and dogmatic.

I think Schapiro is the last idealistic art historian-theorist-critic, certainly the last one who can even think of art as spiritual. But he expects more from art than it can give. Even as its best, art promises more than it can deliver; it is, after all, illusion, and illusion has never solved any lifeworld problems. Moreover, even the most spontaneous, creative, inwardly liberated art is full of orthodoxy and conformity, however much it keeps hope alive. No doubt that is no mean feat. It would be interesting to hear what Schapiro, so strong a defender of modern abstract art, thinks of postmodern abstract art, which treats spontaneity ironically, satirizing and stylizing it, and regards inner freedom as a farce. Not only is modern art over, ironically because it has become orthodox and institutional, but the fact that it is routinely parodied and ironically manipulated suggests that it is despised.[69]

In general, the contemporary scene tends toward orthodoxy and conformity rather than spontaneity and spirituality. It is full of oppressive ideological demands that, whether they come from the left or right, cannot help but suppress genuine creativity. The mind-controlling orthodoxies of the left and right cannot help but produce esthetically incompetent, not to say critically inadequate, art. For any orthodoxy – Christian, Jewish, Marxist, Freudian, feminist, multiculturalist, conservative, liberal, and so on – esthetics is ultimately beside the point. Art is only of use to the extent it reinforces ideological conformity, serves orthodoxy. It must never be allowed to serve individualization and individuation – autonomy. But then esthetically adequate art – art with the interiority and dialectical qualities Schapiro cherishes – has always been rare.

Notes

PREFATORY NOTE

1. Lawrence Alloway, "The Uses and Limits of Art Criticism," in *Topics in American Art Since 1945* (New York: Norton, 1975), p. 255.
2. Charles Baudelaire, "What Is the Good of Criticism?" in "The Salon of 1846," *The Mirror of Art,* ed. Jonathan Mayne (Garden City, NY: Doubleday, 1956), p. 41.
3. Ibid., p. 42.
4. Such criticism is meta-creative, as it were, in that it re-creates the original psychic terms of the art. Or, to say this more elaborately, the creativity of the artist consists in his projection of his psyche into a socially credible art, using whatever means are necessary to separate it from himself. In contrast, critical meta-creativity reverses the process – restores the connection to this psyche, thus demonstrating his art's broadly human significance, which may or may not have anything to do with its social success or failure. Humanly telling, it may seem less than art, but as pure art, it may seem less than human, which in the end will detract from its overall significance.

It is a natural tendency of the human mind to interpret any passing phenomenon it encounters. Interpreted, the phenomenon becomes real – dense with complexity and durability – rather than routinely and innocently given. From being an occasional appearance, naively experienced, it becomes a knowable reality, a stimulus to sophisticated reflection. Thus one needs no special justification to interpret human beings and the works of art they make. The only question is how good the conceptual instruments of the interpretation are. They feed back into the phenomena from which they are derived, the way concepts that are derived from experiential impressions clarify and consolidate them into a reality that seems more than matter-of-fact – incidental, transient, inconsequential.

The problem with journalism is that it lacks adequate conceptual criteria to give facts consequence, which alone makes them durably real to consciousness. If human beings are interpreting animals – they are always interpreting their environment, looking for clues to its significance and value – then the journalist who eschews interpretation is not fully human. Selling cognition short – shortcircuiting it – the journalist remains intellectually immature, and also emotionally immature, that is, insufficiently responsive to the phenomena regarded as newsworthy. Interpretation is the cutting edge of responsiveness, for it involves a caring sensibility, integrated with a knowing mind, suggesting that journalists have no deep feeling – developed sensibility – for what they inform us about. This inhibits cognition, however unexpect-

edly. The journalist splits feeling off to report the facts, a disengagement that betrays their human import and value, and lessens the journalist's value and consequence.

INTRODUCTION: WHY PAINTING?

1. Marion Milner, *On Not Being Able to Paint* (New York: International Universities Press, 1957), p. 162.
2. George Steiner, *Real Presences* (Chicago: University of Chicago Press, 1991), p. 229.
3. Calvin Tomkins, "The Maverick," *The New Yorker,* July 7, 1997, p. 42.
4. Meyer Schapiro, "Recent Abstract Painting" (1957), *Modern Art: 19th and 20th Centuries* (New York: George Braziller, 1980), p. 217, notes that "paintings and sculptures ... are the last hand-made, personal objects within our culture. Almost everything else is produced industrially, in mass, and through a high division of labor. Few people are fortunate enough to make something that represents themselves, that issues entirely from their hands and mind, and to which they can affix their names."
5. Max Horkheimer, *Critique of Instrumental Reason* (New York: Continuum, 1974), p. 99. As Schapiro, p. 224, notes, the "concreteness" of painting and sculpture "exposes them, more than the other arts, to a dangerous corruption. The successful work of painting or sculpture is a unique commodity of high market value. Paintings are perhaps the most costly man-made objects in the world. The enormous importance given to a work of art as a precious object which is advertised and known in connection with its price is bound to affect the consciousness of our culture. It stamps the painting as an object of speculation, confusing the values of art."
6. Quoted in Thierry de Duve, *Pictorial Nominalism: On Marcel Duchamp's Passage from Painting to the Readymade* (Minneapolis: University of Minnesota Press, 1991), p. 33.

There are three basic critiques of painting, all made early in the twentieth century. The first is Duchamp's, which de Duve describes (p. 98) as follows: "painting is named, always already named, even before the artist, impelled by his desire to become a painter, puts his brush to the canvas; his historical task, in a culture circumscribed in time and space by the phenomenon of the avant-garde, is to break the pact that gives painting its name and to anticipate a new pact that will be renewed later in a new situation; the destiny of the artist to whom this is revealed will be linked to the death of painting insofar as this death, always already announced, is the paradoxical historical condition for the survival of painting, the reprieve that comes from its name being unpronounceable for a while." For de Duve, Duchamp's "'invention' of the readymade ... confirm[ed] this revelation."

But what de Duve describes is a general problematic of creativity, not the particular problem of painting. Creativity always, to use Winnicott's wonderful idea, "creates into" what is already named, indeed, what seems to be so completely given through its name that the act of creating into it seems to restore it to namelessness, and thus a peculiar primordiality. Every mode of art is experienced as dead – set in its ways, or fixed in its principles, or completely determined by culture and craft, and thus already named – when one first begins to practice and think about it. It is brought to life only by investing one's "privacy" in it, to use Peter Gay's term. Bringing it to life means unnaming it, even though the result may be renamed, that is, reassimilated into culture and craft.

Duchamp himself has said, less theoretically and more emotionally: "'Stupid like a painter.' The painter was considered stupid, but the poet and the writer were intelli-

gent. I wanted to be intelligent. It is nothing to do what your father did. It is nothing to be another Cézanne. In my visual period there is a little of that stupidity of the painter. All my work in the period before the *Nude* (1912) was visual painting. Then I came to the idea. I thought the ideatic formulation a way to get away from influences." Quoted in Ursula Meyer, ed., *Conceptual Art* (New York: Dutton, 1972), p. x. Clearly there is more than a little intergenerational antagonism, not to say envy of Cézanne, as well as sibling rivalry, for Duchamp's older brother, Jacques Villon, made personal, very abstract, poetic Cubist paintings, and his sister Suzanne Duchamp was also a painter. (Another artistically talented brother was Raymond Duchamp-Villon. The historian H. H. Arnason regards him as the Cubist sculptor with "the greatest potential" and "the least fulfilled ability," because of his early death in 1918.)

There is clearly something very personal in Duchamp's eager acceptance of the expression "stupid like a painter" as a self-evident truth. It follows from his need to putdown his older brother and sister – they must be stupid, because they are painters. This, in turn, follows from his need to differentiate himself from them, a need so great that he became competitive with them, to the extent that he had to find his own artistic métier and identity. He became so hostile to painting – an extension of his hostility to the family painters – that he repudiated it completely, replacing and overthrowing it with his intellectual inventiveness, as Meyer calls it. Duchamp's revolt against the grand tradition of painting became a revolt against his native country France, where so much great painting had been made and was being made – despite the "stupidity" of such contemporary Parisian painters as Matisse, Picasso, Braque, and Delaunay – and against the museum, more particularly, the Louvre, where so much painting was on display.

In a sense, his move to America, where there was little painting of consequence, at least by modern standards, was the climax of his revolt, and confirmed his feeling of foreignness – of alienation from painting, from his family, and from tradition. In the new world he could pursue his idea of art – of art that was not art in the traditional sense, and perhaps not art at all – with a vengeance, for the old world idea of art, and the old world belief in the superiority of painting, made little sense there. In America technology not art ruled: it was a place where inventions were more important, innovative, and intelligent – and certainly more useful – than any art were being made. Is it possible that Duchamp had to assert his intelligence because he had doubts about it, and because he felt inferior to his sibling painters, and generally inadequate – second-rate – as a painter? Did he have to become an inventor of artistic gimmicks – clever artistic gadgets, as it were – to prove that he was as intelligent as the American inventors, or at least looked as if he was? Did he have to show that he had as many ingenious ideas as they did? Was his competitiveness – hostility – so out of hand that he had to trump modern manufactured objects by turning them into art, even if it was only art in name? The depreciation of painting became a depreciation of the machine, the symbol of modernity, which, in that mock painting *The Bride Stripped Bare by Her Bachelors, Even (The Large Glass),* 1915-23, is nihilistically reduced to a perverse sex game. Duchamp, in the end, had to negate even the modernity he admired, as his return to the old-fashioned gas lamp of his childhood in the *Étant Donnés (Given: 1. The Waterfall, 2. The illuminating Gas),* 1944–66 suggests.

The second critique of painting was initiated by the so-called *Last Paintings* of Alexander Rodchenko. Three monochromatic paintings, each in a primary color – *Pure Red Color, Pure Blue Color,* and *Pure Yellow Color* – supposedly "reduced painting

to its logical conclusion." "It's all over," Rodchenko declared, in a curious mix of theoretical dogmatism and arrogant naiveté. The paintings appeared in the *5×5=25* exhibition held in Moscow in September 1921. John Milner, in *Russian Revolutionary Art* (London: Bloomsbury Books, 1987), describes them as "work[s] of anti-art, a cultural gesture" (p. 46). They were "aesthetically boring," not only because they had "no room for illusion," but because their blankness – each was a color "spread unremittingly across" the picture surface – indicated Rodchenko's abandonment of "creative work." The *Last Paintings* signaled Constructivism's shift from art making, even the most advanced art making – the use of "materials and geometrical construction" as abstract ends in themselves – to "the construction of useful and efficient objects and, on the broader level, [Constructivism's] function within the organism of the new society" (p. 52). "The basic material for construction was taken to be the new way of life. 'Life-construction' is a word used in the Constructivist theory of the next few years." In short, autonomous artistic activity – signaled even as it was reduced to absurdity in the *Last Paintings* – was replaced by lifeworld activity, which can only nominally be called art. (Just as Duchamp's readymades, appropriated from the lifeworld, were only nominally art, as de Duve says.)

"As artistic creativity moved closer to work, the Constructivist became a designer and artisan. 'Art,' proclaimed [the theorist Alexei] Gan [in his 1922 book *Constructivism*], 'is inextricably linked with theology, metaphysics and mysticism. Down with Art!'" (p. 52). As Milner sarcastically notes, "this position was more easily maintained by Constructivist theorists than by Constructivist practitioners." I have to say that I agree with Gan: art, particularly painting, is inextricably linked with mysticism, if not so inevitably with theology and metaphysics, that is, dogmatic systems of thought. No doubt my understanding of mysticism is somewhat different from that of Gan, but the point is that in rejecting art – painting – Gan does not invalidate either art or mysticism, but rather turns away from them toward a more mundane activity with a more practical purpose. He rejects transcendence as beside the point of revolution, laboring to give birth to a new society. The Constructivists want to encourage that labor, and be part of the new society. Retrospectively, their ambition seems at once admirable and absurd, naive and pathetic, but the point here is that in dismissing art as belonging to the old society, they failed to recognize that under its facade of newness Russian society was still quite old – the newly constructed person still had a large measure of the old Adam and Eve in him or her – and there would soon, once again, be a need for mysticism and art – artistic mysticism. For individuality and spontaneity would be suppressed in the name of the new social order – they would be sacrificed to the collective good – and artistic mysticism would once again be needed, to keep them – or at least the thought of them – numinously alive. Constructivist practitioners seemed to unconsciously recognize this, in contrast to Constructivist theorists, who had the luxury of being pure and correct, while the practitioners were, after all, working for human beings.

The third critique of painting is not unrelated to the Constructivist critique. Walter Benjamin has famously argued that what "withers in the age of mechanical reproduction is the aura of the work of art," which is "never entirely separated from its ritual function," initially magical, then religious, and finally esthetic in import and character, as suggested by the fact that the most consummate apotheosis of ritual occurs in "the cult of beauty" or "the doctrine of *l'art pour l'art*" or "'pure' art." (Walter Benjamin, "The Work of Art in the Age of Mechanical Reproduction," *Art in*

Theory 1900–1990 [Cambridge, Mass. and Oxford: Blackwell, 1992], p. 514.) Painting is the art which has relentlessly and self-consciously pursued purity, and as such the art in which aura is most refined and alive, and thus the art which suffers most from mechanical reproduction, to the extent that it is degraded and even subtly destroyed. For Benjamin, this is all too the good: the modern mass person is not interested in the transcendence represented by the aura of painting, but in the distraction represented by the mechanical reproducible film (p. 519). The film may be distracting, but it is also demystifying – to be distracted is in a sense to be disenchanted. The film is the mundane antidote to the poison of ritual which pretends to mediate something mysteriously higher, and thus obscures the actual historical practice of life.

The best response to this anti – high art – anti – pure painting – argument is that of Adorno, who in a 1936 letter to Benjamin thought that he all too "casually transfer[red] the concept of magical aura to the 'autonomous work of art' and flatly assign[ed] to the latter a counter-revolutionary function" (p. 521). For Adorno, this misses its "inherently dialectical" character: "within itself it juxtaposes the magical and the mark of freedom." Benjamin completely misses the "explosive power" of autonomy or purity (which to me preserves within its numinosity, the way an extinct flower is preserved in amber, the ideals of psychic vitality and true selfhood, which have become "abstract" – as abstract as painting – in modernity). In other words, Benjamin's critique, like that of the Constructivists, errs on the side of mundane revolution – a naive advocacy of total social change, involving a romanticization of the proletariat, as Adorno writes (p. 522) – and as such cannot help but regard ritual as regressive and "mythological," even if ritual is part of the process of psychic revolution or transformation called transcendence, which is mystified as religious and esthetic magic. (Adorno remarks that Benjamin completely misses the mundane – banally realistic – character of the film, noting that "reality is everywhere *constructed* with an infantile mimetism and then 'photographed.'") Benjamin does not yet see the need to maintain an imaginary space of freedom beyond mundane reality, for he naively thinks that the social revolution will free human beings once and for all time. But of course it never frees them from themselves – however much they can be socially reconstructed they have an intransigent and intractable core with its own dynamics – which no doubt is an old and simple wisdom, which no revolutionary wants to face.

The collapse of painting, and with it the genre of the last painting, is constantly repeated in modern art. Those who announce it do so to affirm their own vanguardism, as though the death of painting means the birth of their own superior idea of art, which of course is the real, ultimate truth of art. "Advance" means "advance beyond painting," at whatever cost to art itself, and to the psyche. The great loss to both suggests how catastrophic the consequences of the compulsion to be avant-garde can be. Indeed, the nineteenth century artists we now regard as the pioneers of avant-garde art did not consciously set out to be "advanced" – their art was "different" because of their "creative apperception" of their environment, to use Winnicott's term, not out of compliance to a preconceived idea of progress in art – while today's would-be advanced artists assume they know what it means to make avant-garde art, which suggests just how commonplace and conventional the idea of artistic revolution has become, indicating that it has lost its raison d'être.

Joseph Kosuth is the latest avatar of such superficial avant-garde authenticity, which gets its abortive identity – a reactive intellectual identity rather than the pri-

mary identity and authenticity that can come only from insight into existential inevitabilities – by defining itself against painting. "The belief system of the old language of painting had collapsed," he writes, "and coinciding with it collapsed our ability to believe in the social, cultural, economic and political order of which it had been part." The only thing that "saves" painting is "the art market's need for stability in the form of quality commodities." Kosuth cannot imagine that "presenting an inward-turning world, as painting had," might continue to be of interest to an inward-looking public, that is, a public concerned to fathom the inner lifeworld. He cannot grasp that it might have a psychic need for painting – for inwardness. Painting, which he says "has become a 'naive' art form because it can no longer include 'self-consciousness' ... in its program," involves more consciousness of self – "theoretically as well as that of historical location," in Kosuth's words, but also experientially – than he can imagine. Joseph Kosuth, "Painting Versus Art Versus Culture (Or, Why You Can Paint If You Want To, But It Probably Won't Matter)" *Art After Philosophy and After: Collected Writings, 1966–1990* (Cambridge, MA: MIT Press, 1993), pp. 90–91.

Heinz Kohut asserts, in what he himself says may be an "overly daring hypothesis," that "what is needed to ensure the survival of the human race ... is the intensification and, above all, the elaboration and expansion of man's inner life." "Man has had to deal increasingly with the problems posed by a world that he himself has created," a world in which "there are more people and there is less space," and thus a world which is "an emotional burden." "It is getting harder to find regions in which we can satisfy our need to roam about freely." The inward-turning world of painting is such a region. It serves "the expansion and intensification of man's inner life," and thus confirms that life is "worth living." It helps one escape from "the demands of civilized existence" without letting oneself go "in orgies of lust and aggression" that inevitably lead to disaster, and without the "meek acceptance of an ascetic existence," involving "the suppression of [the drives] ... a feat apparently ... beyond [human] capacity, despite the efforts of Christianity for two thousand years." Thus so long as painting remains inward-turning it will be the model for all humanly useful art. Such art does not belabor and exemplify abstract theory but concretizes inwardness, saving us from ourselves as well as the world, even as it registers our unavoidable exposure to both. Heinz Kohut, *The Search for the Self: Selected Writings of Heinz Kohut: 1950–1978* (New York: International Universities Press, 1978), vol. 2, pp. 539–41.

Painting then, has its virtues, for it affords insight into inner life even as it intensifies and complicates it. It is finely attuned to its contradictions and longing for self-sufficiency. Painting's untranslatable sensuality bespeaks its respect for the uniqueness of each individual's inner life even as it acknowledges the inescapable tension of inner life as such. In short, what Gustave Moreau said a century ago, in response to the charge of "decadence" that was hurled at painting then, remains truer than ever: "They say it is finished. It is just beginning." Quoted in Dore Ashton, "Gustave Moreau," *Odilon Redon, Gustave Moreau, Rodolphe Bresdin* (New York: Museum of Modern Art, 1962), p. 138.

7. Charles Brenner, *An Elementary Textbook of Psychoanalysis* (New York: Doubleday, Anchor Books, 1974), p. 111.

8. Duchamp may have solved his sexual problems by abandoning painting, but the readymade did not solve his relational problems. *The Bride Stripped Bare By Her*

Bachelors, Even states them explicitly: the bride and the bachelors are in separate realms. They never meet; the connection between them is broken, and in fact never existed, except in fantasy. The sexual bridge by which the bachelors try to link up with the bride is a broken machine. Both bachelors and bride masturbate in Duchamp's pseudo – machinelike – painting. Duchamp's joke is the missing penis, and by extension the absent man. We see him secretly masturbating in *Sad Young Man on a Train*, 1911. *Passage from the Virgin to the Bride*, 1912 – are the *Nude Descending a Staircase No 1*, 1911 and *No. 2*, 1911–12 also ironical versions of this passage? (de Duve [p. 13] describes the two nudes and the sad young man as "cubist self-portraits") – ostensibly deals with the ritual of sexual initiation and marriage. But the man (penis) that effects it – that changes the sexually inexperienced virgin into a sexually mature bride – is not pictured.

Sexuality is the surface of a deeper issue for Duchamp: the difficulty of relating to a woman. The group of paintings about virgins and brides deals with it, and announces Duchamp's "stalemate" – the sad feeling of relational inadequacy that forced him back on lonely masturbation. He rationalizes his inability to establish a meaningful relationship with woman by implying that masturbation is a form of asceticism. The ready-made epitomizes this ironic asceticism. The spectator could always make something of it – experience it esthetically (quasi-sexually) – but there was no guarantee that he or she would. As Duchamp famously said, the spectator is as creative as the artist – even more creative – which leaves the burden of proof of the relationship to him or her.

9. Schapiro, p. 222, writes that "the pathos of the reduction or fragility of the self within a culture that becomes increasingly organized through industry, economy and the state intensifies the desire of the artist to create forms that will manifest his liberty." The grid represents the organization of society, which stunts the growth of the self even as it defines its place in society – indeed, stifles it just by defining it exclusively in social terms – and the sense of freedom and spontaneity that Gehry experienced when he threw out the grid was the beginning of his restoration of his self, which had been enfeebled and all but annihilated by society. As he realized, the perfectly organized grid is a deceptive safety net, not so much supporting the self as locking it into immutable social place.

It is worth emphasizing that the grid system Gehry threw away is the same one that is implicit in much of Duchamp's art. Indeed, his readymades and quasi-organic sexual objects are implicitly pieces on a chess grid, capable of only limited, contrived movement rather than spontaneously active. Gehry in effect restores the feeling of being organically alive that Duchamp's grid negated. If the rigid grid represents the superordinate authority of mechanical rules, then discarding it allows for the rhythmic spontaneity of organic growth and creativity, psychically as well as physically.

The battle between the suppressive mechanical, epitomized by the grid, and disinhibited spontaneity, epitomized by the organically alive – what Adorno calls construction and expression – marks twentieth-century art. Sometimes the former claims to win, as when Duchamp dismissed "instinctive painting," and sometimes the latter seems to win, as when Gehry dismisses the grid system. Neither victory is absolute; if it was, it would be a Pyrrhic victory, for an exclusively mechanical art, or an exclusively organic art, would be insufficiently consummate to make an artistic difference. To sweep the field is to become absolute but also to lose all sense of purpose. Universal construction gains strength from its opposition to individual expression, and vice versa, so much so that the meaning of each is completed by the other. This suggests

that it is the contradiction or tension between them – essentially between closed and open systems – that makes each fruitful. In triumphant isolation, each is sterile.

10. Erich Fromm, *Escape from Freedom* (New York: Avon Books, 1965), p. 267.

11. Horkheimer, pp. 94, 98.

12. Peter Gay, *Art and Act: On Causes in History – Manet, Gropius, Mondrian* (New York: Harper & Row, 1976), p. 17.

13. Fromm (p. 281) observes that "psychologically the automaton, while being alive biologically, is dead emotionally and mentally. While he goes through the motions of living, his life runs through his hands like sand. … He desperately clings to the notion of individuality; he wants to be 'different,' and he has no greater recommendation of anything than that 'it is different.' We are informed of the individual name of the railroad clerk we buy our tickets from; handbags, playing cards, and portable radios are "personalized," by having the initials of the owner put on them. All this indicates the hunger for "difference" and yet these are almost the last vestiges of individuality that are left. Modern man is starved for life. But since, being an automaton, he cannot experience life in the sense of spontaneous activity he takes as surrogate any kind of excitement and thrill: the thrill of drinking, sports, or vicariously living the excitements of fictitious persons on the screen." This can be regarded as another answer to Benjamin's elevation of the distracting film over the auratic painting. It should also be noted that Duchamp's figures and readymades – surrogate figures – are also automatons.

14. Milner, p. 159.

15. Ibid., p. 157. Milner's remarks on painting, and art in general, are worth comparing to those of Adrian Stokes, who writes, in "The Luxury and Necessity of Painting" (1961), *The Critical Writing of Adrian Stokes* (London: Thames and Hudson, 1978, vol. 3, pp. 148–49), that "the simplest relationships, the most sporadic marks, have deep meaning. … The palpable textures of modern painting express the division and disintegration of culture as well as the ambivalent artist's restitution, often carried no further than an assembly of scaffolding. We are then left with an unceremonious image that seems to symbolize the process of art itself, of the hidden content, always immanent, whereby mere space and shape touch in us sensations of pain, struggle, anxiety, or joy that we have already begun to translate into tactile and even visual sensations, since a parallel amalgam is ceaselessly registered in some part of the mind … in just this way much modern art offers us the 'feel' of our own structure, sometimes overriding the communication of particular feelings. Painting usually presents as well a specific subject-matter equivalent to the manifest content of a dream, in terms of an image of the waking world." In short, "unspoken experiences, bodily and mental, have always been incorporated into art through the appeal of formal relationships," especially in the case of painting, which seems to "reconstruct *ab initio* … the rudiments of the body and of the psyche."

16. D. W. Winnicott, "Ego Distortion in Terms of True and False Self" (1960), *The Maturational Processes and the Facilitating Environment* (New York: International Universities Press, 1965), p. 148.

17. Ibid., p. 147.

18. William James, *The Varieties of Religious Experience* (New York: Modern Library, n.d.), pp. 371–72.

19. Daniel Burston, *The Legacy of Erich Fromm* (Cambridge, MA and London: Harvard University Press, 1991, p. 90), notes that for Fromm "the need for transcendence implies a need to rise above our own sense of thrownness or creatureliness by becom-

ing *creators* in our own right." This involves transcendence of the everyday ego, which unconsciously feels thrown into society however integrated in it, and thus all the more vulnerable in its creatureliness. My argument is that transcendence exists more by way of mystical suggestion, in such odd cultural phenomena as modern painting – which remains marginal compared to film and photography – than verifiable fact in modern instrumental-administrative society. Indeed, the need for transcendence itself seems like a mystical illusion in modern society, which may be why it is relegated to the realm of illusion called art.

CHAPTER ONE: CHARLES BURCHFIELD: APOCALYPSE NOW

1. J. Benjamin Townsend, ed., *Charles Burchfeld's Journal. The Poetry of Place* (Albany: State University of New York Press, 1993), p. 389.
2. Religion seems to have been largely a source of guilt in Burchfield's life. His experience of it was essentially "negative," as Jay Grimm convincingly argues in "Charles Burchfield and the Myth-making of America" (M.A. thesis, State University of New York at Stony Brook, 1993), p. 9. Presbyterian Sunday school was "one of the nightmares of my childhood," Burchfield wrote in his journals. What he seemed to have learned there was "that playing cards, dancing and the theater were all manifestations about Satan," and that Catholics would kill Protestants if they could "go undetected."
3. Nancy Weekly, *Charles E. Burchfield: The Sacred Woods* (Albany: State University of New York Press, 1993).
4. William James, *The Varieties of Religious Experience* (New York: Modern Library, 1955), pp. 31–32, describes religion as "the feelings, acts and experiences of individual men in their solitude, so far as they apprehend themselves to stand in relation to whatever they may consider the divine." But the divine turns out to be what effects a sense of unity in "the divided self," more particularly whatever helps it be born again (p. 163). James distinguishes between "the healthy-minded, who need to be born only once, and ... the sick souls, who must be twice-born, to be happy." For the latter, there is a "falsity" in being itself, for it can be "canceled ... by death if not by ... enemies. ... There are two lives, the natural and the spiritual, and we must lose the one before we can participate in the other." In Burchfield's case we might say that there are two lives, the external or social and the naturally spiritual or inward. The former is self-canceling, allowing the latter to emerge.
5. Weekly, p. 11. Virtually all of the Conventions suggest depression, that is, fear of death and madness – a double annihilation anxiety.
6. Quoted in Victor H. Nliesel, "Introduction," in Victor H. Miesel, ed., *Voices of German Expressionism* (Englewood Cliffs, NJ: Prentice-Hall, 1970), p. 1.
7. Ibid., p. 2.
8. Ibid.
9. I propose the equivalency of Burchfield's mother and nature in his mind. His total emotional dependence on his mother is self-evident from his journal entries and his life history.
10. Burchfield was drafted in June 1918. His artistic background obtained him an easy assignment in the Camouflage Corps. He never served abroad and was discharged six months later. See Grimm, p. 18, and Weekly, p. 9.
11. Townsend, p. 61.
12. Ibid., p. 87.

13. The issue is to transcend the topical by formal innovation and arrive at psychic or emotional universality. Burchfield does that more convincingly than any other American Scene artist. The failure of most American Scene art – and it continues to this day – is that it is formally inadequate and thus lacks artistic presence and significant human import. It does not use form as a vehicle for new insight into the human condition, and it does not stretch the limits of art by taking formal risks, which is what Burchfield's Conventions do. In general, topical art lacks a significant sense of self as well as of art.

14. Grimm demonstrates that, contrary to conventional art-historical opinion, Burchfield knew about the 1913 Armory Show, and was exposed, while in the Cleveland School of Art, to avant-garde styles and ideas. His teacher, Henry Keller, "an artist-educator with decidedly modernist leanings" – Keller exhibited in the Armory Show –" explained the different movements from the Old Masters down thru [sic] impressionism pointillism, futurism, cubism and even beyond-metaphysical sensations." The Conventions, in fact, summarize, one might even say epitomize and condense, all of Burchfield's avant-garde knowledge. That is, they reflect his determination to be a modernist artist, and in fact show that he was one. Grimm, pp. 25, 26.

15. Daniel Bell, "The Return of the Sacred?" in *The Winding Path* (New York: Basic Books, 1980), p. 333, argues that culture in general and religion in particular deal with and offer answers, however inadequate, to the "recurrent core existential questions" of "the human predicament": "how one meets death, the meaning of tragedy, the nature of obligation, the character of love."

CHAPTER TWO: SOUTINE'S SHUDDER: JEWISH NAIVETÉ?

1. H. H. Arnason, *History of Modern Art,* 2nd ed. (New York: Harry N. Abrams, 1977), p. 284.

2. T. W. Adorno, *Aesthetic Theory* (London: Routledge and Kegan Paul, 1984), p. 455.

3. Michael Eigen, *Psychic Deadness* (Northvale, NJ, and London: Jason Aronson, 1996), notes that "the evolution of one's sense of aliveness depends partly on the quality of responsiveness versus retaliatory reactiveness of one's milieu" (p. xxii). I will argue that Soutine struggled to maintain his sense of aliveness through his spontaneity while registering the retaliatory reactiveness of his shtetl milieu to him, as well as, more broadly, the retaliatory reactiveness of the world as such toward the Jew.

4. T. W. Adorno, *Negative Dialectics* (New York: Seabury, 1973), p. 344. G. W. F. Hegel, in the *Phenomenology of Spirit,* trans. A. V. Miller (New York: Oxford University Press, 1977), remarks that the "way of the world [spirit]" is "the essenceless play of establishing and nullifying individualities" under the guise of "public *order,*" which claims to be universal (pp. 227–28).

5. D. W. Winnicott, "Ego Distortion in Terms of True and False Self" (1960), *The Maturational Processes and the Facilitating Environment* (New York: International Universities Press, 1965), p. 143. Winnicott writes that "the False Self is represented by the whole organization of the polite and mannered social attitude." In contrast, "the spontaneous gesture and the personal idea" convey the True Self, which "comes from the aliveness of the body tissues and the working of body-functions" (p. 148). The shudder encapsulates the spontaneous gesture and personal idea, and Soutine struggles to maintain belief in the aliveness of Jewish bodies which he knows are in fact dead because they have been falsified (distorted) by the world by "treating" them with spontaneous gestures and offering a personal idea of what it means to be alive and embodied.

6. Gilbert J. Rose, *Necessary Illusion: Art as Witness* (Madison, CT: International Universities Press, 1996), pp. 18–19. It is worth noting that T. S. Eliot thought that the splitting of affect and thought – the "dissociation of sensibility," as he called it (*Selected Essays, 1917–1932* [New York: Harcourt, Brace, 1932], p. 247) – was the disease of modern art and modern life. It is exactly the sense that they are incommensurate and in perpetual conflict that Soutine attempts to overcome in his paintings. So-called conceptual – theoretical, philosophical – art carries the split to an extreme, arguing that thought can dispense with affect.

7. Maurice Tuchman, *Chaim Soutine: 1893–1943* (Los Angeles: Los Angeles County Museum of Art, 1968), p. 7. All subsequent Tuchman quotations are from this book.

8. It is also worth noting that for the Fauves and German Expressionists, the naiveté of spontaneity was a goal to be achieved rather than a given of fresh experience. It was the result of a deliberate process of shedding traditional, ostensibly rational, ideas of painting as well as conventional structures of perception and understanding. The result was not entirely genuine – how can there be an aesthetically sophisticated spontaneity? It invariably seems artful, not to say artificial, even simulated, and is clearly a contradiction in terms. Its intensity is quickly lost, or enlisted in the service of a supposedly higher aesthetic purpose. That is, it is subsumed in works with more "character" – works which satisfy a more traditional ideal of artistic physiognomy – where it functions as lyric ornament.

9. Adorno, *Aesthetic Theory*, p. 451.

10. The critic Bernhard Diebold describes Kokoschka's expressionistic dramas as "screaming images," an idea that can be extended to expressionistic art in general. Quoted in H. l. Schvey, *Oscar Kokoschka, The Painter as Playwright* (Detroit: Wayne State University Press, 1982), p. 7. Kokoschka himself described expressionistic art as, on the one hand, "a single moment appearing in the guise of eternity," and, on the other, "a silence broken by a cry." Schvey points out that many expressionistic plays begin with "an anguished cry" (p. 23).

11. Clement Greenberg, "Soutine," *Art and Culture* (Boston: Beacon, 1965), p. 118. All subsequent Greenberg quotations are from this essay.

12. Elie Faure, *Soutine* (Paris: Editions Grès, 1929), pp. 10, 4, 3.

13. Waldemar George, *Soutine* (Paris: Editions Le Triangle, 1928), p. 9.

14. Quoted in Esti Dunow, "Chaim Soutine, 1893–1943" (Ph.D. dissertation, New York University, Institute of Fine Arts, 1981), p. 4.

15. Ibid., p. 8.

16. Werner Haftmann, *Painting in the Twentieth Century* (New York: Frederick A. Praeger, 1961), p. 265.

17. Richard Chessick, *A Dictionary for Psychotherapists* (Northvale, NJ, and London: Jason Aronson, 1993), pp. 78–79.

18. D. W. Winnicott, "The Manic Defence" (1935), in *Through Pediatrics to Psycho-Analysis* (New York: Basic Books, 1975), describes mania as "a denial of deadness, a defence against depressive 'death inside' ideas" (p. 131).

19. Within the Kleinian framework, "persecutory guilt" is identified with the paranoid-schizoid position, which is destructive of the object; "depressive guilt" is identified with the depressive position, which is reparative or reconstructive. Léon Grinberg, *Guilt and Depression* (London: Karnac Books, 1992), p. 39, argues that "to the ego corresponds the immensely important task of integrating the life-instincts with the death-instincts." Soutine's paintings show the struggle to do so, and the uncertain

result, for they seem as much at odds as integrated in his images. Thus, they suggest the fragile character of Soutine's ego.

20. Max J. Friedländer, *Landscape, Portrait, Still-Life* (New York: Schocken, 1963), p. 230.
21. Arthur Danto, "The End of Art," in *The Death of Art,* ed. Berel Lang (New York: Haven, 1984), p. 31.
22. Ibid., p. 8. Danto's position is an example of philosophy's ongoing narcissistic ambition to make art over in its own godly image – to legislate art history so that it confirms the inevitability of philosophy's triumph over art. Of course, art that accepts instruction from philosophy can never be as theoretically sophisticated as philosophy, however hard it tries. It is never more than an instrument, not to say poor colony, of philosophy.
23. Gaston Bachelard, *The Poetics of Space* (Boston: Beacon, 1969), pp. 152–53.
24. Ibid., p. 155.

CHAPTER FIVE: JACKSON POLLOCK: LIVELY ART, ARTLESS LIFE

1. It is important to realize that Varnedoe and Karmel work for a museum, and that their job is to make it clear that Pollock's works belong in a museum, supposedly the site of immortality. At the least, the imprimatur of the museum guarantees their canonicity. The essentialist approach confirms that works of art belong in museums, for it reduces them to objects whose meaning depends on their physical novelty. (Ironically their physicality is their most mortal aspect.) More particularly, the work's meaning comes to depend on the way the museum administers its physical presence by exhibiting it. Exhibition is essential from a museum point of view, for it confirms that the work is "essential" in itself. Thus, physically reified by exhibitionistic use, which aggrandizes the work for the greater glory of the museum, it cannot help but seem to lack spiritual and broader human purpose.
2. Michael Balint, *The Basic Fault* (Evanston: Northwestern University Press, 1979), p. 74. All subsequent quotations from Balint are from this book. It is worth noting that the pursuit of "oceanic style" or "oceanic feeling" has been a constant of avant-garde art, evident even in Mondrian, as Kenneth Frampton notes in "De Stijl," *Concepts of Modern Art* (New York: Thames and Hudson, 1991), p. 157.

CHAPTER EIGHT: JIRI GEORG DOKOUPIL: REAL HALLUCINATIONS AND ANAL ABSOLUTES

1. Jiri Georg Dokoupil, "Diary Excerpts," *Dokoupil Catalogo* (Ostfildern: Cantz, 1996), p. 16.
2. Janine Chasseguet-Smirgel, *Creativity and Perversion* (London: Free Association Books, 1985), p. 11.
3. Quoted in Fred H. Johnson, *The Anatomy of Hallucinations* (Chicago: Nelson-Hall, 1978), p. 1.
4. Dokoupil, p. 17.
5. Ibid., p. 16.
6. Ibid., p. 15.
7. Ibid., p. 16.
8. Ibid., p. 15.
9. Ibid.

10. Ibid.
11. Ibid., p. 17.
12. Ibid.
13. Ibid., p. 81.
14. Ibid., p. 17.
15. Ibid.
16. Ibid., p. 131.
17. Ibid., p. 16.
18. Ibid., p. 108.
19. Ibid., p. 106.
20. Chasseguet-Smirgel, p. 20.
21. Ernst's art, in its first phase, was an attempt, as he said, to "consume Sir Father slice by slice," all the more so because his father supported German nationalism, which Ernst detested. World War I was a catastrophe for him, and he held his authoritarian father – all the self-righteous German fathers – responsible for it. Prince's Marlboro Man is the archetypal American father figure: he sells the big lie that smoking will make a man out of you, when it will in fact kill you. In attacking the Father through his polymorphous perverse relationships with women as well as his polygamy, and in effect identifying with women, Dokoupil is in fact denying that manliness is a virtue: the horrors it has created – the horrors perpetrated in its name – indicate that it is a vice. Ernst, incidentally, was also a womanizer; Prince's sexual behavior has not yet been published.
22. See Johnson, p. 63, for a discussion of hallucination as a basic indicator of thought disorder or "loss of thought." For Sullivan, a hallucination is not simply a fantasy, but involves "blocking," that is, "a state in which a contradictory impulse predominates over [and thus blocks] the progression of thought."
23. Dokoupil, p. 77.
24. Ibid., p. 78.
25. Ibid., p. 108.
26. Ibid., p. 31.
27. Does Dokoupil, however unwittingly, also exploit and victimize – sexually rather than economically – the third world, by way of the sexual use he makes of the Latino woman? This contrasts with the intellectual use of it made by early modernist "primitivizing" artists, but it nonetheless generally conforms to the avant-garde idealization of "primitivism." Avant-garde artists found emotional release through "primitive" form, and Dokoupil finds emotional release through "primitive" woman – the archaic, prelapsarian Eve rather than the sophisticated seducer to sinful sex. The avant-garde artists, incidentally, were blind to the constraints of "primitive" form, which are as great as those of Western form, and even greater, for the former is more formulaic and stereotypical because socially ritualistic in purpose, rather than in the service of personal imagination, as in the Western avant-garde. Is Dokoupil's attraction to "primitive" woman similarly blind, in that he sees her as a sexual stereotype rather than an individual person, and because his sexual activity with her is performed in a ritualistic way, as though to metaphysically justify it? His remarks on Tantrism suggest as much.

 In short, is Dokoupil simply another dominating Westerner – sexually rather than intellectually dominating? His sexual conquest of the Latino woman seems to turn her into another trophy of Western colonization, however much it indicates a great need

for liberation from the constraints of Western society. Dokoupil seems to have a split personality: on the one side he idealizes and identifies with the outsider woman, with whom he can explore sex beyond the Western pale; on the other side, he behaves like the usual Western male sexist intellectual, who conceives of himself as entitled to power, whether over woman or the mind. In any case, as an untitled 1987 self-portrait suggests, Dokoupil is profoundly split: on one side of his face he is a serious intellectual, on the other side he is raw guts. The halves are carefully stitched together – the same way the red and green halves of his Beuys self-portrait are held together – but the neat, artistic stitches have not yet been taken out and seem permanent, suggesting that the division-wound-conflict in Dokoupil's psyche and life will never heal: he will never be a seamless whole. His body and mind will always be at odds, despite his artistic efforts to unite them – his attempt to use art to sew them together.

28. Ibid., p. 14.
29. Peter Sloterdijk, *Critique of Cynical Reason* (Minneapolis: University of Minnesota Press, 1987), p. 107.

CHAPTER NINE: ABSTRACT PAINTING AND THE SPIRITUAL UNCONSCIOUS

1. Wassily Kandinsky, "On the Spiritual in Art" (1912), *Kandinsky: Complete Writings on Art* (New York: Da Capo Press, 1994), p. 129. All subsequent quotations from Kandinsky are from this work.
2. Alfred North Whitehead, "Symbolism, Its Meaning and Effect," *An Anthology* (New York: Macmillan, 1953), p. 535.
3. William James, *Varieties of Religious Experience* (New York: Modern Library, n.d.), p. 186. All subsequent quotations from James are from this book.
4. Piet Mondrian, "Purely Abstract Art" (1926), *The New Art – The New Life: The Collected Writings of Piet Mondrian* (New York: Da Capo Press, 1993), p. 201. All subsequent quotations from Mondrian are from this essay.
5. Quoted in Michel Butor, "Rothko: The Mosques of New York," *Inventory* (New York: Simon and Schuster, 1968), p. 267.
6. Robert Motherwell, "What Abstract Art Means to Me" (1951), *The Collected Writings of Robert Motherwell* (Oxford and New York: Oxford University Press, 1992), pp. 85–86.
7. Quoted in W. W. Meissner, *Psychoanalysis and Religious Experience* (New Haven and London: Yale University Press, 1984), p. 81.
8. Meyer Schapiro, *Modern Art: 19th and 20th Centuries, Selected Papers* (New York: George Braziller, 1960), p. 41.
9. Gilbert J. Rose, *Necessary Illusion: Art as Witness* (Madison, CT: International Universities Press, 1996), p. 80.
10. In his essay on "Suprematism," Malevich wrote: "No more 'likeness of reality,' no idealistic images – nothing but a desert! But this desert is filled with the spirit of nonobjective sensation which pervades everything … a blissful feeling of liberating nonobjectivity drew me forth into the 'desert,' where nothing is real except feeling … and so feeling became the substance of my life." Quoted in Herschel B. Chipp, *Theories of Modern Art* (Berkeley: University of California Press, 1968), p. 342. Kandinsky, p. 141, says something similar: "The spirit that will lead us into the realms of tomorrow can only be recognized through feeling."
11. Quoted in Chipp, p. 295.

12. W. W. Meissner, *Ignatius of Loyola: The Psychology of a Saint* (New Haven and London: Yale University Press, 1992), p. 78.
13. Harold Rosenberg, *The Tradition of the New* (New York: McGraw-Hill, 1965), p. 25.
14. Yves Bonnefoy, "On Painting and Poetry, on Anxiety and Peace," *The Lure and the Truth of Painting* (Chicago and London: University of Chicago Press, 1995), pp. 171–72.
15. Brett Kahr, *D. W. Winnicott, A Biographical Portrait* (London: Karnac Books, 1996), pp. 31–32.
16. Rosenberg, pp. 33, 35.

CHAPTER TEN: THE PATHOS OF PURITY: PIET MONDRIAN REASSESSED

1. Charles Hanly, *The Problem of Truth in Applied Psychoanalysis* (New York and London: Guilford, 1992), p. 60.
All quotations from Mondrian are from his 1920 essays "Natural and Abstract Reality" and "Neo-Plasticism."

CHAPTER ELEVEN: NEGATIVELY SUBLIME IDENTITY: PIERRE SOULAGES'S ABSTRACT PAINTINGS

1. T. W. Adorno, *Aesthetic Theory* (London: Routledge & Kegan Paul, 1984), p. 45.
2. D. W. Winnicott, "Communicating and Not Communicating Leading to a Study of Certain Opposites," *The Maturational Processes and the Facilitating Environment* (New York: International Universities Press, 1965), p. 187.
3. T. W. Adorno, *Negative Dialectics* (New York, Seabury, 1973), p. 5.
4. Adorno, *Aesthetic Theory*, p. 325.
5. Clement Greenberg, "The Crisis of the Easel Picture," *Partisan Review*, 15 (April 1948):484.
6. Adorno, *Aesthetic Theory*, p. 328.
7. Ibid. Kasimir Malevich made a similar point when he remarked that "objectivity, in itself, is meaningless ... feeling is the determining factor." In his "desperate attempt to free art from the ballast of objectivity" he "took refuge in the square form" – the "desert" of geometry, "where nothing is real except feeling." Quoted in Herschel B. Chipp, *Theories of Modern Art* (Berkeley and London: University of California Press, 1968), pp. 341–42.
8. Ibid., p. 325.
9. Ibid.
10. Winnicott, pp. 183–84, argues that "at the centre of each person is an incommunicado element, and this is sacred and most worthy of preservation." The "abstract picture" can concretize it, that is, can function as a "cul-de-sac communication (communication with subjective objects)" that "carries all the sense of the real." I think that Soulages paints this rare kind of abstract picture: his paintings articulate the isolated, sacred, incommunicado "secret self," "core self," or "true self," as Winnicott variously calls it. Only a desperate inner necessity could produce such radical abstract painting: for Soulages, it was the only means of psychic survival, that is, of feeling real and concrete in a world that made him feel unreal and abstract, of being true to himself in a world that made him feel false – a world in fact that constantly invites all of us to falsify ourselves, supposedly to survive. Ironically, radical

abstract painting uses the world's abstractness against it, that is, redeems the world's objective abstractness by making it subjectively resonant – a dialectical feat that is an essential aspect of its radicality.

To fully grasp Soulages's negation of the world's negation of the self (which is a kind of self-assertion), one must sharply distinguish it from Duchamp's negation, which is negation for the sake of negation – a reification of negation – and as such an ironical embodiment of the worldly pseudoself (and thus a kind of self-negation). Duchamp's negation was a deliberate "joke" and "lie" – a deliberate falseness, as he said. (Pierre Cabanne, *Dialogues with Marcel Duchamp* [New York: Viking, 1977], p. 24.) The result is not simply anti-art, but pseudoart. He not only negated art, but woman, with whom he unconsciously identified art, that is, she personified the truth of art, which is falseness. Woman is thus the ideal symbol of art, for she is as inherently false as art (as well as false to man): both are false ideals (idols) that Duchamp falsifies in order to make their basic falseness manifest. He plays a joke on both, making them seem lies – betrayers of the truth. But in fact he has falsified them by refusing to see their truth – their other side. In a dubious Solomon's wisdom, he has split them, and thrown away one half. Duchamp displaces his misogyny – his refusal to see the truth of woman – onto art. Or is it that he displaces his hatred and distrust of art – his sense of its disgusting falseness – onto woman? In either case, he has betrayed both, for he has told only half their story.

11. Max Horkheimer, *Critique of Instrumental Reason* (New York: Continuum, 1974), p. 99.

12. Joseph Sandler, *From Safety to Superego* (New York and London: Guilford, 1987), p. 5, notes that "perhaps the most convenient way of heightening safety feeling is through the modification and control of perception." To turn radically subjective abstract painting into decoration is to modify and control its perception – to make it recognizable in terms of everyday objective perception, and, more crucially, to deny its inconvenient incommunicado character, which is a threat to ordinary emotional safety.

13. Adorno, *Aesthetic Theory,* p. 45

14. Ibid., p. 46.

15. Marshall McLuhan thought that "on television colors rush at you as in a picture by Soulages." Quoted in Bernard Ceysson, "Interview with Pierre Soulages," Soulages (New York: Crown, 1979), p. 60. Soulages comments: "McLuhan must have been thinking about the pictures where the colors hidden underneath the black are revealed by scraping so that they take on a brilliance that does not come from the light received and reflected by the canvas, but seems to emanate from the canvas itself."

16. Joyce McDougall, *Theaters of the Mind* (New York: Brunner/Mazel, 1991; Paris, Gallimard, 1982, as *Théâtres du Je*), p. 9, writes that "the psychotic plot turns around the unceasing struggle for the right to exist, against the subject's deep conviction ... that the right to an independent life, or even to existence itself, was not desired." I think that Soulages's abstract black paintings, in affirming the isolated incommunicado sacred true self, are a defiant last ditch attempt to assert his right to exist despite society's psychotic plot against his existence, that is, its indifference to whether he – or any one of us – exists or not. It is his assertion of his independence from society, for all his – and everyone's – dependence on it, however much it has become an unfacilitative, abstract environment, as Adorno says.

17. I am playing on Soulages's remark (Ceysson, p. 57) that he was "overwhelmed by the proportions of the interior" of the Romanesque cathedral of Conques. I will return to

this remark later, for it is basic to an understanding of the sensibility involved in Soulages's abstract paintings, and as such helps explain their radicality.

18. Ibid.
19. Ibid., p. 60.
20. Ibid., p. 57. Soulages: "Was my childhood fondness for bare trees due to my love of black as a color? Or was it the other way round? Did I begin to love black because of the trees in winter without their leaves; because of the way the black trunks and branches stood out against the background of sky or snow, making them look brighter by contrast; or was it because of my love for the texture of the wet bark? I shall never know" (ibid., p. 60). Also: "What interested me when I was painting trees was the tracery of the twigs against the sky – the way in which the background became brighter between the black branches." Slowly but surely Soulages realized that he was looking at the tree "in terms of an abstract sculpture, an interacting series of forms, tensions, and colors." This was confirmed by his discovery of Mondrian's series of tree paintings.

 Soulages also notes (ibid., p. 84) his fascination with a "patch of tar," made by "the roadmaker's brush as he tarred the street," and also seen on a hospital wall. He was taken with "the viscosity, the transparency and opaqueness of the tar, the force with which it had been splashed onto the surface, and the way it had run as a result of the slope of the wall and the laws of gravity." It had been "abandoned," but remained "uncompromising" in its blackness, and evoked "the geological folds to which [it] had once belonged." Again, a certain experience of abandoned nature is Soulages's abstract point of departure. It is also his unconscious acknowledgment of his annihilation anxiety – his latent death wish, evoked by the society that has failed him, and thus traumatized him.

 In this context, it is hard not to think of Winnicott's remark that "a great deal is known, and is waiting to be harvested … about the meaning of black in the unconscious." Soulages is one of the great harvesters of black – one of the few not afraid to look steadily into its abyss." D. W. Winnicott, "The Price of Disregarding Psychoanalytic Research, *Home Is Where We Start From* (London: Penguin, 1986), p. 174.
21. Ibid., p. 60.
22. Ibid.
23. Wassily Kandinsky, *Concerning the Spiritual in Art* (New York: Dover, 1977), p. 39.
24. See Ad Reinhardt, "Black as Symbol and Concept," Barbara Rose, ed., *Art As Art: The Selected Writings of Ad Reinhardt* (New York: Viking, 1975, Documents of 20th-Century Art), pp. 86–88. "Black is negation," Reinhardt wrote (p. 101), and his black paintings were a "chain of negations," "ideogram[s] for what it is beyond utterance," statements of the "Buddhist 'theology of negation'" (p. 93). This means that they are "trans-subjective" (p. 114). Nonetheless, very subjectively and self-contradictorily, Reinhardt identifies their "self-sufficiency" with that of the "original part-object, [the] breast" (p. 74), that is, the primordial subjective object (according to Melanie Klein). Thus, if "the one object of fifty years of abstract art is to present art-as-art and as nothing else, to make it into the one thing it is only, separating and defining it more and more, making it purer and emptier" (p. 63), then the object of abstract art is to restore us to our original incommunicado subjectivity, which is inseparable from our identification with the breast.
25. Winnicott, pp. 185–86, writes of "the mystic's withdrawal into a personal world of sophisticated introjects … the loss of contact with the world of shared reality being

counterbalanced by a gain in terms of feeling real." The mystic anesthetizes himself to the world, blanking it out, in order to become sensitive to the deepest layers of himself, which, in Soulages's case, are articulated as autonomous sensory experiences, experienced by the viewer as inordinary intense sensory stimuli.

26. Werner Haftmann, *Painting in the Twentieth Century* (New York: Frederick A. Praeger, 1961), vol. 1, p. 345. James Johnson Sweeney, *Soulages: Paintings Since 1963* (New York, M. Knoedler, 1968), p. 7, also notes Soulages's "interest in architecture ... particularly Romanesque architecture."

27. Hanna Segal, "The Function of Dreams," *The Dream Discourse Today*, ed. Sara Flanders (London: Routledge, 1993), p. 103, writes that "beta elements are raw perceptions and emotions suitable only for projective identification. These raw elements of experience are to be gotten rid of. Beta elements are transformed by the alpha function [of a mother capable of containing projective identification, that is, of being a good breast] into alpha elements. Those are elements which can be stored in memory, which can be repressed and worked through. They are suitable for symbolization and formation of dream thoughts. ... Alpha function is also linked with mental space." I am arguing that the disturbing tragedy of France's fall, which could first be worked through after its liberation, aroused primitive feelings of tragedy in Soulages. He used art to contain them, as though in an abstract dream.

28. Ceysson, *Soulages,* p. 27. One might say that Soulages conveys the feeling of being let down by France – the rapidity of its collapse in World War II, which was moral as well as military, that he experienced as a youth.

29. Quoted in ibid., p. 57.

30. Hans Jonas, "Gnosis, Existentialismus und Nihilismus," *Zwischen Nichts und Ewigkeit: Zur Lehre von Menschen* (Göttingen: Vandenhoeck & Ruprecht, 1963), pp. 5–25, shows how mysticism and existentialism correlate. Kurt Rudolph, *Gnosis: The Nature and History of Gnosticism* (New York: Harper & Row, 1983), p. 55, writes that "gnosis," insight into the light of God while falling in the darkness of the world, is "a knowledge which has at the same time a liberating and redeeming effect. ... It is a knowledge given by revelation, which has been made available only to the elect who are capable of receiving it, and therefore has an esoteric character. ... All gnostic teachings are in some form a part of the redeeming knowledge which gathers together the object of knowledge (the divine nature), the means of knowledge (the redeeming gnosis) and the knower himself," at his most unequivocally subjective, that is, in his mystical identity.

31. Splitting – into good and bad (light and dark, satisfying and frustrating, secure and threatening) – is a fundamental mechanism of defense, discussed in particular detail by Melanie Klein and Otto Kernberg. W. Ronald D. Fairbairn, "Synopsis of an Object-Relations Theory of the Personality," *International Journal of Psychoanalysis,* 44 (1963):224 describes the splitting of the "original ego" as the "basic schizoid position." The mature ego synthesizes the opposites in ambivalence, but the split has done its damage: the ego remains susceptible to rupture from within.

CHAPTER TWELVE: UNCONSCIOUS AND SELF-CONSCIOUS COLOR IN "AMERICAN-TYPE" PAINTING

1. Wassily Kandinsky, *Concerning the Spiritual in Art* (New York: Dover, 1977), p. 43.

2. Guillaume Apollinaire, "Reality, Pure Painting," *The New Art of Color: The Writings of Robert and Sonia Delaunay,* ed. Arthur A. Cohen (New York: Viking Press, 1978), p. 92.

3. *Art as Art: The Selected Writings of Ad Reinhardt,* ed. Barbara Rose (New York: Viking Press, 1975), p. 6.
4. Ibid., p. 82.
5. Clement Greenberg, "'American-Type' Painting," *Art and Culture* (Boston: Beacon Press, 1965, paperback ed.), p. 226.
6. Ibid., p. 208.
7. Ibid., p. 221.
8. Ibid.
9. Ibid., p. 227.
10. Ibid., pp. 225–26.
11. As Delaunay, p. 52, said, "Image in the pure sense of the word means the plastic, organic organization in the vital sense of rhythm."
12. Reinhardt, p. 82.
13. Greenberg, p. 227.
14. Reinhardt, p. 83.
15. Ibid., pp. 29, 47.
16. Ibid., p. 17.
17. Ibid., p. 21.
18. Ibid., p. 27.
19. Ibid., p. 48.
20. Hans Hofmann, quoted in Herschel B. Chipp, ed., *Theories of Modern Art* (Berkeley: University of California Press, 1968), p. 541. Michel Conil-Lacoste, "La transcendence de Rothko," *Le Monde des Arts,* March 29, 1972, p. 13, has argued that, particularly with respect to the late Rothko, "two readings" are possible: "not only the technician of color, but also the engaged heart of mysticism." This can be generalized to Still and Newman.
21. Reinhardt, p. 48.
22. Hofmann, p. 538.
23. Reinhardt, p. 83.
24. Hofmann, p. 539.
25. Quoted in Robert Rosenblum, *Modern Painting and the Northern Romantic Tradition, Friedrich to Rothko* (New York: Harper & Row, Icon Edition, 1975), p. 215.
26. Quoted in Donald B. Kuspit, *Clement Greenberg, Art Critic* (Madison, Wisc: University of Wisconsin Press, 1979), p. 179.
27. Quoted in ibid., p. 178.
28. For example, Greenberg connects Walt Whitman and Still, writing of the "fray-leaf and spread-hide contours that wander across his canvas like souvenirs of the great American outdoors." Indeed, Greenberg has written that "the best modern painting, though it is mostly abstract painting, remains naturalistic to its core, despite all appearances to the contrary. It refers to the structure of the given world both outside and inside human beings." Quoted in Donald Kuspit, *The Critic Is Artist: The Intentionality of Art* (Ann Arbor: UMI Research Press, 1984), p. 202. Similarly, Rosenblum, p. 200, connects Still's abstract paintings with the "sublime storms and mountains of the American West," Newman's with the "experiences of unbounded nature [of] the Romantics" that served as "metaphors of supernatural mysteries" (p. 211), and Rothko's with "metaphorical suggestions of an elemental nature" (p. 214). The problem with this interpretation is that it offers no rationale for the abstraction of nature, that is, it ignores the subjective reasons for its transformation. For these painters abstraction becomes a way of trans-

forming objective into subjective nature, that is, objective nature – particularly its colors, "edgily" divided – is a point of subjective departure for them.

CHAPTER THIRTEEN: RELICS OF TRANSCENDENCE

1. Jack Kroll, "Richard Pousette-Dart: Transcendental Expressionist," *Art News,* 60 (April 1961): 32.
2. Stephen Polcari, *Abstract Expressionism and the Modern Experience* (Cambridge and New York: Cambridge University Press, 1991), p. 336.
3. Quoted in Lowery Stokes Sims, "Ciphering and Deciphering: The Art and Writings of Richard Pousette-Dart," *Richard Pousette-Dart (1916–1992)* (New York: Metropolitan Museum of Art, 1997; exhibition catalogue), p. 15.
4. Ibid., p. 10.
5. Ibid., p. 15.
6. Clement Greenberg, *Arrogant Purpose, 1945–1949, The Collected Essays and Criticism* (Chicago and London: University of Chicago Press, 1988), pp. 6–7.
7. Clement Greenberg, *Perceptions and Judgments, 1939–1944, The Collected Essays and Criticism* (Chicago and London: University of Chicago Press, 1988), p. 210.
8. David Anfam, *Abstract Expressionism* (New York and London: Thames and Hudson, 1990), pp. 171–72.
9. Clement Greenberg, *Arrogant Purpose, 1945–1949,* p. 29.
10. Quoted in Sims, pp. 17, 18.
11. Wilhelm Worringer, *Form in Gothic* (New York: Schocken, 1964), pp. 41, 43, argues that the gothic involves "confused, spasmodic movements" expressing a "heavily oppressed inner life."
12. Pousette-Dart denies that his "pointillism" derives from Seurat's. Rather, it originates in his work retouching color photographs (Sims, p. 18). His own photographs show a preoccupation with the minute detail of nature, suggesting that his paintings are subliminally naturalistic.
13. Stephen Polcari, "Richard Pousette-Dart: Toward the Historical Sacred," *Richard Pousette-Dart (1916–1992),* p. 64.

CHAPTER FIFTEEN: MODERN HISTORY PAINTING IN THE UNITED STATES

1. Christos M. Joachimides and Norman Rosenthal, eds., *The Age of Modernism: Art in the 20th Century* (Berlin: Zeitgeist-Gesellschaft and Stuttgart: Verlag Gerd Hatje, 1997).
2. Peter Selz, *Art in Our Times: A Pictorial History 1890–1980* (New York: Harcourt Brace Jovanovich and Harry N. Abrams, 1981), pp. 286–87.
3. Charles Baudelaire, *The Mirror of Art,* ed. Jonathan Mayne (Garden City, NY: Doubleday Anchor Books, 1956), p. 243.
4. Ibid., p. 259.
5. Ibid., p. 261.
6. Théophile Gautier, "The A. B. C. of the Salon of 1861," *The Art of All Nations 1850–1873: The Emerging Role of Exhibitions and Critics,* ed. Elizabeth Gilmore Holt (Princeton: Princeton University Press, 1982), p. 293.
7. Ibid.

8. Ibid., p. 294.

9. Pietro Selvatico, "The State of Contemporary Historical and Sacred Painting in Italy as Noted in the National Exposition in Florence in 1861," in Holt, p. 320.

10. Ibid.

11. Ibid.

12. Ibid., p. 309.

13. Edmond and Jules de Goncourt, "The Salon of 1852," in Holt, p. 86.

14. Ibid., p. 87.

15. I am thinking of Greenberg's idea that a "superior [avant-garde] culture is inherently a more critical culture" than "official" culture, established by a "political regime" to legitimate itself, and than culture that claims to be "the expression of an absolute," and so beyond reproach. Clement Greenberg, "Avant-Garde and Kitsch," *Art and Culture* (Boston: Beacon Press, 1965), pp. 19, 5.

16. Edmond and Jules de Goncourt, p. 87.

17. Ibid., p. 91.

18. Ibid., p. 90.

19. Ibid., p. 88.

20. Erik H. Erikson, *Life History and the Historical Moment* (New York: Norton, 1975).

21. Poussin's painting is no doubt subject to criticism on feminist grounds – it seems a straightforward display of male dominance and oppression – but it also depicts the founding moment of Rome, as though to demonstrate the ironical way destiny makes itself manifest, that is, the way collective history and power subsume individual history and suffering. I suppose this is the place to say that I do not regard any history as privileged over any other, although I believe a distinction has to be made between dominant and dependent histories. The history of the Sabine women is dependent on the power of the Roman men who use rape to dominate them. But the larger point is that neither the women nor the men are aware that they are the pawns of fate.

22. W. Brian Arthur, "How Fast Is Technology Evolving?", *Scientific American,* 276 (February 1997): 118.

23. I am arguing that social history is increasingly dependent upon technological history, and always has been subliminally. Thus, the invention of the atomic bomb made all the difference in the outcome of the second world war, and the failure of the Chinese to exploit their invention of gunpowder – they used it in firecrackers rather than cannon – made all the difference in world history.

 I believe a technological reference, however indirect, is crucial to social history painting. The weapons may seem secondary to the men who use them in battle pictures, but without their instruments of war they are insignificant, indeed, not really men. As the American saying goes, "the West was won by the Colt [pistol]," not by any particular individual. No doubt strategy also plays a role, but strategy is a form of technology, as the Trojan horse that won the Trojan war for the Greeks suggests.

24. Bernd Schmitt and Alex Simonson, *Marketing Aesthetics* (New York: Free Press, 1997), passim.

25. Jacques Ellul, *The Technological Society* (New York: Random House, Vintage, 1964), p. 67.

26. Ludwig von Bertalanffy, *General System Theory* (New York: George Braziller, 1968), pp. 190–92.

27. Arnold Hauser, *The Social History of Art* (New York: Random House, Vintage, 1958), vol. 3, p. 147.

CHAPTER SIXTEEN: MOURNING AND MEMORY:
WLODEK KSIAZEK'S ABSTRACT PAINTINGS

1. Robert Motherwell, "What Abstract Art Means to Me," *The Collected Writings of Robert Motherwell* (New York: Oxford University Press, 1992), p. 86.
2. Indeed, Ksiazek's paintings reconcile expression and construction, the antitheses of modernism. Their synthesis confirms his postmodernism, and revitalizes both. Where Gerhard Richter and Jonathan Lasky reify expression, and Peter Halley reifies construction, Ksiazek's paintings remind us that postmodernism does not necessarily mean the ironical reification of modernist ideas into inauthentic clichés, that is, their rationalization into and illustration as conceptual stereotypes. It can also mean the innovative reconciliation of what once seemed irreconcilable, affording both new meaning and authenticity.
3. Ksiazek has acknowledged that many of his plans are of religious structures. In rendering the abstract plan rather than an image of the structure, he confirms that the sacred can no longer be made "literally" manifest, and as such is for all practical, communal purposes dead.
4. Thomas A. Sebeok, "Prefigurements of Art," *The Play of Musement* (Bloomington: Indiana University Press, 1981), p. 212.

CHAPTER SEVENTEEN: LÁSZLÓ FEHÉR: MEMORY AND ABANDONMENT

1. Julia Kristeva, "Interview," *Flash Art,* no. 126 (February–March 1986): 47, notes, as many other thinkers have, that modernism emphasizes "fragmentation," while postmodernism tries to achieve an "eclectic unity."
2. Karl Menninger, "The Genius of the Jew in Psychiatry," *A Psychiatrist's World: The Selected Papers of Karl Menninger* (New York: Viking, 1959), pp. 415–24.
3. Quoted in Rolf Wiggershaus, *The Frankfurt School: Its History, Theories, and Political Significance* (Cambridge, MA: MIT Press, 1994), p. 6.
4. Harold Rosenberg, "Is There a Jewish Art?" in *Discovering the Present: Three Decades in Art, Culture and Politics* (Chicago: University of Chicago Press, 1973), p. 230.

CHAPTER EIGHTEEN: ODD NERDRUM, PERVERSE HUMANIST

1. George Frankl, *Civilisation: Utopia and Tragedy, The Social History of the Unconscious,* vol. 2 (London: Open Gate Press, 1990), pp. 167–68.
2. Ibid., pp. 164–65.
3. Robert J. Stoller, *Perversion: The Erotic Form of Hatred* (New York: Delta Books, 1975), p. 4.

CHAPTER TWENTY: AVANTE-GARDE, HOLLYWOOD, DEPRESSION:
THE COLLAPSE OF HIGH ART

1. Max J. Friedländer, *Landscape Portrait Still-Life* (New York: Schocken, 1963), p. 230.
2. Quoted in Peregrine Horden, "Thoughts of Freud," *Freud and the Humanities,* ed. Peregrine Horden (New York: St. Martin's, 1985), p. 1.
3. Otto Kernberg, *Borderline Conditions and Pathological Narcissism* (Northvale, NJ: Jason Aronson, 1990), p. 20.
4. Bruno Bettelheim, "Art and Art Education: A Personal Vision," *Surviving and Other Essays* (New York: Random House, Vintage, 1980), pp. 416–17.

CHAPTER TWENTY-ONE: FAILURE OF IDENTITY? ON BEING HALF AN ARTIST

1. Erik H. Erikson, *Life History and the Historical Moment* (New York: Norton, 1975), p. 21.
2. Quoted in Heinz Lichtenstein, *The Dilemma of Human Identity* (New York: Jason Aronson, 1983), p. 237.
3. Clement Greenberg, *Art and Culture* (Boston: Beacon, 1963), p. 224.
4. Harold Rosenberg, *The Tradition of the New* (New York: McGraw-Hill, 1965), p. 25.
5. Ibid., p. 41.
6. Ibid., p. 42.
7. Erikson, p. 205.
8. Erik H. Erikson, *Childhood and Society* (New York: Norton, 1963), p. 308.
9. Rosenberg, pp. 17, 30, 31.
10. Erikson, *Life History and the Historical Moment,* pp. 206–7.
11. Rosenberg, p. 18.
12. Harold Rosenberg, *The Anxious Object* (New York: Horizon Press, 1964), p. 124.
13. Ibid., pp. 124–25.
14. José Ortega y Gasset, *The Dehumanization of Art and Other Writings on Art, Culture, and Literature* (Garden City, NY: Doubleday, 1950), p. 46.
15. Erikson, *Childhood and Society,* p. 285.
16. Ibid., p. 286.

CHAPTER TWENTY-THREE: HEROIC ISOLATION OR DELUSION OF GRANDEUR? CHUCK CLOSE'S PORTRAITS OF ARTISTS

1. Jakob Rosenberg, *Rembrandt: Life and Work,* 3rd ed. (New York and London: Phaidon, 1968), p. 43. All subsequent quotations about Rembrandt are from this source.
2. Erwin Panofsky, *The Life and Art of Albrecht Dürer,* 3rd ed. (Princeton: Princeton University Press, 1955), p. 43. All subsequent quotations about Dürer are from this source.
3. It may be that there is a defiance of the fate that has crippled him, but the spirit of disdain is evident from the start, long before Close became confined to a wheelchair.

CHAPTER TWENTY-FOUR: NAN GOLDIN: PICTURES OF PATHOLOGY

1. Robert Stoller, "Perversion and the Desire to Harm," *Observing the Erotic Imagination* (New Haven; Yale University Press, 1985), p. 34.
2. Heinz Kohut, *The Restoration of the Self* (New York; International Universities Press, 1977), p. 197. Sheldon Bach, *The Language of Perversion and the Language of Love* (Northvale, NJ; Jason Aronson, 1994), p. 16, writes that "perversions could be viewed as an idealized or denigrated prescription for what was necessary to complete ... sexual identity and sense of self," and that the reason there may be "fewer classical perversions these days" may be because "so many of these people now use drugs to help camouflage and patch over the defect in their ego functioning and reality sense."
3. As Stoller, p. 27, notes, transvestitism often originates in the "traumatic experience of being cross-dressed ... by women" when one was a child. "A defenseless male, who knows and values being a male (it is his core gender identity) but who, at this early age, is not so sure his sense of maleness can withstand assault, is put into girls' clothes; his gender identity is threatened."

4. Luc Sante, "All Yesterday's Parties," *Nan Goldin: I'll Be Your Mirror* (New York: Whitney Museum of American Art, 1996; exhibition catalogue), p. 97.

5. Ibid., p. 100.

6. Ibid., p. 102.

7. Simone Weil defines "force" as "that *x* that turns anybody who is subjected to it into a *thing*. Exercised to the limit, it turns man into a thing in the most literal sense: it makes a corpse out of him." But there is a force "that does not kill just yet," that "turn[s] a human being into a thing while he is still alive." Quoted in Bach, p. xv. Goldin's camera hovers between treating human beings as living, not quite human things – weird, ambiguous specimens of humanity – and prefiguring their deaths, that is, their status as corpses. Indeed, her photographs of corpses laid out for viewing are the most crucial ones in her oeuvre. That is, they indicate the direction in which all her other images are heading. They magnetize the field of her photographs: they make visible the force otherwise invisible in it.

8. As Mario Jacoby, *Individuation and Narcissism: The Psychology of the Self in Jung and Kohut* (New York: Routledge, 1990), p. 66, writes, for Kohut, "empathic attention and caring provide the infant with a mirror, so to speak, in which it can gradually come to recognize and experience itself as a total entity, a self. The mother figure who carries out this mirroring is termed by Kohut the 'self-object.'" Goldin seems torn between being a self-object for her infantile friends by mirroring them with her camera, and wallowing with them in their infantile self-destructiveness and "selflessness."

9. Elisabeth Sussman, "In/Of Her Time: Nan Goldin's Photographs," *Nan Goldin: I'll Be Your Mirror,* p. 28, writes that "Goldin's friends [were] enamoured of picture taking and posing," and that her "portraits capture a birth of identity that is linked with a performance for the camera." But I think the pose aborts identity, and performing for the camera gives one an illusion of identity. Luc de Sante, p. 97, writes: "We were living a movie of youth in black-and-white that in order to be grand needed to be stark … The inner movie might vary from person to person, but the styles overlapped … The makeshift, the beleaguered, the militant, the paranoid, the outcast, the consumptive romantic, the dead-eyed post-everything – all the shifting and coinciding modes and poses played very well against a backdrop of ruins." In other words, they were pretending to be rebels without a cause, but it was only an act – which made their lives all the more catastrophic.

10. Sussman, p. 29, notes Goldin's interest in "the catwalk spectacle of the weekly beauty contest." I think Goldin became interested in the spectacle as an artistic form and cultural mode of (pseudo)self-presentation in itself, that is, a way of creating the illusion of extravagant personality and self-identity. It is not clear that Goldin realized that her photographs were part of what Guy Debord calls *The Society of the Spectacle* (New York: Zone Books, 1995) – a world in which "all that was once directly lived has become mere representation" (p. 12), and in which the spectacle is "the concrete manufacture of alienation" (p. 23) and "corresponds to the historical moment at which the commodity completes its colonization of social life" (p. 29) – but it does seem clear that she understood the unconventional and thus "spectacular" character of the people she photographs. Indeed, she goes out of her way to find such people, and, when she deals with such conventional people as her parents, she tries to make them seem unexpectedly and thus all the more spectacularly unconventional.

11. If, as Stoller, p. 33, argues, "the main aesthetic task, as with so much behavior, is to take knowledge and render it uncertain, ambiguous," then the movie poses of Goldin's people are a way of making our knowledge of them uncertain and ambiguous, while at the same time reifying it. That is, they turn themselves into things by posing (as pseudo-popular Warholesque pseudo-stars), which hides their reality but also ironically reveals that it is nothing but a pose. In other words, Goldin's artful photographs – their art ultimately consists in confirming the theatrical artfulness of her subjects – reveals them to have no self beyond the self they playact: beyond the pretense of posing as a self, pretending to be "somebody."

CHAPTER TWENTY-SIX: WOMAN AT RISK: THE REPRESENTATION OF THE FEMININE IN MODERN AND POSTMODERN ART

1. Quoted in Jimmy Ernst, *A Not-So-Still Life* (Wainscott, NY: Pushcart Press, 1984), p. 91.
2. C. G. Jung, *Memories, Dreams, Reflections* (New York: Vintage Books, 1961), p. 134.
3. Quoted in Axel Madsen, *Sonia Delaunay, Artist of the Lost Generation* (New York: McGraw-Hill, 1989), p. 322.
4. Quoted in Barbara Buhler Lynes, *O'Keeffe, Stieglitz and the Critics, 1916–1929* (Ann Arbor, Mich: UMI Research Press, 1989), p. 22.
5. In a well-known essay on "The Aesthetics of Power in Modern Erotic Art," Carol Duncan argues that such desire is the mask of dominance. Desire can no doubt be used as an instrument of dominance, but this view is blind to the complexities of the sexual drive, especially in its relation to the aggressive drive, in both man and woman. In general, Duncan overideologizes the relationship between man and woman, allowing no room for any psychobiological understanding of it. See pp. 59–69, *Feminist Art Criticism: An Anthology*, eds. Arlene Raven, Cassandra L. Langer, Joanna Frueh (Ann Arbor: UMI Research Press, 1988). This anthology, which involves a variety of interpretive approaches, is perhaps the best collection of critical essays on modern and contemporary feminist art. Whitney Chadwick's *Women, Art, and Society* (New York: Thames and Hudson, 1990) offers an excellent overview of the history and development of woman's art through the ages, as does Ann Sutherland Harris and Linda Nochlin's *Women Artists: 1550–1950* (Los Angeles; Los Angeles County Museum, 1976, exhibition catalogue). There is a huge literature on the subject which cannot be cited in this context.
6. Jessica Benjamin, *Like Subjects, Love Objects: Essays on Recognition and Sexual Difference* (New Haven: Yale University Press, 1995), p. 11.
7. Sally E. Shaywitz, "Dyslexia," *Scientific American*, 275/5 (November 1996):103.
8. For example, Lucy R. Lippard, *From the Center: Feminist Essays on Women's Art* (New York: Dutton, 1976), p. 39, speaks of the "latent difference in sensibility" between "women's art" and men's art. She "expect[s] a body of art history and criticism will emerge that is more suited to women's sensibilities" (p. 39) than "the double mainstream of modern art, the so-called avant-garde, which for better or worse has been largely white and male-dominated" (p. 40). She notes that "the common factor" in women's art is "a vague 'earthiness,' 'organic images,' 'curved lines,' and most convincingly, a centralized focus (Judy Chicago's idea)" (p. 40). These are the traditional essentialist terms used to refer to woman's body. Chicago accepts the conventional idea of the vagina as the central focus of the woman's body, using it symbolically in

The Dinner Table, 1978. However, she does distinguish between "female point of view and feminine sensibility, … something about the female personality structure [brain functioning?] that informs the works" (p. 229). As she says, "what we're really talking about is not the subject matter, but where the approach to the work is conditioned. Those women involved in weaving and sewing and all – that's informed by feminine *sensibility,* by role conditioning, and a certain sensitivity to surface, detail." Presumably such sensitivity, clearly in evidence, is more important in *The Dinner Party* than the complex symbolism of the dinner plate and place setting, which would be the work's subject matter. The question, of course, is what one does with all the many male artists who are sensitive to surface and detail. To reductively label their sensibility "feminine" – to appropriate them for feminism – does not help us understand their sensitivity, and obscures the differences between their particular articulations of surface and detail.

9. See Wolfgang Lederer, *The Fear of Woman* (New York: Grune and Stratton, 1968), for a brilliant, exhaustive account of man's fear of woman, including vagina dentata. I am suggesting that this fantasy expresses not only the male fear of being castrated by the vagina during the act of sexual intercourse, but the male fear of the penis being outsmarted by the subtly "sharper," more cunning vagina. In other words, it is the (justifiable) male fear of losing one's mind or head during sexual intercourse. Samson was not only symbolically castrated by Delilah, but his blindness signals that he lost his wits in the first place when he was tempted by her. She in effect blinded his mind with her dazzling charms. Similarly, Oedipus blinds himself not only in symbolic castration for the incestuous crime of sleeping with his mother, but to acknowledge that he did not have the wit to realize that he did.

10. Arlene Kramer Richards, "What Is New With Women," *Journal of the American Psychoanalytic Association,* 44/4 (1996):1227.

11. Ibid.

12. Ibid., p. 1231.

13. Ibid., p. 1233.

14. Teresa Wennberg, "Through the Electronic Labyrinth: The Meanderings of a Visual Artist," *Leonardo,* 29/3 (1996):187.

15. Silvano Arieti, *The Will to Be Human* (New York; Quadrangle, 1972), p. 33.

16. For a comprehensive account of the feminist goddess movement see Charlene Spretnak, ed., *The Politics of Women's Spirituality, Essays on the Rise of Spiritual Power Within the Feminist Movement* (Garden City, NY; Doubleday Anchor Books, 1982). See also Gloria Feman Orenstein, "The Reemergence of the Archetype of the Great Goddess in Art by Contemporary Women," *Feminist Art Criticism: An Anthology,* pp. 71–86.

17. G. W. F. Hegel, *Phenomenology of Spirit,* trans. A. V. Miller (New York: Oxford University Press, 1977), p. 437.

18. I mean "spectacle" in the sense in which Guy Dbord uses the term in *The Society of the Spectacle* (New York: Zone Books, 1994). In it, "all that once was lived has become mere representation" (p. 12), suggesting that woman is no longer lived – or lives – and has become a mere representation, which in fact is the underlying if unwitting point of many of the images in this exhibition. "Spectacle" implies a separation between reality and image (p. 13): the reality of woman is one thing, her image the other, and in the society of the spectacle they are irreconcilable, and often never meet, not to say merge. "Spectacle corresponds to the historical moment at which the commodity

completes its colonization of social life" (p. 29), suggesting that woman is at her most "spectacular" when she is commodified appearance, which is the way she appears in many glamorous, idealized images. In a sense, the theme of this exhibition is how woman is made into a spectacle by the society of men, but also how she makes herself into a spectacle, perhaps in search of narcissistic gratification.

19. Robert Stoller, "Perversion and the Desire to Harm," *Observing the Erotic Imagination* (New Haven: Yale University Press, 1985), p. 15, defines pornography as "that product manufactured with the *intent* to produce erotic excitement," noting that its main ambition is "dehumanization" (p. 32). "Even the pornographer's seemingly trivial airbrush removes the truth, the little blemishes that are unbearable, unesthetic." In a sense, every male representation of the female in this exhibition is pornographic, in that it dehumanizes the female into esthetic perfection, however many ironic, debunking comments the male artist makes on that perfection. In fact, the idealized images of woman airbrush her into desirability, that is, making her more exciting because they remove any traces of time and suffering from her flesh. This dehumanization rebounds back on the male artist: he "dehumanizes his object in order to feel safe enough to get excited," but he pays the price of dehumanizing himself (p. 32). Thus, in depriving woman of the fullness of her being and precluding intimacy with her, he not only reduces her to a member of a class and the possessor of "selected [body] parts or qualities," but he does the same thing to himself. The excited consumer of pornography as well as the exciting pornographic object are equally overobjective.

CHAPTER TWENTY-SEVEN: UNCONSCIOUSLY, ALWAYS AN ALIEN AND SELF-ALIENATED: THE PROBLEM OF THE JEWISH-AMERICAN ARTIST

1. Sandor Gilman, *Smart Jews: The Construction of the Image of Jewish Superior Intelligence* (Lincoln and London: University of Nebraska Press, 1996).
2. Linda Nochlin, "Introduction: Starting with the Self: Jewish Identity and its Representation," *The Jew in the Text: Modernity and the Construction of Identity,* eds. Linda Nochlin and Tamar Garb (London and New York: Thames and Hudson, 1996), p. 7.
3. All quotations are from Harold Rosenberg, "Is There a Jewish Art?", *Discovering the Present: Three Decades in Art, Culture, and Politics* (Chicago and London: University of Chicago Press, 1973), pp. 223–31.

CHAPTER TWENTY-EIGHT: MEYER SCHAPIRO'S JEWISH UNCONSCIOUS

1. Margaret Olin, "Violating the Second Commandment's Taboo: Why Art Historian Meyer Schapiro Took on Bernard Berenson," *Forward* 98 (November 4, 1994): 23.
2. Harold Rosenberg, "Is There a Jewish Art?" in *Discovering the Present: Three Decades in Art, Culture and Politics* (Chicago: University of Chicago Press, 1973), p. 230.
3. Clement Greenberg, "Kafka's Jewishness," in *Art and Culture* (Boston: Beacon, 1965), p. 273.
4. Ibid., p. 270.
5. Clement Greenberg, "The Impressionists and Proust," *Nation* 163 (August 31, 1946):247. (Review of *Proust and Painting* by Maurice Chernowitz.)
6. Clement Greenberg, "David Smith's New Sculpture," *Art International* 8 (May 1964): 37.

7. Meyer Schapiro, "Chagall's illustrations for the Bible" (1956), in *Modern Art: 19th and 20th Centuries, Selected Papers* (New York: George Braziller, 1978), Vol. 2, p. 133.

8. Ibid., p. 121.

9. Meyer Schapiro, "Cézanne" (1959), in *Modern Art,* p. 40.

10. Meyer Schapiro, "Mr. Berenson's Values" (1961), in *Theory and Philosophy of Art: Style, Artist, and Society, Selected Papers* (New York: George Braziller, 1994), vol. 4, p. 225.

11. Olin, "Violating," p. 23.

12. Schapiro, "Mr. Berenson's Values," p. 225.

13. Ibid., p. 217.

14. Ibid., p. 222.

15. Quoted in Rolf Wiggershaus, *The Frankfurt School: Its History, Theories, and Political Significance* (Cambridge: MIT Press, 1994), p. 6.

16. Ibid., pp. 4–5

17. Meyer Schapiro, On the Aesthetic Attitude in Romanesque Art" (1947), in *Romanesque Art, Selected Papers* (New York: George Braziller, 1977), vol. 1, p. 8.

18. Meyer Schapiro, "The Sculptures of Souillac" (1939), in *Romanesque Art,* p. 104.

19. Meyer Schapiro, "Nature of Abstract Art" (1937), in *Modern Art,* p. 186.

20. Meyer Schapiro, "Recent Abstract Painting" (1957), in *Modern Art,* p. 224.

21. Schapiro, "On the Aesthetic Attitude," p. 1.

22. Schapiro, "Recent Abstract Painting," p. 215. Schapiro qualifies this more concretely: "The pathos of the reduction or fragility of the self within a culture that becomes increasingly organized through industry, economy and the state intensifies the desire of the artist to create forms that will manifest his liberty in this striking [abstract] way" (p. 222). It is worth noting that Schapiro follows Alois Riegl's method in finding "a necessary creative link" between Romanesque and modern abstract art (Schapiro, "Style" [1962], in *Theory and Philosophy of Art,* p. 78).

23. Schapiro, "Nature of Abstract Art," p. 193.

24. Schapiro, "Sculptures of Souillac," p. 104.

25. Schapiro, "On the Aesthetic Attitude," p. 22.

26. Meyer Schapiro, "Courbet and Popular Imagery: An Essay on Realism and Naivete" (1941), in *Modern Art,* p. 73.

27. Meyer Schapiro, "'Muscipula Diaboli,' The Symbolism of the Merode Altarpiece," *Art Bulletin* 27 (1945):185.

28. Ibid., p. 186.

29. Meyer Schapiro, "The Romanesque Sculpture of Moissac I" (1931), in *Romanesque Art,* pp. 187–88.

30. Schapiro, "Sculptures of Souillac," pp. 107, 113–14.

31. Schapiro pays a good deal of attention to the intense color contrasts that prevail in Cézanne's and van Gogh's paintings (*Paul Cézanne* [New York: Abrams, 1965] pp. 11–12; and *Vincent van Gogh* [New York: Abrams, 1950], pp. 19–22). This is not unlike the "intense … burning, heraldically bright … bands of contrasted color … spontaneous primitive" visionary color in "The Beatus Apocalypse of Gerona," a medieval manuscript (*Art News* 61 [1963]:50). In "From Mozarabic to Romanesque in Silos" (1939) (*Romanesque Art,* p. 35) he describes "Mozarabic painting as an art of color," using "constantly varied, maximum oppositions in the color through the contrasts of hue (and, to a lesser extent, of value)," and observes that in the "Beatus manuscripts color is felt as a universal force, active in every point and transcending objects."

It is worth noting that in his recurrent emphasis on "polar meanings," "polarity expressed through ... contrasted positions," "polar structure," and "development between two poles" – to cite various references to polar thinking in his book *Words and Pictures On the Literal and Symbolic in the Illustration of a Text* (The Hague: Mouton, 1973) and his essay on "Style" – Schapiro strongly resembles Alfred North Whitehead. In *Process and Reality* (New York: Humanities, 1955), Whitehead argues that the "doctrine of multiple contrasts ... when there are or may be more than two elements jointly contrasted" is "a commonplace of art" (p. 349). He also writes, "The organism's" creative achievement of "depth of experience" involves "suppressing the mere multiplicities of things, and designing its own contrasts. The canons of art are merely the expression, in specialized forms, of the requisites of depth of experience" (p. 483). Finally, Whitehead philosophizes that "the universe is to be conceived as attaining the active self-expression of its own variety of opposites – of its own freedom and its own necessity, of its own multiplicity and its own unity, of its own imperfection and its own perfection. All the 'opposites' are elements in the nature of things, and are incorrigibly there." They justify "the aesthetic value of discords in art" (p. 531). It is in effect a "minor exemplification" of major, universal opposites.

32. Meyer Schapiro, "The Younger American Painters of Today," *Listener* 55 (January 26, 1956):147.

33. Meyer Schapiro, in "An Illuminated English Psalter" (*Journal of the Warburg and Courtauld Institutes* 22 [1960]:183), observes that "the motif of the crossed legs is a general attribute of the ruler, whether good or evil; it isolates him from ordinary mankind, which sits or stands supported by both feet alike." It is perhaps the most exemplary instance of what Schapiro calls "chiasmic symmetry."

34. Meyer Schapiro and seminar, "The Miniatures of the Florence Diatessaron (Laurentian Ms Or. 81): Their Place in Late Medieval Art and Supposed Connection with Early Christian and Insular Art," *Art Bulletin* 55 (1973): 518.

35. Schapiro, "From Mozarabic," p. 83, n. 87.

36. Ibid., p. 30.

37. Schapiro, "On the Aesthetic Attitude," p. 26, n. 10.

38. Ibid., p. 9.

39. Meyer Schapiro, "Mondrian: Order and Randomness in Abstract Painting" (1978), in *Modern Art,* p. 235.

40. Schapiro, Vincent van Gogh, pp. 29–30.

41. Ibid., pp. 27, 22–23.

42. Schapiro, *Paul Cézanne,* p. 27.

43. Ibid., p. 12.

44. Ibid., p. 18.

45. Ibid., p. 26.

46. Schapiro, *Vincent van Gogh,* p. 8.

47. Ibid., p. 34.

48. Schapiro, *Words and Pictures,* p. 48.

49. Meyer Schapiro, "On Geometrical Schematism in Romanesque Art" (1932), in *Romanesque Art,* p. 268.

50. Meyer Schapiro, "Freud and Leonardo: An Art Historical Study" (1956), in *Theory and Philosophy of Art.* See also, in the same book, "Further Notes on Freud and Leonardo" (1994). Schapiro's critique of Freud's psychoanalysis of Leonardo is eloquently epito-

mized in footnote 9 to "On the Relation of Patron and Artist: Comments on a Proposed Model for the Scientist" (1964) in the same book. Schapiro notes (p. 237) that "Leonardo's slowness of work," which Freud interprets as "a neurotic sign," was a "more common characteristic [of artists] than Freud suspected. If one believes that Leonardo's failures to deliver were greater than those of other artists, it is also true that he has left us more writings, scientific observations, and technical inventions than any artist of the Renaissance, and perhaps of all time." Such slowness has to do with difficulties of creative work, not neurotic inhibition, although that may no doubt play a role.

51. Schapiro's "On Geometrical Schematism in Romanesque Art" takes as its point of departure Jurgis Baltrusiatis's *La Stylistique Ornementale dans la Sculpture Romane* (1931).

52. Schapiro's "Nature of Abstract Art" takes as its point of departure Alfred H. Barr Jr.'s *Cubism and Abstract Art* (1936).

53. Schapiro, "Nature of Abstract Art," p. 222.

54. Schapiro, "Mr. Berenson's Values," p. 222.

55. Ibid., p. 227.

56. Meyer Schapiro, "Diderot on the Artist and Society," in *Theory and Philosophy of Art,* p. 206.

57. Ibid., p. 204.

58. Ibid., p. 205.

59. Ibid.

60. Schapiro, "Mr. Berenson's Values," p. 224.

61. Meyer Schapiro, "Eugene Fromentin as Critic," in *Theory and Philosophy of Art,* p. 105.

62. Meyer Schapiro, "On Some Problems in the Semiotics of Visual Art: Field and Vehicle in Image-Signs," in *Theory and Philosophy of Art,* p. 6.

63. Schapiro, "Mr. Berenson's Values," p. 212.

64. Ibid., p. 218.

65. Ibid., p. 219.

66. Ibid., p. 218.

67. Schapiro, "On the Relation of Patron and Artist: Comments on a Proposed Model for the Scientist," in *Theory and Philosophy of Art,* p. 237.

68. Schapiro, "Mr. Berenson's Values," p. 211.

69. As early as 1967, Clement Greenberg, in "Where Is the Avant-Garde?" described it as "hypertrophied" and "institutional," later noting that "when everybody is a revolutionary the revolution is over" (*Modernism with a Vengeance, 1957–1969: The Collected Essays and Criticism* [Chicago: University of Chicago Press, 1993], vol. 4, pp. 261–62, 299). Harold Rosenberg notes a similar "fashionabilizing" of the avant-garde, in "The Avant-Garde" (1969) (*Discovering the Present* [Chicago: University of Chicago Press, 1973], p. 86).

Publication Data*

I. PAINTING: PAST AND POSSIBLE

1. "Charles Burchfield: Apocalypse Now"
 The Paintings of Charles Burchfield: North by Midwest. Nannette V. Maciejunes and Michael D. Hall, eds. Published in 1997 by Harry N. Abrams, Inc., New York. In association with the Columbus Museum of Art.
2. "Soutine's Shudder: Jewish Naiveté?" *An Expressionist in Paris: The Paintings of Chaim Soutine.* Published in 1998 by the Jewish Museum, New York and Prestel Verlag, Munich and New York.
3. "Picasso's Portraits and the Depths of Modernism"
 Reprinted with permission from *Art New England*, volume 17, August–September 1996.
4. "A Shameful Cultural Sham?: Willem de Kooning's Last Paintings"
 Reprinted with permission from *Art New England*, volume 18, June–July 1997.
5. "Jackson Pollock: Lively Art, Artless Life"
 Reprinted with permission from *Art New England*, volume 20, February–March 1999.
6. "Jasper Johns and Ellsworth Kelly: The Deadend of Modernism"
 Reprinted with permission from *Art New England*, volume 18, February–March 1997.
7. "Ivan Albright: Anachronistic Curiosity or the Ultimate Modern Artist?"
 Reprinted with permission from *Art New England*, volume 18, October–November 1997.
8. "Real Hallucinations and Anal Absolutes: Jiri Georg Dokoupil"
 Jiri Georg Dokoupil. Published in 1997 by the Museum Moderner Kunst Stiftung Ludwig, Vienna.
9. "Abstract Painting and the Spiritual Unconscious"
 Unpublished.
10. "The Pathos of Purity: Piet Mondrian Reassessed"
 Reprinted with permission from *Art New England*, volume 17, April–May 1996.
11. "Negative Sublime Identity: Pierre Soulages's Abstract Paintings"
 Text published in *Soulages, Noir Lumiere*, Paris-Musées/Les Amis du musée d'Art moderne de la Ville de Paris, 1996. Unpublished in English.
12. "Unconscious and Self-Conscious Color in 'American-Type' Painting"
 Unpublished.

*Note: Many of these articles have been revised.

13. "Relics of Transcendence"
 Originally published in *ART IN AMERICA,* Brant Publications, Inc., May 1998.
14. "Gregory Amenoff: Renewing Romantic Mystical Nature Painting"
 The Sky Below: Gregory Amenoff. Published in 1997 by Hard Press, West Stockbridge, Massachusetts.
15. "Modern History Painting in the United States"
 Unpublished.
16. "Mourning and Memory: Wlodzimierz Ksiazek's Abstract Paintings"
 Wlodzimierz Ksiazek: Paintings. Published in 1998 by the Artist-in-Residence Program and Dartmouth College, Hanover, New Hampshire.
17. "László Fehér: Memory and Abandonment"
 László Fehér: Erringerungen an Reales. Published in 1998 by the Museum Moderner Kunst Stiftung Ludwig, Vienna. Unpublished in English.
18. "Odd Nerdrum, Perverse Humanist"
 Odd Nerdrum: Historieforteller oq Selvavslorer. Published in 1998 by Aschehoug Verlag and Astrup Fearnley Museet for Moderne Kunst, Oslo.
19. "Vincent Desiderio: Postmodern Visionary Painting"
 Reprinted with permission from *Art New England,* volume 19, April–May 1998.

II. ANIMADVERSIONS

20. "Avant-Garde, Hollywood, Depression: The Collapse of High Art"
 Unpublished.
21. "Failure of Identity: On Being Half an Artist"
 Multiple Identity: Amerikanische Kunst 1975–1995. Published in 1997 by the Kunstmuseums Bonn. Unpublished in English.
22. "Of the Immature, By the Immature, For the Immature: Keith Haring and Cindy Sherman"
 Reprinted with permission from *Art New England,* volume 19, December 1997–January 1998.
23. "Heroic Isolation or Delusion of Grandeur?: Chuck Close's Portraits of Artists"
 Reprinted with permission from *Art New England,* volume 19, July–August 1998.
24. "Nan Goldin: The Taste for Pathology"
 Unpublished.
25. "David Wojnarowicz: The Last Rimbaud"
 Reprinted with permission from *Art New England,* volume 20, June–July 1999.
26. "Woman at Risk: The Representation of the Feminine in Modern and Posrmodern Art"
 The Female Image. Courtesy of the Nassau County Museum of Art, Rosalyn Harbor, New York, 1996.
27. "Unconsciously, Always an Alien and Self-Alienated: The Problem of the Jewish-American Artist"
 First published in the *New Art Examiner,* April 1997.
28. "Meyer Schapiro's Jewish Unconscious"
 First published in *Prospects,* volume 21, 1996.

Index

Ann T. Kellogg is a Senior Industry Consultant with Campus Management Corporation. Her background in costume history research extends over fifteen years, and she previously coauthored *In An Influential Fashion* for Greenwood Press. Kellogg previously curated costume exhibits on fashion designers and costume history including *Givenchy* and *Traditions and Transitions* for the Chicago Historical Society. She received both a Master's degree and a Bachelor's degree in Costume and Textile History from Michigan State University.

Lynn W. Payne is Executive Director of Higher Education for Renaissance Strategies and previously was Vice President of Education for Career Education Corporation, Vice President of Academic and Student Affairs at American InterContinental University Online, and assistant professor of marketing and management at Langston University. She received her Ph.D. degree from the University of Oklahoma, M.B.A. from Golden Gate University, and B.S. from James Madison University.

About the Contributors

GENERAL EDITOR

Amy T. Peterson is the Vice-president of Course Development for Career Education Corporation. Her background in costume history research extends over twelve years, and she previously coauthored *In An Influential Fashion* for Greenwood Press. Her other publications include *Mythology in Our Midst* and the article "United Neighborhood Organization" in *The Encyclopedia of Chicago History*. She received a Master's degree in Public History from Loyola University and her Bachelor's degree in History from Illinois Wesleyan University.

CONTRIBUTORS

Valerie Hewitt is a full-time general education instructor for Remington College—Largo Campus in Florida. She has an M.Ed. from Trinity University in San Antonio, Texas. She has edited several dissertations in addition to teaching students how to write.

Heather Vaughan is an independent fashion historian who has worked as a guest curator, researcher, and lecturer at institutions including the de Young, Phoenix Art Museum, Los Angeles County Museum of Art, and the Metropolitan Museum of Art Costume Institute. Recent work includes an article in the journal *Dress* as well as lectures for the American Culture/Popular Culture Association and the Costume Society of America's National Symposium, among others.

Cumulative Index

Note: **Boldface** numbers refer to volume numbers; numbers followed by *f* refer to illustrations.

Professional Organizations

Costume Society of America (CSA)
www.costumesocietyamerica.com/

Council of Fashion Designers of America (CFDA)
www.cfda.com

International Textile and Apparel Association (ITAA)
www.itaaonline.org/

Victoria & Albert Museum of Childhood
Among its collections is the children's costumes section, with more than 6,000
 items of children's clothing, from the sixteenth century to the present.
Cambridge Heath Road
London E2 9PA, UK
+44 (0) 20 8983 5200
www.vam.ac.uk/moc/

Western Reserve Historical Society
Includes costumes from the history of the northeastern part of Ohio, from the
 nineteenth century to the present.
10825 East Boulevard
Cleveland, OH 44106
216-721-5722
www.wrhs.org/

WEBSITES

About.com "Fashion History"
http://fashion.about.com/od/historycostumes/Fashion_History.htm

Costume Gallery
www.costumegallery.com

Costumer's Manifesto
www.costumes.org/history/100pages/costhistpage.htm

Exec Style Fashion Dictionary
www.execstyle.com/Fashion_Dictionary.asp

Fashion-Era
www.fashion-era.com/

Fashion Planet
www.fashion-planet.gr

Haute History
www.hautehistory.com/fashhist/index.html

History of Fashion
www.historyoffashion.com/

Stylopedia Fashion Dictionary
www.snapffashun.com/stylopedia/00_a.html

Women's Wear Daily Fashion Dictionary
www.wwd.com/fashion-resources/fashion-dictionary

Metropolitan Museum of Art

The museum's Costume Institute contains 30,000 costumes and accessories, from all over the world and from the last five centuries. The Met also provides a fashion blog on its website.

1000 Fifth Avenue at 82nd Street

New York, NY 10028–0198

212-535-7710

www.metmuseum.org/

www.metmuseum.org/Works_of_Art/the_costume_institute

Royal Ontario Museum

The Patricia Harris Gallery of Textiles and Costumes presents highlights of the museum's more than 50,000 artifacts that date from 1000 BCE to the present day.

100 Queens Park

Toronto, ON

Canada, M5S 2C6

416-586-8000

www.rom.on.ca/

Smithsonian Institute

The National Museum of American History contains more than 30,000 artifacts of clothing, from the 1700s to the present day, ranging from ball gowns to T-shirts.

4202 AHB/MRC-610

Washington, DC 20560

202-633-1000

www.si.edu/

http://americanhistory.si.edu/collections/subject_detail.cfm?key=32&colkey=8

Tassenmuseum Hendrikje (Museum of Bags and Purses)

Herengracht 573

1017 CD Amsterdam

+31 (0) 20-524 64 52

www.tassenmuseum.nl

Victoria & Albert Museum

Among the V&A's holdings is a fashion, jewelry, and accessories section. The fashion collection covers "fashionable dress from the 17th century to the present, emphasizing progressive and influential designs" (from the website).

Cromwell Road

London SW7 2RL, UK

+44 (0) 20 7942 2000

www.vam.ac.uk/

P.O. Box 1970
Dearborn, MI 48121
313-982-6001
www.hfmgv.org/

Hope B. McCormick Costume Collection
1601 N. Clark Street
Chicago, IL 60614
312-642-5035
www.chicagohs.org

Indiana State Museum
Features an online catalog of clothes donated to the museum, with items from
 the nineteenth century through the twentieth century.
202 N. Alabama Street
Indianapolis, IN 46204
317-232-1637
www.in.gov/ism/

Kent State University Museum
The museum provides an online dictionary of fashion, "Bisonnette on Costume" by
 Anne Bissonette, curator of the Fashion Museum at Kent State, featuring pho-
 tos of costumes from the eighteenth century to the present, mainly of American
 fashion and clothing, but including designs from Asia, Greece, and Turkey.
 The museum also has a collection of ethnic dress. Its fashion collection was
 started by a donation of "fashion, historic costume, paintings and decorative
 arts from Shannon Rodgers and Jerry Silverman, partners in Jerry Silverman,
 Inc., a manufacturer of better dresses" in New York City (from the website).
P.O. Box 5190
Rockwell Hall
Kent, OH 44242–0001
330-672-3450
www.kent.edu/museum

Los Angeles County Museum of Art
LACMA's Department of Costume and Textiles contains more than 25,000
 objects, from 100 BCE to the present, much of which is searchable online. "A
 Century of Fashion" presents significant fashion designs by decade, from
 1900–2000.
5905 Wilshire Boulevard
Los Angeles, CA 90036
323-857-6000
www.lacma.org/

Canada, R3B 0M1
204-989-0072
www.costumemuseum.com

Elizabeth Sage Historic Costume Collection
Includes "military, occupational, and sports uniforms; hand-crafted haute couture
 ensembles; ready-to-wear apparel ... garments designed by Hoosier natives
 Bill Blass and Norman Norell and home sewing patterns" (from the website).
Indiana University-Bloomington
1021 East Third Street
Bloomington, IN 47405
812-855-5497
www.indiana.edu/~sagecoll/

Fashion Institute of Design and Merchandising
Includes more than 10,000 costumes, accessories and textiles, from the eighteenth
 century to the present
919 South Grand Avenue
Los Angeles, CA 90015–1421
213-623-5821
www.fidm.edu/resources/museum+galleries/index.html

Fashion Institute of Technology
The Museum
One of the few museums in the world devoted entirely to fashion design, span-
 ning more than 250 years of fashion and textiles.
Seventh Avenue at 27th Street
New York, NY 10001–5992
212-217-5800
www.fitnyc.edu/aspx/Content.aspx?menu=FutureGlobal:Museum

Goldstein Museum of Design
Selections from the Costume Collection are searchable online. It "features works
 from designers Elsa Schiaparelli and Issey Miyake to a Chinese Imperial Robe;
 from an assortment of beaded handbags to children's shoes" (from the website).
University of Minnesota
240 McNeal Hall
1985 Buford Avenue
St. Paul, MN 55108
612-624-7434
http://goldstein.che.umn.edu/

Henry Ford Museum
The Clothing and Personal Effects Collection contains more than 10,000 items
 from 1750 to the present.

Mildred Pierce. Directed by Michael Curtiz. Warner Bros.-First National Pictures, 1945.

Miracle on 34th Street. Directed by George Seaton. Twentieth Century Fox Film Corporation, 1947.

Notorious. Directed by Alfred Hitchcock. Vanguard Films, 1946.

Spellbound. Directed by Alfred Hitchcock. Vanguard Films, 1945.

Suspicion. Directed by Alfred Hitchcock. RKO Radio Pictures, 1941.

The Bachelor and the Bobby-Soxer. Directed by Irving Reis. RKO Radio Pictures, 1947.

The Best Years of Our Lives. Directed by William Wyler. Samuel Goldwyn Company, 1946.

The Great Man's Lady. Directed by William A. Wellman. Paramount Pictures, 1942.

The Maltese Falcon. Directed by John Huston. Warner Bros. Pictures, 1941.

The Philadelphia Story. Directed by George Cukor. Loew's, 1940.

The Postman Always Rings Twice. Directed by Tay Garnett. Loew's, 1946.

The Well-Groomed Bride. Directed by Sidney Lanfield. Paramount Pictures, 1946.

Woman of the Year. Directed by George Stevens. Metro-Goldwyn-Mayer, 1942.

MUSEUMS, ORGANIZATIONS, SPECIAL COLLECTIONS, AND USEFUL WEBSITES

MUSEUMS AND SPECIAL COLLECTIONS

Bata Shoe Museum
327 Bloor Street West
Toronto, ON
Canada M5S 1W7
416-979-7799
www.batashoemuseum.ca

Chicago Historical Museum
An extensive collection of more than 50,000 costume and textile artifacts, designed by and worn by Chicagoans from the famous (Abraham Lincoln and Michael Jordan) to everyday people.

Cincinnati Art Museum
Has an extensive costume and textile collection, searchable online.
953 Eden Park Drive
Cincinnati, OH 45202
513-721-2787
www.cincinnatiartmuseum.org

Costume Museum of Canada
Contains more than 35,000 artifacts from more than 400 years, including designers such as Chanel.
109 Pacific Avenue
Winnipeg, Manitoba

The Forbidden Path. Directed by J. Gordon Edwards. Fox Film Corporation, 1918.

1920s

Fine Manners. Directed by Richard Rosson. Famous Players-Lasky Corporation, 1926.

Head Over Heels. Directed by Paul Bern and Victor Schertzinger. Goldwyn Pictures Corporation, 1922.

Ladies of the Mob. Directed by William A. Wellman. Paramount Famous Lasky Corporation, 1928.

Rolled Stockings. Directed by Richard Rosson. Paramount Famous Lasky Corporation, 1927.

The Law Forbids. Directed by Jess Robbins. Universal Pictures, 1924.

1930s

Big Business Girl. Directed by William A. Seiter. Vitaphone Corporation, 1931.

Curly Top. Directed by Irving Cummings. Fox Film Corporation, 1935.

Front Page Woman. Directed by Michael Curtiz. Warner Bros. Pictures, 1935.

Grand Hotel. Directed by Edmund Goulding. Metro-Goldwyn-Mayer, 1932.

It Happened One Night. Directed by Frank Capra. Columbia Pictures Corporation, 1934.

Mr. Deeds Goes to Town. Directed by Frank Capra. Frank Capra Productions, 1936.

No Man of Her Own. Directed by Wesley Ruggles. Paramount Pictures, 1932.

Platinum Blonde. Directed by Frank Capra. Columbia Pictures Corporation, 1931.

Storm in a Teacup. Directed by Ian Dalrymple and Victor Saville. Victor Saville Productions, 1937.

The Divorcee. Directed by Robert Z. Leonard. Metro-Goldwyn-Mayer, 1930.

The Thin Man. Directed by W. S. Van Dyke. Cosmopolitan Productions, 1934.

Wife vs. Secretary. Directed by Clarence Brown. Metro-Goldwyn-Mayer, 1936.

You Can't Take It With You. Directed by Frank Capra. Columbia Pictures Corporation, 1938.

1940s

A Song to Remember. Directed by Charles Vidor. Columbia Pictures Corporation, 1945.

Adam's Rib. Directed by George Cukor. Loew's, 1949.

Anchors Aweigh. Directed by George Sidney. Metro-Goldwyn-Mayer, 1945.

Casablanca. Directed by Michael Curtiz. Warner Bros. Pictures, 1942.

His Girl Friday. Directed by Howard Hawks. Columbia Pictures Corporation, 1940.

Hollywood Canteen. Directed by Delmer Daves. Warner Bros. Pictures, 1944.

Lost Weekend. Directed by Billy Wilder. Paramount Pictures, 1945.

Manpower. Directed by Raoul Walsh. Warner Bros. Pictures, 1941.

Time Magazine. 1940. "Synthetic Sale," May 27.

Tortora, P. G., and Eubank, K. 2005. *Survey of Historic Costume: A History of Western Dress*, 4th Edition. New York: Fairchild Publications.

U.S. Bureau of Citizenship and Immigration Services. *Statistical Yearbook, Annual*.

U.S. Census Bureau. April 11, 2002. *Current Population Reports, P25–311, P25–802, and P25–1095*.

U.S. Census Bureau. 2001. *No. HS-16. Expectation of Life at Birth by Race and Sex: 1900 to 2001*.

U.S. Census Bureau. 2001. *No. HS-20. Education Summary—Enrollment, 1900 to 2000, and Projections*.

U.S. Census Bureau. 2003. *No. HS-30. Marital Status of Women in the Civilian Labor Force: 1900 to 2002*.

USA Today. 2007. "Army vs. Navy," November 25.

Von Schilling, J. A. 2003. *The Magic Window: American Television 1939–1953*. Binghamton, NY: Haworth Press.

Ware, S. 1982. *Holding Their Own: American Women in the 1930s*. Boston: G. K. Hall.

Warren, V. L. 1934. "Girls Seek a Certain Distinctive Sloppiness in Clothes for the Campus," *Washington Post*, August 19, S7.

Washington Post 1920. "Of Interest to Women," January 12, 8.

Washington Post. 1931. "Clothing for the Young Baby," March 1, MF12.

Washington Post. 1932. "College Girls' Wardrobe Is on Display," September 4, S5.

Washington Post. 1934. "Plaids Brighten Campus Styles," September 7, 14.

Washington Post. 1935. "Rows of Buttons Decline in Favor," October 17, F4.

Watson, L. 2004. *20th Century Fashion*. Buffalo, NY: Firefly Books.

Whitaker, J. 2006. *Service and Style: How the American Department Store Fashioned the Middle Class*. New York: St. Marin's Press.

Willever-Farr, H., and Parascandola, J. The Cadet Nurse Corps, 1943–48. *Public Health Reports, 109*, pp. 455–457.

Wilson, V. P. 1925. "Gowns," *Washington Post*, December 20, X5.

Yeager, L. 1976. *International Monetary Relations: Theory, History, and Policy*. New York: Harper Row.

Zinn, H. 1995. *A People's History of the United States*. New York: Harpers Perennial.

FILMS AND VIDEO MEDIA

1910s

Cruel, Cruel Love. Directed by George Nichols and Mack Sennett. Keystone Film Company, 1914.

Lucille Love: The Girl of Mystery. Directed by Francis Ford. Universal Film Manufacturing, 1914.

Mabel and Fatty Viewing the World's Fair at San Francisco. Directed by Roscoe "Fatty" Arbuckle and Mabel Normand. Keystone Film Company, 1915.

Olian, J., ed. 2003. *Children's Fashions 1900–1950: As Pictured in Sears Catalogs.* Mineola, NY: Dover Publications.

Parrish, A. 1934. "Clothes for Spring Baby in Traditional Style: Timely Advice on His Attire Given to Mothers," *Washington Post*, February 6, 12.

Paul, D. 1973. *The Navajo Code Talkers.* Pittsburgh, PA: Dorrance Publishing.

Peacock, J. 1996. *Men's Fashion: The Complete Source Book.* New York: Thames and Hudson.

Peacock, J. 1998. *Fashion Sourcebooks: The 1940s.* New York: Thames and Hudson.

Peacock, J. 2000. *Fashion Accessories: The Complete 20th Century Sourcebooks with 2000 Full Color Illustrations.* London: Thames and Hudson.

Perrett, G. 1982. *America in the Twenties, A History.* New York: Simon and Schuster.

Pointer, S. 2005. *The Artifice of Beauty: A History and Practical Guide to Perfumes and Cosmetics.* Gloucestershire, UK: Sutton Publishing Limited.

Probert, C. 1981a. *Hats in Vogue since 1910.* New York: Abbeville Press.

Probert, C. 1981b. *Swimwear in Vogue since 1910.* London: Thames and Hudson.

Reeves, T. C. 2000. *Twentieth Century America: A Brief History.* Oxford: Oxford University Press.

Richardson, D. E., ed. 1982. *Vanity Fair: Photographs of an Age, 1914–1936.* New York: Clarkson N. Potter.

Rittenhouse, A. 1910. "What the Well Dressed Women Are Wearing," *New York Times,* April 10.

Rowbotham, S. 1997. *A Century of Women.* New York: Penguin Books.

Schrier, B. A. 1994. *Becoming American Women: Clothing and the Jewish Immigrant Experience 1880–1920.* Chicago: Chicago Historical Society.

Schrum, K. 2004. *Some Wore Bobby Sox: The Emergence of Teenage Girls' Culture 1920–1945.* New York: Palgrave Macmillan.

Seeger, R. 1932. "Lovely Colors Enhance New Things for Baby," *Chicago Daily Tribune,* June 20, 13.

Seeger, R. 1932. "Juniors Help Freshman by Their Clothes," *Chicago Daily Tribune,* August 19, 15.

Seeling, C. 2000. *Fashion: The Century of the Designer 1900–1999.* English edition. Cologne, Germany: Konemann.

Sellars, R. W. 1997. *Preserving Nature in National Parks: A History.* New Haven, CT: Yale University Press.

Simpson, G. E., and Yinger, J. M. 1985. *Racial and Cultural Minorities: An Analysis of Prejudice and Discrimination.* New York: Springer.

Sivulka, J. 1998. *Soap, Sex, and Cigarettes: A Cultural History of American Advertising.* Belmont, CA: Wadsworth Publishing Company.

The American Oil and Gas Historical Society. 2005. "A Crude Story of Vaseline and Mabel's Eyelashes." *The Petroleum Age,* March 1, 2:1.

"The Family Page." 1924. *The Youth's Companion,* June 19, 98:25.

The Guardian. 1945. "Frank Sinatra and the 'Bobby-Soxers,'" January 10.

McKay, J. P. 1999. *A History of Western Society.* New York: Hougton Mifflin.

Mendes, V. D., and De La Haye, A. 1999. *20th Century Fashion.* London: Thames and Hudson.

Metropolitan Museum of Art (n.d.) *Timeline of Art History: Frank Lloyd Wright.* http://www.metmuseum.org/toah/hd/flwt/hd_flwt.htm.

Mizejewski, L. 1999. *Ziegfield Girl: Image and Icon in Culture and Cinema.* Durham, NC: Duke University Press.

Modell, J. 1989. *Into One's Own: From Youth to Adulthood in the United States, 1920–1975.* Berkeley, CA: University of California Press.

Mordden, E. 1978. *That Jazz! An Idiosyncratic Social History of the American Twenties.* New York: Putnam.

Municchi, A. 1996. *Ladies in Furs: 1900–1940.* Modena, Italy: Zanfi Editori.

Murrin, J. M., Johnson, P. E., McPherson, J. M., Gerstle, G., Rosenberg, E. S., and Rosenberg, N. 2004. *Liberty, Equality, Power: A History of the American People.* Vol. 2 since 1863. Belmont, CA: Thomson.

New York Times. 1910. "Marriage of Minors Legal till Annulled," March 13.

New York Times. 1912. "Spring Lingerie Changed to Suit New Gowns," March 24.

New York Times. 1913. "Concealed Marriages of Women Teachers," March 23.

New York Times. 1913. "Writing the Movies: A New and Well-Paid Business," August 3.

New York Times. 1914. "Lauds Sex Lessons in Public Schools," June 16.

New York Times. 1915. "Eugenic Marriages Urged for Jersey," November 20.

New York Times. 1915. "Latest Customs Rulings," December 4.

New York Times. 1917. "Denounce Slackers in Marriage Rush," April 11.

New York Times. 1918. "Slacker Marriage Not a Draft Excuse," January 27.

New York Times. 1923. "Egypt Dominates Fashion Show Here: Designs Copied from Luxor Pictures Decorate Many Suit Models," February 25.

New York Times. 1924. "Pretty Materials in Endless Variety," May 11, X10.

New York Times. 1924. "Choosing the First Party Dress," December 7, X13.

New York Times. 1926. "Styles for Young Charm," December 5, X17.

New York Times. 1928. "Modernistic Dress in the Nursery," December 16, X14.

New York Times. 1930. "Spring Styles Ban the Short Skirt," January 15, 27.

Nolan, C. *Ladies Fashion of the 1940s.* http://www.murrayonhawaii.com/nolan/fashionhistory_1940ladies.html.

Ogren, K. J. 1989. *The Jazz Revolution: Twenties America and the Meaning of Jazz.* New York: Oxford University Press.

Olian, J., ed. 1990. *Authentic French Fashions of the Twenties: 413 Costume Designs from "L'Art et la Mode."* Toronto: Dover Publications.

Olian, J., ed. 1992. *Everyday Fashions of the Forties: As Pictured in Sears Catalogs.* New York: Dover Publications.

Olian, J. 1995. *Everyday Fashions 1909–1920: As Pictured in Sears Catalogs.* New York: Dover Publications.

Olian, J., ed. 1998. *Victorian and Edwardian Fashions from "La Mode Illustree."* Mineola, NY: Dover Publications.

Hobbs, F., and Stoops, N. November 2002. *Demographic Trends in the 20th Century.* U.S. Department of Commerce.

Israel, B. 2002. *Bachelor Girl: The Secret History of Single Women in the Twentieth Century.* New York: William Morrow.

Jones, G. 2005. *Men of Tomorrow: Geeks, Gangsters, and the Birth of the Comic Book.* New York: Basic Books.

Kaledin, E. 2000. *Daily Life in the United States, 1940–1959: Shifting Worlds.* Westport, CT: Greenwood Press.

Kallie, J. 1986. *Viennese Design and the Wiener Werkstatte.* New York: G. Braziller in association with Galerie St. Etienne.

Keenan, B. 1978. *The Women We Wanted to Look Like.* London: Macmillan London Limited.

Kellogg, A. T., Peterson, A. T., Bay, S., and Swindell, N. 2002. *In an Influential Fashion: An Encyclopedia of Nineteenth- and Twentieth-Century Fashion Designers and Retailers Who Shaped Dress.* Westport, CT: Greenwood Press.

Kurian, G. T. 1994. *Datapedia of the United States, 1790–2000.* Lanham, MD: Bernan Press.

Kyvig, D. E. 2002. *Daily Life in the United States, 1920–1940.* Chicago: Ivan R. Dee Publisher.

Laubner, E. 1996. *Fashions of the Roaring '20s.* Atglen, PA: Schiffer Publishing.

Laubner, E. 2000. *Collectible Fashions of the Turbulent 1930s.* Atglen, PA: Schiffer Publishing.

Lee-Potter, C. 1984. *Sportswear in Vogue since 1910.* London: Thames and Hudson.

Lenman, B. P., ed. 1995. *Larousse Dictionary of World History.* New York: Larousse.

Lief, A. 1951. *The Firestone Story: A History of the Firestone Tire and Rubber Company.* New York: Whittlesey House.

Los Angeles Examiner. 1942. "Hair Style Used in Identification of Hoodlums: Suspects Must Not Change Haircut, Judge Rules," October 27.

Los Angeles Times. 1934. "New College Clothes Look Both Cheerful and Casual," September 10, A8.

Lowrey, C. 1920. *The First One Hundred Noted Men and Women of the Screen.* New York: Moffat, Yard and Company.

Lucie-Smith, E. 1996. *Art Deco Painting.* London: Phaidon.

MacPhail, A. 1999. *The Well Dressed Child.* Atglen, PA: Schiffer Publishing.

Marc, E. 1993. *Walt Disney: Hollywood's Dark Prince.* Secaucus, NJ: Carol Publishing Group.

Marling, K. A. 2004. *Debutante: Rites and Regalia of American Debdom.* Lawrence, KS: University Press of Kansas.

Marshall, A. 2006. *Beneath the Metropolis: The Secret Lives of Cities.* Edited by D. Emblidge. New York: Carroll and Graf Publishers.

Matanle, I. 1994. *History of World War II, 1939–1945.* Little Rock, AR: Tiger Books International.

Blum, S. 1981. *Everyday Fashions of the Twenties as Pictured in Sears and Other Catalogs.* New York: Dover Publications.

Blum, S. 1986. *Everyday Fashions of the Thirties as Pictured in Sears Catalogs.* New York: Dover Publications.

Bordwell, D., and Thompson, K. 2002. *Film History: An Introduction.* 2nd revised edition. Columbus, OH: McGraw Hill.

Bouillon, J.-P. 1989. *Art Deco: 1903–1940.* Translated by M. Heron. New York: Rizzoli.

Buxbaum, G., ed. *Icons of Fashion: The Twentieth Century.* New York: Prestel.

Campbell, J. E. 2000. *The American Campaign: U.S. Presidential Campaigns and the National Vote.* College Station, TX: Texas A&M University Press.

Cayton, M. K., and Williams, P. W., eds. 2001. "Ethnicity and Race," In *Encyclopedia of American Cultural and Intellectual History.* New York: Scribner's Sons.

Chadwick, B. A., and Heaton, T. B. 1992. *Statistical Handbook on the American Family.* Westport, CT: Oryx Press.

Chakravorti, B. 2003. *The Slow Pace of Fast Change: Bringing Innovations to Market in a Connected World.* Boston: Harvard Business School Press.

Christian Science Monitor. 1924. "Knitted Layettes," April 11, 13.

Christman, T. 1992. *Brass Button Broadcasters.* Nashville, TN: Turner Publishing Company.

Cole, B., and Gealt, A. 1989. *Art of the Western World.* New York: Summit Books.

Cook, B. M. 1921. "Variations of Time-Tried Themes," *The Washington Post*, July 17.

Dare. 1931. "Style Tips for Co-Eds," *Washington Post*, August 23, A1.

Davies, L. E. 1943 "Zoot-Suit Riots Are Studied: Los Angeles Is Taking Steps to Prevent Renewal of Street Battles," *The New York Times*, June 20.

De Marly, D. 1980. *The History of Haute Couture, 1850–1950.* London: Batsford.

Dolfman, M. L., and McSweeney, D. M. May 2006. *100 Years of U.S. Consumer Spending: Data for the Nation, New York City, and Boston.* BLS Report 991. Bureau of Labor Statistics.

Elliot, M. A., and Merrill, F. E. 1934. *Social Disorganization.* New York: Harper and Brothers.

Ewing, E. 1977. *History of Children's Costume.* London: Batsford.

Eyles, A. 1987. *That Was Hollywood: The 1930s.* London: Batsford.

Flappers: The Birth of the 20th Century Woman, Motion Picture. Produced by K. Botting. Princeton, NJ: Films for the Humanities and Sciences. 2001.

Giddins, G. 2001. *Bing Crosby: A Pocketful of Dreams.* Boston: Back Bay Books.

Gordon, L., and Gordon, A. 1987. *American Chronicle.* Kingsport, TN: Kingsport Press, Inc.

Gould, J. 1942. "One Thing and Another," *The New York Times*, November 8, X12.

Hakim, J. 1999. *War, Peace, and All That Jazz—1918–1945, Book 9.* New York: Oxford University Press.

Handy, W. C. 1991. *Father of the Blues: An Autobiography.* Cambridge, MA: Da Capo Press.

Resource Guide, 1900–1949

PRINT AND ONLINE PUBLICATIONS

Abbott, B. 1973. *Changing New York: New York in the Thirties*. New York: Dover Publications.

Algeo, M. 2006. *Last Team Standing: How the Steelers and the Eagles "The Steagles" Saved Pro Football during World War II*. Cambridge, MA: Da Capo Press.

Andrist, R. K., ed. 1970. *The American Heritage History of the 20s & 30s*. New York: American Heritage Publishing Co., Inc.

Bachu, A. May 1998. *Timing of First Births: 1930–34 to 1990–94*. U.S. Census Bureau, http://www.census.gov/population/www/documentation/twps0025/twps0025.html.

Baker, P. 1992. *Fashions of a Decade: The 1940s*. New York: Facts on File.

Barczewski, S. L. 2004. *Titanic: A Night Remembered*. New York: Continuum International Publishing Group.

Barlow, A. L. 2003. *Between Fear and Hope: Globalization and Race in the United States*. Lanham, MD: Rowman and Littlefield.

Baudot, F. 1999. *Fashion: The Twentieth Century*. London: Thames and Hudson, Limited.

Baughman, J. L. 2006. *Republic of Mass Culture: Journalism, Filmmaking and Broadcasting in America Since 1941*. 3rd edition. Baltimore: Johns Hopkins University Press.

Berkin, C., Miller, C. L., Cherny, R. W., and Gormly, J. L. 1995. *Making America: A History of the United States*. Boston: Houghton Mifflin.

Best, G. D. 1993. *The Nickel and Dime Decade: American Popular Culture during the 1930s*. Westport, CT: Praeger.

Bevans, G. H. 1930. "Assembling the Layette." *Chicago Daily Tribune*, July 6, D4.

Bevans, G. H. 1936. "Fashions in Baby's Clothes Are Stationary." *Chicago Daily Tribune*, June 19, 25.

Bevans, G. H. 1936. "Baby Clothes Should Add to His Comfort." *Chicago Daily Tribune*, June 20, 16.

taffeta: A stiff, shiny fabric made from silk or synthetic fibers typically used in bridal and formal wear.

tailor-made: A women's suit that had masculine styling and was usually made by a tailor.

T-bar shoes: Any shoe form with a T-shaped fastening across the vamp of the shoe.

tulle: A net fabric typically used to stiffen and support garments.

tunic: A simple T-shaped garment with openings for the head and arms. This type of garment is usually hip length or longer.

tweed: A twill weave fabric with slub or nubby yarns interspersed to create a textured surface. English, Harris, Scotch, and Donegal tweeds are popular tweed variations.

U-neckline: A variation on the scoop neckline that plunges deeply across the chest in the shape of a horseshoe.

vamp: The forward section of any shoe.

vent: One or more slits cut into the back or sides of men's and women's suit jackets and blazers, or occasionally men's and women's shirts, from the bottom edge of the hem up into the body of the garment approximately six inches long.

wedge shoe: Any boot, shoe, or sandal with the sole and heel formed from one continuous piece of material. It is typically thick at the heel and tapers to a thin layer under the balls of the feet.

yoke: A structural element used on either the neck and shoulder or hip to provide style lines and fit control.

zazous: A French anti-Nazi cultural youth movement influenced by jazz and swing that preferred exaggerated clothing style similar to the American zoot suit.

zoot suit: An exaggerated look composed of an oversized jacket that fell almost at the knee, sporting wide lapels, exaggerated shoulders, and a contrasting lining. The trousers had a three-inch waistband, were baggy, low crotched, and full at the knees, had suspender buttons, and were tapered at the ankle.

plus fours: A fuller, more loose-fitting version of knickers, so named because they draped four inches below the knee.

polo: A knit shirt with a two- or three-button placket, rib knit collar, and rib knit-edged long or short sleeves.

polo coat: A double-breasted, six-button coat with a half belt in back and made from tan camel's hair.

pompadour: A men's or women's hairstyle whereby the hair is brushed into loose rolls or waves around the face.

prêt-à-porter: Ready-to-wear clothing.

princess seam: A structural seam that runs from the shoulder or armscye (armhole) down the bottom edge of a shirt or dress or from the waist down to the skirt hem that allows a garment to be form-fitted to the body.

raglan sleeve: A sleeve created in one piece with the bodice shoulder rather than through an inset armscye (armhole).

rayon: An artificial fiber made by pressing a cellulose solution through fine holes to produce filaments.

reefer coat: A loose, double-breasted coat with a notched collar and lapels.

reticule: A purse that is shaped like a pouch with drawstrings.

revers: Lapels.

robe-de-style: A modern interpretation of a period dress with crinolines.

Sabrina neckline: See **bateau neckline**.

sailor collar: A collar style that extends from the lapels to a square cape in the back. Usually, the collar would be trimmed with a loose necktie that was knotted beneath the collar.

sarong: A rectangular piece of fabric wrapped around the body to form a skirt.

scoop neck: A deep, rounded neckline.

S-curve: A silhouette that was modeled after the figure of a mature woman. It had a full, heavy monobosom; a narrow, corseted waist; a rounded hip and bottom; and a trumpet-shaped skirt.

serge: A durable yet soft wool fabric.

shalwar or salwars: Trousers that have full, loose legs at the top and taper to become narrow and fitted on the calf.

shearling: A tanned sheep hide with the wool left on.

sheath: A basic dress form, slightly fitted with darts or princess seams to create shape.

shift: A basic dress form that skims but does not fit close to the body.

shingle: A short haircut that involved cutting the hair in the back very short.

shirtwaist: In the late nineteenth century until the 1920s, it meant, for women or girls, a blouse with buttons down the front or tailoring like men's shirts.

slingbacks: A shoe with no cover across the heel, just a thin strap fastening around it to hold the shoe on.

stock neckline: See **ascot**.

surplice: A bodice style in which one side wraps over the other.

swagger coat: A coat with a flared back.

madras: A plaid or checked patterned lightweight cotton fabric originating from Chennai, India.

maillot: A one-piece tank-style swimsuit with a variety of necklines and high-cut or French-cut legs.

mandarin collar: See **Chinese collar**.

Mary Janes: A rounded-toe, medium-heeled shoe with strap across the vamp, often in black or white patent leather.

merry widow: See **bustier**.

monobosom: A bodice silhouette created by the S-bend corset, which forced a woman's hips back and her bosom forward. The bosom looked like one uniform, heavy ridge.

muff: A pillow-like accessory that has openings at each end for the hands. It is used to keep hands warm.

mule: A slip-on shoe with either a high or low heel with either an open or closed vamp but no back.

Norfolk jacket: A belted, hip-length sports jacket.

notched collar: A collar in which the seam between the lapel and collar forms a notch.

Open-toe shoe (also known as a cut-away or peep toe): A shoe form that enclosed the foot but leaves a small opening at the tip of the toe.

organza: A transparent, high-sheen fabric of silk, polyester, or nylon often used in bridal and formal wear.

outseam: The seam that forms the outer edge of the pant leg.

oxford shoe: A basic shoe form with a closed vamp that usually has laces. The women's version has either a lace, buckle, zip, or button closing.

paletot: A loose, three-quarter-length coat with long, straight sleeves.

paniers: Attached undergarments or draped fabric that add extreme width to the sides of the hip.

patch pocket: A pocket sewn to the outside of any garment with or without a flap cover.

pea coat: A double-breasted coat of heavy felted wool or full melton with a notched two-way collar that could be worn with the lapels flat or folded closed.

peau de soie: A medium- to heavyweight drapable fabric with a satin weave and delustered finish.

peep-toe shoe: See **open-toe shoe**.

penny loafer: See **loafer**.

peplum: A short flounce or ruffle attached to the waist line of a blouse, jacket, or dress.

Peter Pan collar: A narrow, flat collar with rounded edges.

petticoat: An underskirt, usually worn to give support or fullness to the overskirt.

picot edging: A decoration consisting of small, thread-like loops at the edge of a garment.

pinafore: A sleeveless garment, similar to an apron, that fastens in the back and is worn over a dress.

duster: A long cotton or linen coat with long sleeves and a convertible collar.

empire waist: A waistline that is positioned just under the bustline. The name is derived from the fashions popular during the reign of Napoleon Bonaparte, emperor of France from 1804 to 1814.

epaulet: A tab or stripe of fabric that lies across the collar bone from the nape of the neck to the shoulder cap. Epaulets may also be used on sleeves or pant legs to position a rolled-up hem.

Eton crop: An exceptionally short women's hairstyle that is closely cropped and styled like a men's 1920s hairstyle.

fez: A brimless conical hat with a flat top.

gabardine: A fabric that is twilled on one side into a fine diagonal weave.

gingham: A yarn-dyed cotton fabric that is usually woven into a check pattern.

godet (also known as a gore): A triangular piece of fabric inserted into a skirt hem to add fullness.

gore: See **godet**.

guimpe: A chemise made of lightweight material that is used to fill in a low neckline.

halter: A bodice style that is held up by a cord or straps around the neck. The shoulders and upper back are left bare.

handkerchief hem: An uneven hem made with diagonally arranged fabric.

herringbone: See **chevron**.

hobble skirt: A long, narrow skirt that narrows further at the hem, creating a limited stride for the wearer.

homburg: A felt hat with a soft creased crown and a narrow stiffened brim that is turned up at the edge.

homespun: A coarse, loosely woven cloth.

inseam: The interior seam on the leg of a pant.

jabot: A frill or ruffle, usually made from lace, that is fastened to the neck and extends down the front of the bodice.

jersey: A knit fabric.

jewel neckline: A round, shallow neckline that curves close to the nape of the neck.

kameeze or kameez: Long tunic with side vents.

kimono sleeve: A sleeve and bodice that was cut in one piece. The sleeve usually widens as it reaches the wrist.

knickerbocker: A style of trousers that had loose, full legs that gathered into a drawstring or band at the knee. They are also known as knickers.

lawn: A lightweight, cotton fabric that was somewhat sheer.

layette: A complete ensemble for a newborn infant consisting of garments, toiletries, and bedding.

leg-o-mutton sleeve: An extremely full, puffy sleeve that is created by gathering fullness into the armscye (armhole) that tapers down the length of the upper arm into a fitted, narrow cylinder covering the forearm, ending at the wrist.

loafer: A simple slip-on, low-heeled shoe finished with a strap across the vamp that may have a slit to hold a coin (see **penny loafer**) or tassels.

brocade: A fabric with a woven satin design on a plain satin or rib-weave background.

buckram: A cotton or linen fabric that has been stiffened to provide support and shaping under other fabrics.

bustier (also known as a merry widow): A corset-style garment, typically strapless, that combines the support of a waist cincher and brassiere ending at the waist or hips.

camisole: A sleeveless undergarment worn beneath the bodice.

chambray: A lightweight fabric with colored warp and white filling yarns.

charmeuse: A lustrous, lightweight fabric made from cotton or silk.

cheviot: A twill wool fabric with a close nap and a rough surface that is generally used for suits and coats.

chevron (also known as herringbone): A broken twill weave structure whose interlacing pattern results in a fabric that appears to have a series of interlocking Vs for a zigzag effect, or any pattern derived from interlocking Vs.

chignon: Hair that is twisted into a bun and worn at the back of the head.

Chinese collar (also known as a mandarin or Mao collar): A stand collar approximately one inch tall with a slight gap between the right and left edges at the center front. The Chinese collar is similar to the Nehru collar, but the Chinese collar has square corners, whereas the Nehru collar typically has rounded corners.

chino: A plain or twill weave cotton fabric often used to make men's pants.

cloche: A hat with a bell-shaped crown.

combination: An undergarment that combines a chemise and petticoat or a chemise and pantaloons.

cowl neckline: A neckline, either in the front or back of a bodice, with fullness draped from shoulder to shoulder.

crêpe de Chine: A finely woven silk crepe.

crinoline: A stiffened underskirt or either buckram or tulle worn to support full skirts.

crown: The top part of a hat.

Cuban heel: A medium high, thick heel with a slight curve.

culottes: See **skort**.

cut-away shoe: See **open-toe shoe**.

décolleté: A neckline cut very low to reveal the shoulders, neck, and bustline cleavage. Décolleté may also be cut very low across the back, revealing the lower back or derrière.

derby: A hat with a stiff, bowl-shaped crown and a narrow brim. These hats were also known as bowlers.

dirndl: A slightly full skirt with a gathered waistline set into a waistband.

dog collar: A tall necklace that extended up from the base of the neck, usually made of several strands of beads or jewels linked together at intervals by bands.

dolman sleeve: A sleeve with a wide armscye (armhole) that may span from the shoulder to the waist with a sleeve that tapers to a tight fit at the wrist.

Glossary, 1900–1949

A-line: A garment silhouette whereby a garment gradually flares out from the narrowest part of the body, either the shoulders or waist, to the hem.

ascot (also known as a stock neckline): A high neckline with a scarf or ties that wrap around the neck and tie in a loop at the center front neck with the ends left hanging loose.

balloon sleeve (also known as a bouffant sleeve): A sleeve that is gathered at the armscye (armhole) and wrist with voluminous fullness in between.

band collar: A narrow collar attached to the neckline and standing straight on the neck.

bandeau: A narrow bra worn to flatten the bust or a narrow ribbon worn around the head to hold hair in place.

Barbour coat (also known as a barn coat): A coat made of cotton that has been weather proofed with oil; typically worn for outdoor work.

barn coat: See **Barbour coat.**

basque: A tight-fitting bodice.

bateau neckline (also known as a boat or Sabrina neckline): A neckline with a shallow curve from shoulder to shoulder.

batiste: A soft, lightweight, finely woven cotton fabric.

Bermuda shorts: A style of men's and women's shorts, either cuffed or uncuffed, with the hem approximately one inch above the knee. Bermuda shorts were first developed for the British Army for tropical and desert uniforms.

bias cut: A technique of cutting garments to use the diagonal direction of the cloth. It is used to achieve stretch, better draping, and to accentuate body lines.

bishop sleeve: A sleeve style that used pleats at the shoulder to create fullness that gathered into a cuff at the wrist.

boat neckline: See **bateau neckline.**

boater: A hat with a low, hard, flat-topped crown; narrow, straight brim; and a ribbon band and bow.

bolero: A waist- or rib-length jacket.

bouffant sleeve: See **balloon sleeve.**

brim: The rim projecting out from a hat.

Schrum, K. 2004. *Some Wore Bobby Sox: The Emergence of Teenage Girls' Culture 1920–1945*. New York: Palgrave Macmillan.

Seeger, R. 1932. "Lovely Colors Enhance New Things for Baby," *Chicago Daily Tribune*, June 20, 13.

Seeger, R. 1932. "Juniors Help Freshman by Their Clothes," *Chicago Daily Tribune*, August 19, 15.

"The Family Page." 1924. *The Youth's Companion*, June 19, 98:25.

Tortora, P. G., and Eubank, K. 2005. *Survey of Historic Costume: A History of Western Dress*, 4th Edition. New York: Fairchild Publications.

Warren, V. L. 1934. "Girls Seek a Certain Distinctive Sloppiness in Clothes for the Campus," *Washington Post*, August 19, S7.

Washington Post. 1931. "Clothing for the Young Baby," March 1, MF12.

Washington Post. 1932. "College Girls' Wardrobe Is on Display," September 4, S5.

Washington Post. 1934. "Plaids Brighten Campus Styles," *Washington Post*, September 7, 14.

Watson, L. 2004. *20th Century Fashion*. Buffalo, NY: Firefly Books.

Ewing, E. 1977. *History of Children's Costume.* London: Batsford.

Laubner, E. 1996. *Fashions of the Roaring '20s.* Atglen, PA: Schiffer Publishing.

Laubner, E. 2000. *Collectible Fashions of the Turbulent 1930s.* Atglen, PA: Schiffer Publishing.

Lee-Potter, C. 1984. *Sportswear in Vogue since 1910.* London: Thames and Hudson.

MacPhail, A. 1999. *The Well Dressed Child.* Atglen, PA: Schiffer Publishing.

Marling, K. A. 2004. *Debutante: Rites and Regalia of American Debdom.* Lawrence, KS: University Press of Kansas.

Martin, Sally. "Hollywood's Charm School: Shirley's Personal Wardrobe." *Hollywood.* November 1936.

Mendes, V. D., and De La Haye, A. 1999. *20th Century Fashion.* London: Thames and Hudson.

Modell, J. 1989. *Into One's Own: From Youth to Adulthood in the United States, 1920–1975.* Berkeley, CA: University of California Press.

Los Angeles Times. September 10, 1934. "New College Clothes Look Both Cheerful and Casual," A8.

New York Times. 1924. "Pretty Materials in Endless Variety," May 11, X10.

New York Times. 1924. "Choosing the First Party Dress," December 7, X13.

New York Times. 1926. "Styles for Young Charm," December 5, X17.

New York Times. 1928. "Modernistic Dress in the Nursery," December 16, X14.

Nolan, C. *Ladies fashion of the 1940s.* http://www.murrayonhawaii.com/nolan/fashionhistory_1940ladies.html.

Olian, J., ed. 1990. *Authentic French Fashions of the Twenties: 413 Costume Designs from "L'Art et la Mode."* Toronto: Dover Publications.

Olian, J., ed. 1992. *Everyday Fashions of the Forties: As Pictured in Sears Catalogs.* New York: Dover Publications.

Olian, J. 1995. *Everyday Fashions 1909–1920: As Pictured in Sears Catalogs.* New York: Dover Publications.

Olian, J., ed. 1998. *Victorian and Edwardian Fashions from "La Mode Illustree."* Mineola, NY: Dover Publications.

Olian, J., ed. 2003. *Children's Fashions 1900–1950: As Pictured in Sears Catalogs.* Mineola, NY: Dover Publications.

Parrish, A. 1934. "Clothes for Spring Baby in Traditional Style: Timely Advice on His Attire Given to Mothers," *Washington Post,* February 6, 12.

Peacock, J. 1998. *Fashion Sourcebooks: The 1940s.* New York: Thames and Hudson.

Pointer, S. 2005. *The Artifice of Beauty: A History and Practical Guide to Perfumes and Cosmetics.* Gloucestershire, UK: Sutton Publishing Limited.

Probert, C. 1981a. *Hats in Vogue since 1910.* New York: Abbeville Press.

Probert, C. 1981b. *Swimwear in Vogue since 1910.* London: Thames and Hudson.

Richardson, D. E., ed. 1982. *Vanity Fair: Photographs of an Age, 1914–1936.* New York: Clarkson N. Potter.

Rittenhouse, A. 1910. "What the Well Dressed Women Are Wearing," *New York Times,* April 10.

snap made of leather or artificial leather were worn by most girls. Gloves were worn out in public. Short gloves were appropriate for most daily occasions. Elbow-length gloves were pushed down, giving them a scrunched, crushed appearance.

Young men wore slender bow ties and four-in-hand neckties with suits, although bow ties were gradually losing favor. Neckties of silk, rayon, cotton, or wool were produced with repeated geometric patterns or stripes. Toward the end of the decade, ties were hand painted with depictions of tropical flowers, cityscapes, landscapes, and even pinup girls.

ALTERNATIVE MOVEMENTS

Born in the early thirties in Harlem's nightclubs, the zoot suit was the height of fashion for bold young men until the War Department restricted the amount of fabric that could be used in clothing. The zoot suit was an exaggerated look comprising an oversized jacket that extended almost to the knee, sporting wide lapels, exaggerated shoulders, and a contrasting lining. The trousers had a three-inch waistband and a baggy, low crotch. It was full at the knees and tapered at the ankle. Considered flamboyant and unpatriotic because of the amount of fabric used, zoot suits were thought of as contraband during the war. They were worn with wide-brimmed hats, brightly patterned ties, and two-toned shoes.

REFERENCES

Baker, P. 1992. *Fashions of a Decade: The 1940s.* New York: Facts on File.

Bevans, G. H. July 6, 1930. "Assembling the Layette." *Chicago Daily Tribune*, D4.

Bevans, G. H. June 19, 1936. "Fashions in Baby's Clothes Are Stationary." *Chicago Daily Tribune*, 25.

Bevans, G. H. 1936. "Baby Clothes Should Add to His Comfort." *Chicago Daily Tribune*, June 20, 16.

Blackford, Marion. "Miss Temple's Best Bib and Tucker." *Screen Play*, August 1936.

Blum, S. 1981. *Everyday Fashions of the Twenties as Pictured in Sears and Other Catalogs.* New York: Dover Publications.

Blum, S. 1986. *Everyday Fashions of the Thirties as Pictured in Sears Catalogs.* New York: Dover Publications.

Christian Science Monitor. April 11, 1924. "Knitted Layettes," 13.

Cook, B. M. 1921. "Variations of Time-Tried Themes," *The Washington Post,* July 17.

Dare. 1931. "Style Tips for Co-Eds," *Washington Post*, August 23, A1.

be worn with everything from a sweater set at the soda shop to a more formal affair.

Hand bags were necessary to carry a lipstick, handkerchief, comb, mirror, and a dime to make a phone call. Shoulder strap bags with a flap and

Zoot-Suit Riots. On May 31, 1943, a clash between white sailors and Los Angeles Hispanics left one sailor, Joe Dacy Coleman, injured and sparked a series of riots. The racial tensions in the city had been rising. The explosive population growth of the city included large Midwestern populations, poor Americans fleeing from the Dust Bowl, African Americans from the south, and Mexican refugees escaping from the Mexican Revolution. Because California was seen as a possible target of Japanese attack during WWII, southern California became a key military location. Also, civilian residents had taken to patrolling the streets.

The young Mexican-American population was tied to the bold image of the zoot suit. The oversized suits were worn to dressier occasions such as parties and dances. The broad-shouldered, long jackets had wide lapels. They were worn with baggy pants that had "ankle choker" hems. They were usually brightly colored and presented a very distinctive silhouette. The young men who wore these suits usually wore their hair in a unique "ducktail comb" hair style.

Tensions between servicemen and civilians intensified as thousands of servicemen were stationed or on leave in Los Angeles. Often indulging in alcohol, women, and violence, servicemen roamed the streets and clashed with the local youths, who often rebelled against the servicemen and sought them out to teach them a lesson.

The incident between the sailors and Hispanics in May of 1943 led to a series of riots. Almost immediately, a group of white sailors headed into the Hispanic neighborhoods looking for retaliation. Police intervened by arresting Hispanics for disturbing the peace. Most police were unwilling to reprimand the servicemen, because they had often served in the military themselves.

Thousands of servicemen joined the attacks and began pursuing African Americans also. They raided movie theaters, pulling Mexican Americans from their seats. Streetcars were stopped while Hispanics and African Americans were pushed from the cars and beaten (Castillo 2000). Mexican Americans began to organize and retaliate by luring the servicemen and beating them. In some cases, the Los Angeles press lauded the attacks against people it considered "hoodlums," but after a week the police and the military stepped in and began treating servicemen who participated in the attacks more harshly, which ended the attacks.

skirt, ankle socks, and loafers or saddle shoes became the trade mark look of the "bobby-soxer," an adolescent girl who wore the fashionable look.

Government restrictions on the use of fabric and shortages of wool during the war tended to shrink the length of young men's socks. Before the war, they came up to the knee, but they shortened to only inches above the ankle. Several types of socks were worn by young men, including white ribbed top, cotton athletic socks, colored argyle socks, and solid-colored wool and cotton socks.

Brown or black leather tie shoes were worn for most occasions, but the slip-on loafer and tone-on-tone saddle shoe was gaining in popularity for casual wear. Two-toned "fancy" saddle shoes popular with the zoot suit were worn by college men. Canvas shoes were reserved for boating and the tennis courts, and leather sandals could be found on beaches and at poolsides.

Bobby-soxers. Bobby-soxers were adolescent girls who wore folded-over cotton bobby socks with penny loafers or saddle shoes. They wore this footwear with skirts and jeans rolled up to the mid-calf. Bobby socks became synonymous with teenagers and youth culture, and the fad continued during the 1950s.

The term "bobby-soxer" gained prominence in the 1940s with the rising popularity of singer Frank Sinatra with teenage girls. Sinatra's teenage fans would become so hysterical that he required security whenever he appeared in public. There were reports of fans breaking store windows and requiring ambulances while waiting for admission into Sinatra's shows.

ACCESSORIES

Infant to Preteen

Young girls coveted charm bracelets made of sterling silver, and they collected charms for every occasion. Necklaces, bracelets, and rings were decorated with bells, horseshoes, wishbones, and four-leaf clovers. Heart-shaped lockets were popular among young girls. Lapel pins came in a variety of motifs, including Disney characters and jitterbuggers.

Teen to College

Young women wore costume jewelry such as necklaces, bracelets, and ceramic pins. Many young women had a single strand of pearls that could

Teen to College

Headwear. Bonnet styles and berets were popular among young women. Most other hats had small crowns and narrow brims. They were embellished with ribbon hat bands, feathers, and veils.

Young men wore caps, fedoras, and homburgs, which had tall crowns with a crease and narrow brims.

Hairstyles. Teenage and college women wore their hair between chin length and shoulder length. As the decade progressed, more women had shorter hair. They styled their hair away from the sides and back from the crown of the head. Side parts were very popular, and women used bobby pins to gather and pin the hair back. Often they pinned a flower or bow at the place where they pinned their hair back. In the back, women curled their hair under.

Young men wore their hair short and slicked back with pomade.

Cosmetics. Young women wore face powder, lipstick, and rouge. Deep-red lipstick was popular, but, by the end of the decade, new products became available, and the emphasis began shifting from lips to eyes. With the shortage of nylon during the war, young women wore leg makeup and painted lines down the backs of their legs to give the illusion of seamed nylon stockings. Leg makeup was available in the form of lotion, cream, stick cake, and pancake.

FOOTWEAR AND LEGWEAR

Infant to Preteen

Infants wore knitted bootees. Once toddlers began to walk, their parents would purchase a pair of white, soft leather, high-top baby shoes and cotton ankle socks. With polio still a frightening possibility, children's feet were cared for with proper support from a very early age to keep the arches and ankles healthy and strong. Little girls wore leather oxfords for playing and Mary Janes for more formal occasions. Canvas high tops became the play shoe of choice for little boys after the war. They were inexpensive and could be washed. When restrictions were lifted after the war, cowboy boots became a sought-after accessory for boys.

Preteen to College

Young girls and women were encouraged to wear ankle socks because nylon was diverted to the war effort. Heavy woolen stockings were worn in winter, and most girls chose to go bare legged in the warmer summer months. Ballet-style shoes, penny loafers, and two-toned saddle shoes were popular among high school and college girls. Rolled up jeans or a

One-piece swim dresses had princess seams and extended to a short, flared skirt that ended at just below the hip. The one piece with half-skirt had a V neckline, shoulder straps, and fit close from the bodice to the hem, which ended at the hip. Colorful prints made from rayon taffeta or rayon jersey were popular for swimsuits.

Golf and tennis were popular sports for young women. Although appropriate tennis attire remained all white, golf sweaters and shirts introduced color. For both sports, teenage and college women wore similar garments. Knit, short-sleeved shirts and collared, woven shirts were typically worn along with tailored, casual pants or full, skirt-like shorts. Long, boxy pullover and cardigan sweaters were designed to be thin and comfortable after players left the court.

Boys' Ensembles. Teenage and college boys wore two styles of swimsuits: wool knit trunks or boxer short trunks. Both styles had a drawstring waist and were drawn up high on the natural waist. The knit style was close fitting and extended to the hip. Sometimes this style had a belt. The boxer short style resembled shorts and extended to the upper thigh. Both styles usually came with a built-in supporter.

To play tennis, young men wore white trousers or shorts. Typically, trousers had pleated fronts, creases, and cuffs. The shorts worn for sports often had an elastic waistband. Short-sleeve knit shirts with or without collars were worn, as well as sleeveless and long-sleeve pullover V-neck sweaters.

HEADWEAR, HAIRSTYLES, AND COSMETICS

Infant to Preteen
Headwear. Young girls wore a variety of hats. Most had low crowns and narrow brims. Berets and headscarves tied under the chin were popular as well.

Young boys wore the pork-pie hat and caps. Cold winter months required more protection, so caps had flaps folded down over the ears and snapped or buckled under the chin. Cowboy hats were worn for play.

Hairstyles. Most young girls had long hair during the 1940s. When it was left loose, it was flipped up or under. It was styled away from the face, and some styles had bangs. Many girls styled their hair into pigtails or two braids. Bows were worn at the end of braids, on a ponytail, and at the side of the head.

Young boys wore their hair short with a side part. It was styled away from the face, and the front was left a little longer to enhance any wave in the hair.

Rain capes were functional garments for young women. They extended just below the knee, had slash pockets, and came with a hood, which was finished with shirred elastic to frame the face to keep wind and rain out.

Boys' Coats. Flight or bomber jackets were popularized during the war. Both styles had zippered fronts and long full sleeves that gathered into a knit cuff. They also had a knit waistband. Most versions of the jacket had a variety of flap and slit pockets at the waist and breast. Hip-length leather jackets were popular among teenage boys. These zip-front garments had convertible collars and slit pockets at the hips.

The double-breasted trench coat remained popular among teenage and college men, but it lost a few details during the war. To conserve materials, the overlaid yoke, shoulder epaulets, and metal belt clasp were removed. Rain coats and overcoats continued to follow a wide-shouldered military style for several years. Another popular outer garment was the gabardine raincoat. This three-quarter-length coat was cut straight and had a notched collar and patch pockets with flaps.

SWIMWEAR AND SPORTSWEAR

Infant to Preteen

Girls' Ensembles. Young girls usually wore one-piece swimsuits with low-cut legs. Some girls wore swim dresses that had flared skirts. Sweetheart necklines were popular, and sometimes the shoulder straps were embellished with trims or braiding. Two-piece suits were worn also. They often had halter-style bra tops and trunks that extended over the navel to the natural waistline. Suits were made from rayon, cotton, wool, or a mix of these fibers. Elastic around the legs helped to keep the suit in place.

Boys' Ensembles. Boys' swim trunks came in two different styles: traditional stretch knit and boxer shorts. The knit style was made of wool or a wool and rayon blend. They fit snuggly and extended from just above the natural waist to the hip. Sometimes they were worn with a web belt or drawstring at the waist. The boxer short style was fuller and resembled shorts. They had a drawstring waist and were made from satin, cotton, or rayon. Sometimes boxer-style trunks were sold with matching cover-up shirts.

Teen to College

Girls' Ensembles. Swimsuits came in three common styles: two piece, one-piece swim dress, and one piece with half-skirt. Two-piece suits often had halter-style bra tops that were shaped by darts. The bottoms consisted of trunks or a skirt that extended slightly above the natural waistline.

puffed at the shoulder. Knee-length coats sometimes were fitted at the waist and had a flared skirt. This silhouette was achieved with princess seams. Peter Pan, notched, and convertible collars were common. Fur was frequently used as trim, and fur collars were popular. Coats had patch or slit pockets, and some coats were belted. Sometimes capes were worn over dresses. They had convertible collars and often had embroidered designs. Girls wore trouser style or bib-top snow pants that were loose fitting and gathered into a knit cuff at the ankle.

Boys' Coats. Rain gear for boys consisted of knee-length rain coats with buttons down the front, raglan sleeves, slash pockets, and separate hood and were made of a tightly woven cotton fabric impregnated with a waterproof plastic substance (Olian 1992). Snowsuit jackets were short, just below the waist, with slash pockets. They were made of wool or cotton gabardine twill and sometimes had matching snow pants that were roomy enough to accommodate the pants underneath.

Leather jackets were popular with older boys. Typically, they were hip length, had a zip closure, a convertible collar, and slit pockets. Aviator-style leather jackets had a lambskin collar, a horizontal seam across the upper chest, and adjustable side and cuff straps.

Teen to College

Girls' Coats. Women's winter coats were made in camel's hair, solid-colored wool, tweeds, and herringbone. Reefer and polo styles were the most popular. The reefer style was either single or double breasted and had princess seams to shape the waist and flare the skirt. The coat extended to the upper calf and had a notched collar with wide lapels and flap pockets. The polo coat had a straight silhouette, was double breasted, and extended to the knee. Usually, it had a notched collar and patch pockets with flaps. Wool pea jackets were also popular. They were double breasted, boxy, and were cut to just below the hip. They had a wide convertible collar and nautical buttons.

Short play jackets or snow jackets were designed to be worn with snow pants. They zipped or buttoned up the front and had either straight sleeves or cuffed sleeves. The length of the jackets ranged from the waist to the hip. Convertible collars were common on this type of jacket, but sometimes they had hoods. Snow pants were cut full and gathered into knit cuffs at the ankle. Often the cuffs had zippers to make it easier to get in and out of the pants. Sometimes snow pants were reinforced at the knee.

Teenage girls adopted their brothers' and boyfriends' large, buffalo plaid wool shirts as lightweight outerwear. These heavyweight shirts had a mannish fit and patch pockets at the breast. This trend was so popular that stores began to market the style to young women.

popular fashion for teenage girls. Dungarees were rolled up to just below the knee and worn with folded-over cotton "bobby socks" and loafers or saddle shoes.

Blue jeans designed for the female figure were advertised so girls no longer had to wear boys' pants that did not fit well. With two side pockets, a tapered waist, and room for hips, these pants still had a side closure because front zippers were still considered inappropriate for women.

Young women wore a variety of separates. Collared blouses were common in short- and long-sleeve styles. Short- and long-sleeved knit shirts gained popularity. Casual, boxy, hip-length jackets were combined with pants. Knee-length pleated skirts were worn with collared blouses. They also wore large, loose sweaters called "sloppy joes."

Boys' Ensembles. Typically, teenage and college men wore trousers or dungarees, which were also known as jeans. Trousers had pleats, creases, and cuffs, whereas jeans usually had tall cuffs that exposed the lighter, back side of the fabric. Both trousers and jeans were worn with a belt. Pants were paired with open-collared, button-down shirts or knit shirts in either short- or long-sleeve styles. In cooler weather, young men wore pullover sweatshirts or sweaters, which usually had a V or round neck and long sleeves. They also wore sweater vests. Popular pullover sweater styles included cable knits and jacquard knit-in designs: V neck or round neck, vest or long sleeves, pullovers, and solids, cables, or designs. Letter or varsity sweaters were popular among athletes. These cardigans were long, extending over the hips, and had long sleeves, a V neck, pockets over the hips, and a button closure. Typically, young men had the letter of their school's name appliquéd onto the front of the sweater between the hip and chest.

OUTERWEAR

Infants and Toddlers
Infants were often bundled in hand-knitted or crocheted jacket, cap, and bootees ensemble. A colored cotton blanket and quilted comforters were placed over the baby on chilly days. Typically, overcoats were simple gray or brown wool, gabardine, or corduroy with few embellishments. Coats came in single- and double-breasted styles, and they had fold-down collars and patch pockets. Wool snow pants or snowsuits, which combined the coat and pants, were worn also.

Children to Preteen
Girls' Coats. Girls' coats were usually made from rayon, wool, or flannel. Double- and single-breasted styles were popular, and sleeves usually

embroidery or appliqués. Young girls also wore overalls or denim pants with a short-sleeve, collared blouse or knit shirt.

Boys' Ensembles. Young boys wore suits and a variety of playclothes. Suits consisted of a jacket and either shorts or long pants. They were worn with a collared shirt.

Playsuits were combined shirts and long pants. They usually had a notched collar. Sometimes the shirt could be a contrasting color or it would be embellished with embroidery or an appliqué.

Sweatshirts, pullover sweaters, and knit shirts were worn with denim or corduroy pants. Button-down shirts had open-neck collars and either short or long sleeves. They came in solids, checks, plaids, and novelty prints such as western themes. Roy Rogers was the hero of most American boys, and western-style shirts were popular.

As the world entered the war and patriotism was on everyone's mind, copies of military uniforms were marketed for young children: naval, marine, and army officer suits for little boys, and Women's Army Auxiliary Corps and Women Accepted for Volunteer Emergency Service uniforms for little girls. Sailor suits were especially popular with wide bell-bottom slacks and pullover shirt with sailor collar. Military appearance remained popular for children throughout the war years.

Teen to College

Girls' Ensembles. Teenage and college girls wore a variety of dresses. Two-piece full-skirted dresses were popular in cotton with bright plaids, stripes, and gingham for summer. In the winter, they wore similar styles in wool and corduroy. Dresses were fitted at the waist and had full, gored, knee-length skirts. Long, straight sleeves, bishop sleeves, and short puffed sleeves were popular. Typically, dresses had Peter Pan or pointed collars. Often the waistline was accented with a sash or belt.

Sweater sets were especially popular among college girls to extend their wardrobe. The same sweater could be worn with a plaid skirt, a pair of tailored pants, or denim pants. Many girls mimicked the "sweater girl" look by wearing longer, tight-fitting sweaters made from soft wool or spun cotton.

Girls' trousers were fashioned after men's wear with belted waist, wide legs, and pleated fronts. Combined fabrics of wool, cotton, rayon, and nylon, these comfortable and stylish slacks could be worn with a man-tailored button-front blouse or sweater.

Durable denim pants, known as dungarees, were often purchased a little long to accommodate growing children. The cuffs would be turned up so as not to drag on the ground. Rolled-up denim pants became a

During the war, the pocket flaps were removed, lapels were narrowed, the jacket length became shorter, trousers lost their pleats and cuffs, and pant legs became narrower and straighter.

Casual Wear

Infant to Toddlers
Babies were dressed in a matching jacket, bonnet or cap, and blanket when going out. Sleep bags for infants had openings for arms and head, and they tied at the bottom. One-piece sleeper sets had buttons on the inseams to ease changing. Mothers favored baby clothes that were easy to wash, quick to dry, required little or no ironing, and would retain whiteness. Knitted booties with ribbons around the ankle to keep the booties in place were made to match little bonnets or caps and jackets.

Toddlers, being quite active, often wore simple, functional garments, such as one-piece rompers with snaps or buttons inside the legs for easy changing. Both boys and girls wore rompers, but girls were dressed in pink and yellow, whereas boys were dressed in blue and green. Little girls had bunnies and other cute appliqués, including the Walt Disney characters Mickey Mouse and Donald Duck, whereas little boys had cowboy adornments such as horses and lassos. Pullover shirts were made with snaps or buttons across one shoulder that made it easier to dress the child.

Children to Preteen
Girls' Ensembles. During the 1940s, young girls wore dresses, jumpers, separates, and playsuits for casual wear. During the summer, floral print poplin dresses were commonly worn. They usually had short, puffed sleeves and a Peter Pan collar. Elastic gathers or a sash nipped in the waist, from which a full skirt extended to the knee or slightly longer.

Jumpers and separates were worn to school. Jumpers often had square or sweetheart necklines and had full, knee-length skirts. Although many girls wore solid-colored jumpers, patterns such as plaids and stripes were popular. Jumpers were typically worn with short- or long-sleeved blouses that had Peter Pan collars. Popular separates included the following: full skirts that came with or without suspenders; short, fitted jackets with puffed long sleeves; pullover sweaters; cardigan sweaters; and blouses with short puffed sleeves and embroidery or smocking.

Playsuits consisted of long pants with an attached bodice. They included the fashionable seen in dresses and blouses. A sash or waistband cinched the waist, the sleeves were short and puffed, and playsuits usually had lace-trimmed Peter Pan collars. Sometimes they were adorned with

above the knee. When restrictions were lifted after the war, dresses fell below the knee and began carrying more ruffles and trims. Washable cotton and rayon taffeta dresses with wide sweeping skirts and ruffled yokes were popular.

Boys' Ensembles. Some boys' suits had jackets and pants that matched, while others had twill, checked, or plaid jackets paired with dark shorts or pants. Generally, suits were made from wool, rayon, corduroy, flannel, or cotton. Jackets were available in both double-breasted and single-breasted suit styles, and they usually sported a belt across the back, wide lapels, and a handkerchief pocket.

Early in the decade, boys wore suits with knickers, but, after the war, shorts and long pants were popular. Knickers came just below the knee and were worn with matching socks and leather lace-up shoes. Traditionally, a major step in a boy's life was to move from knickers to long pants. This transition was often delayed during the war because fabric was conserved and money was tight. Long pants had wide legs with creases and cuffs. By the end of the decade, knickers were replaced with shorts, and young boys continued to look forward to getting their first "longie suit" with ankle-length pants.

Teen to College

Girls' Ensembles. Teenage and college women aspired to look like the glamorous movie stars of the 1940s. Formal dresses worn to weddings, formal dances, and graduation had sweetheart necklines, slim waists, and puffy short sleeves. During the war, however, there was not much occasion for formalwear. Even debutante balls were on hiatus. Young men were enlisted and shipped overseas, so girls saved their nicest dresses for furlough dates and the few boys who were able to stay behind and attend college. When the boys were home again and regular dating resumed later in the forties, styles for juniors were quite sophisticated. Mid-calf was the new length for special-occasion dresses. Not as extreme as the New Look for adults, young ladies' dresses had a fitted waist with full or straight skirt. Teenagers' fashions assumed they did not have the ample curves of women, so they did not create or emphasize an hourglass figure. The lines were softer and more demure with capped sleeves and sweetheart or round necklines.

Boys' Ensembles. Boys' suit styles early in the forties copied the glamour of Hollywood. Typically suits had either single- or double-breasted jackets. The popular sports coat look featured a jacket, often made from a textured material such as herringbone or tweed, and solid, dark-colored pants. Jackets were longer and had wide lapels and flaps over the pockets. Before the war, trousers had a high-rise waist, wide legs, and cuffs.

Other Accessories
Layettes came in thirty-four- and forty-eight-piece sets and included all the accoutrements a newborn needed, including cotton flannel vests, slips, diapers, bibs, and even crib sheets. Bibs were traditionally decorated with lace and embroidery, but, beginning in the 1930s, they began to be decorated with the newly introduced Disney cartoon characters. Mickey Mouse and Donald Duck were first used on bibs and feeders and eventually appeared on other clothing designed for children.

1940s,

WORLD WAR II

FORMALWEAR

Infant to Toddlers
Mothers and grandmothers would sew and crochet long, white christening gowns. White booties, bonnets, gowns, and blankets with delicate embroidery, lace, and crochet swaddled the infant who was being shown off to the church, family, and friends on its special day. White satin ribbon was used to tie the booties and bonnets, as well as provide tie strings for over jackets. Both boys and girls still wore christening gowns for this occasion.

Toddlers were often used in weddings as ring bearers and flower girls. Little girls usually wore simple cotton, rayon, and satin dresses that had very little adornment and flowered headbands. Layered petticoats added some extra support for the full skirt. In addition, they wore white or black patent leather shoes and white socks with crocheted tops. Little boys dressed in suits with short pants with knee socks and leather tie shoes.

Children to Preteen
There were not many occasions for children to dress up in formal attire during the forties. Emerging from the Depression followed by wartime shortages and frugal use of resources, few children had a need to dress up. Religious ceremonies were the exception. First communion for Catholic children was a major event in grade school, and Jewish children celebrated bar or bat mitzvah in middle school. Although the religious ceremonies were quite special to the families, most clothing was handmade and handed down from one child to another.

Girls' Ensembles. Party dresses for girls would be made from left-over fabric. Typically, girls wore dresses with a Peter Pan collar, short puffed sleeves, fitted waist with tie in back, and a full skirt that extended just

moccasin styles. High-top boots continued to be worn in colder weather, and T-strap sandals were worn in the summer.

Teen to College

Saddle shoes and T-strap sandals with heels were marketed directly to teens. Loafers were another casual alternative, and high-heeled styles were borrowed from adult fashions. Lace-up two-toned saddle shoes with leather uppers and rubber soles worn with ankle socks were one of the most popular looks worn by teenage girls.

Socks were an equally important part of the trend. In the early 1930s, ankle socks were worn as a part of high school girls' athletic uniforms. As the decade progressed, girls experimented with sock decorations. Worn in bold or muted shades, they were sometimes worn with gadgets, charms, and boys' garters. The shoes themselves were also altered and were painted with various pictures, songs, or friends' names (Schrum 2004).

Teen and college-age boys continued to wear styles dictated by adult men. Although boys also wore saddle shoes, they also continued to wear boots in the winter and T-strap sandals in the summer.

ACCESSORIES

Jewelry

Jewelry for young ladies also became more prominent during this period. These included pearl necklaces, gold lockets, bangle bracelets, and charm bracelets featuring nursery rhyme characters. Children's rings often featured birthstones or engraved initials. Children's watches and other jewelry also featured Mickey Mouse and Orphan Annie faces.

Boys' watches featured Buck Rogers, Dick Tracy, and Boy Scout faces. Neck-wear for young boys included ties featuring more masculine cartoon characters such as Popeye, Dick Tracy, and Mickey Mouse.

In the 1930s, teens began to express their creativity through jewelry. They made accessories out of everyday materials such as macaroni, Life Savers Candy, sugar cubes, and nail polish brushes. This kind of jewelry remained popular into the late 1930s. College-age women focused their attention on more adult styles in fine materials. Teen and college-aged men began to show interest in the adult style of wearing a watch on a chain, with a watch fob.

Gloves and Handbags

Little girls did carry miniature versions of purses worn by their mothers. Popular decorations for children's handbags included appliquéd Scottie dogs. Special-occasion bags often featured embroidered white seed beads.

Popular hats for boys included knit caps, jockey caps, and aviator-style helmets of leather or wool that were worn outdoors in the winter. Different headwear was available for different sports, such as hockey caps, golf caps, and ski caps, complete with ear flaps.

Hairstyles. Shirley Temple had a strong effect on girls' hairstyles, making the bob with corkscrew curls or braids popular. Coordinating ribbons were tied with a bow around the head, with the bow at the top.

Teen to College

Headwear. Teen hat and hair fashions were almost indistinguishable from adult styles. Hat brims were dropped low over one eye.

Hairstyles. Popular trends included permanent waves and dyed platinum blond hair.

Cosmetics. In both the 1920s and 1930s, high schools typically forbade the use of cosmetics at school but increasingly included beauty education in their curriculum. The 1930s saw an increase in the use of makeup by teen and adult women, with eye shadow, eyeliner, and nail polish becoming popular and acceptable. Powder, lipstick, and eyebrow pencil continued to be used but were less novel. Makeup styles of teenage girls continued to mimic those of adult women.

FOOTWEAR AND LEGWEAR

Infant to Toddlers

Newborns and infants wore hand-knitted or crocheted bootees, made of cotton or rayon with tasseled drawstrings. Moccasins continued to be popular. They were often made of silk crepe and trimmed with pastel embroidery. Both baby and children's slippers were often trimmed with rabbit fur during this time.

Children to Preteen

Young girls of the 1930s wore shoes based on adult designs but with broad toes and low heels. Canvas shoes were worn for sports, ballet, or gym and were made of leather and canvas. Dressier occasions called for patent and plain leather Mary Janes or oxfords, with elongated and rounded toes, buckles on the ankle strap, and rubber soles. Sandal styles were based on Roman high tops, with as many as four straps.

These shoes were typically worn with ankle socks, which were also becoming popular in adult fashion. In the winter, buttonless wool leggings were worn by children through age 6.

Boys' shoes continued to focus on styles worn by adult men. These included saddle shoes and leather oxfords, now available in two-tone and

cotton. Boys' snow clothing included printed double-breasted jackets with coordinating bib overall pants in a solid color. Pant hems and jacket cuffs were rib-knit to keep out the snow.

Boys remained interested in "dress up" clothes, focusing on baseball, aviator, cowboy, and Indian costumes. Sturdy playwear suits resembled mechanics overalls, with heavy stitching.

Teen to College

Girls' Ensembles. Golf wear for teenage and college-age women included a hip-length round or V-neck sweater worn over a below-knee-length, A-line skirt. A belt was often worn over the sweater at the natural waist. Tennis clothing consisted of sleeveless button-up blouses, worn with knee-length skirts, or above-the-knee-length shorts. Cardigan sweaters were worn for added warmth.

Ski clothing included both all-in-one ski suits and separate jacket and trousers combinations. They were available in solid colors and a variety of prints and styles. Following the silhouette of the late 1930s, jackets had square-ish shoulders and nipped-in waists. Trousers had rib knit at the lower hem and bagged above thick socks. Designers such as Schiaparelli and Lelong began creating sportswear in response to a general enthusiasm for sports.

Boys' Ensembles. In the early 1930s, young men continued to wear ankle-length pants that bagged at mid-calf with a tailored shirt or sweater. Toward the end of the 1930s, full trousers replaced plus fours.

Young men's tennis attire continued to follow adult designs. White cotton trousers with pleated fronts and a light-colored collared polo shirt were typically seen. Cable-knit V-neck sweaters with a single stripe accenting the collar line were also worn.

HEADWEAR, HAIRSTYLES, AND COSMETICS

Infant to Preteen

Headwear. Baby bonnets had either projected brims or shirred ruffles to protect the baby's face. Unisex hats were made from a variety of materials, including silk and rayon. They were frequently decorated with embroidery, ribbon flowers, or picot edging. Winter hats were often made from flannel wool.

Popular hats for young girls included sailor hats, straw hats, and bonnets for the spring and summer. Often, these were trimmed with flowers or wide ribbons. Cloches were popular for warm and cold weather. Formal occasions required fine materials such as angora, feathers, wool, and felt. These were used for berets and Tyrolean hats.

Preteen and children's coats became shorter and more fitted, especially when worn with matching zippered leggings by younger children. Pea coat styles with fur trim continued to be popular for both boys and girls. Aviator-style leather or faux leather coats with shearling lining were available in a variety of styles as well. Both round and pointed collars were available, as were double- or single-breasted coats of wool or wool chinchilla cloth.

Girls' Coats. Toward the latter 1930s, shoulders became broader, and coats flared from a nipped-in waist. Preteen coats also began to include capelets, were belted at the natural waist, and had longer, knee-length hemlines.

Boys' Coats. Coats for older boys included trench and "G-Man" coat styles. These styles continued into the teen and college markets.

SWIMWEAR AND SPORTSWEAR

Infant to Preteen

Swimwear. Both beach attire and snow clothing were similar for very young boys and girls. Toddlers through preteens wore swimsuits or sunsuits with a bib top and short pants. Available in seersucker, crepe, or broadcloth, these suits could be worn with or without an undershirt. Designers also began experimenting with fast-drying, form-fitting materials such as Lastex and rayon. Older girls began to wear slacks or pajamas over their suits for lounging at the beach.

Wool snow suits for toddlers and young children included a tight-fitting, belted, button-down coat and a pair of trousers with rib-knit cuffs. One-piece belted varieties were available for younger children. Darker colors were popular for boys, lighter for girls.

Girls' Ensembles. Tennis suits consisted of mid-calf-length shorts and a sleeveless V-neck top of cotton linen. Gym suits for children through college-age girls were usually a one-piece cotton ensemble consisting of a sleeveless, V-neck top and loose bloomers with elastic at the knee and a drop seat. It was also available with a pleated skirt. Separates including the middy or sailor-style blouse and cotton knickers were also common.

Horseback riding gear typically included wide-hipped riding breeches and jodhpurs with leather reinforcements and side button closures. Cotton shirts and riding vests were also typical for young girls through high school age.

Boys' Ensembles. For golf, young boys wore tailored, button-down white cotton shirts (short or long sleeved) with mid-calf-length tweed trousers, with elastic at the hem. Boys' tennis wear was remarkably similar to girls' and included shorts and a tailored shirt, in white sport-weight

Teen to College

Girls' Ensembles. Advice columns in the 1930s focused on what the college-age girl would need in her wardrobe. College women were a newly identified market and declared that clothing must be simple to be fashionable.

Casual-style dresses were deemed most appropriate for wear on campus, including "semi-sports type frocks" (Dare 1931), tunic dresses, and one-piece dresses of sheer wool. Knit dresses came in bright patterns, including stripes and checks. Detachable collar and cuffs were popular for these, as were bolero-cut bodices with scarf ties at the neck. Afternoon dresses were slightly more formal and were preferred in materials such as silk crepe, velvet, silk georgette, or satin in bright or pastel shades.

Suits were also appropriate for college wear. Including a cardigan or jacket, suits helped to add variety to a young lady's wardrobe. Tweed, knit, wool jersey, or angora suits were worn both on campus and for weekend wear. Notched lapels and a wide leather belt and fur trim added interest to these simple garments.

The most common, and commented-on, "uniform" for the collegian was a sweater and skirt combination. Advice columnists told young women, "it is advisable to have as many sweaters as possible" (*Washington Post* 1932). Sweater sets, of a cardigan and pullover, came in both solid and modern-style pattern designs. Recommended colors included brown, maroon, dark green, and gray. It was advised that brighter-colored sweaters only be worn singly and not as a set. Popular colors included orange, scarlet, and aquamarine. Occasionally, velveteen jackets and blouses were worn in place of the sweater. The most popular skirt was tweed, either cut straight or in a wraparound style. Knit jersey and plaid were also popular options.

Boys' Ensembles. Young men wore cardigans, sweaters, or sweater vests over soft-collar button-down shirts. Knit polo shirts and T-shirts were commonly worn for more active endeavors. Trousers had wide legs that were creased and cuffed, and the waistline was narrow.

OUTERWEAR

Children to Preteen

Coats. Zippered baby bunting, basically a custom-fitted blanket, had no arm holes and was edged with satin binding and decorated with embroidery or appliqué. Baby coats were made of rayon taffeta, silk crepe, or wool flannel and were decorated with smocking or appliqué. Additionally, their Peter Pan collars were trimmed with lace or embroidery.

ruffled wing sleeves. Another option was the pinafore, which included a bib or shoulder strap top, attached to a variety of skirt styles. In warm weather, a pinafore alone was enough; in winter, it might be worn over another dress of heavier material. Any of these dresses might be worn with an attached bolero-style jacket.

Overalls and playsuits were popular alternatives for girls (and boys) in the 1930s. Girls' playsuits were generally more decorative and featured puffed or long fitted sleeves, a Peter Pan collar, and patch pockets. Unisex or brother and sister outfits were another option. A brother and sister would wear matching shirts, with shorts for boys and pleated skirts for sisters. Sweaters with V necks were also popular.

Various types of light fabrics were favored for summer dresses, such as crepe, dimity, organdy, gingham, pique, and nainsook. Pinafores were made to be light and were especially popular in sheers or white eyelet in floral prints, checks, and stripes. Wool, corduroy, and taffeta and heavier fabrics were reserved for winter wear. Overalls were made of heavy fabrics such as these, as well as cotton broadcloth, seersucker, and khaki. Playsuits, for both boys and girls, were made of denim, chambray, and corduroy.

Trimmings and decoration were more varied than in the 1920s and included lace, ruffles, binding, edging, rickrack, and piping. Embroidery, smocking, and appliquéd floral figures remained popular. Buttons received renewed interest and often featured themes, including cartoon characters, animals, and nursery rhyme characters, among other things. Braids, ties, and nautical emblems were especially popular on sailor-style dresses.

Boys' Ensembles. Boys not only wore unisex or matching brother-sister outfits but also wore informal suits. Toddlers' versions were a shirt and pants combination that buttoned together at the waistline. The shirts were either long or short sleeved, depending on the weather, with crew necklines, or Peter Pan or Bermuda collar. Older boys wore two-piece suits that were single or double breasted with wide-legged long pants or knickers. Sailor suits were popular for boys as well as girls and included long, bell-bottomed pants with a front-buttoned fall. Boys' dress-up playsuits continued to be popular and resembled costumes worn by cowboys, aviators, Indians, and baseball players.

Sweaters for boys in the 1930s had crew, V, and turtle necks, and were produced in solids and stripes. Mickey Mouse sweaters were popular as well. Corduroy pants were popular and were even adopted for school uniforms, in both long and short lengths. Pants were also made of cotton broadcloth, serge, and wool jersey. Boys' shirts were of cotton broadcloth, and sailor suits were of cotton poplin or flannel.

Rompers or creepers were popular for crawling babies, especially in the summer. These practical cotton garments were all-in-one with a snap crotch closure. They were short sleeved, with short pants, and were made of seersucker, crepe, or broadcloth. Trimming included appliqué, smocking, and embroidery.

Separates for very young babies were all that was necessary in the summer and included a cotton shirt, an abdominal band/binders, and a diaper. Diapers were available in a variety of materials, including the knitted cotton bird's-eye cloth and a fine surgical-weave diaper treated to make it more absorbent. Although prevalent in the 1920s, binders were used less and less as the decade progressed. Silk and cotton-blend shirts with nonbinding sleeves were recommended. Innovative underarm cuts helped ease babies' arms into the sleeves. In the winter, wrappers and sweaters were used for added warmth. Slip-on sweaters were either slip-on, open front, or a new surplice style. Kimonos and knitted jackets were often included in layettes. These featured kimono or raglan sleeves and were made of light flannel, silk, or cotton knit.

Whereas the previous decade saw most newborns dressed in white, the 1930s witnessed the rise in popularity of pastel colors for babies. Pale pink, various blues, lavender, and buttercup yellow or maize were popular. Whites and dark linen blue were also trendy, as were prints and piques. Silk was a popular choice for baby dresses, especially in varieties such as china silk, crepe de Chine (or pure dye silk), pongee, and crinkle crepe. Some advice columnists even preferred silk to cotton in terms of durability. Sheer linen, lawn, nainsook, and batiste were also heavily used for baby clothes.

These fine materials continued to be decorated with trimming such as smocking, shirring, hand tucks, embroidery, and lace. Button-hole stitch edging was also popular. Cartoon character appliqués and prints also gained popularity. Mickey Mouse, Donald Duck, and other Disney characters were particularly popular on children's wear and especially T-shirts.

Children to Preteen

Girls' Ensembles. Bloomer dresses, popular in the 1920s, continued to be worn by children throughout the 1930s. In the thirties, rather than simply being an unfitted chemise, these dresses flared over the matching panties. Sailor-style dresses were also trendy in the early 1930s. Following adult silhouettes, the later thirties saw a waistline begin to appear in children's wear. Bodices now ended at the natural waist and included a self-fabric belt or matching sash tied at the back. The bodice was attached to a circle or gathered skirt. Peter Pan and Bermuda collars were popular, as were

worn with a short-sleeved bolero jacket. Utilitarian black satin suits were practical for street wear and formalwear. Formal attire needed to work for such occasions as dances, teas, dinners, and attending religious functions.

Boys' Ensembles. Teenage and college boys wore three-piece suits. Jackets were fitted and typically were hip length and single breasted. Many jackets had a half-belt in the back. Some jackets were waist length and zipped up the front. Vests generally matched the suit, and trousers had full, wide legs with cuffs.

CASUAL WEAR

Infant to Toddlers

Continuing from the 1920s, baby boys and girls dressed similarly for the first few months of life. However, there was some debate over when to begin differentiating through details such as round boyish collars or tiny puffed sleeves, ribbons, and sheer pastels for girls. The length of baby dresses also continued to shorten as the decade progressed. Initially around twenty-four inches in 1930, it had shortened to eighteen inches by the late 1930s (Ewing 1977, 137). Four- to 6-month-old babies' dresses were considerably shorter to allow greater freedom of movement for crawling. Petticoats for babies became less practical for wear under increasingly shorter dresses. Generally, they were offered in muslin and were only required under thin cotton for modesty.

It was generally acknowledged that the silhouette and style of babies' clothes changed very little over the years, and the only novelty lay in the details. Simple, short-sleeved white dresses with embroidery and pin tucks began to be imported from the Philippines in a variety of lengths. These dresses were common enough, but practicality led advice columnists to recommend that mothers "stock up on nightgowns and wrappers" (Parrish 1934).

A typical toddler gown from the 1930s. [Library of Congress]

eventually developing their own clothing lines. Although Buck Rodgers and similar adult stars continued to influence boys' clothing through to WWII, younger stars began to have a greater influence.

A host of youthful Hollywood stars such as Judy Garland, Virginia Weidler, Mickey Rooney, Jane Withers, and Sonja Henie had their own clothing lines or began endorsing clothing for department store catalogs, including the Sears catalog. By the late 1930s, Hollywood costume designers such as Vera West and Edith Head were being recognized for the costumes designed for their petite stars. With the popularity of Walt Disney's feature-length and short cartoons, Mickey Mouse and other Disney characters appeared on T-shirts and other sportswear for both boys and girls.

Of course, the most famous child star of the 1930s was Shirley Temple, who set the bar for all other child endorsers and merchandisers. She made her film debut at the age of 5 in 1934, and, by the following year, she was making $1,000 a week from merchandising tie-ins alone (Cook 2004). Mothers everywhere dressed their children in Temple-imitating clothing.

Temple merchandise included dresses, coats, snow suits, raincoats, toys, and accessories. However, it was the Shirley Temple "look" that most mothers were after. Her iconic hairstyle of all-over ringlets was imitated everywhere and is still recognized today. Her style of dress, frequently identified with toddlerhood, included simple frocks made to accentuate a toddler's belly, with puffed sleeves and hemlines that were consistently nineteen inches from the floor (Blackford 1936). These were trimmed with simple and unobtrusive decorative elements, such as embroidery or appliqué, and lace-edged hemlines and collars. Interestingly, conflicting fan magazine reports suggest that Temple was both uninterested in her film costumes (Blackford 1936) and insistent that they be of a consistent design (Martin 1936). Regardless, her style left its imprint on children's fashion of the 1930s.

Non-film child celebrities also drew considerable attention and affected children's clothing trends. The child Princesses Elizabeth and Margaret of England affected design worldwide. The press regularly photographed the pair and reported on their preferences. Beginning in 1932, young girls in England began wearing "Margaret Rose" dresses, which were rosebud-trimmed, knitted dresses. Primrose yellow and pink were the reported favorite colors of Princess Elizabeth, thus dresses in those colors flew off the shelves.

Teen to College
Girls' Ensembles. Most teens and young women were advised to keep formalwear purchases to a minimum when planning their college wardrobes (Dare 1931). However, they were also told that a few formal gowns would be needed. Crepe and other silk dresses were popular, especially when

Egyptian themes. Drawstring bags and leather pouches were fashionable, as were decorative belts on dropped waists.

1930s,

THE GREAT DEPRESSION

FORMALWEAR

Infant to Toddlers
As a result of the Depression, formalwear for babies was only a necessity for christening gowns. Long white dresses with matching hats remained standard for both boys and girls. The very wealthy who could afford to splurge on formalwear for children tended toward white organdy for afternoon dress-up, often trimmed with narrow piping. Alternatives included silk smock-like dresses trimmed with embroidery or colored appliqué designs of animals and flowers.

Children to Preteen
Girls' Ensembles. Shirley Temple dresses and those worn by Princesses Elizabeth and Margaret dominated the style for young girls aged 2 through 10. Rosebuds, knitted dresses, and fine materials such as organdy and hand embroidery were most popular for formal attire, when it was called for.

Boys' Ensembles. Toddlers continued to wear two-piece suits with short pants for formal occasions. The shirts worn under these suits were often made of knitted cotton jersey. Pants were typically corduroy or cotton broadcloth, among others. Older boys wore single- or double-breasted jackets with short or long wide-legged pants. Young boys' ties were offered in a variety of printed silk designs that included cartoon characters such as Mickey Mouse, Popeye, and Dick Tracy.

Celebrity, Children, and Fashion in the 1920s and 1930s
The twenties and thirties saw an increase in movie attendance, and children were influenced by the films they saw and child stars. Not only did popular child movie stars create or endorse their own clothing lines for both boys and girls, but they also affected trends in general.

In the 1920s, Charles Lindbergh's famous flight in *The Spirit of St. Louis* was highly publicized through newsreels, and subsequently aviator outfits became popular playwear. Film archetypes were also imitated, including space men, cowboys, Indians, and baseball heroes. Film stars Douglas Fairbanks Jr. and Jackie Coogan appeared in ads for boys' clothes,

or crocheted. These were usually white, with pastel colors used for accents and trim. Additionally, fine cotton or wool socks were worn in the winter, some that came with garters.

Baby shoes were made of a variety of materials, including felted wool and soft kid leather. They were usually made in some variation of a T-bar shoe and were typically decorated with floral appliqué and/or embroidery. Moccasins were also popular and were often lined in a light-colored silk.

Children to Preteen

As children grew older, greater differentiation between styles for boys and girls became apparent. Into the 1920s, both genders frequently wore high-button boots with black woolen socks.

However, as styles progressed, these boots began to be seen as a winter shoe for young girls. Round-toed patent leather and plain leather shoes with a single strap across the ankle or arch were popular at parties and other dressy occasions. These were sometimes decorated with a simple bow at the toe. The latter 1920s saw the increased use of long spats or leggings worn under dresses and over shoes for warmth.

Boys' shoes mimicked styles and shapes of their adult counterparts. Everyday shoes were white, black, red, or brown lace-up shoes of canvas and vulcanized rubber. They were most typically made in oxford style, either as a boot or shoe.

Teen to College

Teen and college fashions very closely followed adult styles and trends. In the 1920s, this included pumps, oxfords, or sandals worn with stockings. A growing trend, however, was wearing socks instead of stockings. It was during this time that ankle or bobby socks began their rise to popularity.

Teen and college-age boys continued to wear styles based on adult men. Oxford styles in leather for everyday and dress and canvas shoes for sport were common.

ACCESSORIES

The immediate postwar years saw a rise in hand-knitted goods, including scarves for both boys and girls. Girls also tended to wear muffs to keep their hands warm. These were made of rabbit or lamb's wool outer portions with soft inner linings. They frequently included a toy doll, bear, or dog head attached at the top.

Accessories such as bags, jewelry barrettes and sunglasses all mirrored trends in adult fashion. Pearls and beads were popular but not for everyday wear. Art deco and Bakelite jewelry was popular and featured

Teen and college-age men generally wore adult styles while golfing. This included argyle sweaters, plus fours, and argyle socks.

For tennis, full-length white tailored trousers were worn with button-down white collared shirts by young men. In cooler weather, they wore a thin-knit, relatively plain white sweater as well.

HEADWEAR, HAIRSTYLES, AND COSMETICS

Infant to Preteen

Headwear. Babies and infants wore bonnets or hats for protection from the elements. Generally, they matched the garment being worn and were made of cotton or silk with fine lace or white-work trim. Older infants also wore velvet bonnets with silk embroidery for more dressy occasions. Older girls wore headbands with ribbons and flowers, usually to match a particular dress. The fashion for hand-knitted accessories, including caps and hats for both boys and girls, had extended from the wartime trend of hand-knitted gifts for the troops.

Teen to College

Hairstyles. Teen and college-age girls of the 1920s wore their hair in much the same way adult women did. Bobbed hair, influenced by celebrities such as Irene Castle, was considered highly controversial among parents and teachers. Eventually, just getting a new haircut became the fashion. The latter 1920s saw adolescent girls growing their hair long. The new permanent waves garnered attention, as did hair dyes. Thanks in part to Hollywood starlets, platinum blond was a popular color (Schrum 2004).

Cosmetics. Throughout the 1920s and 1930s, young women imitated the trends they saw at the movies, in magazines, and in advertising. Cosmetics advertising was not yet geared specifically to teens and college-age women, but they were more prone to use new products than their adult counterparts (Schrum 2004). Cream and face powder were novelty items in the early 1920s and were popular among teens in the form of compacts. In the late 1920s, lipstick and an eyebrow pencil became the focus for young women. Stars such as Clara Bow and Mae Murray had an impact on makeup trends with high school girls. First introduced in the early 1920s, nail polish was considered vulgar through the 1930s. It was popular among teens and college-age women.

FOOTWEAR AND LEGWEAR

Infant to Toddlers

Footwear. There was little difference between footwear for boys and girls while in infancy. Newborns and infants wore bootees, often hand knitted

A middy shirt, a long-waisted, sailor-style shirt with a neck sash, paired with a knee-length pleated skirt was a general sportswear ensemble for young girls. Alternatives included tank-style dresses with pleated skirts or a knickers and tailored shirt combination. Materials frequently used included broadcloth, wool flannel, and other washable fabrics.

For winter sports such as ice skating and winter hiking, preteen girls wore hip-length cardigans or pull-over V-neck sweaters in plain or argyle designs. These were available belted or loose with or without pockets. Collar varieties included shawl, pointed, and V neck. Young ladies usually wore these with wool pleated or straight knee-length skirts or knickers with knee-socks in a complementary pattern.

Boys' Ensembles. Boys' golf wear had less variety than girls' wear did. Young boys wore a tailored, button-down white cotton shirt with knee-length tweed knickers and a belt. The same ensembles were worn by young caddies, with the addition of a matching or complementary tailored jacket.

General playwear for young boys included "dress up" outfits, including cowboy and Indian outfits, aviator suits, and baseball uniforms in bright colors and "authentic" decoration. Plain playclothes included one-piece coveralls (complete with a drop seat) of heavy duty fabrics such as denim. They featured front patch pockets, button-up and zipper closures, and a variety of collar styles. Summer playclothes offered short-sleeve and short varieties, with button-up closures and belts.

Preteen boys' wear for outdoor sports such as ice hockey and cycling included V-neck and button-down argyle sweaters worn with knee-breeches or trousers.

Teen to College

Girls' Ensembles. One-piece, knitted, and belted swimsuits with form-fitting short overskirts were popular among teen and college-age women. Less-functional swimwear of the early 1920s included frills and multiple layers for modesty. Necklines varied and were round, V neck, or cross over. Suits offered little to no chest support. Beach shoes were a necessity and resembled today's lace-up kick-boxing boots. An early popular trend was to sunburn the name of a popular film star onto a leg or arm.

Teen and college-age golfers wore long-waisted and belted knitted shirts and knickers bloused at the knee in somber colors. Tennis attire consisted of a roomy and longish pleated skirt and shirt ensemble in white. Alternatively, but in the same silhouette, sleeveless white boat-necked dresses with dropped waists and long skirts were popular.

Boys' Ensembles. One-piece, knitted and belted swimsuits with a tank top upper and form-fitting shorts were popular for both men and boys.

Six-month-olds to 2-year-olds wore a shorter, "walking" version. Alternatives included high-collared baby capes and sailor-style pea coats.

Girls' Coats. Young girls also wore fur coats with high wrap-around collars. Girls' cloth coats were made of plain or plaid wool and included fur collar and cuffs. A-line cut overcoats with a side button and tie closure and a short, knee-length hem were typical.

For preteen and young girls, typical design elements for coats and capes included large collars, dropped and belted waists, patch pockets, large buttons, and sometimes an inverted pleat at the back. Hems usually fell at or above the dress hem. Capes were knee length and made of wool, although some were knit and lined with fleece. Decorations often focused on art deco themes.

Boys' Coats. Boys' coats were based on men's styles and included styles such as sailor or pilot coats or swagger coats. Double-breasted coats of mock raccoon or wool with fur collars were typical. Pocket varieties included patch, side flap, or envelop pockets at the chest. Both belted and unbelted styles were available.

Teen to College

Girls' Coats. Jackets were cut on adult lines and again included fur trim at the collar and cuffs. Both tubular and flared coats were popular, worn belted or loose. Cloth coats were made of wool or velveteen and included patch pockets. Fur coats were also popular among college-age girls.

Boys' Coats. College-age men in the 1920s are well known to have worn raccoon coats, especially to sports events. They usually included wide lapels and were lined in plaids or tweeds.

SWIMWEAR AND SPORTSWEAR

Infant to Preteen

Swimwear. One-piece, knitted tank-style suits with shorts were popular for both young boys and girls. Both buttoned up the center front, although girls usually had more upper-body coverage than boys. Suits were popular in a variety of colors, but wide horizontal stripes were a particular favorite.

Female Ensembles. Golf wear for young girls strongly resembled their casual wear. Typically, it included a pair of roomy trousers or pleated skirt, paired with a long- or short-sleeved button-down blouse. Young ladies' tennis attire was similar to that of adults and consisted of a full and longish pleated skirt and middy shirt ensemble in white or with a darker skirt and a white shirt.

Boys' Ensembles. Boys basically wore miniature versions of adult clothing in the 1920s. Suits, rompers, and separates were most common for boys. A white, button-down shirt and a pair of short pants was the typical uniform. One-piece rompers consisted of a shirt and short pants combo with elastic cuffs on the pants. These were available plain or with sailor-style detailing. Older boys wore suits with short pants for sport. During this period, it was also common for boys to play "dress up." Outfits that resembled cowboys, Indians, baseball uniforms, and aviator uniforms became common styles of playwear began appearing in the 1920s (Olian 2003).

Teen to College

Girls' Ensembles. Teen and college-age casual wear differed very little from adult fashions. Although trends may have differed, the overall silhouette remained consistent. Marketing to teen and college-age girls was a relatively new phenomenon and was mostly focused on the college-aged girl preparing her wardrobe.

Lowered waistlines and short hems were just as popular, if not more so, for the college and high school girl as for the full-grown woman. Dresses were typically cut loose and had a self-fabric belt at the hipline. Deep collars, a scarf, and a cape of matching material helped add interest to the otherwise simple tunic dress. Handkerchief linen, taffeta, and floral prints were popular in pastels for summer dresses, with heavier fabrics and darker colors for winter wear. Typically, less ostentatious trimming was used for these young ladies' dresses than for children's attire. Pleating was particularly popular on skirts, tunics, sleeves, collars, and edging in fabrics such as crepe, voile, and georgette. Smocking with bright threads was another conservative way in which young ladies' dresses were trimmed. Generally, teen and college-age fashion, for both sexes, closely followed more general trends and silhouettes.

Boys' Ensembles. Young men typically wore sweaters or sweater vests over their soft-collared button-down shirts, because jackets were no longer required for casual occasion. V-neck patterned pullover sweaters were popular as well as cardigans. Norfolk jackets were worn by college students. This sports jacket had inset panels and a belt. Knickers were commonly worn by college students.

OUTERWEAR

Children to Preteen

Coats. Babies and infants typically wore a "long-coat," a long, sleeved gown with a shoulder cape usually trimmed with embroidery or lace.

uniforms were also reflective of the modish silhouette, with bodices low and skirt hems short.

Basic dresses for little girls included a bloomer-style dress of a matching smock and panty set, matching bib and little sister dresses, and a simple chemise-style dresses that could be slipped on over the head. One-piece smocked frocks were appropriate for all ages and included a yoke, girdle, and cuffs fitted through decorative smocking. Whereas simpler dresses were preferred for younger children, older girls' frocks were more complex. A straight-cut jumper blouse was popular for young preteens in the 1920s.

Low-waisted and bloused bodices were popular, although chemise dresses were typically cut loose and worn with simple string belts. Irregular necklines were often shown for girls aged 8 to 10. These closed at one side and included a white linen collar. The Byron collar and raglan sleeves were also popular at this time.

Skirt hems were generally quite short on smaller girls and grew longer with age. Bloomer dresses were short enough to show the matching panties underneath. For slightly older girls, a popular element was to have skirt fullness gathered in the front. Box-pleated skirts and deep front pockets were used as well.

An alternative to dresses for children's daywear included two- and three-piece suits, with the blouse and skirt attached. Suitable for girls aged 2 to 6, these included a pleated skirt sewn to an undershirt-style top with a sweater worn over the top. Jumper styles were also popular. Separate sweaters were often made of jersey and featured "modernistic" bold, geometric designs in bright colors.

Fine-weight woolens in check and plaids (especially Navajo and Yukon) were popular for children's daywear. Overblouses for two-piece suits were made of crepe, linen, or muslin. Three-piece suits were made of contrasting colors. Jersey was worn by girls of all ages and was used heavily for toddlers. Velveteen was popular for winter. Handkerchief linen, silk, and crepe were especially popular in citron, lavender, and other pastel colors for summer wear. Taffeta was also popular in the summer.

Plain or block patterns were popular for dresses. Stripes, plaids, dots, and conventional figures in bright colors were often used for summer, whereas rich, dark colors such as wood brown were modish in winter. Colors and materials were frequently combined for added effect, such as blue plaid with blue and tan striped jersey.

Popular trimming included smocking, especially in conjunction with bright-colored threads. Embroidery, ribbons, and ribbon rosettes were popular, too. French embroidery, Italian drawn work, and other fine needlework in simple patterns were preferred.

boys and girls wore short smock-style dresses with matching, bloomer-style undergarments. Differentiation between clothing for boys and girls increased from the time babies could crawl and was generally confined to the length of the skirt and style of the sleeve, collar, and trimming.

Dresses for infants and babies varied during the twenties. One option was a long white dress of cotton lawn or nainsook, heavily decorated and worn with a matching bonnet and cape. This was available in sleeveless and long-sleeved forms. Typically, an extra petticoat was worn under the dress for added warmth and modesty (when the overdress was especially sheer). These petticoats were made of flannel cotton/wool/silk mixture or white muslin.

Boys playing sandlot baseball show some very casual clothes of the period. [Library of Congress]

Babies of crawling age were switched from dresses to rompers to allow greater movement for the legs. Another alternative was a three-piece, hand-knitted ensemble of a long-sleeved, double-breasted shirt, leggings, and a jersey. It was also recommended in newspapers and magazines that infants wear an abdominal band under their clothes to "protect the abdomen and support the abdominal walls" ("The Family Page" 1924) until the navel was dry. These were made of knitted silk or wool flannel.

Infants' clothing in the 1920s was typically decorated with "bows, ribbon rosettes, embroidery, pin tucks, shirring, and inserts of lace." French embroidery, lace edging, elaborate hem stitching, smocking, and other fine needlework were popular as well. When not made of lawn or nainsook, white dresses were made of old-fashioned dimity with checks and hairlines or plain muslin, handkerchief linen, batiste, and ninon.

Children to Preteen
Girls' Ensembles. For younger girls, simplicity was preferred, and many clothes replicated versions of older children's and adult styles. School

For other special occasions, such as Christmas and holiday parties, young girls often wore miniature versions of what their mothers wore to the parties, with a complementary floral headband. A replica of the young girls' dress was also often made for her doll to wear at the party (Wilson 1925). Dances were popular for school-age girls, and their first was considered a very special occasion. Preteen and slightly younger girls' dresses of the 1920s were designed with short puffed sleeves and longer skirts.

Generally, formalwear offered a variety of styles based on adult silhouettes, especially the robe-de-style or long-skirted "period costume" (*New York Times*, December 7, 1924). Deep cape collars and bateau necklines were often seen on these formal gowns. Box and kilt pleats were used on dresses that fell just above, below, or at the knee. Other skirt details included flounced skirts and decorative pockets.

Girls' formalwear was made of such extravagant materials as velvet, satin, taffeta, crepe, tulle, and chiffon. Most advice columns recommended that a child's wardrobe have at least one black velvet dress for special occasions. Trimmings focused on ribbon and embroidery. The most popular ribbons were moire, grosgrain, or in bunches tied into floral shapes. Embroidery in metallic threads such as gold and silver were trendy, especially in chain stitch on pockets worn over velvet. Crewel embroidery was popular over white for holidays. Other decorative details included nosegays of flowers, ruffles, and smocking or shirring.

Boys' Ensembles. Boys' formalwear followed adult styles more closely than did girls'. The early twenties saw the continued interest in the Norfolk suit that had been popular in the teens. Younger boys continued to wear shorts or knickers with a belted jacket. As the decade progressed, the belt began to disappear. Older boys wore full-length pants with their suit coats for formal occasions.

Teen to College

Girls' Ensembles. Formalwear for teen and college-aged girls in the 1920s closely resembled both adult and juvenile styles. Youthful-looking fashions were popular for adults during this time, and so they were for those girls making their debuts. Ribbon decoration and trim accessorized shorter dresses worn to dances and special-occasion parties.

Boys' Ensembles. For teen and college-aged boys of the upper classes, prep school, naval, or military uniforms were favored in formal situations such as dances and debuts. Those not in uniform wore suits resembling men's wear.

CASUAL WEAR

Infant to Toddlers

Long flowing dresses, generally eighteen inches in length, were worn by both boys and girls for the first month or two. Up through the toddler age, both

Teenage and college boys wore suspenders that buttoned into their trousers. Leather belts with engraved buckles were also worn.

1920s,

THE JAZZ AGE

FORMALWEAR

Infants and Toddlers

Formalwear for such a young age was relatively unused, except for special occasions such as christenings. Christening gowns for both boys and girls were ornate and included frills, embroidery, and fine lace. Insertions and edgings were frequently made with baby Irish lace or embroidery executed on net bands.

Toddler-aged girls typically wore loose tunic dresses with a pair of matching panties, commonly known as a "bloomer dress." The bloomers were just barely visible below the skirt hems. These and other types of dresses were made of sheer and soft materials such as crepe and georgette. Initially, these dresses were trimmed with decorative elements, including embroidery, smocking rosettes, and all manner of ribbon decoration, but as the twenties progressed, simplicity became the norm. Trim was used sparsely, focusing on "delicate patterns and fine workmanship" (*New York Times* 1928). All-white gowns were popular in the late twenties, especially in dimity and white muslin.

Children to Preteen

Girls' Ensembles. Couture designers were particularly interested in designing formalwear for young and preteen girls. Most well-known of the couture children's designers was Jeanne Lanvin, who first began designing for her young daughter. She became well known for her "Mother and Daughter" dresses (Laubner 1996). Other designers, such as Paquin, Chanel, and Vionnet, also designed formal attire for young ladies.

Formalwear in general was worn by young girls and teens for special occasions, such as first communion, holiday parties, and school dances. First communion dresses were essentially child-sized versions of a wedding dress, including a floral headpiece with a veil. These dresses featured a great many frills and flounces. The twenties also saw a trend for white or pale-colored chemise dresses of muslin, handkerchief linen, or dimity decorated with hand needlework. These were worn by girls through age 14 and were slipped on over the head.

FOOTWEAR AND LEGWEAR

Children to Preteen

Footwear. Infant and toddler children wore high-topped leather shoes with button or lacing closures. Decorative or contrasting color uppers were common. These shoes with either heelless or had a very short heel.

Girls wore low-cut leather shoes with a short, wide heel. One or more straps secured the shoe to the foot. Oxfords, a style of shoe that had a covered vamp secured with buttons or lace, were popular also. Open vamp shoes with an ankle strap were also available.

Legwear. Young girls wore dark stockings during the winter and lighter ones during the summer. Young boys wore dark knee-length socks beneath their knickerbocker pants.

Teen to College

Footwear. Teenage and college women wore high and low styles of shoes. Both pointed- and blunt-toed shoes were typical. High shoes either laced up or had button closures. Low shoes were available in oxford or open vamp styles. Early in the decade, open vamp styles had straps to secure the shoe to the foot. By the end of the decade, many of the open vamp styles did not have straps.

Young men wore high and low styles of shoes as well. Both styles had button or lace closures. Dress shoes worn for formal or business occasions often had decorated toecaps. A variety of high and low canvas shoes were worn during the summer and for athletic activities.

Legwear. Young women wore dark cotton or wool stockings during the day and light-colored silk stockings for formal occasions. Rayon stockings had become available as an alternative to silk.

Young men wore cotton, wool, or silk knee-length socks that were held up by garters worn around the calf.

ACCESSORIES

Floppy bow ties and smaller bow ties were commonly worn with young boys' suits. Teenage and college boys wore four-in-hand ties in plaids and other patterns. They also wore bow ties.

In the winter months, preteen and teenage girls favored fur sets consisting of a muff and collar or wrap. Both imitation and real fur were popular. The muffs tended to be large and round. A common wrap consisted of a small animal wrapped around the neck and secured to the body of the animal with a clasp at the animal's mouth. Muffs made from velvet or corduroy were also popular.

usually made from cloth, straw, or felt and trimmed with artificial flowers, ribbons, lace, and ruffles.

Young boys wore a variety of hats and caps, including straw boaters, sailor hats, caps with visors, caps that extended over the ears, and tam-o'-shanters. Another popular style was the tyrolean hat, which had a high soft crown, a narrow brim that was upturned on one side, and a few small feathers tucked into the hat band.

Hairstyles. Young girls began to crop their hair into short bobs often with bangs. Some young girls kept their hair long, and older girls usually had long hair that was parted in the middle or on the side and pulled back away from the face or pulled up into a low bun. Oversize, stiffened bows were popular hair accessories. Young girls wore them on the opposite side of their part or at the back of the head.

Younger boys often wore the pageboy style, curled under at the mid-ear, and had thick bangs. Older boys wore their hair short, especially on the sides and in the back. The sides were styled away from the face, and the top was often slicked down.

Teen to College

Headwear. The hats worn by teenage and college women were like those worn by adult women. Early in the decade, hats had wide brims and the crowns were adorned with a profusion of feathers, fabric flowers, ribbons, and scarves. As the decade progressed, brims narrowed and the crowns increased in height. By the end of the decade, the crowns came down in height, and decoration became more minimal.

Teenage and college men wore the prevailing adult styles. Straw boaters with petersham ribbon hatbands were especially popular. Young men also wore caps made from a variety of fabrics and leather.

Hairstyles. Teenage and college women wore their hair in styles that were soft and wavy. Either parted in the middle or on the side, the hair was often swept across the forehead. Both low and high buns were popular. Tendrils of curls or waves were arranged over the ears. The marcel wave was popular. It created a natural-feeling wave that could last up to a week.

For young men, the prevailing style was short, especially around the ears and back. The hair at the crown of the head was either slicked back or parted and slicked down. The hair's natural wave was emphasized by the shine left by pomade.

Cosmetics. Cosmetics were used, but they were subtle and not widely admitted. Young women used pencils to darken their eyebrows. Powder compacts became available. They usually held both powder and rouge in peach and apricot colors. Some women used lip cosmetics.

Another style was a cotton weave mid-thigh-length dress over a knit underpiece. Typically, it had a waistband or sash. This type of swim dress either buttoned up the front or slid over the head. V necks, round necks, sailor collars, and wide collars were typical. Young women would wear cloth or knitted swimming caps and swimming shoes that tied around the ankle like ballet pointe slippers.

Young men wore the same tunic-style swimsuits as adult men. There were one- and two-piece versions made from knit cotton, wool, or a combination of the two. The sleeveless tunic had either a V or round neckline and ended at the hip. Short, mid-thigh-length shorts were worn underneath the tunic.

Other Activities. Baseball was an immensely popular sport in the 1910s, and high school and college teams were prevalent during this period. Uniforms were often made from homespun, a durable, coarsely woven fabric that was lightweight enough for summer play. Uniform shirts were cut loose and tucked into the pants. Typically, they had a wide collar. The shirts were either pulled over the head and laced closed or buttoned up the front. They came in a variety of sleeve styles, including full-length sleeves with cuffs, elbow-length sleeves, and detachable sleeves.

Pants were cut very full at the hip and knees and came in padded and unpadded varieties. The pants ended just below the knee and were usually closed with drawstrings or elastic. Young men wore heavyweight wool stockings that extended to the knee.

Various hat styles were worn, and they were usually associated with the major league teams that wore the styles. One style had a cylindrical crown that was flat on top and a visor brim. This style would be solid colored or feature horizontal bands of color. In another style, the crown was made from six pieces. Sometimes the six-piece style would have vent holes and a cloth-covered button at the top of the crown where the pieces met.

When playing tennis, young men wore long white pants made from flannel or duck. They rolled up the sleeves of their white shirts and wore neckties. Young women wore loose-fitting untucked middy blouses over simple mid-calf-length skirts. Frequently, they wore headbands or narrow scarves to keep their hair out of their face. Both men and women wore low canvas sports shoes with rubber soles.

HEADWEAR, HAIRSTYLES, AND COSMETICS

Children to Preteen
Headwear. The hats for young girls had soft crowns and narrow brims that were either upturned to various degrees or angled down. Hats were

square collars. Typically, winter coats were made from heavyweight wool or fur, and spring coats were made from linen, cotton, or silk.

During the war, the military influence was seen in young women's coats. Double-breasted styles became more popular, as did large collars. Belted waistlines became more common in coats, and the waist moved up to the natural waistline. The silhouette became fuller to accommodate the wide-hipped skirts that were especially fashionable among young women.

Rubberized wool or cotton was used to make raincoats for teenage girls and young women. The coats were cut long and full and often had a turned-over collar that extended high up on the neck. The hem usually extended to the ankle to protect the undergarments from the rain.

Teenage and college boys popularized the swagger-style coat, which was usually made of cheviot and had a wide, full back and raglan sleeves. Trench coats, which were popularized during the war, became fashionable for young men.

SWIMWEAR AND SPORTSWEAR

Children to Preteen

Swimwear. Boys and girls under age 6 usually wore a one-piece knitted suit. Made from wool, cotton, or a blend of the two, this type of swimsuit was had a sleeveless tank combined with shorts that ended at the mid-thigh. The neckline was V or round.

Older boys' suits mimicked those of adult men. Typically, they were one-piece suits comprising a long tunic over mid-thigh-length shorts. They were sleeveless and could have round or V necks. Knit from wool, cotton, or a blend, they usually came in dark colors with light-colored bands along the sleeves, neck, and at the bottom of the tunic.

Older girls often wore swim dresses made from woven fabric with knitted underpieces. Swim dresses fit like a loose, knee-length dress with a waistband or belt. These dresses were sleeveless or had short sleeves that were shorter at the shoulder than under the arm. Sometimes, these swim dresses had collars. Some versions pulled over the head, whereas others buttoned up the front.

Teen to College

Swimwear. Teenage and college girls wore the same types of swimsuits as adult women. One of the predominant styles was a one-piece jersey knit swim dress. This sleeveless garment fit closely in the bodice and had a narrow mid-thigh-length skirt. This style was available in V neck, round neck and sailor collar versions. Sometimes this style was loosely belted.

When doing manual labor, young men would often wear overalls. They were full fit in the hip and leg. Made from blue denim, they often had extra layers at the knee for durability. The bib of the overalls was suspended by two shoulder straps that buckled to the bib. Typical overalls had pockets on the bib and at the hips.

Teenage boys could join the Boy Scouts for which they would need a uniform. The complete uniform included a single-breasted military-style jacket, long breeches that were cut full in the hip and thigh and tight in the calf, and a hat that had a crown that was creased on four sides and had a wide, stiff brim.

OUTERWEAR

Children to Preteen

Coats. The coats of girls under age 7 were generally cut full and extended to just below the knee. Double-breasted styles were popular, and single-breasted coats often offset the placket to the left side. Shawl and sailor collars were common. Spring coats were often made of cotton poplin, and winter coats were commonly made of wool serge. Embroidery and lace often decorated the lapels and cuffs.

A dropped waist was fashionable in older girls' coats by the beginning of WWI. The silhouette was boxy, and raglan or kimono sleeves were typical. The waist was often accented by a belt or trim, and the hem extended down to the mid-calf. Most winter coats were made of wool, but they were being finished to resemble more expensive animal materials such as pony or baby lamb. During the war, military-inspired coats became popular.

Raincoats were made from waterproof fabric and fit loosely over clothing. The hem extended to a few inches above the ground. The coat could be either single or double breasted.

Boys' coats were either single or double breasted and had a jacket lapel-style collar. The coat length went slightly past the knee. Dark gray, olive green, brown, and navy blue were all common colors for boys' coats.

Teen to College

Teenage girls wore coats that followed adult women's fashions. They were mid-calf to ankle length and cut full. Single-breasted coats often had low hip-height button closures and lap-over fronts, which was a style that drew the front of the coat across the body much like a double-breasted coat without the extra row of buttons. Wide, embellished cuffs were typical, and collars came in a variety of styles, including notched, shawl, and

dresses had high necks or round necklines accented by round or lace collars. In general, skirts laid flat over the front of the hips and legs, but they had fullness in the back. Three-quarter-length sleeves and long close-fitting sleeves with cuffs were fashionable. Decoration tended to be more subdued than women's dresses during the period. Lace collars, narrow neckties, and button trims were popular.

By the middle of the decade, the waistline had loosened and been lowered. Necklines became slightly more open as turned-over collars and sailor collars became more popular. Overskirts became typical on most dresses and added width in the hip areas. Young women also wore blouses with wide-hipped skirts. For active endeavors, they usually wore a loose middy blouse with a narrow silhouetted skirt that had hidden pleating for easy movement.

In the summer, young women would wear white lace dresses made from lawn or voile. These followed the popular silhouette and had skirts with flounces, ruffles, and layers of lace overskirts. These dresses had V, square, or round necklines or collars accented with lace.

By the end of the decade, the loose, wide-hipped silhouette became more exaggerated. Hems shortened to the mid-calf level. Decoration became more minimal. Textured and patterned fabrics, pleating, rows of buttons, and contrasting fabric insets were common embellishments.

Sweaters became popular for teenage and college girls. Usually, they wore long hip-length cardigans, but pullover styles became more prevalent as the 1910s wore on. Sweaters had a variety of collar types, including shawl, fold-over, and high necks. Oftentimes, sweaters had patch pockets and a loose belt.

Young women wore overalls for active chores. They consisted of full pants that gathered into a cuff at the ankle and a blouse or bib. Blouse styles were either short or long sleeved. Bib styles were worn with a blouse underneath.

Boys' Ensembles. During their early teen years, usually to age 14 or 15, boys dressed like younger boys. They wore knickbocker suits with belted jackets that were either single or double breasted. The jackets were looser and longer than they had been in the previous decade. To accompany the suits, they wore shirts and either bow or slender four-in-hand ties.

Older teen boys dressed in styles worn by men. They wore form-fitting single-breasted jackets that extended just below the hip with single-breasted, five-button waistcoats without collars. These suits also included narrow trousers that extended to the bottom of the ankle. They were made from wool or cotton in a variety of weaves, including serge, herringbone, and tweed.

The young girl to the right wears a sailor dress popular to the period of the 1910s and a large hair bow. [Library of Congress]

The "Buster Brown" suit was popularized in the 1910s. This brown pinstriped suit had a long, straight double-breasted jacket with a belt. The jacket covered most of the knickers. The outfit was completed with a bow tie and a straw boater.

Character playsuits became popular in the 1910s. Although there were some playsuits for girls, most playsuits were made for boys. Popular characters included cowboys, Indians, policemen, and soldiers. Sometimes the outfits would include accessories such as a headdress for the Indian costume and a toy pistol and holster for the cowboy outfit.

Boys under the age of 6 often wore playsuits made of washable cotton or linen. The tops were blouses, tunics, or jackets, and they often had a belt. The pants were either knickerbockers or straight knee pants. Sailor collars were especially popular, but other collar styles, such as mandarin, Plymouth, and shawl, were available as well.

Unisex Ensembles. Girls and boys under age 7 wore rompers. These functional garments were made of chambray, gingham, and other washable, durable fabrics. As one-piece garments, they were combination shirts and pants with either long or short sleeves and collared or collarless necklines. They were designed for playtime and were loose fitting with loose belts.

Sweaters were worn by both boys and girls. Under age 7, these garments looked the same for both sexes. Sweaters were usually hip length with a button closure that extended down the length of the front. They often had fold-over collars and belts.

Teen to College

Girls' Ensembles. Early in the 1910s, the dresses worn by teenage and college women had narrow silhouettes and high waistlines. The monobosom of the previous decade was still evident but less emphasized. Typical

Children probably dressed up for the photo, and posed with bicycles and tricycles.
[Library of Congress]

sleeves. The waistline was placed at the natural waist or at the hip, and the hem ended just below the knee. The skirt tended to be full and often had two layers.

By the end of the decade, some girls wore overalls for play or chores. These consisted of knee-length, loose pants and a blouse or bib-style top. Typically, they were made from durable, washable cotton fabrics.

Boys' Ensembles. Young boys wore suits with knee pants. The jackets were either single or double breasted, and there was greater variety in jacket style than the previous decade. Belted jackets were popular, as were blouse-style jackets that gathered at the waist and blouse over the waistline. Side plackets were available in straight, blouse-style, and belted jackets. Sailor-style tops continued to be popular, and they were made in additional colors such as white and gray. Coat lapels and "button to the neck" were the most common collar styles.

Nearly all suits came with knickerbocker pants that fit loosely and gathered at the knee. Gray, dark blue, olive brown, brown, tweeds, and pinstripes were frequently used for boys' winter suits made from wool and cotton fabrics. Khaki became a popular summer color, and summer suits were made from linen and cotton.

wide hips enhanced by tiers of overskirts. Loose bodices and waists that were slightly above the natural waistline were common.

Early 1910s formal dresses typically had a long net tunic over a silk empire-waist dress with a narrow skirt. Surplice bodices were very fashionable, and the wide sash often separated the bodice from the skirt. V necks were the most common neckline, and sheer short sleeves were the norm.

By 1916, the progression to the later silhouette was evident. Silk, chiffon, and lace were arranged as overskirts and flounces to add width to the hips of evening dresses. Hemlines gradually rose to the mid-calf point. Bodices and waistlines were loose-fitting, with square, V, or round necklines. Typically, formal dresses had short or elbow-length raglan sleeves.

Boys' Ensembles. The formalwear worn by teenage and college boys was the same as adult men. The athletic silhouette of the 1910s was quickly adopted by young men. The black dinner jacket, or tuxedo jacket, was frequently worn for all types of formal occasions. It was close fitting and had a collar and lapels that were faced with satin. Underneath the jacket, young men wore a low-necked black vest and a collared white shirt. The dinner jacket was worn with black pants that had narrow legs.

CASUAL WEAR

Children to Preteen

Girls' Ensembles. Early in the decade, young girls wore dresses that were similar to ones worn in the previous decade, but slight changes began to occur. Made from plaid and solid-colored wool or cotton serge, many of these dresses featured bertha or sailor collars. Generally, the collars were not as oversized as they had been in the 1900s. Waistlines had dropped slightly below the natural waistline, but the dresses retained high necks. The hem extended just below the knee, and the skirts were usually pleated. Sleeves, which had been puffy and loose, became close fitting. Buttons, cord, braiding, and embroidery were common embellishments.

The dresses for girls under 7 years old were simplified. The waists had dropped, and the enormous bertha collars disappeared. Sailor collars continued to be popular. Aprons were commonly worn over dresses to extend their life.

In the summer, older girls would wear lace-covered white dresses made from cotton lawn, organdy, or a similarly sheer fabric. Lace, silk ribbons, and pleats would embellish the bodice, sleeves, and skirt. These dresses would have square, V, or round necklines and three-quarter-length

were drawn together with a bow or straps. In summer footwear, there were canvas oxford styles available. By the end of the decade, low styles, called oxfords, were becoming more popular.

Legwear. Girls wore stockings. Dark or black ones were worn during the winter, and white was worn during the summer.

Boys wore dark knee-length socks under their knee pants.

Teen to College

Footwear. Young women's shoes had two-and-a-half-inch heels and pointed toes. They either had an open vamp, with a strap across it, or they were oxford style with a closed vamp.

Young men's footwear was the same as what was worn by older men. They wore lace-up leather shoes or boots with low, stacked heels. Athletes wore sport shoes made of canvas uppers and rubber soles for traction.

Legwear. Teenage and college girls wore cotton stockings.

Teenage and college boys wore knee-length socks that were held up by garters that encircled the calf.

ACCESSORIES

Young children often wore detachable collars and cuffs to quickly dress up their ensembles. This could be very fancy with finely woven lace or hand-stitched embroidery.

Young girls usually wore aprons over their dresses to keep them clean. These could be made from delicate cotton lawn, finely embroidered, and trimmed with ruffles. Utilitarian aprons were made from durable cotton weave such as gingham and could extend over the entire dress in some cases.

Training corsets were available for young girls to help them adjust to using more restrictive corsets when they reached adolescence.

Teenage and college girls and boys used the same types and styles of accessories that were fashionable for adults.

THE
1910s

FORMALWEAR

Teen to College

Girls' Ensembles. During the 1910s, teenage and college girls' clothing transitioned between two silhouettes. The silhouette at the beginning of the decade involved a high waistline located just beneath the bust and a slim skirt. By the end of the decade, the fashionable silhouette focused on

could be trimmed with embroidery, braiding, and cords, but it usually had a pom-pom, tassel, or large button that extended from the center of its top. A square version that resembles a modern graduation mortar board was also available.

Typically, boys wore caps with visor brims. These were made in velvet, flannel, and wool. Another boys' style resembled a sleeping cap. It fit low on a boy's head and had a small end that flopped over to the side and was usually trimmed with a tassel.

Hairstyles. Girls' hair was either parted in the center and pulled back or left loose. Hair bows were quite popular. Small ones were placed high up on each side to pull hair away from the face. A medium or large bow might be placed high on top of the head or at the back of the head on top of a chignon as decoration. Larger bows were also used to pull hair back into a low ponytail.

Younger boys sometimes wore their hair longer and kept thick bangs. Older boys cut their hair short, parted it in the middle or on the side, and slicked it down.

Teen to College

Headwear. Teenage and college girls wore women's hats, including the broad picture hats that were laden with flowers, ribbons, lace, and feathers.

Teenage and college boys wore men's hats such as the Panama, straw boater, derby, and fedora.

Hairstyles. Young women wore their hair in the pompadour hairstyle, keeping it full and loose around the face and pulling the back in a loose bun or chignon. They often used a marcel wave to give their hair a natural-looking wave that lasted up to a week.

Young men either wore their hair short and slicked down or styled it into a pompadour, in which it was loose and full on the top and often cascaded over the eyes.

Cosmetics. Although cosmetics were widely used, few women admitted to using them, and makeup application was subtle. Powder and pink rouge were commonly used. Some women tinted their lips and used pencil or charcoal to darken their eyebrows.

FOOTWEAR AND LEGWEAR

Children to Preteen

Footwear. Both boys and girls wore high, lace-up leather shoes with short stacked heels. They were often embellished with a patent leather toecap. Smaller children often wore the button-up variety of high shoe. In addition, girls wore low shoes with open vamps. The sides of this style of shoe

SWIMWEAR AND SPORTSWEAR

Children to Preteen

Swimwear. Young children wore a one-piece wool tank suit for swimming. Typically, the legs of the suit extended to the mid-thigh. Older boys wore a similar suit or one that had a long tunic over a pair of mid-thigh-length shorts. The tunic either had short sleeves or was sleeveless. Generally, these suits were made of wool, but sometimes they were made of cotton or a blend of wool and cotton.

Older girls typically wore woven loose-fitting swim dresses with a knitted underpiece. They often had short sleeves, but some versions were sleeveless. Usually, these dresses were belted or had distinct waistbands. Some dresses had collars.

Teen to College

Swimwear. The woven swim dress was the common bathing costume for teenage and college girls. Usually made from dark-colored cotton or silk, these dresses had a wool undersuit. They came in styles with and without sleeves but usually had a waistband or sash. Generally, swim dresses had V necks, round necklines, sailor collars, or wide collars. Young women would wear cloth or knitted swimming caps and swimming shoes that tied around the ankle like ballet pointe slippers.

The knit tunic over shorts was a popular style for teenage and college men. They came in one- and two-piece versions and were often sleeveless. This style was made from wool, cotton, or a combination of the two.

Other Activities. Tennis was a popular sport in the first decade of the century, and players followed tradition and wore white garments. Young men wore soft-collared white button-down shirts and rolled the sleeves up to the elbows. They usually wore neckties also. Long, white trousers made from flannel or duck were worn.

Young women wore a similar outfit. They wore casual white blouses tucked into full white skirts. Typically, the skirts were shorter than those worn for other daytime occasions.

HEADWEAR, HAIRSTYLES, AND COSMETICS

Children to Preteen

Headwear. Infants wore bonnets made of cloth, usually trimmed with lace, ribbons, and embroidery. The bonnet tied beneath the child's chin.

Tam-o'-shanter-style hats were popular for young girls. These hats consisted of a band that encircled the head and a flat platter that sat on top of it. This style of hat was made of either silk, flannel, or velvet. It

Young men frequently wore sack coats. Vests were worn under jackets, and the shirt was only visible from the top of the vest to the collar. This was a looser, more square style of jacket. Pants were cut full in the hip and more closely in the leg.

Outerwear

Children to Preteen

Coats. Coats for young girls were available in long and short styles. Shorter styles were sometimes referred to as "automobile jackets." The short styles would extend to the hip line, whereas longer coats ranged from below the hip to just below the knee.

Reefer-style coats were popular throughout the decade. This style was double breasted and fit fairly straight along the body. Long coats that flared out at the hem were also seen. Coats were not cinched at the waist. Sleeves came in a variety of styles, including close fitting, full and gathered into the cuff, and raglan.

There were four main types of collars used on girls' coats during the 1900s. The first is the common coat collar with notched lapels. This type of collar was usually trimmed with velvet in a contrasting color. The second type of collar was referred to as a "storm" collar. This round collar buttoned high up on the neck and folded over to extend slightly below the natural neckline. The third type mimicked the bertha collars on girls' dresses and consisted of a shoulder cape of circular or square shape. It was usually topped with a storm collar. By the end of the decade, sailor collars gained in popularity. In this type of collar, the lapels extended into a square cape on the back. It included a necktie that was tied loosely below the collar.

Most coats were made of wool, silk, or cotton and trimmed with velvet, braids, silk cord, or embroidery along the collar, cuffs, and pockets. Common coat colors included blue, red, brown, and gray.

Boys had a lot of variety in their coats. Short top coats imitated those of their fathers and were usually worn by boys over the age of 10. Older boys also had longer styles of coats that were made in adult men's styles. Reefer coats were like those worn by girls but without the embellishments. Younger boys also wore cape-style overcoats.

Teen to College

Coats. Coat styles followed the men's and women's styles of the time period.

Beneath the suits, boys would wear shirtwaists. Fancier styles were designed to be worn without jackets. They featured wide, cape-like collars and ruffles or embroidery. Most shirts were plainer in style and were made from cotton, linen, or flannel. Some came with attached collars, whereas others had detachable ones. Plaids, stripes, and solids were the most common patterns. Military-style shirts were popular during the early part of the decade. The shirt placket and closures ran from the edge of the right shoulder down to the shirt hem.

Boys' and girls' clothing in the early 1900s. The girl wears a sleeveless dress with ruffled yoke; the boy's hair has curls customary to the period. [Library of Congress]

Like boys' pants, boys' shirts often had features designed for their active lifestyles. Easily washable material was a feature, as were double-sewed seams. Some shirts included a band of buttons along the waistline to help keep the shirt tucked.

Playsuits were popular for younger boys. These garments were one-piece combination shirts and pants. They were designed for children's grimier playtime. Instead of ruining expensive suits and dresses, parents could put their children in an inexpensive playsuit instead. Playsuits came in long and knee-length pant styles and were usually belted.

Teen to College

Girls' Ensembles. The clothing of teenage and college girls followed the dominant S-curve silhouette. They wore dresses, suits, and separates that conformed to the silhouette's monobosom bodice and trumpet-shaped skirt. Shirtwaists and bodices were adorned with lace inserts and embroidery. Waistlines were cinched and accented by belts, sashes, and wide waistbands. Leg-of-mutton sleeves remained popular, although they were not taken to the extremes as they were during their peak in the 1890s. This sleeve style consisted of a full puffed sleeve from the shoulder to the elbow that tapered into a close-fitting sleeve from the elbow to the wrist.

Boys' Ensembles. Boys' clothing followed the silhouette of the men's clothing during the period. Suits were the norm, although jackets could be single or double breasted. Regardless of the closure, the jacket was cut full at the torso giving even young men a barrel-chested appearance.

wrap-over vests for warmth, one or two blankets, two or three pairs of knit booties, and two dozen diapers. Often the nightgowns would have drawstrings or sashes to accommodate the width of the growing child.

Baby and toddler boys and girls were dressed alike until the 1920s. Typically, they wore cotton, linen, or silk dresses or jacket and skirt combinations. In the 1900s, colors became popular. Before then, infant clothes were usually white or cream colored. Peach and pink were considered girls' colors, and blue and lemon yellow were boys' colors.

Gingham, chambray, lightweight cotton, and wool were common materials for toddler dresses. Some were solid colored, but stripes, plaids, and other patterns were also popular. Most dresses had a ruffle at the yoke and a high neck. Empire, natural, and dropped waists were all common, and the hemline was either below the knee or mid-calf. Sleeves were close fitting or loose and gathered into the cuff.

Children to Preteen

Girls' Ensembles. Girls wore solid or plaid dresses during the 1900s. Depending on the season, the dresses were made of wool flannel, wool cashmere, or cotton lawn. Dresses had high necks that mimicked those in adult women's dress. Round or square yokes were accented by wide geometric lapels, berthas, that might be round, scalloped, square, triangular, or notched. In dresses made of lawn, a ruffle was another form of yoke embellishment. The yokes were trimmed with tucks, buttons, lace, or embroidery. The edges of the bertha were usually decorated with braid, ribbon, velvet, cord, lace, embroidery, or inset fabric. The bodice was generally loose to allow easy movement and growth.

A belt, waistband, or sash cinched the dress at the natural waist or slightly lower. Occasionally, the waistband dipped into a V in the front, imitating adult dress. Supported by petticoats, the skirt flared out and ended just below the knee.

Sailor dresses were very popular with girls. These navy blue dresses usually had pleated skirts and sailor collars, which extended from the lapels to a square cape in the back. The collar would be trimmed with white, and a loose necktie was knotted beneath the collar.

Boys' Ensembles. Once boys emerged from toddlerhood, they began wearing suits. Typically, suits consisted of a single- or double-breasted jacket, a waistcoat, and close-fitting, straight knee pants. The knees and seat of the pants were often double layered to improve the durability. The pants were secured at the knee with buttons or a buckle.

By the end of the decade, the silhouette of boys' suits had changed. Double-breasted jackets became the norm, and they were cut more loosely. The close-fitting knee pants gave way to the looser knee-length knickerbockers that gathered at the knee.

during the first half of the twentieth century. Bonnets styled after the ones in *Gone with the Wind* and dresses inspired by *Little Women* found their way to clothing store racks during this period.

At the beginning of the century, children's clothing was much like it had been in the previous century. The themes that had been consistent in children's fashions, such as similarity to adult clothing, restrictiveness, and slow transitions in styles, changed significantly over the course of the next forty-nine years. Styles changed with increasing frequency, a new youthful teenage market emerged, and children's styles deviated clearly from adult styles.

THE
1900s

FORMALWEAR

Infants and Toddlers
Christening gowns were the most formal of infant clothing. Worn during a christening ceremony, this long white cotton gown was usually finely embroidered and inset with lace. The gowns would measure anywhere between thirty-five and fifty inches in length (MacPhail 1999). They were considered prized possessions to be worn by all of the children in the family and would be passed down from generation to generation.

Teen and College
The teen and college styles for both young men and women closely followed adult fashions, although teenagers and college-age young people were more likely to adopt the new clothing trends.

During the Edwardian period, teenage girls and young women dressed like older women, wearing the tightly corseted fashions with extensive lace trim and sweeping, trumpet-shaped skirts. Their silhouette differed slightly from older women, because the monobosom was not as pronounced in their eveningwear.

CASUAL WEAR

Infants and Toddlers
During the 1900s, properly outfitting an infant required many clothes. At that time, diapers were made of wool or cotton and did not have rubber or plastic overpants, so every time the baby wet, it soiled most of its clothes. A typical layette consisted of three or four long cotton nightgowns, two or three cotton or woolen jackets called matinees, three or four wool

they modified existing garments, like rolling up jeans or wearing bobby socks, stores began marketing those items and creating reproductions of teenagers' homemade trends.

During this era, there was a transition in the functionality of children's clothing. Early in the century, children's clothing had a lot of adornment and tended to be tight fitting. By the 1920s, playwear became a staple of a child's wardrobe. Rompers and playsuits allowed children to get messy and be active without any concerns about ruining their more formal garments. American society's emphasis on health and the outdoors continued during the remainder of the era and further popularized play clothes and active garments.

There were many innovations in children's garments that allowed them to be more comfortable and active. From the youngest toddler to the college student, there were new details that affected every child's clothing. Toddlers had elastic leg openings that eased their movement and snaps along the inseams of their trousers to speed up diaper changes. New fabrics such as rayon and nylon were used to make a variety of clothing from coats to swimsuits. Rubber was used to make raincoats, new yarns for swimsuits, and the soles for athletic shoes. Elastic made stocking garters more comfortable, and raglan sleeves made arm movements freer.

Between 1900 and 1949, the United States was involved in two wars and a major economic depression. These events affected the clothing of all Americans, including children. During the wars, common materials such as silk and metal were rationed and in scarce supply. Manufacturers were required to reduce their use of fabrics and certain embellishments, so clothing became shorter, narrower, and less decorated. Patriotism during the wars led to the popularity of military styles among children. Military-style coats, shirts, and hairstyles were popular. During WWII, copies of military uniforms were available for children.

The Depression limited the purchasing power of most Americans. Children were often outfitted in hand-me-downs or donations from aid organizations. Usually, these garments were old-fashioned, outdated styles. Most families could not afford extensive wardrobes for their children, so very formal styles were purchased infrequently and most children wore casual clothing for nearly all of their activities.

Children's fashions were affected by popular culture during this period more than it ever had before. Hollywood had a significant influence on children's clothing. Child stars such as Judy Garland, Shirley Temple, and Deanna Durbin became fashion trendsetters, and they had lines of clothing. Cowboy stars such as Tom Mix and Roy Rogers popularized cowboy culture for young boys. Cowboy boots, hats, and motif shirts were popular among boys. Popular children's books became inspirations for fashion

9

Children's Fashions

OVERVIEW

In the years between 1900 and 1949, children's lives in the United States changed dramatically. At the beginning of the period, children were widely exploited by factories, education beyond grammar school was unusual, and teenagers were seen as young adults. By the end of the period, child labor laws had been passed, most children were educated through the high school level, and a new adolescent market was being exploited by marketers.

In the 1900s, young children were dressed alike. It was common to see a boy under the age of 6 wearing a dress and sporting long curls. Once they turned 6, they were dressed like young boys. This long-held custom had primarily disappeared by the 1920s. By that time, only infants were outfitted in dresses regardless of their sex. Once boys became toddlers, they wore boys' clothing. Although they were no longer dressed the same as girls, young boys continued to have a "coming of age" clothing experience through the end of this era. They wore knee pants or short pants until they were 6 or 7, when they were allowed to wear long pants.

At the beginning of the 1900s, teenagers were seen as young adults in many ways, and they dressed like young adults. By the 1940s, they were seen as a separate category: not quite adults and not exactly children. Marketers seized on this new group of teenager trendsetters and innovators. Companies began developing products specifically for teenagers. As

Olian, J. 1995. *Everyday Fashions 1909–1920: As Pictured in Sears Catalogs.* New York: Dover Publications.

Olian, J., ed. 1998. *Victorian and Edwardian Fashions from "La Mode Illustree."* Mineola, NY: Dover Publications.

Peacock, J. 1996. *Men's Fashion: The Complete Source Book.* New York: Thames and Hudson.

Peacock, J. 1998. *Fashion Sourcebooks: The 1940s.* New York: Thames and Hudson.

Peacock, J. 2000. *Fashion Accessories: The Complete 20th Century Sourcebooks with 2000 Full Color Illustrations.* London: Thames and Hudson.

Richardson, D. E., ed. 1982. *Vanity Fair: Photographs of an Age, 1914–1936.* New York: Clarkson N. Potter.

Seeling, C. 2000. *Fashion: The Century of the Designer 1900–1999.* English edition. Cologne, Germany: Konemann.

Tortora, P. G., and Eubank, K. 2005. *Survey of Historic Costume: A History of Western Dress*, 4th Edition. New York: Fairchild Publications.

Watson, L. 2004. *20th Century Fashion.* Buffalo, NY: Firefly Books.

Jewelry

Men did not wear much in the way of jewelry during the 1940s. They wore watches and rings on a regular basis. For dressier occasions, they wore tiepins, shirt studs, and cuff links.

Other

As a whole, men wore fewer accessories than they had earlier in the century. Belts were a common accessory, as was a handkerchief tucked into the breast pocket. Gloves and scarves were worn, and umbrellas were carried. Sunglasses became available after an Army pilot requested goggles that filtered out sunlight. The goggle manufacturer, Bausch and Lomb, marketed the resulting solution, and Americans began wearing sunglasses regularly.

REFERENCES

Baker, P. 1992. *Fashions of a Decade: The 1940s.* New York: Facts on File.

Baudot, F. 1999. *Fashion: The Twentieth Century.* London: Thames and Hudson, Limited.

Blum, S. 1981. *Everyday Fashions of the Twenties as Pictured in Sears and Other Catalogs.* New York: Dover Publications.

Blum, S. 1986. *Everyday Fashions of the Thirties as Pictured in Sears Catalogs.* New York: Dover Publications.

Bordwell, D., and Thompson, K. 2002. *Film History: An Introduction.* 2nd revised edition. Columbus, OH: McGraw Hill.

Buxbaum, G., ed. *Icons of Fashion: The Twentieth Century.* New York: Prestel.

Eyles, A. 1987. *That Was Hollywood: The 1930s.* London: Batsford.

Kellogg, A. T., Peterson, A. T., Bay, S., and Swindell, N. 2002. *In an Influential Fashion: An Encyclopedia of Nineteenth and Twentieth Century Fashion Designers and Retailers Who Shaped Dress.* Westport, CT: Greenwood Press.

Laubner, E. 1996. *Fashions of the Roaring '20s.* Atglen, PA: Schiffer Publishing.

Laubner, E. 2000. *Collectible Fashions of the Turbulent 1930s.* Atglen, PA: Schiffer Publishing.

Lee-Potter, C. 1984. *Sportswear in Vogue since 1910.* London: Thames and Hudson.

Mendes, V. D., and De La Haye, A. 1999. *20th Century Fashion.* London: Thames and Hudson.

Olian, J., ed. 1990. *Authentic French Fashions of the Twenties: 413 Costume Designs from "L'Art et la Mode."* Toronto: Dover Publications.

Olian, J., ed. 1992. *Everyday Fashions of the Forties: As Pictured in Sears Catalogs.* New York: Dover Publications.

Cosmetics

Men used hair tonics and aftershave lotions.

FOOTWEAR AND LEGWEAR

Footwear

Oxford-style shoes predominated. They had low, stacked heels and lacing at the vamp. Typically, they were made from brown, russet, and tan leather or suede. Some styles had toecaps and topstitching details. White and two-toned versions were worn during the summer. One version of oxfords, called sport oxfords, had fabric uppers and lightweight cork soles. They were designed to be worn with casual wear.

Although not as popular as oxfords, chukkas were worn with casual clothing. This style of shoe tied high up at the ankle. Generally, they were made from suede.

G. H. Bass introduced weejuns, or "penny loafers," in 1936, and they became a common casual shoe in the 1940s. They were worn with casual outfits and business suits. They continued to be popular through the end of the decade.

Sport shoes were worn for any athletic activity and with some casual outfits. They had canvas uppers and nonskid rubber soles. Sometimes they had rubber toecaps to protect the foot and improve the durability of the shoe.

Galoshes or overshoes were worn to protect leather and canvas shoes. They closed in the front with either zippers or snaps. During the war, when there was a shortage of rubber, galoshes were made from synthetic rubber.

Legwear

Socks were colorful during the 1940s. They came in argyle, chevron, and diamond patterns. Elastic was added to the tops of socks, so garters were no longer necessary.

NECKWEAR AND OTHER ACCESSORIES

Neckwear

Men wore ties with formal, business, and casual wear. Plaid, striped, and patterned ties were popular, and they became wider as the decade continued. They were made from wool, cotton, silk, and rayon and usually featured brilliant colors. Some men wore neck scarves tucked into open collars, and knit ties were worn sometimes with sports coats.

of wartime ingenuity provided waterproofing, windproofing, and more stretch in pants and jackets. Zippers were once again available for civilian clothing, making pants and jacket closures a better protection from the elements for skiing and sailing.

UNDERWEAR AND INTIMATE APPAREL

Undergarments

By the 1940s, there was great diversity in men's undergarments. The one-piece union suits of earlier decades were worn. They had either long or short sleeves and legs, and some styles were sleeveless.

For men who did not wear union suits, there were new, modern options. Servicemen wore T-shirts, and they became common undergarments and found their way into sportswear. Athletic shirts, which were knitted tanks, were an alternative to T-shirts. Boxer shorts had been introduced in the 1930s and had earned many converts. In 1935, a fitted, knit short was patented, called a Jockey short. In 1942, a Y-shaped opening was added to the style.

Sleepwear

By the 1940s, pajamas had replaced nightshirts. Usually, the coat or shirt of the pajamas had a simple center front-button closure, but some closed far to the left or had belted tunics.

Other garments

Robes came in a great variety. There were silk robes in the kimono style and paid flannel robes with cord or fabric belts.

HEADWEAR, HAIRSTYLES, AND COSMETICS

Headwear

The hat styles that had been common in previous decades continued to be popular. High-crowned, narrow-brimmed hats such as fedoras, derbies, and homburgs were worn with business suits. They were typically made from felt, but straw styles were popular in the summer. Soft-crowned hats, such as sports caps and pork pies, were worn with more casual clothes and sportswear. These were made from wool or cotton.

Hairstyles

Men wore their hair short, especially during the war. Mustaches went out of fashion, and clean-shaven G.I.s became the ideal.

OUTERWEAR

Coats

The coat styles that dominated the previous decades continued to be popular during the 1940s. Chesterfields, trench coats, swagger coats, and coats with raglan sleeves were common. Both double- and single-breasted styles were available. Sometimes coats were belted, and they typically had notched collars. Herringbone and plaid were popular patterns.

Coats with a military influence became popular. Pea jackets patterned from the ones American sailors wore were double-breasted dark-colored wool with a notched collar and large, naval-themed buttons. Battle jackets, also known as Eisenhower jackets, were common as well. They were waist length and bloused slightly. They were gathered into an attached belt.

SWIMWEAR AND SPORTSWEAR

Swimwear

Men wore bathing trunks to go swimming. These boxer-style shorts gathered into an elastic waistband. They extended to the upper thigh, and sometimes they had a pocket. Usually, they included built-in support. Matching trunks and shirt sets were available.

Golf

When playing golf, men wore knit or button-down woven shirts with sweaters or jackets. They also wore either casual trousers or shorts.

Tennis

René Lacoste, a number one-ranked tennis player in the 1920s, developed a short-sleeve knit tennis shirt with a ribbed collar and long shirt tails to keep the shirt tucked in. He partnered with a manufacturing company to produce the shirt in the 1930s. Although he halted business during WWII, when he resumed after the war, he exported the shirt to the United States, where it became an automatic hit.

Tennis players also wore knit T-shirts and pleated white pants or shorts. White outfits continued to be a requirement of many tennis clubs. Before and after games, players wore cable knit pullover sweaters in vest and long-sleeve styles. Sometimes they also wore a tennis visor or cap.

Skiwear

Snow skiing was becoming a popular sport because soldiers learned cross-country skiing during the war. New synthetic fibers developed as a result

CASUAL WEAR

Silhouette

The casual wear silhouette followed that of business wear. It was broad shouldered with some thickness through the waist and leg.

Jackets

Casual jackets were cut along the same lines as business jackets. The broad shoulders were padded, and they were single breasted and cut loose. They were worn with contrasting trousers. Often the trousers or the jacket was patterned, and the other piece was solid colored. More casual sports coats had patch pockets, oversized collars, or contrasting collars. Some jackets had half-belts in the back or full belts.

Norfolk jackets continued to be worn, and bush jackets became popular. These were short-sleeved tan cotton jackets with four large flapped pockets. They were reminiscent of the jackets worn by African explorers.

Slack suits, which were coordinated shirt and trouser combinations, were marketed for casual occasions. Shirts had either short or long sleeves and large, flapped patch pockets at the chest. Some shirts were designed to be tucked into belted trousers, whereas other "blazer" styles were to be worn untucked. The shirts often had yokes and shirring at the back for added comfort. The trousers in these ensembles were full and loose fitting, with pleats, creases, and cuffs.

Later in the decade, jackets became longer and continued to be single breasted. Sometimes they had larger collars and were belted. Western "ranch-style" details were popular. Many styles had a breast pocket for a handkerchief.

Shirts

Sports coats were usually worn with white soft-collared shirts. During the colder months, men often wore pullover sweaters or sweater vests under their sports coats. Cardigans with button or zipper closure were popular as well. Hawaiian print shirts became popular, and polo shirts were commonly worn.

Pants

Casual pants came in a variety of colors and patterns, including plaid, checked, and striped. They were pleated at the hip and had creases and cuffs. Walking shorts were worn as casual wear during summer months. Jeans were worn as well, although they followed a simplified silhouette. They did not have creases or pleats.

Production Board set the maximum length of jackets and eliminated dou-
ble-breasted styles and vests. The jackets had slit pockets at the hips with
and without flaps and a breast pocket in which a handkerchief was
tucked.

Shirts

Typically men wore soft-collared, button-down shirts with their business
suits. Some men wore striped shirts, and collars became wider. Although
cotton was the most common fabric for shirts, nylon was used again after
the war.

Pants

At the beginning of the decade, men's trousers followed the silhouette
that had been popular during the 1930s. They were pleated at the waist
and had wide legs, creases, and cuffs. Tweeds and plaids were popular.

The War Production Board set maximum lengths for trouser inseams.
It also limited suits to one pair of pants and eliminated cuffs and pleats.
Although the pants narrowed from the wide-legged silhouette that had
dominated in the 1930s, they continued to be full.

Decorative Details

Business suits were usually made from wool or rayon. Pinstripes, herring-
bone, plaids, and solid-colored suits were popular. Brown, gray, and navy
blue were common suit colors.

Military Uniform

The U.S. Army field jacket remained essentially unchanged from WWI
until the end of the 1930s, when it moved to create a more functional
garment that protected soldiers on the battlefield. The resulting design
was the olive drab cotton field jacket, which was adopted in 1940. The
Navy and Marine Corps soon adopted similarly styled jackets.

Modeled after the windbreaker used in sportswear, the cotton jacket
had a zipper closure with a button flap over it. It was lined with flannel
and had buttons at the notched collar to attach a hood. This jacket was
worn by nearly all Army personnel and became a symbol of the armed
forces during WWII.

The rest of the uniform was made in the olive drab color also. Pants,
shirts, and even caps and the tie were made of the same color. These gar-
ments were made from wool, and soldiers wore components of the uni-
form in both summer and winter. When it was cold, the wool provided
warmth, and, in warmer environments, it provided breathability.

1940s,

WORLD WAR II

FORMALWEAR

Silhouette

The silhouette of formalwear generally followed that of the business suit. The jacket had a thick torso and wide shoulders, and the trousers had a somewhat full cut.

Jackets and Vest

Tails were reserved for only the most formal occasions. Usually, men wore tuxedo jackets for most formal occasions. The jacket either had a rolled collar covered in silk or a notched collar. Most of these jackets were black, but some versions were midnight blue. Instead of a vest, men wore a cummerbund beneath the jacket. White dinner jackets were worn during the summer.

Shirts

Shirts with starched fronts and white ties were worn with tail coats. Tuxedo jackets were worn with soft front shirts and dark ties that matched the jacket.

Pants

Trousers followed daytime lines with full legs and pleating by the waistband. A line of braid that matched the color of the pants was added along the outer seam.

BUSINESS WEAR

Silhouette

Business suits had broad-shouldered jackets that fit loosely through the waist and hips after the first years of the decade. Trousers narrowed from the previous decade but remained somewhat full.

Jackets and Vest

Early in the 1940s, jackets were cut in the English drape style, which was wide at the shoulder and chest and fell with a slight drape in that area. The jacket fit close to the waist and came in single- and double-breasted styles. It was worn with or without a vest that was close fitting in the waist.

Wartime restrictions changed the cut of jackets. The drape at the chest was reduced, although the shoulders remained broad. The War

were popular with trendy collegiates. Toes were wide and rounded in the early part of the 1930s, tapering to an elongated point by the middle of the decade. Moccasins or weejuns were new options for casual footwear, along with canvas athletic shoes. Rubber galoshes with buckles or zippers were worn as protective wear over oxfords.

Legwear

Men's stockings continued to be highly patterned and colorful throughout the 1930s. New to the 1930s were stockings incorporating elastic into the knit at the top of the band, thus eliminating the need for garters. Argyle, chevron, and diamond patterns in a range of colors were available for business, formal, and casual wear.

NECKWEAR AND OTHER ACCESSORIES

Neckwear

The Windsor knot replaced the four-in-hand knot for neckties in the 1930s. The preference for wide-spread collars allowed for larger knots than could be accommodated by the 1920s preference for pinning under collar points. Ties also became longer in length because of the lowered stance of jacket and vest buttons. Ties were also slightly less wide than in the previous decade. Dark ties were always worn with dinner jackets and tuxedos, and white ties were worn with tail coats. Neckties were available in a wide range of colors, including blue, rust, gold, and maroon, and in floral prints and diagonal stripes.

Jewelry

Little, if any, jewelry was worn by most men in the 1930s. Many who had items of value sold them for basic necessities. Simple wrist watches, cuff links, shirt studs, cuff links, and rings were worn.

Other Accessories

Canes or walking sticks, handkerchiefs, pocket squares, and scarves were still carried by businessmen or for formal affairs. Sophisticated men also carried pipes and cigarette cases with lighters. The increase in enclosed automobiles meant that protective gloves and goggles were no longer a necessity, but the driving gloves and sunglasses were a must to look "swanky" behind the wheel.

he was not wearing an undershirt. Undershirt sales dropped as men believed this film was an indicator they no longer needed to wear undershirts (Tortora and Eubank 2005, 396). Those that did wear undershirts opted for the more athletic tank-style shirt in ribbed knit cotton.

Sleepwear

Two-piece pajama ensembles continued to be preferred to nightshirts. Pajama tops resembled button-down men's shirts but with a more relaxed fit and featured either small stand collars or convertible spread collars. Robes and smoking jackets continued to show Asian influence with oriental patterns and kimono sleeves.

HEADWEAR, HAIRSTYLES, AND COSMETICS

Headwear

Black or brown bowlers, fedoras, derbies, and homburgs were worn for business wear and formalwear. During the summer, these hats were replaced by straw boaters and Panama hats. Soft crown tams or golf caps with visors in tweeds and plaids were worn for sporting activities.

Hairstyles

The hairstyle popularized by cinema stars Rudolph Valentino and Douglas Fairbanks Jr. in the 1920s continued to serve as the standard men's hairstyle throughout the 1930s. Hair was worn short, parted on the side or the middle, or combed straight back. Pomade, hair creams, and hair tonic were applied to keep hair slicked back into place. Some men used pomades to create slight waves in their hair, similar to the marcel waves seen in women's hair. The majority of men were clean shaven, with either no or very small sideburns, but some men did sport small pencil-thin mustaches in the early part of the decade.

Cosmetics

Cosmetics for men in the 1930s were limited to hair tonics and pomades used to create sculpted hairstyles.

FOOTWEAR AND LEGWEAR

Footwear

Oxford shoes in brown and black were standard issue for business, casual, and formal dress. Perforations and topstitching decorated the toe, vamp, and heel. Two-tone white and black or white and brown "sporty" oxfords

Tennis star René Lacoste (right) in a polo shirt. [AP / Wide World Photos]

Other Activewear

The tennis star René "Le Crocodile" Lacoste joined forces with a French knitwear company in the 1930s to produce a line of tennis apparel and sportswear featuring his namesake, the crocodile, as the line's logo. The lightweight, knit shirts with short sleeves and ribbed collars and cuffs featured longer shirt tails that stayed tucked in during athletic activity. These functional shirts were paired with flannel pants and shorts on the tennis court. White was still the only acceptable color for tennis wear.

UNDERWEAR AND INTIMATE APPAREL

Underwear

Men's underwear was revolutionized in the 1930s with the introduction of briefs by Jockey in 1934. The new brief was knitted from cotton, producing a tight fit and support for athletic activity. To promote their new product, Jockey hired athletes Babe Ruth, Ty Cobb, and Harold "Red" Grange to promote the athletic benefits of briefs over boxers. The desire for slim waist and athletic build also led some manufacturers to add "tummy control" panels to their briefs (Blum 1986, 111). Men's underwear was further revolutionized (or scandalized) when movie star Clark Gable removed his shirt in the film *It Happened One Night* (1934) to reveal

Other Garments

The increase in informality and sporting activities also increased the demand for short jackets. Leather and wool waist-length jackets with zipper fronts were popular for casual events. Both leather and wool jackets featured shoulder yokes, welt pockets, either fitted waistbands or adjustable tabs, and either snaps or buttons on the sleeves. Some jackets had knitted waistbands and cuffs. Parkas with hoods and lumberjack or mackinaw jackets were also worn.

SWIMWEAR AND SPORTSWEAR

Swimwear

Swimming continued to increase in popularity throughout the 1930s because of the continued emphasis on health and the preference for males to have an athletic build. Swimsuits were still predominantly knitted from wool jersey but also incorporated elastic for a more supportive fit. Swim trunks, worn either alone or with a tank-style top or braces, were fitted high on the waist and around the leg openings, resembling the new Jockey briefs. Swim trunks featured belts, fly zippers, coin pockets, and internal athletic supporters. Topstitching and side racing stripes provided decorative elements on the trunks. Navy, blue, and black were popular color choices.

Golf

Although ski, swim, and tennis apparel became more specialized, golfers continued to wear everyday apparel on the golf course. Button-down shirts, ties, sweaters, sweater vests, and Norfolk jackets were paired with wide-leg trousers or shorts. Soft crown caps with visors completed the ensemble.

Skiwear

The increased popularity of skiing was spurred on by the 1932 Olympic Games held in Lake Placid, New York, and the opening of ski resorts, such as Sun Valley in Idaho, that attracted movie stars and socialites. The increased interest in skiing brought a new demand for specialty apparel for the sport. Wool sweaters were still a key component, but new wind-resistant and water-repellant jackets were available to provide warmth and protection. Jackets were either hip length or waist length, with wide collars and lapels, and either double breasted with buttons or with center front zippers. Belts or adjustable tabs were added to help fit the coat snuggly around the waist for additional warmth. Knickers, popular in the 1920s for skiing, were replaced by long pants gathered into knit ankle cuffs providing fuller coverage of the leg.

worn for casual sporting activities. Soft-collar button-down shirts were worn in both long- and short-sleeved styles. Cowboy or western shirts were new alternatives to more traditional button-down shirts and featured shoulder yokes and scalloped pocket flaps. Turtleneck, crew neck, and V-neck sweaters and sweater vests were popular, as were cardigans. Cardigan sweaters featured either wide shawl collars or were collarless.

Pants

Trousers for casual wear featured the same wide leg as business and dress trousers. Trousers typically featured pleat fronts, center-front leg creases, and cuffs, with a wide waistband that sat above the natural waistline to emphasize the narrow waist.

Zippers replaced buttons on the pant fly. Knickers were replaced by walking shorts similar to those worn by the British military, paired with knee-high socks.

Decorative Details

Large-scale geometric patterns, checks, stripes, and plaids were popular for pants, shirts, jackets, and sweaters. Unlike business suits, jackets, vests, and pants for casual wear were rarely all made from the same fabric. Knit polo shirts and western shirts came in bright colors. Polo shirts, T-shirts, and Henleys featured contrast rib knit trim on the neck and sleeve cuff. Cardigan sweaters more commonly featured center front zipper closures than button closures, and often incorporated zip closure pockets. Sweaters featured wide multicolored horizontal stripes across the chest.

OUTERWEAR

Coats

Polo coats, popularized by the British polo team in the 1920s, continued to be fashionable throughout the 1930s. The tan camel's hair polo coats were slightly broader across the chest and shoulders than in the previous decade but were still double breasted, with either a belt or half-belt. Chesterfields and Ulsters in solid wool melton, plaid, tweed, or herringbone were popular and now featured zip-in wool linings. Double-breasted styles were more popular in the first half of the decade, whereas single-breasted styles were more common in the closing years of the 1930s. Navy blue English guard's coats with wide collars and lapels, inverted center back pleat, and half-belt, and water-repellent trench coats with zip-in liners were new additions to men's outerwear. Dark greens, browns, grays, and navys were the dominant color palette for men's outerwear.

Shirts

Button-down cotton shirts in white, cream, or colored pinstripes were worn under business suits. Shirts featured spread collars with pointed tips to accommodate large Windsor knots in neckties.

Pants

Trousers had wide legs with cuffs and pressed center front creases. Zippers replaced buttons on the pant fly. Waistbands sat above the natural waistline with tab closures.

Decorative Details

Worsted wools and gabardines in solid navy, brown, and gray as well as checks, plaids, and stripes were used for business suits. Decorative details were limited to welt pockets, shoulder yokes, and half-belts on jackets and cuffs on pants.

CASUAL WEAR

Silhouette

The popularity of sports, such as tennis, skiing, football, and swimming, meant that the ideal silhouette for menswear in the 1930s was athletic, featuring broad shoulders and chest with a narrow waist and hips. The increased informality in society, combined with a decrease in disposable income, also meant that casual wear now bore less resemblance to business attire and more to athletic or sporting attire.

Jackets

Jackets were no longer a necessity for casual wear and were often replaced by cardigans, sweaters, or sweater vests. The Norfolk jacket and the bush jacket, both introduced by the Prince of Wales, were the two most common types of casual jackets. The Norfolk jacket was waist length, with a belted waistband, front and back shoulder yokes, large patch pockets with flap closures, and extensive topstitching. The bush jacket, popularized by the Prince's trip to Africa in the 1930s, was similar to the Norfolk jacket but featured short sleeves and was made from cotton rather than wool. Other hip-length single-breasted jackets were also worn, featuring half-belts, waist belts, shoulder yokes, or inverted pleats. Vests in matching or contrasting fabric were still occasionally worn with jackets.

Shirts

Knit polo shirts popularized by tennis-star-turned-fashion-designer René Lacoste were very popular for casual wear. Henleys and T-shirts were also

discontinued. Standard spread collars and button-down collars were the norm. Some men opted for wingtip collars for formal events in the last years of the decade. Shirt studs were worn by some men for very formal events.

Pants

Pants worn with tuxedo and dinner jackets were full cut through the legs and hips, displayed a center front crease and braids on the outseam, and ended in a cuff. The fly zipper replaced buttons. Waistlines were narrow and accented with wide waistbands with tab front closures.

Decorative Details

Formalwear was typically black or midnight blue, except for dinner jackets, which were typically white. Braids on the outseams of pants were the extent of surface decoration.

BUSINESS WEAR

Silhouette

The three-piece suit was the standard wardrobe for businessmen in the 1930s. All three pieces, jacket, trousers, and vest, were constructed from the same fabric. Over the course of the decade, the preference for an athletic build manifested itself in broader-shouldered suits with narrow waists and hips creating a V silhouette. The archetype of this silhouette was dubbed the English drape suit, so called because, when the jacket was closed, the fabric from the shoulders crossed the chest with soft drapes flowing downward to the button stance just about the natural waistline. Balancing out the broad shoulders of the suit were full-cut, wide trouser legs.

Jackets and Vests

Over the course of the decade, jackets continued to grower broader across the shoulders and chest, emphasizing an athletic build. Jacket collars and lapels lengthened and narrowed slightly compared with the previous decades. Single-breasted styles with one- or two-button closures were more common and aligned with the prevailing English drape suit silhouette. Jackets also featured darts for shaping the narrow waist, welt pockets with or without flaps, and half-belts. Vests were still worn as a standard component of business suits. Vests were fitted, either single or double breasted, and without lapels.

from dust and inclement weather. The popularity of smoking for both men and women meant that men always carried cigarette cases and lighters.

1930s,

THE GREAT DEPRESSION

FORMALWEAR

Silhouette

The increased informality in society, brought on by the stock market crash of 1929 and the Great Depression, resulted in fewer formal or even semi-formal events in America. For events and special occasions, men now often wore their best suit or rented a tuxedo rather than purchasing it. Men's fashions, always slow to change, showed small differences in overall silhouette and form from before the stock market crash until after WWII. For those who could afford new formalwear, the overall silhouette in men's jackets continued to broaden across the shoulders, pants remained full through the hips and legs, and the waist was narrow.

Jackets and Vests

Double-breasted tuxedo jackets with either notched or rolled (shawl) lapels faced in silk were preferred to single-breasted tuxedo jackets. Lapels, whether notched or shawl, were wide and longer than in the 1920s. Double-breasted jackets featured six buttons, four of which were functional, whereas single-breasted jackets featured only one or two buttons compared with three in the previous decade. Single-breasted dinner jackets, especially white dinner jackets for summer, with shawl lapels and a single button, were equally as popular as tuxedos for formal events. Tail-coats made resurgence in popularity thanks to films by Fred Astaire and Ginger Rogers that depicted glamorous couples sipping champagne and waltzing untouched by the economic despair gripping the majority of the country. Waistcoats or vests were worn for formal occasions but, perhaps in an attempt to decrease overall costs, were transformed from full vests to halter-style, backless vests. Additionally, men began to substitute cummerbunds, a wide, pleated waist sash, for vests.

Shirts

White shirts were the standard accompaniment to tuxedos and dinner jackets. Shirts were slim fitting with soft collars (detachable collars were no longer worn) and long fitted sleeves. The practice of pinning collar points underneath the tie knot that had dominated the 1920s was

FOOTWEAR AND LEGWEAR

Footwear

Oxfords and wingtip shoes replaced the high-button boots or spats of the previous eras. Both oxfords and wingtips featured either pointed or squared toes and either perforated or embossed designs. Brown, tan, and black leather were the most common colors, although white or two-toned shoes were worn in summer. High-top canvas "sporting" shoes with rubber soles became available for athletic wear.

Legwear

Socks were highly patterned and colored in the 1920s, especially those worn with knickers or plus fours. Argyles, chevrons, diamonds, and stripes were common patterns.

NECKWEAR AND OTHER ACCESSORIES

Neckwear

The four-in-hand tie was the most popular neckwear style in the 1920s. Ties were shorter in length, ending well above the waistline (because they were worn under vests or waistcoats), and either wide, ending in a point, or straight and narrow with a straight hem. Bow ties and ascots were both alternatives to neckties, especially for formalwear. Neckties, bow ties, and ascots were all available in a wide range of colors, including blue, lavender, red, purple, and green, and in a range of floral and geometric prints. Horizontal and diagonal stripes and polka dots were also popular patterns. Neckwear also provided the perfect canvas for patterns: Egyptian patterns inspired by the discovery of King Tut's tomb, ethnic motifs drawn from costumes in the Ballet Russe, and curve-linear art deco patterns.

Jewelry

Men wore limited jewelry during the 1920s. Wrist watches, tiepins, and cuff links were worn as a normal component of daily wear, whereas matching sets of tiepins, shirt studs, and cuff links were worn for formal occasions. Some men also wore rings.

Other Accessories

Some men carried canes or walking sticks when dressed for business or formal activities. Handkerchiefs, pocket squares, and scarves were also accompaniments to business and formal attire. The new sport of motoring also required driving gloves and goggles to be donned to protect the wearer

Sleepwear

Full-length nightshirts were still worn in early part of the 1920s. Nightshirts featured long center front-button plackets and long sleeves. Pajamas replaced nightshirts by the middle of the decade. Pajamas featured long button-down shirts paired with matching trousers. Some pajama tops were either collarless or featured soft collars, and many featured a belt or sash. Men's pajamas, in keeping with the fascination with oriental styles, also incorporated kimono sleeves, band collars, asymmetrical frog closures, and oriental patterns. Kimono robes were also popular. Nightshirts, pajamas, and robes were fabricated from cotton, flannel, silk, and rayon in plain white, solid colors, stripes, and geometric or oriental prints.

HEADWEAR, HAIRSTYLES, AND COSMETICS

Headwear

Men wore a range of felted bowlers, fedoras, derbies, and homburgs for business and formal occasions. Hats were in basic tans, browns, blacks, and grays and featured grosgrain ribbon hat bands, typically in black or dark brown. Straw boaters and Panama hats in tan or white were worn for summer business attire and casual activities, whereas tweed, plaid, and striped wool tams or soft crown caps with small visors were for golfing, riding, skiing, and other sporting activities.

Hairstyles

The cinema star Rudolph Valentino was the epitome of men's fashions and hair styling in the 1920s. His short cropped hair was plastered tight to his head with pomade, as if his hair was a hard helmet. Adaptations of his signature style were either center parted, side parted, or combed straight back. Although men were predominantly clean shaven throughout the decade, some men did sport a pencil-thin mustache.

Cosmetics

Fashionable men in the 1920s styled their hair with pomades, hair creams, and tonics to create sculpted, smooth styles.

Rudolph Valentino. [Library of Congress]

jackets or rib knit cardigan or shawl-collar sweaters. Norfolk jackets, also popularized by the Duke of Windsor, featured waist seams with belts or tab closures, front and back shoulder yokes, large patch pockets with flap closures, and extensive topstitching. Soft-collar button-down shirts were worn under jackets and sweaters. Soft crown golf caps or tams with small visors completed the ensemble. Brown, olive, and gray tweeds were the most common fabrications.

Skiwear
Skiing, another extremely popular sport in the 1920s, co-opted golf clothing to combine warmth and functionality on the slopes. Knickers or plus fours, heavy cardigans, turtle necks and shawl-collar sweaters, and Norfolk jackets were donned for the ski slopes as well as the golf course.

Other Activewear
Tennis, popularized by René Lacoste's (nicknamed "Le Crocodile") string of victories in the mid to late 1920s, also produced a need for functional apparel. In the early part of the 1920s, standard soft-collar, button-down shirts were worn with flannel trousers by most men playing tennis. Lacoste popularized an alternative shirt (later dubbed the polo shirt), fabricated from lightweight cotton knit with short sleeves and rib knit collar, that was not only cooler but provided stretch for ease of movement. White was considered the only acceptable color on the tennis court.

The 1924 Olympics held in Paris, France, help to popularize all forms of sports and athletics. The interest in sports and athletics during the 1920s also witnessed increased popularity in riding, hunting, and hiking because of the growth of the middle class with increased funds to spend on leisure pursuits. All three sports also co-opted versions of the golf ensemble. However, riding pants were more fitted through the hips than golf knickers, and riding ensembles were paired with tall boots rather than the oxford shoes worn for golfing.

Underwear and Intimate Apparel

Underwear
One-piece union suits with short or long sleeves and short or long legs were common throughout the first part of the 1920s. As the decade progressed, knee-length drawers paired with sleeveless undershirts replaced the one-piece union suits. Drawers featured a button fly, and the undershirts were sleeveless and were either pullovers or featured button fronts. Both wovens and knits were used to fabricate men's underwear.

team played exhibition matches in the United States (Tortora and Eubank 2005, 399). Polo coats were made from tan camel's hair and were double breasted with six buttons and a half-belt across the back. Fashionable collegiate young men also donned the ubiquitous raccoon coats.

Other Garments

Long dusters in cotton canvas, either single or double breasted, were a must for "motoring" to protect a man's suit from the dust and inclement weather encountered in open-air vehicles on dirt roads. Leather jackets lined with lamb's wool were worn for casual activities, whereas fishermen's gear and rubber coats were adopted as raincoats.

SWIMWEAR AND SPORTSWEAR

Swimwear

The 1920s witnessed an increase in the sport of swimming, spurred on by Gertrude Ederle's record-breaking swim across the English Channel and a preference for healthy-looking, sun-tanned skin as a status symbol of wealth and leisure. As a result, men's swimwear continued to diminish in size and increase in functionality.

Both one-piece and two-piece styles were available in lightweight wool jersey knit. Suits featured either one-piece construction with trunks and tank knit as one unit with buttons across the shoulder, or two-piece construction with separate tank and trunks. Tanks on two-piece designs were either worn long, with a slightly flared hemline, on the outside of the trunks or more fitted and tucked into the trunks. As the decade progressed, the tank became smaller in scale or was replaced by only shoulder straps. Both one- and two-piece designs featured horizontal stripes across the chest and tank hem and contrast trim around the armholes, both typically in red or white. Gray, navy, red, and black were standard colors for swimwear.

Golf

The Prince of Wales (also known as the Duke of Windsor after he abdicated the throne) was a sports enthusiast and fashion leader during the 1920s. The baggy, full-cut knickers he was depicted wearing during golf outings, dubbed plus fours because they draped four inches below the knees, became a key component of the quintessential golf ensemble worn by men on the course. Knickers and plus fours either buttoned at the knee or were gathered into knit bands and were paired with fitted Norfolk

shirts. Crew neck and shawl collar pullover sweaters and cardigan sweaters with shawl collars in heavy rib and shaker knits were preferred to jackets.

Pants

Knickers are probably one of the garments most synonymous with men's casual wear from the 1920s. Knickers (originally called knickerbockers), previously only worn by young boys, were adopted by men as emblematic of the youth movement sweeping America. Knickers came in two distinct forms: oxford bags and plus fours. Plus fours were originally popularized by the Prince of Wales (known as the Duke of Windsor after his abdication of the throne) for golfing and athletic activities. Oxford bags were a more extreme version of plus fours, up to thirty-two inches in diameter, that are believed to have originated at Oxford College (Tortora and Eubank 2005, 396). The style was so named because the pants were four inches longer than the more traditional knickers. Knickers in any form, although popular with college students, were deemed inappropriate by college faculty. The ban on knickers reportedly enticed some students to wear extremely wide-legged trousers over their knickers so that, after class, they could drop their trousers and be instantly ready for social activities. Whether this long-held story has any basis in reality, the fact remains that when not wearing knickers, wide-leg trousers were the preferred pant form for casual events.

Decorative Details

Casual wear was not only a departure from traditional dress in form, but it was also a departure in color and pattern. Knickers, trousers, jackets, and vests were all fabricated separately, mixing and matching solids and patterns so that no two pieces ever matched. Bold colors, such as maroon, orange, gold, and navy, and patterns, such as checks, stripes, and plaids, were combined together for eclectic sporty, collegiate looks.

OUTERWEAR

Coats

Traditional Chesterfields in wool melton with velvet collars and Ulsters were worn for business wear and formalwear. Both featured single-breasted, fly-front button-down closures with either set-in or raglan sleeves and often sported belts or half-belts across the back. Chesterfields and Ulsters were available in plaids, stripes, tweeds, and herringbones. More fashion-forward men and young men preferred polo coats to Chesterfields and Ulsters. Polo coats became popular after the British polo

Decorative Details

The components of business suits were always fabricated from the same cloth, creating matching jackets, trousers, and vests or waistcoats. Colors were subdued browns, tans, and grays in tweeds and herringbones. As the decade progressed plaids, checks, and both pinstripes and chalk stripes became more popular than tweeds and herringbones. White replaced dark colors for summer suits in linen or flannel for those who could afford seasonal wardrobes as depicted in F. Scott Fitzgerald's *The Great Gatsby*. Decorative elements were minimal in men's suiting and were typically limited to welt pockets, half-belts, and shoulder yokes. Solid cotton shirts in white or cream were standard for most conservative businessmen. However, a range of stripes, checks, and geometric patterns were also popular in lavender, pink, and blue rayon and silk fabrics.

CASUAL WEAR

Silhouette

In the 1920s, radio, movies, telephones, airplanes, and automobiles made the world a smaller place, and jazz music gave American society a rhythm. Society became more health conscious and participated in numerous sports such as football, swimming, tennis, and skiing. The youth movement replaced courtship with dating, taking young couples out of the family parlor and into a movie theater, speakeasy, or motoring excursion. Increasing numbers of both men and women moved away from home to attend college. These factors, combined together, brought the demand for a new sporting wear (later dubbed "sportswear") that could be worn for informal gatherings and athletic activity (Blum 1981, 3). The need for comfort and functionality demanded a departure from the traditional forms of clothing previously worn by the middle and upper classes.

Jackets

The Norfolk jacket was worn for casual activities in the 1920s. Norfolk jackets featured many structural details such as belts, shoulder yokes, inset panels, and large patch pockets compared with business wear and formalwear jackets. Norfolk jackets were worn over vests or, more typically, sweater vests, by many college students, thus dubbing the look the "collegiate style."

Shirts

Jackets were no longer a mandatory component of men's casual wear. Sweaters and cardigans became substitutes for jackets in the 1920s, whereas turtlenecks and polo shirts became substitutes for button-down

and morning coats men wore for business attire in previous decades but still were impeccably tailored, and, when finances allowed, English tailored suits were considered the best. The resulting silhouette for jackets was slim fitting in the early part of the decade and using waist seams and darts to create shaping, and became more relaxed and boxy as the decade progressed. Business trousers followed the same gradual shift as men's jackets, fitting close with tapered legs in the early part of the decade and trending toward fuller cuts with wide legs by mid-decade. Three-piece suits consisting of jacket, trousers, and vest or waistcoat were worn by all businessmen.

Jackets and Vests

Suit jackets were slim fitting, featuring either waist seams or darts to provide soft shaping and center back vents. As the decade progressed, the fit began to relax and broaden, moving away from the natural shoulder line. Single-breasted, three-button styles prevailed over double-breasted styles. Collars and notched lapels were short and wide, ending in a high stance below the chest for most of the decade. By the end of the 1920s, collars and lapels both began to narrow and lengthen. Welt breast and hip pockets were either set in at an angle or straight. Some jackets featured elements commonly found in Norfolk jackets, such as back shoulder yokes with or without inverted pleats and waist belts or half-belts. Vests or waistcoats were single breasted, very fitted, closing high on the chest above the suit jacket closure, with five buttons. Vests or waistcoats for business suits rarely sported lapels.

Shirts

The early years of the 1920s saw a continuation of shirts with detachable collars. However, because of improvements in manufacturing as well as an increase in the use and quality of home washing machines, "hard" detachable collars were replaced by "soft" attached collared shirts. Shirts were slim fitting with straight fitted sleeves and French cuffs. Soft collars were pointed and typically pinned together under the tie with a tiepin, tie bar, or self-fabric tab.

Pants

Trousers were slim fitting, with straight legs and cuffs in the early part of the 1920s. As the decade progressed, trousers for business suits grew wider and fuller cut, retained their cuffs, but did not reach the extremes seen in casual or collegiate styles.

ARROW
COLLARS and SHIRTS

BALTIC—a notch collar with ample space for cravat. Easy to put on or take off. Stays closed in front, yet permits the wearing of a large knot cravat. $1.50 a dozen

WHEN you buy an Arrow Shirt you know in advance that the color is fast, the style right, the garment well made, the fit perfect. $1.50 and $2.00

Send for booklets. CLUETT, PEABODY & COMPANY, Makers, River Street, TROY, N. Y.

One of the famous and distinctive Arrow shirt ads, created by J.C. Leyendecker, showing a handsome gentleman in a striped shirt, from about 1920. [Library of Congress]

Jackets and Vests

Morning jackets and tail coats were worn only by older, wealthy men for very formal occasions. Tuxedo jackets and dinner jackets were now the standard components of formalwear. Tuxedos were typically double breasted, whereas dinner jackets were typically single breasted. Tuxedo jackets featured either rolled or notched lapels, faced in silk. Dinner jackets, a popular alternative for night clubs and society gatherings, typically featured shawl or rolled lapels and had a single-button closure. Single-breasted vests or waistcoats were still worn for more formal occasions under tuxedo, morning, and tail coats and featured rolled or shawl lapels.

Shirts

White shirts with starched fronts that closed with shirt studs were worn by older men for very formal occasions. White "soft front" cotton, rayon, or silk shirts were worn under tuxedo and dinner jackets by the trendy crowd.

Pants

Tuxedo pants and pants worn with dinner jackets were fuller cut, featuring wide legs with a braid on the outseam. Pants were typically cuffless.

Decorative Details

Midnight blue and black were the preferred colors for eveningwear. Tuxedo jackets, vests or waistcoats, and trousers were all cut from the same cloth. Dinner jackets were typically white, especially for summer outings, and were paired with black trousers. Bow ties were the preferred neckwear for eveningwear and formal events.

BUSINESS WEAR

Silhouette

The sack suit, seen as early as the 1840s, continued to serve as the basis for men's business attire. Sack suits were less structured than the frock coats

blue, gray, and brown. Bow ties were tied by the wearer. Although clip-on bow ties became available, they were not considered fashionable. Four-in-had ties tended to be wide, and, at the extreme, they were scarf-like. Regardless of the width, four-in-hand ties had pointed hems.

Jewelry

Before the 1910s, men had worn pocket watches attached to watch chains. With the rise in automobile driving and WWI, wristwatches became a popular, more convenient way to check the time. Tiepins, shirt studs, and cuff links continued to be widely used.

Other

Walking sticks fell out of favor as more people began using automobiles. Scarves, handkerchiefs, and leather gloves were common accessories. Gloves were closely fitted and fastened at the back of the wrist by a snap, a button, or two buttons.

1920s,

THE JAZZ AGE

FORMALWEAR

Silhouette

Prohibition changed the nature of social gatherings in the 1920s, although the increased prosperity of the 1920s meant that people could work less and socialize more. Whereas gentlemen in past eras attended formal receptions and balls in morning jackets and cut-away or tail coats, men in the 1920s attended society parties and went to speakeasies to drink and dance the blackbottom or the Charleston. Formal suits with top hats, tails, and fitted trousers were not congruent with the new youthful social scene. Tuxedo coats and dinner jackets paired with trousers and vests (or waistcoats) provided dashing alternatives to past conservative styles. Formalwear now had a relaxed fit with soft shirts rather than starched fronts to allow dancing all night.

TWYEFFORT, Inc.
580 5th AVENUE
NEW YORK

A man models his walking suit, c. mid-1920s. [Library of Congress]

Hairstyles

Generally, men wore their hair short and parted. Hair became shorter during WWI because military cuts were shorter and easier to care for on the battlefield. The frequency of beards and facial hair diminished during war partially because it interfered with gas masks, which were very important during a war that relied on attacking the enemy with mustard gas.

Cosmetics

Men used hair tonics and pomades to style their hair. They used shaving creams and aftershave tonics for their facial hair.

FOOTWEAR AND LEGWEAR

Footwear

During the 1910s, men typically wore leather lace-up shoes or boots for most day and evening occasions. Both shoes and boots had stacked heels. Black and brown were the most common colors, but the details varied. Both pointed and blunt tips were available. Most shoes and boots had some sort of decorated toecap, including wingtip toecaps. Topstitching along the toecap, heel, or apron was a common embellishment.

Sports required special sport shoes in either canvas or leather. They had rubber soles to help grip the playing surface, and they laced up. Some leather sport shoes had vents to cool the feet.

Slippers were another specialty shoe. These had not changed significantly from the previous decade. They were made from leather or silk and had cutaway sides. Usually, they had some kind of decorative trim.

Legwear

Men wore knee-length neutral-colored socks that were suspended from garters around a man's upper calf.

NECKWEAR AND OTHER ACCESSORIES

Neckwear

Collars and cuffs came attached to shirts and as detachable accessories. By using the detachable variety, men could wear the same shirt for several days and simply change out the collar and cuffs. Disposable collars were very stiff, and softer attached collars became the norm during WWI and after.

Bow ties and four-in-hand ties from the previous decade remained popular during the 1910s. Ties were made from silk, wool, or cotton, and they usually had patterns on colorful backgrounds like lilac, red, green,

sleeve, sleeveless, and coat cut, which was cut wider like a coat and buttoned up the front. Drawers came in ankle length or knee length, and some companies developed special varieties for especially tall or stout customers. Many men continued to wear union suits, which combined the undershirt and drawers together. Union suits came in a variety of sleeve and leg lengths as well.

Sleepwear

Some men continued to wear loose-fitting, long nightgowns to bed, but pajamas were becoming more popular. Pajama coats resembled loose-fitting shirts with full sleeves that gathered into cuffs. Short-sleeve versions were also available. Typically, they had a soft notched collar and buttons down the center front. Pajama pants were loose fitting and straight legged. They were secured with a drawstring or elastic.

Other garments

Men continued to wear smoking jackets when they were relaxing. They would change into these boxy sack jackets after they returned home. Typically, these jackets would have a quilted shawl collar and a simple sash or cord belt to close the jacket. Dark red was a popular color for this style of jacket.

Bathing and lounging robes were worn. These robes were long with shawl collars and a sash or belt closure.

HEADWEAR, HAIRSTYLES, AND COSMETICS

Headwear

Many of the hats men wore during the 1910s were similar to those in the previous decade, but some styles, such as the derby, became less common. Typical hats were gray, black, brown, or olive green and were made from felt or fur felt, which had a nap to it. They had soft crowns, which were creased, flat, or rounded. Brims were generally narrow and upturned at the sides, although straight brims and brims that were upturned on all sides were available too. During the summer, straw boater hats remained fashionable. Hatbands were usually made of silk or petersham ribbon and matched the color of the hat.

Caps remained popular for casual occasions and active sports. They consisted of a soft, full crown and a brim over the eyes. Sometimes caps were made from eight crown sections stitched together and decorated with ventilation holes and a cloth-covered button at the top.

sleeveless and had round or V necklines. The typical silhouette featured a long, hip-length tunic over body-hugging shorts. A new silhouette was emerging; it featured a shorter tunic tucked into shorts that had a contrasting colored belt with a buckle. Most suits were dark colors such as navy blue, black, red, green, and royal blue. Popular suits were trimmed with bands of white around the armholes, neckline, at the end of the tunic, and sometimes across the chest.

Golf
Men wore a variety of casual clothing when playing golf. Some men wore knickers, whereas others wore long flannel pants. Typically they wore soft-collared shirts and a casual jacket. Sack-style sports jackets and Norfolk jackets were common.

Tennis
When playing tennis, men would wear plain white shirts with the sleeves rolled to the elbow. White pants made from durable cotton fabrics such as duck, cotton, and flannel were worn. They were roomy in the hip and thigh and tapered to the cuff. Many men wore neckties while playing tennis. They wore low, flat shoes, which were usually made of canvas and had rubber soles.

Other Activewear
As automobiles increased in popularity, so did automobile dusters, the long linen or cotton overcoats used to keep men's garments clean. They were either single or double breasted and extended to the mid-calf. They had turn-over collars and slash pockets at the hips.

Motorcycling also required special garments. A close-fitting, belted jacket with a high standing collar was paired with full-cut breeches that laced below the knee and gaiters that protected the calves.

Hunting and outdoor sports usually required durable suits made from khaki material that did not show dust and dirt. Norfolk and sack jackets were commonly worn, as were jackets with high military collars. Pants were cuffed and cut full in the hips and tighter on the leg.

UNDERWEAR AND INTIMATE APPAREL

Undergarments
Men wore undershirts and drawers, which is what underpants were called. These undergarments were typically made from cotton, linen, silk, or wool. Undershirts came in a variety of styles, including long sleeve, short

elbow-length sleeves and a shawl collar that buttoned close to the neck. It was not worn with necktie. This style was sometimes called an outing shirt.

Pants

Men wore either long pants or knee pants for casual activities. Long pants followed the fashionable silhouette and had a full-cut hip that tapered to narrow legs. They were worn either creased or uncreased, and they were usually cuffed. Some styles included buttons to keep the cuffs upturned.

Knee pants, or knickers as they were often called, were cut full in the hip and narrow along the leg. They ended just below the knee, and the bottoms were held in place with a drawstring, a button, or a buckle. They were worn with dark stockings and high shoes. Sturdier fabrics were widely used for casual pants. Serge, flannel, twills, and duck were popular.

Sweaters

Pullover and cardigan sweaters were commonly worn as part of casual and active wear. Brooks Brothers had popularized an American version of the Shetland sweater, and roll neck sweaters, which resembled turtleneck sweaters, were popular for athletic pursuits.

OUTER WEAR

Coats

Burberry trench coats were immensely popular during the 1910s. Thomas Burberry had developed a wrinkle-resistant, waterproof gabardine and fashioned it into a trench coat that was used by the military during WWI. It quickly became popular among consumers. This loose-fitting, belted coat had a notched convertible collar and straps at the ends of the sleeves that could be cinched to keep out the elements. The coat was lined with Burberry's trademarked tan, red, and black plaid.

There were a variety of coats available to men during the 1910s. Wool top coats with raglan sleeves and long camel hair polo coats were popular. Men also wore coats with capes over the shoulders called Inverness coats.

SWIMWEAR AND SPORTSWEAR

Swimwear

Men's swimwear covered the chest and extended to the mid-calf. One-piece and two-piece versions were available. Typically, the suits were knitted from cotton, wool, or a combination of the two. By the 1910s, suits were

close fitting in the torso and flared out from the waist. It had a military-style band collar and four large patch pockets with flaps. The hat had a wide brim, and the crown was depressed on four sides of the crown. During battle, they wore helmets with brims and low crowns.

CASUAL WEAR

Silhouette
The silhouette for casual wear was similar to the one for other men's garments during this decade. Both the waist and legs were close fitting, creating a lean, tall silhouette.

Jackets
The most popular jacket for casual wear was the single-breasted sack coat. Typically, it had a three-button closure, patch pockets, and a notched collar. It was available in a variety of fabrics, including wool serge, flannel, corduroy, and linen. Military-inspired jackets were also fashionable. These had high standing collars and were sometimes belted. Norfolk jackets were popular as well. Fashionable jacket colors included navy blue, tan, brown tweed, and black.

Shirts
Men usually wore a soft-collared shirt and necktie for casual wear. A new, more relaxed shirt became popular for active endeavors. This shirt had

Men sport the new "soft collar" shirt. [Library of Congress]

Business Wear

Silhouette

The ideal silhouette for businessmen in the 1910s was slim and athletic. The shoulders and chest tapered into a fitted waist, and the pant legs were cut narrowly.

Jackets and Vest

As the silhouette narrowed, the shoulders of jackets became less padded. The sack jacket, also known as the lounge jacket, became the norm. The jacket became more fitted and ended just below the hip. During WWI, jackets gradually shortened.

Single-breasted jackets had three buttons, and double-breasted jackets had six. Most jackets had a notched lapel collar. The narrow cut of the coat necessitated a vent that was placed at the center back. Most jackets had three small buttons at the end of each sleeve, slit pockets at the hips, and a handkerchief tucked into the breast pocket.

Vests generally matched the suit, were high cut, and had a narrow notched collar or no lapels.

Shirts

Shirts came with either detachable or attached collars. The fashionable style was a high collar with rounded edges. Some shirts came with detachable, soft French cuffs that allowed the wearer to reverse them to hide stains. Generally, shirts were white, striped, or colored.

Pants

Fashionable pants were peg-top pants. They were loose fitting in the hip and narrow in the legs. Most pants were creased and cuffed. Although wristwatches were becoming popular, most pants came with a watch pocket.

Decorative Details

Most business suits were made of wool serge. Dark blue was a very popular color, but pinstripes, checks, and other dark colors were fashionable as well. In the summer, lighter colors and lighter fabrics were marketed. Men who could afford several suits often had summer suits made of lightweight flannel and linen.

Military Uniforms

During WWI, American soldiers wore an olive drab uniform consisting of a tunic-style jacket, trousers, shirt, hat, and leggings. The tunic was

Jewelry

Men's jewelry tended to be limited. Watches were worn on watch chains, as wristwatches would not become popular until the next decade. Tiepins held down neckties, shirt studs took the place of buttons, and cuff links secured cuffs. Some men wore rings.

Other

Common men's accessories included gloves and handkerchiefs. Walking sticks were popular gifts and were often made from luxurious materials.

THE
1910s

FORMAL WEAR

Silhouette

The silhouette continued its transformation from the thick, barrel-chested silhouette at the turn of the century to a svelte, athletic silhouette of the 1910s. Shoulder padding decreased, the waist became narrower, and the pants became peg topped.

Jackets and Vest

The dinner jacket and the formal suit were the most popular types of formalwear in the 1910s. The dinner jacket, also known as the tuxedo jacket, was commonly worn for all types of formal occasions. Its fit narrowed, and the waist was nipped in. The collar was faced with satin. Underneath the jacket, men wore a low-necked vest that exposed much of the shirt beneath.

The formal suit had a short-waisted jacket with tails. It retained the cut of the previous decade. A black or white low-necked vest was worn beneath the jacket.

Shirts

White shirts were worn with formal suits. Typically, they had stiff fronts that were exposed through the vest. Sometimes the front of the shirt was pleated.

Pants

The black pants worn with formal suits followed the fashionable cut of the decade. They fit loose in the hips and tapered to narrow legs. The hem ended slightly above the top of the shoe.

Cosmetics

Men used pomades and hair tonics to style their hair. They also used aftershaves.

FOOTWEAR AND LEGWEAR

Footwear

Men's footwear during the 1900s generally falls into five categories: lace-up shoes, boots, sport shoes, house slippers, and evening shoes. Leather lace-up shoes were most commonly used with daywear and business wear. They would have blunt or pointed toes and stacked heels, and sometimes they featured toecaps. Brogue edges were a common decoration on this type of shoe.

Many men favored high-cut sturdy leather boots. These usually featured button or lacing closures, but some had elasticized side gussets in place of a closure. Boots had low stacked heels that were similar to leather lace-up shoes. Some boots had toecaps or contrasting uppers.

The other types of shoes were specialty shoes. Typically, sport shoes were made of canvas, had low heels, and had texturized rubber soles. House slippers were made from leather and fabric that was more colorful than the neutral colors used for everyday shoes. They often had pointed toes, and stitched or embroidered decorations were common. Evening shoes were black patent leather with pointed toes, ribbon laces, and low stacked heels. Cloth spats were worn over the shoes to protect them. They had a side button closure and a buckle that fastened under the foot.

Legwear

Men's legwear consisted of neutral-colored stockings held up with elastic garters that wrapped around the upper calf. The tops of the stockings were ribbed and sometimes patterned with stripes.

NECKWEAR AND OTHER ACCESSORIES

Neckwear

Men's ensembles were not complete without neckwear. For the daytime, a four-in-hand in white or patterned silk was appropriate for most suits. A four-in-hand was much like the modern necktie, but wider and with a large knot. Sometimes an elastic extension was included on the band to ease its restrictive quality. Small bow ties were common and came in a variety of solids and patterns. Formal eveningwear required a black bow tie. As the decade continued, narrower silk or wool neckties were another option.

Other garments

Some men wore lounging or bathing robes made from terry cloth. These ankle-length robes had long, full sleeves, a fold-over collar, and a cord sash.

Smoking jackets were also popular. Men changed into these boxy, easy-fitting jackets after they returned home from work. They were worn over a shirt and tie, and typically they had a shawl collar, full sleeves with cuffs, and patch pockets.

HEADWEAR, HAIRSTYLES, AND COSMETICS

Headwear

Men rarely went anywhere without a hat. In 1901, no self-respecting man would be without a Panama hat, which had a shallow crown with a crease pressed into it, a soft brim turned up in the back, and a ribbon band with a flat bow. There were a wide variety of popular hat styles, and they were made from materials such as fur, felt, silk, straw, and wool.

The homburg was a felt hat with a soft creased crown and a narrow stiffened brim that was turned up at the edge. The black silk top hat was required for formal occasions. It had a high cylindrical crown, a ribbon band, and a brim that curled up on the sides. In the summer, most men wore straw boaters, which helped keep them cool. Boaters had low, hard, flat-topped crowns, narrow, straight brims, and a ribbon band and bow. Bowlers were made of felt, had a hard rounded crown, and had a narrow brim that curved at the sides.

Caps were worn for more active occasions. For boating, men wore a blue cloth cap with a leather visor. It was trimmed with a gold braid attached by two gold buttons. A less constructed form of cap in wool tweed was used for most outdoor activities. In the winter, tweed caps sometimes had earflaps that were pulled up and fastened on the top of the crown when they were not in use.

Hairstyles

Typically, hair was kept short and parted in the center or on the side. Some men wore their hair in a pompadour, lifting the front and top up high. Other men would brush a thick mass over one eye. Until about 1904, most men were clean shaven because many doctors recommended the practice for hygienic reasons. From 1904 to WWI, more men began growing facial hair. Pointed goatees and mustaches were the most common forms of facial hair.

A motoring costume, c. 1903. [Library of Congress]

Other Activewear

Horseback riding, hiking, and hunting required similar outfits. Men wore mixed tweed suits with knee breeches. When yachting, men would wear a double-breasted sack coat and a yachting cap. This ensemble was often mandated by yachting clubs.

UNDERWEAR AND INTIMATE APPAREL

Undergarments

Most of men's underwear was made of wool or cotton, but some brands offered silk and linen varieties. Their underwear varied depending on the season. In the summer, they wore short-legged union suits in lightweight fabrics. In the winter, they changed to long-legged union suits. Advertisements during this period touted the health value of different brands of underwear. Companies proclaimed their underwear would reduce contact with germs and would eliminate perspiration. Breathable fabrics were prized during the summer months.

Sleepwear

Men usually slept in long nightgowns or pajama suits consisting of a pajama coat and pants. The coat was a long- or short-sleeve shirt that usually buttoned up the front.

contrasting fabric was usually velvet. The sleeves were straight and without cuffs. Slit pockets were placed at the hips.

Other fashionable outer garments included the Inverness coat and Macintosh. The Inverness coat had a wrist-length cape over the coat to keep the wearer warm. The Macintosh was the name given to raincoats. The name comes from Charles Macintosh, who patented a process for making waterproof fabric by coating one side of the cloth with rubber and affixing another piece of cloth to the tacky side of the rubber. His technique was so popular that all raincoats, regardless of how they were made waterproof, were referred to as Macintoshes.

SWIMWEAR AND SPORTSWEAR

Swimwear

Men typically wore one-piece, knit jersey trunks. They had round necklines and short sleeves, although some versions were sleeveless. The shorts of the costume extended to the mid-thigh. This style of suit was either solid colored or striped. Another style consisted of a pair of knit shorts with a long knit tunic over the top. This style was available in round and V necklines and had either short sleeves or was sleeveless.

Golf

Whereas some golfers wore knickers, others wore white striped flannels with cuffs. Flannel jackets or sack jackets were worn with a sweater or madras shirt underneath.

Tennis

Typically, men wore plain white shirts and white flannel or duck trousers on the tennis court. They rolled up their shirt sleeves to their elbows. Some men wore a combination shirt, which consisted of a shirt attached to a pair of underwear. This kept the shirt tucked in no matter how vigorous the player. They also wore white canvas athletic shoes with rubber soles.

Five men, including John D. Rockefeller at the far left, wear sports attire. [Library of Congress]

frock coat and silk top hat. When Prince Edward of Wales showed up to a race wearing a lounge suit, he singlehandedly and swiftly transformed the appropriate men's dress for that type of social event. Soon men were seen wearing navy blue blazers, duck trousers, and boaters, which were all casual garments, at the races.

As men's dress relaxed, many more options became acceptable for everyday dress. White duck trousers worn with a black or blue serge jacket was seen as acceptable morning dress. The Norfolk jacket was primarily worn while traveling or in the country.

Shirts

In casual wear, shirts were exposed more than they were in business wear, in which they were covered by vests. Casual and athletic activities allowed men to shed their vests. Striped, dotted, and colored shirts were fashionable.

Pants

Typically, pants were made of wool serge, cotton duck, flannel, and linen. In the hip and seat area, they had extra room to allow easy movement.

Sweaters

Sweaters were popular casual garments in the 1900s. They were available in lightweight and heavyweight styles, and both pullover and cardigan styles were fashionable. Although most cardigans were single breasted, there were some double-breasted styles. Most cardigans had V necks, and high military collars were fashionable as well. Many cardigans had pockets at the front hips. A popular pullover style had a high roll neck. Knitted sleeveless vests were available also. Popular sweater colors included navy blue, black, oxford gray, olive brown, maroon, and dark green.

Decorative Details

During the summer, men would turn from suits made from wool to those made from homespun, serge, light tweeds, and flannels. Grays, blacks, and blues were the most fashionable choices.

OUTERWEAR

Coats

Chesterfields were a popular overcoat for men. The hem extended to the knee, and the skirt of the jacket flared out from the waist. The collar was typically adorned with a contrasting fabric. For evening coats, the

President Taft in a day suit. [Library of Congress]

Pants

Pants were cut full in the hip and seat, and they were worn both with and without creases down the front. For business wear, typically the pants matched the jacket.

Decorative Details

Generally, suits were made from dark-colored wool serge, and dark blue was an especially popular color. During the summer, suits were made from lightweight fabrics, including flannel, linen, and lightweight serge.

CASUAL WEAR

Silhouette

For informal social occasions, men typically wore a sports jacket, pants, and shirt. The jacket was a loose-fitting sack jacket that became more fitted later in the decade. The pants were straight legged.

Jackets

At the races, men wore tweed suits and bowler hats at the beginning of the century, unless royalty was expected. In that case, they wore a black

in the front and extended into "tails" that reached the knee in the back. A low-cut black or white vest was worn beneath the jacket. Tapered black peg-top pants were also worn. The dinner jacket or tuxedo suit, as it was informally called, had a black hip-length jacket, which had lapels that were faced with black satin. It was worn with a three-button, low-cut vest and black pants.

Shirts
Formal suits were worn with a plain or pleated white shirt and tie. The shirts usually had stiffened fronts. Black ties were often worn with dinner jackets.

Pants
The prevailing pant style was cut loose in the hip and close fitting in the leg.

Decorative Details
Formal suits were made from wool and worn with black patent leather shoes.

BUSINESS WEAR

Silhouette
The silhouette of men's business wear shifted over the course of the 1900s. Although the barrel-chested silhouette dominated at the turn of the century, it gradually changed to a more youthful look with a narrower waist and legs.

Jackets and Vest
Businessmen wore suits, whereas laborers wore sturdier pants and shirts. Jackets were cut long and buttoned high, and they had small lapels. Early in the decade, they were cut full through the torso and padded at the shoulders. Suit jackets were dark colored, whereas vests were light or colored.

Shirts
Shirts continued to be available with hard detatchable collars or soft attached collars. The height of collars gradually decreased. White and colored shirts were fashionable, and many men wore shirts patterned with dots or stripes.

wear. At the same time, fashions in formalwear became stagnant. Other than slight modifications in silhouette, the dinner jacket and tuxedo jacket remained constant styles.

Athleticism became a desirable trait in men, and sports became a popular way to spend leisure time. The variety of sportswear increased, and it progressively became more oriented to performance. Innovations such as knit shirts, waterproof and windproof ski clothes, and raglan sleeves enhanced men's performance in a range of sports, including swimming, golf, and tennis.

A greater emphasis was placed on the comfort and functionality of men's clothing. The starched shirts and hard collars of the first decade of the century gave way to knit shirts and soft collars. For casual occasions, sweaters were worn instead of jackets. Over the course of this period, the silhouette of men's clothing became looser and fuller, and it enhanced an athletic physique. By the 1940s, men no longer wore garters to hold up socks or suspenders to hold up their pants. Even underwear had been made more comfortable, with breathable fabrics and less restrictive construction.

THE
1900s

Men's wear was far slower to transition to new silhouettes and cuts than women's wear during the 1900s.

FORMAL WEAR

Silhouette

During the 1900s, the men's silhouette gradually became more fitted. Jackets moved from a barrel silhouette to one with a closer-fitting waist and less-exaggerated shoulder padding. Pants became narrower in the leg.

Jackets and Vest

There were three main types of formal suits for men during the first decade of the twentieth century. The Prince Albert suit was a style that had endured from the previous century. It featured a doubled-breasted, knee-length black jacket that was fitted at the waist and flared out at the hem. Beneath the jacket, men would wear a five-button single-breasted vest with a notched collar. The pants were cut full at the waist and more narrowly in the leg. They were usually patterned.

Two more modern styles gained popularity and acceptance during this period. The full dress suit featured a black jacket that was cut to the waist

8

Men's Fashions

The shifts in men's fashions were not as dramatic as women's and children's during the period from 1900 to 1949. There were slight silhouette changes each decade, but many of the popular styles, such as the trench coat, the sack coat, and evening jacket, endured essentially unchanged for most of the period. Even the fabrics and patterns used to create suits and coats remained in fashion decade after decade.

The two world wars during this period influenced men's fashion. They popularized military styles, especially in outerwear. The trench coat emerged from WWI as a favorite of soldiers and civilians alike. The navy pea coat and Eisenhower jacket were styles that were used by the military during WWII and gained popularity among both male and female civilians.

Rationing during the wars had an effect on men's fashion as well. Restrictions on the fabric used in garments narrowed fashionable silhouettes. The scarcity of natural fibers led to the use of artificial fibers, such as rayon, which continued to be a widely used menswear fabric after WWII.

After WWI, many men had more leisure time and fewer formal occasions. As a result, men began wearing casual wear more often and to a wider variety of occasions. By the 1940s, men had a wide variety of casual

Olian, J., ed. 1998. *Victorian and Edwardian Fashions from "La Mode Illustree."* Mineola, NY: Dover Publications.

Peacock, J. 1998. *Fashion Sourcebooks: The 1940s.* New York: Thames and Hudson.

Peacock, J. 2000. *Fashion Accessories: The Complete 20th Century Sourcebooks with 2000 Full Color Illustrations.* London: Thames and Hudson.

Pointer, S. 2005. *The Artifice of Beauty: A History and Practical Guide to Perfumes and Cosmetics.* Gloucestershire, UK: Sutton Publishing Limited.

Probert, C. 1981a. *Hats in Vogue since 1910.* New York: Abbeville Press.

Probert, C. 1981b. *Swimwear in Vogue since 1910.* London: Thames and Hudson.

Richardson, D. E., ed. 1982. *Vanity Fair: Photographs of an Age, 1914–1936.* New York: Clarkson N. Potter.

Rittenhouse, A. 1910. "What the Well Dressed Women Are Wearing," *New York Times,* April 10.

Rowbotham, S. 1997. *A Century of Women.* New York: Penguin Books.

Seeling, C. 2000. *Fashion: The Century of the Designer 1900–1999.* English edition. Cologne, Germany: Konemann.

Tortora, P. G., and Eubank, K. 2005. *Survey of Historic Costume: A History of Western Dress*, 4th Edition. New York: Fairchild Publications.

Ware, S. 1982. *Holding Their Own: American Women in the 1930s.* Boston: G. K. Hall.

Washington Post. 1920. "Of Interest to Women," January 12, 8.

Washington Post. 1935. "Rows of Buttons Decline in Favor," October 17, F4.

Watson, L. 2004. *20th Century Fashion.* Buffalo, NY: Firefly Books.

Wilson, V. P. 1925. "Gowns," *Washington Post*, December 20, X5.

REFERENCES

Baker, P. 1992. *Fashions of a Decade: The 1940s*. New York: Facts on File.

Baudot, F. 1999. *Fashion: The Twentieth Century*. London: Thames and Hudson, Limited.

Blum, S. 1981. *Everyday Fashions of the Twenties as Pictured in Sears and Other Catalogs*. New York: Dover Publications.

Blum, S. 1986. *Everyday Fashions of the Thirties as Pictured in Sears Catalogs*. New York: Dover Publications.

Bordwell, D., and Thompson, K. 2002. *Film History: An Introduction*. 2nd revised edition. Columbus, OH: McGraw Hill.

Buxbaum, G., ed. *Icons of Fashion: The Twentieth Century*. New York: Prestel.

Eyles, A. 1987. *That Was Hollywood: The 1930s*. London: Batsford.

Flappers: The Birth of the 20th Century Woman. Produced by K. Botting. Princeton, NJ: Films for the Humanities and Sciences, 2001.

Israel, B. 2002. *Bachelor Girl: The Secret History of Single Women in the Twentieth Century*. New York: William Morrow.

Keenan, B. 1978. *The Women We Wanted to Look Like*. London: Macmillan London Limited.

Kellogg, A. T., Peterson, A. T., Bay, S., and Swindell, N. 2002. *In an Influential Fashion: An Encyclopedia of Nineteenth and Twentieth Century Fashion Designers and Retailers Who Shaped Dress*. Westport, CT: Greenwood Press.

Laubner, E. 1996. *Fashions of the Roaring '20s*. Atglen, PA: Schiffer Publishing.

Laubner, E. 2000. *Collectible Fashions of the Turbulent 1930s*. Atglen, PA: Schiffer Publishing.

Lee-Potter, C. 1984. *Sportswear in Vogue since 1910*. London: Thames and Hudson.

Mordden. 1978. *That Jazz! An Idiosyncratic Social History of the American Twenties*. New York: Putnam.

New York Times. 1915. "Latest Customs Rulings," December 4.

New York Times. 1924. "Pretty Materials in Endless Variety," May 11, X10.

New York Times. 1930. "Spring Styles Ban the Short Skirt," January 15, 27.

Nolan, C. *Ladies Fashion of the 1940s*. http://www.murrayonhawaii.com/nolan/fashionhistory_1940ladies.html.

Ogren, K. J. 1989. *The Jazz Revolution: Twenties America and the Meaning of Jazz*. New York: Oxford University Press.

Olian, J., ed. 1990. *Authentic French Fashions of the Twenties: 413 Costume Designs from "L'Art et la Mode."* Toronto: Dover Publications.

Olian, J., ed. 1992. *Everyday Fashions of the Forties: As Pictured in Sears Catalogs*. New York: Dover Publications.

Olian, J. 1995. *Everyday Fashions 1909–1920: As Pictured in Sears Catalogs*. New York: Dover Publications.

Cosmetics

After the war, women indulged in cosmetics that had not been available during the war. Sun-kissed skin was popular, and pancake makeup, powder, and rouge were used to achieve the ideal, flawless complexion. Max Factor introduced the first smear-proof lipstick, Tru Color, in 1940 and panstick makeup in 1948. Twist-up tubes of lipstick were used by most women, and they often had exotic names such as Tahiti Rose and Black Magic (Pointer 2005). Nails were worn long and lacquered.

FOOTWEAR AND LEGWEAR

Footwear

Post-war shoes came in all shapes and sizes. Most shoes were high heeled and came in a variety of styles, including open toe, slingback, closed toed, and sandals. Platforms remained popular through the decade. Shoes were decorated with bows, punch-outs, multicolors, buckles, nail heads, alligator grain, and raffia. Women's shoe wardrobes became extensive because it became fashionable to closely match one's shoes with each outfit.

Popular casual and sport shoes included canvas tennis shoes, loafers, ballet slippers, and flat sandals.

Legwear

For most occasions, women wore stockings, or "nylons" as they had become known. The more popular style had a seam that ran up the back of the legs. Short cotton socks known as anklets were also worn.

NECKWEAR AND OTHER ACCESSORIES

Jewelry

Necklaces usually fit close to the neck. Bracelets and earrings were commonly worn. Jewelry was frequently adorned with imitation pearls, glass stones, and rhinestones.

Handbags

Handbags continued to be large shoulder bags as they had been during the war. Leather began to be used as a material again, and, as metal became plentiful again, clasp styles became popular.

Other Accessories

Women wore both leather and cloth gloves. Daytime gloves were usually wrist length or slightly longer.

New synthetic fabrics allowed women to avoid the painful boning and lacing that had been required earlier in the century. Bras lifted the breasts into the fashionable peaked shape, and strapless bras were worn underneath strapless dresses. Girdles, which were also known as foundation garments, were made from tight elastic panels that nipped the waist. Attached to the girdle, there were garters to hold up stockings.

Petticoats were worn beneath full skirts. Permanently stiffened fabric was attached to the hem of the petticoat. For evening and wedding dresses, the full skirts were supported by hoop skirts.

Nylon stockings were once again available after the war and even came back as an improved version. As a result of technologies developed during the war, nylon stockings kept their shape better and were less prone to sags and wrinkles. They transitioned from a seam up the back to a later seamless version. Women were slow to appreciate the seamless version because bare legs were considered inappropriate, and the presence of a seam was an indication of proper attire. As women grew tired of straightening twisted seams, the seamless version gradually increased in popularity.

Sleepwear

Nightgowns were popular, but they had fuller skirts than they had during the war years. The bodices tended to be close fitting and the gowns were often made from sheer material. Two-piece pajamas were also popular.

HEADWEAR, HAIRSTYLES, AND COSMETICS

Headwear

After the war, women continued to wear a vast variety of hat types. Some styles that were fashionable during the war, including the beret and the bonnet, continued to be worn. New angles on berets were popularized. One style featured a pompon off the side, and another involved an oversized beret secured to the head with a hatpin.

Some new styles emerged, such as small net hats worn on the side of the head and covered in an open net veil. By 1949, pillbox hats adorned with feather or veils became popular. Cloches with bonnet brims were also popular.

Hairstyles

As the decade came to a close, women began cutting their hair shorter and arranging it in waves and curls close to the head. Short bangs became popular, too.

Raglan and kimono sleeves were popular. Three-quarter-length sleeves were worn with long gloves. Full coats were flared in the skirt, and swing styles became popular. Short jackets were popular because they could be easily worn with full skirt styles.

Opulence being stylish again after the war, the late forties saw a renewal in the use of fur and faux fur. Red fox and silver fox were popular for swing coats, both in tuxedo style with slash pockets. Fur stoles or a series of martens or mink were draped over the top of a coat.

SWIMWEAR AND SPORTSWEAR

Swimwear

Both one- and two-piece swimsuits were popular during the late 1940s. Generally, two-piece suits showed little skin between the bra and bottom. Some suits had bottoms like shorts, whereas others had skirts. Cotton, nylon, and Lastex were the most popular fabrics. Strapless, halter necks, and suits with straps were common. The bra or bodice of the suit was fitted and used darts for an uplifted bust line.

Golf

Typically, women did not wear special clothing to the golf course. They usually paired a blouse and sweater with shorts, long pants, or a skirt. Some golf blouses had extra pleats of fabric at the shoulders to accommodate a woman's golf swing.

Tennis

On the tennis court, women wore button-front blouses or knitted tops that were sleeveless or had short sleeves. These were worn with short skirts or shorts. Most tennis clubs required players to wear white, but women who played on public courts usually wore colored outfits.

Skiwear

When skiing, some women wore wool pants and short jackets, whereas others wore snow suits, which consisted of narrow pants with a matching narrow-waisted jacket.

UNDERWEAR AND INTIMATE APPAREL

Undergarments

By the end of the forties, ladies' undergarments had transitioned into two separate pieces, the bra and girdle. To achieve the New Look, women wore confining undergarments that had not been worn since the 1910s.

Some sundresses had halter necks or peplums. Two-piece sundresses sometimes bared the midriff. In those dresses, a sleeveless or cap-sleeve top was paired with an A-line or full skirt. Some two-piece dresses came with shorts as an alternate to the skirt.

Separates

Blouses/Shirts. Typically, blouses had darts and seams to fit smoothly against the contours of the torso. Simply tailored blouses were common. They had Peter Pan, rolled, notched, or shawl collars, straight sleeves that gathered into the cuff, and sometimes a breast pocket.

Pants. Denim pants, which were known as jeans, were an extremely popular casual wear choice. Most styles had a tailored look with a narrow waistband, a pleated front to give a round hip, and creases. Most jeans were ankle length, but many young women rolled up the hem until it was just beneath the knee. Other casual pants followed the same silhouette and were usually worn with a belt. Generally, shorts were upper thigh length and creased.

Other Separates. Sweaters were form fitting and either tucked into the waist of skirts or pants or left untucked and accessorized with a belt. Matching cardigans and pullovers were also popular.

Decorative Details

Silhouette. Boxy shoulders with loose blouse and wide-legged slacks gave way to tightly fitting straight-legged slacks and tight sweaters. The New Look for casual wear featured a modified hourglass appearance with fitted waist and full skirt or flounced jacket just below the waistline, providing more accent to the hips.

Dresses. Early in the decade, two-piece full-skirted dresses were popular in cotton with bright plaids, stripes, and gingham for summer, and heavier wool suit styles for cooler weather. Skirts fell just below the knee before the war, with full or pleated skirts. The New Look had an influence on casual dresses with fitted bodice and waist and very full skirt.

Separates. The New Look influenced sweater styles to be tighter, skirts to be well below the knee, and slacks to fit the hips, better accenting tiny waistlines and curvy hips.

OUTERWEAR

Coats

Coats followed the fashionable silhouette of daywear. The New Look took advantage of the end of fabric restriction. Capes and coats included hoods by 1947, again taking advantage of restrictions having been lifted.

Dresses

Dresses epitomized the feminine New Look silhouette. They had fitted bodices that tapered into small, corseted waists that curved into full "ballerina" skirts that extended to the mid-calf. Round necklines and Peter Pan collars were especially popular. Sashes were sometimes used to emphasize the narrow waist. Although solid-colored dresses predominated, plaid, polka dot, and floral prints were popular also.

Suits

Suit jackets used shaped shoulder pads to achieve a gently sloping shoulder. They were tightly fitted; darts nipped in the waist and peplums and padded basques were used to create the softly curving hip. If the jacket did not have a peplum, it usually ended at the top of the hip. Peter Pan, notched, and cape collars were common. Sometimes a bolero jacket was worn over a dress to create a suit-like style.

Skirts were either full and swingy or pencil thin. Both silhouettes extended to the mid-calf. Typically, suits were made from rayon faille, taffeta, or wool crepe.

Separates

Blouses of the New Look had big bows, ruffles, and frills. Sleeves were puffy, collars were full, and lace was added around the neckline. Cap sleeves were common, also.

Full, swingy ballerina skirts had narrow waistbands. They had the narrow waistline of the silhouette, and pleats or gores gave the skirt its fullness. Typically, skirts were made from rayon crepe, rayon faille, and wool. Black, gray, and dark brown were common colors for skirts.

Decorative Details

With the New Look, the architectural lines of the silhouette were the focal point of the garments. The drape of the fabric was emphasized, and seams and buttons were carefully placed for visual interest.

CASUAL WEAR

Silhouette

Casual wear, despite its emphasis on comfort, featured uplifted breasts, a nipped waist, and curvy hips.

Dresses

Cotton sundresses were popular summer garments. Typically, they had a full mid-calf-length skirt, nipped waist, and a low neckline or straps.

bust, constricted waist, and padded hips. In 1947, Christian Dior's first line, "Corolle," popularized this silhouette. Skirts were enormously full or pencil thin.

Skirts

It was not until 1947, after the war, when women's fashion changed to a soft, romantic image featuring longer lengths and fuller skirts. With fabric restrictions lifted, luxurious femininity became the theme for wedding wear and formalwear. Two skirt silhouettes predominated, and they were at opposite ends of the spectrum. At one end, voluminously full skirts were supported by layers of crinoline petticoats. At the other end, form-fitting pencil-thin skirts hugged the hips and legs. Both silhouettes emphasized the curve of the hip. Hemlines were lower than earlier in the decade. Shorter formal skirts reached the mid-calf, whereas longer ones grazed the floor.

Bodices

Bodices were close fitting and featured narrow, sloped shoulders, uplifted breasts, and tightly corseted waists.

Neckline

Strapless dresses were very popular during the last years of the 1940s. Sometimes short bolero jackets or wraps were worn over strapless dresses. Even if they were not strapless, most evening dresses were low cut. Square, sweetheart, and low-cut round necklines were common.

Sleeves

A variety of sleeve lengths were popular, from sleeveless to wrist length, but typically sleeves were close fitting.

Decorative Details

Many of the decorative details during this time period emphasized femininity or the curves present in the silhouette. Ruffle trim, lace insets, uneven hemlines, peplums, belts, and sequins were common forms of embellishment.

BUSINESS WEAR

Silhouette

Moving away from the boxy wartime profile, designers such as Christian Dior and Cristobal Balenciaga created a profile with softer, longer lines. The post-war silhouette included gored, swingy skirts topped with feminine blouses or tailored jackets with nipped waists and soft, curvy hips.

Leather and metal were restricted, as were most other materials, so recycling became the way to accessorize any outfit. Adding found objects to shoes, belts, hats, and handbags provided color, texture, and interest to an outfit.

Gloves both long and short were a necessary accessory for any lady leaving the house for work, shopping, or visiting. Crushed suede gloves were popular for daywear. They were elbow length but pushed down, giving them a scrunched or crushed appearance. Whereas leather was used in the earlier years, wartime shortage made cotton gloves and shirred rayon jersey more available. Although they were difficult to keep clean, "shorties" gained popularity during the war because they were less expensive.

1947–1949,

THE NEW LOOK

After the war, women quickly adopted silhouettes that were dramatically different from the one they wore throughout the war. Christian Dior was the design leader of these new silhouettes, and his designs were dubbed the New Look.

FORMALWEAR

The debutante "season" was resumed in 1947. This meant more formal occasions for socialites and young ladies being presented to society. These occasions demanded appropriate attire, which meant that evening gowns and debutante ball gowns were made with firmly boned, fitted bodices, either strapless or with spaghetti straps, and full skirts in tulle or organza shimmering with embroidery and sequins. Dresses for more mature ladies were made in ribbed silk or heavy satin with embroidered panels.

Silhouette

Following the war, the New Look was characterized by sloping shoulders, articulated

A fashion model wears a New Look dress, introduced in Paris by Christian Dior in 1947. [AP / Wide World Photos]

Younger women often opted for ankle socks. Heavy woolen stockings were worn in winter, and many women chose to go bare legged in the warmer summer months. Cotton and wool stockings were worn with sportswear.

Eight days after Japan's surrender, DuPont announced a return to production of nylon stockings. "Nylon riots" ensued throughout 1945 as women mobbed the stores. Fights broke out when stores ran out of supply. By March of 1946, finally back up to pre-war production capacity, DuPont was producing 30 million pairs of nylon stockings a month, and the "nylon riots" came to an end.

NECKWEAR AND OTHER ACCESSORIES

Jewelry

Brooches were a common accessory because wartime made necklines more modest. They were worn on both day and evening outfits. Flowers, natural motifs, and knots were popular, and some included colored glass, enameling, or precious stones as embellishment.

Collar-style necklaces and other styles that were worn high up on the neck were fashionable. Bracelets were usually worn over gloves or on unadorned wrists. Bangles and linked bracelets were both popular. Many women wore drop earrings.

Handbags

Early in the 1940s, clutches and small handbags were the most fashionable. They were available in clasp and fold-over styles. Larger handbags with long straps and shoulder bags made their way onto the fashion scene because women needed to carry more to and from work at the factories. With metal zippers and metal closures scarce, drawstring tops and fold-over tops became both fashionable and practical. Simple, geometric lines were incorporated into Sunday or business handbags. They appeared as little square boxes, octagonal boxes, and circular boxes with a single or double strap, and flat-faced clutches with rectangular or triangular flaps made of leather, felt, plastic, or rayon faille. During the war years, basic black was the most common color available. Dyed leather became available after the war restrictions were lifted.

Other Accessories

Scarves became staples of fashion because they could be used to add color to an outfit when they were tied around the neck or at the waist. They could cover and protect the hair, or they could be tied as a halter top.

Lipsticks were now softer pinks, and eyes were popping with black liner and long lashes.

Footwear and Legwear

Footwear

During WWII, materials were rationed and designers had to be creative, using every imaginable material for shoes. Chunky cork and wood were used to make wedges and platforms. Sisal, composition, and plastic were all used as materials for soles.

With leather in high demand for military items, uppers were often made of canvas. Adults were limited to two new pairs of shoes a year, so women had to be creative with making their shoes work with different outfits. Women would adorn their shoes with anything they could find, including pipe cleaners and feathers. Taking advantage of the exemption of play shoes and ballet slippers from U.S. restrictions, American designer Claire McCardell asked the maker of ballet shoes to create a ballet shoe with a sturdier sole and heel for outdoor use.

In the early 1940s, oxford-style pumps with high vamps were popular. Wedge heels were considered fashionable as well. Around 1943, platform soles became more prevalent in pumps and wedges. Slingbacks were also common.

Legwear

Silk stockings had long been the norm for women. They had seams that ran up the back of the leg, and women were forever adjusting the seams to make sure they were straight. When nylon stockings were launched at New York department stores in 1940, women lined up to buy them. Each consumer was limited to purchasing two pairs, but they cleaned out the city's 6,000 dozen pair stock. Although nylon stocking had been introduced a couple of years earlier, DuPont, the patent owner of nylon, allowed stocking manufacturers to purchase nylon without a license (*Time Magazine* 1940).

Soon, however, DuPont was forced to divert its nylon production to war-related materials. Nylon and silk were unavailable for stockings during the war so women were encouraged to wear ankle socks. This solution was not appropriate for a dressier occasion, so women turned to leg makeup. It was available in the form of lotion, cream, stick cake, and pancake. Women even painted lines down the backs of their legs, giving the illusion of seamed stockings.

Betty Grable, left, sporting an upsweep hairstyle as was very popular at the time. [Courtesy of Photofest]

neck. Princess Elizabeth popularized wearing a headscarf tied under the chin.

Hairstyles

Special emphasis was placed on hairstyles and makeup because clothing and accessories were in short supply (Mendes and De La Haye 1999). Hollywood divas Rita Hayworth, Betty Grable, and Bette Davis continued to project ideals of beauty with upswept hair in glamour photos. Rather than cutting the hair short, women would arrange their hair in a pompadour, victory roll, or French twist. Pin curls or soft waves on the sides and top kept the pulled-back hair from looking too severe. Although the hair was up, it still had volume and style. When hair was worn down, it was generally parted on the side without bangs, shoulder length with a page-boy curl at the base, making a neat under curl all the way around. Veronica Lake, a Hollywood actress famous for her sultry long blond hairstyle, joined the war effort by pulling her hair back and encouraging other women to do the same. Joining the war effort, beauty journalists encouraged women to get a healthy shine in their hair from brushing rather than using Brilliantine and buffing their nails rather than using varnish, which was in short supply.

Cosmetics

Results of a U.S. War Board survey of American women revealed that women agreed that face powder, lipstick, rouge, and deodorant were very crucial. Bath oils were essential, although bath salts were not (Baker 1992). With most of the foundation components used in the production of makeup scarce during the war, emphasis was on the lips. Deep-red lipstick was advocated as the sensual look for cheering up the soldiers returning home from war. By the end of the decade, new products became available with postwar expansion, and the emphasis began shifting from lips to eyes. Eyeliner and mascara made the transition into the fifties.

Headwear, Hairstyles, and Cosmetics

Headwear

Accessories, like hats, were fashion essentials throughout the forties but were harder to come by during the war years because many of the materials were rationed or unavailable. Hats of every shape and size were fashionable and not considered excessive. Hats allowed women to make a fashion statement during the war and perk up an otherwise drab outfit without appearing to be unpatriotic.

The Department of Agriculture's Extension Service taught women how to make their own hats from remnant material as a cost-saving and material-saving activity. Ladies would choose the hat styles they wanted, then frames were purchased from New York, and the ladies would finish their hats with feathers, small pieces of remnant fabric, and trim. When felt, tulle, and feathers could not be found, braided paper and even cellophane was used for decorative trim.

Throughout the 1940s, hats came in an amazing variety. In the early years of the war, berets were popular. They were commonly made from felt. Sometimes they sat toward the back of the head, and other times they were slouched asymmetrically over one ear. They usually had some form of bow on them.

Architectural-looking hats were also popular during the early war years. These hats consisted of felt molded into a skullcap for the base, and then more molded felt would be sculpted into brims and other projections. Sometimes this style would be tilted forward on the head and held in place with a felt strap at the back of the head.

Many women wore hats with broad, wired brims. This style was usually made from straw and had a shallow crown. The crown was accented with a ribbon and bow.

As the war progressed, most hats became smaller. One trend involved small boater-style hats worn tilted forward on the head. These hats would be trimmed with ribbon bands, chiffon scarves, and even fur.

By 1945, open net veils were often worn over smaller hats, and feathers were a popular trim. Bonnet-shaped hats also became popular. Usually made from felt, these had an upturned brim that resembled a bonnet from the nineteenth century.

Women now working in factories had safety issues to consider. Long hair getting tangled in machinery could be life threatening. Turbans, snoods, and scarves were donned to keep the hair out of the way and clean from the industrial environment. Snoods made of fabric, knitted or crocheted, were worn to hold long hair in place at the nape of the

narrow waisted, had padded shoulders, and often had belts. Both single- and double-breasted styles were common, and buttons and zippers were typical closures.

Other Activewear

When horseback riding, women wore tweed jackets with jodhpurs and high riding boots. When ice skating, they wore a gored wool skirt, a close-fitting short jacket, and wool stockings.

UNDERWEAR AND INTIMATE APPAREL

Undergarments

Undergarments helped create the silhouette of a woman during WWII. Undergarments emphasized a woman's curves by nipping the waist and lifting the breasts. Corsets extended slightly above the waist and shaped the body with elasticized panels. Rigidly boned corsets continued to be worn by larger women.

Younger women wore tighter underwear, known as briefs, which allowed them to easily wear sportswear. Older women continued to wear drawers, which were looser, bloomer-style underwear. Wealthier women could afford silk underwear, but most American women wore underwear made of acetate, cotton, or rayon.

Finding appropriate materials for undergarments was difficult. Rubber, nylon, silk, and even wool were all diverted to the war effort. One-piece corsets made of cotton with molded and seamed cups provided foundation, and attached garters held up stockings. The corset had a lower panel across the front of the thighs, allowing leg movement. Slips made of rayon satin or cotton lacked any adornment because they were simply foundation garments and their embellishment was considered nonessential in wartime. Women were now wearing slacks regularly, increasing popularity of the camisole rather than a full slip, which was worn beneath a dress or skirt and blouse outfit.

Sleepwear

Nightgowns followed the silhouette of daywear with a slender waist. They were floor length and often sleeveless. Often they would come with a matching robe that had thickly padded shoulders. Fancy nightgowns and robes would be made from layers of sheer material and lace. Women also wore pajamas in masculine styles and feminine styles that had blouse-like tops.

Swimwear

Bathing suit designers were careful not to reveal cleavage and modestly covered the hips with a skirt or half-skirt. Made of rayon jersey, rayon taffeta, or rayon with cotton, suits had colorful floral designs, tropical prints, pinstripes, or appliqués. One-piece suits came in a swim dress style that had a loose skirt and the half-skirt style that stretched the suit fabric across the front of the hips. The bodices of suits were held up by thin straps or a halter neck.

In 1943, the government ordered a reduction of 10 percent in the amount of fabric used in women's swimwear. This helped popularize two-piece suits. They had a gored skirt with a waistband that covered the navel and underpanties with elastic around the leg. The bra provided full coverage of the breasts and had darts to ensure a gap-free fit. In 1946, a new style of two-piece suit was introduced by Jacques Heim and Louis Reard. They called their creation the bikini after Bikini Atoll, the site of atomic bomb testing. Few American women adopted this skimpy style, because they preferred the coverage of their more modest two-piece suits.

Some suits were made from a new yarn, called Lastex, that was made from a rubber core covered by another fiber. Suits made from Lastex were form fitting and free from wrinkles. The yarn stretched, making Lastex suits comfortable for swimming.

Golf

When women golfed during the 1940s, they did not wear a specific style of outfit. Typically, they would wear a tweed skirt designed for active endeavors. Usually, this was paired with a blouse and a pullover sweater.

Tennis

White continued to be the traditional color for tennis clothing. Pullover and cardigan sweaters, as well as full-cut sports jackets, were commonly worn. Tennis dresses were usually sleeveless and collarless and extended to the mid-thigh. Separates were also popular. Women would wear short-sleeved, loose-fitting, collared white blouses with shorts or culottes.

Skiwear

Skiwear consisted of full trousers with a matching jacket and a sweater. The pants usually gathered at the ankle, often into zipped knit cuffs. Sometimes they had elastic stirrups to keep the pants tucked into the boots and suspenders to keep the waistband tucked under. Jackets were

Short-sleeve sweater sets consisting of a cardigan over a crew-neck sweater were popular. Longer, clingy pullover sweaters made from soft wool or spun cotton created the "sweater girl" look that was popularized by Hollywood pinup girls. Wool pullover sweaters and cardigans with crew necks and three-quarter or long sleeves were popular. Pink, yellow, light blue, light green, red, and white were typical sweater colors.

Decorative Details

The casual American look was led by the designer Claire McCardell. Pioneering the use of unexpected fabric, her line included cotton denim, gingham, calico, and striped mattress ticking. Both functional and comfortable, her designs had dolman sleeves, adjustable waistlines, and deep pockets. Exploiting the U.S. ration exemption on sport shoes and ballet slippers, McCardell asked a leading New York maker of ballet shoes to create an outdoor version with stronger soles and heels, which launched the popularity of ballet flats for casual wear.

OUTERWEAR

Coats

Most coats had large collars and lapels and noticeably padded shoulders. Raglan and dolman sleeves were popular. In general, coat lengths were just below the knee, whereas jackets were hip or waist length.

Belted trench coat styles in gabardine or all-weather fabric were popular for everyday wear. As the United States entered the war, the number of buttons was reduced and the metal belt clasp disappeared for a tied belt look. Wool double-breasted polo coats that extended below the knee were replaced in 1943 by the rayon-lined wool single-breasted fitted coats with slash pockets rather than the earlier pocket flaps.

Very little adornment was found on coats from 1942 to 1946. Stitching was simple, and fabric was limited. Luxury worsted wool fitted coats falling below the knee were often found to have wide collars of silver fox early in the decade. Fur coats and jackets were popular. Typically, fur jackets had padded shoulders and wide sleeves. During the war, furs were collected to be used for lining the vests and jackets of airmen.

SWIMWEAR AND SPORTSWEAR

When Paris fell to Germany in 1940, the Germans cut off French fashion from the rest of the world. During this time, the United States emerged as the sportswear capital of the world.

Jane Russell, in a pin-up pose much loved by World War II servicemen, wears an unadorned but well-fitting dress from the 1943 film *The Outlaw.* [Courtesy of Photofest]

Betty Grable in one of her famous pinup poses, a favorite of American soliders. [Library of Congress]

Pinup and Sweater Girls. Pinups were mass-produced photographs and drawings of women. Although the term was coined in 1941, these images existed since the 1890s. With so many men being off at the front and away from their wives and girlfriends, the pinup industry boomed. Men mounted these images in their lockers and inside their helmets. Film stars were popular pinups, and some of the favorites included Betty Grable in a bathing suit, showing off her famous legs, and Rita Hayworth, Ava Gardner, Veronica Lake, Jane Russell, and Lana Turner, all looking rather sultry.

Pinup girls sometimes wore tight-fitting sweaters that emphasized their breasts. This style was copied by many young women. When the management at the Vought-Sikorsky plant decided that women wearing this style to work was too distracting for the male workers, they created a company rule that prohibited sweaters. The company sent home fifty-three women who violated the rule, and twenty-two others walked out. Despite the company's opposition to the trend, women continued to wear the popular style.

They followed the lines of other casual dresses, but they had a split skirt. Matching mother-daughter dresses were available. These youthful cotton garments had close-fitting bodices with sweetheart or square necklines and puffed short sleeves. The full skirt was often trimmed with ricrac.

Separates

Blouses/Shirts. Typically, blouses had puffed sleeves or padded shoulders. Sleeve lengths were short, three-quarter length, or long. Convertible collars and round necklines were common. Floral prints and stripes were popular prints.

Tailored halter tops that exposed the midriff were popular. They had a V neckline and straps that crossed in back or tied. Another popular style was the dirndl blouse. It was loose-fitting blouse made from cotton batiste with puffed short sleeves. Typically, it was edged with lace and had a square or low round neckline.

Pants. Women's trousers were fashioned after menswear, with belted waist, wide legs, and creased fronts. Some versions were cuffed and others were not. Typically, casual fabrics were made from denim, cotton twill, seersucker, gabardine, and wool. Overalls and shortalls became popular. They had the same trim, tailored silhouette as pants. They were creased and cuffed. The bib was fitted and had crossover straps in back. Culottes, which were split skirts, were also popular. They were often paired with a jacket.

Skirts. Casual skirts were designed for easy movement. A-line skirts often had vents or pleats to allow women to move easily. A popular style was the dirndl skirt, which was a full skirt gathered into the waistband. Typically, it was made in floral prints, and the hem was often trimmed with ribbon or ricrac.

Other Separates. Playsuits were popular for casual wear. They were combinations of a blouse and shorts with an overskirt, which could be a wrap skirt or a skirt with a bib top or suspenders. Another style had a mid-thigh-length skirt with underpanties and a midriff-baring halter top. Playsuits usually came in patterns such as stripes, checks, and floral patterns.

Coveralls were worn for work and chores. They were loose in the hip and leg, and the legs tapered at the ankle. Although they were loose fitting, the legs were creased and they had a fitted waistband. The bodice usually had padded shoulders with a convertible collar and long straight sleeves or full sleeves gathered into the cuff. They were made from durable cotton cloth or corduroy. Generally, they had work pockets at the chest and front and back of the hips.

The garments of women volunteers in the Civilian Defense program reflect wartime restrictions. [Library of Congress]

train and streetcar conductor jobs went to women. They wore a simple dark blue suit consisting of an A-line skirt and fitted jacket with matching blue hat that was copied from the men's uniform. Stamped gold-tone buttons were worn on the single-breasted jacket and on the sides of the billed hat.

Casual Wear

Silhouette
The idea of separates was introduced by American designers during the forties. Mix and match ensembles along with multipurpose and multiseason outfits were popular during the years of war restrictions because they created the illusion of more outfits than one actually had. The silhouette during this period included puffed or padded shoulders, a slender, natural waist, and close-fitting skirts and pants.

Dresses
Early in the decade, two-piece full-skirted dresses were popular in cotton with bright plaids, stripes, and gingham for summer, and heavier wool suit styles for cooler weather. Skirts fell just below the knee before the war, with full or pleated skirts. Culotte dresses were also popular.

Suits

Early in the decade, man-tailored suits were fashionable. These suits had fitted, hip-length jackets with padded shoulders and long straight sleeves. The jackets had patch or slit pockets and a masculine, notched collar. The skirts were narrow. This style of suit was available in typical men's colors such as navy, black, gray, beige, and pinstripes.

As the wartime clothing restrictions emerged, suits became more minimal. Two-piece suits usually had knee-length, straight skirts and jackets that were twenty-five inches or less in height as American designers complied with government restrictions on yardage and fabric. Lapels were narrow, pockets were flapless, jackets were short, and skirts were straight. Bolero jackets were popular short jackets the ended just below the bust. The Eisenhower jacket, which slightly bloused and gathered into a fitted belt at the waist, was modeled after military jackets.

By the end of the war, jackets had exaggerated shoulder padding and peplums. The skirts no longer had gores; they had been replaced with vents or pleats to ease movement. Typical solid suits had been joined by suits made from patterned fabric, including herringbone, tweed, and plaid.

Decorative Details

Very little trim was applied, so detail was provided in covered buttons and stitching. Simple, minimalist designs reduced the amount of fabric used in length, fullness, and accoutrements. Everything was restricted, including pleats, the number of buttons, use of metal zippers, cuffs, yokes, and pockets.

Uniforms

Women had many opportunities to serve the war effort in uniform. Tasks ranged from medical practice to office duties, coding, and transcription. Women Accepted for Voluntary Emergency Service and Women's Auxiliary Corps wore feminine versions of men's uniforms. Class-A uniforms were navy or black skirt and fitted jacket with white blouse, with white hat with dark bill and trim. Field duty required olive drab skirt and fitted suit jacket with tailored tan blouse with short or long sleeves. A-line skirts fell just below the knee and were worn with chunky black or brown oxfords. Although women did not carry military rank, their jacket lapels did carry the insignia of the branch served. Nurses' uniforms were white dresses with fitted waist and buttons down the front, similar to those found in civilian hospitals.

Women could be found holding civilian jobs traditionally held by men that required uniforms as well. With most able-bodied men going to war,

Decorative Details

Clothing was lacking in ornamentation throughout most of the 1940s as a result of wartime restrictions. General Limitation L-85 Order issued by the U.S. War Production Board was in effect from 1942 to 1946. This order forbade nonessential details and outlawed certain garments. Included in the forbidden items were woolen wraps, full evening dresses, bias cut, and dolman sleeves. Sheath evening dresses replaced the long flowing gowns of the thirties. American designers used eye-catching fabric inserts and other creative measures that complied with the fabric-saving regulations.

Rayon was commonly used in eveningwear. It came in various weaves, including taffeta, velvet, satin, chiffon, and crepe. The jersey weave was popular because the fabric hung nicely and draped well when walking. Gowns were also made of velvet and taffeta. During the war, rayon became the fabric of choice for wedding gowns because silk was in high demand for parachutes and cotton was being used for duffle bags and uniforms.

Sleeves were long, often tapered with a wedding point to balance the simple train of the dress. Trains were shorter during the war, but veils from finger-tip-length silk tulle with beaded buckram crowns to floor-length silk-tulle veils with wax flowers and silk ribbons completed the look. Although wedding gowns were exempt from the government's L-85 guidelines restricting the use of fabric, many brides were married in suits because young men were soon to be shipped overseas and they did not have time to plan lavish weddings.

BUSINESS WEAR

Silhouette

The silhouette established at the beginning of the decade effectively froze during the war. Skirts extended just below the knee, the waist was natural, and shoulders broadened.

Dresses

Dresses were very popular during the war. They were available in a variety of solid colors and prints. Often they had a fitted bodice that buttoned up the front. Square, V, or round necklines were common, as well as lace-trimmed collars. The skirts were flat across hips, and the skirts were gored to flare at the knee-length hem. Usually, there was a belt at the natural waist, even if a dress had an empire-waist seam. Short or elbow-length sleeves were popular, and they gathered into an elastic band. Long straight sleeves were also common.

WWII evening dresses feature narrow silhouettes and emphasized shoulders. [Library of Congress]

war years of the 1940s. This triangular silhouette was created by large shoulder pads, the narrow waist, and the flared skirt. As the war continued, the skirt narrowed, and this look was transformed into a slim sheath. Waistless shifts reduced the use of fabric by 50%, and straight skirts falling from a slightly gathered waist provided a slim profile.

Skirts

Floor-length skirts were often gored to add fullness. During the war, few women invested in floor-length skirts because of rationing and specific government directives restricting the use of fabric. Short skirts retained some fullness until later in the war.

Bodice

During the war years, bodices were typically softly draped and fell gently from the shoulder to a fitted waist or princess waist. The new bodice was form fitting over a conical stitched understructure defining a pointy chest with tiny wasp waist. Sometimes bodices were accessorized with bolero jackets, collars, or rhinestone brooches.

Women wore separates for some formal occasions. Long, gored skirts were paired with jacket-style blouses, rayon blouses with full sleeves, and sweaters embellished with sequins.

Necklines

Most formal gowns featured V, round, and sweetheart necklines.

Sleeves

Sleeves that extended just above or below the elbow were pleated from the shoulder pad and fell straight with little extra fabric. Puffy, short sleeves were another popular style.

popular, and art deco continued to influence the early 1930s. Chinese and East Indian motifs and shapes were particularly favored by jewelers such as Cartier. Alternatively, the 1930s also saw an increase in the use of costume jewelry using materials such as Bakelite and celluloid. Both real and artificial flowers were frequently used for corsages, necklaces, and bracelets, reflecting a late 1930s interest in romanticism.

Handbags

The 1930s was a transitional period for handbags, between the smallish bags of the 1920s to the larger styles of the 1940s. Envelope-style pouchettes or clutch bags were the most common of this time and were most frequently made of leather for daytime use. Small, handmade crocheted or cloth bags also reflected the romantic mood. Beaded bags remained appropriate for evening and fancy afternoon dress, although bags made of wooden beads were used during the day. Metal mesh bags remained popular for evening, in addition to armor-mesh bags with floral or faux-brocade motifs.

Miscellaneous Accessories

Because of the popularity of sunbathing, the most necessary fashion accessory for summer in the 1930s was sunglasses. Popularized by Hollywood stars, tortoiseshell rims were particularly favored. Belts, too, drew attention, and, as the waistline was returned to its proper place, highly decorative clasps featuring jewels, metal, and plastic became the norm. The late 1930s interest in romanticism brought an interest in long fingerless lace gloves and floral print fans.

1940–1946,

WORLD WAR II

WWII placed tight restrictions on materials that were used in clothing. Manufacturers and designers innovated to adapt to rationing and the limited availability of common clothing materials. Women's more active role in public life and the workplace was expressed in their masculine silhouette and more comfortable clothing. This era is named after the war.

FORMALWEAR

Silhouette

Boxy and broad shoulders sloping into a draped bodice, down to a slim waistline with floor-length skirt flaring just below the waist represented the soft, understated feminine silhouette that remained dominant during the

women even removed theirs entirely to draw them in high and arched like Jean Harlow's.

FOOTWEAR AND LEGWEAR

Footwear

The 1930s saw a shift in focus for shoe design. Comfort became more of a concern to designers and shoppers at large. To this end, shoes became wider and toes less pointed. Heels were not as high and were constructed with a wider base for a more solid foundation.

Also during the 1930s, differences between shoe types became more pronounced, with specific shoes for specific activities. Following a more widespread interest in health, innovations in sports shoes were prevalent. Commonly known as the tennis shoe, the first linen shoes with rubber soles were developed in 1934 and were used for golf, sailing, and other sports activities. Along with flat sandals, these shoes were typically worn with shorts and women's trousers. Heeled sandals were worn with eveningwear in a variety of styles, including the cutaway or open toes. Slingbacks were another alternative.

The first platform shoe was developed in the mid-thirties by the French shoemaker Roger Vivier. Innovative Italian designer Salvatore Ferragamo designed the first wedge shoe in 1936. Wood and cork were used to create these soles and were frequently covered with cloth and leather and were decorated with sequins, embroidery, or bows.

After the vibrant colors of the 1920s, shoes of the 1930s were more subdued in tone and were often made to match the color of the dress. Velvet, crêpe de Chine, and satin were popular materials for evening footwear. Leather continued to be worn during the day and evening. However, beginning in 1939, wartime leather shortages caused considerable restrictions on shoe styles in Europe, which later affected the U.S. market.

Legwear

Silk was still the most popular material for stockings, but the 1930s saw the rise of rayon as an alternative. By 1939, however, rayon had been completely replaced by nylon.

OTHER ACCESSORIES

Jewelry

Whimsical, imaginative jewelry by designers such as Elsa Schiaparelli was inspired by surrealist ideas. Native- and tribal-influenced jewelry was

later years, man-tailored pajamas became more popular, complete with a button-front tailored top. Late 1930s sleeping pajamas included shoulder yokes, puffed sleeves, and square shoulders.

Other garments

Loungewear included the ever-popular lounge pajama, bathrobes, whose construction generally resembled outerwear garments, extravagant bed jackets of marabou feathers, and satin housecoats.

HEADWEAR AND HAIRSTYLES

Headwear

Although the 1920s was dominated by variations on a single style of hat, the 1930s saw a continuous flow of new shapes and styles. In general, hats revealed more of the head than in the previous decade and were influenced by fantasy and surrealism, especially those designed by Elsa Schiaparelli. Many brims draped low over one eye, adding drama. Sports hats were a necessity and had casual soft crowns and brims. The fez, boaters, tricornes, pillboxes, flat straw hats, berets, and hats based on professional headwear (tailors, sailors, and cowboys) were also popular. Just before the start of WWII, veils became popular. Film continued to influence fashion trend, and Greta Garbo's headwear in *Mata Hari* and other films made a significant impact.

Hairstyles

Taking over from the 1920s bob, the "floue" became the most prominent hairstyle of the 1930s. The floue was waved and fluid over the crown of the head, ending in a nestle of curls or ringlets at the nape of the neck. In general, hair was longer than in the previous decade, although *Vogue* noted in 1930 that "long hair is not smart" (Probert 1981a, 30). Hollywood gained momentum in its influence on hair, with Jean Harlow's blond tresses leading the pack in the 1931 film *Platinum Blonde*.

Cosmetics

During the 1930s, the cosmetics industry continued to grow, mostly as a result of Hollywood's continual prevalence in society through films and advertising campaigns. Face powder, rouge, lipstick, and mascara were now standard in the beautification process. Innovations continued, and false eyelashes became available for the first time (Watson 2004). A cake form of Maybelline mascara was also available to all levels of consumers. Eyebrows continued to be the focus, and some

Ginger Rogers wears a glamorous V-neck nightgown that looks like an evening gown, from the 1937 film *Shall We Dance*, with Fred Astaire. [Courtesy of Photofest]

Those with less-ample bustlines could use various kinds of padding and falsies that were developed over the decade. The now standard A, B, C, and D cup sizes were established by the Warner company in 1935, and the strapless bra was introduced in 1938 (Laubner 2000).

Panties were introduced for the first time in the 1930s and resembled the mid-thigh-length, wide-legged tap pants worn by tap dancers in movies. Other undergarment options included bloomers, bloomer knee suit, step-in, pantie-girdles, vests, union suits, and a variety of other combination garments.

Sleepwear

During the early part of the decade, nightgowns were shapeless, unfitted tubes, but they became more defined through the use of vertical pin tucks and sashes tied at the back. In the mid-thirties, high-waisted gowns were popular, and, by the late 1930s, nightgowns resembled eveningwear. They featured V necks with a high empire waist.

Sleeping pajamas consisted of wide-legged trousers, with a belted or girdled top featuring decorations similar to those seen on nightgowns. In

Golf

One- and two-piece ensembles in tweed were popular for golf. Some were adamantly in favor of one over the other. However, professional golfer Molly Gourlay claimed that "any form of one-piece garment; anything hung from the shoulders impedes balance" (Lee-Potter 1984, 35). Brightly colored double-breasted jackets in suede were popular throughout the decade. Coordinating pieces that allowed for adaptation to changing weather were created in contrasting colors, with flamboyant details. Companies, such as Burberry, produced wraparound skirts, culottes, short tailored jackets, and similar garments for the relatively formal sport, although by the end of the decade slacks became acceptable.

Tennis

The shirt and shorts suit was typical attire in the early thirties. By the late thirties, a shorts dress with side button was fashionable. Halter necklines were popular. The cardigan of the 1920s was replaced by a silk or tweed coat. Detailing focused on the back and included small bows, buttons, and contrasting trim. Voluminous skirts were created through goring and bias cuts rather than pleating. Sportswear for tennis was made of washable silk, linen, or broadcloth. Tennis celebrities caused sensations in the 1930s as well. Mrs. Fearnley-Whittingstall played without stockings in 1931, and Alice Marble wore shorts to Wimbledon in 1933.

Other Activewear

Other fashionable sports for women in the thirties included waterskiing, running, fencing, and mountaineering. All sports clothing required expert tailoring. In general, shorts and pockets were the innovations of the day. Cycling required pants or shorts made of sturdy materials such as flannel, leather, or tweed and were worn with masculine shirts. For hunting and fishing, various types of bifurcated garments became acceptable for women. These included trousers, plus-fours, jodhpurs, and divided skirts.

UNDERWEAR AND INTIMATE APPAREL

Undergarments

When fashion returned to a feminine figure and the bias cut grew popular, undergarments became smooth, undecorated, and supportive. Popular backless, figure-hugging evening gowns were frequently worn without any underwear.

Shaped bras for the youthful figure elevated, separated, and defined breasts by using gathers, adjustable drawstrings, tucks, darts, and elastic.

The U.S. women's Olympic swim team, 1936. [AP / Wide World Photos]

Skiwear

Skiing did not become a popular sport in the United States until the 1930s. Winter festivals on the east coast, beginning in 1931, and the Winter Olympics of 1932 at Lake Placid helped the sport to rise in popularity for the wealthy elite.

The typical ski outfit for both men and women was a double-breasted boxy jacket worn with Norwegian-style trousers that were gathered at the ankle using Lastex yarn. Stirrup pants were later introduced at the 1936 Olympics in Germany. Darker colors were initially worn, with brighter tones appearing later. Expert skiers wore white, which in the 1920s had been frowned on. Two-tone suits and brightly trimmed accessories were also popular. Typical high-fashion fabrics such as gabardine, silk, wool, and jersey were waterproofed for skiwear. Schiaparelli even went so far as to introduce tortoiseshell-rimmed ski goggles in 1936 for wealthy women to wear on the slopes.

oxford gray, navy, and brown were popular in the early 1930s, with more vibrant colors such as wine, rust, teal, and pink gaining popularity in the later 1930s.

Fur coats continued to be popular with the wealthy, and particular attention was paid to silver fox, sable, and the novelty of monkey fur. Fur scarves and pieces continued to be worn over suits and dresses as status symbols.

Shawls/Wraps

Evening wraps and capes followed feminine lines throughout the decade. Long and slender coats in dark velvet lined in light-colored silk, taffeta, or satin were most popular. Shorter, jacket versions were also frequently worn. Peter Pan and bumper collars were frequently used on these garments. Inspired by period movies, evening capes of velvet, taffeta, and satin had shawl or stand collars, with hoods becoming popular at the end of the decade. Lengths varied and were found as short as the elbow and as long as a full-length gown, with anything in between permitted.

SWIMWEAR/SPORTWEAR

Swimwear

Sunbathing continued to be popular, but a fitness craze was also in full swing. Toned bodies were shown off in tighter, flesh-revealing styles. Elastic fabrics such as Lastex and Contralex developed by companies like Jantzen helped to shape the figure (Probert 1981b). The overskirts and extra material of the previous decade were discarded for brief one- and two-piece suits that resembled men's styles. Swimsuits of the time were also very low in the back with cross-over straps and halter necklines. White suits became popular to show off a tan, and later bright colors became popular. In 1935, the two-piece later known as the "bikini" appeared but did not proliferate until the 1940s. In the late thirties, the elasticity and cut of swimwear focus moved from the back to the hips.

Although exposure was common on the beach, covering up had a multitude of fashionable options. Beach pajamas, now cut on the bias, continued to be worn and were frequently seen in a variety of sporting activities, including yachting. Other types of beachwear included beach suits, bicycle beach suits, and basic coordinates. Other cover-up options included tailored hip-length beach coats and capes. Fabrics for beachwear ran the gamut and included terry cloth, spongy cotton, and wool in a variety of knits.

Large sun hats tied with a ribbon under the chin helped protect bathers from sunburn. Heeled and flat sandals, sometimes with lacing up the legs, were also frequently worn.

blouses, and skirts were becoming a part of the fashionable wardrobe. Trousers continued along similar lines as in the previous decade. They had a flat front, were wide legged, and were often paired with short-sleeved, collared knit tops with geometric graphic designs. More formal silk tops featured draped pieces and were frequently belted and trimmed with ribbon.

Decorative Details

Daywear colors depended on time and location. Subdued tones such as black, navy, and gray were popular in the city; browns and greens were prevalent in the fall. Afternoon wear was usually black or a pastel shade of peach, green, blue, or pink.

Buttons were a popular trim, especially square ones (*Washington Post* 1935). Innovator Elsa Shiaparelli frequently used creative shapes such as acrobats and lovebirds. The zip fastener also began to be used on hand-bags and eventually on daywear. Belts worn at the natural waist were nearly universal. Fur trim made of flat pelts was also used for daywear.

OUTERWEAR

Coats

As it had in the early 1920s, the silhouette of the 1930s swung from feminine to more masculine shapes as the decade progressed. Early 1930s coats were rounded and feminine to match the silhouette of the garments underneath. Shoulders became more pronounced as the decade progressed, and, eventually, the overall look become boxy and square. Both collars and lapels grew in size as the decade progressed. Popular details included added fabric at the back in the form of pleated, "action-back" detailing, and fishtail backs, which were created with large rippling pleats from a shoulder yoke. The early 1930s saw coat hems ending below the calf, but they rose to the knee in 1937 and remained there for the duration of WWII.

Several coat styles carried over from the previous decade. These included the surplice coat and polo coats. Initially worn by men to polo matches in the 1920s, women adopted the double-breasted, caramel-colored sport coat in the early 1930s. Later styles included the following: the reefer coat, which was inspired by the U.S. Navy pea coat; the swagger coat, which featured a flared or fishtail back; the hourglass-shaped princess coat; and the short, square box coat of the late 1930s.

Wool and wool blends were the most popular for cloth coats, in check, herringbone, plaid, and ombre stripe. Solid somber colors such as tan,

suit skirts were long and either flared or pleated below the knee. In the early years, the hem was below the calf. Toward the end of the decade, skirts, which were now A-line, ended below the knee. Irish and Scottish wool in tartans, checks, herringbone, flannel, jersey, and tweeds were the most popular materials for business suits and were seen throughout the decade.

CASUAL WEAR

Silhouette

Fashion changed drastically from the straight lines and boyish look of the 1920s. The 1930s silhouette emphasized feminine curves and sculptural curves, as well as long skirts, natural and narrow waistlines, and broadened shoulders. With the drastic changes in the economy, small touches of luxury were added to higher-quality day dresses rather than the overt displays of wealth of the previous decade.

Dresses

Dresses were still more popular for daywear than other types of garments. Button-up, shirt-style dresses with blouson tops were common. Dresses designed in the early part of the decade sometimes had two waist seams: one at the natural waist and one at the hip, evidencing the transition from the earlier 1920s dropped waist. High collars or fur scarves framed the face and added a chicness to more formal daywear dresses.

Sleeves and shoulders were the focus of the 1930s silhouette. Sleeves themselves were generally full from the elbow to the wrist. Referred to as a "coat-hanger silhouette," the exaggerated shoulder was the focus for a variety of designers beginning in 1933. Pagoda shoulders, shoulder flares, tabs, and layering all added to the bulk of the shoulder. The focus on the shoulder was also emphasized by shoulder-wide collars, ruffles, flounces, wrap tops, and ruffled sleeves. Capes and cape sleeves continued to be fashionable.

Skirts became narrow across the hips, were slightly flared, and were much longer. The time of day dictated the length, and typically daywear was approximately fourteen inches from the ground, with afternoon wear approximately twelve inches from the ground. Inset triangular sections, flares, and a variety of pleats added interest to skirt shapes and emphasized movement.

Separates

In the early 1930s, ensembles were more popular than separates, but they slowly found their way into daywear (*New York Times* 1930). Knitwear,

fashions were best. As with daywear, hemlines lowered, and the ideal woman was tall and slender and wore dresses that showed her figure. Because of changes in the economy, women were encouraged to remake their dresses to extend the life of the garments.

Dresses

"Town and country dresses" were meant for business, shopping, and other similar outings. The classic shirtwaist dress (a dress with a shirt-style, button-down bodice) was popular, as were blouse frocks and jacket dresses. The blouse dress resembled a skirt and blouse but was in fact a single garment made of two fabrics, usually in a twin print or a solid with a complementary print. The jacket dress was a tailored frock with a matching jacket. As the decade progressed, the jacket changed as trends shifted. Initially the hip-length and boxy jackets were beltless, but eventually a belt was added at the natural waist. Boleros also became popular toward the latter part of the decade, and the ensemble was trimmed with a waist sash. Chanel's little black dress, as introduced in the 1920s, now became practical work wear. It was now made with removable collar and cuffs for easy laundering.

A variety of collars were typical, but the Peter Pan, shawl, and Chelsea were among the most popular. Collarless V necks were also popular for summer wear. Sleeveless and short-sleeved shirtwaist dresses were practical for summer, and long fitted sleeves ending in more formal French cuffs were acceptable for winter wear.

Suits

Suits, too, were an important part of business fashion for women. Led by MGM costume designer Gilbert Adrian and actress Joan Crawford, suit jackets of this period favored a masculine silhouette. The trend for broad shoulders was emphasized by the use of shoulder pads. Single- and double-breasted jackets with increasingly wide lapels emphasized the narrow waist. Throughout the decade, capes were frequently attached at the shoulders for added warmth and style. Shawl and notched collars, as well as collarless jackets, were also prevalent.

In the middle part of the decade, jackets with an inverted pleat at the back became popular, following the trend in men's wear. Sleeves varied, and popular styles included straight fitted, pleat-top, raglan, and pouch style (or bishop sleeves).

Although suits with skirts were the norm, Hollywood starlets such as Marlene Dietrich, Greta Garbo, and Katharine Hepburn frequently wore wide-legged pants suits as early as 1932. For the less-adventurous woman,

The Marriage of the Duke of Windsor and Mrs. Wallis Simpson. Despite the emphasis on marriage as a practical necessity in the 1930s, the most famous wedding during this era was famous because it was an impractical marriage. The Prince of Wales became King Edward VIII on January 20, 1936, but he abdicated to marry the woman he loved, an American divorcee named Wallis Simpson. Their marriage was a civil ceremony at the Chateau de Conde in France held on June 3, 1937. The gown worn by Simpson has been described as one of the most copied dresses in fashion history. Designed by Mainbocher, the first American designer to open a salon in Paris, the gown was of a special blue-gray crepe that would become known as "Wallis Blue." It was developed specially to complement the bride's eyes (Laubner, 2000).

According to researchers at the Metropolitan Museum of Art, copies of the dress were available at major New York retailers such as Bonwit Teller, Lord & Taylor, and Klein's just one week after the nuptials. These ranged in price from $25 to $9, although the original had cost $250. Shortly thereafter, copies were available nationwide (Metropolitan Museum of Art, n.d.)

Now known as the Duke and Duchess of Windsor, the couple would remain tastemakers and trendsetters during this and later eras. The Duchess in particular became something of a style icon, known for wearing such haute couture designers as Balmain, Schiaparelli, Paquin, Molyneux Lelong, Ferragamo, and others.

Decorative Details

Smooth, bias-cut textiles such as satin and charmeuse were being used for the more sculptural gowns, whereas the bustled romantic gowns were frequently made of silk, taffeta, velvet, and tulle. Sometimes these were woven with threads of cellophane for added sparkle. Special-occasion gowns, such as wedding dresses, were often made in the romantic style and were decorated with vast amounts of silk and lace to add volume to the wearer's figure. Despite this rich display of wealth, in 1932, Coco Chanel introduced a collection of evening gowns of cotton in an effort to increase the affordability of her creations.

BUSINESS WEAR

Silhouette

The silhouette for business of course followed the changing trends of the decade, although as in previous years, simple, unfussy, and practical

Full-length, slightly flared evening gowns with natural waistlines were standard.

Designers such as Coco Chanel and Madeline Vionnet continued to be influential. In particular, Vionnet's innovations in bias cut and her interest in classical Greek dress left their mark on 1930s eveningwear. Film costumes also inspired the silhouette. In 1932, Joan Crawford wore a full-length white gown with large puffed sleeves designed by Gilbert Adrian in *Letty Lynton*. Copies of the dress sold well. Ginger Rogers' film costumes of the 1930s also impacted fashion's appetite for glamorous eveningwear.

Skirts

The full-length, voluminous skirts of this decade required more fabric to make than in the previous decade, and designers used a variety of techniques to create the nineteenth-century look. Cutting, padding, and lightweight hoops or crinolines were used, and bustles or bows were placed at the back for added effect. Skirts were also often decorated with threads of cellophane to add sparkle and shine. Bias-cut dresses frequently had inset fabric sections such as fan pleats or triangular insets to add movement to the skirt.

Bodices

In contrast to the loose styles of the previous decade, the 1930s waistline focused on a fitted bodice and the natural waist. Some gowns were even corseted, whereas others bloused slightly. Belts were also more common in eveningwear.

Neckline

Deep Vs in the front and back, cowels, and similarly draped necklines were prevalent and attractively complimented the new curve-hugging silhouette. Necklines also frequently featured a draping scarf or sash to be wrapped or left trailing. Backless gowns and bare shoulders were also popular.

Sleeves

Variety was the name of the game for sleeve styles on evening gowns. Cape sleeves were popular, as were gowns without sleeves. Backless gowns frequently featured halter necks and were held up by thin or wide shoulder straps. As the decade progressed, full-length tailored sleeves with ruffled edges and slight shoulder padding became popular. Beginning in 1933, however, the exaggerated shoulder took hold and progressed into all manner of variations.

influenced by Ballet Russe versions of Asian styles, including carved jade, ivory, and bone. Egyptian motifs and shapes, especially the scarab, followed the opening of King Tut's tomb in 1922. A decorative arts exhibition in Paris in 1925 introduced geometric art deco shapes and materials such as Bakelite, marcasite, and pearls. The women of the 1920s were also the first to wear wristwatches.

Handbags

Primarily used during daytime activities, hand-tooled brown and black leather bags, as well as envelope-style Pouchettes, were popular. Daytime cloth reticules, which was a pouch with drawstrings, were often handmade. Reticules were sometimes beaded as well and worn with eveningwear. Metal mesh and beaded bags were typically used for special occasions. Vanity bags were also popular for holding makeup.

Miscellaneous Accessories

The dropped waist focused attention on the hips and, consequently, belts. By mid-decade, a wide sash or gypsy girdle was used with daywear and eveningwear and was accented with a metal or Bakelite clasp. Other popular accessories of this era included ostentatious feather fans, often made of ostrich, and silk muslin umbrellas with appliqué. Despite prohibition, drinking and smoking accessories continued to be popular and reflected the interest in art deco and Bakelite.

1930s,

THE GREAT DEPRESSION

The Great Depression effectively froze the silhouette for the decade, because most women could not afford to update the wardrobe. The sluggish economy and unemployment of the Depression permeated social and cultural life and lent its name to the decade.

FORMALWEAR

Silhouette

In direct reaction to the previous decade's more masculine fashions, a feminine mood took over in the 1930s. Softer, sculptural clothes now accentuated the contours of the female form. By 1934, a romantic mood had taken hold, and women began wearing mid- to late-nineteenth-century-style gowns, complete with crinolines, bustles, and rustling fabrics.

Miss Mary Jayne, with a bob haircut and T-bar shoes. [Library of Congress]

fashions of these and other designers were a direct reaction to the recent lean and somber war years.

Legwear

The new hemline not only exposed the shoe as a focus of fashion but afforded the same attention to women's legs. In the previous era, women had worn stockings in either black and white, but flappers of the 1920s wore shocking new flesh-colored and sheer silk stockings. There were a variety of fads associated with stockings, including wearing them rolled down to the thighs. Plain-colored stockings in neutral shades were preferred for daywear and eveningwear. The most flamboyant stockings included crossword-puzzle-patterned stockings, tartan, and checked designs and were worn with sportswear.

OTHER ACCESSORIES

Jewelry

Iconic jewelry trends of the 1920s included long necklaces of pearls and beads, as well as fake (or costume) jewelry. In general, jewelry styles were

Greta Garbo wears a page-boy bob, fashionable in the 1920s and into the 1930s. Garbo was among the most-admired actresses for her style. [Courtesy of Photofest]

FOOTWEAR AND LEGWEAR

Footwear

The rise in hemlines during the 1920s resulted in a renewed interest in shoe design. Beginning in 1922, tongues and Cuban heels became fashionable for sports and walking shoes. By 1924, the dance craze necessitated T-bars or crossover straps. In combination with this, pointed toes were standard. After 1926, shoes became lighter and more delicate. Day shoes were generally made of two-tone leather or reptile skin. Evening shoes were high heeled, were brightly colored silks or gilded kid, and were embellished with embroidered or brocaded fabrics. They also featured highly decorative heels and buckles encrusted with semiprecious materials, including pearls, diamante, and sequins.

Shoe styles were influenced by the Exhibition of Decorative Arts in 1925 in Paris and showed Greek, Asian, and Egyptian motifs. The most coveted of the fantastical and exotic designers of the 1920s include French shoemakers Andre Perugia and Hellstern and Sons. The extremely ornate

Louise Brooks' straight-haired bob, c. 1929. [Courtesy of Photofest]

also began looking to permanent waves to enhance their newly shortened locks, and others added a single curl fixed to the face with setting lotion. Film had its influence, too, and frequently women imitated the looks of their favorite film stars. Claudette Colbert's bangs and Louise Brooks' bob had significant influence in hair salons.

Cosmetics

For the first time, the overt use of cosmetics became commonplace. The new fashionable woman was, for the first time, frequently seen applying lipstick in public, something that was shocking to the previous generation. Clara Bow's cupid-bow mouth, created by Hollywood make-up artist Max Factor, caused a sensation. Innovations in technology allowed for greater effect, including the invention of the first eyelash curler in 1923. The eyebrow pencil also began its rise in popularity in the latter part of the decade, when Greta Garbo's makeup style began to influence the general public.

Sleepwear

Sleeping pajamas had an Eastern flare and were typically sleeveless, V-neck tunics combined with wide-leg pants. Coolie coats, or kimono-style robes, were frequently worn over pajamas. Simple, unfitted ankle-length nightgowns had square or V-shaped necklines. Blanket-cloth robes, surplice robes with Eastern and art deco prints, were also common.

Other garments included combing sacques, a luxury item worn when applying makeup or when having hair styled, kimonos, hostess coats, and boudoir caps and bandeux.

Other garments

Hose were of particular interest to fashionable young ladies and were available in a variety of patterns, colors, and materials. Ornamental jazz garters were frequently worn by flappers to accentuate their legs while dancing. Union suits or long johns were practical one-piece undergarments worn by both sexes for warmth rather than style.

Fashionable Mlle. Rhea wears a cloche hat, Cuban heels, and a flask in her garter. [Library of Congress]

HEADWEAR AND HAIRSTYLES

Headwear

Although the cloche hat was by far the most popular hat style of the 1920s, it was by no means the only style available. The toque, berets, boaters, turbans, and drape-crowned hats also typified the mode. After the release of the 1923 film *The Three Musketeers*, Musketeer-style hats became popular. Because the basic shapes changed little over this decade, variation was derived from the decorations. Flowers, lace, tulle, and netting were all popular. The toque provided the perfect platform for three-dimensional art-deco-style trim.

Hairstyles

Hat and hair shapes were closely linked, and both followed the streamlined shape of the youthful, androgynous bob. Brilliantine added sleekness and shine to variations such as the shingle and the Eton crop. Women

UNDERWEAR AND INTIMATE APPAREL

Undergarments

The boyish silhouette of the 1920s required special undergarments. Generally, a single piece of fabric, called a bandeau, was used to flatten the bust. Corsets and girdles were still heavily boned. Corset substitutes were made of softer elastic and referred to as "step-ins" (Laubner 1996). Specialty corsets were created for wear during sports, dancing, and even pregnancy. Toward the end of the decade, as a natural shape became more popular, brassieres with cups and mild shaping were developed.

Loose-fitting bloomers or knickers were made of silk or rayon and were gathered just above the knee. They came in a number of forms, including one-piece camiknickers, teddies, step-ins, or just plain drawers (which resembled slightly flared, bifurcated skirts). During the early years of the 1920s, calf-length petticoats were worn, but, as hemlines rose, these garments were rendered obsolete.

A young woman in camiknickers. [Library of Congress]

were worn by both throughout the decade. From 1921 on, Lenglen wore white tennis ensembles designed by popular sportswear designer Jean Patou. This usually consisted of a wide bandeau worn wrapped around her head with a below-the-knee pleated shift dress that showed the top of her rolled stockings. She occasionally wore a sleeveless monogrammed cardigan. Beginning in 1927, Hellen Wills consistently wore a visor or "eye-shade" with a white skirt and shirt also by Patou.

Although both wore head coverings, by the end of the decade, it was acceptable to play tennis bare headed. Patou further paired down tennis fashion by designing sleeveless tennis dresses with raised hemlines. Sometimes tennis suits had a matching cape, often made of flannel for warmth.

Although white was traditional for tennis, other light or pale colors were used as well. Initially, sportswear designers experimented with wool and jersey for tennis but eventually settled on more practical washable silks and crêpe de Chine.

Skiwear

Skiing outfits for women consisted of a sweater and/or tunic with breeches or jodhpur-like trousers, usually in a waterproof material. Tweed, plaid, and camel hair were initially popular, followed by gabardine. White was considered inappropriate for mountain slopes. Blue and red were initially favored, followed by more subdued colors such as gray and beige. Mittens were frequently made of waterproofed leather, calf-skin, and horse hide. Hats and scarves with fur trim were essential for warmth.

Golf

Short skirts and knickerbocker golf suits with medium-length coats were deemed appropriate for golf beginning in 1921. The coats were paired with loose, full, knee-length pants that gathered at the hem. Decorative pleats were frowned upon, and only inverted pleats at the side or front to facilitate movement were acceptable. White was also forbidden for golf, although jersey and tweeds were frequently used.

Other Activewear

Other popular sports during this time included ice skating, driving (or motoring), flying, hunting, fishing, and horseback riding. Each had their own uniform. A bifurcated skirt or culottes was acceptable for ice skating, and generally one-piece garments were preferred. For motoring, practicality required protective headgear and goggles along with a large military-style overcoat. Similar outfits were designed for flying. For most of these fringe sports, it was accepted that women would adopt masculine-style garments.

A 1947 photo of various swimsuits. [AP/Wide World Photos]

An evening dress with lobster print, designed
by Elsa Schiaparelli in collaboration with
Salvador Dali. [AP/Wide World Photos]

Mens' Army uniforms during World War I. [Library of Congress]

A Gibson Girl in evening dress, with décolletage neckline and pompadour hair style, c.1901. [Library of Congress]

A 1910 advertisement for mens' shirts. [Lordprice Collection/Alamy]

An American fashion ilustration from 1935 shows men enjoying after-dinner brandy and cigars. [Lordprice Collection/Alamy]

An advertising postcard for Abel Morrall's Hat Pins, c. 1905 [Amoret Tanner/Alamy]

Shirley Temple in the 1939 film *The Little Princess*. [Photofest, Inc.]

Socks were colorful during the 1940s. They came in argyle, chevron, and diamond patterns. Elastic was added to the tops of socks, so garters were no longer necessary. [Lordprice Collection/Alamy]

Examples of girls' and boy's clothing in the 1940s. [ClassicStock/Alamy]

A day suit, c. 1909. [Mary Evans Picture Library/Alamy]

A Chinese influenced black dress by Madeleine Vionnet, 1923.
[Mary Evans Picture Library/Alamy]

Stylish tunic dresses worn with fur stoles, 1915.
[Mary Evans Picture Library/Alamy]

Jantzen bathing suits, 1948. [Mary Evans Picture
Library/Alamy]

Womens' swimwear in 1918. [Scala/Art Resource, NY]

Two flappers gossip at a bar, 1928. [Mary Evans
Picture Library/Alamy]

Dress (Robe de Style), 1924-1925. [The Metropolitan
Museum of Art/Art Resource]

At the beginning of the 1920s, there was concern about swimwear being too short and skimpy. Here, a bathing suit "policeman," measures the distance between knee and bathing suit, Washington, DC. 1922. [Library of Congress]

Suits were made of knitted fabrics in an array of cubist-inspired geometric patterns and stripes. For two-piece suits, tops and shorts matched or contrasted (often with a printed top and solid trunks). Beach ensembles were of contrasting bright tones, such as orange with green or bright red with yellow or, alternatively, white with dark trim.

With the loss of material covering the body, the need for cover-ups arose. These initially included matching capes, shawls, and coats that were highly tailored. In 1927, wide-legged beach-pajamas were introduced and first appeared in bright oriental prints that matched or complemented swimsuits. Wide-brimmed beach hats were also popular, as were tight-fitting swimming caps. Shoes worn on the beach were flat and generally made of rubber or canvas.

Tennis

In the 1920s, tennis moved from a participant to a spectator sport. Consequently, tennis fashions were significantly influenced by star competitors such as Suzanne Lenglen and Helen Wills. One- and two-piece garments

King Tut Sparks Fashion Inspiration. When Howard Carter discovered King Tutankhamun's tomb in November of 1922, he had no idea about the fashion craze that his discovery would inspire. Within weeks, fashion designers had incorporated Egyptian motifs into their designs, and women started snapping up Egyptian-themed dresses, coats, and accessories. Stylized Egyptian motifs, such as scarabs, lotus blossoms, and sphinxes, were incorporated into garments. For example, in a design contest held by the United Cloak and Suit Designers' Association of America, the garment that won the top prize in 1923 was a wrap that included an Egyptian hathor, or sacred cow, created from beads, a scarab design, and colors inspired by those found in Tutankhamun's tomb.

Lighter outerwear, including the highly popular Spanish and Russian embroidered shawls, were fashionable for summer. These shawls were embroidered with floral and folk designs and trimmed with fringe. Frequently, they were worn over robe-de-style gowns. Shawls were imported from Lyons, India, China, and Russia throughout the 1920s and into the 1930s (Mendes and De La Haye 1999). Alternatively, Assuit stoles of exotic linen were imported from Egypt. Made in the town of Assuit, they were rectangular linen net decorated with metallic pieces in geometric art deco patterns.

Other garments
Other evening outerwear included ostrich-feather boas with long silk tassels in dark colors. Worn between 1920 and 1925, they had been trendy garments during the teens.

SWIMWEAR/SPORTWEAR

Swimwear
By 1920, sunbathing was the height of fashion, necessitating an extensive beach wardrobe requiring careful planning. The style of swimwear now exposed a considerable amount of skin to the sun and public view compared with previous decades. Swimwear followed the silhouette of the decade, with belts worn at the dropped waist. Knitted two-piece tubular suits were popular at the beginning of the decade, consisting of long tunics over straight-legged shorts, emphasizing the hipline. One-piece suits grew in popularity as the 1920s progressed. More skin was exposed as sleeves were eliminated and trunks shortened to mid-thigh. Some suits had short overskirts, but those were generally abandoned by mid-decade.

Misses Edith and Irene Mayer, wearing fur and fur-trimmed coats. [Library of Congress]

an overall wedge shape. Sleeves were set in and had deep cuffs. Convertible collars added interest and were broad or cape-like when opened and when closed were choker or high standing, acting to further insulate against the cold.

As the decade progressed, the silhouette of women's coats progressed, too. When the hemline dropped, belts disappeared from coats altogether. Unbelted, straight-cut surplice coats became popular beginning in 1923. These slender and tubular coats combined collar and lapel, and the back portion of the collar was normally worn up. The right side of the coat typically overlapped over the left and was fasted at the side with a single button. Coats often featured batwing and bell sleeves.

At mid-decade, a shorter coat became popular. Double-breasted, knee-length coats had godets at the hem, causing a slight flare. Notched and shawl collars were equally popular. Surplice coats continued to be popular throughout the decade, with variation in fabrics and trim adding interest.

Cloth coats were made of wool, velveteen plush, and velour in colors including black, gray, brown, tan, rust, and cranberry. Toward the end of the decade, art deco patterned fabrics were common, as was art deco-style trim. Collars and cuffs were also frequently trimmed with "oriental buttons," tassels, and especially fur.

Also in the 1920s, fur coats moved from the luxury class into the general wardrobe. Sears catalogs even carried short fur coats. Fur pieces were frequently worn over cloth coats as a symbol of wealth and status. The most popular furs for coats were ermine, sable, and chinchilla, and mixing fur types was common (Municchi 1996).

Shawls/Wraps

During the 1920s, wide-sleeved evening wraps and capes of luxurious fabrics were worn over eveningwear. Kimono, dolman, and batwing sleeves were popular with designers such as Poiret and Doucet. In addition to collars similar to those seen in daywear coats, high funnel collars were stylish. Silk, velvet, satin, and metallic brocaded garments were trimmed with metallic braid, embroidery, tassels, and fur.

until 1924, and by 1925, they had risen to the knee. Although hemlines remained here for the rest of the decade, intrigue was created through irregular hemlines such as handkerchief hems, asymmetrical draping, and diamond-shaped pieces. Rows of flounces and gathered layers were also fashionable. Beginning in 1929, however, hemlines dropped dramatically.

Separates

In general, separates were not yet a popular form of daywear, and women generally wore ensembles purchased together. However, trousers became a focal point during this period. Initially introduced as fashionable women's wear in 1922 by Paul Poiret as pajamas, they eventually evolved into casual wear worn for specific occasions, such as sleeping, lounging, and at the beach. Lounging pajamas, according to *Vogue*, were for "when informal entertainments and masquerades are the order of the day" (Watson 2004, 42). Chanel helped with the general acceptance of women's trousers and was often seen wearing sailor-style pants. Pants of this era were loose with an elastic or drawstring waist with a side closure.

Decorative Details

Popular colors of the decade included coordinating tones such as "sunset orange," "Nile green," "maize," and various shades of blue (French, Copenhagen, or gracklehead) (Laubner 1996). Prints were also popular. Thanks to Chanel and her little black dress of 1926, black dresses in crêpe, wool, and other matte fabrics were popular for daywear. Worn during household chores, cotton housedresses were made of broadcloth, Indian head cloth, and gingham. After 1926, rayon began to be used for daywear as well.

Embroidery was a popular form of ornamentation during the decade and was frequently executed in silk, with tiny beads and in natural motifs. In the early twenties, braid trim or ribbons were frequently used in floral and scroll work. After 1925, art deco motifs became popular decorations. Flowers made of silk or velvet were also often placed at the shoulder or hip. A more cost-effective decoration was accomplished by focusing on seaming itself as decoration. Additionally, fringe was often added to dance dresses to emphasize movement. Other hemline trimming including picot edging used at the edge of sheer dresses.

OUTERWEAR

Coats

Coats of the early 1920s showed remnants of the previous decade's silhouette. They were high waisted, often gathered under the bust with a self-fabric, crisscrossed belt. Hemlines ended below the calf, and skirts slightly flared to create

Between 1923 and 1924, hem lengths dropped all the way to the ankles, and hip-length boxy suit jackets followed the general trend toward a lowered waistline. Also during this time, Coco Chanel introduced her most well-known suit. It consisted of a collarless, square-cut jacket trimmed in contrasting braid, paired with a matching straight skirt. The quilted silk lining of the jacket was meant to match the blouse. Chanel's signature suit also contained a chain inside the hem of the jacket to weight it.

From 1925 until the end of the decade, both single- and double-breasted square suit jackets were the norm, although jackets that met at the center front, held together by a toggle, were also popular. Jackets were paired with straight-cut, knee-length skirts.

In general, cardigan suits of knitted jersey were a staple in women's closets. Typically, suits of the 1920s were made in subdued colors such as navy, tan, brown, and black. White pinstripes were frequently seen as well. Trimming was minimal, although in the latter half of the decade, fur pieces sometimes adorned shoulders for added glitz.

CASUAL WEAR

Silhouette

During the 1920s, in part because of a renewed interest in sports and increasing wealth, the upper class became interested in fashionable casual daytime wear. Casual wear generally followed the youthful trend for the flat-chested garçonne look. Straight cuts with little shaping and a dropped waist gave the effect of slenderness. Chemise dresses that hung from the shoulder were popular, although in the middle part of the decade, fashions became more slender and streamlined. Beginning in 1927, bias cuts were introduced, and the technique would continue to be favored into the 1930s. Art deco also had its influence on fashion of this period and frequently manifested in geometrical decoration.

Dresses

At the end of the previous decade, the waistline was just under the bust, but it quickly dropped. From 1922 through the remainder of the decade, it remained at the hips. The bodice of the twenties was loose fitting and had minimal if any darting. Necklines were square, boat, or V neck. Bell and cap sleeves were light and airy. Bias-cut cape collars and cape sleeves remained popular into the 1930s.

Hemlines for daywear in the early part of the decade were frequent. From 1920 to 1922, hemlines were just below the calf, then at the ankle

de Chine, silk satin, and charmeuse were used throughout the 1920s for evening finery. Solid, quiet colors such as ivory and peach were preferred to show off the sparkling decorations and trims. When patterns were used, they were generally small and scattered to complement the asymmetrical design, bias cuts, and pieced garments.

Coco Chanel's little black dress of 1926 promoted black as elegant for eveningwear and was usually made of velvet, silk, or satin, with diamante trim. Although initially introduced earlier in the decade, rayon became an acceptable fabric for eveningwear by 1926 (Mendes and De La Haye 1999).

BUSINESS WEAR

Silhouette

In the 1920s, "businesswomen" were advised to pay careful attention to the difference between social and working dress. According to *Vogue*, "We must stoutly protest that the sport, garden party or reception dress is out of place in the shop or office. Short sleeves do not look well for such wear, ever. Elbow-length is permissible, but the really short sleeve is bad form and the sleeveless street gown is unspeakably vulgar" (Watson 2004, 44). Muted colors and simple fabrics were also advised. Generally, business wear walked a line between formal social attire and at-home "work" wear, combining simplicity and functionality with chicness.

Dresses

Where dresses were appropriate, they resembled women's morning or housedresses. In the early 1920s, these work dresses had waist yokes and raglan sleeves. Overskirts created an apron effect, and pockets were a must for practicality. Similarly, three-quarter-length sleeves were useful. These dresses were made of serge, tricotine, and gabardine. Although satin was sometimes used, trimming was kept to a minimum so as not to appear "fussy" (*Washington Post* 1920).

Suits

The 1920s saw the rise in popularity of the suit, consisting of a dress and matching jacket, or of the more familiar three-piece variety, with a skirt, blouse, and jacket. Throughout the decade, the skirts of the ensembles were slender and had knife or inverted pleats.

During the first few years of the 1920s, wool suits were the most popular and consisted of a calf-length tunic-like dress or skirt worn with a thigh-length unfitted jacket. Decoration on these early suits usually included Chelsea and notched collars and a number of belts, crisscrossing over the jacket.

often referred to as the garçonne or "flapper" look and was associated with a boyish figure. Epitomized by Coco Chanel's "little black dress," it was popular from 1926 through 1929 (Mendes to De La Haye 1999).

Skirts

During this time, hem lengths were the same for day and eveningwear but varied throughout the decade. In the early twenties, hems were two or three inches above the ankle, dropping to ankle length in 1923 and 1924, and rising to the knee in 1925. Hems stayed high until 1929, when they suddenly dropped back down again.

Although skirts were straight cut and tubular, interest was added through a variety of creative attachments. Panels, handkerchief squares, asymmetrical draping, and scallops all created the irregular hemlines that were popular throughout the decade.

Bodices

Complementing the romantic styles of the early 1920s, the waistline was placed slightly above the natural line but quickly moved down to the hips to complement the flapper look in 1922. Generally, unstructured blouson bodices were popular, and the waistline was trimmed with a wide sash and bow or with excess fabric draped and pinned on one side.

Neckline

For the romantic robe-de-style, the neckline was usually a shallow boat neck, often trimmed with lace. For the more iconic garçonne shape, eveningwear was typically very low cut in the front and/or the back in either a U or V shape. Designer Madeline Vionnet offered alternatives such as the halter or cowl neckline. Other alternatives included a square, untailored shape that cut across the top of the chest.

Sleeves

Picture dresses varied but frequently featured tight-fitting long sleeves of diaphanous material with a single ruffle at the cuff. Evening gowns with garçonne styling were sleeveless or had thin shoulder straps.

Decorative Details

For both the earlier and later silhouettes, high-quality materials and decorations epitomized formal eveningwear. Sparkling fabrics and decorations were particularly popular, especially beading and gold and silver lamé. Metallic embroidery, diamante, and rhinestones were also favored trims. Luxurious fabrics such as brocaded silk, metallic lace, chiffon velvet, crêpe

Around 1916, party boxes were sold as an evening alternative to handbags. Party bags were hard-sided rectangular metal cases that hung from short chains or a strap. Both sides of the case could open to reveal neatly organized compartments for a variety of essential items such as powder and puff, pins, coins, comb, mirror, lipstick, calling cards, nail file, and perfume.

Other Accessories

Women wore both flat and round fur muffs, along with animal-style boas, which included the animal's head and tail. Plain fur scarves with fur tassels were fashionable later in the decade.

Fabric sash-style belts were a common accessory. Elastic webbing usually served as the base beneath the fabric, and the belt was secured with a buckle or hook fasteners. Bows, buttons, buckles, and silk flowers were used to adorn the front of the belt.

Women carried umbrellas and wore fitted leather or fabric gloves.

1920s,

THE JAZZ AGE

Aside from the transition from the WWI silhouette to the characteristic 1920s silhouette, styles remained relatively consistent during the 1920s. The decade was dubbed the Jazz Age because of the popularity of the music style and the emphasis on parties and dancing during the decade.

FORMALWEAR

Silhouette

The early 1920s silhouette focused on the romantic robe-de-style or "picture dress." Based on historical styles, features of this shape included a boned bodice, an ankle-length oval skirt supported by panniers, and a broad neckline (Laubner 1996). Resembling a romantic shepherdess, the gowns were frequently made in pastel colors and decorated with ribbons. Designers such as Lanvin and Lady Duff Gordon (Lucile) focused on this shape and created dresses using silk taffeta, organdy, velvet, or satin.

Generally, however, evening gowns of the twenties were ankle-length, straight-cut sleeveless sheaths worn over colorful slips. They often had a dropped waist with geometric inserts, draping, and were low-cut in the front, the back, or both. Gowns were frequently cut on the bias and featured asymmetrical piecing. This straightened and flattened silhouette was

Cosmetics

Women still wore pale face powder, but they began wearing peach-colored rouge instead of pink. During the war, cosmetics became more difficult to find. Women used the end of a burnt match to darken their eyebrows and beetroot juice to tint their lips.

FOOTWEAR AND LEGWEAR

Footwear

During the last half of the 1910s, footwear became more visible with the rising hemlines. Although high button shoes kept feet warm in cold weather, low shoes became more widely worn. They were usually secured to the foot with a strap across the vamp that buttoned on the opposite side. By 1918, oxfords had become very popular, and low shoes without straps were widely available.

Both blunt and pointed toes were common. Heels were made from a variety of materials, including wood, celluloid (an early plastic), and rubber. Evening shoes had elaborate lattice straps with decorative stitching or decorative buckles.

Legwear

As women had done in the previous decade, they wore dark cotton stockings during the day and light-colored silk ones for formal occasions. Rayon stocking were introduced as artificial silk.

NECKWEAR AND OTHER ACCESSORIES

Jewelry

Women wore drop earrings and long necklaces made from chains and beads. Necklaces were often wrapped around the neck a few times. For formal occasions, women would wear tiaras. Hat pins and scarf pins were used to secure those accessories. Brooches were worn on blouses and jackets. Both pocket watches and bracelet-style wristwatches were worn.

Handbags

Handbags consisted of fabric or leather pouches attached to a metal or ivory frame, which had a clasp to keep the bag closed. Also attached to the frame was a short strap made from leather or fabric or a metal chain, which allowed the bag to be worn on the wrist. Most of the embellishment was on the metal frame. Some purses had beaded pouches that were finished with tassels.

During the war, heavy duties had been placed on imported garments, and retailers tried to avoid having duties imposed on the goods they imported. Marshall Field and Company was no exception. They tried to skirt the duty on embroidered garments for a shipment of nightgowns, but a customs ruling found them dutiable at 50 percent (*New York Times*, December 4, 1915).

HEADWEAR, HAIRSTYLES, AND COSMETICS

Headwear

By 1915, women's headwear featured high, wide crowns with relatively narrow or upturned brims. The trimmings continued to be the focal point of the hat. Silk roses, feathers, wide ribbons, and artificial flowers were all piled along the crown of the hat. Face veils were fashionable during this period. Within a couple of years, brims widened and trimmings were usually limited to a wide ribbon hatband with a large bow.

Hairstyles

During this period, hair was worn closer to the face as women moved away from the full pompadour style. By the end of the decade, women built height in the hair at the back of their head and arranged their hair forward over their ears on the sides. They continued to wear their hair up in a bun or chignon. Some women experimented with permanent waves. They used hairpins and decorative barrettes to secure their hairstyles.

Mascara. Modern mascara has its origins in another product: Vaseline. After learning about a waxy petroleum byproduct that clogged oil-well heads, chemist Robert Augustus Chesebrough marketed a purified version of the substance under the name Vaseline in 1872. By the end of the nineteenth century, Vaseline was a common product in most American households.

This versatile substance was used in a variety of ways, including treating cuts, softening hands and lips, preventing rust, polishing wood, and baking. Women, eager for an easy way to darken their eyelashes, mixed Vaseline with coal dust or lamp black, which was acquired by holding a saucer over a lit candle until it got sooty. Thomas L. Williams learned of this trick and began selling the mixture under the name "Lash-Brow-Ine" in 1913. It was immediately popular, and he rechristened the product "Maybelline" after his sister Mabel. Maybelline is now a subsidiary of L'Oréal.

cotton, loose-fitting tunic. These blouses were worn with skirts for a wide variety of athletic pursuits. Usually, the collar was a sailor collar with a necktie beneath it, but sometimes stylized notched collars were used. The blouses had three-quarter-length or full-length loose sleeves. These functional garments usually had patch pockets on the front. By 1918, loose belts were added to the blouse.

Skirts were full but narrower than everyday skirts. They were shorter, coming an inch or two higher than mid-calf. They usually had pockets but few other adornments.

Skiwear

American women were expected to wear skirts while skiing as a way to retain their modesty and femininity in an unfeminine sport. They usually wore long, full wool skirts with sweaters, although their European counterparts wore more sensible pants.

Other Activewear

For horseback riding or cycling, women wore dresses or skirts with divided skirts. Some styles obscured the skirt division with a flap that could be unbuttoned in the front. Norfolk-style jackets, middy blouses, and other blouse styles would be worn with the skirt.

UNDERWEAR AND INTIMATE APPAREL

Undergarments

Most corsets ended below the bust, so a new garment had to be developed to support the breasts. The brassiere emerged to fill this purpose. As skirts became wider, fuller petticoats were needed to give them lift. A new combination garment was created that merged together camisoles and drawers. It was called camiknickers and featured buttons at the crotch. Women still wore union suits, especially in the colder months. Union suits were marketed as health suits because they kept germs away from one's body and perspiration off of one's clothes.

Sleepwear

Nightgowns were cut with straight long waists. They were decorated with flat panels of lace, flat bows, and lace-edged sleeves and collars. Valenciennes lace was particularly popular. White and pink batiste, a lightweight cotton fabric, were popular for summer nightgowns. During the rest of the year, silks, cotton, crêpe de Chine, georgette, and flannel were used. By 1916, flesh-colored gowns became popular.

above the knee and flared out from the waistband. Fur coats followed the full-cut, loose silhouette, and they usually featured a straight hem.

Raglan sleeves that ended in cuffs were fashionable throughout the decade. Shawl collars, collars with notched lapels, and square-back collars were all common. Silk embroidered with Asian designs was inlayed into the wide collars. Fur collars were fashionable as well. Velour, wool, fur, and corduroy were used to make fall and winter coats, while cotton, linen, silk moiré, and satin were used for spring coats.

The war's military influence can be seen in the popular copy of military trench coat. It was full cut and belted. Its straight sleeves were embellished with straps and buttons like a typical men's trench coat. Also, it had a large, stand-up collar and large patch pockets with pocket flaps. Epaulets were added to the shoulders of coats, too.

Raincoats were much longer than other coats of this period. They were ankle length to protect the garments underneath. The back was cut full and belted. Usually, they had close-fitting sleeves with cuffs, but kimono, raglan, and cape sleeves were also available. Raincoats were made from a variety of fabrics, which were coated on the inside with rubber to make them waterproof.

Swimwear and Sportswear

Swimwear

Women wore a variety of suit styles. Knit wool tank styles were worn by athletic women. These had round or V necklines, were sleeveless, and had shorts that extended to the mid-thigh. Generally, these were worn with long stockings. Most women wore woven silk or cotton swim dresses with knit wool undersuits. These suits had round or V necklines, and sometimes they had a collar. They were sleeveless or had short sleeves. They often buttoned up the front and had a belt. The skirt of the dress extended to the mid-thigh. In between these two styles there were knit jersey swim dresses. These hugged the body like the tank style but then ended in a skirt instead of shorts.

Golf

Typically, women wore wide, calf-length skirts with a middy blouse or a pullover sweater to play golf.

Tennis

To play tennis, women would wear middy blouses and loose full skirts. A more casual style of blouse, the middy blouse, or middy coat, was a sturdy

narrow or wide. V, round, or square necklines were common, as were Medici, fold-over, and sailor collars.

Compared with the previous decade, the blouses of this period had simple embellishments. Necklines and cuffs were trimmed with ruffles or lace. Embroidery, pleating, and buttons were frequently used to decorate blouses.

In 1918, a bohemian-style blouse became popular. This garment was loose fitting with full sleeves that gathered into a cuff. The yoke of the blouse was embroidered with bohemian designs. Sometimes this blouse was worn tucked in, whereas it was worn as a belted tunic at other times.

Pants. When the United States joined WWI, overalls were marketed to women because they took up many of the jobs and chores of men who left to serve in the war. Made from heavyweight chambray, overalls were loose fitting and belted at the waist. The full, loose pants gathered into narrow, buttoned cuffs at the ankle. They were available in one- and two-piece versions. One style, which was worn with a blouse, had a round neck and two straps that crossed in the back. Other versions could be worn without a blouse. These came in a variety of styles, including long sleeves, short sleeves, V necks, and collared. Invariably, they had large patch pockets on the front of the pants. Solid blue and tan were popular colors, but many styles came in stripes and checks.

Skirts. Skirts sat high on the waist and usually did not have a waistband. The wideness of skirts at the hip was accentuated by overskirts that reached a variety of lengths from mid-thigh to mid-calf. Sometimes pleating at lower leg was added for enhanced ease of movement. Commonly used as trim, rows of buttons were arranged in various places on the skirt, including the side, overskirt, underskirt, and near the waist.

Other Separates. Sweaters gained popularity during this period. Although cardigan styles had been commonly worn for some time, pullovers became popular in 1915. They had a straight fit, were belted at the hip, and had long sleeves. Coco Chanel is credited for popularizing pullovers (Tortora and Eubank 2005).

OUTERWEAR

Coats

In general, coats grew wider to accommodate wide skirts. As skirt hems began to flare out at the end of 1915, coat hems followed the trend. Most were cut full, but many had loose belts or belts along the back. Ankle-length coats were fashionable in 1914, but three-quarter-length coats became popular in 1916. By 1918, sport-length coats were popular as well. These ended

frequently used for trim. They were arranged in rows on belts, suit jackets, and skirts.

CASUAL WEAR

Silhouette

During the war, women's dresses became wider and shorter. By 1917, the hems were as far as eight inches from the ground (Tortora and Eubank 2005). They had loosely belted waistlines that were placed at the natural waist or slightly above. Skirts were wide at the hip. In the last two years of the decade, the waistlines grew wider, skirts narrowed, and hemlines lengthened.

Dresses

Casual dresses had easy-fitting bodices and loose-fitting belts or sashes around high waists. Necklines were V-shaped or squared, and sailor collars were popular. Typically, sleeves were close-fitting and had cuffs.

Skirts were ankle length or shorter, and they were gored, pleated, or gathered to add to their fullness. Overskirts added fullness to the skirt. Although most overskirts went completely around the body, some only extended over the side and back. Some overskirts had handkerchief hems, and others were finished with ruffles or other embellishments. Skirts sometimes had pleats on the sides to ease movement.

Dresses were typically made from wool challis, wool serge, wool crepe, silk, crêpe de Chine, and moiré. Black, brown, navy blue, and dark green were common colors, although white was a popular summer color. Typical embellishments included rows of buttons on skirts and bodices and flat bows on the bodice or sash.

Housedresses were worn for work activities around the house. They were made from durable fabrics such as chambray, flannel, and cotton serge. They had a narrower ankle-length silhouette with no overskirts. They had simple turned-over collars and close-fitting three-quarter or full-length sleeves. Everything about this style of dress was more austere than regular daywear. These dresses usually came in muted colors that did not show dirt easily, such as blue, gray, and lavender. There were few trimmings beyond buttons.

Separates

Blouses/Shirts. Blouses had sleeves and yokes that were cut in one piece. Raglan sleeves were very popular because they were comfortable and allowed easy movement. Turnover cuffs were common, and they could be

BUSINESS WEAR

Silhouette

The silhouette of business wear was similar to that of formalwear: loose bodice, loose waist, and full, wide skirts. The waistline in business wear tended to be closer to the natural waist.

Dresses

After 1914, dresses became less popular that suits. Dress bodices were relaxed, and, although waistlines were loose, they were defined with loose-fitting belts. Various necklines were popular, including V-shaped, squared, and occasionally round. Sailor collars, which were extremely popular for young people, were worn by women as well. Generally, sleeves were straight and fitted. Skirts were full at the hip and the hem. The fullness was achieved through gathering, pleating, or gores supported by petticoats. Overskirts were designed into dresses to add fullness at the hip.

Suits

Because of their functional nature, suits became more popular than dresses during this period. Suit jackets were long and belted at or slightly above the waist. They had close-fitting sleeves and cuffs. In 1914 and 1915, many jackets were three-quarter length and had a cutaway hem that gently sloped back from the front. By 1916, the straight hem was more popular, and jackets had become shorter. The jacket closure usually consisted of buttons beginning below the bust.

Suit skirts were full with extra width at the hip. In 1914, they were ankle length, but they gradually shortened to mid-calf length by the end of the decade. Initially, skirts were somewhat narrow at the hem, but, by 1915, the fullness that started at the hip continued to the hem. The skirt waist was raised slightly above the natural waistline. Overskirts and tiered skirts added fullness, and gores and pleats were used to flare skirts out at the hem.

The Norfolk jacket became popular for women. This hip-length jacket had close-fitting sleeves, a simple, notched collar, and a loosely belted waist. Often it had two vertical bands extended from the hem, over the belt and shoulder, and ended at the hem on the opposite side. Many women wore military-style jackets with a high, standing buttoned collar, a row of metal buttons down the front, and a belt.

Decorative Details

Suits were usually made from wool or cotton in serge, crepe, or jersey weaves. Popular colors included navy blue, brown, black, dark green, and tan. Many suits had contrasting color fabric on the lapels. Buttons were

FORMALWEAR

Silhouette

The silhouette during this period featured wide, loose bodices and waists and wide hips that were augmented by tiered skirts and flounces. The formalwear silhouette is similar to the daytime lines, although the waistline was usually higher than the natural waist.

Skirts

The width of the skirt made it a focal point. Overskirts, flounces, gathers, ruffles, and floating panels of fabric were situated to give the hip a wide appearance. At the beginning period, skirts extended to the ankle, but toward the end of the decade, they were several inches from the ground.

Formal dresses often had more than one layer of overskirt made from a variety of light, delicate fabrics such as chiffon, lace, and crêpe de Chine. The overskirts came in various lengths from just below the hip to mid-ankle. Some overskirts had handkerchief hems or draped hems.

Bodices

Bodices were loose fitting and accented by a loose waistband or sash that was above the natural waistline.

Neckline

Popular necklines included square, V, and round. Sometimes décolletage was filled with transparent fabric.

Sleeves

Sleeves were either short or extended to the elbow. Raglan sleeves were very popular, and the dropped shoulder created by the sleeve style was often emphasized with fabric or lace draped from the waistline over the shoulder. Sleeveless styles only had narrow straps over the shoulder.

Decorative Details

Formal gowns were usually made in light-colored fabrics such as pink, light blue, and white. Black was another popular color. Silk, crêpe de Chine, chiffon, lace, and georgette crepe were commonly used for formal dresses. Beading and embroidery in gold and silver remained popular trimmings. Embroidered chiffon overlays were commonly used, as were lace trim and insets. Satin sashes were another frequent formalwear feature.

Cosmetics

Women continued to aspire to have flawless, pale complexions, which they achieved with powder and carefully applied rouge. Colored salves tinted the lips, and pencils darkened brows.

FOOTWEAR AND LEGWEAR

Footwear

Daytime footwear was made from leather, whereas evening shoes were made from satin, silk brocade, or kid leather. Most shoes had a two-and-a-half-inch heel and featured straps that crossed the vamp and fastened on the opposite side with a button. In another popular style, the shoe tongue was visible beneath a decorative buckle. Oxford style shoes were popular as well.

Legwear

Legwear did not change from the Edwardian period. During the day, women wore cotton stockings in neutral or dark colors. In the evening, they wore silk stockings.

NECKWEAR AND OTHER ACCESSORIES

Jewelry

Pendant necklaces, drop earrings, rings, and cuff bracelets were popular. Decorative and jeweled hair pins and hat pins were common eveningwear. Multiple strands of pearls were worn with evening gowns, and wealthy women piled strands of precious stones around their necks for social occasions.

Handbags

Although leather and fabric handbags on metal or ivory frames continued to be popular, a new pouch-style bag emerged. The pouch-style bag made from either leather or fabric had a longer handle and a flap and button fastener.

Other

Women continued to wear gloves, carry parasols, and wear both fabric and leather belts.

1914–1919,

WORLD WAR I

This period is named for the war that dominated the social landscape of America during this time. Fashions shifted to become more utilitarian and functional.

narrowed close to the body. A typical style included two bands of flat lace that extended over the shoulders and down to the hem. They were broken by two transverse bands of lace at the neckline and just below the bust. Gowns could be practically sleeveless or have longer sleeves or kimono sleeves. Square and V necks were popular.

Parisian designers such as Paul Poiret dabbled in sleepwear. In 1910, they designed nightgowns in the "peasant style" (Rittenhouse 1910). These nightgowns were cut in a square silhouette like peasant smocks. They were straight and long, with a long, narrow panel of eyelet down the front. The sleeves could be straight and narrow, ending in a cuff with lace edging, loose and full, or three-quarter length. Sometimes this style of nightgown had a low-cut neckline that was filled with heavy white net.

Muslin, lawn, crêpe de Chine, and flannel were commonly used fabrics for nightgowns, and white and pastels were popular colors. Flat bands of lace, wide embroidered beading on the sleeves, flat bows, embroidered buttonholes, and flat rosettes made from ribbon were common embellishments.

Boudoir caps were made of strips of heavy brocade, which covered a lace foundation. Another popular cap was a crêpe de Chine bandana-style wrap that had ends that snapped together.

Other garments

For lounging, women would wear kimonos and dressing sacques.

HEADWEAR, HAIRSTYLES, AND COSMETICS

Headwear

Around 1910, oversized hats were popular. These substantial hats could be as wide as a woman's shoulders and quite tall. Embellishments were heaped onto these hats. They were topped with enormous ribbons tied into bows, artificial flowers and leaves, and exotic feathers. By 1912, the decoration became more subdued and the height of the crown shrunk. Narrower, less constructed hats such as berets and turbans became stylish. By 1913, plumes of exotic feather jutted vertically and horizontally from hats. Hats were constructed of straw, velvet, and woven horsehair.

Hairstyles

The pompadour fell out of favor, and hair was less bouffant. It was still pulled into a bun at the back or top of the head and arranged loosely around the face and sides. Marcel waves and other waving techniques were still used by women with straight hair.

suits had rounded or V necklines, were sleeveless, and had long tunic-style tops over shorts that extended to the mid-thigh. These suits were worn with a matching cap and stockings that went up to the mid-calf. In 1910, Jantzen marketed a new fabric called rib stitch that stretched and kept its shape when wet.

Sometimes suits still had skirts for modesty. Many people thought the form-fitting suits were scandalous, and they exposed too much of the arms, legs, and neck. Sometimes bathers who showed too much skin risked arrest and indecent exposure charges.

Golf

Golf required a sport suit with a short shirt that extended to mid-calf. The suit was loosely fitted in the jacket and waist and had raglan sleeves. Sometimes the skirt would have a slit to ease movement.

Other Activewear

Ice skating was quite popular during the Empire Revival period. Ice skating costumes featured wider hemmed skirts than typical casual wear. Slits were added to the skirts for freer movements. Over the skirts, belted mid-thigh-length jackets were worn. Sometimes the belts were worn high up over the waist, and other times they were lower at the natural waist or below. Warm hats, gloves, and muffs completed the ensemble.

Generally, activewear was tailored for easier movement. Raglan sleeves, jackets with loose-fitting backs, and knitted jackets allowed free arm movements. Hemlines were shorter and broader. Caps and hats were lower and fit more closely to the head, so they no longer needed to be tied down by a veil.

UNDERWEAR AND INTIMATE APPAREL

Undergarments

The fashions of the Empire Revival period did not require as many undergarments as the fashions earlier in the century. Although most women continued to wear corsets, many women gave them up, and several designers created garments that did not require them. Combination underwear that brought together drawers and the chemise continued to be popular. As the silhouette narrowed, princess-style petticoats became popular because women did not need extra bulk underneath their dresses. The ruffles, fluffy bows, and puffs of lace from the 1900s were replaced with flat bows and bands of lace.

Sleepwear

The changes in nightgowns mirror those in undergarments. Extravagant ruffles, lace, and gathers of fabric fell out of fashion. The silhouette

finely woven lightweight cotton. Silk shantung, which incorporated the irregularities of the fiber into the weave, was used for dressier daytime garments. Wool was frequently used, especially in fall and winter casual wear. It was woven into plain weave and cheviot. Silk cashmere and velvet were commonly used in finer casual wear for the afternoon.

Embellishments tended to be clustered along the edges of garments. Common decorations included lace collars and cuffs, edging on the hem of a tunic or skirt, and braids and embroidery along collars, cuffs, and necklines. By 1912, fur was commonly used as a trim along necklines, sleeves, and hems. Lapels, also known as revers, became a focal point of embellishment with contrasting colors of satin, velvet, and embroidery. Fabric sashes, fabric belts, and leather belts accentuated the elevated waistlines.

OUTERWEAR

Coats
Daytime coats were long or extended to the mid-thigh or knee. By the end of the era, some coats were so short that they extended just below the hip. They followed the narrow empire silhouette. The shorter, looser versions of coats were called paletots. Some had front closures, whereas other coats wrapped across the body and fastened on the far left side. Lapels could be broad and accented with embroidery or contrasting fabric trim. Frequently, fur trimmed the collar, cuffs, and hemline. Early in this era, buttons not only served as closures but as decoration along the back and sides of the skirt. A variety of materials were used to make coats, including wool herringbone, velvet, silk, corduroy, and a variety of furs.

Evening coats were loose and full-cut across the back. A few styles had asymmetrical hemlines that dipped into points on the sides.

Shawls/Wraps
Fur stoles continued to be popular, and sometimes their ends were embellished with fur tassels. Capes were less frequently used.

SWIMWEAR AND SPORTSWEAR

Swimwear
Athleticism began to override the prevailing modesty. Previously, swimsuits had followed the lines of dresses replete with voluminous skirts. By 1910, a wool tighter-fitting one-piece suit was generally accepted. When it got wet, it sagged considerably and hugged a woman's curves. Typically,

Bodices became more fitted, and the pouch of the previous years had completely vanished by 1912. The abundant frilly lace that dominated bodices earlier in the decade became quieter accents along the neckline and sleeves. The full bishop sleeve disappeared and was replaced by close-fitting sleeves that ended in cuffs, shorter kimono-style sleeves, and elbow or three-quarter-length sleeves. Undersleeves appeared beneath shorter sleeves. High collars, which had been a fashion staple for decades, gradually disappeared and were replaced by V, round, and square necklines. Guimpes, which were inserts into V and square necklines to add modesty, were common. Bolero-style bodices were common by 1913, and dresses that simulated a pinafore-style bodice were popular as well.

From 1909 to 1911, simple narrow skirts were the norm, but, in 1912, the hemline narrowed further. The most extreme of these skirts was a hobble skirt, because it effectively restricted the wearer's stride. Some women wore restraints around their ankles to keep themselves from ripping their skirts. Less severe skirts often included a slit to ease movement.

Separates

Blouses/Shirts. Tunic layers over underskirts were very common. Tunics came in a wide variety of styles. Some were narrow, some followed the dress silhouette in which they were full at the hip and narrowed toward the hem, whereas others were full from the waist to the hem.

Shirtwaists continued to be paired with skirts and suits. They were less elaborately decorated than the ones earlier in the decade. Some of them were tailored like men's shirts, complete with high collars and separate neckties. Others had lower lapels and lower necklines, which were often worn with jabots.

Skirts. Like the skirts of dresses, separate skirts ranged in silhouette from straight and slim to exaggerated emphasis on the hip and extremely narrow hemlines. Peg-top skirts were fashionable. They were full over the hip and then narrowed to the hem.

Decorative Details

Although frills and trims continued to be used, they were less elaborate than they were earlier in the decade. Popular colors moved away from candy-colored pastels to putty, brown, black, cypress green, navy blue, plum, mauve, and delft blue (Olian 1998).

Frequently used fabrics included foulard, which was a silk or cotton made into a finely woven twill, and printed with geometric patterns such as circles and stripes. Another common summertime fabric was batiste, a

applied asymmetrically. Surplice bodices were trimmed with a variety of embellishments, including ruffles, fur, and fabric rosettes.

BUSINESS WEAR

Silhouette

Business wear followed a silhouette that was similar to the one used for eveningwear. The empire waistline was usually a little lower than the one used for eveningwear, but it was still well above the natural waistline. Skirts were narrow and shorter, and the bodice included a tunic or long jacket.

Suits

Suits consisted of narrow skirts and long, belted jackets. As early as 1908, the waistline was moving up toward the bust, and the jacket was belted, nipped, or featured a waistband at the elevated waistline. Later in the period, jackets gathered at the waistline and expanded into fullness around the hips. The hem of the jacket extended past the hips, and the sleeves were generally close fitting. Sometimes they included cuffs. The skirts narrowed as the period progressed, and they were slit at the front or side for easier maneuverability.

Decorative Details

Wool was a common fabric choice for suits. Frequently, cheviot, a rough-surfaced twill, was used for its durability. Buttons and embroidery were used as embellishments. Contrasting silk or velvet insets trimmed cuffs and lapels.

CASUAL WEAR

Silhouette

Like business wear, the silhouette of casual wear was dominated by the elevated empire waistline, but it was not as high as the ones used in eveningwear. The skirts were slim, with hemlines that were one to three inches off the ground.

Dresses

Usually, dresses were one piece, although separates and suits were equally popular. By 1909, the silhouette had straightened, eliminating the S-curve that had been popular earlier in the decade. The waistline had begun moving toward the bust, and the skirt narrowed.

Examples of the harem ensemble, c. 1912–1914. Outfits such as these and those by Paul Poiret showed exotic Turkish-style designs. [Library of Congress]

Bodices

Compared with the Edwardian period, bodices greatly simplified during the Empire Revival period. They were more closely fitted to the body and lost the pouch in the front. They often had front closures, making it much easier for women to dress themselves. Surplice bodices were extremely popular, and the crossover in the fabric was usually emphasized with trim. Typically, the bodice was a tunic that extended to just above the knee. The tunic was nipped at the elevated empire waistline by a sash.

Paul Poiret created an extreme version of the tunic style called the minaret or lampshade tunic. A surplice top gathered into a sash at the empire waistline, and the skirt of the tunic was held out in a full circle with boning. Beneath the tunic, he used draped, narrow hemmed skirts and occasionally loose Turkish-style trousers.

Neckline

The dominant neckline of the period was the V neck. Sometimes it would be a deep V with a horizontal inset. Occasionally, round and square necklines were used. Horizontal insets in square necklines were common as well.

Sleeves

Sleeves were usually short for eveningwear. They were often sheerer than the dress itself. Many times, they would be edged with fringe or fur. Women wore long gloves with the short sleeves. Kimono sleeves were also popular.

Decorative Details

Usually, the tunic was net over silk to give the dress a diaphanous appearance. Pale colors such as steel blue, pale blue, lemon yellow, cream, pink, and white were popular, but dark colors such as black, royal blue, and emerald were not rare (Olian 1998). The oriental influence was incorporated in the decoration, especially the embroidery. Other common forms of decoration included beading, lace insets, lace trim, fringe, and trains. Frequently, decoration was

about to disappear, and the fashion drivers of the period between 1909 and the war pushed to move the masses in that direction. The era is named for its revival of the Empire aesthetic that was popular from 1800 to 1815.

FORMALWEAR

Silhouette

The silhouette of this period is aptly named the empire silhouette. It is characterized by a narrow bodice, a high waistline located just beneath the bust, and a slim skirt.

Skirts

Skirts narrowed and became shorter. Earlier in the decade, skirt designs required five yards, and, by 1912, they only required two (*New York Times* 1912). Skirts behaved more like underskirts, because they usually had a long tunic over them that extended to the lower thigh. Usually, evening skirts were made of silk and included a component of visual interest such as pleating, asymmetrical draping, or beading. By 1913, many skirts featured panniers, which consisted of gathered fabric to give the hips extra fullness.

Three variations of empire waist tunics with skirts, including a lampshade tunic on the right. [Library of Congress]

A day suit with coat, hat and muff. [Library of Congress]

NECKWEAR AND OTHER ACCESSORIES

Jewelry

Most jewelry followed natural themes such as flowers, butterflies, dragonflies, and animals. Brooches, pendant necklaces, and earrings included this motif, and they often were crafted in the Art Nouveau style. Dog collars were very popular for eveningwear. These were tall necklaces that extended up from the base of the neck. They usually were made of several strands of beads or jewels linked together at intervals by bands. Although wealthy women wore jewelry made from precious metals and stones, most women wore jewelry from less-expensive materials. Paste stones, cut glass, and imitation pearls were popular, and they were often set into silver gilt.

Handbags

Handbags were usually made of fabric or leather set onto a metal or ivory frame with a clasp at the top. The handles were short, because they were intended to be worn on the wrist. A variety of leathers such as calfskin and ostrich skin were used for the bags. When fabric was used, usually it was silk. Often the metal frames were engraved with decorations, and sometimes the handles were tied into a bow.

Other Accessories

Muffs were popular winter accessories. They were flat and made of fur. They were usually coordinated with a stole. Decorative parasols were popular accessories and were used to keep the sun from tanning women's skin. The handle of the parasol may have been made of ivory, silver, or fine wood, but usually the fabric of the parasol was silk. Collapsible fabric or ostrich fans were popular, and women often wore boas made of marabou feathers, especially with eveningwear.

1909–1914,
EMPIRE REVIVAL

In the years preceding WWI, Americans were shifting toward a break with past fashions. The highly corseted fashions that extended to the floor were

HEADWEAR, HAIRSTYLES, AND COSMETICS

Headwear

Hats came in a variety of styles. Large-scale picture hats complemented the S-curve silhouette. Although some hats were brimless, most had some type of brim. There were a variety of brim styles, including the brim angled down, a large brim angled up, an asymmetrical brim angled up, a narrow brim angled up, and a narrow brim angled up in the back. Toward the end of this era, hats were angled forward toward a woman's eyes.

Most hats were made from straw, woven horsehair, and velvet. They were decorated with a variety of items, including feathers, cloth flowers and leaves, artificial berries, ribbon, lace, jet, and birds. Ostrich plume and marabou plumes were often dyed vibrant colors. The trend of using exotic bird feathers led to the endangerment of many birds.

Hairstyles

Hairstyles were loose and full. At the back of the neck or the top of the head, hair was pulled into a bun or chignon. The natural wave of the hair was emphasized. For women who did not have a natural wave, they got a marcel wave, an artificial process that lasted up to a week in properly prepared hair. The pompadour hairstyle puffed the hair up high in the front and side. Often, supports were added underneath the hair to keep it up. Evening hairstyles were decorated with jeweled hair ornaments, plumes, and flowers arranged in the hair.

Cosmetics

During the 1900s, cosmetics were very subtle. It was considered unlady-like to wear noticeable makeup. Very fair skin was fashionable, and women perfected the pale, flawless look with powder. They colored their cheeks with pink rouge and the brows with eyebrow pencils. They also used tinting on their lips.

FOOTWEAR AND LEGWEAR

Footwear

Shoes were slender and had two-and-a-half-inch heels. They had pointed toes. Daytime shoes were made of leather and usually had a strap across the vamp that buttoned on the opposite side. Sometimes shoes would cover the vamp with leather. Evening shoes were usually made of silk and were often embroidered. Boots were less popular and had button or lacing closures.

Legwear

During the day, women wore cotton stockings in neutral or dark colors. In the evening, they wore silk stockings.

tan color hid the dust that would cover it after a day of motoring. Women would wear large hats and veils over their faces. Green was a popular color for the veils. Low, flat caps were another popular form of headwear for this sport. Gloves were worn also.

Bicycling was another common sport at the turn of the century. Bicycling costumes featured a skirt that was split to accommodate the bicycle. Its hem came a few inches below the knee to facilitate pedaling and to avoid the bicycle's chain. Women wore high-buttoned boots with this type of outfit. Sometimes women would wear veils over simple hats while they bicycled.

Both men and women went hunting together. Women would wear a tweed suit that had a hem that was three to four inches from the ground. The suit had a fitted jacket and few embellishments. Women often wore a low, flat cap with the outfit.

When horseback riding, women would wear split skirts and masculine-style riding jackets with a simple shirtwaist. A derby hat and gloves would complete the outfit.

UNDERWEAR AND INTIMATE APPAREL

Undergarments

Undergarments were complicated during this era. The first layer consisted of a set of drawers and a chemise or a combination, which was a combination of the two. These were often decorated with frilly lace, and ribbon woven between eyelets was frequently used.

The next layer included the corset and sometimes the bust bodice. The corset was well boned and nipped in the waist. Some corsets supported the bust, whereas others ended before the bust. In those cases, women wore an extra undergarment called the bust bodice, which supported the breasts. Bust improvers made of celluloid or cotton pads were available for women who wanted to enhance their bustline.

Camisoles could be worn over the corset, and petticoats would be worn in layers to fill out skirts. The petticoats included flounces at the bottom to enhance the trumpet shape in skirts.

Sleepwear

Most women wore nightgowns and boudoir caps to bed. The gowns were made of cambric, muslin, and flannel depending on the season. White was the most common color, but pastels and pinstripes were also popular. Typically, they included a yoke and ruffles around the neck and cuffs. Round and V necklines were the most common, and styles featured either long or short sleeves. Trimmings included lace, lace insertions, and tucks in the yoke.

Annette Kellerman. Australian Annette Kellerman gained international prominence in 1905 when she attempted to swim the English Channel, a feat that she attempted three times before admitting defeat. Within two years, she would be the center of the American decency debate. Kellerman took up swimming when she was 6 as a way to strengthen her weak legs. By 1902, she won championships in women's one hundred yard and mile swims, and the following year she began performing swimming and diving exhibitions in a vaudeville act.

While touring with the vaudeville act in the United States, she caused significant controversy because of her form-fitting one-piece bathing suit. Her athleticism required a less cumbersome garment than the voluminous swim dresses typically worn at the time. During her attempts to cross the English Channel, she made her own suit by modifying a boy's knit tank suit with dark stockings sewn to the legs. Many Americans found this body-hugging style of suit to be immodest. When she brought her swimming and diving demonstrations to Boston in 1907, she riled the conservatives in the city. When she visited a public beach, she was arrested for indecency for wearing her trademark suit. The arrest generated significant publicity and helped relax laws regarding women's swimwear. Within the next few years, athletic tank styles became common for women, and the style became known as "The Annette Kellerman." She also promoted her own line of women's swimwear.

Kellerman continued swimming and promoting physical activity for women. She authored books including *How to Swim* (1918) and *Physical Beauty: How to Keep it* (1919). She appeared in numerous films performing a variety of swimming and diving stunts. Many times she played a mermaid and developed her own mermaid costumes that were comfortable for swimming. She lectured widely in the United States, talking about health and fitness.

Tennis

Tennis costumes consisted of a simple shirtwaist and skirt made of cotton flannel. Decoration was kept to a minimum, the sleeves were close fitting but roomy, and the skirt hem was a few inches off the floor. A low flat cap completed the ensemble.

Other Activewear

Because motoring was a dusty, dirty amusement, it required a special outfit. A long, loose-fitting duster would be worn to protect the motorist's clothing. Typically, the duster was made of cotton, linen, or silk, and its

matching separates. Other women would wear a dark skirt with a light-colored shirtwaist. Striped shirtwaists were popular, too.

Lace was seen all over women's garments during this era. It was used on the center front of bodices, along the sleeves, in the collars, and in bands along skirts. Lace inserts, lace ruffles, lace jabots, and lace cuffs were all common applications.

Both skirts and bodices included other decorative elements. Some frequently used embellishments were insets, pleats, tucks, embroidery, buttons, bows, and contrasting piping.

OUTERWEAR

Coats
Coats were available in both fitted and unfitted styles. Some sleeves were fitted, whereas others followed the bishop style of dresses. Some coats incorporated cape-style sleeves. Kimono-style coats became popular as Asian styles gained interest. Coats were embellished with embroidery, buttons, and piping.

Shawls/Wraps
High-necked capes and cloaks were popular outdoor garments. Capes were commonly worn over eveningwear. Like coats, embroidery, buttons, and piping decorated capes and cloaks.

Other garments
Boas and fur stoles were worn. As motoring became popular, women began to adopt the sport and wore dusters, loose-fitting long overcoats made of cotton, linen, or silk, to protect their garments.

SWIMWEAR AND SPORTSWEAR

Swimwear
Swimwear during the Edwardian period was similar to bathing costumes of the 1890s. These impractical outfits were cumbersome dresses that included skirts, sleeves, and long stockings. These silk or wool dresses usually had a wool undersuit beneath the dress. A matching swimming cap was also worn.

Golf
When golfing, women typically wore simple suits with hems that came an inch or two off the floor. They often kept their hat on their head with a veil or scarf that tied beneath the chin.

like the kind used on undergarments at the time. Tea gowns, another daytime style worn by wealthy women, were unfitted dresses that were worn in the afternoon.

Most bodices included frilly embellishments such as lace and tucks. Usually, decoration further emphasized the monobosom silhouette. The sleeves were either close fitting along the whole arm or close fitting along the upper arm and puffed along the forearm and gathered at the wrist. This style was called a bishop sleeve. Lace insets were common along the forearm. Toward the end of the decade, sleeves shortened into a three-quarter length, although the sleeve usually gathered at the elbow and a ruffle extended partway down the forearm. Kimono sleeves were also popular. High, boned lace collars were the norm, but men's-style collars were sometimes worn.

Skirts were trumpet shaped. The effect was achieved by fitting the skirt closely to the body to the knee and using goring to flare the skirt down to the hem. Usually, the back of the skirt was flared as well. Skirts extended completely down to the floor often

A morning gown, with gauzy material and the popular bell-shaped skirt, c. 1903. [Library of Congress]

with a slight crease. The full back gave the illusion of a small train. It was common to have a sash or belt at the waist where the skirt and bodice joined.

Separates

Blouses/Shirts. Shirtwaists, as blouses were known in the 1900s, followed the style of dress bodices.

Skirts. Skirts followed the style of dress skirts.

Decorative Details

Usually, casual wear was made from soft fabrics such as cotton lawn, velvet, and silk. During the winter, wool was commonly used. Light colors such as pinks, pale blues, and light yellows were popular, but darker colors such as emerald green and burgundy were not uncommon (Olian 1998). Light colors were common for separates, and many women wore

The skirt and jacket were usually made of wool in a tweed or serge. The skirt was short enough to clear the ground, making it easy to get around and work. The jackets featured sleeves that puffed at the top of the sleeve and were narrow from the elbow to the wrist. Although the hem of many jackets ended at the hip, others ended just above the waist to highlight the narrow waistline. Both single- and double-breasted jackets were stylish.

Separates

The blouses that were worn under suits tended to be less elaborate than other blouses that were worn during the Edwardian period. They usually did not have elaborate ruffles or gathers, because they were worn under close-fitting jackets. They featured high collars, with wire supports, that reached up to the chin. The monobosom silhouette and the puffed sleeves were evident even in these more utilitarian garments.

Often, working women would wear a shirtwaist blouse and skirt. The shirtwaists could be simply designed, like a man's shirt with a folded over collar and tie, but invariably they would feature feminine puffed sleeves. Other shirtwaists followed the lacy, ruffled styles that were popular in other daywear. Typically, these more elaborate shirtwaists would have pleats or ruffles down the front, a high lace collar, and puffed sleeves. Sometimes the sleeves would be puffed and loose for the entire length of the arm. Shirtwaists featured a wide variety of decoration, from lace, embroidery, applied fabric, pleats, and tucks. Embroidery on blouse fabric became so popular that machines were built to cheaply produce embroidered fabric to supply the demand.

Following the S-shaped silhouette, skirts fit closely over the hips and flared out at the hem. Gores helped created a trumpet shape in these simple, functional skirts, which did not have trains and had hems that cleared the floor.

Casual Wear

Silhouette

Like all other garments during this period, casual daywear followed the S-curve silhouette. The bodice featured a monobosom and a high collar. The skirts sat closely to the hip and were bell shaped.

Dresses

Dresses were usually one piece, although they may have been made as separate bodices and skirts, but they were sewn together at the waist. Lingerie dresses were a popular daytime style. They were made of white-colored light fabrics such as cotton or linen and featured frilly lace, much

Unlike ball gowns, dinner gowns had high necklines or collars that were similar to daytime necklines. Many dinner gowns had high lace collars inset into deep V necklines. High, square necklines were popular as well.

Sleeves

Ball gowns highlighted the graceful femininity of a woman's shoulders. Most women opted for puffed short sleeves made of lace or sheer material, although a few women wore sleeveless or off-the-shoulder gowns. Dinner gowns featured puffed sleeves that extended to the elbow or just below it.

Decorative Details

Queen Alexandra of Great Britain, who succeeded Queen Victoria in 1901, ushered in the popularity of the pastel colors that dominated the sumptuous ball dresses of the first decade of the twentieth century. The popular colors included silver, gold, white, and soft colors that were often described as "sweet pea" colors. These pale colors were a departure from the vivid colors produced by the aniline dyes that were popular in the previous decade.

Ball gowns were typically made from lightweight silk that was tucked and folded to create elaborate detailing. Lace, embroidery, ribbons, jet beads, net, and flowers were frequently used to trim dresses. Cloth was often draped in swags along necklines and hems. Frequently, bows and flowers accented the tops of the swags.

Whereas dinner toilettes were usually adorned with lace, the decoration was far less elaborate than it was on ball gowns. Dinner gowns were made in dark colors that offset the white of the lace.

BUSINESS WEAR

Silhouette

Business wear followed the S-curve silhouette, with its emphasis on the monobosom, tiny waist, and thrust-back buttocks.

Suits

During the Edwardian period, many women had firmly established themselves in the workplace, and tailor-made suits were an all-purpose outfit that women found functional and comfortable. These suits were often called "tailor-mades" and consisted of a narrow skirt, a simple jacket, and a basic blouse, which was called a shirtwaist. Tailor-mades were worn as an everyday outfit, for traveling, and by working women.

An evening gown with open neckline and tiara, c. 1905. [Library of Congress]

elaborate of these skirts included as many as fifteen gores. Sweeping skirts with trains were fashionable for women when they attended receptions or the opera. Typically, these skirts were only worn by the wealthy, those who had enough money for carriages and valets to keep their skirts from getting dirty.

On ball gowns, the detailing on the skirts generally emphasized the waist or the hem. Often the waist was highlighted with a sash-like waistband. The hem might be trimmed with lace or ruffles. Many popular designs featured underskirts that were revealed from under the hem of the skirt or through a slit in the front or side of it.

Dinner gowns featured more modest trains and generally did not include underskirts. Like the ball gowns, they highlighted the waist with an exaggerated waistband and often emphasized the hem with trim. Most often the trim on the hem was a contrasting fabric or dark-colored lace.

Bodice

In formalwear, the bodices were tightly fitted and usually included boning of their own, almost like a second corset. Some ball gowns featured an empire waist, which was a waistline that began just below the breast. Even in empire-waist dresses, the torso and waist were corseted and fitted.

Necklines

During the Edwardian period, a long, graceful neck was fashionable, and ball gowns were designed to accentuate it. Their necklines were low and appeared in sweetheart, round, or square shapes. Although these formal necklines were more revealing than daytime ones, they were shaped into a monobosom and did not reveal any cleavage. Lace, ruffles, and draped fabric usually encircled the neckline, enhancing it.

were worn at formal events. Sportswear had become multipurpose; the same outfit could be worn for golf, tennis, and cycling.

At the beginning of the century, Paris was the undisputed fashion capital of the Western world. Haute couture fashions originated from there and were copied by American manufacturers. When the United States was cut off from Parisian fashions during WWII, the center of American fashion moved to New York City. Unlike Parisian couturiers who created designs for private clients and retail stores, which then licensed the design and reproduced it, American designers worked for ready-to-wear manufacturers. They created designs that were immediately mass produced and disseminated to retail stores. By the end of the 1940s, Paris reemerged as the world's fashion capitol, but American designers continued to have a significant influence on the U.S. casualwear market.

1900–1908,
THE EDWARDIAN OR LA BELLE EPOQUE ERA

During the Edwardian period, women wore formal clothes for dinner and balls. Dinner gowns or "dinner toilettes" were less elaborate and more somber than ball gowns. This period was named after Edward VII, who ascended to the British throne in 1901.

FORMALWEAR

Silhouette

The S-curve silhouette marked every style of women's fashion during the Edwardian period. The silhouette was modeled after the figure of a mature woman and featured a full, heavy monobosom that whittled into tiny, corseted waist, which blossomed into a rounded hip and bottom. The corset pushed the bosom forward and threw the hips backward, resulting in a curvaceous S shape when a woman was viewed from the side. This silhouette was worn by old and young alike.

Skirts

During the Edwardian period, dresses were usually two pieces: the skirt and bodice. Formal skirts fit tightly across the hips and reached the ground. They were gored to achieve a trumpet or bell shape. The most

cotton, linen, or silk, which were the primary fibers for nearly all fabrics. Even when they secured raw fibers, the labor shortages slowed the production of finished fabrics. As a result, less fabric was used for women's garments as the skirts became shorter, the volume in skirts was reduced to a shorter overskirt, jackets became shorter, lapels became smaller, and ornamentation was eliminated.

After the war and winning the right to vote, women became more active in sports and outdoor activities. Women's sportswear became a growing industry. Manufacturers developed both general activewear and sportswear for specific sports such as golf, tennis, and horseback riding. In the 1920s, outdoor activities became more popular, and tanned skin acquired through outdoor leisure pursuits was fashionable. By the 1940s, sportswear became as common as everyday wear and had reached unprecedented levels of popularity.

The Great Depression of the 1930s required women to be resourceful in procuring garments. They reworked existing garments into new fashions and sewed much of their families' clothes. The emergence of new trends slowed as women were less able to purchase new fashionable wardrobes.

The production of supplies for WWII caused a scarcity of materials for most American consumers. Wool, cotton, linen, and silk fabrics were diverted to wartime production, and newly developed artificial fibers such as rayon became the fabric used for many mass-produced garments. The War Production Board issued L-85 Regulations that governed the production of garments. These regulations had a distinct influence on the fashions created during the war because they restricted French cuffs, full sleeve styles like balloon, dolman, and leg-of-mutton, coats with capes or hoods, dresses with belts larger than two inches, and hems longer than two inches.

In the short period between 1900 and 1949, the influence of social class on fashion changed. In 1900, the wealthiest classes set the styles of popular fashions. Their styles of dresses were publicized in magazines and newspapers. By the end of this time period, the Hollywood and youth culture had supplanted the wealthy as trendsetters.

Distinctions between types of dress began to erode during this period. At the beginning of the century, women wore several, distinct styles of dress each day. Morning dresses, tea gowns, walking suits, dinner gowns, and ball gowns each had their place within a woman's wardrobe. Additional garments such as cycling suits and riding ensembles were worn for specific sports. By 1949, casual wear became the norm for daytime. Suits were worn for business or dressier daytime activities, and evening dresses

7

Women's Fashions

Women's lives changed dramatically during the period from 1900 to 1940.

During the first two decades of the century, women fought for and won the right to vote. The women's suffrage movement divided households and made the role of women a topic of public debate. The ways in which women acted and dressed was scrutinized and discussed. On one side of the spectrum, people thought women should maintain a sense of propriety, dress femininely, and be confined to the private, domestic world. On the other side, they thought women should express their opinions publicly, dress comfortably in clothing designed for an active lifestyle, and be part of public life and work.

By the time women won the right to vote, they had brought their suffrage arguments to public forums for over sixty years and taken over men's jobs during WWI. During the war, women took on many of the responsibilities and jobs that men left when they enlisted in the service. Women's clothes adapted to meet the needs of their more active lifestyles; they became shorter and allowed free movement. They also shed the confining corsets that had been an integral part of women's fashion for centuries.

The first half of the twentieth century was characterized by a shortage of materials and suppressed consumerism because of WWI, the Great Depression, and WWII. WWI resulted in a scarcity of materials for making clothing. Manufacturers found themselves with very little wool,

Blum, S. 1986. *Every Day Fashions of the Thirties as Pictured in Sears Catalogs.* New York: Dover Publications.

Bordwell, D., and Thompson, K. 2002. *Film History: An Introduction.* 2nd revised edition. Columbus, OH: McGraw Hill.

Dolfman, M. L., and McSweeney, D. M. May 2006. *100 Years of U.S. Consumer Spending: Data for the Nation, New York City, and Boston.* BLS Report 991. Bureau of Labor Statistics.

Eyles, A. 1987. *That Was Hollywood: The 1930s.* London: Batsford.

Joseph, M. 1998. *Essential Textiles.* New York: Holt, Rinehart, and Winston.

Kaledin, E. 2000. *Shifting Worlds: Daily Life in the United States, 1940–1959.* Westport, CT: Greenwood Press.

Kellogg, A. T., Peterson, A. T., Bay, S., and Swindell, N. 2002. *In an Influential Fashion: An Encyclopedia of Nineteenth and Twentieth Century Fashion Designers and Retailers who Shaped Dress.* Westport, CT: Greenwood Press.

Kyvig, D. E. 2002. *Daily Life in the United States, 1920–1940.* Chicago: Ivan R. Dee Publisher.

Laubner, E. 1996. *Fashions of the Roaring '20s.* Atglen, PA: Schiffer.

Laubner, E. 2000. *Collectible Fashions of the Turbulent 1930s.* Atglen, PA: Schiffer.

Matanle, I. 1994. *History of World War II, 1939–1945.* Little Rock, AR: Tiger Books International.

Mendes, V. D., and De La Haye, A. 1999. *20th Century Fashion.* London: Thames and Hudson.

Milbank, Caroline Rennolds. 1996. *New York Fashion: The Evolution of American Style.* New York: Harry N. Abrams, Inc.

Nolan, C. *Ladies Fashion of the 1940s.* http://www.murrayonhawaii.com/nolan/fashionhistory_1940ladies.html.

Seeling, C. 2000. *Fashion: The Century of the Designer 1900–1999.* English edition. Cologne, Germany: Konemann.

Tortora, P. G., and Eubank, K. 2005. *Survey of Historic Costume: A History of Western Dress.* 4th edition. New York: Fairchild Publications.

Watson, L. 2004. *20th Century Fashion.* Buffalo, NY: Firefly Books.

Whitaker, J. 2006. *Service and Style: How the American Department Store Fashioned the Middle Class.* New York: St. Martin's Press.

Eubank 2005, 378), they were not reliable and regularly fell open. Zippers were improved in the 1920s and 1930s, with new "locks" or catches to keep the zipper up and closed. With zipper closures secure, they rapidly replaced buttons on the fly of men's pants and drawers. Zippers also became a novelty item and were incorporated into coats and boots.

Technological advances in hat blocking increased the quantity and quality of mass-produced headwear available in the 1920s and 1930s. Headwear, an important component of a woman's wardrobe, was previously custom made. Hats were carefully fitted and trimmed to the wearer's specifications and, because of the great expense, were typically retrimmed each season. With the popularity of the cloche form of hat, the simple felt shape could be easily blocked on a form by mechanical equipment. Because most cloche hats were simply trimmed with hat bands and cockades, new machines were also developed to support the mechanization of hat decorating. The end result was increased availability of goods and a lower price point, allowing women to purchase numerous hats rather than having to retrim a single hat regularly.

1940s

Many new fabrics and uses of material came from the material shortages and technologies developed during the war. Faced with severe shortages of leather, Italian shoemaker Salvatore Ferragamo used synthetic resins and cork to produce stylish and colorful wedge-soled shoes. Because leather was used exclusively for soldiers' boots during the war, Ferragamo used diverse materials such as rhodoid from Bakelite, hemp, felt, and raffia.

Artificial fabrics developed during the war led to new sportswear such as "drip-dry" poplin sport shirts and lightweight quick-drying "wind breakers" for sailing; waterproofing and lightweight warmth alternatives to wool made outdoor activities more comfortable.

One of these new fibers, nylon, was marketed in 1938 but was not widely used for consumer purposes until after the war. It became a popular and affordable fiber for stockings, eventually replacing silk as the most common type of stocking. Also, nylon was widely used in its stiffened form for the petticoats under the full skirts that characterized the early New Look.

REFERENCES

Baker, P. 1992. *Fashions of a Decade: The 1940s.* New York: Facts on File.
Blum, S. 1981. *Every Day Fashions of the Twenties as Pictured in Sears and Other Catalogs.* New York: Dover Publications.

during this period sped clothing manufacturing and helped make ready-to-wear clothing more widely available.

1920s and 1930s

Viscose, renamed rayon in 1925 by the Department of Commerce, was developed by English scientists in 1891 and manufactured in America by the American Viscose Corporation in 1910 (Joseph 1988, 82). However, it was not until companies such as DuPont and Celanese began producing viscose between 1916 and 1930 that production levels were sufficient for a significant volume of apparel production.

Initially dubbed "artificial silk," garments made from rayon were initially rejected from both performance standards (they did not withstand laundering) and a skepticism over anything artificial. During the 1920s, the performance properties of rayon were drastically improved. The 1920s was also a period of increased mechanization, whereby mechanical and artificial items were met with fascination, not resistance. Rayon found particular favor among working and middle-class women who wanted to dress like their wealthier counterparts but could not afford to do so. The need for an inexpensive fabric that could imitate silk was also important during the 1930s Depression, whereby women wanted glamorous silk dresses but could not afford silk fabrics.

Acetate, a modified cellulosic fiber, was first produced in 1869 and was developed for use in apparel in 1904. By 1924, production of acetate had also reached sufficient levels to support apparel manufacturing demands. Acetate, like rayon, could be woven into "silk-like" satins for inexpensive women's evening wear during the 1920s and 1930s. By the late 1930s and early 1940s, experiments with two new man-made fibers, nylon and polyester, would soon provide even better alternatives than acetate and rayon to silk.

Rayon and acetate both played another important supporting role in women's fashions: undergarments. The new underpants and brassieres, as well as slips, were made from woven or knitted rayon or acetate and provided "silky" smooth undergarments for women's tubular dresses in the 1920s and clingy bias-cut dresses in the 1930s. The crinolines, corsets, and bustles of previous eras disappeared, as did the manufacturers, and were replaced by undergarments that provided natural shaping and support. The new shorter hemlines in the 1920s also meant that, for the first time in centuries, women were showing a substantial portion of their legs. Rayon, which could be knit as well as woven, provided an inexpensive alternative to silk hosiery.

Menswear also underwent a technological revolution in the 1920s and 1930s: zippers. Although zippers were first invented in 1891 (Tortora and

Movie studios had aggressive publicity departments that ensured that their stars were well covered in the media. They staged photo opportunities that gave the stars more exposure. The clothes that stars wore both onscreen and offscreen became an interest of American women. Fan magazines, which featured photos of popular stars, were well read by much of America.

The costume designers from movies retained prominence and influence during the 1940s. Most had established themselves by the 1930s, but continued to costume Hollywood's biggest stars in the 1940s. Travis Banton clothed Betty Grable in *Moon Over Miami* (1941), Rita Hayworth in *Cover Girl* (1944), and Merle Oberon in *A Song to Remember* (1945). Adrian designed costumes for Katharine Hepburn in *Woman of the Year* (1942), the cast of *Ziegfeld Girl* (1941), and Rosalind Russell in *Flight for Freedom* (1943). Walter Plunkett's notable 1940s design credits include *Summer Holiday* (1948) and Joan Blondell in *Lady for a Night* (1942).

Mail-order catalogs such as Sears, Roebuck and Company and Montgomery Ward were the most popular communication tool for fashion after Hollywood. Because of WWII, these catalogs often marked pages with "unavailable" as wartime restrictions depleted stock and raw materials. When women could not get new clothes because of lack of availability or expense, they consulted pattern books to remake existing garments into more fashionable ones. McCalls, Butterick, and Vogue produced patterns that allowed the war-sensitive consumer to create new items out of old suits and tablecloths.

FASHION TECHNOLOGY

1900s AND 1910s

Fashion technology did not evolve much in the first two decades of the century. The technological advances of the previous century were becoming more widely used during the 1900s and 1910s. Sewing machines, cutting machines, and sized patterns became commonplace. The industry had adopted a piecework model of clothing manufacture, in which a worker only completes one step in the manufacturing process. The repetition allows the worker to complete the task faster than if she had to transition from one type of task to another.

Although electricity began to be harnessed in the 1890s, it was not widely available. In the 1900s and 1910s, electricity was installed in more areas, and it became important as the power behind the new sewing and cutting machine technologies. In essence, the new technologies being used

in 1922. Miss America became a standard bearer for beauty and fashion, and the photographs and newsreels of the event were seen across the country, influencing women's fashions and social conduct. In an era marked by increased autonomy amongst women, the pageant caused outrage and protest by some who considered the display of the female form indecent. By 1928, the Miss America Pageant was discontinued, but, in response to the despair of the Great Depression, the pageant was reborn in 1933, once again broadcasting beauty and fashion ideals for women around the country through both photographs and newsreels.

Improvements in air travel in the 1920s and 1930s increased the mobility of Americans. Cross-continent and transatlantic flights opened the door to holiday travel and airmail service for magazines, postcards, and letters, both of which helped to decrease the time required for a fashion trend to move from Paris to New York and vice versa. The prosperity of the 1920s increased travel in the United States and Europe, a trend that continued for those with the economic means in the 1930s. The world was becoming smaller, and the lag time in the dissemination of fashion trends from Paris to New York to Smallville was decreasing exponentially with each passing year.

1940s

The Nazis censored fashion magazines, which was a primary fashion communication vehicle. So Hollywood and American periodicals picked up where the fashion magazines left off.

In the United States, *Mademoiselle*, *Woman's Day*, and *Vogue* continued publication. They included plentiful images and articles about fashion. Copies of these magazines were often shared among women.

Hollywood, which served as a welcome distraction during the war, had a profound influence on the fashion of the 1940s. Unlike women's magazines, Hollywood influenced not just women's fashions but fashions for everyone in the family and every ideal.

Young girls wanted to look like Shirley Temple as she grew up from toddler to young lady. Young starlets such as Judy Garland, Gene Tierney, and Myrna Loy gave teenagers an image to copy. The wholesome yet sophisticated look of Lauren Bacall and Grace Kelly kept pace with the pinup selections of Betty Grable and Marilyn Monroe.

Men had their silver screen models as well. Fred Astaire and William Powell showed men how to dress stylishly. Gene Kelly, Gregory Peck, and Humphrey Bogart established ideals for men as well. Movie stars were featured on posters, billboards, calendars, and pinups.

dance, smoke, and wear make-up, the 1930s films attempted to mask the economic struggles engulfing the American economy. Plot lines involving champagne and ballroom dancing transported moviegoers from their difficult routines during the Great Depression through glamorous gowns, tuxedos, and top hats.

Before each screening, cinemas also ran newsreels to bring political and social news to every town. Newsreels became another source of fashion information by taping "real people," especially Hollywood celebrities and socialites, attending sporting and social events. The fashions seen in the newsreels were perhaps even more influential than those in the films, because the newsreels depicted how people really dressed and looked, not how characters were stylized for a movie plot.

Building on the popularity of the "PB," or Professional Beauties, of the Gibson Girl era, an American icon was established in the 1920s: Miss America. The first Inner-City Beauty Pageant was held in 1921 in Atlantic City, New Jersey, and was renamed Miss America the following year,

Beauty contests began to be popular in the early 1920s. Here, four beauty contest winners, at Washington Bathing Beach, Washington, DC, 1922. [Library of Congress]

existence, it did not gain prominence until the 1950s and 1960s. *Vogue* magazine transformed fashion communication beginning in 1909, when it was purchased by Condé Nast, and the company slowly began to grow the magazine.

Mail-order catalogs and pattern catalogs provided another source of fashion communication. Both of these featured a variety of details about fashionable silhouettes, fabrics, and trims. They also were an important style resource for women who purchased ready-to-wear clothing or made their own clothing.

During the early years of the twentieth century, the United States' wealthiest class was a visible and publicized component of American society. The elite were often featured in newspapers through both articles and photographs. When women in the uppermost social circles went to parties and events, their fashions were often described in social sections of the newspapers. This provided another helpful resource for women looking for the most up-to-date fashion information, because the social elite's fashions usually came directly from the haute couture designers in Paris.

1920S AND 1930S

The increased popularity of photography and the use of photographs in magazines increased the pace at which fashion trends were disseminated across the country and around the world. Rather than illustrations, magazines such as *Vogue*, *Harper's Bazaar*, and *Esquire* carried photographs of major social events, society balls, and weddings, including the marriage of the Prince of Wales to Wallis Simpson in 1937. Photographs were also incorporated into mail-order catalogs, such as Sears, Roebuck and Company, that were distributed to the smallest towns in America. Photographs of Hollywood starlets were also popular to collect and provided clear and complete details on the latest fashions, hairstyles, and cosmetic trends. Film stars such as Clara Bow, Gloria Swanson, and Joan Crawford even made appearances in Sears catalogs, endorsing the latest fashions available for the mass market (Blum 1981, 2).

Another new medium, film, also played a pivotal role in fashion communication in the 1920s and 1930s. Movie houses, or cinemas, opened across the United States, in large cities and small towns, where new movies, first black and white and later color, were virtually simultaneously released in New York City and Smallville. Going to "the shows" was a favorite pastime of young and old, all of whom were immediately and directly influenced by the fashions and mores projected on the silver screen. Whereas the 1920s films paved the way for women to drink,

market research was conducted by hosting panels and discussion groups. Buyers for major stores began relying on teen magazines and Hollywood. After the war, women became the main purchasers of the family's clothing, even their husbands' clothing.

Department, boutique, and specialty stores placed more emphasis on marketing campaigns and drawing in customers. Easter, Christmas, and back-to-school campaigns were launched each year with newspaper advertisements. Easter was an especially important clothing buying event, because the whole family needed appropriate and fashionable clothing and hats for church on Easter Sunday.

Smaller retailers continued to thrive. These were usually family-run businesses, and they were located in large and small cities and towns. This type of retailer included men's stores, women's stores, family stores, and specialty shops.

FASHION COMMUNICATION

1900s AND 1910s

Designer Paul Poiret was not only an innovator of fashion design but also of fashion communication. He developed inventive new ways to disseminate his ideas in an age that had limited means of communication compared with the modern day. He hired illustrator Paul Iribe to help him create fashion booklets called *Les Robes de Paul Poiret*. He launched fashion shows of his designs at garden parties and theme parties, and he went on lecture tours across Europe to promote his fashions.

Fashion and ladies' magazines were a primary form of communicating fashion to women. They were inexpensive and readily available to most American women. Initially, fashions within these magazines were hand-drawn pictures of several women within an appropriate surrounding, such as a garden or a parlor. They illustrated several women to show the variety in styles. When illustrating accessories, the magazines would often group together a variety of the same type of accessory, such as brooches, undergarments, hats, or fans. Another typical type of illustration isolated portions of a garment. For example, a series of sleeves might be shown. In the 1910s, it was not uncommon to see additional illustrations of the back of a garment. These magazines often included articles about fashions in addition to illustrations. As the century progressed, photographs were often reproduced in the magazines.

The periodical *Women's Wear Daily* was established in 1910 as an outgrowth of the men's wear publication *Daily News Record*. Despite its early

and "five & dime" stores proved to be vital resources for fashionable dress to large segments of the U.S. population throughout the Great Depression.

Even during the Great Depression, the American population was becoming increasingly mobile, with continued access to and improvements in the automobile. The automobile allowed rural families, whose only avenue for acquiring fashionable goods had been mail-order catalogs, to "drive to town" and shop for the latest fashions. In response, the mail-order giant Sears, Roebuck and Company opened their first store in their Chicago-based mail-order facility in 1925. Sears, a trusted name in rural areas, was so successful with the first store that seven additional stores were opened by the end of the year, a fact that inspired Sears' catalog competitor Montgomery Ward to do the same. In a time of economic depression, while many businesses were closing, by 1933, Sears, Roebuck and Company operated 400 stores, with store sales exceeding catalog sales. Mail order, although still a major segment of the retail industry, had diminished in importance as individuals now had the means, thanks to the automobile, to view and try on fashions first hand.

1940s

Major department stores continued to be popular with consumers. They were a fixture in American popular culture. Even the 1947 movie *Miracle on 34th Street* features the Gimbels department store in New York.

After the war, department stores began a shift in location. They had traditionally been located in the center of city shopping districts. As Americans moved out to the suburbs after the war, the department stores followed their customers. They began building stores in suburban shopping malls, a trend that continued for the remainder of the century.

They carried designer fashions at affordable prices with some custom tailoring. Line-for-line copies of designer garments were available in many department stores. They were attractive because women could rarely afford the originals, which were extremely expensive as a result of import duties during the war.

Most department stores offered store credit cards to consumers. This was not a new practice but, in the 1940s, credit card sales began to exceed the other popular form of credit: installment plans. Credit cards made it easier for customers to purchase the latest fashions, because they did not need to save up to afford the latest trend.

Larger stores began to use market research to improve sales in their stores. They learned through personal contacts what teenage girls wanted. Special shops and departments were set up within department stores, and

States (Tortora and Eubank 2005, 355), and they demanded professional attire for work, dresses for evening, and sportswear for weekend outings.

Department stores provided all the latest New York and Paris fashions for women with the disposable income to acquire fashionable dress. Upscale department stores in major urban centers, such as Marshall Field's, Macy's, Henri Bendel, Bonwit Teller, and Nordstrom, also employed in-house designers for private-label goods as well as purchased Paris models (or samples) for reproduction. Parisian goods, whether a dress or stockings, were the ultimate status symbol for the upper and middle classes, and a retailer only had to advertising carrying the "latest Paris imports" to produce a crowded store. In addition to ready-to-wear clothing departments, the best stores also featured custom-made and import departments for women's fashions. Some stores added caché to their import departments by dubbing them with French names, such as Saks' Salon Moderne or Wanamaker's Coin de Paris (Milbank 1996, pp. 96–97).

An example of the marcel wave, still popular in 1934. [Library of Congress]

Once taboo, cosmetics counters also sprang up in department stores because makeup was no longer just for actresses and women of ill repute, featuring cosmetics by Max Factor and nail polish by Revlon (Charles Revson). Not only was makeup sold in department stores, but a new type of retail business quickly grew in the 1920s and 1930s: the beauty salon. The new short hairstyles and penchant for makeup and nail polish translated into big business for beauty salons. These salons provided haircuts, marcel or permanent waves, manicures, facials, and cosmetic lessons for women.

The concept of chain stores brought well-known retail names into regional and national prominence as major retailers expanded beyond their urban downtown locations. Discount stores, such as Woolworth's, provided an outlet for fashionable dress and cosmetics in smaller towns and rural areas and to lower socioeconomic groups in urban centers. Woolworth's

slacks, sweaters, and jackets, it gave the illusion of more outfits and a larger wardrobe. Classic sportswear styles became popular on college campuses and soon were adopted by society at large.

RETAIL OPERATIONS

1900s AND 1910s

Early in the twentieth century, tailor shops and seamstresses proliferated in most urban areas and provided custom-made clothing and alterations of store-purchased garments. Both large and small urban areas had a variety of small, boutique clothing shops. Many of them were family owned. Some offered only men's wear, only women's wear, or only children's wear, whereas others catered to entire families. There were many specialty shops for accessories such as jewelry or footwear. Some shops specialized in used clothing, whereas others specialized in imported clothing.

Department stores owners built magnificent, multistory stores with ornate décor. These elaborate stores were often described as shopping "palaces" and became destinations for family outings. Department stores were located in the heart of urban shopping areas and gathered together all of a family's shopping needs under one roof. As the department stores became more popular, they created multiple branch stores. For example, J.C. Penney had thirty-six Golden Rule Stores by 1913. The stores' name was later changed to J.C. Penney's.

Although department stores had long offered installment plans for big-ticket items, they began offering credit plans for smaller purchases such as clothes. They often advertised credit plans for clothing, especially winter clothing. It was a necessity when the weather turned cold, but many times people had not saved up to purchase new coats, sweaters, and warmer clothes.

People who lived outside of cities purchased their clothing at local dry goods stores or through mail-order catalogs. Sears Roebuck and Montgomery Ward's businesses were built on mail orders well before they established physical stores.

1920s AND 1930s

The economic boom that swept America after WWI created a high demand for consumer goods such as automobiles, radios, home appliances, and telephones, not to mention fashionable apparel, especially for working women. By 1920, nearly 9 million women were working in the United

America meant that American designers no longer had the funds to visit Paris for shows and began to rely less and less on Paris for fashion influence. American designers began creating their own designs rather than knocking off Paris trends. American designers, such as Adrian, Claire McCardell, Norman Norell, Valentina, and Adele Simpson, were among the new class of designers who established the American fashion industry in New York City in the 1920s and 1930s. Although American designers may have looked to Paris for overall silhouette and trend, their interpretations were uniquely American: casual, simple, and comfortable.

1940s

Better methods of large-scale production resulted from experience gained during the war, when rapid mass production of uniforms was necessary. The clothing industry was changed forever by innovations such as economical cutting, using materials in different ways, better mechanized methods of large-scale production, and the scientific discoveries of new manmade materials.

Garment production for soldiers during the war resulted in increased efficiency, lower cost, and standardization in quality and sizes. Mass production of clothing became the way of the market after the war. Once rations were lifted, the nation that saved together was ready to spend on items for which they had done without for so long. Ready-to-wear clothing was no longer considered a second-class choice but a necessity to be fashionable. It was often referred to by the French term prêt-à-porter.

Rationing along with strict wartime regulations ensured that manufacturers would create garments in a quick, efficient, and economic manner that achieved a standard of quality control at the same time. Mass-produced garments offered through mail-order companies such as Sears, Spiegel, and Montgomery Ward became popular, because very few people were able to pay the high prices for high fashion during the war and reconstruction.

Designers such as Claire McCardell began producing ready-made daywear and sportswear for the common American woman believing in freedom, democracy, and casualness. Although her designs with their simplicity and modern lines seemed radical at first, women liked the fit and comfort of her garments. American designers, such as McCardell and Norman Norell, led the way in work and leisure wear, combining stylishness and practicality.

Perhaps inspired by the government's mandate to ration fabric, American designers introduced the concept of separates. By coordinating skirts,

The popularity of attending and playing sports in the 1920s and 1930s created a demand for functional, comfortable, and yet stylish clothing for both men and women. Sportswear, so dubbed because it was clothing worn by spectators at sporting events, became a new classification of apparel in the 1920s. Although the ready-to-wear industry had been established for decades, the demand for sportswear provided the impetus for the growth of the ready-to-wear industry. Low-cost, stylish wardrobes were needed by both men and women to attend horse races, football games, and other outdoor sporting events.

Another major contributing factor to the growth of the ready-to-wear industry in the 1920s was the working woman. Women were now entering the workforce in increasing numbers and needed an affordable wardrobe. Working women did not have time for home sewing or to visit a seamstress for fittings, thus ready-to-wear apparel was the ideal choice for the "working girl." Dresses, skirts, jackets, and tops could all be purchased as separates or coordinates, allowing working women to create a "mix-and-match" versatile wardrobe for work and play.

Perhaps the single most important factor that impacted the growth of the ready-to-wear market was the change in silhouette and undergarments that occurred in the 1920s. Whereby the fashionable silhouette in previous decades required elaborate support structures to create bustles and mono-bosoms, the tubular silhouette of the 1920s required only a simple slip, brassiere, and drawers. The silhouette and fit were simple and required minimal engineering of pattern pieces to create high-quality, attractive, well-fitting garments. The simple designs were well suited to mass manufacturing on the new cutting, pressing, buttonhole, and hemming machines, eliminating the need for hand sewing and treadle machines. Productivity was increased, although overall costs were decreased using assembly line techniques, allowing fashionable clothing to be produced at price points that could be afforded by all socioeconomic classes of society.

America led the charge in manufacturing and developed a new type of couturier, the fashion designer. These designers were employed by either department stores or manufacturers to develop apparel lines targeting the new middle class who demanded comfortable, affordable, high-quality ready-to-wear clothing. American designers began as "knockoff artists," making line-for-line copies of Paris originals. Retailers and manufacturers would employ artists and designers to attend the Paris fashion shows, who, in turn, were charged with memorizing every detail of a single dress. After the show, the artist or designer would sketch all the details, and the sketch would be translated to a garment, sold as a "French import" in retail establishments. By the 1930s, the change in the economic climate of

and launched a new silhouette twice a year, so to remain fashionable women had to regularly purchase new wardrobes. In essence, Dior sped up fashion changes to a modern pace.

READY–TO–WEAR

1900S AND 1910S

In the early years of the century, most American designers worked for ready-to-wear manufacturers. They prepared designs for the spring, fall, summer, and holiday seasons, and, in some cases, they produced a resort line (Tortora and Eubank 2005, 382). The American designers' relationship with ready-to-wear manufacturers remained essentially unchanged until WWII.

Ready-to-wear garments were especially important to the working class. Both men and women were attracted by ready-to-wear garments because they were relatively inexpensive and did not require the time commitment of sewing the garment oneself or visiting a tailor or seamstress. For recently arrived immigrants who brought clothing from their home countries, ready-to-wear garments allowed them to quickly adopt a more "American" look. Although it allowed them to blend into their new home, the new look also kept them from looking like a "greenhorn" (newly arrived immigrant), which helped protect them from being targets of con men and scams.

Customers of the ready-to-wear market also included sports enthusiasts and the military. Hunters, fishermen, and hikers often chose ready-to-wear garments like the ones produced by Burberry's. During WWI, the U.S. government needed tens of thousands of uniforms quickly, and they turned to ready-to-wear manufacturers to fill the orders.

Shoes and accessories were commonly created by ready-to-wear manufacturers. Gloves, undergarments, and coats were often readymade.

Knockoffs of French designer fashions were common in America at the beginning of the century. When Paul Poiret came to the United States in 1913 to market his lines, he left in anger over the number of Americans wearing copies of his designs. In France, he began to lobby for legislation to outlaw the copying of designs, but that would not occur until the 1950s.

1920S AND 1930S

Although Paris remained the arbiter of style for women's fashions, the increased informality in society created a new wardrobe demand: sportswear.

rationed provided a creative outlet. American designers were doing more than creating design for a small elite population. They were responsible for generating a positive response to the strict clothing regulations and building morale on the home front.

When Paris was liberated from the German occupation, French designers who had cooperated with the Nazis were perceived unfavorably. Although Coco Channel closed her Paris fashion a year before the war, her love affair with a high Nazi official made it difficult to open her salon for many years after the war. Furthermore, many French designers had proceeded with free use of material despite the frugality that non-French designers had adopted during the war to comply with rationing. These two attitudes, combined with the emerging popularity of American designers, initiated a shift away from Paris as the arbiter of all fashion.

In an effort to reestablish Paris as the fashion center of the world, fifty-three French couturiers banded together in 1945 to create a traveling exhibition, known as Théâtre de la Mode. This group included Cristóbal Balenciaga, Jacques Fath, Jean Patou, Elsa Schiaparelli, and Robert Ricci. They revived an age-old method of displaying new designs by dressing 200 dolls that were complete with lingerie, hats, shoes, gloves, belts, umbrellas, jewelry, and handbags.

In spring of 1947, when Christian Dior launched his "Corolle" collection, he brought a new vibrancy to French haute couture. The silhouette of this collection was a stark contrast to wartime fashions. Whereas wartime fashions had broad, padded shoulders, Dior's collection featured slender, feminine shoulders. Dior replaced the natural waist and bust of the war with a corseted, nipped waist and uplifted breasts. In further contrast to wartime fashions, he replaced the modest, somewhat narrow skirts with wide, crinoline-stuffed skirts. Initially, the collection sparked criticism because it was dramatically different from the fashions that had been popular at the time.

Carmel Snow, the editor at *Harper's Bazaar*, called Dior's collection the "New Look," and it received praise as well as criticism. Many women were enthusiastic about the feminine look specifically because it was a stark contrast to the rationing and masculine silhouette that had dominated their clothing during the early and mid-1940s. Although Dior is credited with originating this look, other designers had tried to introduce similar looks at the same time. Charles James, Jacques Fath, and Cristóbal Balenciaga introduced the silhouette in evening wear, although Dior was the first to introduce it in daywear.

The New Look became so popular that it solidified Dior as a preeminent style dictator for the next ten years. He passionately took on the role

continued to simplify, removing elaborate and expensive trims, offering up simple silk dresses to those that still had the means to afford formal dresses.

Challenging Paris' role as fashion dictator in the 1920s and 1930s, a new class of trendsetters arose: Hollywood stylists. Travis Banton, Edith Head, and Adrian were three of the individuals responsible for launching worldwide fashion trends through their wardrobe selections and original designs for actresses Lillian Gish, Clara Bow, Marlene Dietrich, Tallulah Bankhead, Joan Crawford, and Carole Lombard. Their designs were featured on the big screen as well as in fashion magazines such as *Vogue* and *Harper's Bazaar* and were adopted by women around the world. Paris had no choice but to take heed of the garments on the "big screen" and incorporate the design elements into the couture collections.

1940s

Paris, the center of haute couture since Louis XIV established it as the epicenter of fashion in the late seventeenth century, fell to Germany in 1940. When Hitler took Paris, many top designers retired, went into exile, or fled the country rather than design for the Nazis. This, in addition to the mass exodus of the Jewish fashion workforce, led to the temporary collapse of the French fashion industry center. The German occupation now controlled haute couture. Nazism demanded ultranationalism and absolute conformity, including conformity in clothing.

The few fashion houses that remained worked mainly in collaboration with the Germans. Because the United States and Great Britain stationed battleships blockading the French coast, New York designers were cut off from the annual fashion shows of opulent French haute couture. Americans and Brits could no longer receive inspiration from Paris because no news was coming from occupied Europe. Social trends dictate fashion, and the entire civilized world was engaged in the war effort.

Before WWII, thousands of people worked for the couture industry, with each worker specializing in one area such as seamstress, pattern drafter, or trimmer (De Marly, 1980). Because the war devastated the moneyed class and scattered the seamstress talent across Europe and the United States, American designers now had the freedom to develop new styles without the influence of Paris. Because supplies were short and most materials were rationed, an opportunity emerged for creative design along with the use of unique materials.

Hats became the item to dress up an otherwise politically correct design. The adornment of feathers, raffia, and other leftover items not

the war adopted the wartime silhouette, which consisted of wide, barrel-shaped skirts supported by petticoats with loose bodices. The hips were often further accented with a peplum.

As the world emerged from the war in 1918, haute couture designers found themselves in a more modern world. Those who adapted and created more liberated designs found success in the 1920s and beyond, but many couturiers found themselves out of step with the times and permanently closed their houses not long after the war.

1920S AND 1930S

By the 1920s the role of the couturier as fashion dictator and trendsetter was firmly established. Haute couture houses through Paris began vying for the honor of originating new fashion trends through the production of two collections per year. In keeping with the changing role of women in the 1920s, an increasing number of haute couture houses were established by couturieres (female couturiers), including Callot Souers, Vionnet, Madame Gres, Schiaperelli, and, of course, Gabrielle "Coco" Chanel.

Chanel infused her personal style into her designs, favoring simple wool jersey dresses, skirts, and sweaters rather than elaborate day dresses. Her creations broke with tradition and gave women an alternative to "fussy" fashions that required extensive fittings and assistance when dressing. The simplistic styles she promoted were perfectly suited to the new, active woman. Many couturiers attempted to return fashion to its previous complex and elaborate state, but American women refused to participate in these trends. So Paris, the dictator of fashion, in turn was dictated to by American women who had the means more than their European counterparts to purchase one-of-a-kind custom-made clothing.

The increased prosperity in America and abroad in the 1920s meant that more women could afford couture garments, and Parisian fashions became the ultimate status symbol. Once the domain of "old money," couture became a means for movie actresses and the wives and daughters of the new industrial tycoons to display their new-found affluence. Royalty and the social elite attended couture shows and fittings with the nouveaux riche, blurring the lines between past class distinctions.

The Great Depression of the 1930s devastated the haute couture establishment in Paris. Haute couture, once the second-largest export from Paris, dropped to twenty-seventh place by 1933 (Ewing 2001, 105). American department stores cancelled orders. Both American and European clientele no longer had the funds to travel abroad to indulge in expensive, one-of-a-kind, custom-fit garments. In response, fashions

Charles Frederick Worth, who founded the House of Worth in the 1860s, is seen as the "father of haute couture." By the turn of the century, his sons had taken over the business and hired Paul Poiret as a designer. Poiret did not last long working for the Worths, and he opened his own house in 1903. Poiret rebelled against the "S-curve" silhouette that reigned during the first decade of the 1900s. By 1906, he introduced the empire silhouette, with a slim skirt, a style that was inspired by classical Greek dress.

Poiret was aggressive in his promotion of the designs, and they quickly caught on. He also created Rosine, the first perfume by a couturier. He coordinated the packaging, fragrance, and marketing campaign for it. Poiret was not the only popular designer who was inspired by classic Greek costume.

Mariano Fortuny made his name as a designer by introducing the "Delphos gown" in 1907. This slim-silhouetted, richly dyed gown was made of finely pleated silk. The edges were trimmed with small glass beads to weigh down

Mrs. Condé Nast in a Fortuny pleated tea gown, c. 1910. [Library of Congress]

the silk. It varied dramatically from the popular silhouette of the day, because it was uncorseted and flowing. The style highlighted the natural female form.

Callot Souers' designs were ultra-feminine and were usually covered in lace. This is no surprise because Madame Gerber, the oldest of the three founding sisters, had owned a lace shop, and their mother was a lace maker. Although they opened the house in 1895, they emerged as popular designers in the 1910s. Day clothes trimmed in lace and ribbon and lingerie were their staple, but they also created a following for their period gowns, which were contemporary versions of eighteenth-century dresses complete with tightly corseted waistlines, hoop skirts, and pastel tulle.

During WWI, many of the couture houses shut down, at least temporarily. Even Paul Poiret shifted toward the war effort by enlisting in the French infantry as a tailor. The couturiers who continued to design during

garment production after the war, and ready-to-wear clothing became less expensive and easier to make.

Clothing retailers at the beginning of the century included tailors, seamstresses, department stores, and mail-order companies. After WWI, American consumerism flourished, and department stores marketed Parisian imports and installed make-up counters. Chain stores and discount stores emerged and proliferated with the greater number of cost-conscious consumers during the Great Depression. After WWII, department stores moved out to the suburbs to follow the wave of consumers.

New fashion communication vehicles emerged during the first half of the century. In the early decades of the century, Americans primarily relied on ladies magazines and mail-order catalogs for up-to-date fashion information. Fashion shows, a new type of marketing, were held and soon became a critical form of fashion dissemination. By the 1920s, the increased use of photos in magazines, catalogs, and newspapers helped proliferate fashion trends. In the 1930s, Hollywood and Miss America Pageants defined new fashions and communicated them to Americans. The influence of Hollywood heightened in the 1940s as stars and Hollywood designers gained mainstream prominence.

Technological innovations shaped the business of fashion during the first half of the twentieth century. Clothing manufacturers relied on sewing and cutting machines to speed their processes in the 1900s, and, for the first time, they used electricity to power these machines. In the 1920s, several new artificial fibers were developed. Rayon, acetate, nylon, and polyester were invented and woven into a variety of garments. Some of these fabrics did not see wide use until WWII when the shortage of natural fibers such as wool, cotton, linen, and silk necessitated the use of artificial ones. Zippers became a widely used fastener in the 1930s, supplanting the buttons used for many closures.

HAUTE COUTURE

1900s and 1910s

During the first decades of the twentieth century, the French dominated haute couture. Houses such as Worth and Callot Souers were the driving forces behind many of the popular styles. The century launched with the L'Esposition Universalle in Paris in 1900. Because French houses such as Worth and Callot Souers, but also Drecoll and Paquin, participated in L'Esposition, the modern concept of haute couture gained a worldwide audience.

6

The Business of Fashion

The business of fashion experienced innovations and changes to its character during the period from 1900 to 1949. Haute couture, the French high-end fashion business, was at its height for most of the period. American designers copied French fashions line-by-line, and French designers competed against each other to produce the original styles that shaped trends.

Haute couturiers extended their reach into American markets with inventive marketing techniques and licensing opportunities. They distributed booklets of their designs and held fashion shows. They created perfumes and name-brand accessories such as gloves and stockings to entrench their names in Americans' minds. Although the two world wars and the Great Depression cut off the influence of haute couturiers from Americans, they resumed their dominance after each event.

At the beginning of the century, ready-to-wear clothing was worn primarily by the working class. Readymade clothing helped immigrants quickly adopt an American look. By the 1920s, the popularity of ready-to-wear clothing had increased. Most sportswear was readymade, and the growing numbers of working women adopted prêt-à-porter clothing. The simplified silhouettes of the 1920s and 1930s meant that ready-to-wear garments fit better and were easier to make than they had been in the past. Efficient wartime production during WWII led to more efficient

PART II

Fashion and the Fashion Industry, 1900–1949

New York Times. 1914. "Lauds Sex Lessons in Public Schools," June 16.

New York Times. 1915. "Eugenic Marriages Urged For Jersey," November 20.

New York Times. 1917. "Denounce Slackers in Marriage Rush," April 11.

New York Times. 1918. "Slacker Marriage Not a Draft Excuse," January 27.

Perrett, G. 1982. *America in the Twenties, A History.* New York: Simon and Schuster.

Reeves, T. C. 2000. *Twentieth Century America: A Brief History.* Oxford: Oxford University Press.

Richardson, D. E., ed. 1982. *Vanity Fair: Photographs of an Age, 1914–1936.* New York: Clarkson N. Potter.

Rowbotham, S. 1997. *A Century of Women.* New York: Penguin Books.

Schrum, K. 2004. *Some Wore Bobby Sox: The Emergence of Teenage Girls' Culture 1920–1945.* New York: Palgrave Macmillan.

U.S. Census Bureau. *No. HS–16. Expectation of Life at Birth by Race and Sex: 1900 to 2001.*

U.S. Census Bureau. 2001. *No. HS–20. Education Summary—Enrollment, 1900 to 2000, and Projections.*

U.S. Census Bureau. 2002. *No. HS–30 Marital Status of Women in the Civilian Labor Force: 1900 to 2002.*

Yapp, Nicholas. 1998. "The Hulton Getty Picture Collection: The Thirties." *Decades of the 20th Century.* Cologne: Konemann.

Ware, S. 1982. *Holding Their Own: American Women in the 1930s.* Boston: G. K. Hall.

soon joined in the workforce by married women who were soon allowed to work.

REFERENCES

Abbott, B. 1973. *Changing New York: New York in the Thirties.* New York: Dover.

Andrist, R. K., ed. 1970. *The American Heritage History of the 20s & 30s.* New York: American Heritage Publishing Co., Inc.

Bachu, A. May 1998. *Timing of First Births: 1930–34 to 1990–94.* U.S. Census Bureau: http://www.census.gov/population/www/documentation/twps0025/twps0025.html.

Baker, P. 1992. *Fashions of a Decade: The 1940s.* New York: Facts on File.

Berkin, C., Miller, C. L., Cherny, R. W., and Gormly, J. L. 1995. *Making America: A History of the United States.* Boston: Houghton Mifflin.

Best, G. D. 1993. *The Nickel and Dime Decade: American Popular Culture During the 1930s.* Westport, CT: Praeger.

Bevans, G. H. 1930. "Assembling the Layette." *Chicago Daily Tribune*, July 6, D4.

Bordwell, D., and Thompson, K. 2002. *Film History: An Introduction*, 2nd revised ed. New York: McGraw Hill.

Cole, B., and Gealt, A. 1989. *Art of The Western World.* New York: Summit Books.

Dolfman, M. L., and McSweeney, D. M. 2006. *100 Years of U.S. Consumer Spending: Data for the Nation, New York City, and Boston.* BLS Report 991, May. Bureau of Labor Statistics.

Eyles, A. 1987. *That Was Hollywood: The 1930s.* London: Batsford.

Flappers: The Birth of the 20th Century Woman, Motion picture. Produced by K. Botting. 2001; Princeton, NJ: Films for the Humanities and Sciences.

Gordon, L., and Gordon, A. 1987. *American Chronicle.* Kingsport, TN: Kingsport Press, Inc.

Hobbs, F., and Stoops, N. November 2002. *Demographic Trends in the 20th Century.* U.S. Department of Commerce.

Israel, B. 2002. *Bachelor Girl: The Secret History of Single Women in the Twentieth Century.* New York: William Morrow.

Kaledin, E. 2000. *Daily Life in the United States, 1940–1959: Shifting Worlds.* Westport, CT: Greenwood Press.

Keenan, B. 1978. *The Women We Wanted to Look Like.* London: Macmillan London Limited.

Kyvig, D. E. 2002. *Daily Life in the United States, 1920–1940.* Chicago: Ivan R. Dee Publisher.

Modell, J. 1989. *Into One's Own: From Youth to Adulthood in the United States, 1920–1975.* Berkeley, CA: University of California Press.

New York Times. 1910. "Marriage of Minors Legal Till Annulled," March 13.

New York Times. 1913. "Concealed Marriages of Women Teachers," March 23.

life. One way the youths could participate was to tend the gardens and collect paper and tin cans for the war effort. In many ways, the war kept children from having a childhood. Instead, they were expected to fulfill the responsibilities of the war effort. School enrollment went down as teenagers enlisted and took jobs to help out. Boys and girls were taught to respect adults and authority.

Families went back to their frugal ways of the Depression years as they dealt with rationing of basic goods. Hand-me-down and homemade clothing was typical. Clothing was often handed down from one sibling to another and was modified from boy's to girl's when necessary. It was a milestone for young boys to wear long pants, and some of them had to wear the knickers that had been fashionable in the 1930s because it was all the family had.

Growing up during the war often meant living with extended families and sharing whatever was available. Families generally stayed in the same towns and even the same neighborhoods. It was quite common for cousins to grow up together and for family activities to include aunts, uncles, and cousins each weekend.

While adults scrimped and saved to get by, children learned not to be wasteful and not to ask for treats or special items. Children were sometimes able to get odd jobs such as clearing lots and picking vegetables because all able-bodied men were at war. This type of work did not pay much, but it allowed children to help make ends meet during a time of rationing and low wages. Boys looked forward to the opportunity to serve their country by enlisting as soon as they came of age, whereas girls flocked to see Humphrey Bogart at the movies and spent their weekends at the USO dancing with soldiers on leave to the music of Frank Sinatra and other numbers from the Hit Parade. Many boys lied about their age to enlist early. Some did this out of patriotism, some for escape, some for want of adventure, and some to choose a branch of service before the government chose one for them. High school graduation classes were disproportionately made up of girls, because the boys were drafted or enlisted.

Emphasis now was not only providing for the family but volunteering for efforts to support soldiers and sailors overseas. Young women went to work outside of the home, some as young as 15 years of age. This provided not only income but exposure to life "off of the farm."

As young couples delayed marriage and starting families during the Depression, the war changed that trend and attitudes. Marriages right after high school were common as young men rushed off to war with the anticipation that life would be better after the war was over. With the continued need for factory workers in defense plants, single women were

Women were proud to do their part to support the war effort and were encouraged to join the workforce by Rosie the Riveter posters. Traditional barriers clearly defining men's work and women's work and the conventions of dressing up quickly broke down. Trousers required for work in the factories became acceptable to wear outside of the factory, because there simply was not enough available fabric for an extensive wardrobe.

Women in the workforce did create issues for the men who were managers and the older men who were not serving in the military. Although most factory clothing was not flattering, management wanted to be sure it stayed that way so as not to distract the men. Slacks and jumpsuits were practical for factory work, but they could not reveal a woman's form. Work had to be done and women should not tempt men with provocative clothing.

The Vought-Skilorsky Aircraft Corporation sent fifty-three women home on moral grounds that the sweaters the women wore were too sexy. When the union pointed out that sweaters had been approved for office workers, the company then cited safety reasons. The National Safety Council confirmed that sweaters could attract static electricity and start fires. The dichotomy persisted of good girls not dressing in a provocative manner, but it was all right for performers who were doing their patriotic duty. In fact, when zippers were reintroduced with stretch pants after the war, they were located on the side because a front zipper was considered too provocative.

Men found female motivation from women who were very different from Rosie the Riveter in her jeans, rolled-up sleeves, and bandana. Pinup posters of Betty Grable and other starlets adorned the walls, tents, and lockers of young men around the world. Hollywood assisted the government in boosting the morale of the men and boys at the front by sending USO tours with lots of pretty girls. As a partner in the war effort, Hollywood design had to pass a censorship board to guard against provocative costumes. It was not considered to be in the best interest of the country for men at home to be distracted or tempted by women.

Along with boosting morale by sending showgirls around the world, the government also provided news reels and information warning soldiers about the dangers of sexually transmitted diseases. The idea was to help the men remember their wives and girlfriends at home to motivate them to fight for freedom.

GROWING UP IN AMERICA

Young people in America spent much of the early 1940s contributing to the war effort. Victory gardening and recycling became a patriotic way of

young man they knew out of patriotic duty to keep up the spirits of those fighting for the country. Servicemen enjoyed receiving letters and took time to write back sanitized versions of battlefield experiences.

During the Great Depression of the 1930s, many couples delayed marriage and families because saving and frugality were a way of life. WWII motivated people in different ways. Some believed the war was the answer to a new economy, and marriage gave both men and women something to hang on to as a promise of better things to come as the men left for the battlefield. Some, afraid they would not return from the war, wanted to enjoy marriage even if briefly before they left. Needless to say, the marriage rate increased dramatically as a result of the United States entering WWII. Naturally, a baby boom followed.

During the 1940s, the baby boom started as returning G.I.s started families. Families in all socioeconomic and racial groups contributed to the boom. Child-rearing methods of the past regarded properly disciplined children as "seen and not heard." Doctor Benjamin Spock changed the way parents raised their children in 1946 with his book *The Common Sense Book of Baby and Child Care*. Spock identified children as individuals who should be treated with natural affection. This was a revolutionary concept in child rearing, and his books became indispensable to parents throughout the remainder of the forties and fifties. Parents, who as children felt deprived, vowed they would give their own children everything they did not have as children. Some believe that the flower children of the sixties are the result of an undisciplined child-rearing approach advocated by Spock.

SEXUALITY AND MORALITY

Little girls were restricted in their activities as to what was proper for little girls in this still conservative society. Young ladies were taught when to speak and what was appropriate conversation. Although dating was an approved social activity, it was usually in groups or double dates. In public, any visible sign of affection between a man and woman was avoided. Both clothing and activity were conservative so as not to draw attention to one's sexuality. Girls and women wore dresses because showing the shape of the entire leg was considered vulgar. On the farm, however, girls did wear baggy slacks.

WWII changed the role of women in the family. During the war, nearly every family had a man in uniform, and women were taking on the responsibilities traditionally held by men. Severe labor shortages on both the farm and in factories could only be alleviated by employing women.

GROWING UP IN AMERICA

At the beginning of the 1930s, a man's life expectancy was 58.1 years and a woman's was 61.6. By the end of the decade, a man could expect to live to be 60.8 years old, and a woman's life expectancy jumped to 68.2 years (U.S. Census Bureau 2002). The rapid extension of the lifespan was only one small indicator that life in the United States had changed greatly. Medical advances meant that children were more likely to live through child birth and infancy.

Although the times were hard, people had the simpler life that many of them had desired during the madcap twenties. Life had its good points and bad: young people did not spend so much time in bars or clubs, yet some children could not go to school because there was not enough money to pay the teachers. Many girls and young women returned to the pursuits of their mothers, which were tending to the household, children, and family. Most young people did not have the opportunity, or the money, to "fritter away the night" at a nightclub.

Children had unprecedented access to their grandparents and older siblings. In previous decades, these relations would live in other residences, whereas they moved in with their extended families during the Depression. Many children had more adult oversight than ever.

During the Depression, most urban kids attended school. It was difficult enough for adults to find jobs, so children worked much less during this period than in previous eras. Children filled their free time with radio adventures, such as *Little Orphan Annie*, and comic books. Many popular classic toys were launched during the 1930s, including Scrabble, Sorry, Monopoly, and the Viewmaster Viewer.

THE
1940s

MARRIAGE AND FAMILY

Keeping up morale for the men and women in service as well as those on the home front was everyone's job throughout much of the 1940s. Men went to war, women went to work, and children were just as eager to do their patriotic duty in collecting recyclables and earning money. Daily life during the war years centered on the war and surviving it. A book entitled *So Your Husband's Gone to War* provided practical advice in 1942 for how to write a letter, how often to write, and the vital role that mail played in building and sustaining morale. Many young women would write to every

to live in housing that was substandard by any measure. Many families to-gether would create small communities of nothing but old boxes or old crates or train cars. Plumbing and electricity were almost nonexistent, and women would have to cook much the same way that their grandmothers did, on open fires.

For the first time in this century, men found their gender role chang-ing. With the scarcity of jobs, they frequently had time on their hands. Their wives often picked up extra jobs such as doing laundry or serving as maids. This disrupted men's status as the breadwinner of the family, which angered most men. This role reversal was not welcomed by men or women. They usually tried to maintain a patriarchal household regardless of the economic struggles they experienced.

SEXUALITY AND MORALITY

The crash of 1929 and the Depression that followed seemed to dampen the sexual attitudes of the country. Many people were either looking for work or working long hours to maintain a living wage. Many people could not afford the more "frivolous" activities that they had enjoyed dur-ing the 1920s. The economic depression also helped fuel a mental depres-sion in men.

The austerity brought on by economics kept many people close to home. Activities that remained popular were the movies and music. For a relatively small price, people could attend a weekend matinee and forget their daily lives for an hour or two. The actors in the films were attractive, and most of the movies were lavish, costume scenes, adventures, or fantasies.

In the 1920s, movies pushed the boundaries of what many Americans considered decent. In response, the United States Motion Picture Produc-tion Code, also known as the Hayes Code, was passed in 1930. When the code began to be enforced in 1934, it prohibited content that would lower the standards of the audience that watched it. It kept filmmakers from showing nudity, ridiculing religion, discussing sexual perversion and vene-real diseases, and showing explicit representations of methods of crime, such as safecracking. The code even discouraged "scenes of passion" that were not essential to the plot.

Although premarital sex was frowned on, young couples still engaged in it. From 1930 to 1934, one in every six first-time births was conceived before marriage among 15- to 29-year-olds (Bachu 1998). Young people were having sex and solving out-of-wedlock pregnancy by getting married.

such as Charles Lindbergh, Jack Dempsey, and George Herman "Babe" Ruth, who were idolized for their individual skills and accomplishments.

THE
1930s

Marriage and Family

During the Great Depression, marriages were often postponed to save money by those with limited resources and, in some instances, rushed by those with greater financial capabilities. For those with little means, parents and families occasionally offered a "parental subsidy to solidify the marriage contract" (Modell 1989). This could include the option of living with in-laws, parents, siblings, or friends to save on expenses. Some favored a longer engagement to ensure a real commitment and a good match.

Since the 1920s, activists had been advocating that couples should have thorough medical exams before marriage. They hoped that this would ensure that a new husband or wife did not learn about their loved one's fatal disease on their honeymoon. In 1938, New York passed a law that required a medical exam and blood test before a couple could marry, and other states soon followed suit. Once married, couples generally stayed that way for both emotional and financial stability. Generally, divorce was too expensive for couples to consider. Gift registries were also established for the first time in department stores after a 1935 marketing campaign by Lenox China (Whitaker 2006).

The most famous wedding of the era was nearly royal. The marriage of the Duke of Windsor and Wallis Simpson, an American divorcee, made headlines when Windsor chose to abdicate the English throne to marry Simpson in 1937.

The Depression had a dramatic effect on the makeup of households. When Americans saw their savings evaporate, they often moved in with extended family members. This was especially true of young married couples and elderly parents. Single people in their teens and twenties often lived with their parents to save money. Sometimes families would send their children to live with family members in the country. It was not uncommon for one parent to abandon the family when they faced the prospect of poverty.

Many families had to sell the furniture and luxuries as they moved from place to place looking for work. Sometimes families would be forced

born. Rural children could dream that they might one day live in a city. Both rural and urban children could dream that they might be movie stars, radio entertainers, or pilots. Children of the 1920s had options that their ancestors could never even imagine.

The education of children became the center of a national debate during the 1920s. John Scopes, a biology teacher in Dayton, Tennessee, dared to teach Darwin's theory of evolution in his high school classes. What originally was a local issue became front page news for most papers across the county. Although Scopes lost the trial, the case demonstrated the polarization of the country. Many educational systems noticed the controversy the trial caused and refused to purchase any text that mentioned Darwin or the theory of evolution. Textbooks would not change for another fifty years, although the controversy never diminished.

Most young people in their teen years were spending more time in school and less in the workforce. They also had more leisure time. Much of that time was spent in frivolous activities such as seeing how many people could fit into a vehicle, swallowing goldfish, dancing for hours in dance marathons, sitting on flagpoles, or standing on the wings of planes while the plane was flying. Young people would try almost anything if it was considered "new and different."

In the 1920s, many American families were able to live a lifestyle that only the wealthy could afford in the nineteenth century. Although this improvement meant that life was simpler in many ways, life also became more dangerous for children. In the nineteenth century, most parents knew that their children would be safe in their communities: everyone knew each other, and stories about children's behavior, good or bad, would ultimately be told to the parents. In the 1920s, parents were no longer sure what experiences their children would have.

Urban life, although it brought improved technology and a major lifestyle change, also meant that one's neighbors might not be the same from one year to the next. Parents who wanted to raise their children to practice "old-fashioned values" could not know whether the children's teachers or classmates or even the children down the street might practice some new and "horrible" custom, such as wearing makeup. With the rampant production of illegal alcohol, the crimes, and relatively flagrant sexual activity of the flapper and her beaux, parents were fearful of the activities that they could not control.

There were some new activities for children and young people. Comic books became common during the decade. Superman became a hero for many boys, although many parents did not like the idea that Lois Lane was an independent woman. Young people had other, real, everyday heroes,

sensationalism. Other periodicals, such as Bernarr MacFadden's *Evening Graphic*, specialized in photographs of scantily clad individuals. MacFadden was a health and fitness fanatic, who found the athletic human body beautiful. In many situations, the pictures would be of MacFadden's own body, but athletic people barely clad or wearing body-hugging clothing were regularly featured. The publication encountered difficulties with a variety of obscenity laws, but it continued to depict photographs that highlighted the human form.

MacFadden also began publishing "women's magazines" that emphasized love stories. The heroines of the stories were supposed to be told by an "ordinary" American woman; however, the stories were created by writers, many of them males, on MacFadden's payroll. By the end of the 1920s, each issue of the magazines was selling at a rate of more than 2 million copies (Jones 2005).

Growing Up in America

Although families were still the primary social unit, multigenerational families were becoming less frequent, but they were still common. Children, as a rule, tended to grow up in the communities in which they were born, although more and more families were moving to follow available work. Many families were headed by a woman at the beginning of the decade, primarily because of the death or disability of a husband or father during the war.

Technology and a growing middle class allowed many young people to remain in school. By the 1920s, people advocated a high school education for all Americans. Although this would not become universal for several years, the idea that youths could remain in school without entering the workforce allowed youths to remain young longer than any generation before theirs. Adolescence, a new concept, also seemed to indicate that youths would clash with the beliefs and morals of their elders.

The burgeoning group of adolescents, the young men who had returned from the war, and the young women who had supported themselves and their families during the war did not want a return to the culture in which their parents were raised. They flocked to the automobile, urban areas, and the newly developed illegal bars called speakeasies. These situations allowed women to experience a degree of sexual freedom that their ancestors never had, and they embraced that freedom with a ferocity that helped to change the American culture.

In the 1920s, for the first time in history, children could dream of becoming famous in activities that did not even exist before they were

alcohol, dated men she hardly knew, and danced the night away in clubs, bars, and "speakeasies." These young women enjoyed the activities and would not let the morality of their parents' generation prevent them from having a good time. Women, for the first time on a large scale, were publicly acknowledging that they enjoyed their activities, the company of men, and the physical sensations that came with being young.

The old order was shocked and attempted to classify the flapper as less intelligent or somehow mentally disturbed. Some communities attempted to arrest young women found alone in cars with single men. Many considered the behavior of the flapper frivolous and licentious, yet young girls were literally dying to emulate the flapper style. There were stories that young girls committed suicide when their mothers would not allow them to adopt the flapper style.

The fashions of the flapper, in retrospect, seem relatively tame compared with the fashions of fifty years later. The dresses were short, but they also tended to hide the woman's figure. The dresses were loose and had a tendency to make the women who wore them look as if they had the figures of young boys. The dresses hid the fact that women had breasts. A woman would bind her breasts if they would disturb the flat-chested look. The short length of the skirt horrified many people who found the visibility of a woman's leg to be scandalous, but young women saw the fashions as liberating. The new styles represented a feeling that women could do what they wanted to do. They could go where they wanted when they wanted, have jobs, postpone marriage, and generally live the same kind of life that men could live. Interestingly enough, men tended to wear more clothes than women did.

This culture and attitude was partially shaped by literature and the increasing popularity of the moving pictures. Romance and love began to be seen as necessary for marriage. In the movies, couples who accepted arranged marriages tended to be unhappy and searching for love. Couples who sought love and companionship were portrayed as being happier than those who married for other reasons. Women were not only portrayed as being more independent than their mothers, they were also seen as sexual beings, not simply as mothers and wives.

Men, according to the popular media, preferred a woman who would be an equal partner in a relationship. The movies even portrayed workaholic men as being somewhat unattractive to women. The goal, according to the movies, was that a couple would be companions, sharing each other's activities.

In the print media, the tabloids became increasingly popular. These magazines and newspapers would report on any activity that exploited

In some cases, the women had to work, because there was no man available to provide a paycheck. In other cases, many women did not want to subjugate themselves to men and found ways to get around a community's attempts to keep women at home.

The stock market crash of 1929 accomplished what legislation and public opinion could not do during the previous years. More families stayed home; they simply did not have the finances to do anything else. Many families could afford relatively inexpensive records and go to a movie every week or so, but many other activities were too expensive. Electricity again helped many people pass the time.

Radio kept many people occupied, and the programs would allow everyone to gather around the radio and enjoy an evening of listening to music or other forms of entertainment. During the day, women would listen to a new kind of program called a soap opera. Sponsored by companies that made washing products, programs such as *Stella Dallas* would keep people listening to discover the new adventures of the young heroine.

SEXUALITY AND MORALITY

The decade ushered in a major attempt by government to legislate morality. On January 16, 1920, the Volstead Act ushered in the era of American history commonly referred to as Prohibition. The act made the manufacturing and sale of alcohol illegal. Almost as soon as the ink was dry, Americans began searching for ways to evade the legislation.

The convenience of cars transformed dating for young people. They quickly discovered that the automobile allowed men and women to ignore the heavily chaperoned dates that had been the primary form of courtship before WWI. A young man could meet a young woman, they could drive off, and no other adults would be able to know where they went.

In earlier decades, women encouraged men to be as chaste outside of marriage as women, but, in the 1920s, that concept disappeared as women seemed to believe that they had the rights to be as sexually active as men. Before the war, sexual activity was rarely discussed. In the 1920s, it was a common topic of conversation. American naiveté had changed so much that the American public became aware of homosexuality, although it held stigma among most Americans.

The flapper seemed to be the center of sexual confrontation. There seems to be a variety of origins for the term flapper, but most people agree that the 1920s use of the word flapper meant a young woman who embraced the ideas of modern womanhood. She wore short skirts, bobbed their hair, ignored the "courting customs" of their ancestors, drank illegal

intervals between children. Women began using birth control devices in increasing numbers, although many people thought that was inappropriate. Without the fear of pregnancy, many women began to enjoy sex.

The divorce rate began to climb. Women wanted more equality in their relationships and would often leave a husband who did not, or could not, take care of a family. Premarital sex became more common and openly discussed. Many of the young men of the day, especially the more affluent or more educated men, no longer believed that it was necessary to marry a virgin. The fact that many young couples had sex before marriage had one unexpected consequence: fewer men were visiting prostitutes. This in turn helped lower the rate of sexually transmitted diseases, but few people thought that the end result was worth the fact that young people were engaging in sex outside of marriage (Elliot and Merrill 1934).

Women who did marry had lives that were similar yet different from their mothers. Women still were responsible for the maintenance of the home. Men were the breadwinners; women were responsible for the cooking and cleaning and all the chores that had been considered as "women's work." What now changed was that most urban women had an assistant. That assistant was called electricity.

Housework was still housework, but most families were able to buy appliances on credit. Advertisers were especially skilled at convincing the American family that they needed all sorts of labor-saving devices. When faced with the choice of going into debt to buy an electric stove or slaving over a wood stove, most women probably opted for electricity. Not only could they cook with the new-fangled electrical marvel, but they could sew, wash, and iron clothes using new electrical appliances.

These appliances might have saved, or ruined, many relationships. Instead of having to spend all her time keeping house, a woman now was able to greet her husband at the end of the day and have time to talk to him. New-fangled gadgets such as pressure cookers allowed a woman to change a menu if her husband unexpectedly brought his boss home for dinner.

After dinner, the couple might be able to have some leisure time together, attending a show or some other attraction that was available to them. Many of these attractions were child friendly and the entire family could attend.

Some men found the new, more assertive woman threatening. Many men believed that women were frail and needed a man to protect them. Some men tried to keep women home or make it illegal for them to work, but most women simply ignored these attempts to keep them at home.

delayed marriage and child rearing until they were in their late twenties or even their thirties. Women realized that their individuality and roles did not have to depend on the occupation or wealth of their husbands.

Culturally important marriages of the time included the 1922 nuptials of Princess Mary and the Earl of Harewood, which because of technological advances became the first royal wedding to be broadcast in the United Kingdom. Consequently, "the wedding game," in which two children dressed up and pretended to get married, became popular both in the United Kingdom and in the United States (Yapp 1998).

Americans witnessed a change in family behavior by the 1920s. In the late Victorian period, families were hierarchical, with the father as the leader. The family ideal espoused in the 1920s was the "compassionate family." This ideal was friendly and affectionate, and it included an emphasis on nurturing children. This ideal became more attainable as the size of the American family decreased.

The writings of Freud and other psychiatrists and psychologists became popular, as did Margaret Sanger and other advocates of birth control. Sex became an acceptable topic of conversation. People would discuss the scientific reasons for other people's behavior and support their opinions with research and academic literature. Usually, people could find something in print that would allow everyone to validate his or her own personal belief.

For a few years, the birth rate in the United States declined to such a low that the country was not reproducing itself. Women wanted to control their bodies and their pregnancies. At the beginning of the century, few people knew about, or discussed, birth control. During the 1920s, information about it was more widespread, but not all of the information was factual. Advertisers catered to the misconceptions.

Pregnant women began to have a life outside the home. Before this time, most women would be confined to the home once a pregnancy became obvious. Although ready-to wear maternity clothes had been available for about a decade, most women would not be seen in public if they were obviously pregnant.

Pregnancy was causing less fear in women. Although children were still dying of childhood diseases, the lower birth rate and increased age of the mother allowed many women to deliver a healthy child. The advances in medicine also meant that, for the first time, women could be given drugs and be allowed to "sleep through" the entire delivery process. Women no longer had to suffer the pain of childbirth. Although this might have meant that women would be more eager to have children, women began to want more control over the number of children and the

The 1920s may have been "wild and crazy" for some, but many believe that the image of the flapper was typical only of a relatively small group of young people who had some money and lived in urban areas. People in rural areas tended to become more fundamental in their beliefs, possibly as a backlash of the social upheaval created during the Great War. Regardless of the point of view, the 1920s are usually seen as a time of social change for the family and the individual.

The "war to end all wars" had an impact on most individuals living in the United States. Almost everyone was involved in the war effort to some extent. Many families lost friends and relatives in the war. Some of the soldiers were affected by the mustard gas used in Europe and were unable to resume the lives they had lived before the war. Many soldiers and their wives wanted their lives to return to the way they had lived before the war, but this was almost impossible for most people.

The suffrage amendment passed in 1920, allowing women to vote. Attitudes had changed and women's role had changed with it. Women had worked in most jobs during the war. Some men expected that women would be content to return to their roles as wives and mothers once the soldiers returned home. Although this may have happened in some situations, many women would have to remain in the workforce because their husbands, brothers, and fathers had died during the war or had become so incapacitated that they were unable to be the major financial support of the family. Other women, having tasted independence, would not return to the lives they led before the war.

The relative independence that women had experienced during the war taught them that they could manage on their own, without a man to protect or care for them. They no longer were dependent on their parents or husbands. Women started retaining control of the money they earned; they did not automatically give it to their husbands or fathers. As the roles of men and women began to change, the attitudes of marriage and family changed as well.

Compared with modern equivalents, a greater number of young couples were married during the twenties. Three of five people over the age of 15 were married, partly because of the widespread prosperity of the decade (Kyvig 2002; Modell 1989). Location also played a factor in marriage age, with rural marriages occurring at a younger age and urban marriages at a slightly older age. Generally, however, women were actually spending more time in the work world and on their own before committing to a marriage (Israel 2002). Most men, however, got married after age 21.

Increasingly, young women believed that they did not have to be married and have children by the time they were 20. Many young women

The idea that children were different than adults was a concept that gained strength around the turn of the century. The concept of "adolescence" did not emerge until the twentieth century. Until then, children were simply considered small adults. They dressed like adults and were expected to act maturely. If children seemed to develop differently, many people believed that to be an indication that the parents were not appropriately disciplining the child. Parents rarely considered if a child was developmentally able to cope with a job or with marriage. Once married or employed, childhood was over; adulthood and all its responsibilities had begun.

An increasing number of social activists began to take up the cause of child workers. The political situation in Europe became a greater concern to many Americans. When war was declared in 1917, many of the organizations put their agendas on hold until the end of the war. They thought that they would resume fighting for their principles after the war. No one knew how much the war would change life for everyone, regardless of age. Laws regarding child labor would not be seen until the 1930s.

THE
1920s

MARRIAGE AND FAMILY

It can be argued that the 1920s would be one of the most revolutionary decades in human history. Just a few years before the start of the decade, more people were transported across greater distances in a shorter period of time than ever before in history. Women who only five years earlier had been content to be wives and mothers, had gone to work and done jobs formerly done only by men. People who were born at the beginning of the century and who expected to grow up and die in their home communities were moved from their homes to new areas, sometimes even across the Atlantic Ocean to Europe and then return to their homes. Travel is said to change a person's perspective, and the perspective for many Americans had changed drastically by the beginning of the 1920s.

People were moving to urban areas. There they found new technology and new opportunities. Medicine and technology were enabling the population to live longer. Children were staying in school longer because they were not needed in the workforce. Leisure time was increasing, and people were finding new ways to spend that time. Although not everyone could enjoy all of the cultural and financial opportunities, more and more people were improving their lifestyles.

educated and in touch with the world outside their own, WWI began and gave them opportunities to participate in a daily public life that they did not have previously.

During the war, many young men were drafted or enlisted. Before they were shipped out, many men visited brothels. Many American men visited European prostitutes when they were not fighting, and venereal diseases increased because of this practice. The government became concerned because venereal disease was keeping many men from fighting the war. The government responded by forcing an ethic of purity on its citizens. This allowed the government to imprison or expel unwanted social reformers. These government rules would continue after the war.

At the same time, with the men fighting a war across an ocean, women had to start working at jobs that had only been considered "man's work." Women had to make their own decisions and lead their own lives. Many marriages failed when men returned home after the war. The soldiers wanted their wives to resume the roles they had before the war, but many women refused. The struggle between sexuality and morality for women and men would lead to changes that would make the 1920s a unique decade in American history.

Growing Up in America

The idea of schooling for children became more popular in the twentieth century. Young girls would get more academic educations and were slowly being allowed to attend college. Many women's colleges were little more than finishing schools, teaching women the finer points of etiquette or the new science of home economics. There were a handful of colleges that were preparing women to become physicians and lawyers. Initially, college-educated women had a difficult time finding respectable jobs, but as the Progressive party advocated the idea of helping others, and, as war decimated the number of men available for work, educating women became more acceptable.

Girls who attended school learned the skills men thought they needed to maintain a household and be a good wife and mother. If they had the means to do so, girls would start a "hope chest" at an early age. They would acquire some of the things that they were expected to bring with them to a marriage, such as linens and cooking pots. Frequently, a girl would be married to whichever young man her parents selected. Girls were often married at an early age, sometimes even 14 or 15, and they might find themselves married to a youth they had never met, but a youth whose parents were known by her parents.

publish, and mail her own newsletter. She was arrested for distributing obscene literature. In 1918, she was convicted of violating obscenity laws because she tried to disseminate birth control information in New York.

By 1914, teaching sex education became a frequent and controversial topic. Some experiments were conducted in public schools. These involved separating the sexes and explaining "personal hygiene" to them. Proponents lauded the success of these programs, but there were far more opponents who railed against this candor in a society that was rooted in suppressing desires.

Despite all of the activism to broaden opinions and knowledge about sex, it continued to be socially acceptable in marriage only. For women, this standard was absolute. For men, society often accepted a man's need to "sow his oats." By the first decades of the twentieth century, syphilis had become a publicized problem. Women were urged to stop accepting this double standard and men were encouraged to stop sleeping around, but these campaigns had little effect on what people did.

White slavery was one of the most shocking sexual issues of the 1910s. This term referred to forced female prostitution. Sensationalized stories of national vice rings abounded, outraging most Americans. In 1910, the Mann Act, also known as the White Slave Traffic Act, was passed. It outlawed the transportation of women across state lines for immoral purposes.

Masturbation was thought of as a nasty habit that should be eradicated in both men and women. Self-help books encouraged their readers to achieve an ideal of "purity" and listed numerous side effects of what it often referred to as "self-abuse." Anyone who engaged in this habit could suffer from a poor complexion, weakened energy, and even hairy palms. To break the habit, people were advised to avoid sensational love stories and focus on distractions.

Much of the women's education in the late 1800s was genteel: needle-work or the new science of home economics. By the 1910s, women were getting educated in more academically rigorous topics. Slowly, young women were beginning to believe that they had a right to an education. More and more colleges were opening their doors to women. Of the women who did not go to college, many of them postponed marriage and engaged in some kind of work that they hoped would be helpful to the less fortunate.

As these young women learned about the lives of poor women, they began to believe that women should have more rights than their mothers had. Sexuality and morality became topics for conversation and frequently led to very animated conversations. As women were becoming more

a conflict in the Domestic Relations Act that governed marriages. One portion of the act allowed city clerks to issue marriage licenses to minors as long as there was parental permission. Another portion of the act gave courts the right to void marriages of minors. For a period, city clerks stopped issuing licenses to minors, which included men under 21 and women under 18, until the conflict in the law could be resolved (*New York Times* 1910).

Once a woman married, she was expected to give up her job, stay at home, and take care of her husband. This belief remained prevalent in the 1910s despite a Supreme Court ruling that made it illegal to dismiss a female employee because she was married. In 1913, many teachers in the New York public school system hid their marriages to continue working, because the school system opposed employing married women (*New York Times* March 23, 1913).

WWI created a "matrimonial drive" among many young men. When President Wilson announced in 1917 that the draft may be instituted for single men aged 19 to 25, many young couples rushed their wedding plans. The surge of weddings caused animosity from many Americans who felt these young men were shunning their duty. They called these weddings "slacker marriages," and laws were created that withdrew the marriage exemption for men who had married after the selective law was announced.

With so many fathers and husbands off fighting the war, families suffered without their primary breadwinner. Numerous organizations and personal pleas requested aid for servicemen's families. This benevolence continued after the war as many men were injured or killed.

SEXUALITY AND MORALITY

Margaret Sanger fought for the right of a woman to have birth control information and to be able to make choices about her life. Although she might have thought woman's suffrage was a good goal, she spent more time trying to educate women about their own bodies and sexuality. Sanger collected the best information that was available at the time and distributed it in a pamphlet entitled *What Every Girl Should Know*. She managed to get some of the information published in radical newsletters in New York City. Although this was ignored by most "polite" people, Sanger apparently caused too much of a stir when she announced that she would publish information on venereal disease. The local authorities did not arrest Sanger; they threatened the publications that printed and distributed her information. She then raised enough money to produce,

and be ready to do any work that the employer wanted done at any time. Many African-American women rarely got to see their children, unless they quit their jobs.

Children in the middle and upper classes were able to get some formal education. Children who did not live in urban areas might have to be sent away to school, but children in cities frequently had schools they could attend that were close to home. Boys would attend school to learn the skills necessary to acquire an occupation and earn the money necessary to maintain a family.

THE
1910s

MARRIAGE AND FAMILY

Perhaps because parents had some idea of the restrictions place on married women, young, unmarried American women were allowed considerable freedom. This freedom, however, totally disappeared, for most women, the moment they married. Visitors to the United States were surprised at this sudden shift of behaviors. Over time, American women began to wonder about it themselves. Young women debated the benefits of a restricted married life versus a life as an unmarried spinster. Although most women ultimately did marry, an increasing number of them believed that married women should have some of the freedoms of their unmarried sisters.

At the end of the nineteenth century and the beginning of the twentieth, "women's causes" were varied. It was not unusual for a woman to want more freedom, but many of them were also anti-abortion and anti-suffrage. There were many women who wanted the right to vote but did not think women needed additional changes in their lives.

There were just as many women who vocally opposed the changes that feminists proposed. They believed that the concepts of feminism and family were fundamentally at conflict. Like women's rights activists, they saw feminism as the right to lead one's own life as an individual. Anti-suffrage women saw the feminist as turning her back on society and family. They also saw it as deposing the man as the breadwinner of the family. These women held meetings and lectures at private houses and in public places to disseminate their opinions. These meetings were often covered in local newspapers.

Young marriages continued to be frequent in the 1910s. The marriage of minors became a Supreme Court issue in 1910, when the court found

Society was not making children work. Children started working because business owners became increasingly greedy. There were no rules or guidelines to protect workers from unscrupulous supervisors. If the nature of the work did not require an adult, many business owners simply hired children because children earned less money. In some communities, the parents could not find work because companies hired children. Thus, to have any money, a family would be forced to send the children to work.

Some children, especially girls, did not work outside their home. They worked in their homes. Many mothers had to go to work because they had no husband or because their husband's job did not pay enough to support the family. These mothers would have to entrust the care of the children to the oldest children in the families. These children, if they were old enough, would actually remain at home and care for their smaller siblings. Some children would be sent to live with other relatives until the parents were able to obtain jobs that could keep the entire family together.

Another option was for the mother and the children to work at home. This would allow the mother to be home with her children, but she would have to enlist the aid of her children in the job as well. Many times, the children would have little or no schooling, because they were needed to help supply income to the family. Poor families wanted their children to get educations because they viewed education as the way out of poverty.

Initially, there were no laws that covered child labor. As the use of child labor grew unchecked, many practices got worse. Only in the 1900s did some of the advocates of the Progressive movement begin to push for change. One such demonstration was led by an Irish-born woman called "Mother Jones." In 1903, in an attempt to gain recognition for the plight of child workers, she organized a march of children past President Theodore Roosevelt's home in Long Island. Mother Jones also managed to have the march publicized. Her intent was to make a comparison between Roosevelt's children and the child workers. Roosevelt did not acknowledge the children, but the publicity helped Mother Jones draw attention to the needs of children.

African-American families wanted their children educated, but prejudice kept the children in poorer schools. Their parents were not able to get jobs that would allow the children to attend a better school. In many cases, African-American women would have to take jobs as domestic workers, because that was the only job they could get. For many women, this meant that they would have to live in the home of their employer

caught the measles, it was potentially fatal. If a child cried a lot, good parents were known to give their children alcohol or drugs to quiet them. Some children were even given laudanum, an opium derivative, to keep them calm and quiet.

Because mothers had almost total supervision of their children, they were deemed responsible for the outcome of their children. If a child was too noisy, too lazy, or did not behave as the community expected, it was the mother's fault. The Victorian ideal that the woman was responsible for the family's morality continued in the first decade of the century.

Unless a girl was born into a wealthy family, she was expected to help her mother with her younger siblings as well as the household chores. Depending on where the family lived, a girl might attend some school. If a school was available, some girls would attend only when they were not needed at home. Most families did not think that girls needed as much education as boys did. Many women, especially in rural areas, received very little education.

Girls born into urban families might have no education at all. If they were old enough, some girls would stay at home and care for their siblings and keep house while their parents were working. In some cases, children could earn more than their parents did, so both girls and boys would get jobs as soon as they were able to do so. Most of these jobs lasted ten or more hours a day and consisted of difficult work that adults did not want to do or could not do.

Generally speaking, most boys were raised with the belief that they needed to learn the skills necessary to be a wage earner. Some boys would become apprentices, some would work on farms or at unskilled labor, and some, if the family could afford it, would attend school. Girls, conversely, would learn the domestic skills they would need when they became wives and mothers. Many girls, however, would learn skills such as needlecraft or singing, but they rarely learned the skills necessary to run a household. Many marriages suffered when a young wife was suddenly faced with the need to cook, clean, and manage a household.

Urban children of the working-class poor, which included most of the newly arrived immigrants, usually started working as soon as they were old enough. Many children worked in dirty, dangerous jobs that needed someone small or agile, and children were prime candidates. Many of these jobs were cleaning up after the older adult workers. Children, for example, would take away the used bobbin spools in mills and return with full bobbins so the adults could continue their work. They worked long hours and got little pay. What money they did earn they brought home to their families.

longer a necessity. Some women wanted to limit the size of their families, for a variety of reasons, but birth control was not considered an appropriate topic for discussion or an appropriate choice for any woman.

In the latter part of the 1800s, birth control and abortion became, if not popular topics of conversation, at least more available if one knew how to find information. Literature on birth control was easy to obtain through the mail. Accurate information, however, was harder to get. The birth rate was declining, but sex, menstruation, birth control, and abortion were considered inappropriate topics of conversation, even between a woman and her doctor.

This was taken to such an extreme that it was not even wise for a male physician to look directly at a woman while she was giving birth. It was thought that the physician would develop "impure" ideas if he actually saw his patient naked. Some women would not let their husbands see them naked and refused to visit a doctor because of their sense of modesty. Women began to get medical training, but women physicians were rare. Those women who did practice medicine were thought to be abortionists and were frequently ostracized.

GROWING UP IN AMERICA

Considering what is known in the twenty-first century about children and how to raise a child, it is somewhat surprising that so many children from earlier centuries actually survived childhood. The first obstacle was childbirth. Many children, or their mothers, did not survive childbirth in the early days of this century because little was known about infections and how to prevent excessive bleeding. Very little was known about miscarriages or reasons for early births. If a woman was going into labor before the fetus had matured enough to live on its own, there was little a woman could do to help her child.

Once born, infants in urban areas were often raised in less than sanitary conditions because everyone lived in those conditions. Other than the wealthiest city dwellers, most urbanites dealt with inadequate sewer systems, lack of clean water, and air pollution from factories. Because the general public did not understand germs, children's diapers might not be washed thoroughly between uses. Many children would be wrapped so that they could hardly move. They would be left like that for hours, if not an entire day. This practice continued even into the beginning of the twentieth century.

Healthy children might be in contact with sick children or sick adults. Standard medications for childhood diseases did not exist. If a child

"unnatural" desire for sex simply for pleasure. Because women can get pregnant, many women who had sex outside of the boundaries of marriage were ostracized and considered to be somehow unfit and possibly even evil. A community's reaction to a pregnant, unmarried woman, or a woman who was not pregnant with her husband's child, could face a variety of sanctions, depending on the size and location of the community. Many families would not allow their unmarried daughters to associate with a pregnant, unmarried woman for fear that the reputation of the "innocent" daughter would be damaged. That might mean that the daughter could not get a good husband, which was the primary goal for most young women.

Most people expected to be married for life, because most marriages existed until one of the partners died. Divorce was rarely an option; at the beginning of the century, only about 5 percent of the entire population had been divorced (Chadwick and Heaton 1992). There were times when divorce would have been socially acceptable, usually when a man refused to support his wife and children, but many women would not divorce a husband because they had no skills to support a family without the husband's presence. In some cases, women could return to their birth families, but many women did not have relatives who could support a woman with children. Whereas a divorced woman also found it difficult to remarry, a divorced man usually had no problem.

This dual sense of morality existed in one form or another for centuries. It might have been modified somewhat in the frontier communities in the latter half of the nineteenth century. Some frontier communities had few women, and those women were allowed more freedoms than women in the more established rural communities of the east. It was not uncommon for a young woman to come west to live in a town with few other single women. A young girl could become a prostitute, earn a respectable amount of money, and then later make a good marriage. Once she was married, her past had little meaning. Once the community began to grow, however, and the number of men and women were more equal, this tolerance diminished. This change in behavior was attributable partially to the fact that many women from "back east," with their more conservative expectations, were now living in what had been a more liberal community.

Originally, families needed many children because the children could be put to work on the family farm. Many children also died before they grew to maturity, so families needed a high birth rate to partially compensate for the high child mortality rate. As the country grew and became urbanized and healthcare improved, large numbers of children were no

The Gibson Girl. Charles Dana Gibson was a popular illustrator for magazines and advertisements at the turn of the century. The ideal woman he created in the 1890s continued to be extremely popular until WWI. He created pen and ink drawings of a wasp-waisted young woman with soft, feminine features and hair arranged in a full pompadour. His illustrations were so popular that they were merchandised on a wide variety of items, including ashtrays, fans, pillow covers, souvenir spoons, and tablecloths.

outside the home needed to become more acceptable for businesses to succeed. As more women worked, the accepted standards of morality began to change.

In a minor way, President Theodore Roosevelt may have helped the cause of the "new woman." His daughter Alice was not a prim and proper example of Victorian womanhood. Alice had a mind of her own and felt no restrictions if she wanted to share her opinions. Alice enjoyed causing trouble in staid Washington, DC. People felt that if the president allowed his daughter to adopt a modern role, they should be able to treat their own daughters the same way.

SEXUALITY AND MORALITY

Sexuality at the beginning of the twentieth century was considered a masculine characteristic. It was common knowledge that men had sexual desires, and many men saw nothing wrong with satisfying those desires. Women were raised to be mothers, not sexual creatures. Sex was considered a woman's duty and necessary for the production of children, but women were not supposed to have sexual desires. They were to satisfy their husband's desires and to produce children, especially boys who could carry on the family name.

Men were considered to be far more passionate than women, so it was not uncommon for men to engage in sexual activities outside their home. In many situations, these extramarital affairs were frowned on only if the relationship was obvious. Sexual relations with women other than a man's wife were accepted, provided they did not exceed the boundaries of a given community's tolerance. In wealthy families, it was not uncommon for the wife to have a party or other social activity without her husband.

Women, however, had little, if any, latitude regarding appropriate sexual behavior. It was totally unacceptable for any woman to display an

in some sports, depending on where they lived and how old they were, or they could join men's clubs and engage in whatever activities were acceptable for men in their community

The concept that a woman's life revolved around her house and home whereas her husband's life revolved around his work and leisure activities tended to be more accurate for the urban middle classes, although there were exceptions to that rule. Most poor families had to put almost everyone to work to have enough money to pay the bills and buy food and clothing. The farther west one traveled, the less likely the woman's role was very different from her husband's. There was just too much work to do to tame the wilderness, and both men and women shouldered much of the work together.

The one thing that did not seem to change for women, under most circumstances, was that the woman was responsible for the home and housekeeping. This included raising the children, keeping the house clean, and ensuring that her husband was cared for and fed. Whereas women might have worked in factories or put their shoulders to a plow, men were never expected to feed the children or stir the cooking pot. This attitude began to change with the coming of the 1900s.

By 1900, women had started organizations to make changes. Some women wanted the right to vote. Some women wanted more autonomy in their lives. Some women wanted nothing to do with suffrage but wanted to abolish liquor. Other women's organizations had different agendas, but they all wanted change.

The new millennium was being called the age of "the new woman." Depending on where one lived, that phrase had a variety of meanings, but as the decade developed, the phrase came to mean that women did not want to be the compliant, self-sacrificing mothers and wives that they had been in the past. Although many people advocated abolishing marriage totally, that was one of the more radical views and was never really accepted by the majority of men or women; however, it might have been discussed at length in some of the more liberal newspapers and magazines of the era.

The industrialization of the workforce indirectly contributed to the changing views of morality. Technology and science had begun to make noticeable changes in people's lives. As new products were developed and distributed, the nature of work began to change. Workers moved to urban areas and companies needed larger offices and a larger sales force. Bureaucracy was developed to help streamline production. Efficiency experts were creating new ways to increase production. Women entered the workforce as typists, phone operators, and office workers because they did not need to be paid as much as men. The mingling of men and women

An Asian woman, for example, would have learned not to look any man directly in the eyes. Possibly she would have learned to obey her Japanese husband in all matters. Once in America, she realized that her behaviors were not as limited as they had been in Japan. Other women who had been told since childhood that they had to accept their husband's drunkenness or physical abuse learned that they had options. If a man was known to be physically violent or could not support his family because of alcoholism, a woman was permitted to divorce him. She might leave the area in search of a new life and call herself a widow, but it was an option that she would not have had in her native country.

Blacks, after the Civil War, adopted most of the rules of the southern white culture. Women would get wedding dresses and follow the "traditional" southern wedding ceremony. Former slaves brought with them one tradition: that of stepping over a broom. The couple might have been married by a preacher, but the marriage was not really final until they stepped over a broom handle as they entered the house in which they would live. Some couples, especially in areas without a preacher, would simply step over the broom. Once it was known that a couple had done that, they were considered legally married.

According to the accepted philosophy of the day, women's work was primarily to produce and raise children; therefore, the lives of women deviated sharply from the lives of the men in their families. Women remained in the house, running the household and raising the children. The men would be expected to work outside the home. As fathers, men were supposed to establish the rules of the home and provide the financial support, but otherwise, men were not expected to have much to do with the daily operations of the household.

Southern women were not supposed to need any skills other than managing a home and raising children. Occasionally, however, a woman's husband would die or become unable to manage the work of a plantation. Women, somehow, were expected to step in and manage, and many women did. Some women, however, found they had so few skills that they would have to remarry or depend on some male to oversee the work of the plantation. Women who were able to assume the responsibilities of their dead or incapacitated husbands were allowed much more freedom than other women. Although some people still expected a woman to have a man be responsible for her, a widow was allowed more latitude than her single or married sisters.

Men worked outside the home; therefore, they developed an extensive set of social contacts outside the home as well. Men generally engaged in leisure activities that excluded their wives and children. Men could engage

5

The Individual and Family

Families looked profoundly different from the beginning of the century to the end of the 1940s. In the first years of the century, marriage was seen as an ideal to which women aspired. Often, marriages were arranged by the parents. If they were not arranged, they still required the parents' approval. Divorce was scandalous, and if a young woman got pregnant, she was usually forced into marriage.

Men's and women's roles in the 1900s were quite different. Men were seen as the breadwinners, whereas women were the keepers of the family's virtue and morals. Women were expected to support and guide the family as the mother and wife, two roles that were held in high regard by society. Women began advocating for more rights, including the right to vote. Not all women agreed that their position should change, and there were frequent debates about the subject.

Sexuality in the 1900s was rarely discussed, and, when it was, it was always done in private. Women were expected to suppress any sexual desires and never to have sex outside of marriage. Conversely, it was accepted when men had sex outside of marriage. As families sought to limit the number of children they had, they began seeking birth control methods but could rarely find reliable information.

For children, the potential for illness was great and a source of fear for parents. Mothers had the responsibility of caring for their children's health and their upbringing. Lower-class children often worked to

supplement their family's income, and educational opportunities for girls were limited.

The 1910s allowed women more freedom in choosing marriage partners. Many women chose to marry young, and, when WWI began, many couples rushed to the altar to keep the man from being drafted. During this period, women who held professional jobs, such as teachers, were expected to give up the job once they were married.

Sex education and information was a common theme in the 1910s. Activists pushed for sex education in the public schools and more readily available information about birth control. There were many critics of these plans, so they were rarely implemented. Syphilis became a problem especially during WWI, when men would frequent brothels. White slavery, or forced prostitution, became a sensational topic and the impetus for legislation outlawing the practice.

Young women began to have more choices in education. Although there had been many "finishing" programs available, professional programs for women grew in the 1910s. Activists took on the cause of child labor in the long fight to protect children from the often hazardous and fatiguing factory work in which many of them were employed.

Women won the right to vote in 1920, and many of them chose to delay marriage and children. More often couples were choosing marriage for love over arranged marriages. Families became more affectionate and nuclear. Pregnancy was less of a risk, and families were eager to have more control over the spacing of their children. The divorce rate climbed as the social stigma of ending a marriage began to erode and the expectations of a loving marriage rose.

People were more open about sexuality in the 1920s than they were in previous decades. The period was characterized by the sexually open flapper who went to parties and night clubs unchaperoned. Cars provided a way for young couples to get away from the prying eyes of parents and chaperones.

For children growing up in the 1920s, multigenerational households were less frequent. Grandparents lived in their own households, and older siblings moved out once they married or established themselves. More children attended school than in previous times.

The Great Depression from 1929 to about 1941 colored the lives of many young couples and families. Marriages were often postponed or preceded by long engagements. It was common for newly married couples to live with their parents to save on expenses. Multigenerational households became more common again, and women often picked up extra jobs to supplement the family's income.

In some ways, the Depression dampened people's sexual appetites. Couples still engaged in premarital sex, and pregnancy continued to be a stimulus for marriage. The Hayes Code enforced a strict morality on motion pictures, which forced studios away from nudity and sensationalism.

Despite the frugality and malnutrition of the Depression, people of the 1930s had a greater life expectancy than before. More children went to school and fewer of them worked.

In the 1940s, the marriage rate increased in part because of the men who went off to serve in the war. Women held up the home front by working in factories and contributing to all of the government campaigns. The baby boom began as the war was ending.

Sexual messages conflicted during the 1940s. Women were urged to avoid provocative dress when they worked in the factories. At the same time, servicemen ogled at scantily clad "pinup" girls as motivation while overseas. Then the government issued literature to servicemen warning of the dangers of sexually transmitted disease.

Children of the 1940s may have experienced the new child-rearing techniques espoused by Dr. Benjamin Spock. He exhorted parents to treat their children with affection, a strange notion to parents who were raised in an era when affection was thought to warp a child. Children participated in the war effort just as their parents did. Adolescent boys enlisted in the services, and adolescent girls often married right after high school.

THE 1900s

MARRIAGE AND FAMILY

Women in the early 1900s lived life much as their ancestors did. The lives of women who were born into wealthy families were somewhat easier than the lives of women born into poorer families, but all women tended to share some of the same problems.

It was not uncommon for a girl to be married, sometimes against her will, at a very early age. Girls were, in some cases, considered a drain on the family's budget. Boys were able to get jobs and produce income. Although some urban girls were forced to work almost as soon as they could walk, they rarely earned the salary that their brothers did. It was easier to marry them to a young man who wanted to start a family of his own. He, then, had the responsibility of caring for his wife.

Marriage was part of the ideal for women. Divorce remained scandalous, but women found that marriage was not an equitable arrangement. Before 1900, many states would not allow women to own property in their own name. Any property they had became the husband's property. Although the laws that allowed women to keep property were advances, there were other laws that reinforced their inferior position. In 1907, a law was passed that mandated that all women take on their husband's nationality upon marriage. Women continued to struggle for equal rights.

Girls from the upper-middle class and their wealthier sisters would be chaperoned when they reached a marriageable age. Group activities were the norm. "Proper" young ladies were not to be alone with any male. Daughters were expected to marry a suitor of the parents' choice. A lot of marriages were arranged many years before the young people were old enough to be interested in marriage. Marriages were to maintain or to improve the social standing of a family. Males were not expected to "marry down," but females were expected to "marry up," preferably to a man who had a good income. Few women were allowed any choice in their mate. The higher up the social ladder their parents were, the less choice a girl had in her marriage.

The families of the working poor had few such restrictions. Many girls were allowed to meet a variety of eligible males, and the couple was frequently able to make their own decision about marriage. In many cases, a marriage might be "forced" because the girl was pregnant, but a poor girl with a child and no husband did not have the same stigma that her wealthier sister would have in the same situation.

A marriage proposal, once accepted, carried with it the force of a signed contract for the man. Once an announcement was made about a wedding, a man could not change his mind. Some states, usually in the south, had laws that would allow a man to be prosecuted for breaking an engagement. This was one situation in which women had more freedom than men because women could change their minds. Society, perhaps, granted a woman this option because she was usually forced to remain in a marriage once it was performed.

Marriage for immigrant families was often difficult. Once a family had come to the United States, they not only had to earn a living, but they had to manage with a different set of social customs. Although women in the early 1900s might seem to have been restricted by the standards that were prevalent even sixty years later, they were freer than the women in Europe or Asia. Men and women who came to America learned that many of their cherished beliefs were not shared by their new country.

Hobbs, F., and Stoops, N. 2002. *Demographic Trends in the 20th Century*. U.S. Department of Commerce, November.

Kaledin, E. 2000. *Daily Life in the United States, 1940–1959: Shifting Worlds*. Westport, CT: Greenwood Press.

Keenan, B. 1978. *The Women We Wanted to Look Like*. London: Macmillan London Limited.

Kyvig, D. E. 2002. *Daily Life in the United States, 1920–1940*. Chicago: Ivan R. Dee Publisher.

Marling, K. A. 2004. *Debutante: Rites and Regalia of American Debdom*. Lawrence, KS: University Press of Kansas.

Marshall, A. 2006. *Beneath the Metropolis: the Secret Lives of Cities*, edited by D. Emblidge. New York: Carroll and Graf Publishers.

McKay, J. P. 1999. *A History of Western Society*. New York: Hougton Mifflin.

Mendes, V. D., and De La Haye, A. 1999. *20th Century Fashion*. London: Thames and Hudson.

Murrin, J. M., Johnson, P. E., McPherson, J. M., Gerstle, G., Rosenberg, E. S., and Rosenberg, N. 2004. *Liberty, Equality, Power: A History of the American People*, Vol. 2 since 1863. Belmont, CA: Thomson.

Olian, J., ed. 2003. *Children's Fashions 1900–1950: As Pictured in Sears Catalogs*. Mineola, NY: Dover.

Perrett, G. 1982. *America in the Twenties, A History*. New York: Simon and Schuster.

Reeves, T. C. 2000. *Twentieth Century America: A Brief History*. Oxford: Oxford University Press.

U.S. Census Bureau. 2001. *Expectation of Life at Birth by Race and Sex, 1900–2001 HS-16*.

Whereas boys could choose from a number of organized activities including baseball, soccer, swimming, sailing, rowing, basketball, and football, girls often had only badminton and basketball available as a competitive sport. As the All-American Girls' Baseball League emerged, so did the All-American Girls' Basketball League. Winter sports were popular in the northern part of the country. Sleds and toboggans slid through the snow, and Americans skated on any frozen pond or creek. In addition, skiing was available in mountainous northern states.

Postwar activities were influenced by a rising standard of living, technological advancements, and new fashions and fads. Cross-country skiing was more popular than before the war thanks to returning soldiers who used it as a necessity throughout Scandinavia and the Alps during the war.

Generally speaking, the upper and upper-middle class spent more time in museums, dining out, at the theatre, concert hall, golf course, and college football games. Lower-class families tended to appreciate baseball, boxing, and horse racing. When Detroit resumed production of automobiles in 1946 and gasoline was no longer rationed, the open roads provided opportunity for "escape" and Americans took to the highways. With movies still a key entertainment venue, drive-in movie theaters sprang up across the country to meet the needs of Americans on wheels.

People had the freedom to move about the country and the means with which to do it. Getting away for a weekend or week of vacation was becoming popular. People went to the beach, to the lake, to the mountains, just getting away. The end of the war brought a sudden upswing in the number of national park visitors. Visitors to the national park system jumped from 11.7 million in 1945 to 25.5 million in 1947 (Sellars 1997, 173). Favorite driving destination vacations included Niagara Falls, Luray Caverns, and Yellowstone National Park.

REFERENCES

Andrist, R. K., Ed. 1970. *The American Heritage History of the 20s & 30s.* New York: American Heritage Publishing Co., Inc.

Baker, P. 1992. *Fashions of a Decade: The 1940s.* New York: Facts on File.

Berkin, C., Miller, C. L., Cherny, R. W., and Gormly, J. L. 1995. *Making America: A History of the United States.* Boston: Houghton Mifflin.

Best, G. D. 1993. *The Nickel and Dime Decade: American Popular Culture During the 1930s.* Westport, CT: Praeger.

Bevans, G. H. 1930. Assembling the Layette. *Chicago Daily Tribune,* July 6, D4.

Gordon, L., and Gordon, A. 1987. *American Chronicle.* Kingsport, TN: Kingsport Press, Inc.

a beauty kit including a daily beauty routine, exercises for beauty, fitness, posture, relaxation, wardrobe choices, etiquette, sportsmanship, and public relations. The greatest emphasis was to appear wholesome and polite.

Major League Baseball had lost its excitement because of inferior players and equipment. The league did not allow African Americans to play, so they created their own leagues. The Negro League packed games across the country. African Americans were kept out of many military occupations, and, thus, more experienced players were able to stay in the game. They became very popular during the war and competed in a Negro World Series that pitted the winners of the Negro National League against the winners of the Negro American League. The series was played every year from 1942 to 1948.

The African-American players were so good that the Major League began scouting the Negro League. Jackie Robinson broke the color barrier when he signed with the Brooklyn Dodgers in 1947. That was the beginning of the end for the Negro League as more players crossed over.

When the Japanese first attacked Pearl Harbor on December 7, 1941, three scheduled National Football League games were underway. At New York's Polo Grounds, the public address announcer interrupted a celebration for star running back Tuffy Leeman, telling all servicemen to report to their units. The same announcement was heard at Chicago's Comisky Park. Reporters were told to check with their offices at Washington's Griffith Stadium. The announcer paged high-ranking government and military personnel in attendance but did not mention the attack.

As with the other professional sports teams, hundreds of football players enlisted to support the war effort. More than $4 million in sales of war bonds were driven by the National Football League in 1942, and a halftime rally at the Steagles-Bears game in 1943 raised an additional $364,150 (Algeo 2006, 98).

Football was so popular and important for morale that innovative tactics were taken to preserve the game. Travel restrictions attributable to the war effort made it impossible for fans to follow their favorite teams. To keep the excitement up from the crowd and give fair advantage to both teams, during the 1942 Army-Navy game played in Annapolis, half the midshipmen were assigned to cheer for West Point (*USA Today* 2007).

Teenagers' free time was usually spent in team sports in school, outdoor activities such as hiking, camping, swimming, skating, and sledding, church-sponsored activities, or neighborhood get-togethers and dances. Golf and tennis were supported mostly by upper-class families and private high schools, but courts were not regularly available to lower-income families.

Jitterbug. The Jitterbug referred to various types of swing dances, such as the lindy hop and the East Coast swing, that were popular during the 1940s. These energetic dances were done in nightclubs and dance halls to the sounds of big bands. The dances had fast, bouncy, and sometimes acrobatic movements. It was not uncommon to hear about jitterbug injuries for those who were unfamiliar with the moves. The clothing worn for this style of dancing needed to be comfortable and allow for exaggerated, large movements. Fuller skirts, low-heeled shoes, and bobby socks were commonly worn by women. The mambo, a dance that emerged during this period, combined the athletic moves of the jitterbug with the smooth flow of the rhumba.

The jitterbug was extremely popular with service men. Whenever they had leave, they were found at nightclubs and USOs, jitterbugging the night away. They popularized the dance in both England and France when they were stationed there.

sponsored by baseball teams. Baseball provided entertainment on the home front and served as a connection to home for those serving around the world. Equipment was gathered and shipped to the troops overseas, and many coaches, umpires, and players enlisted, including Joe DiMaggio, one of the greatest hitters and centerfielders of all time. Baseball games were considered so important to morale that the Japanese tried to jam radio broadcasts of the games.

By 1943, half of the professional players had enlisted. Older baseball veterans and even a one-armed outfielder, Pete Gray of the St. Louis Browns, were recruited to fill the void. Wood was in short supply so it was difficult to find bats. Rubber went to military use, so baseballs became soggy and unresponsive. Baseball, the American game of games, made an interesting diversion during the war.

With most able-bodied men between 18 and 26 off at the front, the favorite American pastime turned to who was left: women and African Americans. The emergence of the All-American Girls' Professional Baseball League helped. A pioneering new sport for women, this was a tough sell to the public. These ladies not only had to exhibit enough athletic ability to keep the game interesting, but, in the conservative society of the 1940s, they also had to show refinement and become proper role models for young girls. The image of the sport and its participants was so important, the league prepared a document titled, *A Guide for All American Girls.* Suggestions in this document included the necessary components of

generally had larger schools with indoor plumbing, even some laboratory equipment in the higher grades.

SOCIAL OCCASIONS

American society was disrupted by the war. Spare time was dedicated to the war effort in many different ways. The USO and Red Cross provided opportunities for civilians to contribute to the war effort. Established in 1940, the USO included the Young Men's Club of America, the Young Women's Club of America, Salvation Army, National Catholic Commission Service, National Jewish Welfare Board, and the National Travelers Aid Society. The USO operated mobile and stationary canteens, visited hospitals, and entertained the troops around the world. The Red Cross served understaffed hospitals, sent relief parcels to the troops, and collected blood plasma.

Everything in support of the war effort became a social occasion. Neighborhoods would work together to collect tin and rubber and in victory gardens and sharing produce. Ladies' community and church groups taught each other how to "make, do, and mend." They would turn men's suits into ladies' suits, make hats for church and going into town, and put up canned goods. Even shopping and cooking economically became a social occasion.

Like adults, teenagers contributed to the war effort. Some worked in factories after school, whereas others volunteered to make care packages for the troops. They still found time to socialize. Dances, movies, and sing-alongs were group activities for all to enjoy. Dances were held in high school gyms and the USO on weekends. Thanks to big bands and swing music, the jitterbug became the favorite dance of teens. Neighborhood dances became quite popular, with speakers strung outside around the block. Churches and high school gyms were also favorite dance halls for local teenagers.

Movies were usually attended in groups or double dates. The movies helped the teenagers to both connect with the war and escape from it. Sing-alongs were another popular diversion from the realities of life during the war. Teenagers would sing together sitting around a campfire or gathered in someone's living room. They would sing wartime favorites such as "Boogie Woogie Bugle Boy of Company B" and "Don't Sit Under the Apple Tree with Anyone Else but Me."

HEALTH AND LEISURE ACTIVITIES

Leisure activities were limited during the war. Every effort went to support the war, and baseball was no exception. War bond drives were

K-rations for the troops. The Department of Agriculture called for 18 million victory gardens beginning in 1943 to help feed the military and allies. Individuals and communities responded, producing close to two-thirds of all the produce consumed in the United States between 1943 and 1945.

Significant contributions made by people on the home front included salvaging and recycling materials. Recycled kitchen grease was collected to help make explosives, medicine, rubber, and nylon for parachutes. During the war, empty cans and license plates were collected to help produce tanks. Toothpaste tubes were saved for the lead content. Another government slogan was, "Use it up, wear it out, make it do or do without."

Americans were encouraged to contribute 10 percent of their pay toward the purchase of war bonds. Despite emerging from the Depression, this was not generally difficult for many Americans. More people had more income than ever before. Although the salaries were low, there was not much available to purchase because of war-time rationing.

Every neighborhood had a civil defense warden. Thousands of men and women volunteered to protect the country by making sure their neighbors followed air-raid and blackout precautions during drills and scheduled blackout times.

Most everyone who had a telephone during the 1940s had a party line. With this type of line, several residences would share a phone number, and the number of rings would indicate which family should answer the call. Although listening in on other people's calls showed bad manners, it did occur and it was often the source of town gossip. High school days were not filled with much dating because most young men were serving in the military, so party-line eavesdropping was a substitute for entertainment. Girls would also go to the movies in groups, sobbing through the news reels that had current combat films from all over the world. This was calculated propaganda to inform the public of the conditions of war brought on by America's enemies, in turn creating a strong determination from the public to support the war effort.

Attending grade school in a one-room schoolhouse was still common outside of the bigger cities. The country was still mostly agrarian aside from key manufacturing industries. Many farm children were unable to attend school during the war because extra help was needed running the farms. Summer vacation was in response to farms that needed children to help with the chores and harvests. Many of the one-room schoolhouses had no running water or heat. Children would take turns going out to the pump and using the necessary house, one for boys and one for girls. In the winter, the boys would take turns bringing in coal or wood to stoke the pot-bellied stove that produced heat for the classroom. City kids

decade of affluence and abundance. So too, exercise and fitness were less of a concern for the struggling masses. As the thirties progressed, however, the middle class and upper class returned to diet fads from the previous decade and relied on various sports to keep them fit.

Both men and women participated in sports activities in the 1930s. Swimming and sunbathing remained fashionable, and other popular sports included running, fencing, mountain climbing, horseback riding, sailing, hunting, and cycling. Both water skiing and tennis were gaining in popularity.

Winter sports, such as snow skiing and ice skating, gained in popularity starting in 1931, attributable in large part to several winter carnivals and travel promotions. The Winter Olympics in 1932, held at Lake Placid, brought skiing further into the limelight. Less active games and fads spread across the country as well, including miniature golf starting in 1930, as well as card playing and jigsaw puzzles.

Despite the inability of most people to travel for leisure, the thirties saw a host of travel innovations that aided in getting people to more remote locations in much quicker and luxurious or convenient ways. The Greyhound bus line was inaugurated in 1930, and the largest ocean liner, the Queen Mary, was launched in 1934. In 1938, the Queen Mary crossed the Atlantic Ocean in just over three days, a record at the time.

World's Fairs were popular travel destinations during this period: Chicago in 1933, New York in 1939, and San Francisco, also in 1939. These fairs offered an opportunity for attendees to see the latest in technology, entertainment, art, and architecture.

Leisure time was filled with inexpensive pastimes. Many families played board games such as Monopoly, enjoyed card games such as Bridge, and completed cardboard jigsaw puzzles. Reading, listening to the radio, and writing letters were popular as well.

In December 1933, Prohibition was repealed and drinking was again a legal activity. Consequently, the price of alcohol decreased and therefore became more commonplace. Taverns became popular places to gather for the working class, whereas the middle and upper class preferred to drink at home. Cigarettes remained popular and were still seen as a chic accessory.

THE
1940s

"A Successful Victory Garden is a Blow to the Enemy" could be found on government-issued posters along with Rosie the Riveter and Uncle Sam. Growing vegetables locally eased wartime demands on the transportation system, as well as augmenting available produce for processing C-rations and

unending material consumption, despite the woes of the Depression. In fact, because of the vast discrepancies between rich and poor, debutante balls were covered even more in the press as a kind of escapism, similar to the kind achieved by Hollywood films at this time. Thus, the most attractive of the celebrities, along with "debutante slouches," were of the most interest.

Some of the most famous were the 1930 debut of Woolworth heiress Barbara Hutton and the 1936 debut of Barbara Field, daughter of Marshall Field. Field's party cost a whopping $50,000, and still another 1936 debut cost nearly $100,000 in Philadelphia. These debutantes became both hated and adored for their ostentatious displays of wealth. The decorations at these vastly expensive parties were often bizarre and, despite Prohibition, usually included alcoholic beverages (Marling 2004).

Some of the most famous group debutante balls began in the 1930s and recurred each year. In New York, the "Debutante Cotillion and Christmas Ball," "Gotham Ball," and "Debutante Assembly and New Year's Ball" have become the most important and were all established in the thirties. They each debuted hundreds of girls annually and used classical cotillion figures and white gloves.

Christmas really came into its own as a commercial holiday in the early thirties. In 1931, Coca-Cola hired artist Haddon Sundblom to draw a cartoon of Santa Claus to advertise its soda in magazines and newspapers across the country. Consequently, celebrations surrounding the holiday became more frequent and focused on the idea of St. Nick bringing toys and trinkets for children.

Celebrations by the lower and middle class were kept to a minimum by the economics of the Depression, although the wealthy continued to drink and smoke at informal cocktail parties, horse races, dog races, teas, and dances.

HEALTH AND LEISURE

In the 1930s, the depression hindered Americans' ability to feed themselves adequately. Approximately 40 percent were underfed, but, by 1935, meals were healthier and more nutritional. Frozen foods had been developed in the twenties, and, by the mid-thirties, Americans gobbled up 39 million pounds each year. When not eating frozen meals, people in the eastern United States had the opportunity to visit one of the many new chain restaurants. Howard Johnson's, White Castle, and several others opened during the 1930s.

In large part attributable to the Depression, dieting for weight loss was less of a concern in the early thirties than it had been in the previous

to work in areas that did not have public transportation. Cars also allowed couples to have more privacy on dates. With the rise in popularity of automobiles, the federal government passed the Federal Highway Act in 1921, which gave federal funds to states to build an interstate highway system.

Although Prohibition, enacted in the United States in January 1920, was intended to stop the consumption of alcohol, the law only ended up criminalizing the production, transportation, and sale of it. Bootleggers and speakeasies in larger cities, including San Francisco, New York, and New Orleans, helped ensure that Americans could drink throughout the roaring twenties. Imported liquor was generally both of higher quality and higher expense, and domestic alcohol was already a fairly expensive item during Prohibition. Drinking was popular among immigrant populations as well as the wealthy.

Another popular drug of choice was tobacco. Women were specifically targeted by cigarette advertisers in the 1920s, and it was touted as a symbol of equality. Ads also often featured "doctors" explaining the health benefits of smoking, which often included a reference to weight management (Kyvig 2002). Consequently, cigarette consumption doubled to 43 billion in the 1920s (Gordon and Gordon 1987; Kyvig 2002).

THE
1930s

The rampant unemployment that plagued the 1930s significantly disrupted men's lives. When they lost work, their self-esteem suffered. They tried to maintain their breadwinner status, but they often found themselves out of work with a lot of time on their hands.

Americans spent significant time and focus on keeping their spending within their budgets and performing activities to conserve their resources. Women worked to stretch their food budget. Leftovers were stretched into even more meals. In place of the backyard, most families created gardens to supplement their menus. Some even raised chickens for the eggs.

Women enhanced their sewing skills because, during this decade, few clothes were store bought. Torn clothing was mended and worn clothing was patched or made into a new piece of clothing. Nearly everything was saved and reused: rubber bands, tin foil, paper bags, jars, and shoe boxes.

SOCIAL OCCASIONS

Debutantes continued to use press agents to manage their public images, and the public continued to be interested in the gossip surrounding their

foods such as Wonder Bread and grape juice were labeled to cater to dieters, highlighting their nonfattening and energizing properties.

During the previous decade, large numbers of volunteers became used to exertion during the war effort. This led to an increased interest in nonsedentary activities. Women began exercising in gymnasiums as a group, which was also known as calisthenics. Although not quite exercise, fads or "crazes" became popular for youngsters and teenagers. These included run-of-the-mill activities such as dancing and cycling but also included more creative activities such as flagpole sitting, miniature golf, multi-day dance marathons, and even crossword puzzles, mah-jongg tournaments, and scavenger hunts.

Athletics and sports were highly popular at this time, attributable in part to the 1924 Summer Olympics held in Paris. Although many people enjoyed sports as spectators, an ever-increasing number of the upper and middle class began to participate in sports as a leisure activity. Especially popular were tennis, swimming, cycling, golf, and even hunting for both men and women. Winter sports such as skiing and ice skating became more popular as well. Swimming was thrust into the headlines when Gertrude Ederle broke both male and female records by swimming the English Channel. Other popular spectator sports included dog and horse racing, American baseball, and boxing.

Dancing was a favorite pastime. Americans adopted energetic dances to match their taste for "wild" ragtime and jazz music. Dances such as the Charleston, the Shimmy, and the Black Bottom were derived from African-American dances. Dance halls and commercial ballrooms proliferated during the 1920s to meet the popularity of the dance craze.

In the early twenties, affluence was more prevalent, and people were working less and vacationing more. More people were able to enjoy annual vacations, including the wealthy, salaried employees, and occasionally even farmers (Kyvig 2002). The car played an important role in the American vacation, as production of automobiles more than doubled between 1920 and 1930 (Olian 2003).

Family car trips were the most popular form of leisure travel, although underdeveloped routes and accommodations often necessitated that travelers pack camping supplies as a precaution. Destinations often included parks and other natural attractions such as Cape Cod, Niagra Falls, Yellowstone, Yosemite, and the Grand Canyon (Kyving 2002). Many travelers preferred beaches, such as those in Florida and California, as a part of the new sunbathing obsession of the 1920s.

Driving became a leisure activity as well as a symbol of freedom and independence to women, who had learned to drive out of necessity during the war. Men who worked in the city typically enjoyed driving as a leisure activity on Sunday afternoons. Car ownership allowed people to commute

HEALTH AND LEISURE

A postwar interest developed in nutrition, caloric consumption, and physical exertion that remained present throughout the twenties. On a national scale, over one hundred county health departments had been added by 1920, and nearly 600 were serving the U.S. population (Center for Disease Control). Vitamins and minerals were recognized as important to overall health, and several "new" vitamins were discovered during the decade. The potential of vitamin E to prevent sterility and its ability to prevent rickets were two of the most important. Vitamins A, B, C, and K were also discovered (Kyvig 2002).

Also during this time, servants were hired only by the wealthy. The middle class began to have a greater self-reliance and cooked for themselves, often using processed foods. The market quickly evolved to meet their needs in a variety of ways. Condensed soups, especially Campbell's, flourished, and sales of other canned fruits and vegetables improved. In 1925, a new quick-freeze method of preserving food changed how both restaurants and homes served meals. Convenient and easy-to-make foods such as salad, fruit, Jello, and mayonnaise became popular as well (Kyvig 2002).

Fashionable young woman, posed next to a roadster, 1926. [Library of Congress]

Many products were marketed for their "healthy" properties, including cigarettes, salt, grape juice, and even chocolate. The trend was started by breakfast cereal companies in the previous century, and marketers in the 1920s capitalized on the newly found importance of vitamins in their advertising.

General Mills invented Betty Crocker as part of a marketing strategy for its products. This fictional housewife provided advice and recipes via radio, newspapers, and cookbooks, subtly encouraging the purchase of General Mills products.

In part because of the increased use of photography in fashion magazines of the 1920s, dieting and exercise became especially important for middle-class women. Most of these low-calorie diets involved grapefruit, coffee, buttermilk, or melba toast and were featured in chart form in fashion magazines such as *Vogue*. Additionally, advertisements for everyday

The Flapper. Fashion in the twenties was epitomized by the iconic image of the flapper. A flapper was a new, modern woman whose interests included being independent, liberal, healthy, and outgoing. She was slender, with bobbed hair, and was the antithesis of the ideal of womanhood from the previous generation. The look was often referred to as La Garçonne, a term coined in 1922, when Victor Margueritte wrote the novel *La Garçonne,* which told the story of a young woman who leaves home to explore an independent life.

The flapper appears prominently in other forms of mass media, notably movies and cartoons. The 1923 production *Flaming Youth* starred actress Colleen Moore, who offered the new flapper image to the masses. A continual stream of movies followed this example, most notably *It,* starring Clara Bow. John Held Jr., a well-known cartoonist for *Life* and *The New Yorker* in the twenties, depicted the flapper and her love interests, who were frequently described as "Held's Hellions."

The term "flapper'" has strange roots. According to researchers, these young independent women often wore their rain boots, known as galoshes, unfastened, causing them to flap as they walked, but there was much more to the flapper appearance than this. Most strikingly, the new silhouette of the flapper demanded flat lines and no curves, with an almost prepubescent or childlike appearance. Described as sleek or svelte, the look was both youthful and androgynous. Women of this era cut their hair to emulate Colleen Moore's Dutch bob, dieted to keep their hips narrow, and flattened their chests. Pointed shoes and rolled hose completed the picture.

Conflicting reports describe the flappers' demise. *The New Republic* suggested that, as early as 1925, the appeal of the flapper was already passé. By 1926, the look had reached its international peak, and *The New York Times* reported the death of the flapper era in 1928.

celebrations included luncheons, teas, and tea dances. Attire for these events was as fanciful and decadent as evening attire. Other opportunities to socialize and show off included horse races, dog races, and scavenger hunts, along with the regular cacophony of cotillions, and society parties provided ample opportunities to display the latest fashions (Keenan 1978). The informal cocktail party also came into vogue, in some instances replacing the traditional luncheon, tea dance, and formal dinner party.

Other society parties were frequent during the early years of the 1920s. French couturier Paul Poiret was known for his extravagant Parisian fetes, which were theme based. His most famous was "The Thousand and Second Night," a fantasy based on the tales of *The Arabian Nights.*

the period was dominated by optimism, there were troubling trends. Prohibition and violent crime marred the rosy ideal of the carefree twenties.

Prohibition went into effect in 1920. It outlawed the manufacturing and sale of alcoholic beverage. Temperance leaders had been fighting alcohol since the nineteenth century, and the Eighteenth Amendment that created Prohibition was their victory. Prohibition divided the nation. Rural America saw drinking as an urban problem and generally complied with the new law. "Wets," those who wanted Prohibition to end, often lived in urban areas. For them, the local pub or saloon was a neighborhood meeting place. They would hold weddings and dances there.

Despite the law, people continued to drink. They would go to speak-easies, which were unofficial drinking establishments. Some people made their own liquor, and others began drinking alcoholic-like substances that often had physical effects such as blindness and slow paralysis.

The alcohol in drinking establishments was provided by bootleggers. These were criminals who supplied alcohol, and they were often involved in organized crime. As Prohibition wore on, organized crime grew in power and violence. In addition to bootlegging, they operated brothels and gambling rings and sold drugs. Chicago was the base of operations for Al Capone, one of the most notorious gangsters. Violent deaths associated with organized crime dramatically increased in the city during Prohibition.

Social Occasions

The 1920s saw many changes for debutante balls, also known as coming-out parties. For the first time, debutantes began using the services of press agents to manage and encourage their increasing celebrity status. Similar to Hollywood celebrities, New York "celebutantes" of the twenties were caricatured in the press by illustrator John Held Jr. Often considered junior members of café society, debutante gossip was followed closely in the press (Marling 2004).

The cost of coming-out parties continued to increase as well, although in the early twenties they were usually group affairs with several girls coming out at one party. Attire for the debutante ball remained formal, with a special dress designed specifically for the party. However, the traditional white had been abandoned, and bright colors were the most fashionable; the more extravagant the better (Marling 2004).

Given the prosperity of the decade, it should come as no surprise that celebrations and parties were frequent and lively. Birthdays became a more celebratory event in general, and it was during this decade that cards were created and produced specifically for birthdays. Other forms of formal

iceberg about 400 miles off Newfoundland, Canada. Less than three hours later, the *Titanic* plunged to the bottom of the sea, taking more than 1,500 people with her (Barczewski 2004, 71). Only a fraction of her passengers were saved. The world was stunned to learn of the fate of the unsinkable *Titanic*. It carried some of the richest, most powerful industrialists of her day. Together, their personal fortunes were worth $600 million in 1912 money. In addition to wealthy and the middle-class passengers, she carried poor emigrants from Europe and the Middle East seeking economic and social freedom in the New World.

The sinking of the *Titanic* was a shock to many people. Ships had sunk before, but the advancements in communication meant that much of the world knew about the tragedy within days after it happened. Many people delayed any nonessential ship travel out of concern that they might meet the same fate. Before ship travel could regain the prestige and popularity it had held before the *Titanic*, war in Europe was declared. When the German U-boat sank the passenger ship *Lusitania*, fewer people wanted to travel by ship. Many people chose to travel by rail, or they would take an adventurous ride in the increasingly popular automobile.

The use of the assembly line meant that Henry Ford could produce automobiles more cheaply and quickly. In 1905, there were 77,000 registered automobiles in the country. By 1920, there were more than 8 million (Lief 1951, 23). The automobile had gone from a plaything for the rich to an everyday mode of transportation for the American masses.

Although Americans continued to attend the theater and symphony, a new art form, movies, had captured their imagination. Increasingly, movies became a leisure activity of choice. Americans were also fond of going to clubs to dance and listening to popular music.

Before 1910, marijuana had been used for medicinal purposes. In 1910, as many Mexicans immigrated to the United States after the Mexican revolution, they popularized the recreational use of marijuana. Beginning in 1906, states began to regulate its use. In 1914, the Harrison Narcotics Act regulated and taxed opiates including opium and cocaine. After WWI, the temperance movement was able to leverage anti-German sentiment to pass the Eighteenth Amendment in 1919, which established Prohibition.

THE
1920s

The 1920s are often referred to as the "roaring twenties" in reference to the parties and socialization that occurred during the decade. Although

the right to vote, participating in social organizations, and taking advantage of educational lectures. The Victorian ideals of womanhood that had reigned since the middle of the nineteenth century finally began to erode.

Americans continued to enjoy society balls and introducing their daughters to society through debutante balls. The debutantes typically "came out" in groups of several girls. In this respect, upper-class society separated itself from middle- and lower-class societies, which did not have the means to participate or host these types of soirees.

Health and Leisure

Life expectancy had dramatically increased since 1900, when Americans could expect to live an average of forty-seven years. By 1919, their life expectancy had increased to fifty-five years. The year 1918 was an exception to this trend, when life expectancy dropped to thirty-nine years (U.S. Census Bureau 2001). This was a result of a widespread flu pandemic known as the Spanish flu, which started in the United States and traveled around the globe. At least 50 million people died of it because of its extremely high infection rate.

The athletic trend that began in the first decade of the 1900s continued in the 1910s. What was remarkable about these sports is that women would play them, even while wearing some of the confining clothes that fashion dictated. In time, fashion followed need and clothes were developed that gave a woman more freedom of movement. Although these clothes might have been restrictive by today's standards, they did indicate a subtle change in the apparel of women and men. A subtle change in one outfit was not necessarily a major trend, but, taken together, younger women and girls began to expect that their clothes would fit their lifestyles. As these young women grew to adulthood, they refused to be confined by their clothes as their mothers and grandmothers had been. Skirts became somewhat shorter around 1910, allowing a woman to show her ankles. Part of this trend was to allow a woman more freedom when she practiced her favorite sport.

For the extremely rich and the growing middle class, travel was a popular leisure activity. One of the favorite modes of travel was by ship. Travel across the oceans took time, which allowed the passengers to bring their personal items and live life onboard ship almost as they lived it on land. Everyone knew there was a chance that a ship would sink, but that did not seem to be a major concern for most people. To some degree, this would change on April 10, 1912.

It was on this date that the RMS *Titanic* set sail from Southampton on her maiden voyage to New York. At that time, she was the largest and most luxurious ship ever built. At 11:40 PM on April 14, 1912, she struck an

Irene and Vernon Castle. Irene and Vernon Castle were a dynamic husband and wife ballroom dancing duo, who helped popularize modern dancing. The couple debuted in New York in 1912 performing ragtime dances such as the "turkey trot" and "grizzly bear." Their popularity was immediate, and they were soon in demand in stage productions, vaudeville, and motion pictures.

They opened a dancing school, Castle House, in New York and taught local socialites modern dancing. Their dance lessons were often secured by private clients, and they commanded high prices. They are attributed with refining and popularizing the fox trot. They appeared in the newsreel *Social and Theatrical Dancing* in 1914 and wrote the book *Modern Dancing*, which became a bestseller. Although they appeared in numerous movies, their best success was their performance in Irving Berlin's first musical, *Watch Your Step*, in 1914.

Irene became a fashion icon during the 1910s. She bobbed her hair several years before it was common. She wore shorter skirts and wore dresses designed by Lucille or herself. In magazines, she was held up as a model of the fashionable woman, with the grace to successfully carry any style. Vernon, who was a pilot,

Irene and Vernon Castle demonstrating dance. [Library of Congress]

died during WWI training maneuvers in 1918, but Irene continued to appear in films. In 1939, their story was made into the movie *The Story of Vernon and Irene Castle*, starring Fred Astaire and Ginger Rogers.

SOCIAL OCCASIONS

Women continued to aspire to marriage, and society continued to expect them to remain devoted wives to their dominant husbands. The war had changed this dynamic, and many women began to spend time marching for

By the end of WWI, women had the right to vote, which brought social issues into the political limelight. Birth control became a volatile issue. Margaret Sanger tried to educate women about birth control, which spurred critical backlash from conservatives. Temperance groups gained momentum. Their work against alcohol would see fruition during Prohibition in the next decade.

The isolation of rural life evaporated as new forms of communication linked rural residents to cities and the outside world. Their lives changed in other ways as well. They were able to purchase the same products as urbanites by ordering from the Sears Roebuck and Montgomery Ward catalogs. Motorized machinery reduced much of the backbreaking labor and need to hire additional workers or purchase draft animals. Prices for crops went up during the war, so farmers experienced profitable harvests.

Cities continued to grow as immigrants settled there. Most ethnic groups settled in distinct ethnic neighborhoods. With their ethnic group, they built social structures, such as houses of worship, stores, aid societies, unions, theater groups, and native language newspapers. The immigrants' sons and daughters often broke away from their parents' ethnic life and adopted a more homogenous American lifestyle.

In addition to the war, new technologies influenced daily life in the 1910s. The electric light bulb, a seemingly innocuous item, could be said to have changed the daily life of the world. The light bulb would allow people to extend their lives beyond the daylight hours. It was cleaner and safer than gas and candles. As more people wanted to have their houses wired for light, people began to consider other things that could be done with electricity. Once people had their homes wired for light, it was simple to find other uses for the electricity.

One such item was the phonograph. This invention allowed music and voice to be reproduced and played back repeatedly. People who could afford to have several phonograph disks would be able to entertain themselves and their friends at home. A radio, although not in widespread use in the early twentieth century, was available in some large urban areas. People could turn on their radios and get a variety of news and entertainment items without leaving their homes.

Large cities had subways and electric trolleys, which brought people to large areas such as parks to listen to bands and other forms of entertainment. Whereas some people would continue to go to the theater and see plays, others would visit vaudeville houses and be entertained by music such as Scott Joplin's ragtime music. Various comedy and dramatic acts would also be seen on the vaudeville stage. Life and entertainment became more casual.

on Germany, most communities had several young men who enlisted in the war effort. As Europeans had discovered, someone had to keep the country going to support the troops and create the weapons and materials that the troops needed. For the first time, American women in large numbers became employed in a variety of jobs, most of which had been done by men.

Women drove automobiles and worked in factories, and they joined military-like units that provided support to the military troops. They held jobs in large numbers and it was respectable. Their clothes, however, had to change. Nurses could not help the wounded and sick while wearing hobble skirts or bustles. Women who worked with machinery could not wear ornate dresses. Women wore work clothes that were strictly utilitarian. Corsets were still required for many clothes, but, instead of restricting motion, they were supposed to help support the body. Some women actually wore pants, because the job required them. Many wore a form of culottes because they made the work easier. Many wore dresses that resembled military uniforms. Skirts, which had slowly become shorter to accommodate bicycles and other sports, became even shorter. Women in the workforce needed and demanded clothes that were comfortable.

Many of the superfluous fashions of past generations disappeared. Hats with lots of feathers and jewels, dresses of silk and velvet, and skirts with yards and yards of material were seen as unpatriotic. The material was needed for uniforms and bandages for the soldiers. People were encouraged to buy war bonds rather than expensive dresses and jewelry. Flaunting wealth by wearing expensive clothing was considered inappropriate considering the many families who had family members die in the war.

After the war, many women wanted to return to the simpler lives they had before the war. Many could not because their soldiers did not return or were so wounded that they could not get good jobs. Many women were thus forced to retain their jobs and become the support of their families. Many women found that they did not want to return to the restrictive lifestyles they had before the war. This caused much tension across the country as men saw women competing for the same jobs. It also blurred the lines between home life and work life.

Women had achieved a level of independence; they had jobs to do and those jobs helped the Allies win the war. Many women, especially those in the middle classes, realized that they could survive on their own without a man to make decisions for them. Women did not want to follow the lives their mothers and grandmothers led, nor did they want their fashions.

Americans enjoyed other sports during this period. Tennis and golf achieved popularity and were played by both men and women. Each sport required a different kind of outfit. Few sports could be played by a woman wearing a corset or bustle.

Although these sports did not emancipate women as the bicycle did, these activities had one thing in common: the women who engaged in these sports began to complain about their clothes, insisting that "old-fashioned" fashion was inhibiting their lifestyles. Not everyone would engage in travel or sports, but enough women did that fashion started to change. The great fashion houses could not afford to ignore the growing numbers of women who wanted clothes that fit their new lifestyles.

Travel was another popular leisure activity. Young wealthy Americans frequently went on a European tour for their honeymoons or before they started working. Europe was seen as the center of culture despite the vast artistic talent in the United States and the American museums filled with fine art.

The age of westward expansion had come to a close, and rail lines linked the east coast and midwest to the western half of the United States. Train travel tended to be dirty, loud, and uncomfortable, but it was the fastest way to get around the United States.

In the first decade of the century, only the wealthy could afford automobiles. The general public saw them more as expensive toys and nuisances than a mode of transportation. They would frequently break down, and the owner would need to acquire the skills to fix it or bring along a mechanic for the ride. The open cabin and lack of a windshield on the automobile resulted in dust-covered drivers and passengers. To protect themselves, motorists would wear a long coat called a duster, gloves, goggles, and a hat.

Although alcohol was the drug of choice during the 1900s, the temperance movement sought to combat it. Reformers saw alcohol as a counteragent to family values. Opium was another drug under scrutiny during this period. It was associated with Chinese immigrants, some of whom imported the drug. Opium dens were dark, hazy rooms where opium users stayed while they were on the drug. The proliferation of opium use led to the outlaw of its importation in 1909.

THE
1910s

WWI had a tremendous impact on the daily life of many Americans. Many men joined the war effort in Europe. After the United States declared war

relied on pit toilets and outhouses (Marshall 2006, 28). Like New York, most cities worked valiantly to overcome their sewage problems and saw much progress in the early years of the new century. Chicago was able to overcome decades of disease with the opening of its Sanitary and Ship Canal in 1900. By cleaning up the water and sewer systems, most cities saw their disease rates plummet.

Diet and exercise were almost unknown in the sense that people use the terms today. Most of the working class got enough exercise from their jobs. Those in the upper classes did not see the need for exercise. A slender figure might mean that an individual had to work for a living. People who had money could afford more food and they had more leisure time. Having a few extra pounds actually was an attractive feature in some circles because that could indicate that people had lots of leisure time. Adult women, especially rich adult women, were not to be seen sweating. These women would have servants doing any heavy work.

As the middle class and the Progressive party grew more popular, people became more conscious of health issues. Slowly, the country learned and accepted that an individual's health would suffer if he or she worked long hours in filthy or hazardous surroundings. Labor unions developed, and they fought for better working conditions for their members. A better financial situation for many families allowed them to have more leisure time. Many young people found that sports were an enjoyable way to spend leisure time.

For the first time ever, women started to publicly enjoy sports as much as men did, and they participated in some of the same sports men enjoyed. The bicycle became exceptionally popular in the late 1800s, and its popularity continued to grow in the new century. It was acceptable for men and women to ride bicycles and women did, in large numbers. The bicycle allowed a woman to travel freely, without a man to help her. The younger women began to go places and do things by themselves. Many people feared that the bicycle would destroy the family structure because women could go places on their own. They also feared what men and women would do if they were unchaperoned. Although it did not destroy the family as much as some feared, it did eventually cause designers to consider clothing that would be more appropriate. Still, many women rode their bikes while wearing even the "S-bend" corset.

In 1895, bowling became standardized. Before that time, every community developed different rules. When the rules became standardized, they also included rules for women's play. Many women learned to enjoy the sport.

Evening activities usually revolved around one's social circle or the arts. Dinner parties and balls were carefully arranged. Invitees had to be of a certain social standing, and great effort was placed on inviting excellent conversationalists and graceful dancers. Bachelor men with good conversation skills were seen as a valuable commodity and were often invited to parties as a fill-in for someone who could not make it or to entertain spinster aunts. Theater productions, symphonies, and operas were other popular evening activities.

HEALTH AND LEISURE ACTIVITIES

Leisure activities were rare for the rural population and the urban poor. Men would work during the day, and, in the evening, they might join a few

An example of the popular S-bend corset. [Library of Congress]

friends and go to a local tavern and socialize over a mug of beer. Women would work in the fields or at their jobs during the day, then do housework or take care of their children in the evening. Urban women who worked as domestics, especially in the north, would live in the homes of their employers. Those who were able to go home on weekends or at the end of the day still had to care for their own families. Live-in domestic help were always on-call and rarely got any leisure time at all, which accounted for the high turnover rate.

For the majority of people at the beginning of the 1900s, health was precarious at best, especially for those living in urban areas. If they did not get caught in some kind of dangerous activity or a dangerous occupation, they were susceptible to whatever illnesses might come their way. Medical science was still in its infancy, and there were few physicians, most of whom were in the cities. Rural areas relied on the traditions that their families and communities used for generations.

The growth of urban centers had exploded, and the infrastructure and engineering had not kept up. Most city dwellers did not have access to clean water, which led to epidemics, including cholera and yellow fever. For example, in the beginning of the century, many New Yorkers still

Advertising 1900–1910. In the first decades of the century, most companies turned their advertising over to advertising agencies. Providing a wide range of services, including planning, research, ad creation, and the implementation of campaigns, agencies modernized product advertising. They became focused on how well the advertising worked. They created basic customer surveys and compared how the same ad performed in various publications.

Women became principal targets for advertisers because women were the primary purchasers of the family's consumer goods. Food, soap, and cosmetics advertisements had strong appeals to women. They were usually written in an editorial style with claims about the product and a coupon or sample. Crisco vegetable shortening, Maxwell House coffee, Ivory soap, and Cutex nail polish were all advertised in this way.

A new form of advertising called atmospheric advertising emerged during these decades. It created a desirable atmosphere around the product through large stylized images and text that stopped the reader from turning the page. There were fewer words on the page, and the whole look of the ad was intended to give the impression of integrity, quality, and prestige. Multiple-plate printing allowed for colorful, pictorial-style ads.

This period became the golden age of trademarked advertising. Agencies developed memorable characters such as the Morton Salt Girl, the Campbell's Kids, Buster Brown, Planter's Mr. Peanut, and Cracker Jack's Sailor Jack. Copywriters developed carefully worded slogans such as Maxwell House's "Good to the last drop," Greyhound Bus's "Leave the driving to us," and Morton Salt's "When it rains, it pours."

During this era, there was an emphasis on health and cleanliness, and advertisers focused on these themes. In 1906, the U.S. government passed the Pure Food and Drugs Act, which required a listing of ingredients on all foods and medicines. Advertisers included health claims in the copy for many products, including Dixie cups and Scott Tissue. Some of the copy was sensational with its frank explanation of the health horrors that might befall someone who chose another product.

then leave to return home and change clothes for dinner. If a couple were going out for the evening, yet another change of clothes was required. Miscellaneous activities such as walking the dog might require yet another change of clothes. Women were to be seen, and they needed to be seen in different outfits. Even on vacation, an upper-class woman could not be seen in the same outfit twice during a week.

same outfit twice in one day, she could bring scandal and ridicule onto her family. At the beginning of the twentieth century, few women were willing to do this. Subtle changes were occurring and dramatic events, such as WWI, were on the horizon, so it was not long before this particular lifestyle would be gone forever.

During the last half of the nineteenth century, technology and industry developed a series of inventions that would change the course of life more rapidly than in any previous century. Most of these inventions seemed to become established in the urban areas. Urban areas grew into large cities, and the residents of those cities demanded the new inventions and conveniences, such as electric light and indoor plumbing. These conveniences helped attract more people to urban areas, which tended to increase the desire for new technology. One of those initially unassuming inventions was the telephone.

The telephone was invented in 1876. Whereas its predecessor, the telegraph, had begun to change how people communicated across great distances, the telephone increased the speed of those changes. By the end of 1909, the telephone was no longer a "curiosity." It was common in urban areas and allowed news to travel quickly. The leisurely pace of life began to speed up, and women were less accepting of the time it took to wear the clothes that had been fashionable a mere decade earlier.

SOCIAL OCCASIONS

For the upper classes, "social" meant almost anything outside the house. The rather rigid expectations of daily life that existed in the late 1800s slid into the beginning of the 1900s. Each different activity occurred during a specific time of day, and each required a specific outfit.

The early mornings were usually spent in delegating the day's activities. Generally, the men were at work, so the women would be home and a relatively comfortable, but fashionable, dress could be worn. The afternoon hours were spent visiting others. Many of these visits were not simply friendly social calls but calls women made to other women in an attempt to get on a particular guest list for an upcoming activity. The visits were strictly set for fifteen minutes each, after which another guest could be expected. These were very formal visits and required a formal outfit designed for that specific kind of occasion.

At about 5:00 in the afternoon, women could make friendlier visits that did not require as formal an outfit as the earlier visits. If a woman was invited "to tea," then the woman would have to wear something more formal than if she was simply visiting a good friend. The women would

poor to become a millionaire, but this generally meant that people had to move to the city. Individuals and families had to work hard, but the poor could join the middle class and those in the middle class worked to become wealthy. The rich had somewhat more leisurely lives, but they, too, had a rather rigid daily schedule. Class distinctions and rigorous rules of etiquette governed every aspect of social life during the first decade of the century.

Upper-class women were frequently objects for display. The implication was that the less work they did, the more leisurely they seemed to be, the more money their husbands and fathers made. Those families trying to join the upper classes would work diligently to have their women appear as if they had nothing to do, even if that was not true. Appearances were important. Upper-class women were expected to have a variety of activities during the day. Each activity meant a different outfit; a woman could not be seen at afternoon tea wearing the same outfit she wore during a morning's activity.

Fashion at the turn of the century meant clothes that were trouble-some. A woman could not just "throw on a dress" and be ready to receive guests or go shopping. There were corsets and garments that required the attendance of at least one maid. The "S-bend" corset, popular at the turn of the century, forced a woman's hips back and her bosom forward, pro-ducing the popular "S" shape. The corset also created what was referred to as the "monobosom." This corset required at least one maid to help lace and tighten the corset until the wearer's figure attained the appropriate shape. Many physicians complained about this corset, saying that it did more harm than good to a woman's bones and internal organs, but weal-thy women needed to look as if they did not need to worry about such things. No country farm woman, or any of the working-class women, could work in this corset. Also, they could not afford a maid to take care of the corset or the rest of the clothes.

A maid was required to maintain the wardrobe for the lady of the house. The maid was responsible for the cleaning, mending, ironing, and general maintenance of a wealthy woman's wardrobe. The maid would also have to help the lady dress, because there was no way any one woman could fasten, attach, and arrange the various garments that the "well-dressed woman" of the early 1900s needed. Women may have found some of the fashion dictates to be uncomfortable and confining, but that was the point. The ideal in the 1900s envisioned women in a confined role; they were not supposed to have anything better to do than be ladylike, manage their households, and raise their children.

Middle- and upper-class women spent much of their day constantly changing clothes. If a woman were to dress comfortably or be seen in the

and families still found enough pocket change to go to the movies. The 1932 Winter Olympics in Lake Placid inspired many Americans to take up sports such as skiing and ice skating. Swimming remained a widespread pastime, but most Americans chose inexpensive pastimes such as board games, puzzles, and listening to the radio.

The first half of the 1940s was dominated by WWII. For the adults who did not serve in the war, daily life involved working in factories. Civilians were responsible for conserving and contributing to the war effort as much as they could. This usually involved salvaging, recycling, and planting Victory Gardens.

Most socialization during the 1940s revolved around the war effort. People went to USOs to dance and entertain the servicemen. Movies and sing-alongs were popular group activities, and baseball was seen as the all-American sport. Although many of the major league players were off fighting overseas, African Americans and women held games for eager crowds.

After the war, Americans took advantage of the increased production of commercial cars. Families took Sunday drives and road trips. National parks across the United States were frequent destinations. By the close of the decade, Americans no longer had to abide by train schedules; they could get nearly anywhere they wanted in their cars.

THE
1900s

At the turn of the century, the population was shifting away from rural areas and into cities. The urban areas not only had the possibility for work, they also had amenities such as telephones, electricity and indoor plumbing. Even the most poor tenement housing had indoor plumbing, although one bathroom might be shared by four or five families.

Daily life tended to be fairly consistent for each class. One day was much like another, except for holidays and the rare special occasion. The working class worked. Those that managed to find themselves in the growing middle class worked as well, although the nature of their work tended to be less grueling than that of the working class. Technology and industrialization created jobs that needed education and skills that were usually only available in urban areas. Increasingly, fewer farms could feed more people. Industrialization was moving the country, and that meant that the population was shifting to the urban areas.

For the first time in history, large numbers of people were improving their economic status. It was truly possible for someone who was born dirt

tennis, golf, and lawn games such as croquet and badminton. Travel, especially European travel, was enjoyed by affluent Americans.

During the 1910s, World War I dominated the daily life of Americans. As men went to war, women went to work to alleviate the labor shortage. They also assisted the war effort by selling war bonds and helping aid organizations.

The world of Americans, especially those in rural locales, was shrinking and changing. Newspapers, magazines, and catalogs brought the outside world and factory-made products to people through the United States. Electricity expanded the daylight hours, leaving people with more usable leisure time. After the war, women refocused on the debates over women's suffrage and birth control.

Life expectancy increased during the 1910s, although many Americans perished after contracting the Spanish flu in 1918. The government began to take a tougher stance on drugs. In 1914, the Harrison Narcotics Act outlawed the use of opium and cocaine, two drugs that had experienced a surge in popularity.

The 1920s is sometimes characterized by wild parties and loose morals. Social occasions were frequent. People got together over teas, luncheons, at horse races, and at night clubs. Theme parties were common, and alcohol and cigarettes were in plentiful supply.

Prohibition went into effect during this decade, but this did not keep people from drinking. Upper- and middle-class people frequented speakeasies to imbibe, whereas lower-class people found cheap, often low-quality alternatives. In urban environments, prohibition received scorn, because drinking establishments were often an integral part of communities.

Americans' health and leisure activities became strikingly modern during the 1920s. Many women ate low-calorie diets to attain and keep the slim, boyish figure that was in fashion. Americans became more aware of nutrients in their foods, as several new vitamins were discovered. Fewer servants meant that more women cooked the family's food. There was a surge of interest in sports during the 1924 Summer Olympics in Paris, and dancing continued to be a popular pastime. The proliferation of automobiles made car travel a common activity.

The decadence of the 1920s ended quickly after the stock market crash in 1929. Parties and conspicuous consumption were replaced with frugality and restraint. Families found themselves resourcefully stretching budgets to make ends meet. Much of the nation was underfed and many were homeless. Men's self-esteem suffered when they found themselves out of work.

Despite the poverty of much of the nation, extravagant debutante balls and weddings still occurred. Christmas became a commercialized holiday,

4

Daily Life

Daily life in the United States shifted from a dependence on servants and strict class distinctions to a more democratic, self-sufficient way of life. During the first decade of the century, many Americans moved from farms into cities in search of jobs. Upward mobility was a possibility for most Americans and was idealized in much of the literature of the time.

Class distinctions were a significant component of early twentieth-century living. Upper-class families had several servants, and even middle-class families often had cooks, housekeepers, and nannies. In contrast, lower-class families were responsible for all of their own housekeeping, cooking, and child care.

Socialization followed class lines, too. Middle- and upper-class women followed a rigidly structured series of visits to their friends during the day. Each visit had to be scheduled, and the visitor would be presented to the hostess. Lower-class women visited their friends in a much more informal format.

Health was precarious during the 1900s. Medical science was still primitive, and urbanites often lived with the threat of cholera epidemics. Injuries, such as broken bones or deep cuts, frequently became infected and could result in death. Within the next decades, medical advances would curtail diseases and allow doctors to prevent and treat infections.

Although sports would gain popularity later in the century, in the 1900s, bicycling was extremely popular. Upper-class Americans enjoyed

Turner helped to keep morale high in *Casablanca*, *Above Suspicion*, *Wake Island*, and *Guadalcanal*. These films never depicted the actual harsh realities of battle but engaged patriotism as they romanticized war.

The other job of the entertainment industry was to take minds off of the tensions of war. Classic musicals such as *State Fair*, *Meet Me in St. Louis*, *Easter Parade*, and *Anchors Aweigh* were immensely popular. Abbott and Costello comedies were well liked, and there were many popular comedy shorts, including *Laurel and Hardy*, *Our Gang*, and *The Three Stooges*. Serials were another popular movie format. Moviegoers came back each week to see the next installment in the exciting serial adventures, such as *The Adventures of Captain Marvel* and *Dick Tracy vs. Crime Inc.*

The films of the 1940s were not all simply propaganda and comedies. Many critically lauded, classical dramas emerged from this era. Orson Welles' *Citizen Kane* criticized the life of William Randolph Hearst. *Gaslight* featured one of Ingrid Bergman's finest performances. *The Lost Weekend*, *Mildred Pierce*, *Twelve O'Clock High*, and *The Best Years of Our Lives* vied for Academy Awards and remain atop critics' lists of the best films and performances of all time.

Hollywood continued to capitalize on world events after the war by replacing Japanese and Nazi villains with Communists as America's enemies. *The Iron Curtain* (1948) and *I Married a Communist* (1949) reminded Americans that the Soviets were now the enemy in the Cold War. Drive-in movie theaters began a new trend in movie going as production of commercial cars resumed and Americans could afford to buy them.

RADIO AND TELEVISION

Radio was the lifeline for Americans in the 1940s, providing news, music, and entertainment. Roosevelt continued his fireside chats from the 1930s, and Americans received nearly up-to-the-minute news about the war. People would gather around the radio to listen to their favorite programs, and, by 1942, some estimates put the American radio audience at 40 million people (Gould 1942).

Classical music, provided by the New York Metropolitan Opera and the NBC Symphony Orchestra, was popular. Listeners would hear big bands in special remote broadcasts of their performances. Musicians of all sorts were popular on variety shows, and this type of show would often feature a regular vocalist.

Programming included soap operas, quiz shows, children's hours, mystery stories, fine drama, and sports. Kate Smith and Arthur Godfrey were

popular radio hosts. Popular comedies included *Burns and Allen*, *Our Miss Brooks*, and *The Aldrich Family*. The popularity of serialized radio shows paralleled serialized movies. Each week, listeners would tune in to hear the latest adventures from *The Cisco Kid*, *Captain Midnight*, and *The Tom Mix Ralston Straight Shooters*. These serials often featured gimmicks that encouraged listeners to write in to get badges, decoders, or special rings. Dramas, such as *Escape* and *Suspense*, and detective stories, such as *Boston Blackie* and *The Shadow*, were popular, too. Many of the most popular radio shows continued on in television, including *The Adventures of Ozzie and Harriet*, *The Lone Ranger*, *Jack Benny*, and *Truth or Consequences*.

Everyone was concerned with keeping up morale of the troops overseas, and the government established the Armed Forces Radio Services (AFRS). The service was heard by servicemen overseas, not by people in the United States. Originally, the AFRS recorded existing radio programs and removed the commercials. The programs were recorded on transcription disks and sent overseas to the troops. Eventually, the AFRS created original programming designed specifically for servicemen. By 1945, the service was creating twenty hours of original programming each week, including *Mail Call*, *G. I. Journal*, and *Jubilee* (Christman 1992, 60).

Television provided a new opportunity for Americans to actually see much of what they had been hearing about on radio for many years. At the end of the decade, the percentage of homes with television shot up from 0.4 percent in 1948 to 9.0 percent in 1950 (Baughman 2006, 41). In 1946, *The Hour Glass* became the first regularly scheduled variety show on television. In 1947, television reached its first mass audience when 3 million viewers tuned in to watch the 1947 World Series (Von Schilling 2003, 95). As more Americans owned sets, the demand for programming grew, which added opportunity for advertisers. Most programming in the early days was sponsored by corporate giants, such as Texaco. It sponsored *Texaco Star Theater*, which launched the first television star: Milton Berle. As the Golden Age of Television began in 1949, radio soon faded in popularity.

REFERENCES

Andrist, R. K., ed. 1970. *The American Heritage History of the 20s & 30s*. New York: American Heritage Publishing Co., Inc.

Berkin, C., Miller, C. L., Cherny, R. W., and Gormly, J. L. 1995. *Making America: A History of the United States*. Boston: Houghton Mifflin.

Best, G. D. 1993. *The Nickel and Dime Decade: American Popular Culture During the 1930s*. Westport, CT: Praeger.

Bordwell, D., and Thompson, K. 2002. *Film History: An Introduction*, 2nd revised ed. New York: McGraw Hill.

Bouillon, J.-P. 1989. *Art Deco: 1903–1940*. Translated by M. Heron. New York: Rizzoli.

Cole, B., and Gealt, A. 1989. *Art of The Western World*. New York: Summit Books.

Eyles, A. 1987. *That Was Hollywood: The 1930s*. London: Batsford.

Gordon, L., and Gordon, A. 1987. *American Chronicle*. Kingsport, TN: Kingsport Press, Inc.

Kallie, J. 1986. *Viennese Design and the Wiener Werkstatte*. New York: G. Braziller in association with Galerie St. Etienne.

Keenan, B. 1978. *The Women We Wanted to Look Like*. London: Macmillan London Limited.

Kyvig, D. E. 2002. *Daily Life in the United States, 1920–1940*. Chicago: Ivan R. Dee Publisher.

Lucie-Smith, E. 1996. *Art Deco Painting*. London: Phaidon.

McKay, J. P. 1999. *A History of Western Society*. New York: Hougton Mifflin.

Mendes, V. D., and De La Haye, A. 1999. *20th Century Fashion*. London: Thames and Hudson.

Metropolitan Museum of Art (n.d.) *Timeline of Art History: Frank Lloyd Wright.*, http://www.metmuseum.org/toah/hd/flwt/hd_flwt.htm.

Mordden, E. 1978. *That Jazz! An Idiosyncratic Social History of the American Twenties*. New York: Putnam.

Murrin, J. M., Johnson, P. E., McPherson, J. M., Gerstle, G., Rosenberg, E. S., and Rosenberg, N. 2004. *Liberty, Equality, Power: A History of the American People*, Vol. 2 since 1863. Belmont, CA: Thomson.

Ogren, K. J. 1989. *The Jazz Revolution. Twenties America and the Meaning of Jazz*. New York: Oxford University Press.

Perrett, G. 1982. *America in the Twenties, A History*. New York: Simon and Schuster.

Reeves, T. C. 2000. *Twentieth Century America: A Brief History*. Oxford: Oxford University Press.

Richardson, D. E., ed. 1982. *Vanity Fair: Photographs of an Age, 1914–1936*. New York: Clarkson N. Potter.

Willever-Farr, H., Parascandola, J. *The Cadet Nurse Corps, 1943–1948*. Available at: http://www.lhncbc.nlm.nih.gov/apdb/phsHistory/resources/pdf/cadetnurse.pdf.

Zinn, H. 1995. *A People's History of the United States*. New York: Harpers Perennial.

As Americans sought escape from the war, comic books became popular. They were a cheap and exciting form of entertainment. Although they are commonly associated with children, comic books in the 1940s were avidly read by adults, too. The superheroes such as Superman, Captain America, and Batman provided inspiring stories about the triumph of good over evil when America needed those stories most. The first American paperback imprint, Pocket Books, was formed in 1939 and quickly became popular as an affordable format for the masses. Literary classics were reprinted as paperbacks, and the format helped popularize Western and detective fiction.

THEATER AND MOVIES

The forties, often referred to as the Golden Age of Hollywood, was a heyday for movies. Sales of movie tickets soared to 3.5 billion a year as movies reinforced the values important to the country (Kaledin 2000, 31). The Office of War declared movies an essential industry for morale and propaganda. This helped to boost the movie industry to become the sixth largest industry in the United States by 1941. The government worked with Hollywood studios to produce newsreels sending patriotic messages across the home front. Patriotism shown by the movie industry through their commitment to the war effort helped educate soldiers and civilians alike.

Most movie plots appealed to American patriotism and concerned some aspect of the war-torn world between 1941 and 1945. Americans' fear and hatred of the Germans and Japanese intensified when the plots depicted them as villains. Even Walt Disney helped the war effort with *Donald Gets Drafted*, *Out of the Frying Pan into the Firing Line*, and *Der Fuehrer's Face* released in 1942. Disney Studios produced more than 90 percent of its footage during the 1940s for the government (Marc 1993).

The 1940s was one of Disney Studios' most productive and successful periods. In 1940, it released *Pinocchio* and *Fantasia*. *Dumbo* was released in 1941, and throughout the decade the studio produced popular Mickey Mouse shorts that aired before feature films.

Most Hollywood war-focused films had a fairly narrow and predictable set of morals: the valiant Americans had to overcome the evil Japanese and Germans. These films were designed to maintain the morale of Americans. Leading actors such as Gary Cooper, Humphrey Bogart, Katharine Hepburn, Cary Grant, Bette Davis, Marlene Dietrich, Joan Crawford, Judy Garland, Ginger Rogers, Jimmy Stewart, and Lana

artists in the late 1940s. It was a specific type of music that was the fore-runner of rock and roll, and many swing bands incorporated R&B into their music. Count Basie had a weekly live R&B broadcast from Harlem that helped to bring this genre into American households.

Bebop and cool jazz also had their origins in the 1940s. They featured fast tempos and improvisation. The exploration of harmonies was the element that distinguished these genres from popular jazz, which emphasized melody instead. Charlie Parker and Thelonious Monk emerged as early leaders. When Miles Davis came to New York in the early 1940s to attend the Juilliard School, he neglected his studies to seek out his chosen mentor, Charlie Parker.

Not to be forgotten was the emergence of American folk music as a more widely accepted genre. Woody Guthrie, the original folk hero, used the traditional folk ballad as a vehicle for social protest and observation. Most famous of his hundreds of ballads is "This Land is Your Land." Later, in the 1950s and 1960s, Pete Seeger and Bob Dylan shared Guthrie's style of communication to the masses. Bill Monroe established the Blue Grass Boys and disseminated the sound of Appalachian folk music. Bluegrass gained popularity, but it did not rise to the mainstream. In the late 1940s, Clifton Chenier developed zydeco music by updating a form of Cajun music.

Although American literature is a constant experiment with viewpoint and form, the majority of works created during the war years remained realistic. Literature was generally believed to represent a common national essence; thus, American realism was used to describe the 1940s. Ernest Hemingway wrote of traditionally masculine pursuits, war, and death; William Faulkner brought southern culture and the sweltering heat of Mississippi to life in his powerful novels based on southern tradition, community, family, the land, race, and passion; Sinclair Lewis described the bourgeois; and playwright Eugene O'Neill brought the finality of tragedy to the simple lives built on dreams of fancy.

The end of WWII and beginning of the Cold War provided prime material for grim naturalism without glorifying combat. During the 1940s, novelists looked to European instead of American writers for inspiration. Norman Mailer wrote *The Naked and the Dead*, and Irwin Shaw wrote *The Young Lions* during this time period. Arthur Miller and Tennessee Williams emerged as the "new blood" on the literary scene and focused on the balance between personal growth and responsibility to family and community. T. S. Eliot and Ezra Pound dominated the literary scene in poetry, introducing modernism and giving poetry a connection to contemporary life.

Shep Fields' band got the name Shep Fields and His Rippling Rhythm as one of his sidemen blew bubbles through a straw in a glass of water. Gary Gordon and his Tick Tock Rhythm came about as he developed his trademark sound using temple blocks in his arrangements.

Vocalists traveled with the bands but were considered secondary to the instrumentalists. Oftentimes, the entire band would sing or "scat" an entire chorus in the southern tradition of call and response. Patriotic music was great for sing-a-longs, and everyone joined in to sing Johnny Mercer's "G.I. Jive," Carl Hoff's "You're a Sap Mr. Jap," and the unforgettable "Praise the Lord and Pass the Ammunition" by Kay Kyser. Kate Smith will always be remembered for her rendition of "God Bless America," and the Andrews Sisters will forever be associated with "Boogie Woogie Bugle Boy of Company B."

Sentimental crooners became popular, and Bing Crosby was the most popular. He introduced "White Christmas" in 1942 and "Silent Night" in 1943, and, from 1944 to 1948, he was voted the top money-making star at the box office five times in the Quigley Publications annual poll (Giddins 2001). Frank Sinatra caused fan hysteria early in 1940 and soon became the teen idol of America. When he appeared at New York's Times Square in 1943, he was mobbed by "bobbysoxers," teenage girls who wore short white socks instead of pantyhose.

Ballads became slower and more sentimental, whereas fast "jump" tunes became almost frantic. Bands would alternate slow ballads with jump tunes to give the dancers a breather. Whereas the action-packed dance tunes really livened up a place, the slower ballads were very popular and nicknamed "G.I. nostalgia" for the young servicemen who left girlfriends behind when they went off to war (Hakim 1999).

Every segment of society found a form of swing appropriate for listening or dancing. There was fox-trotting to "Moonlight Serenade" for the upper crust, a circle dance to "The Big Apple" for college kids, and aerial acrobatics of the lindy hop for anyone bold and flexible enough to keep up with the rhythm.

Record companies were selling more records than ever before. The durable plastic 45 RPM and 33⅓ long-playing records introduced in 1948 were a huge advancement over the old 78s, which were quite brittle. Musicians went on strike twice in the 1940s to get more advantageous deals with the record companies. In 1942 and 1948, the strikes effectively stopped the issuance of new recordings until musicians and record companies could agree on new deals.

Rhythm and blues (R&B) was coined as a musical marketing term used to identify a combination of jazz and blues being played by African-American

referred to as the New York School, and it grew to its peak in the 1950s and 1960s.

MUSIC AND LITERATURE

Although classical music remained popular throughout the decade, jazz and its many variations eclipsed all other genres of music in the United States during the 1940s. This period was known as the Big Band Era, and, during it, swing music was king. Swing, or swing jazz, was a variation of jazz that featured a strong rhythm section and fast tempos. It had evolved from an alternative music style into popular music by 1935, and, by the early 1940s, it peaked as a music genre that is inextricably linked to WWII. Originally recorded in 1939, Glenn Miller's "In the Mood" is considered by most to be the musical anthem of WWII. White audiences were drawn to the Glenn Miller, Tommy Dorsey, and Benny Goodman orchestras because the music was easy to dance to and had an upbeat rhythm. Most clubs and hotels were still segregated at that time, and although black musicians were allowed to entertain, they were not allowed to patronize the same establishments.

Wartime was depressing and good music with lively dancing was one way to leave the war behind. Dance bands, or swing bands, got everyone on their feet. Dancing in the 1940s was a popular pastime for nearly every age and ethnic group. Either live at a club or hotel or heard on the radio, people got up and began to dance with any partner available. Swing music had a dense rhythm and used a hard riff against which the melody could be played. Tightly arranged three-minute pieces were written for 78 RPM records, but longer improvisations created open-ended arrangements for radio and live performances.

The instrumentation in swing music was a departure from that of the early bands. Larger bands, often 16 pieces, included trumpets and trombones for lighter and brighter sound, counterbalanced by saxophones and clarinets. The rhythm was jazzed up a bit with an expanded drum set, piano, and a string bass.

A lone conductor waving his baton was replaced by leader musicians who took center stage. Bandleader Benny Goodman was proclaimed the "King of Swing," but he was also an accomplished clarinetist whose solos were flashy and toe tapping. Similarly, bandleaders Glenn Miller, Tommy Dorsey, and Artie Shaw would alternate between leading the group and playing a solo on each piece. Count Basie and Duke Ellington played piano full time on each song while also leading their bands. Many bands developed gimmicks that made them stand out from the other bands.

In 1937 and 1938, *Fortune* magazine conducted a survey that found radio to be the most popular pastime in the nation. Because of the trust listeners placed in radio broadcasts, one of the biggest broadcasting debacles occurred on Halloween of 1938. A live performance of H. G. Wells' fictional tale of alien invasion, *War of the Worlds*, was produced by Orson Welles and broadcast on CBS, causing a considerable panic among listeners, who believed that the alien invasion was actually taking place.

Television was still in development in the 1930s, and an early incarnation was taken by RCA engineers to the 1939 New York World's Fair. Neither programming nor commercial television sets were available to the masses until the following decade.

THE
1940s

ART MOVEMENTS

As the world was transformed by WWII, the environment of the newly global, technological society brought about a larger art movement called Modernism. European artists fled their home countries and brought the concept of Modernism to the United States with them. This was the second generation of Modernism, a movement that emphasized the power of human beings to create, shape, and improve their environment. Artists achieved this power by reexamining everything and using scientific knowledge, technology, and practical experimentation. By the 1940s, Modernism was infused in all forms of American art: photography, sculpture, paintings, literature, wearable art, furniture, and architecture.

Modernism spawned another movement called abstract expressionism, which could be described as an attitude rather than a specific style. It was characterized by individuality, spontaneous improvisation, and freedom of expression. Jackson Pollock, Willem de Kooning, and Mark Rothko were artists with very different styles, but they are all considered abstract expressionists. This art was introspective, with artists and writers looking internally for their inspiration instead of looking out at the larger world. They moved away from political themes and toward individual expression.

New York City was full of artists who adopted characteristics of abstract expressionism. Many of these artists had been introduced to each other by the Federal Arts Project in the 1930s. American had seen an influx of European artists since the beginning of the war, and these emigrants tutored their American counterparts. New York City had replaced Paris as the art capital of the world. This informal group was

Film Costume Designers and the Fashion Industry. Although most costume designers of the 1920s received little or no attention for their work on Hollywood films, by the 1930s, these and many more designers were beginning to be recognized and valued by the industry as a necessary component to a film's success. Attributable in part to the increasing interest of executives in gaining larger female audiences, the costume designer became an integral part of the publicity machine. This, in turn, caused the fashion press to pay greater attention to the "looks" that these designers were creating for the screen, looks that appealed to shoppers from all walks of life.

Designers were frequent voices in fan magazines such as *Silver Screen, New Movie, Screen Book Magazine, Screenland,* and the ever-popular *Photoplay.* They discussed trends, what their jobs were like, and gossip from backstage. Reports in these magazines were keen to note new designs and highlight the designers' individual influences on the fashion industry. Adrian, in particular, was often highlighted for his work with Greta Garbo, Joan Crawford, and Norma Shearer.

Designers reacted to this newfound appreciation and notoriety in diverse ways. Many designers used the publicity to further their careers within film, getting increasingly more important projects. Others used their success to gain celebrity

The 1939 film *The Women* shows examples of evening gowns with long, flared skirts. [Courtesy of Photofest]

clientele, designing their personal wardrobes. A select few attempted to make the bridge from film design to fashion, with mixed success. Designers such as Edith Head, Orry-Kelly, Walter Plunkett, Travis Banton, and Howard Greer ventured into fashion design with some success. Adrian, however, had one of the more successful cross-over careers into fashion in the forties, in part because of his continual appearance in film fan magazines in the thirties and despite having never been nominated for an Academy Award.

decade included the Marx Brothers' *Animal Crackers*, Charlie Chaplin's *City Lights*, Joseph Von Sternberg's *Blue Angel* and *Morocco*, and George Cukor's *The Women* and *Marie Antoinette*.

During the 1930s, the costume designer became more well known to the general public. Because of the emphasis on the lavish, fantastical, and glamorous, designers such as Edith Head, Adrian, and Travis Banton became known to the general public. These costume designers held massive influence not only over the costumes used in movies but the everyday fashion trends of the 1930s as well. From the *Mata Hari* hat, to platinum blond hair, to Victorian-style evening capes, these designers unintentionally skewed the fashion world.

RADIO

The majority of the necessary technology for commercial radio was developed in the previous decade. Government continued to reevaluate the way radio was controlled, and, in 1934, the Federal Communications Commission took over from the Federal Radio Commission that had been established in 1927.

Programming in general became more refined and stable. By the mid-thirties, there were regular news broadcasts with substantial news programs. The standard morning programming included the weather, talk, and recorded music. When FDR became president in 1933, he instituted a radio series called fireside chats in which he explained his plans for relief from the Great Depression.

Advertisers and marketers more aggressively targeted radio audiences by associating various products with specific programs. Broadway and Hollywood performers and famous newscasters used their popularity to sell any number of commercial products. Sponsored serial dramas or "soap operas" including *The Romance of Helen Trent* and *Ma Perkins* drew audiences week after week.

Some popular entertainment programs included vaudeville-like performers such as Fibber McGee and Molly, George Burns and Gracie Allen, Charlie McCarthy (with ventriloquist Edgar Bergen), Jack Benny, and Kate Smith. *Amos n' Andy* was a series about two black men from the country who were continually confused by city life. It began as a local Chicago program in the late 1920s, became a national NBC program in 1929, and peaked in popularity in the early 1930s at 40 million people (Kyvig 2002). Other entertainment programs featured on the radio included the quiz show *Information Please*, *One Man's Family* featuring typical family chatter, and the *WLS Barn Dance*.

to the fore. Actors such as Laurence Olivier, Noel Coward, Preston Sturges, Lynn Fontanne, Beatrice Lillie, and Hope Williams all had noted roles on the stage.

Two of the most famous dancers to come out of the thirties were Martha Graham and Serge Lifar. Graham, a native New Yorker, was an interpretive dancer and choreographer. Lifar was a Russian dancer and choreographer, who had danced with Diaghilev in the twenties. A self-taught artist, she made her American debut in 1933.

In part because of the amount of nudity present in the films of the early thirties, the Catholic Legion of Decency (also known as the Hayes Department) was formed in 1933 and began pressuring the industry to enforce the Production Code, a plan for self-censorship that had been instituted in the twenties that had been all but ignored. In 1934, the film industry succumbed to the pressure and began censoring films for nudity, sex, and violence.

Despite the new censorship, the public still went in droves to the movies, primarily to escape the dregs of the Depression. In answer to this, many films had a fantastical, elaborate, inflated atmosphere meant to help everyday people forget their troubles. Gangster and horror movies were especially popular, as were romances, dramas, and musicals.

Many call this era the "Golden Age of Hollywood," a time when stars were their brightest and films their most impressive. Stars such as Norma Shearer, Jean Harlow, Joan Crawford, Marlene Dietrich, Bette Davis, Carol Lombard, and Mae West had huge followings, as did male stars such as Cary Grant, Gary Cooper, Clark Gable, James Stewart, and Claude Rains. The most popular comedies featured the Marx Brothers and W. C. Fields. Pre-code musicals choreographed by Busby Berkeley featured huge numbers of chorus girls in various states of undress. William Powell was featured in an extremely popular detective series, beginning with *The Thin Man*.

Ginger Rogers and Fred Astaire danced into the hearts of their adoring public. Although not dancers, other couples such as Joan Blondell and James Cagney or Katharine Hepburn and Spencer Tracy were repeatedly paired to great success and box office receipts. Child star Shirley Temple won the hearts of thousands with her tap-dancing skills and professional cuteness.

The most memorable films of the decade, however, all seem to have been produced the same year. Moviegoers were able to see *The Wizard of Oz*; *Gone with the Wind*; *Young Mr. Lincoln*; *Dark Victory*; *Goodbye, Mr. Chips*; and *Another Thin Man* in 1939 alone. Others produced during that

Joan Crawford in the 1932 film *Letty Lynton*. [Courtesy of Photofest]

African-American writers and poets such as Langston Hughes, Countee Cullen, Zora Neale Hurston, and Claude McKay.

Other novelists of the era included Thomas Wolfe and W. Somerset Maugham. Thomas Wolfe was interested primarily with "Americana," in both *Look Homeward, Angel*, and *Of Time and the River*. Maugham's *Of Human Bondage* is considered one of the best books to emerge from the twentieth century (Richardson 1982). Nathanael West wrote surrealist and fantasy social commentaries such as *Miss Lonelyhearts* and *The Day of the Locust*. Another notable book to come out of the thirties was the bestselling *How to Win Friends and Influence People* by Dale Carnegie. Especially popular with the newly emerging teen and young-adult market was the Nancy Drew series, which got its start in 1930.

THEATER AND MOVIES

Despite the increasing success of Hollywood films and the rising toll of the Great Depression, the theatrical world remained vibrant. The Works Projects Administration's Federal Theater Project provided much-needed work for many of the theater's unemployed. In December 1932, Radio City Music Hall opened, and, at the time, it was the largest indoor theater in the world, with seating for 6,200 (Andrist 1970).

Some of Broadway's most successful plays, playwrights, and composers established themselves in the thirties. In the early years, *Green Pastures* and *Of Thee I Sing* were hits, as was *The Barretts of Wimpole Street*. Many of the plays produced during this period later became some of Hollywood's best-known feature films, including *The Man Who Came to Dinner*. Other notables include *Life with Father*, *Pins and Needles*, *Our Town*, *Of Mice and Men*, and George White's *Scandals*. Eugene O'Neil, Bernard Shaw, Clifford Odets, and Thornton Wilder all had hits on the Great White Way. Composers and librettists such as Cole Porter, George Gershwin, and the team of Richard Rodgers and Lorenz Hart first came

of Chinese designs with art deco that influenced printed silks and detailing. Valentina, Mainbocher, and Molyneux in particular focused on these tactics in the mid to late 1930s and often included brightly colored garments with mandarin collars, kimono sleeves, narrow tube skirts, and forked trains in their collections.

Surrealist art strongly influenced the world of fashion in the mid to late 1930s. Schiaparelli worked directly with several surrealist artists, including Salvador Dali, Christian Berard, and Jean Cocteau. To capitalize on the new movement, fashion marketers used surrealist imagery in advertising and window displays to lure potential shoppers inside (Mendes and De La Haye 1999).

Modernist fashion photographers such as Steichen and Hoyningen-Huene enjoyed continued success in the 1930s, as did the surrealist photographer Man Ray. Newcomers included Horst P. Horst and realist photographers such as Martin Mankasci and Toni Frissell. Surrealist photography remained a favored style in fashion magazines into the early 1940s.

MUSIC AND LITERATURE

The 1930s saw a continued interest in the musical forms and artists of the previous decade, with new artists and genres contributing to the mix. Thanks to technological innovation in recorded music and radio, music as a whole gained a wider audience. Aaron Copland, George Gershwin, and Roy Harris contributed significantly to the cultural landscape, as did the Russian émigré Sergei Rachmaninoff. Additionally, "The Star Spangled Banner" was declared the official U.S. national anthem on March 3, 1931.

As white America accepted jazz as a genre, the style began to change. Big bands rose in popularity, including those led by Tommy and Jimmy Dorsey, as well as Guy Lombardo. These big bands often highlighted high-profile singers such as Bing Crosby and the four Mills Brothers. Country stars remained popular on many radio programs, and "foreign" or "ethnic" music saw a slight rise in popularity. On the whole, however, the Depression stifled record sales.

The major literary figures of the thirties included authors with vastly different styles and intentions. William Faulkner, John Steinbeck, and Harlem Renaissance authors emerged at the forefront. Nobel Prize-winner William Faulkner published the *Sound and the Fury* in 1929, continuing with *A Light in August, Sanctuary*, and others into the thirties. Steinbeck, focusing on the plight of dispossessed California migrant farm workers, published *The Grapes of Wrath* in 1939, for which he later received the Pulitzer Prize. The Harlem Renaissance was in full swing, highlighting

Modern Art in New York. The film *Metropolis* (1927) reflects this style, as did the modernist architecture of Charles Edouard Jeaneret-Gris, who was also known as Le Corbusier. His work was "like a Cubist painting, the house is a precise, rational, abstract statement about materials and forms and their interrelationships" (Cole and Gealt 1989).

Architect Frank Lloyd Wright, who was 60 in the 1930s, was by now generally accepted as the leader of modern architecture (*Timeline of Art History: Frank Lloyd Wright*, n.d.). His work continued to emphasize the relationship between landscape and design. One of his most famous houses, Fallingwater, was constructed in Pittsburgh, Pennsylvania, from 1935 to 1939. During this period, he also designed the first of his "Usonian" houses, simple house designs that were aimed at middle-class clients. These houses set the design for future suburban houses.

New art movements of the 1930s wielded great influence over the arts and artists. Neo-classicism and an interest in Greek simplicity greatly influenced the fine and visual arts during this decade. The Great Depression focused many American artists on "regionalism," realism, and everyday life in rural and urban America. Examples include Grant Wood's "American Gothic," Georgia O'Keeffe's southwestern themed paintings, and photographer Dorthea Lange's documentary-style realism.

Murals, often supported by the Federal Works Projects, rose in popularity during this time as well. Two of the most well-known muralists were Mexican Americans Diego Rivera and Jose Clemente Orozco. Rivera was especially controversial because of his apparent connection to Lenin and his depictions of laborers.

In terms of new architectural movements, skyscrapers were considered modern marvels and had increasing influence on visual culture and design in general. The Empire State Building, Chrysler Building, and Rockefeller Center were built during this decade. This style of architecture was sleek and aerodynamic in appearance; it influenced everything from industrial design to commercial design.

In addition to the Great Depression, other historical events that affected the arts included Hitler's 1933 appointment as chancellor of Germany, after which some 60,000 artists, writers, actors, and musicians began leaving Europe. Many relocated to the United States, helping to make it the "new artistic center of the West" (Cole and Gealt 1989).

The influence of these various art movements on fashion design was especially evident with art deco-style orientalism and surrealism. Baby clothes in particular reflected the earlier interest in orientalism. Season collections frequently showed little kimonos, or kimono sleeve details, often in silk and cotton (Bevans 1930). In adult fashions, it was the mixing

included performances by musical acts such as the New York Orchestra and a soprano from Chicago, as well as comedian Will Rogers.

Generally, radio in the 1920s included a wide variety of programming, including news and weather reports, religious programming, music, educational and children's programming, as well as recorded music and live performances. In general, some of the most popular programs included "Real Folks" with Agnes Moorehead, along with sportscasts by Graham McNamee, the news with Floyd Gibbons, and comedian Jack Pearl. Educational programming included exercise instruction, auto repair, baby care, and health care.

Sports broadcasts were especially popular and from the start had drawn large audiences. The boxing match between the American Jack Dempsey and the Frenchman Georges Carpentier was broadcast over radio in July 1921. It was heard by approximately 300,000 people, at least 100,000 of those gathered in New York's Times Square to listen via loudspeakers (Kyvig 2002).

Musical programming was also popular. Radio helped jazz and country music to reach greater numbers and encouraged the establishment of more local bands and orchestras. In 1925, the Grand Ole Opry began broadcasting over the radio (Kyvig 2002).

Although some technological elements of television were in development by the late 1920s, it was not commercially viable at this point.

THE
1930s

ART MOVEMENTS

Many artists and movements that began in the 1920s hit their stride in the 1930s. Although the art deco movement reached its zenith in the 1920s, its influence remained visible through the 1930s. Although it began in the previous decade, surrealism became more widespread and well known to the general population. Painters such as Pablo Picasso and Salvador Dali continued to create and shape the direction of surrealism. Andre Breton, who wrote the surrealism manifesto in 1924, held major exhibitions in 1936 and 1938. Modernism in general continued its upswing, and, in the 1930s, Constantin Brancusi, a Roman sculptor who worked in Paris, garnered more attention in the art world with his abstract egg- and bird-shaped sculptures.

Alongside art deco, the "machine aesthetic" became popular, in part because of the Machine Age Exhibition held in 1934 at the Museum of

Films had a huge impact on both the industry and their audiences, especially if they were epics made by Cecil B. de Mille or D. W. Griffith. Erich von Stroheim's *Greed* left a lasting impression, as did King Vidor's *Big Parade*. Foreign horror films such as *The Cabinet of Dr. Caligari* and *Nosferatu* expanded audience's imaginations and stretched actors' skills. Other famous films of this era include the futuristic *Metropolis*, the drama *Sunrise*, Greta Garbo's *Anna Christie*, and *The Taming of the Shrew*, starring husband and wife team Douglas Fairbanks and Mary Pickford.

Radio

During the 1920s, radio developed significantly as a medium. Before radio had been established, rural areas were more isolated and less aware of national events and trends. In 1920, the first commercial radio station (KDKA) was established by the Westinghouse Electric Company in Pittsburgh by Robert Conrad. Westinghouse planned to create demand for their newly engineered commercial radio equipment through programs. Initially, the sets were small, cheap crystal sets, but, as popularity grew, large console sets were sold as living room furniture pieces. In 1920, the first news station went on the air. By the end of 1921, there were ten radio stations, and, in 1922, ninety more went on the air. By 1925, 50 million people were listening on these sets. By 1927, listeners across the country had access to both local and national programming. Amazingly, the first car radio had been designed by 1928, but its reception was too poor and its design was too bulky to be commercially viable (Kyvig 2002; Andrist 1970).

This larger audience necessitated greater governmental regulation and control. In response, Congress established the Federal Radio Commission (which later became the Federal Communications Commission) as a part of the Radio Act of 1927. This act acknowledged that airwaves belonged to the people and that the government must be responsible for managing them in the common interest (Kyvig 2002).

Even in the early twenties, radio helped to link urban and rural areas with common information and entertainment. KDKA's first program reported that Warren G. Harding and Calvin Coolidge had won the presidential election. The station's early programs attracted more than 6,000 listeners by 1920, who tuned in for the vocal and musical broadcasts. Their schedule also began to be printed in the local newspaper (Kyvig 2002).

As time went on, competition built, with NBC establishing a station in 1926. With an estimated audience of 12 million, their first broadcast

Fontanne were members of the Theatre Guild and performed in many of Shaw's plays, including *Arms of the Man* and *Pygmalion*, to much critical acclaim and audience enthusiasm.

The Green Hat, which had first been a successful novel, was produced for the stage in 1925 and starred the stage actress Katharine Cornell. She later became the first major American to form a repertory company. Not to be outdone, Eve Le Gallienne founded the Civic Repertory Theatre in New York in 1926.

In terms of theatrical dance, options abounded. Modern or interpretive, ballet, and even burlesque styles were popular with the theater-going public. Isadora Duncan became famous for her Grecian-style dancing and costume. Rodin went so far as to say, "The brilliance of her spirit makes the glory of the Parthenon live again" (Richardson 1982, 58). Ballet Rusee dancers Bronislava Nijinska and Leonie Massine not only danced but acted as choreographers in the early twenties. Ruth St. Denis was an American ballerina who "reflected the soul of India" (Richardson 1982, 94). She and husband Ted Shawn were founders of the Denishawn dance schools in New York and Los Angeles. Fannie Brice, star of the *Ziegfeld Follies*, performed to acclaimed review throughout the decade. Two of the most famous paired dancers of the era, Adele and Fred Astaire, gained much notoriety while performing on Broadway.

A number of important milestones of film history occurred in the 1920s. Films were silent until "talkies" began with *The Jazz Singer* starring Al Jolson in 1927. Before sound was added, dialog would appear as text on the screen, and a live piano player or band would provide musical accompaniment. In 1929, the first Academy Awards ceremony was held to honor achievements in films from 1927 and 1928. The famous actor Douglas Fairbanks hosted the event. During the 1920s, tragedies, war movies, epics, and horror films were popular, as were comedies, westerns, romances, and later musicals.

The most well-known comedy players included Charlie Chaplin, Harold Lloyd, Buster Keaton, and members of Mack Sennett's company. Popular actresses from the early years of the twenties included Clara Bow, Mary Pickford, the exotic Pola Negri, and flappers Louise Brooks and Colleen Moore. In the later twenties, actresses such as Greta Garbo, Claudette Colbert, and Jean Harlow began their rise to stardom. By the end of the decade, Gloria Swanson was the highest paid woman in the world (Richardson 1982). The first real heartthrob, Rudolph Valentino, was extremely popular until his untimely death in 1926. Adventure star Douglas Fairbanks and cowboys like Tom Mix grew in popularity, helping to establish the action genre as an early favorite.

invention, it found audiences the world over, especially in Paris. Initially played in small clubs, especially in Chicago and Harlem, it eventually made its way to big bands and Broadway. Artists such as Jelly Roll Morton, Louis Armstrong, Duke Ellington, and Cab Calloway and blues chanteuses such as Bessie Smith and Ma Rainey have since become legends in the genre. Dancing was popular as an evening activity, and one of the most well known of the social dances was the Charleston, which was born when a song was published under this title (Andrist 1970).

The 1920s saw the rise of some of the prominent American writers. "The Lost Generation" included Gertrude Stein, who coined the phrase, Ernest Hemingway, F. Scott Fitzgerald, John Dos Passos, and Sinclair Lewis, among others. During this time, expatriate Ernest Hemingway published *The Sun Also Rises*, which made the best-sellers list. F. Scott Fitzgerald, perhaps the voice of his generation, produced *This Side of Paradise*. Both Hemingway and Fitzgerald focused on postwar youth. Sinclair Lewis' *Main Street* and *Babbitt*, of the early twenties, were two of the most popular novels of the decade. Although he refused it, Lewis was awarded the Pulitzer Prize for *Arrowsmith* in 1925.

A number of other prominent novelists developed during the decade. Out of Greenwich Village in New York City some talented literary figures emerged, including Willa Cather, Theodore Dreiser, and Sherwood Anderson. Aldous Leonard Huxley published *Crome Yellow* at the age of 28 and James Joyce released his epic, *Ulysses*. Other literary figures of the decade included Nobel Prize winners George Bernard Shaw and Thomas Mann as well as poets Ezra Pound and Jean Cocteau. The public also preferred popular works such as James Branch Cabell's *Jurgen* and John Erskine's *The Private Life of Helen of Troy*. Imported novels were also popular, especially Michael Arlen's *The Green Hat*, which depicted stylish London life. This work was so popular that it was turned into a stage play staring Leslie Howard.

THEATER AND MOVIES

The American theatrical world was still riding high in the 1920s. The films of Hollywood had not yet completely eclipsed the popularity of the Great White Way. Notable performers included Billie Burke, the wife of Florenz Ziegfled Jr., and John Barrymore, whose most famous stage role was as Hamlet in London. He, like many others including Billie Burke, would later make a successful move into the film world. Another actress and stage manager, Grace George, performed in George Bernard Shaw's *Major Barbara* and the comedy *The Ruined Lady*. Alfred Lunt and Lynn

abstraction, this style was first introduced at the Arts Decoratifs et Indus-triels Moderns held in Paris in 1925. It is from this exhibit that the style derived its name. Architecture, industrial design, graphic arts, and fashion design of the 1920s frequently reflect the art deco aesthetic. The United States saw a rise in its popularity during the 1930s and into the 1940s.

The Bauhaus, a modernist art school based in Germany, lasted from 1919 to 1933. Architect Walter Gropius founded the school to teach architecture, arts, crafts, theater, typography, weaving, and other applied arts. His intention was to create functional, classic architecture that could be easily produced by machine. Professors included Paul Klee and Wassily Kandinsky, who would become more well known as artists in the 1930s. Architect and designer Ludwig Mies van der Rohe, who had been the head of the Deutscher Werkbund in the 1920s, was director of the Bau-haus from 1930 until it succumbed to political pressure from the Nazis and closed in 1933.

Art and fashion frequently mingled during the 1920s, often with the artist choosing to branch out into fashion. Cubist painter Sonia Delaunay was one such individual, as were many of the Russian Constructivists, such as Varvara Stepanova. (Cole and Gealt 1989).

Fashion photography also came into its own during this period, having largely replaced illustration in fashion magazines by 1925. The photo-graphs of Baron de Meyer, Edward Steichen, Man Ray, Cecil Beaton, and George Hoyningen-Huene were most often used in the pages of *Vogue* and *Harper's Bazaar* to use avant-garde styles to display the fashions of the day (Mendes and De La Haye 1999).

MUSIC AND LITERATURE

Although the 1920s is most often recognized as the Jazz Era, classical music retained an avid following as well. Modernism extended into the musical world, and Claude Debussy was regarded as "ultra-modern." Another "modernist" composer who came to the fore in the twenties was Igor Stravinsky, who took much inspiration from Bach. The French musician Erik Satie had become a major force in the classical world by 1922. Another innovative French group of the twenties was Les Six and consisted of Louis Durey, Germaine Tailleferre, Francis Poulenc, Arthur Honneger, Darius Milhaud, and Geroges Auric. They worked with Jean Cocteau to develop their unique sound.

Popular music of the twenties was dominated by jazz, at first limited to the African-American community and slowly branching out to the world at large. Although jazz is generally considered to be a U.S.

stars could be seen rolling bandages or doing some form of activity to encourage Americans to work toward the war effort. Many actors and musicians took to the road, volunteering their time and talent to raise money for the Red Cross.

THE
1920s

ART MOVEMENTS

A number of art movements and artists continued from the previous decade through the 1920s and beyond. Both Dadaism and cubism were movements of the previous decade, begun in response to WWI. They directly influenced the surrealist movement that began in the 1920s.

The Wiener Werkstatte, an Arts and Crafts workshop in Vienna, was established in the early 1900s around the notion of the "Gesamtkunstwerk," a total work of art that integrates "all of the various design elements in a single aesthetic environment" (Kallie 1986). The craftspeople and artists who contributed to the work created fabrics, clothing, ceramics, jewelry, and furniture. Gustav Klimt, Josef Hoffmann, and Dagobert Peche were all members of the group. In 1921, the Wiener Werstatte opened a branch in New York, although it faced difficulties by the 1920s and had disbanded by the early 1930s.

DeStijl (meaning "the style") was a collective founded by Dutch artist Theo van Doesburg in 1917. Lasting through the twenties, this movement was also often referred to as Neo-Plasticism and incorporated the strict use of geometric shapes in architecture, painting, and sculpture. The most well-known DeStijl artist was painter Piet Mondrian. In the 1920s, Mondrian continued to develop his distinct geometric style.

The most well-known painters of this era were generally moving from one style toward a new idiom. Henri Matisse, who had experimented with cubism early on, continued to explore a modernist style. Cubism originator Pablo Picasso began to move towards surrealism during the 1920s, although his interest in a variety of interrelated styles makes him difficult to pin down (Cole and Gealt 1989). Georgia O'Keefe, who worked with photographer Alfred Stieglitz, developed a style that focused on female sexuality during this era.

Many of the art movements to come out of the 1920s were based on grand exhibitions that encompassed a variety of disciplines. Art deco is one of the major styles to come out of the 1920s. A kind of geometric

The Silent Screen Star. In the 1910s, silent movies became a national obsession, and film actors and actresses such as Theda Bara, Rudolph Valentino, and, in 1920, Clara Bow, became stars. Studios worked to promote their new stars by blurring the lines between the character and actor. The movie studio transformed the actress Theodosia Goodman, the daughter of a Cincinnati tailor, into the exotic Theda Bara, the daughter of a French artist and his Arabian mistress.

Studios fueled the fixation on their stars by creating fan materials, including lobby cards, trade photos, and even Dixie cup tops. Fan magazines became popular among movie goers. Two magazines, *Motion Picture Story* and *Photoplay,* were founded in 1911. Fan magazines were filled with plot synopses, star biographies, letters to the editor, and popularity contests. Many times, the content of these magazines were filled with stories manufactured by studios. Even newspapers included tidbits about the upcoming roles of popular actors and actresses.

During the 1910s, movies were often called photo plays, and individual writers were called on to write 100–150 stories a year. Usually, they created stories "made to order" to promote a certain actor or actress, but sometimes they had to incorporate a specific locale or an animal the studio had purchased (*New York Times*, August 3, 1913). The obsession with movies and stars may have launched in the 1910s, but it would grow to new heights in the following decades.

Actress Clara Bow in a sultry pose. [Library of Congress]

material in skirts. She adopted a simpler style of dress, and women everywhere began to follow her lead. Russell was also willing to tell people what she thought of just about anything, and many people would copy her style, hoping to be like her.

One of the reasons for the popularity of the early movies was one of its limitations: the movies had no sound. By today's standards, that would be a problem. When many large cities had a large immigrant population, the action on the screen could be followed by anyone regardless of his or her native language. A Russian could be seated next to a Chinese immigrant and both of them could understand the movie equally well. The movies were one of the most popular forms of entertainment for the poor who could not afford anything else. This egalitarianism was not deliberate, but it did encourage the growth of this form of entertainment.

This popularity created a new industry. Hollywood learned quickly that sex sells, and it produced many movies that incited conservative groups. Many of these movies featured enticing temptresses like Theda Bara rather than "good girls" like Mary Pickford.

Interestingly, Thomas Edison claimed that the movie studios had to pay him a royalty for using the cameras he invented. The studios found an easy way to dodge this expense. If a producer or movie studio was afraid of going over budget for a film, the film crew would leave and finish the film in Mexico, only about one hundred miles away, to avoid paying the royalty.

During the 1910s, musical theater was a popular form of entertainment. As movies got longer and longer, musical theater productions were adapted for film. Florenz Ziegfeld created a group called the "Follies Girls," which was made up of young women who would dance to some of the popular music. Although the Follies Girls debuted on Broadway, it made a very successful transition to film. What astounded many was the dress, or lack of it, of the young women. They were a hit and would remain so for many years. Many young women would dream of becoming a Follies Girl. Some of them wanted to be seen because many of the early ones married millionaires, but Follies Girls were also well paid. In a decade when the average annual salary was $750, a Follies Girl could earn $75 a week (Mizejewski 1999).

After the United States declared war in 1917, the young movie industry and the thriving theaters put their talent and energy into the war effort. Many productions were blatantly patriotic and served as propaganda. One production was named *The Barbarous Hun* and was meant to portray the Germans poorly. Other movies were used to get people involved in some form of help for the soldiers. At some point, just about all popular actors and actresses were selling Liberty Bonds. Many could sell thousands of dollars of bonds during one performance of a play. Other

became at least as popular as his first song. The blues quickly became part of American music.

The blues, a bit of ragtime, and other components of African-American music, combined with a touch of the classical music of Europe and the United States, would ultimately lead to the creation of jazz. Depending on one's definition of jazz, the style began in the early 1900s or developed in the 1920s. The seeds, however, of what would become a distinctive musical style were mostly collected in the early years of the twentieth century.

THEATER AND MOVIES

The second decade of the new millennium also brought with it a wondrous form of entertainment: the movie theater. The first movies, starting in about 1902, were essentially short films of a variety of topics, but they were rapidly developing. The first feature-length motion picture was *Queen Elizabeth*, in 1912, staring Sarah Bernhardt. Some movies were serialized, as in *The Perils of Pauline*, or comedies with such stars as Charlie Chaplin.

Mary Pickford became famous in 1901 and was one of the first movie stars. Called "America's Sweetheart," she seemed to be the kind of young woman everyone wanted young women to be. Her popularity grew along with the popularity of movies. Originally a minor actress on Broadway, she earned $25 a week until about 1910. That year, she was lured to Hollywood for the unheard-of salary of $175 per week. By 1915, her salary had been raised from $1,000 to $2,000 per week plus 50 percent of the profits (Lowrey 1920, 157), all without saying a word for the camera.

In 1914, William Fox cast an actress named Theda Bara in a movie about a woman with an uninhibited (for the time) sexual appetite. Bara's character led to the coining of the term "vamp." She had used the term to discuss a character in a vampire movie, but the term stuck to her. It came to mean a woman who had a mind of her own, actually enjoyed men and sex, and would do as she pleased.

Almost overnight movies became popular, and the actors and actresses in these productions became household names. The concept of a movie star quickly emerged from this new medium. Actresses became very influential in transforming fashion and attitudes. Women wanted to copy the dress, hair style, and opinions of their favorite star.

Some stars, such as Lillian Russell, helped to change lifestyles in a slightly different way. She loved the freedom a bicycle gave her. She did not like the restrictions found in fancy clothes, corsets, and yards of

works by any American artist, although few people recognize it by the painting's proper name. Most people recognize the painting as *Whistler's Mother*.

The 1910s represented a fertile period of new technologies in photography. In 1912, a process was developed that would allow color pictures to be developed. This led to what Kodak called "Kodachrome" and further revolutionized photography. Photography also contributed to the motion picture industry when it developed a way of making moving pictures.

LITERATURE AND MUSIC

The censoring of literature that emerged in the 1900s continued in the 1910s. Authors such as F. Scott Fitzgerald were eager to create stories that the youths of America wanted to read, but they had to worry about censorship. This made creativity and innovation difficult. Many magazine articles, books, nickelodeons, films, and even newspapers were subject to censorship. What was permissible was different from community to community, which made it hard for authors to appeal to a wide audience. Increased availability of transportation and a more reliable mail system allowed a variety of materials to be seen by anyone who wanted to see them. A person might have to travel to another city or county to do it, but they were available. Because the automobile was becoming increasingly popular, it was not difficult for anyone who really wanted to find a censored book to do so. Many popular authors of the time were Edith Wharton, Willa Cather, Jack London, Zane Grey, T. S. Eliot (who wrote *The Love Song of J. Alfred Prufrock* in 1915), Robert Frost, Carl Sandburg, and Edna St. Vincent Millay.

Music, especially in New York City, started to cross cultures. Up to this point, most music stayed within the culture in which it was written. With the popularity of music produced in Tin Pan Alley and the spread of the phonograph, ethnic music became American music. Irish songs such as "My Wild Irish Rose" (1899), "When Irish Eyes Are Smiling" (1912), and "Danny Boy" (1913) became popular throughout the country. Irish music was not the only popular ethnic music.

African-American music entered the mainstream with the publication of the blues song "Memphis Blues" in 1912. The song was originally written to attract attention to a local election in Memphis, Tennessee. The sheet music for the song sold out in three days, but the store told the composer, William Christopher Handy, that the song was a failure. He sold the rights to the song for $50 (Handy 1991, 108). When he discovered that he had been swindled, Handy wrote several other songs that

Because towns and cities acquired electricity, penny arcades proliferated and presented nickelodeons. For pocket change, people could view a variety of topics, depending on what was allowed in their communities. Topics could range from pictures of boats to flowers to girls climbing apple trees. They were usually short pieces of entertainment, but there were many of them and they were different from anything anyone had seen.

Before WWI, Broadway theaters developed three types of productions: light comedy, operettas, and vaudeville. Some of the operettas, such as *Babes in Toyland*, *Naughty Marietta*, *The Merry Widow*, and *The Wizard of Oz*, later found themselves in new incarnations as Hollywood movies. Victor Herbert, a classically trained musician, was so pleased with the success of *Babes in Toyland* in 1903 that he produced some form of the production almost every year after that until he died in 1924.

THE
1910s

ART MOVEMENTS

Cubism was a style that was increasingly noticed after 1910. Many of the cubists, including Pablo Picasso, Georges Braque, and Juan Gris, were European, but increasing numbers of Americans adopted the style because they felt that something needed to replace the idealized, representative art of the past century. Cubism involved deconstructing the objects in an image, flattening them into two-dimensional, geometric parts, analyzing them, and reassembling them at randomly intersecting angles. The style was ridiculed in print and cartoonists enjoyed making fun of the style, but it continued to grow despite the antagonism of the press and many art critics.

Realistic forms of painting were as popular as abstract ones. In 1916, an editor of *The Saturday Evening Post* met a young man who wanted to paint a cover for the magazine. The editor was positively impressed and Norman Rockwell painted the first of many *Post* covers, and a beloved American trademark was born.

Another popular artist who did not follow the trend of abstraction was James McNeil Whistler. He was an American artist who lived most of his life in Europe, usually London or Paris. His work was realistic, but he preferred using gray and black in his paintings to demonstrate the interplay of light and dark, as well as form. His *Arrangement in Grey and Black* is probably his most famous work, possibly one of the most famous

movements were seen as suggestive. Many people thought the new music would give youths "ideas" that they would not have otherwise. Many tried to ban dance halls and the music played in them, but the music was too popular. Adults who were working in or outside the home could not follow their children everywhere.

Even if people did not go to dance halls, many people wanted to play the music. Sheet music was popular and easy to obtain. Sheet music had been a popular medium for spreading music across the population. Then came the phonograph. In New York City, an area referred to as "Tin Pan Alley" started producing phonograph records that would allow anyone who did not play an instrument to play music at home. In the next several years, the phonograph led to the decline of the popularity of sheet music.

THEATER AND MOVIES

People in urban areas were able to easily visit live theater. People in the rural areas might be able to put on some shows of their own for a special occasion, such as the Fourth of July, but many people looked forward to traveling shows, such as the circus or a traveling theater troupe. Some of the actors from large metropolitan areas such as New York would travel to smaller urban areas and give live performances. Very rural areas or areas that had some reason to limit entertainment, such as very mountainous regions, rarely had such opportunities. Many acts were Shakespearean plays or varieties that were popular in a particular region of the county.

American theater is closely connected to Broadway, in New York City. Madison Square Theater had been built in 1887, but new theaters were being built after 1900. It was in these theaters that George M. Cohan, Jerome Kern, George Bernard Shaw, and Henrik Ibsen presented their plays to the American public. Some, such as Ibsen's *Camille* and *Doll House*, had to be modified so that they could pass the censors, but audiences loved them. Americans also became enamored with an odd tale of crocodiles and alarm clocks and boys who never grew up when *Peter Pan* first appeared in 1905.

In 1901, Sarah Bernhardt, the famous French actress, appeared in *Hamlet*, playing the title role. Perhaps because the play was in French, it was not liked by American audiences. As a result of the poor reception from Americans, Bernhardt said she would not return to America, but the popular star could not stay away from the lucrative American theater and returned to the United States in 1906. Other young actors learned their craft on the Broadway stage. Many, such as the Barrymore family and Helen Hayes, would later become big stars in motion pictures.

Literature was changing in others ways as well. Because the population was more urbanized, stories were focusing on people and the new experiences that the city provided. Many heroines would experiment with single life and a variety of jobs and men. Women in literature were becoming less inhibited, and many people did not like it. A variety of attempts were made to censor some of the new literature; many communities developed some sort of "anti-vice" committee in an attempt to ensure that youths were not led astray. The attempts to destroy material deemed improper only made it more popular.

Newspapers and magazines, although not exactly "literature," became a popular form of storytelling. Generally, newspapers told the news. Then Ida M. Tarbell and Lincoln Steffens wrote what might be called "exposés." Ida Tarbell documented John D. Rockefeller and his Standard Oil Company. Steffens started writing about the poverty and the problems of city living. Originally, these were intended to be simply stories, but the public reaction was overwhelming. Editors learned that people would pay to buy anything with a scandalous or sensational story to it. Editors started hiring people to write more such stories, called "muckraking" by President Roosevelt, simply to boost circulation.

One such "muckraking" story was *The Jungle*, written in 1906 by Upton Sinclair. The story discussed some of the "evils" of the industrialized cities. Its hero wanted to destroy the capitalist system, so most editors would not publish it. Sinclair found a socialist newspaper, *The Appeal to Reason*, that ran the story, and Sinclair's novel became popular. When it was published in book form, even President Roosevelt was supposed to have a copy. The book, along with some of the other newspaper and magazine stories, started changing people's minds about living conditions in the cities. Some believe the book's popularity caused Congress to pass laws that would prohibit some of the excesses of the greedier industrialists. This kind of legislation would have been unthinkable even ten years earlier.

Books were not the only commodity that people considered censoring. Music was becoming "evil." Perhaps not the music itself, but the fact that much music encouraged young people to dance and the way they danced was horrifying to many adults. Some of the popular tunes during the period 1900–1909 were "In the Good Old Summertime" and "Give My Regards to Broadway." Rags, such as "Alexander's Ragtime Band" by Irving Berlin, became popular. Other dances, such as the tango, became very popular in dance halls before WWI.

One of the greatest sins of the music was that it made people move; they might wiggle and then move other parts of their bodies, and the

Girls too had their stories. Many of them were presented as melodramas on a local stage. Frequently, a young girl would be engaged in some kind of dispute with a very wealthy woman. The wealthy women were often portrayed as thoughtless and frequently unscrupulous. The wealthy woman would be doing everything she could to maintain the wealth of her family and to continue living a life of what many called "conspicuous consumption." The poor young girl might be nothing in the rich woman's eye, but the plot to the story was obviously meant to demonstrate that the poor girl was a better person than the rich one. As in Horatio Alger's stories, the poor young girl would be rewarded for her virtue by the end of the story, much like the ending of the *Cinderella* story. What was rarely discussed, however, was whether or not the young girl married her rich husband and then became a conspicuous member of the idle rich.

Much of the popular literature reflected the ideals of the times. Some of the best known novels of the late 1800s, stories such as Tolstoy's *Anna Karenina* or Thomas Hardy's *Tess of the d'Urbervilles*, reflected stories of women who, for a variety of reasons, left their husbands for another man. These fictional women might have some weeks or months of happiness, but, invariably, they met disaster. The idea was clear: a woman's place was with her husband and children.

People who did not live a "proper life" were also the subject of the many pamphlets and stories that reformers made popular. As the world started changing, many groups banded together to do something about that change. Women who joined the Women's Christian Temperance Union advocated stories that would demonstrate how someone could start out on the "right path," become confused and misguided by "demon rum" or another form of alcohol, and then learn that following the footsteps of one's forebears was the path to happiness. Many stories were also written in which the hero or heroine would be tempted but never gave into the temptations. Many such stories were aimed at young people. Edgar Rice Burroughs' stories about Tarzan preached the virtues of ignoring the fancy trappings of the city life and living a simple life.

One subtle shift, however, was taking place in literature. At the beginning of the nineteenth century, stories ended with the marriage. The main characters had met, overcome their obstacles, and "lived happily ever after" in conjugal bliss. By the beginning of the nineteenth century, however, stories began with the marriage and then discussed issues related to family life. Although the idea that a woman could leave her husband was not a totally acceptable behavior, the literature was beginning to reflect the reality that married life was not the "happily ever after" that everyone wanted marriage to be.

The century also saw the rudimentary beginnings of mass photography. The first Kodak camera had been introduced in 1888, and professional and talented amateur photographers had been taking portraits and pictures of scenery for years. Frank Brownell developed a small camera called the "Brownie" for George Eastman in 1900. This camera cost $1 and was inexpensive enough that most Americans could buy one, making photography, for the first time, something that anyone could do (Chakravorti 2003).

The Brownie, by the way, was not named after its developer. George Eastman was aware that children read books about elves and children, and there was a character called "Brownie" that was popular at that time. Eastman thought that, if the camera had a name that children would like, it might catch on, and he was correct.

Architects were able to take advantage of some of the era's new technology to "solve" some of the big problems of the cities. People kept flocking to the cities in hopes of finding work or in hopes of finding a better life. They needed someplace to live and work. The skyscraper was born to house offices, but it also could be used to house people. The new technique of creating steel beams that were strong and light would allow buildings to be built higher than anyone could have dreamed.

The motto "form follows function" became a trademark of early American architects such as Frank Lloyd Wright and Louis Sullivan. Neither man saw a point to the useless details and ornamentation on many older buildings. Sullivan's work stressed the function and the structure of the building itself. Wright considered Sullivan a master in the field, but Wright was able to construct buildings that looked as if they were grown from the area around them. Both men would have major impacts on American architecture in later decades.

LITERATURE AND MUSIC

Horatio Alger, a poor writer who found a successful formula, was a popular author for boys' novels at the turn of the century. The plots of the stories all concerned young boys who had origins in poverty. The boys leave their family to seek fortunes elsewhere. These children did not earn their fortunes, but they were unfailingly polite and good role models for any young boy. They became wealthy simply because they would do something quickly and save someone or something, and then they would be rewarded for their bravery and quick thinking. Alger wanted to demonstrate to his readers that somehow, their virtuous behavior would be rewarded. In the world that Alger created in his books, boys who did not follow the rules tended to be evil or have troubles their entire lives.

A Gibson girl in shirtwaist and picture hat, c. 1910. [Library of Congress]

Gibson's vision indicated a young woman who was sturdy, self-reliant, and knew what she wanted. Although not openly advocating any political or social causes, the Gibson girl would engage in sports, ride a bicycle without a chaperone, and might, on occasion, engage in some mild form of strenuous activity. She did not faint, nor did she change her behavior to appeal to men. Women tried to model themselves after Gibson's ideal, and men wanted to marry them.

Not all art was intent at presenting life in a positive, romantic manner. Perhaps because 1900 was seen as the beginning of a new millennium and the United States was growing past its isolationist stages and branching out into world politics, but in the 1900s, American artists started reconsidering what "art" was. Many of the young artists at the time saw little point in producing the fantasized illustrations of life that had been painted for centuries. They wanted to bring more realism to their work, hence the concept of "realism."

Part of the new trend was a result of finally having artists who were trained in the United States. During the nineteenth century, most artists went to Europe to learn the styles of the European masters. After the Civil War, many families could not afford to send children to Europe. The economic depressions and the horrors of the war impressed the artistic youth of this country. They began to see what really existed. By the end of the nineteenth century, artists were painting scenes of their area of the country. Homer Winslow, from New England, painted dramatic ocean scenes. Frederick Remington put the lives of common cowboys, horses, and cattle on canvas. The younger artists were starting to challenge the way art had been done for decades, if not centuries.

One of the first art movements in New York to challenge the status quo was a group of artists referred to as the Ash Can school. They painted scenes of life as it really existed on the streets of New York. Major museums and art critics deplored this art, but the artists insisted that it was real and that art should reflect life as it was, not as the artist wanted it to be. For the first year or two, no one was willing to allow such artists to display their work, so the artists joined forces and created their own studios and galleries that would display the more realistic scenes of life.

most popular programs. FDR reached out to Americans via the radio in his fireside chats.

Despite the economic hardships of the decade, movies continued to be a popular attraction. American audiences visited the movie theater as often as they could, often weekly. The demand and interest in stars kept the movie studios' publicity machines going. The United States Motion Picture Production Code was enacted during this decade and imposed tight moral restrictions on movie studios.

In the 1940s, artists embraced Modernism, and some, such as Jackson Pollack, used Abstract Expressionism. The arts became more introspective and focused on the individual, whether it was created by a visual artist, musician, or writer.

During WWII, big band music remained popular, and it served as a reminder of home to the troops abroad. Increasingly, vocalists were featured in compositions and became popular in their own right. After the war, Bebop and Cool Jazz emerged as new musical styles.

Radio matured and nearly every American household owned a set. By the end of the decade, the new medium of television had taken hold. After the war, Americans could afford to purchase these new entertainment luxuries. As more sets were purchased, programming increased.

Movies were in their golden age during the 1940s. Movie stars generated huge public interest, and high-caliber movies were being produced every year. Musicals became extremely popular, and the most bankable stars could sing, dance, and act. In addition, Hollywood generated numerous comedy shorts, serials, and animation shorts. At the beginning of the century, no one could anticipate the interest that movies would generate by the 1940s.

THE
1900s

ART MOVEMENTS

One of the most famous artists of this period was Charles Dana Gibson. Arguably, his most famous creation was "the Gibson girl," a young girl with her hair in curls, shirtwaist blouses, and simple skirts. She became a model for many young women in the first two decades of the twentieth century. The Gibson girl was an illustration of the ideal American woman, admired by working women as well as her wealthier sisters. She was not obviously a suffragette, nor a temperance advocate slinging an axe in a saloon.

entertainment spot. Theater was a widespread pastime in urban areas, whereas traveling and regional groups frequented rural areas. Vaudeville, operettas, and comedies were popular genres.

In the 1910s, realism was still a widely used artistic style, but cubism emerged on the scene. Its two-dimensional geometric compositions were a strong contrast to other styles. Photographic technology made additional advances, allowing advances in motion pictures. The first full-length picture was released during this decade, and the concept of the "movie star" was created.

The audiences for art widened over the decade. Musical theater drew large audiences, and literature became more widely available. In the case of literature, the wide dissemination drew criticism of literary subject matter and a call for censorship. Ethnic music, although it had existed before, saw a wider distribution than in previous decades.

The 1920s were fertile with artistic movements, including art deco, Bauhaus, cubism, Dadaism, and surrealism. These movements permeated nearly all art forms from paintings and sculpture to architecture and literature. By the end of the decade, this generation of artists had thoroughly broken with the past.

The Jazz Era began during the 1920s by starting in small clubs. By the end of the decade, the style had been incorporated into big bands and was on its way into mainstream popularity in the 1930s. Energetic dancing to this fast-tempo music dominated dance halls.

Motion pictures made their leap to "talkies." Although some actors saw their careers vanish because their voices did not fit their portrayals, the new technology set the stage for the popularity of musicals in subsequent decades. Stars existed in every genre, and movie studios generated enormous publicity campaigns to keep their stars in the limelight.

During the 1920s, radio had emerged from its infancy. More and more households acquired a radio, not just for newscasts but for concerts, comedy and drama programming, and the incredibly popular sporting events.

Art deco and surrealism continued to remain popular in the 1930s. Art deco especially fit in with the minimalism brought on by the Great Depression. The Depression also renewed the artistic interest in rural America and regionalism. The United States witnessed an influx of European artists who fled as Adolph Hitler's aggressions intensified.

By the mid 1930s, big band music was mainstream and requisite in dance halls. Technological innovations in music recording and radios helped publicize new music styles and new artists. By the end of the decade, radio programming became stable, and advertisers were a staple in

3

Art and Entertainment

In the first decade of the 1900s, art and entertainment had more in common with the previous century that it did with the next decades. Technological advances had a profound effect on the first half of the twentieth century. Not only did it shape the media being used, but it shaped the artists as well.

The artists working in the first decade used a realistic style and subject matter. They glorified American landscapes whether they were mountains, plains, or shining seas. They also used gritty urban life as subject matter and were subsequently scolded by critics who dubbed these compositions as "Ash Can" art.

Refinements in photographic technology allowed ordinary people to own and easily operate a camera. Americans captured their lives and the landscapes and people around them. Documentary photographers became more prevalent and captured images of the less-glamorous side of American life.

Literature in the 1900s often included a moral message or a reflection of societal values. Horatio Alger stories were a popular example of this type of literature. The hero would begin the story in a desperate position, but through his hard work and good values, he would achieve success. Reformers also used literature to disseminate their messages.

Popular music in the first decade of the century was a break from the past. Ragtime music emerged, and dance halls became a favorite

Murrin, J. M., Johnson, P. E., McPherson, J. M., Gerstle, G., Rosenberg, E. S., and Rosenberg, N. 2004. *Liberty, Equality, Power: A History of the American People*, Vol. 2 since 1863. Belmont, CA: Thomson.

Perrett, G. 1982. *America in the Twenties, A History.* New York: Simon and Schuster.

Reeves, T. C. 2000. *Twentieth Century America: A Brief History.* Oxford: Oxford University Press.

Zinn, H. 1995. *A People's History of the United States.* New York: Harpers Perennial.

in the Marine Corps. The men worked together and depended on each other (Paul 1973).

The concept of racial purity espoused by the Nazis disturbed many Americans. Congress passed the Alien Registration Act of 1940, which encouraged noncitizens to become citizens. The initiative was a success, with almost 1 million people acquiring citizenship between 1943 and 1944. The country's ideal was to merge the ethnicities into a single American society, but nonwhites were not welcomed into this ideal.

Although Mexican Americans were encouraged to serve in the military during the war, they tended to be given menial positions. In 1943, racial tensions flared when a group of white soldiers heard a false report that a Mexican American had beaten a white sailor. The ensuing violence was named the Zoot Suit Riots, after the distinctive suits worn by young Mexican Americans and African Americans. When there was a labor shortage for field workers in 1942, the U.S. government allowed thousands of Mexican immigrants to cross the border to work on farms in the southwest.

Regardless of ethnicity, anyone who served in the armed forces could take advantage of the G.I. Bill. The bill provided money for education, and 8 million veterans took advantage of the bill and went to school rather than return directly to work. Education and professional status were now available to all ethnicities and income levels, but many schools had admissions policies that discriminated against women and blacks.

REFERENCES

Abbott, B. 1973. *Changing New York: New York in the Thirties.* New York: Dover.

Andrist, R. K., ed. 1970. *The American Heritage History of the 20s & 30s.* New York: American Heritage Publishing Co., Inc.

Baker, P. 1992. *Fashions of a Decade: The 1940s.* New York: Facts on File.

Barlow, A. L. 2003. *Between Fear and Hope: Globalization and Race in the United States.* Lanham, MD: Rowman and Littlefield.

Berkin, C., Miller, C. L., Cherny, R. W., and Gormly, J. L. 1995. *Making America: A History of the United States.* Boston: Houghton Mifflin.

Gordon, L., and Gordon, A. 1987. *American Chronicle.* Kingsport, TN: Kingsport Press, Inc.

Kurian, G. T. 1994. *Datapedia of the United States, 1790–2000.* Lanham, MD: Bernan Press.

Matanle, I. 1994. *History of WWII, 1939–1945.* Little Rock, AR: Tiger Books International.

McKay, J. P. 1999. *A History of Western Society.* New York: Hougton Mifflin.

Nearly four years after WWII many European countries, the United States, and Canada were still fearful of attacks from other countries. In April 1949, they created a military alliance called the North Atlantic Treaty Organization (NATO). The member countries agreed to come to the defense of any other member country that was being attacked by an outside country.

ETHNICITY IN AMERICA

Jim Crow laws, a set of state and local laws in the American South, allowed "separate, but equal" treatment and accommodation for African Americans and whites. "Separate, but equal" meant that African Americans and whites had separate schools, public bathrooms, and entrances to buildings. Invariably, the accommodations for African Americans were inferior to those of whites. After WWII, the Civil Rights Movement to eliminate these laws began to gain momentum. The U.S. Supreme Court began to rule some of these laws as unconstitutional. For example, the courts deemed segregation in interstate transportation was unconstitutional in 1946 in *Irene Morgan v. Virginia*.

The sacrifice of African Americans during WWII brought renewed scrutiny to their treatment. Section 4(a) of the 1940 Selective Service Act clearly banned discrimination based on race or color. Even though the U.S. military was fighting against a racist dictator, Hitler, President Roosevelt refused to integrate the armed forces, believing it would undermine military discipline and morale during a time of national crisis. During the war, the Marine Corps excluded African Americans, the Navy used them as servants, and the Army created separate regiments for them. In 1948, President Truman abolished racial segregation in the U.S. armed forces.

African-American women fared better than their male counterparts in the military. The Federal Nurses Training Bill prohibited racial bias in selection of candidates for nurses training, which allowed thousands of African-American women to enroll in the Cadet Nurse Corps. Many of them reached officer ranks, and the remarkable contributions of the more than 59,000 women in the army nurse corps helped to keep the mortality rate among American military forces very low (Willever-Farr and Parascandola, n.d.).

Native Americans played a unique role during WWII: they became the secret weapon that assisted the Marines in taking key Pacific holdings from the Japanese. Their secret was the Navajo language; its complexity made it the perfect unbreakable code. Race friction was not commonplace

destroyed many of Europe's cities, and both civilian and military casualties had mounted. In April 1945, after the Soviets invaded Germany, Adolph Hitler committed suicide in his bunker. Grand Admiral Karl Dönitz became the new leader of Germany, but German resolve evaporated with the loss of Hitler. The German forces in Berlin, Italy, northern Germany, Denmark, The Netherlands, and France surrendered in May 1945.

Although the Germans had given up the fight, the Japanese continued their attacks. In August 1945, Harry Truman, who assumed the presidency after FDR's death in April, ordered a decisive attack on the Japanese to try to bring about a swift end to the war. U.S. bombers dropped nuclear bombs on Hiroshima and Nagasaki in Japan, which devastated the cities and killed or injured 225,000 people. (Lenman 1995, pp. 420, 650). In addition, tens of thousands suffered and later died from the radiation. The Japanese surrendered six days later.

The closing year of the war also set the stage for the Cold War that would dominate world relations for the next few decades. British Prime Minister Winston Churchill, U.S. President Franklin Roosevelt, and Soviet Premier Joseph Stalin met in Yalta in February 1945. During the conference they agreed to give Stalin control of Eastern Europe, but he did not allow free elections in his newly acquired land. As a result, Americans and the British grew hostile toward Russia, and hostility grew into the Cold War.

European economies were devastated as a result of WWII, so the leading allied countries considered various plans to restore order to international monetary relations. Twenty-nine countries created the International Money Fund (IMF) in December 1945. The institution was designed to oversee the international monetary system, promote the elimination of exchange restrictions relating to trade in goods and services, and support the stability of exchange rates. It approved its first loan on May 9, 1947, of $250 million to France for postwar reconstruction. (Yeager 1976).

The Nuremburg Trials, which were conducted from 1945 to 1949, attempted to serve justice in the crimes that Nazis inflicted on Jews, Catholics, homosexuals, and others they deemed as "undesirable." The media coverage of the trials brought the unspeakable crimes into public consciousness. Americans responded to the atrocities with a shift toward conservatism and patriotism.

Postwar U.S. foreign policy marked a distinct break from the isolationism that characterized the country before the war. U.S. President Harry Truman described the new strategy as the Truman Doctrine in a speech on March 12, 1947. He defined it by casting the United States as the "world's policeman."

Residential construction had virtually ceased during the Depression and war years of the 1930s and early 1940s. After the war, new housing became a critical need, because the marriage rate began to rise along with the birth rate of babies, resulting in the "baby boom." These parents wanted a yard and plenty of room for their growing families. In response to these wants, a few developers pioneered the concept of suburban subdivisions. Accessible by cars provided by the growing automobile industry, suburban living became part of the "American dream."

The American dream was a description of the popular ideal of American living. In addition to a suburban house, a shiny car, and a happy nuclear family, the ideal espoused a host of modern conveniences. Everything from dishwashers to barbeque grills were marketed to increasingly materialistic Americans. Production of consumer products including innovations from the war efforts now began to show up in stores and advertised on the new medium of television.

During the late 1940s, the U.S. economic environment had shifted from the deprivation of WWII to the prosperity and consumerism of the 1950s. Many families found it possible to buy a home in the suburbs, a car, a refrigerator, a washing machine, and to have children and to give them everything their parents had been deprived of for so long. Although many young women temporarily left the work force to begin families, overall, married women's labor force participation continued to rise after the war and has been rising ever since.

INTERNATIONAL DEVELOPMENTS

Although Europe had been embroiled in WWII since 1939, the United States had remained neutral in the conflict through the early years of the conflict. By summer 1941 Poland, China, France, Denmark, Norway, Great Britain, and the Soviet Union had all become victims of German, Italian, and Japanese aggression. As the War escalated, the United States found it more difficult to remain neutral as other nations were devastated. FDR worked with the U.S. Congress to revise the neutrality act to allow the United States to sell millions of tons of war material to Britain under the Lend-Lease Act of 1941.

By December 1941, the United States was provoked into the war when the Japanese attacked Pearl Harbor, a U.S naval base. Germany declared war on the United States three days later. The U.S. entry into the war transformed it into a truly global conflict.

By 1945, the war that had dominated the political, social, and economic worlds for the better part of five years began its close. The war had

Advertising during WWII. During WWII, the Office of War Information created the most extensive advertising campaign in history. The foci of the campaign were internal security, rationing, war bond sales, precautions against venereal disease, and calls out to women to join the wartime workforce. The Office of War Information established the War Advertising Council in 1942 to carry out the advertising campaign, and they worked with private advertising agencies that donated nearly all of the copy and artwork.

One of the council's most famous campaigns, Rosie the Riveter, came out of the J. Walter Thompson Agency. Initially, the campaign starred Rose Will Monroe, a riveter at the Willow Run Aircraft Factory in Michigan. She appeared in a promotional film about the war effort. Soon thereafter, she inspired a song, and J. Howard Miller created the iconic image of a female riveter with her bared bicep under the slogan, "We can do it!" Although she was not labeled as "Rosie" at the time, the fictional character later became synonymous with the image. In 1943, Norman Rockwell's depiction of "Rosie" appeared on the cover of *The Saturday Evening Post*. Rosie the Riveter became a cultural icon and increased the number of women working in factories. She also broadened the acceptability of manual jobs for women.

Norman Rockwell cover illustration for *The Saturday Evening Post* showing "Rosie the Riveter" taking a lunch break. [Library of Congress]

Advertising for consumer goods also focused on the war effort. Companies emphasized their contribution to the war effort and positioned their products in ways that contributed to it. For example, Brer Rabbit molasses provided recipes that conserved sugar, and Stetson hats reminded consumers to carefully guard information and "Keep it under your Stetson." Advertisers touted themes such as patriotism, conservation, and teamwork.

to alleviate its labor shortages by employing women and African Americans, agriculture still felt the effects of the shortage. In some areas, schools were closed to allow children time to help with the harvest.

Generally, women were proud to do their part to support the war effort and were encouraged to join the workforce by Rosie the Riveter posters. Traditional barriers clearly defining "men's work" and "women's work" quickly dissolved as women became crucial to America's production efforts. Although wage disparity continued, women enjoyed the greater opportunities that war work provided (Baker 1992).

The upturn in the economy exploded during the postwar period. As price controls and restrictions were lifted, prices began to climb. The rising prices forced many women to continue work to help buy things their families needed, but working women faced criticism. Most Americans were afraid women were taking jobs away from returning veterans. Women were expected to go back home and tend to their families so that the men could return to their rightful place as head of the household. It was a difficult transition for both men and women. Some women who had grown accustomed to their new-found independence did not appreciate being forced back into a solely domestic role.

Employers were gearing up with new technology and an expanding economy, and many returning veterans did not have the experience to compete for the emerging jobs. The greatest injustice was to soldiers who had been injured. Many employers did not want to be slowed down by an employee who they believed would not be productive enough as a result of a war injury.

Personal savings increased dramatically during the war because of higher employment rates and a scarcity of products. As the workforce returned from serving the military, companies were able to increase their production levels. Released from the burdens of manufacturing for the war effort, American industry focused on producing more consumer goods than ever. Technological innovations led to new products, and exposure to mass media, specifically television in the home, shaped the public's desire for modern conveniences. New installment-plan financing made consumer items more easily available because families could now enjoy a new product before completing the payments.

The Serviceman's Readjustment Act of 1944, also known as the G.I. Bill of Rights, provided a variety of benefits for veterans of the war. The act included financial assistance to help defer the cost of education, which allowed more men to attend college and training schools. The guaranteed home loans for veterans offered by the act were of great value for getting back on track after military service.

In the coming weeks and months, Japanese Americans were forced to address difficult questions of identity, family, and patriotism.

Thousands of Japanese Americans on the west coast were sent to internment camps in the spring of 1942, presumably to prevent spying and sabotage. Their homes were seized, possessions confiscated, and freedom lost as Japanese Americans were forcibly evicted and incarcerated in American-style concentration camps. Some were able to relocate outside the restricted west coast zone, some enlisted in the military to prove their loyalty to the United States, and others resettled in the midwest and on the east coast (Cayton and Williams 2001).

After the Japanese attacked Pearl Harbor and the United States entered the war, the U.S. government established the War Production Board, which began rationing certain items that it deemed important to the war effort. In 1942, the War Production Board began rationing sugar, gasoline, and coffee, followed by meat, fat, cheese, canned goods, leather, and shoes in 1943. Also, it began severely restricting the amount of fabric used in garments. The board and the rationing it imposed were dissolved after Japan's defeat in 1945.

The spirit of isolationism as an American foreign policy ended when representatives of fifty nations met in San Francisco in April 1945 to design the framework of the United Nations. Containment of the Soviet Union became American policy after the war. This containment called for extensive economic aid to assist the recovery of western Europe. The Marshall Plan, known officially after its enactment as the European Recovery Program, was the primary plan of the United States for rebuilding the allied countries of Europe and repelling communism after WWII. The reconstruction plan was developed at a meeting of the participating European states in July 1947.

After the war, anticommunist Republicans began to surface. Senator Joseph McCarthy and Congressman Richard Nixon attacked President Truman's administration for being too soft on communism. They condemned Republicans who embraced FDR's New Deal programs, which they described as "creeping socialism." The air of suspicion would continue through the Cold War in the decades to come.

ECONOMIC TRENDS

WWII pulled the United States out of the Great Depression, during which millions of Americans were unemployed. The war called most men into service, and the labor surplus was replaced with a severe labor shortage on both farms and in factories. Although industry attempted

25 percent, for minorities it was 50 percent (Simpson and Yinger 1985, 195). Minorities were the first groups who lost their jobs, and, for those who were able to keep them, their pay was decreased. Racial discrimination was widespread during the Depression, and minority workers were denied jobs in public works programs and overlooked by many charities. Animosity toward minorities rose as the economy declined, and violence including lynching increased.

In the south, many African Americans were sharecroppers. They farmed rented land and lived in small shacks without electricity or running water. As the Depression continued, hundreds of thousands of African Americans left the south with the hope of more opportunities in the north. Scarcity of jobs left many of these migrants waiting in bread lines.

FDR tried easing the nation's suffering with the New Deal programs, but African Americans were generally excluded from the benefits of these programs. FDR's second New Deal offered many more opportunities for them. The administration remedied some of the discrimination in the federal programs. They even appointed blacks to several federal positions.

Mexican Americans were poorly treated during the Depression. Like African Americans, they were the target of racism because whites thought their jobs were unfairly going to minorities. Most Mexican Americans lived in the southwest as migrant farm workers. During Hoover's administration, were rounded up by county and local police and deported. The police would often make mass arrests and go door-to-door demanding proof of residency.

During the 1930s, the FDR administration attempted to redress the wrongs inflicted on Native Americans in previous generations. In 1934, the Indian Reorganization Act was signed into law. The act made tribes eligible for federal funds to receive social services, purchase land, and start businesses. In the following year, Congress encouraged the production of Native-American crafts by creating the Indian Arts and Crafts Board. It even allowed Native Americans to trademark their designs.

THE
1940s

GOVERNMENT AND POLITICAL MOVEMENTS

WWII transformed the life of Americans during the 1940s. Throughout the 1930s, the United States had successfully stayed isolated from the German aggression in Europe. On the morning of December 7, 1941, the Japanese bombed Pearl Harbor. Shocked by this direct attack, Americans were drawn into the war and became suspicious of Japanese Americans.

to withdraw from Manchuria, but Japan instead withdrew from the League of Nations. The League was powerless to do anything to help China.

The United States was disturbed by the Japanese tactics, but the Hoover administration refused to allow sanctions against the Japanese. Although Secretary of State Henry L. Stimson wanted a tougher response to Japan, President Hoover refused. A note was sent to Japan indicating that the United States would intervene if American interests were violated. This doctrine, ironically, came to be called the Stimson Act. The Japanese interpreted Hoover's response to mean that the United States would not prevent Japan from attaining additional power in Asia.

To a great degree, the Japanese were correct. Americans still remembered the Great War, and they did not want to become involved in another foreign entanglement. They believed the country was safe because it was bordered by the Atlantic and Pacific Oceans. Americans wanted to remain neutral and let others fight their own battles. The attitude was definitely isolationist. As Germany, Italy, and Japan increased their aggressive behaviors during the 1930s, FDR became increasingly concerned that the United States would have to enter another war.

Germany and Italy invaded other countries, and there was no real effort to stop their aggression. Most countries would issue statements condemning the German invasion of Austria and Czechoslovakia in 1938 but believed Hitler each time he said that he would invade no other countries. Although his behaviors contradicted his comments to world leaders, no one made any actual attempts to stop Germany until its invasion of Poland in 1939. Much of Europe began to arm with the intent of stopping Germany, but they had begun their preparations too late. By the end of 1939, much of Europe was, or soon would be, under German control.

Recognizing that the majority of the people would not approve of any signs of war preparations, FDR did what he could to prepare the military and to help the country's allies to prepare for war. FDR would frequently meet with the new British Prime Minister Winston Churchill, and the two leaders would discuss how the United States could best aid Britain and the rest of Europe. Both men believed that war was inevitable, but they did not know how to overcome the intense American desire for isolationism and neutrality.

ETHNICITY

The Great Depression was difficult for all Americans, but minorities were hit especially hard. Whereas the general unemployment rate in 1933 was

although his movements were limited because of polio. FDR immediately started a variety of plans aimed at restoring the nation's financial institutions and the economic health of the American people. These plans were often referred to as "alphabet" programs because most of them were known by letters. The Federal Emergency Relief Administration granted money to the poor. The Civilian Conservation Corps created environmentally friendly jobs for millions of men. The Homeowners Loan Corporation helped homeowners refinance their mortgages. One of the largest projects was the Tennessee Valley Authority, which provided a variety of projects on the Tennessee River, including flood control and the harnessing of electrical power.

Although many of his programs had detractors, FDR was successful in getting the economy moving upward. He easily won reelection in 1936 and he continued his programs, most of which were aimed at breaking up large corporate agencies and shifting the tax burden from the middle class to the wealthier segments of the population. He also worked to develop international trade and relationships with countries throughout the world, not just in Latin America. His administration worked to obtain free trade agreements with other countries, although FDR's foreign plans never were as successful as his domestic policies. Many foreign countries, Germany and Italian chief among them, thought that their future lay in a strong military and not in trade.

INTERNATIONAL DEVELOPMENTS

In 1932, a World Disarmament Conference was held in Geneva, Switzerland. The goal of the conference was to establish rules that would prevent the military buildup of any country, thus preventing additional wars. Because the United States, Britain, and France had improved their militaries, Germany was able to denounce the conference and withdrew from it. Germany had already begun to rearm and rebuild its military with the express goal of regaining control of Europe.

Japan, a country that had not had a major role in the Great War, nevertheless had ideas of becoming a power in Asia. During the 1920s, the leaders of Japan believed that it could continue to grow and become a world power only by taking control of Asia. In 1927, Japan began preparing to take control of Manchuria, an area in northern China that had a large Japanese population. In 1931, Japan invaded Manchuria and gained complete control of the province by 1932. China appealed to the League of Nations, but that organization was unable to force the Japanese to withdraw from Manchuria. The League issued a warning that Japan had

across the Atlantic and received a hero's welcome when he returned to the United States. Amelia Earhart became the first female aviator to fly solo across the Atlantic. Earhart's popularity did not completely reflect the attitudes of the country toward women. Many corporations would not hire married women. Despite the achievements of Earhart, Mrs. Roosevelt, and others like them, the country continued to believe the Victorian notions that women were fragile and needed extra protection.

ECONOMIC TRENDS

The 1930s were largely shaped by the Great Depression. The stock market crash of 1929 was not the sole cause the Great Depression. The economic difficulties of the 1930s were the result of the business practices of the 1920s. Many other countries also experienced some level of economic depression in the 1930s. The practices and policies of the 1920s caused a slow deterioration that had gone unnoticed until the crash. The crash was a profound, memorable occasion that would remain in the minds of most people. They knew bad times were coming, but they could not expect the decade that followed the seemingly prosperous 1920s.

President Herbert Hoover had been secretary of commerce during Coolidge's administration. Hoover believed that cooperation between businesses, rather than government intervention, would improve business. After the crash, Hoover would not allow the government to directly intervene in the affairs of individual Americans. He thought that people needed an incentive to work; if the government gave indigent, unemployed, and homeless people some form of government handout, then people would lose the incentive to work. His administration only loaned money to corporations that were likely to repay the loan.

When a group of WWI veterans asked the government in 1932 for early payment of a bonus that Congress had granted them, the House agreed to discuss the issue with them, but the Senate refused. Hoover refused to meet with the veterans. The veterans camped in Washington, DC, demanding their appeals be considered. Hoover sent federal troops led by General Douglas MacArthur to their encampment. The veterans' shanties were burned and the veterans were forced out of Washington. Regardless of what Americans thought of the veterans' request, many were appalled at Hoover's apparent disregard for their safety. When the elections were held later that year, Hoover was turned out of office when his opponent, FDR, won by a landslide.

FDR, a cousin of Theodore Roosevelt, won the 1932 election easily. He was a personable individual who was never seen publicly as an invalid,

visibly active first lady in the nation's history. Her presence and her ability to listen to what she was told helped FDR maintain his popularity throughout his presidency.

Initially, FDR's main concern was with the country's economy. He used the radio to broadcast a series of fireside chats to tell the American public what was happening around the country. Many Americans would gather around the radio to listen to what FDR had to say, and the fact that he was willing to "talk to them" seem to give the country hope and encouragement. FDR seemed approachable, a complete contrast to Hoover.

As the economy improved, FDR's attention was drawn to international politics. He was aware of the change in Europe and the increasing popularity of Hitler and Mussolini. He also began to distrust the increasing aggression of the Japanese government. Roosevelt realized that the American people still remembered the Great War of 1917 and the country did not want to become involved in foreign problems. Believing that the United States would, at best, have to protect itself against other military powers, FDR kept a quiet watch over international affairs, building a strong relationship with the British.

FDR did have his critics. Many Americans believed that FDR's policies were aimed at businesses and management. Many people did not feel as if the Democratic agenda was benefiting them. Huey Long, a senator from Louisiana and a former governor of that state, acquired a large following throughout the south and midwest. Long might have been a challenge to FDR during the 1936 elections, but Long was assassinated before the campaign began.

An anti-Semitic priest, Father Charles Coughlin, also used the radio to tell Americans that FDR's policies were only helping "rich Jewish bankers" in large cities. Coughlin developed increasingly conservative views that criticized the democratic form of government and what he believed to be the control of the government by the Jews. By the end of the 1930s, many radio stations would refuse to broadcast his speeches, but many Americans continued to believe in Coughlin's policies.

By the end of the decade, labor had begun to challenge management and corporate America. Labor unions, such as the United Mine Workers, the United Auto Workers, the American Federation of Labor, and the Congress of Industrial Organizations, began to gain strength. Movies and popular literature portrayed labor unions as being the voice of the American people, and the growth of labor unions helped curtail the power that corporate America had during decades of Republican presidencies.

The shift from corporate power to the people also encouraged a series of activities by individuals. Charles Lindbergh was the first to fly solo

Many African Americans had left the south after the Civil War, but they did not find the freedom and equality that they had hoped to find. African Americans were usually only allowed to live in areas that were specifically designated for them. These areas tended to be the poorer areas of a town or city, with limited city services such as sanitation. Given the high concentration of African Americans in these areas, many died because of disease.

One of the largest and probably the best-known African-American communitties was Harlem, in New York City. Harlem was ideally located to benefit from all the new ideas, fads, and trends that came to New York City. Many talented and educated African Americans moved to Harlem to participate in this activity. The area prospered and attracted even more talented and educated African Americans. The Harlem Renaissance was a result of this influx of talent and creativity.

The Harlem clubs became hotbeds of activity around the popular forms of music that had been mostly confined to the smaller African-American communities. Jazz, the blues, and ragtime became popular in the larger, white community. Many white New Yorkers would come to the Harlem clubs to hear bands play the new music and hear the new musicians, such as Louis Armstrong, Duke Ellington, and Billie Holliday. Poets such as Langston Hughes would also be featured at these clubs to read their poetry while the music played and whites danced. Ironically, the clubs that fostered the African-American culture were often owned by whites. African Americans were only allowed into the clubs if they worked there; they were not allowed admission to the clubs, even if they could afford the entry price.

During the Great Depression, ethnicities were discriminated against as they had been in previous decades. It would not be until the later part of the twentieth century that the civil rights movement would begin to address some of the blatant discrimination ethnicities suffered during the early part of the century.

THE
1930s

GOVERNMENT AND POLITICAL MOVEMENTS

Hoover's successor, FDR, was a wealthy man from a patrician family who managed to be seen as a man of and for the people. Stricken with polio as a young man, FDR sent his wife, Eleanor, around the country to visit a variety of people in a variety of circumstances. She was his eyes and ears and she reported what she encountered on her trips. She was the first

In some communities, especially in rural areas, there was a rebirth of fundamentalist Protestant beliefs. More liberal Protestants were considered impure and an indication of how urban areas could corrupt and destroy American society. Many fundamentalists believed that science, liberal ideas, and the different cultures that had "invaded" the country were destroying the ideals that made America a powerful nation that could win the Great War.

This fear of ideas outside of fundamentalist belief was nationally publicized in Dayton, Tennessee, in 1925 when a young biology teacher, John Scopes, defied fundamentalist teachings by teaching Charles Darwin's Theory of Evolution in his classes. William Jennings Bryan, who had run unsuccessfully for the American presidency, was the lawyer who prosecuted Scopes. Clarence Darrow, a famous liberal trial lawyer of the era, came to Dayton to defend Scopes. The trial riveted the American population. Many Americans rejected the fundamentalist argument, and many fundamentalists retreated from the political arena. Scopes was convicted of violating school policy and accepted standards. Many publishers of textbooks noticed the trial publicity and removed references to Darwin and evolution from their texts. This policy remained in effect until the 1960s.

Immigrants from Mexico became the new "cheap labor" in the 1920s, especially after the passage of the Johnson-Reed Act. They migrated primarily into the southwestern states, with a large influx into southern California. Many California cities grew rapidly during the 1920s as their Mexican communities grew. There were so many Mexicans in the southwest that they were able to develop their own radio stations as well as newspapers and even their own movies and theatres.

Eastern Europeans tended to remain in the northeastern and midwestern states. Large cities such as New York, Philadelphia, and Chicago saw a rapid increase in ethnic communities. Like the Mexican communities in the southwest, these ethnic communities developed many subcultures that included their own radio stations and other activities. These ethnicities tended to adapt to the larger culture, learning English and being accepted as part of the larger American culture, but that usually occurred in the second and third generations of individual families. These ethnic groups were ostracized and restricted to low-wage jobs with poor working conditions. The Republicans were seen to be responsible for this discrimination, so many ethnic groups began a push to register their members in the Democratic party. This surge of ethnic Democrats could not help the party win the 1924 presidential election, but they did contribute to Hoover's defeat in the 1928 election.

environment for two men, Adolf Hitler in Germany and Benito Mussolini in Italy, to enter politics with the idea that their countries should return to their glory days and rule Europe and the rest of the world. Mussolini was able to assume control of Italy during the 1920s because of an absence of any other leader. Hitler's rise to power took several years; he took advantage of the time by increasing his power base slowly but surely. Ironically, he assumed the chancellorship of Germany in 1932, the same year that FDR became president of the United States. Both Hitler and Mussolini took advantage of the fears and discriminatory beliefs of their people and pledged that their countries would become "pure," without the ethnicities that had helped to destroy their countries in the past. These leaders claimed that Jews were responsible for the economic woes of both countries and therefore had to leave or otherwise be eliminated.

ETHNICITY IN AMERICA

After the Great War, the United States seemed to socially withdraw unto itself. It did not want to become entangled with the affairs of nations outside of the two American continents. Many Americans seemed to think that the war was a "foreign" problem and that "foreigners" should solve their own problems in the future. The country was willing to trade with other countries, as long as American businesses were not economically hurt, but the country seemed to want to isolate itself from the problems of the rest of the world. This isolationism helped create a sense of "America First," which in turn contributed to the idea that foreigners were not always wanted in the United States.

This anti-foreigner attitude was not against all foreign-born people. The popular concept was that anyone who was not white, Anglo-Saxon, and Protestant was not really welcome any longer. In 1924, the Johnson-Reed Act was passed, restricting the number of immigrants who could come from outside the western hemisphere. Those immigrants, especially those from southern Europe, Asia, or Africa, who were already in the country, were not readily accepted into American communities. These ethnic groups tended therefore to cluster together in enclaves that became ghettos in many large cities.

The Ku Klux Klan saw a rebirth after the Great War. Originally a white supremacist group that wanted to suppress African Americans, the Klan grew in the 1920s into an organization that wanted to restore a so-called Anglo-Saxon "purity." The organization targeted specifically African Americans, Jews, and Catholics, although Klans in individual communities might have targeted other ethnic groups.

The passion that Americans acquired for consumerism was equal to their enthusiasm for the stock market. During the 1920s, ordinary people began investing in the stock market, an activity that they rarely did before. Some borrowed money or paid "on margin" to acquire stocks. Both methods indebted the shareholder and set the scene for devastating financial losses later in the decade.

The Republicans, assured of continued success, nominated Herbert Hoover for president in 1928, and he won 58 percent of the vote (Campbell 2000, 66). Hoover rode a tide of popularity until the fall of 1929. At that time, shares on the New York Stock Exchange started fluctuating wildly. Finally, on Tuesday, October 29, 1929, shares dropped and stayed low. Money that had been invested in stocks evaporated. Many big businessmen and middle-class people saw their life savings disappear.

INTERNATIONAL DEVELOPMENTS

After the Great War, President Woodrow Wilson wanted the United States to participate in a League of Nations. The League would be an organization of the nations of the world that, in theory, would be able to settle disputes and prevent future wars. The League was largely developed by Wilson. He had idealistic plans for the organization, but he had to modify those plans when the leaders of other countries insisted on a variety of changes. Most of those changes were based in the antagonism and biases that that helped to start the Great War, but Wilson had to modify his plans or risk having the entire idea destroyed. Wilson battled to get the Congress to allow the United States to become a member of the League, but Congress refused. The League, an idea born before its time, was never able to live up to the ideals of Wilson's vision.

The United States had become a world power after the country helped win the Great War. Most European countries, even those who had not been defeated, had to rebuild their economies after the war. The defeated countries, Germany especially, were required to pay reparations to the countries that had conquered them. These reparations were frequently major problems for a growing economy. As the years progressed, the payments were adjusted and were less of a problem economically, but they became a point of contention. Hitler, for example, used the payments to incite hatred of those who won the war. These people, according to Hitler, were the western countries who were "run by the very rich Jewish bankers."

After WWI, the people of Germany and Italy both felt that they had been wronged by the outcome of the war. This established the

The administration would slash taxes for the very rich, increase the taxes on the middle class, raise tariffs on imports, and would not consider canceling the reparations from any of the European countries that owed the United States money as a result of the Great War. The country began to isolate itself from Europe and Asia but would be aggressive for American investors in Latin America. Coolidge would even station marines in a variety of Latin American countries if local uprisings threatened any American investments in those countries.

Farmers had a difficult time during the 1920s. During WWI, farmers increased their production to meet the demands of the war. When the war was over, they were left with few buyers and surplus crops. Food prices plummeted, and many farmers and young people who had grown up on farms moved to the city to find factory work.

With the proliferation of factory work, young people moved into cities to get the high-paying factory jobs. Usually little experience or education was required for this type of work, so apprenticeships and schooling were no longer part of a young person's career path. Although the factory jobs paid well, they were mundane, and there were few opportunities for advancement.

Factories produced goods and Americans bought them. The idea of "buy now, pay later" became popular, not simply to start a crop or begin a business but to buy goods that a family might want. Many families began to go into debt to buy consumer goods such as washing or sewing machines. Advertisers began learning the psychology of advertising, and they began campaigns that told people they "couldn't live without" their products. People who never thought of athlete's foot, bad breath, or any of a number of problems suddenly felt a compulsion to buy products to prevent whatever problem the advertisers from Madison Avenue convinced them they needed. Businesses grew, but so did the debt incurred by most Americans.

The economy was stoked by new technologies. Industries welcomed faster, more efficient machinery into their factories. Consumers purchased modern "labor-saving" devices as well as items that had been extravagant luxury items, such as automobiles, a decade earlier. Prices were good and people became focused on consumption. The focus on saving money was replaced with spending it.

A new scientific approach was applied to business management. Frederick Taylor, as former machinist, studied the interaction between workers and machines to determine how to get them to work together best. During the 1920s, business was now considered a profession, and the study of business was legitimized by the emergence of business schools such as the Harvard Graduate School of Business, which was established in 1924.

death. Many historians have considered Harding one of the worst presidents, if not the worst, the country ever had.

Calvin Coolidge became president upon Harding's death and quickly replaced the cronies and incompetents that he inherited from Harding. Known for his own personal honesty, Coolidge won the next election on his own, with some help from a Democratic Party that was split over politics.

Coolidge's Secretary of Commerce, Herbert Hoover, was considered the man best educated and qualified to succeed Coolidge. Seen as one of the architects of the apparent prosperity of the 1920s, Hoover won the 1928 election easily. Alhough he wanted to end poverty and improve the status of the working man, Hoover believed that the economy would be maximized if businesses learned to associate and communicate with each other. Like earlier Republicans, he believed that the best government was one that did not interact with individuals. He encouraged corporations to talk to each other and learn to solve problems so that all business would help each other, instead of meeting in competition. Although he was unable to achieve this ideal, Hoover's popularity was high for his first year in office.

After the stock market crash in 1929, Hoover began to realize that corporations would not communicate as he had hoped they would. He still believed that limited government was the best way to help the country and refused to consider anything that seemed to be a government handout. He might have wanted to help the poor and homeless, but his policies were mostly aimed at helping businesses and the wealthy grow stronger. Many Americans lost faith in him after the crash, and many others strongly disapproved of his management of the Great War veterans who came to Washington, DC, seeking financial assistance. Many Americans considered Hoover indifferent to the "little man" and state of the national economy. He never regained the popularity he had in his first year. Although he was not individually responsible for the economic downturn, many Americans blamed him for it, and he was overwhelmingly defeated in the 1932 elections.

Economic Trends

Coolidge and the leading Republicans believed that business was the key to American prosperity, so his presidency was kind to big business and the already rich entrepreneurs. Coolidge's administration was close to bankers and tended to advocate policies that benefited only those who worked on Wall Street.

surface. German Americans were a focus of these fears, because they were associated with America's primary enemy in the war.

African Americans suffered from hostility as well. During the war, they moved north for the higher wages being paid by industries suffering from the labor shortage. As they migrated to cities in large numbers, racial violence flared. Chicago, Houston, St. Louis, and Washington, DC, all experienced race riots. Even in the south, people were angry that African Americans were moving north and creating a labor shortage.

Some Americans organized around their fears and resentment, resulting in the reemergence of the Ku Klux Klan, which had lain dormant for nearly fifty years. The Klan took advantage of some of the rhetoric of WWI and reestablished itself under the guise of Americans First. Klan members tended to be white, Anglo-Saxon Protestants, and their hatred extended beyond African Americans to include Jews, Catholics, and many people who did not speak English, which in some communities meant immigrants of any nationality. The war itself tended to limit the growth of the Klan because most Americans were united in the war effort. After the war, issues relating to discrimination did not get national attention until the 1920s.

THE
1920s

GOVERNMENT AND POLITICAL MOVEMENTS

The 1920s will be remembered for many things, not the least of which will be the fact that Warren Gamaliel Harding was the first president of the decade. Harding, a passive man who would do whatever the Republican Party bosses told him to do, helped his friends and paid off political debts by appointing people to government offices whether or not they had any skills or knowledge of the office. Harding must have been a trusting person, because he only seemed to have realized late in his presidency that most of his "friends" had used their offices to gain money and enjoy the "perks" their positions could get them. One of the scandals uncovered by the press was the fact that Albert B. Fall, the Secretary of the Interior, leased the navy's petroleum reserves in Teapot Dome, Wyoming, to two oilmen. The oilmen, Harry Sinclair and Edward L. Doheny, showed their appreciation by "loaning" Fall hundreds of thousands of dollars.

Harding also had several adulterous affairs while in office, which the press did not make public until after his death. Harding died of massive heart failure before his term was completed, and the American public learned the full extent of the improprieties of his administration after his

and they fed into America's burgeoning economy. When America left its isolationism and began to trade heavily with other countries, goods needed to be produced for trade. Manufacturing and industry needed cheap labor, and much of it came from new immigrants. New immigrants needed work, and they were willing to take the dirty and dangerous jobs that most Americans did not want. These jobs were frequently found in coal mines, steel mills, the railroads, and slaughterhouses.

Slowly, many Americans began to resent the presence of these immigrants. Hostility intensified during WWI when latent fears rose to the

Triangle Shirtwaist Factory Tragedy. In the 1900s and early 1910s, it was common for young women to work in factory jobs, especially in the garment manufacturing industry. They usually worked long hours for low wages in unsafe conditions. It was typical for a woman to work from 7:30 in the morning to 6:00 at night six or seven days a week.

These working conditions existed at the Triangle Shirtwaist Factory in Manhattan. The company employed 500 people, mostly young women between the ages of 16 and 23. Most were recent Italian and European Jewish immigrants who spoke little English. They sewed garments by hand and on sewing machines and cut fabric from tissue patterns that were suspended above the work areas on lines. Their factory was illuminated with open gas lighting. Fabric scraps littered the floors, and smoking in the work space was common among the few male workers.

On March 25, 1911, just before closing time, a deadly fire broke out near the top of the ten-story building that held the factory. As the fire blazed through the top three floors, the employees tried to flee the building. Some were able to escape using the exterior fire escape before it collapsed, and others were able to make it to the roof and climb onto adjacent buildings. One hundred forty-six were trapped inside the building and burned, suffocated, or jumped to their deaths.

There was immediate public outrage, and the factory owners were brought to trial to determine whether they had purposefully locked the exits, trapping the employees inside. Although they were acquitted, the resulting anger and protest had long-reaching effects. It solidified the influence and support of the International Ladies' Garment Workers' Union, who organized aid and relief for the victims and their families. In addition, it spurred the growth of the organization. Within a month, New York State appointed a Factory Investigating Commission to conduct hearings about factory safety, which led to factory safety regulations in the state.

Although Theodore Roosevelt might have gotten the country involved in the war earlier, he was no longer president. Woodrow Wilson did his best to maintain the neutrality of the United States. This was not an absolute neutrality because the United States had become closely tied to England and France by trade agreements. The "neutral" president allowed shipments of goods and supplies to be shipped to England and France. When the British blockaded American ports to prevent the Germans from entering, Wilson protested, but he never suspended trade.

Germany, in its attempt to tip the balance of power, began to use the first effective submarine, or U-boat. The most famous sinking by a U-boat may be that of the *Lusitania* on May 7, 1915 (Murrin et al. 2004). The lives of 1,198 people were lost, including 128 Americans. The *Lusitania* was a passenger ship, and its sinking shifted the tide of American thinking away from neutrality. Wilson protested and Germans agreed not to torpedo passenger ships, especially ships of neutral countries, but that was a promise that Germany did not keep. Wilson maintained American neutrality, against much criticism, until the publication of the Zimmermann telegram, which reportedly came from the German minister to Mexico. The telegram requested that the Mexican government attack the United States in the event that the United States declared war on Germany. Mexico's reward for this "favor" would be the return of lands that the United States had obtained from Mexico over the years. That land included Texas, Arizona, and New Mexico. This telegram, as well as the overthrow of the czarist regime by the Bolsheviks, forced Wilson to ask Congress to declare war on Germany, which it did on April 6, 1917.

After the war, Wilson worked for a just peace and the development of the League of Nations. He presented his plan, called Wilson's Fourteen Points, for what he believed was an appropriate resolution for all of the countries involved. He also hoped that a global organization would help prevent other wars, but his efforts to broker a peace that satisfied everyone and a long-term global organization were not successful. Many others felt that Germany should be severely punished for its behavior in the war. Wilson's critics did not realize that the so-called peace treaty and the lack of a global organization that would work for peace would plant the seeds for an even greater war.

ETHNICITY

Over the first two decades of the twentieth century, Americans saw an increase in the number of immigrants of all nationalities. The 1910s were the last major phase of immigrants from eastern and southern Europe,

which outlawed monopolies, and the Federal Trade Commission, which investigated and enforced the Clayton Antitrust Act.

Taft was president when the Sixteenth Amendment was ratified. Through the amendment, a federal income tax could be established, and everyone, theoretically, would be taxed fairly, by rules established by Congress. Although overshadowed to some degree by the political situation in Europe and the eventual start of WWI, the federal income tax would have an economic impact on the country that no one could recognize at that time.

Another seemingly small change that would have major repercussions was the status of women. At the beginning of the century, it was expected that the lives of women would continue much as they had always been, centered on the home. The country's economic development changed rapidly as the situation in Europe deteriorated. Once war was declared, the economy became driven by the need to provide American fighting men the tools they needed. The war was larger than any war man had experienced up to that time. So many American men were sent overseas that women volunteered to do the tasks that men had been doing. For the first time in history, American women were working in numbers no one had ever imagined. If many men expected women to return to the domestic roles they had before the war, they were surprised. Women had entered the American workforce. The initial effects on the economy would not be seen until the 1920s.

INTERNATIONAL DEVELOPMENTS

In 1914, a Bosnia nationalist assassinated the Archduke Franz Ferdinand, heir to the Austro-Hungarian Empire in Sarajevo, Bosnia. The assassination most likely was intended to be a message to the Austro-Hungarians that the area wanted its independence. The empire declared war on Serbia, because the country was seen as being responsible for the duke's murder.

What had been a "simple" assassination triggered the alliances that had been established in the preceding years. Countries who were obligated by their treaties to protect Serbia declared war on the Austro-Hungarians. Countries that had treaties with the Austro-Hungarians declared war on Serbia and its allies. It was not long before all of Europe, as well as Russia and the Ottoman Empire, was involved in the largest war seen in the world up to that time. The two sides were evenly matched, so the war dragged on for years. Each side tried to acquire more allies to tip the balance of power in its favor.

ECONOMIC TRENDS

The building of the Panama Canal in the early 1900s was considered one of the greatest construction achievements of the world. The economic impact of the canal was even greater than its engineering achievements. The canal had originally been planned for Nicaragua. When political complications arose, Congress tried to get an agreement with Colombia to build the canal. None of the plans worked until Panama won its independence, with considerable help from the United States, and granted the United States permission to build the canal. The canal cost the lives of thousands of men, mainly as a result of malaria and yellow fever. Walter Reed, a U.S. Army surgeon, aided in the development of a vaccine that helped eradicate the disease. Once the canal was finished in 1914, it was extremely successful. It cut the shipping route by half, thereby dramatically reducing the cost and travel time of goods.

Big business, a term that was used to describe large-scale or powerful businesses, started the century believing it controlled the country. Big business was extremely powerful and generally got what it wanted. It sacrificed workers' quality of life for profits. Many workers were subjected to long hours, hazardous working conditions, low pay, and unstable jobs. Workers established unions and fought to get business to adopt rules that would benefit them. Although the unions' pressure resulted in successes at individual companies and within individual industries throughout the 1910s, they were also having an impact on business as a whole. Their work led to the Fair Labor Standards Act in 1938. A combination of events, including the persistency of the unions, the increase in the popularity of the Progressive Party, and the improved economy, gradually weakened the strength of the business moguls and equalized the economic prosperity the country was experiencing.

William Howard Taft was Roosevelt's successor. During the administrations of both presidents, the United States became interested in and increased the amount of land under conservation control of the federal government. Many businesses saw this as an infringement on their right to grow their businesses. Both presidents fought against business trusts in an attempt to allow smaller businesses to grow. Taft initiated eighty antitrust suits against big business that unfairly dominated their industries.

When President Wilson took office, he continued the offensive against big business. He implemented a reform program called "New Freedom" that aimed at banking reform and business regulation. He used these strategies to erode the power of corporate trusts and build the power of small businesses. In 1914, he proposed the Clayton Antitrust Act,

THE
1910s

GOVERNMENT AND POLITICAL MOVEMENTS

Progress was a word that characterized the early 1900s, and the Progressive movement hit its zenith in the 1910s. The reformers who were part of this movement aimed to improve nearly every facet of American life. By tackling issues from lowering tariffs and breaking up business trusts to improving working conditions and allowing women to vote, reformers from the local to the federal level worked to progress the country forward.

William Howard Taft assumed the presidency in 1909. He was hand-picked by Theodore Roosevelt, but, during his four years in office, he managed to alienate Roosevelt, big business, and reformers. During the election of 1912, Taft received the fewest electoral votes of an incumbent president.

Woodrow Wilson, an educator, became president in 1913. He was aware that Europe was in turmoil and did not think that the United States should interfere in what he believed was a strictly European conflict. For three years, Wilson kept the country out of the European war. It was only in 1917, after Wilson had won his second term in office, that he began to realize that the United States would have to enter the war. After the "Zimmermann telegram," in which the Germans told the Mexican government that Mexico could regain its territory if it attacked the United States, the county was incensed. Furthermore, Germany continued to attack neutral ships with its first effective submarine, the Unterseeboot (U-boat), and the czarist regime in Russia fell. Without the help of the Russian army, the Allies would have increased trouble with Germany. Wilson did not want to go to war, but he thought his country needed to help the Allies. Congress declared war in 1917.

By the time WWI was over, the United States had solidified its role as a world power. Many citizens wanted to return to the peaceful years of isolation before the war, but that was not to be. The returning soldiers had seen parts of the world that most Americans had never visited. With men away at the war, women had taken on tasks and jobs, and they were not interested in returning to a role that limited them to the kitchen. Women campaigned for and eventually received the right to vote. The United States that celebrated the peace in 1918 was a country with new ideas, a new attitude about its role in the world, and a desire to establish new policies and customs instead of following what others had created.

discriminated against them and their religious beliefs, Eastern European Jews were forced to live as outcasts in their home countries. Facing lives of poverty, starvation, and violence, two million Jews left their homelands in search of better lives (Schrier 1994).

Like many immigrant families, Eastern European Jewish families often sent husbands and sons to America first to establish themselves and get jobs before the women and children in the family made the voyage. There was often a gap of one to three years before families were reunited, and the men usually had adapted to the vastly different American lifestyle within that gap. Americanized men and women were often ashamed of their family members' old-fashioned appearance when they came to America. They did not want their family to look like "greenhorns," and they purchased new American clothing for their arrival.

No Wigs. In their homelands, Eastern European Jewish women wore traditional dress, which included an uncorseted dress, an apron, and a headscarf. Married Jewish women were expected to cut their hair short and wear a sheitl, a wig made of obviously artificial hair. They did this in accordance with the Jewish custom that required married women to keep their hair covered at all times. It was an act of modesty. When they did not wear the wig, they wore a headscarf to fulfill the custom.

On reaching American shores, most married women were encouraged to give up the custom and traditional dress by their relatives or country people. This was often a contentious decision for older women, who felt they were sinning and betraying their conviction to their religion. They were usually encouraged by their families to give up their old-fashioned dress that made them look older than they were.

Americanized relatives found sheitls particularly embarrassing, because the custom was very noticeable and unique to their ethnic group. They found that looking and acting "American" helped them achieve success, and they were not tolerant of outward appearances that differentiated them. Not all women could be persuaded, and many older women especially, and grandmothers, continued to wear traditional dress and sheitls.

Typically, younger women who were not strict observers of orthodox Judaism quickly adopted fashionable American dress. They usually worked in the garment industry, and being around the latest fashions naturally piqued their interest in wearing up-to-date garments. They embraced tightly corseted waists, shirtwaists with monobosoms, the full, thick pompadour hairstyle, and enormous, lavishly decorated hats.

other. If two countries declared a treaty, some other country would feel threatened, and it formed a treaty with a fourth country. In many treaties, there was a clause that said if a country was attacked, other countries would automatically come to its aid. In this way, a mesh of alliances was developed that would engage the world in the largest war the globe had ever seen.

ETHNICITY IN AMERICA

The American Civil War was still a clear memory in the minds of many Americans. Many war veterans were still alive at the dawn of the new millennium. Reconstruction was a bad memory to many in the South, and attitudes toward "negroes," as African Americans were called, were still negative. Many people, especially in the South, blamed the negroes for the war. Many whites could remember the days before the war and wished that Southern lifestyle still existed. Lynchings had reached a high point in the 1890s (Murrin et al. 2004); although they had diminished in number, new laws intended to disenfranchise African Americans were passed. The so-called "separate but equal" facilities were established, and the Supreme Court, in the landmark *Plessy v. Ferguson* case in 1896, sanctioned the "Jim Crow" laws.

In last part of the 1890s and the early 1900s, black leaders such as Booker T. Washington accepted the discrimination as long as there was still some level of advancement. Many blacks agreed that, as long as there was some advancement, such as the establishment of negro colleges, the Jim Crow laws were acceptable. Blacks were able to enlist in the military, but they were only allowed to join all-negro units. Theodore Roosevelt relied on black units during the Spanish-American War but shied away from acknowledging their efficiency in later years (Murrin et al. 2004).

Blacks were not the only recipients of discrimination. Asians on the American west coast were as poorly treated as negroes were in the South. The federal government had limited the number of Chinese immigrants in the late 1800s, but as Japan grew in power and population, many Japanese began to immigrate to California. In a "gentlemen's agreement" in 1907, Roosevelt agreed to halt blatant discrimination against the Japanese if Japan would stop the immigration of adult males into the United States (Murrin et al. 2004, 532).

At the turn of the century, Eastern European Jews immigrated to the United States in great numbers. Unlike other immigrants, when Jews from Russia, Poland, Romania, Austria-Hungary, and the Ukraine left their homelands, they had no intent of returning. Governed by laws that

acquire territory outside the geographical boundaries of the country. He mediated an end to the Russo-Japanese War and won a Noble Peace Prize for his efforts. The fact that neither side was totally satisfied with the peace was ignored by most world leaders. Years later, the world would realize that the treaty planted the seeds that would create more problems than could be envisioned.

Both the Russian and Japanese Empires wanted control over Manchuria and Korea. Their competing ambitions led to the Russo-Japanese War (1904–1905). Russia and most of the rest of the world were surprised that the Russian Empire could not win a war against Japan. This upset many people, who blamed the czar for the defeat. Many of the people, as well as many powerful Russians, felt that the czar's government was weak and corrupt. They perceived the defeat as a loss of power and a signal that the czar's government had to change. This attitude would ultimately allow Vladimir Lenin to successfully overthrow the Russian monarchy and establish a Soviet state in Russia. Few people expected this change in government to have far-reaching consequences. This particular change would have a major impact on the world long after the Russian Revolution of 1917.

The Japanese also felt that the peace treaty diminished its reputation in the eyes of the world. They believed they could win a war with Russia, although Russia was considered much more powerful at the start of the war. Many Japanese began to feel that they needed to do something to show the world that they were a strong and powerful country. Although some thoughtful people were aware that Japan felt the treaty an insult to the country and its emperor, few people had any idea that the desire to show their power to the world would result in a much larger war decades later.

Few American people gave much thought to either Russia or Japan. Many in the United States wanted to be recognized and respected by the rest of the world so that the United States could benefit from trade with other countries. Outside of trade concerns, many Americans were generally disinterested and wanted to stay uninvolved with the affairs of other countries. Americans, even if they were not aware of George Washington's belief that the country should isolate itself from the affairs of Europe and Asia, acted on that belief. They were willing to trade with Europe and Asia, but they did not want to get involved in the problems of other nations.

Many of those other nations, however, felt as if they had to defend themselves against past slights from past enemies. Allies shifted and changed, and then the European nations settled into treaties with each

as Spain's diminished. When it was crafted in 1823, the Monroe Doctrine prevented European countries from colonizing in any of the Americas and proclaimed that the United States would remain neutral in European affairs unless it was provoked. Roosevelt added a component to the doctrine by considering any attempt to colonize in the Americas as a threat to U.S. security.

The United States acquired territory that had belonged to Spain, including Cuba, Guam, the Philippines, and Puerto Rico. Although the United States had little intention of making any of the territory into a new state, the country did not have any problems with overthrowing the status quo in the territories and attempting to "enforce" a democracy in lands that had barely even heard of the concept. Much of this heavy-handed behavior occurred during Theodore Roosevelt's presidency.

Roosevelt apparently believed that the ends justified the means. If he was able to somehow advance the prosperity of Americans by getting involved in the politics of other governments, he would. A classic example of this was his involvement in the development of the Panama Canal.

The French had tried unsuccessfully to build a canal across the Isthmus of Panama in the latter half of the 1800s. Disease, the mountainous terrain, and the distance from France caused problems, and the company trying to build the canal abandoned the project. Roosevelt wanted a canal because he believed it would simplify the transfer of goods between the two coasts of the continental United States. Roosevelt did not want to pay for the rights to the parts of the canal that had been completed by the French, so he identified another site and negotiated with the Nicaraguans for rights to a canal.

The Isthmus of Panama was at that time located in the country of Colombia. The company that owned the rights to the canal wanted the United States to complete what the French had started, so they lowered the price. Eventually, the U.S. Senate opted for the Panama Canal site after an effective lobbying campaign by the French canal group that owned large portions of land in the path of the proposed Panama site. When the Colombians tried to get more money into their government coffers, Roosevelt encouraged the Panamanians to revolt against the Colombian government. When they did, with the help of the U.S. Navy, Roosevelt acknowledged the Panamanian government and negotiated a treaty with them to complete the canal. Roosevelt even managed to keep control of the canal itself in American hands, and Panama did not assume control of the canal until almost seventy years later.

During the next several years, Roosevelt engaged in activities that were intended to enforce the Monroe Doctrine. Roosevelt was willing to

depression of the 1890s. The depression, the beginning of a new century, and the sudden political changes brought on by the unexpected and shocking assassination of William McKinley caused people to wonder whether things would be better as they had been before the depression or whether it was necessary to look at new ways to solve old economic problems.

Before the turn of the century, there was a great debate over whether gold or silver should be the basis of the country's economy. Many voters felt that the decision would help pull America out of the depression. During the 1900 election, William Jennings Bryan had declared himself an advocate for making silver the basis of the economy. McKinley focused his campaign on foreign policy. Most of the discussion regarding the silver and gold issue stopped after the Gold Standard Act of 1900 was passed, although the question would reemerge when Bryan ran against William H. Taft in 1908.

Technology seemed to be advancing at a rapid pace. The first plane flew at Kitty Hawk, North Carolina, in 1903. As automobiles became easier to drive and repair, they became increasingly popular. Machinery became more complicated but was able to replace the need for manpower. The technological advances gave some people the opportunity for increased leisure, but it also increased the numbers of workers whose skills were not up-to-date in the new technological age.

Not only did Americans need to find ways to acquire new skills, the country faced a huge increase in the number of immigrants who entered the country at the end of the 1800s and the first decade of the 1900s. They came to the United States looking for new opportunities and to escape the difficult conditions in their native countries. Upon arriving in the United States, many immigrants lived in cramped, unsanitary quarters, and they faced an unwelcome reception from Americans, many of whom were immigrants themselves, because they thought the immigrants would take away their jobs.

INTERNATIONAL DEVELOPMENTS

At the beginning of the 1900s, the world was beginning to change as well as shrink, although few realized it at the time. The Spanish, who had long been considered a world power, were defeated by the young United States in the Spanish-American War in 1898 and 1899, which surprised a lot of people. Spain lost much of its control over territory in the Americas. Later, when Theodore Roosevelt became president, he reinforced the idea of the Monroe Doctrine, and the influence of the United States grew

The Progressive Party had its birth in the years before 1900, but the growth of the economy, the growing American presence around the world, the growth of the cities, and the new political era allowed many people to become more interested in social issues. The improved economy allowed some people to earn enough that they could enjoy more leisure time. The urban middle class was growing, and many of them used their leisure time for civic activities. Women were becoming more active in their communities and working to help improve the lives of the poor and of children. Many young, educated, middle-class women postponed marriage to work toward goals of improving their community's social problems.

Politically, the country was beginning an unexpected and unforeseen set of changes. In the years since the U.S. Civil War, Congress had gradually gained such power that the position of president of the United States had become little more than a title. The people who gained great fortunes in the late 1800s, such as the Vanderbilt family and J. P. Morgan, had been able to convince or bribe Congress into doing what big business wanted. A young politician by the name of Theodore Roosevelt had become an irritant to big business. Roosevelt had gained popularity after his successes as a leader of the "Rough Riders" in the Spanish-American War in the 1890s. He used that popularity to gain political power.

The business moguls and congressional leaders were unhappy with Roosevelt's perceived anti-business views. They decided that the easiest way to keep Roosevelt from gaining more power was to make him vice-president of the United States. Their expectation was that Roosevelt would fade from memory because the vice presidency was considered a dead-end job. No one, especially business leaders, realized exactly how the world would change when President William McKinley was shot by an anarchist early in 1901 and Roosevelt became president. Although some people did not like the new president, no one could foresee that Roosevelt would make the presidency more powerful than it had been in decades, attempt to curb the power of big business, and change how the country viewed itself and its position in the world.

ECONOMIC TRENDS

In the 1890s, the country had fallen into a major economic depression that lasted for several years. Many people in the country felt the results of that depression, and times were hard. It was only at the end of the 1890s that the country began to see hope in their future. This hope slowly grew and took hold in the early 1900s. Many of the choices people made in the early part of the century were based in their memories of the

Rationing and scarcity of goods reduced wartime commercial consumption, so most Americans were able to build up their savings.

After the war ended, Americans enjoyed renewed prosperity. In the last half of the 1940s, Americans embraced consumerism as they were released from rationing and factories switched over to commercial production. The G.I. (for "government issue") Bill offered education opportunities and home loans to returning servicemen, which eased their transition back to civilian life. It also encouraged movement to suburbs and newly built single-family homes. In essence, the American people shifted from a rural, to an urban, and finally to a suburban culture during the first half of the century.

THE
1900s

GOVERNMENT AND POLITICAL MOVEMENTS

Americans were very hopeful on January 1, 1900, and that optimism colored the decade. It was considered the beginning of a new millennium, and many hoped that the new century was the beginning of a better future. The depression of the 1890s was history for most of the country. Gold had been discovered in Alaska, and gold had replaced silver as the basis for the American dollar. New political ideas were emerging, and people were beginning to look at social issues, wanting to make life better for everyone. The United States had beaten Spain in the Spanish-American war and had acquired territory around the globe. Americans were getting used to the idea that those territories might somehow make their lives better, as well as make the United States more important in the eyes of the world. Life seemed full of promise.

One indicator of the change that was to come was the strengthening of the Progressive and Socialist Parties. The Socialist Party considered capitalism as the source of the world's social problems. Eugene Debs, who founded the party in 1901, advocated ideas such as an eight-hour workday, a minimum wage for all workers, and government ownership of communications, transportation, banking, and finance. Although the Socialists managed to win several elections at the state and municipal level, they never managed to win any national elections. Americans of the time liked many of the Socialists' goals but were unable to completely accept the idea of a state-controlled economy. Although many people did not like the control of the country that big business had, few people were willing to allow the government to assume control. Socialism slowly lost popularity, and its followers found the goals of the Progressive Party to be an adequate substitute.

Immigrants living in the United States experienced hostility from Americans who had lived in the country for generations. Recent immigrants, including the large wave of eastern and southern Europeans, received the brunt of the hostility. The 1910s would see the last large wave of immigrants in the first half of the century.

The government and unions continued to attack big business during the 1910s. The Clayton Antitrust Act of 1914 made it illegal to create monopolies, and the government began breaking up the giant companies that had dominated the landscape a decade earlier. Unions fought against poor working conditions, long work hours, and low pay.

The 1920s were a period of great prosperity and a more lenient attitude toward businesses. After President Warren Harding's scandal-ridden term in office, President Calvin Coolidge assumed the presidency and worked with businesses in an effort to get them to cooperate with each other.

Urban areas grew as Americans progressively abandoned rural life for the opportunities in the factories of cities. Segregation between African Americans and whites was enforced in the south. In the north, African Americans began to create economic and cultural enclaves in Harlem in New York and Bronzeville in Chicago.

The prosperity and parties of the 1920s effectively ended in 1929 when the stock market crashed, wiping out many Americans' savings. Many people lost their jobs and, at the extreme, had to sell off their possessions and became homeless. For most people, the following decade became one of few resources. They had to use ingenuity, take on additional work, budget carefully, and make the most out of what they had. Minorities were hit especially hard because of discrimination. Many unemployed whites felt animosity toward African Americans and Mexicans who had jobs.

FDR focused on restoring the country's financial institutions and Americans' livelihoods. He tried to instill hope and encouragement regarding the economy, and he implemented numerous programs to ease Americans' burdens. Despite his efforts, the country did not get much relief from the Depression until the United States entered WWII.

Like Woodrow Wilson, FDR tried to keep America out of what was seen as a European war, but the United States was drawn into the war when the Japanese attacked the U.S. naval base Pearl Harbor, in the Pacific, in 1941. The United States quickly mobilized, and able-bodied men were called up to serve their country. Wartime production escalated at American factories, and, as men went to fight overseas, they created a labor shortage. Women and minorities took their place in factory jobs.

2

Political and Cultural Events

The political and cultural scene of the first half of the twentieth century included two world wars and a dramatic shift of world and economic power. The 1940s ended with an optimism that was paralleled by the optimism of the 1900s. At the turn of the century, Americans, energized by the Progressive movement, tackled social issues in the communities in which they lived. In urban areas, they waged war on the poverty around them and created organizations to help the vast numbers of immigrants assimilate and succeed in America.

President Theodore Roosevelt, himself a Progressivism proponent, led the nation in a war against "big business." His agenda aimed to reduce the political power of monopolies. This task seemed herculean, not only because of the size of these companies and the dollars in their coffers but also because of the rapid technological advances that kept the money pouring in.

WWI, originally known as the Great War, was the defining event of the 1910s. President Woodrow Wilson did his best to keep the United States out of the war, but, in 1917, he broke American isolation to help the European countries that were being devastated by the war. The Allies' victory in the war solidified the status of the United States as a world power, but the dissatisfaction with the peace treaty on the part of Germany and Italy would lead to another world war in a few decades.

REFERENCES

Berkin, C., Miller, C. L., Cherny, R. W., and Gormly, J. L. 1995. *Making America: A History of the United States.* Boston: Houghton Mifflin.

Israel, B. 2002. *Bachelor Girl: The Secret History of Single Women in the Twentieth Century.* New York: William Morrow.

Kurian, G. T. 1994. *Datapedia of the United States, 1790–2000.* Lanham, MD: Bernan Press.

McKay, J. P. 1999. *A History of Western Society.* New York: Hougton Mifflin.

Perrett, G. 1982. *America in the Twenties, A History.* New York: Simon and Schuster.

Rowbotham, S. 1997. *A Century of Women.* New York: Penguin Books.

U.S. Bureau of Citizenship and Immigration Services. *Statistical Yearbook, Annual.*

U.S. Census Bureau. 2001. *No. HS-20. Education Summary—Enrollment, 1900 to 2000, and Projections.*

U.S. Census Bureau. April 11, 2002. *Current Population Reports, P25–311, P25–802, and P25–1095.*

U.S. Census Bureau. *No. HS-16. Expectation of Life at Birth by Race and Sex, 1900 to 2001.*

U.S. Census Bureau. *No. HS30. Marital Status of Women in the Civilian Labor Force: 1900 to 2002.*

Zinn, H. 1995. *A People's History of the United States.* New York: Harpers Perennial.

on the dissemination of fashion as millions flocked to movie palaces each week. Dictating fashion trends was no longer the exclusive prerogative of Paris. Hollywood became a source of new fashion trends, and the American fashion designer was born.

The influence of movies continued through the 1940s, and they played a prominent role in the war effort. Theaters frequently showed propaganda films, and rationing and contributing to the war effort were frequent themes of these films. Veronica Lake, an actress famous for her long, sultry hair, began to pull her hair back into an upsweep and publicly requested women in factories to do the same for safety. Even subtle styling in movies hinted at the impact the war had on fashion. For instance, *Casablanca*, with all of its intrigue, showed Humphrey Bogart with his trench coat belt knotted, not buckled, as metal was diverted to the war effort.

At the start of the 1900s, the "S" silhouette was fashionable. The tightly corseted waist of this silhouette was offset by the ample, and often padded, bosom and the round bottom. By the 1910s, the corseting had loosened and waists resumed a somewhat more natural shape. Skirts became shorter and more functional, and women began to wear untucked tunics over skirts by the end of the decade.

A boyish pencil-thin silhouette marked the 1920s. Hemlines rose to mid-calf and, in some cases, nearly knee-length. At the same time waistlines lowered, hair was bobbed and topped by a close-fitting cloche style hat. The economic hardships brought about by the Great Depression soon changed the ideal body shape for both men and women: thin was no longer in. Shapely curves for women and broad shoulders for men helped camouflage weight loss brought on by malnourishment.

The 1940s came with renewed prosperity and wartime frugality. Fabrics and metals were to be conserved so the silhouette was streamlined to minimize the use of materials. Details such as lapels, buckles, and pocket flaps were omitted from clothing. Women often had to assume the man's role at home, and soon the woman's silhouette sported masculine shoulder pads and close-fitting skirts.

Every period has its own ideal of beauty, shaped by the political, social, and cultural events of its time. Taken out of context, fashion can often appear ludicrous. Only when examined as an element of an era can fashion be understood. The first half of the twentieth century was marked by numerous significant political and cultural changes: war, activism, fluctuations in immigrant populations, and changes in the perception of women, all of which manifested themselves in the fashions worn by men, women, and children. Society was transformed, changing the way people viewed the world around them, and fashion reflected those changes.

During the first decades of the twentieth century, mail-order catalogs, such as Sears, were beloved reading material in American households. Urban and rural households alike could purchase ready-made fashions at affordable prices. The illustrations alone helped communicate new fashions to even the most remote locations.

By the 1920s, the mail-order business began to decline in popularity with the advent of the automobile and the growth of the department store. Although mail-order catalogs remained the primary source for obtaining fashions for rural areas, the department store became the new mecca for urban and suburban areas. Small boutiques were replaced by large department stores, which offered large volume, wide selection, and a range of price points for the entire family. Department stores began to form chains across America, leveraging wide-scale purchasing power to further reduce retail prices.

Until the 1930s, most fashion information was disseminated through print. Newspapers dramatically increased their reach from 3 million in daily circulation in 1899 to 24 million by 1909. Invariably, newspapers included advertisements from clothing and department stores that illustrated current fashions and enticed consumers to buy the latest in clothing and accessories.

Fashion magazines were also an important means for communicating fashion information from as early as 1900. *Vogue*, *Harper's Bazaar*, and *Ladies Home Journal* all found receptive audiences and saw readership grow. Each of the magazines featured the latest advancements in fashion through illustrations and eventually photography. They were a particularly efficient means of disseminating fashion information across the geographically dispersed American population.

By the 1920s, these magazines had the largest impact on the general population through the reporting and publicizing of fashion trends. During the 1920s and 1930s, they regularly featured the latest Paris designs as well as the glamorous wardrobes of Hollywood starlets. By the 1940s, the magazines provided a plethora of advice for handling the sacrifices of the war and staying beautiful at the same time.

Teenagers became a recognized force in the forties. With the men off to war, teenagers, both boys and girls, found employment readily available and so had money to spend. In response to this new adolescent consumer audience, *Seventeen* magazine was established in 1944 to entice teens to make fashion purchases.

Although films gained audiences in the first three decades of the twentieth century, they did not achieve mainstream popularity until the 1930s. During that decade, Hollywood came to have a tremendous impact

and only the very wealthy Americans could afford designer garments. Most Americans wore ready-to-wear or homemade knockoffs of popular styles. By 1949, many designers were household names and had learned how to market their businesses through vast product lines.

In many ways, fashion was democratized during the first half of the century. The formalness of public interaction had been simplified: women no longer had to own morning gowns, suits, tea gowns, dinner gowns, ball gowns, and the other situation-specific clothing. One dress could satisfy a whole day's worth of clothing needs. More women were able to afford designer products. Although a woman might not be able to purchase a Dior evening gown, she may be able to purchase something from his hosiery or accessory lines.

By the end of WWII, Paris' dominance over the fashion industry was shared by American fashion houses. Claire McCardell and others had pioneered the American look, which focused on comfortable, stylish clothes that fit the everyday life of work and leisure.

In the earliest decade of the century, homemade clothes were commonplace. Through 1949, the reliance of homemade clothes was gradually overtaken by ready-to-wear clothing, but this did not mean that people stopped making their own clothes. Sewing was still an important skill for young women to learn. The skill came in handy during WWII. Efforts were made to help the women at home become frugal and practical because supplies were limited as a result of the war effort. When the War Department restricted the amount of fabric that could be used in garments, women found ways to conserve fabric through revising existing garments. As men went off to war, their suits were converted to ladies suits, and McCall's even developed patterns for transforming men's into ladies' suits and ladies' dresses into children's clothing.

Changes in women's fashions during and after WWI for the first time allowed mass production techniques previously applied to men's wear to be applied on a wide scale to women's wear. The simple dresses, skirts, and blouses of the 1920s allowed for standardization in size and fit for both day wear and evening wear.

Mass production allowed for the rapid and inexpensive reproduction of Paris-dictated fashions. Middle- and lower-class individuals could now participate in fashion trends almost simultaneously with the social elite. Social status could no longer be exclusively discerned from dress. The new synthetic silk (rayon) provided an inexpensive substitute for real silk, and the new synthetic dyes that provided a wide range of intense colors both greatly reduced the cost of bringing Paris fashions to small-town America.

For the duration of the 1940s, children were to be seen and not heard. Roles were very specific for boys and girls, and they were taught to respect adults. Clothing was often handed down from one sibling to another and modified from boy's to girl's when necessary. It was a milestone for young boys to wear long pants. Frugality from the depression era coupled with strong religious and ethnic influence prevented the awareness of children as people. Mothers cooked, cleaned, mended, and cared for the family, fathers worked hard to support the family or were absent because of the war, and children were expected to go to school and entertain themselves. Growing up during the war often meant living with extended families and sharing whatever was available. Whereas adults scrimped and saved to get by, children learned not to be wasteful and not to ask for treats or special items.

Children were sometimes able to get odd jobs such as clearing lots and picking vegetables, because all able-bodied men were at war. It did not pay much, but it allowed children to help make ends meet during a time of rationing and low wages. Boys looked forward to the opportunity to serve their country by enlisting as soon as they came of age, whereas girls flocked to see Humphrey Bogart at the movies and spent their weekends at the USO dancing with soldiers on leave to the music of Frank Sinatra and other numbers from the Hit Parade.

Emphasis now was not only providing for the family but volunteering for efforts to support soldiers and sailors overseas. Young women went to work outside of the home, and traditional roles were left to grandmothers and older siblings. Some young girls went to work as early as 15 years of age. This provided not only income but exposure to life "off of the farm."

Young couples delayed marriage and starting families during the Depression, but the war changed that trend and those attitudes. Marriages were common as men rushed off to war with the anticipation that life would be better after the war was over. Although only single women were employed at first, married women were soon allowed to work because so many young brides were not starting families with their new husbands shipped overseas. This had an impact on family life in both rural and urban settings.

FASHION

The world of fashion may have changed significantly from 1900 to 1949, but many of these were not a linear progression but more of a series of fits, starts, and regression. There were few true fashion designers in 1900,

(U.S. Census Bureau 2001). Many children, some as young as 5, were expected to work and contribute to the family's income. Children worked in a variety of jobs, including farm labor, sewing, operating factory machinery, selling newspapers, and shucking oysters. By the time a child reached high school age, it was often considered foolish to waste time in the classroom instead of earning a wage.

Although many children worked from a young age, many activists began pushing to get children out of the factories and into classrooms. The activists would cite the disfigurement and health risks that children suffered in the factories. Others complained that children took employment from adults, thereby exacerbating unemployment rates. Although the Progressives pushed for reform, the prohibition of child labor was not set into law until the Fair Labor Standards Act was passed in 1938.

For the first time, in the 1920s and 1930s, school became the focal point of children's lives. Improved transportation allowed for a school bus system. One-room school houses were replaced by centrally located consolidated school systems. Education became more varied and grade specific and included lessons in hygiene as well as English, math, and history.

The decision to educate children was no longer a family decision but a community requirement. Education was funded by community resources, and attendance was compulsory in many states. However, the quality and quantity of education varied greatly across the United States, depending on the value individual communities placed on education, especially for minorities.

School also became the primary sphere of influence in children's social development. Extracurricular activities became a normal part of a child's life. Schools sponsored after-school activities such as Boy Scouts, Girl Scouts, drama clubs, athletic teams, and dances. Children now spent more time with friends than family, and peer influence and peer opinions became more important than those of family.

The economic strain placed on many families during the Great Depression resulted in increased divorce, desertion, and abandonment rates. Although restrictions on divorce were eased in many states, the cost of divorce prohibited the process. Instead, many women and children found themselves deserted or abandoned by husbands and fathers who could no longer face their inability to provide for their families.

In general, children were treated with more affection and regard through the 1920s and 1930s. Child labor laws were enacted to protect them from workplace abuse. Children were now children, not miniature adults. A new youth culture was born, and the perennial teenage request for the car keys began.

needed to be accompanied by a chaperone if she wanted to visit with a man. If a man wanted to propose to a woman, he asked her father or male guardian first. Physical contact before marriage was frowned on, and women who were interested in sex were seen as deviants.

The tradition of courtship changed drastically in the 1920s. Traditionally, the gentleman would "call" on a woman and spend the evening engaged in social activities with her and her family in the parlor. The pair would always be under the watchful eye of the girl's parents or a chaperone. In the 1920s, dating replaced old-fashioned courtship rituals. Couples escaped to movies, theaters, or other social settings, sometimes alone, sometimes with another couple. Whereas calling or courting was intended to lead to marriage, dating was for fun, with no implication of future commitment.

The automobile also allowed for a new-found privacy as couples engaged in "petting" and sexual exploration before marriage. According to one study of college students, "…92 percent of coeds petted and a third eventually had sexual intercourse, though usually with a fiancé" (Rowbotham 1997, 168). With greater sexual freedom and activity, the market for sex-related products increased. By 1926, condoms were available in gas stations, drug stores, and the Sears catalog. Magazines advertised "French Cures," a euphemism for abortion, and birth control education and devices were promoted by women's rights activists such as Margaret Sanger.

Dating as a form of social entertainment continued in the 1930s. Economic hardship forced many couples to delay marriage. Those who did wed did so for love and companionship rather than economic and social standing. Finding a partner who was romantic and affectionate became more important than finding one who was a good provider or trained in the domestic arts.

Despite the advances during the 1920s and 1930, by the 1940s, America was still a very conservative society. Little girls were restricted in their activities as to what was "proper." Young ladies were taught when to speak and what was appropriate conversation. Any visible sign of affection between a man and woman in public was discouraged. Both clothing and activity were conservative so as not to draw attention to one's sexuality.

GROWING UP IN AMERICA

During the first two decades of the century, the daily life of children was very different from what children experience today. Although most children attended grade school, just under 11 percent of 14- to 17-year-olds attended high school in 1900. By 1949, that figure was almost 75 percent

the United States (U.S. Census Bureau 2002). WWI intensified the opportunities for these women as many men went off to fight the war. At the same time, women were trying to redefine the Victorian attitudes that curtailed their rights. Suffragettes fought to expand rights for women, who did not get the right to vote until 1920. Also, women fought to get birth control, property rights, and the ability to retain custody of their children in the event of a divorce.

The 1920s also brought many social changes in the United States. Independent women, now known as "flappers," were free to smoke, drink, use contraceptives, and pursue careers. However, many viewed the flapper as a threat to the nation's morality who was trespassing into male arenas. Women could now be found in both the local bar and office.

During WWI, women joined the workforce in vast numbers to fill positions left vacant by men called off to war. However, after the war, women continued to work, not out of duty to country but as a means toward independence. Many young women now elected to work or enroll in college as alternatives to marriage. By 1920, women made up 47 percent of college enrollments, and the 1930 census reveals that approximately 10 million women had entered the workforce, an increase of 29 percent from the 1910 census.

Many Americans were not comfortable with the new independent flapper, and, as unemployment escalated during the Great Depression, many felt that women should not be allowed to work so that men would have more opportunities. By 1932, "legislation in twenty-six states prohibited married women from holding any jobs whatsoever" (Israel 2002, 150), and a 1936 Gallup poll indicated that "82 percent of the population thought wives should not work if their husbands had jobs and a majority were in favour of legal restrictions" (Rowbotham 1997, 203).

The advancements in women's roles gained during WWI and through obtaining the right to vote in 1920 suffered minor but not permanent setbacks from the 1930s Depression. As the country began to recover from the Depression and the threat of WWII loomed, women would again be able to assert themselves into the work place and gain even greater independence. Heightened wartime production combined with a shortage in the workforce attributable to the numbers of enlisted men gave women the opportunity to work in factories in jobs that had been held previously by men only.

SEXUALITY AND MORALITY

At the turn of the century, protective and restrictive attitudes regarding women formalized the courting process. Respectable unmarried women

During the first half of the century, caring for the needs of the household was transformed through a wide variety of innovations. Prepackaged meats and canned goods made shopping and cooking easier. Housewives no longer had to visit the baker, butcher, produce stand, and dry goods stores to acquire food. The new supermarket streamlined shopping, and Betty Crocker, a fictitious homemaker invented by General Mills, taught women how to cook nutritious and varied meals for their families. Electricity and gas became commonplace in the 1930s, illuminating homes and powering appliances. Blenders, irons, washing machines, refrigerators, and vacuum cleaners became modern necessities for maintaining a clean home and healthy diet.

Whereas daily life changed and improved rapidly in cities, communication and modern conveniences were slow in coming to rural areas. Despite the economic hardships in both rural and urban settings during the Great Depression, a new consumer culture was born that embraced the importance of the modern home, the motor car, exercise, and foreign travel.

During WWII, daily life experienced another shift because of the war and scientific advances. Because money and materials were limited and most able-bodied men were off to war, time was spent sewing, canning, and volunteering. Although tuberculosis and polio were still feared for their devastating crippling effects, penicillin became mass produced in 1941, reducing the number of amputees from infection after injuries and combat wounds.

The end of the war brought a gradual return to weekend and holiday activities. By 1947, we saw a return of "the season" and debutante rounds. "Society" was back in vogue. The wealthy could once again engage in leisure activities such as tennis and yachting without feeling unpatriotic. As the economy began to recover, automobiles were put back into production, and families had more opportunity to drive out to visit friends, parks, zoos, and the beach. Family vacations and destinations were soon to become the American way.

THE CHANGING ROLE OF WOMEN

At the beginning of the century, Victorian attitudes about women prevailed. People who held these attitudes believed that women should be protected and sheltered. The goal of women should be marriage, and they should not work outside of the home. Divorce during this time was rare and scandalous.

Despite these prevailing attitudes, many single women supported themselves, and, by 1911, there were 5 million self-supporting women in

The advent of sound in films brought an entirely new dimension to the theater experience, at a time when America needed to "escape to the movies" even more: the Great Depression. Escape from unemployment and hunger could be purchased for a few cents.

The forties were the heyday for movies, but even Hollywood was dominated by the driving force of war. The Office of War declared movies an essential industry for morale and propaganda. Hollywood design, however, had to pass a censorship board to guard against provocative costumes and maintain restrictions on the use of fabric and materials. Movie themes were romantic and pro-United States, making villains of the Germans and Japanese.

DAILY LIFE

The Industrial Revolution that had started during the previous century had transformed the economy and work life for most Americans. The machinery in the factories replaced skilled craftsmen. A majority of jobs called for unskilled workers, and those who filled these jobs found themselves easily replaced and job security a scarcity. This insecurity led to labor strife and activism during the remainder of the first half of the century.

The mass production techniques that were perfected during WWI were quickly applied to consumer industries. Assembly line practices were used to manufacture everything from household goods to clothing, bringing large quantities of goods to the mass market quickly and inexpensively.

WWI acted as a catalyst and accelerated changes in the economy and advances in technologies. Radio, movies, telephones, airplanes, and automobiles made it easier and faster to communicate with geographically distant areas. In 1895, only four automobiles were registered, but by 1920, the number reached more than 8 million, and by 1927 that number had nearly doubled (McKay 1999, 251). In the first decades of the century, motoring was seen as an exotic sport taken up by wealthy thrill-seekers. It was not until the national highway system was improved and expanded in the 1930s that automobiles became a popular form of transportation, encouraging people to travel the country for vacations.

The prosperity of the 1920s meant people were working less and socializing more. Horse races, dog races, cotillions, and society parties all came into vogue, replacing the traditional luncheons and teas. In general, society was more active and pursued more active interests, especially athletics. Americans became more health conscious. Dieting and exercise became popular, and a slim suntanned figure replaced the plump figure and pale countenance of previous generations.

popular songs. Although the radio had been invented, it was not a widespread consumer item. People heard new music at concerts, dancehalls, and in the theater.

The 1920s were often dubbed the "Jazz Age," and nothing was more important in the decade than jazz music. It dominated Broadway and vaudeville musical theaters. Composers and song writers such as George Gershwin, Jerome Kern, and Irving Berlin and dancers such as Josephine Baker, Isadora Duncan, and Irene Castle helped solidify the genre for the public.

The 1930s and 1940s were also shaped by music and dance. Young singles and couples alike packed dancehalls for jitterbug marathons. Swing music became the rage, and Glenn Miller's orchestra led the trend. Ballroom dancing also helped couples escape the bleak times of the Depression by envisioning themselves gracing the dance floor in a glamorous gown or top hat and tails such as those donned by Ginger Rogers and Fred Astaire in movies. During WWII, dancing was a great escape from the war, and girls would fill the United Service Organizations (USO) halls when the boys were home on leave or ready to ship out.

Although transatlantic radio broadcasts had been possible since 1904, it was not until 1920 when events were broadcast through the medium to the public. Radio not only transported the new jazz music, but it also became a powerful tool used by politicians to influence voters. FDR regularly held "fireside chats" via the radio to bolster support for his political agenda during the Great Depression.

By the 1940s, radio was the lifeline for Americans, providing news, music, and entertainment. Programming included soap operas, quiz shows, children's hours, mystery stories, fine drama, and sports. Families would gather around the radio for evening entertainment. The government relied heavily on radio for updates on the war and propaganda. The message was clear and sent often, that it was everyone's job to fight for freedom and support the United States by purchasing war bonds, volunteering, and keeping a look out for spies.

Despite radio's popularity, it could not compete with "moving pictures." The first motion pictures appeared in penny arcades in the 1890s and became the preferred form of entertainment after WWI. The United States dominated the industry, and short, slapstick films were produced at the rate of two or more per week (McKay 1999, 938). Soon the short comedies evolved into longer films with story lines, many containing social commentary. The influence of film was felt nationwide, and, by 1925, 113 million people were receiving the messages broadcast across the silver screen on a weekly basis.

traveled to America's shore from Germany, Ireland, Scandinavia, Canada, the United Kingdom, the Caribbean, and Mexico (U.S. Bureau of Citizenship and Immigration Services). During this time, the United States added restrictions on who could immigrate to the country. WWI effectively stopped mass migration to the United States.

By the end of WWI, nearly all Asian immigrants were banned from entering the United States, and other immigrants had to demonstrate that they were literate in their native language. These changes were the beginning of additional restrictions on immigration that would emerge through the remainder of the early 1900s.

Immigrants entered the United States but rarely assimilated. Instead, they attempted to retain as much of their ethnic identity and cultural practices by settling in pockets within neighborhoods, building stores, churches, and services identical to those left behind in their native lands. This separatism, combined with language barriers, often led to conflict and discrimination.

During WWI, more than 500,000 African Americans migrated north in search of factory work. After the war was over, fierce competition erupted in the north between African American and working-class whites for jobs and economical housing. Racial tensions, once restricted to the south, now plagued many northern urban centers, resulting in frequent race riots. Legal segregation as well as Jim Crow laws left African Americans in isolation without a voice to object to their situation. Activists Booker T. Washington and W. E. B. DuBois worked to develop solutions to the racial tension and prejudice. Other minorities had similar discrimination and poverty problems. Hispanic and Asian women were frequently relegated to domestic service, textile mills, and industrial laundries (Rowbotham 1997, pp. 159–60).

Ethnic heritage was not worn on one's sleeve in the 1940s. Who was fighting with or against the Allies would determine how a recent immigrant was received by the community, especially in search of employment. Ethnic neighborhoods were tolerated as long as they did not try to mingle with mainstream society. Segregation was enforced for people of color, although black soldiers and Native Americans gave their lives for the same country. Although some people of lighter color would try to "pass" and blend in with the majority white population, there were those who were defiant and tried to make a statement with their activities and wardrobe.

ART AND ENTERTAINMENT

Music and dance remained prominent forms of entertainment through the first half of the twentieth century. In the 1900s and 1910s, many households had a piano, and people would purchase sheet music of the

Warren G. Harding was elected president of the United States in 1920 on a platform calling for a "return to normalcy" after WWI, promising to reduce American involvement in international politics and focus on domestic issues. For the first time, the federal government asserted itself into the daily lives of its citizen through the *ratification* of the ratified 1919, went into effect in 1920 and ratified 1920 Amendments to the constitution. Before 1920, the only exposure Americans had to the federal government was through the postal system.

The Eighteenth Amendment made the distilling, brewing, and sale of alcoholic beverages illegal in 1920, a prohibition not repealed until 1933. Often ignored by the general public and law enforcement officials, the Eighteenth Amendment did little to prevent the sale of liquor in America. However, the ratification of the Nineteenth Amendment, also in 1920, redefined the political landscape. Women now had the right to vote, and the League of Women Voters worked to educate women about politics, studied issues important to women, and influenced politicians.

President Herbert Hoover had the distinction of ushering America through the first three years of the Great Depression, from 1929 to 1932. Unfortunately, Hoover was unable to produce any positive changes in the America economy, and, in 1932, the American public elected Franklin Delano Roosevelt (FDR) and his "New Deal" to lead the country. FDR strove to reform capitalism to prevent another such occurrence as the Great Depression and launched numerous government-sponsored programs designed to put Americans back to work.

The grip of the Great Depression was loosened when America entered WWII on December 7, 1941, when the Japanese bombed Pearl Harbor. As FDR increased expenditures to mobilize the United States, unemployment almost disappeared as men were drafted. The government reclassified 55 percent of the jobs previously held by men, allowing women and blacks to fill them.

By 1942, the government began rationing sugar, gasoline, and coffee, followed by rationing of meat, fat, cheese, canned goods, leather, and shoes in 1943. Salvage drives produced millions of tons of iron, scrap steel, and tin, all for the war effort. The War Production Board began severely restricting the amount of yardage used in garments.

ETHNICITY IN AMERICA

During the first decade of the century, immigrants flowed into the country, with 8,795,400 from 1901 to 1910, a majority of them coming from Italy and the Soviet Union. Hundreds of thousands of immigrants

As the second decade of the twentieth century drew to a close, disaster struck on October 24, 1929, when the stock market collapsed. The onslaught of mass unemployment from the disintegration of the business sector and failure of farms caused by flooding and drought devastated millions of people worldwide. The world output of goods fell by 38 percent, whereas unemployment in the United States soared from 5 percent in the 1920s to 33 percent by 1933 (McKay 1999, 946). Despite many efforts on the part of state and federal government, the recovery was slow and incomplete until the advent of World War II (WWII).

Production to support the war efforts of WWII pulled the country out of the depression. With unemployment reaching 8,120,000 of a population of 132,122,000, the war created a way out of poverty. For many men, military service provided a steady income, and, for the first time in American history, women in high numbers were going outside of the home to work. The war affected the availability of goods, as well as changed the fabric of our society.

POLITICS IN AMERICA

At the beginning of the century, Progressivism played a central role in the politics of America. Although the Progressive movement meant many different things to different people, improving life for everyone was the core concept of the movement. Most Progressives felt the government should help solve social problems, such as labor issues, poverty, slums, and disenfranchisement.

Throughout the first two decades of the 1900s, politicians and activists worked to resolve the labor unrest that marked the period. Violent strikes led to government involvement, and eventually there was an improvement in factory conditions, hours, and workers' rights.

During the terms of Presidents Roosevelt and Taft, new laws were enacted that expanded government control of business, immigration, and government services. An income tax was added to pay for this new, larger government. Citizens also gained more control of their government. The Seventeenth Amendment allowed voters to directly elect senators, and, by 1920, women had been granted the right to vote.

During the first years of Woodrow Wilson's first term, he focused on similar social advancements, but his attention was divided by the turmoil of WWI in Europe. He avoided U.S. involvement in the conflict until 1917, but he could not avoid the lasting impact that the war would have on the country. Women entered the workplace to take the place of the men who were off fighting the war, and the government expanded its powers to manage the war effort.

There was a marked economic divide between the rich and the poor in the country during the first decade of the century. There were very few wealthy people, but they lived in a grand and ostentatious style that the rest of Americans could only dream of affording. They lived in great mansions that often took up entire city blocks or on country estates with dozens of rooms. Their homes featured indoor plumbing, electricity, and fine furnishings from around the world. They could afford all of luxury and convenience that money could buy, but they comprised a very small part of the population.

Many more Americans were very poor. They lived in tenements often consisting of only one or two rooms for the entire family. In poor families, men, women, and children worked to earn enough money to make ends meet. They did not have indoor plumbing or electricity.

Many prominent middle-class people and politicians, such as Jane Addams and Theodore Roosevelt, took up the cause to improve the lives of poor Americans through educational programs and support services. This activism, known as the Progressive movement, reflected the optimistic attitude that the nation adopted at the turn of the century. Progressives felt they had an opportunity to better themselves and their fellow citizens.

The nation's refreshed, positive attitude that marked the first decade of the century dissolved into a practical somberness when the United States entered World War I (WWI) in 1917. The nation's entry into the war broke its trend of isolation from the outside world. The economy shifted to meet the needs of the wartime nation, and much of the workforce was enlisting and being shipped overseas. At home, frugality took over consumer spending and household consumption.

The beginning of the second decade of the twentieth century was plagued by high inflation, widespread unemployment, deep cuts in government spending, a return of soldiers (many of whom were disabled), and a decrease in per capita income (Perrett 1982, 31). Europe lay in ruins from WWI. The United States stepped forward as a new world power, shifting itself from an industrial-based to a service-based economy. Although the change brought prosperity to the service industry, other business sectors suffered. Shipping, railroads, coal mining, and textiles businesses were all in financial trouble, and many farms, then the largest sector of the economy in the United States, filed bankruptcy (Perrett 1982, pp. 120–1).

Although the rapidly growing economy resulted in a labor shortage during the 1920s, the growth in personal wealth traditionally associated with the decade did not apply equally to all; by 1927, the average person realized an increase in annual savings of only $11 over 1899 (Perrett 1982, 324).

1

The United States in 1900–1949: An Overview

Dramatic changes occurred during the first half of the twentieth century in the United States. The country's population transformed from a rural, economically divided "melting pot" at the beginning of the century to a patriotic, technologically advanced country at war by the close of the 1940s. This transformation in American society can be seen within the path of fashion during this time period. This volume will describe the parallel courses of societal change and fashion evolution.

Before one can discuss the course of fashion, one must recognize the historical changes that affect fashion. This introduction seeks to outline the historical landscape of the early half of the twentieth century. By describing the political, societal, and cultural themes of this time period, the reader becomes acquainted with the ideas that shape the fashion trends.

The population of the United States nearly doubled from 76,094,000 in 1900 to 148,665,000 in 1949 (U.S. Census Bureau 2002). Not only did the population increase, but its makeup significantly changed as well. Remarkable advances in living conditions, working conditions, and medicine resulted in an increase of almost twenty years in life expectancy (U.S. Census Bureau 2002). At the start of the century, most of the population lived in rural areas, but by midcentury, much of the population clustered in urban centers to take advantage of the job opportunities in the factories.

3

PART I

The Social Significance of Dress, 1900–1949

1948 The garment industry grows through increased mass production.
1948 LP records on vinyl are introduced.
1949 East and West Germany divide on October 7.
1949 The North Atlantic Treaty Organization (NATO) is formed.
1949 The Soviet Union achieves the A bomb.
1949 *South Pacific* opens on Broadway.
1949 RCA introduces the 45 rpm record.

1944 Paris is liberated by the Allies on August 25.

1944 Franklin Delano Roosevelt is elected for a fourth term as president of the United States.

1944 Forty-two percent of west coast aircraft factory workers are women.

1944 American and British governments ban wide-scale media coverage of Paris fashion shows.

1945 Fifty nations meet in New York to design the framework for the United Nations charter.

1945 Germany surrenders on May 7.

1945 The United States bombs Hiroshima and Nagasaki on August 6 and 9.

1945 The microwave oven is invented.

1945 The ENIAC computer (short for the electronic numerical integrator and computer) successfully operates.

1945 After Japan's surrender, DuPont resumes production of nylon for stockings.

1945 Balenciaga pronounces that the ideal hemline should be fifteen inches from the ground.

1945 Designers return to Paris and begin reopening salons.

1946 The U.S. Supreme Court bans segregation on interstate buses.

1946 President Truman creates the Committee on Civil Rights on December 5.

1946 Dr. Spock publishes *The Common Sense Book of Baby and Child Care.*

1946 The United Nations begins operations in New York City.

1946 Jukeboxes go into mass production.

1946 Ranch and split-level homes dominate the postwar construction boom.

1946 Jacques Heim and Louis Reard introduce the bikini.

1947 Christian Dior shows the first "New Look" collection in Paris on February 12.

1947 *The Howdy Doody Show,* for children, is first seen on television on December 17.

1947 Pan Am makes around-the-globe travel commercially available.

1947 The Polaroid camera is invented.

1948 Gandhi is assassinated.

1948 Israel becomes a country.

1948 The Cold War begins.

1948 The Emmy Awards are broadcast on television.

1939 John Steinbeck publishes *Grapes of Wrath.*

1939 *Wizard of Oz* is released.

1939 *Gone with the Wind* is released.

1939 World War II begins.

1939 Nylon stockings are first manufactured.

1940 Winston Churchill becomes prime minister of Great Britain on May 10.

1940 DuPont introduces ladies' nylon stockings.

1940 The German army reaches Paris.

1940 The Pennsylvania Turnpike (first multi-lane highway) opens on September 30.

1940 First official network television broadcast on NBC.

1940 Zazous and zoot suits make their first appearance.

1940 Schiaparelli's last French collection is taken to America.

1941 The United Service Organizations is incorporated in New York on February 4.

1941 Germany invades the Soviet Union on June 22.

1941 Franklin Delano Roosevelt is elected for third term as president of United States.

1941 Japanese bombs Pearl Harbor on December 7.

1941 CBS and NBC begin television transmissions with paid advertising.

1942 President Roosevelt shifts to wartime economy.

1942 U.S. auto production is discontinued to support war effort.

1942 General Limitation L-85 orders government rationing of clothing and materials beginning on March 8.

1942 Japanese Americans from west coast are sent to internment camps.

1942 The Women's Auxiliary Army Corp is organized on May 14.

1942 Bing Crosby records "White Christmas."

1942 Hollywood releases *Casablanca* and *Yankee Doodle Dandy* in support of the war effort.

1942 *So Your Husband's Gone to War* is published.

1942 Atomic fusion is developed at the Fermi laboratory.

1942 Nylon is diverted to the war effort, and leg painting replaces stockings.

1943 Rogers and Hammerstein released *Oklahoma.*

1943 Detroit race riots devastate the city.

1944 D-Day Allies successfully invade German-occupied France on June 6.

1944 G.I. Bill of Rights is enacted by Congress.

1932	Amelia Earhart is the first woman to fly solo across the Atlantic.
1933	Adolf Hitler becomes the chancellor of Germany.
1933	Hitler proclaims the Third Reich.
1933	The first Nazi concentration camp opens at Cachau on March 20.
1933	Prohibition repealed by the Twenty-First Amendment to the U.S. Constitution.
1933	Men's tennis star René Lacoste introduces his own line of clothing with the trademark crocodile (his nickname).
1933	Japan withdraws from League of Nations.
1933	United States goes off the gold standard.
1933	Public Works Administration is created in the United States.
1934	Shirley Temple debuts in first film, *Stand Up and Cheer*.
1934	Bonnie Parker and Clyde Barrow are shot dead in police ambush.
1934	John Dillinger is shot dead by authorities in Chicago.
1934	Hitler nominates himself as Fuhrer on August 2.
1934	Launch of *The Queen Mary*, the world's largest liner, on September 26.
1934	The Film Production Code is enforced by the league of decency.
1934	The Civil Works Emergency Relief Act is passed in the United States.
1934	Clark Gable in *It Happened One Night* is seen without an under-shirt, and the sale of men's undershirts plummets.
1935	Dust Bowl drought devastates Kansas, Colorado, Wyoming, Okalahoma, Texas, and New Mexico.
1935	The Social Security Act is signed by President Roosevelt.
1935	The Rumba dance becomes popular.
1935	Jockey shorts, fitted knit briefs for men, are introduced.
1936	Opening of the Berlin Olympics on August 1.
1936	Dali and Schiaparelli collaborate to make "the desk suit."
1936	Salvatore Ferragamo invents the wedge heel.
1936	The Hoover (Boulder) Dam is completed on the Colorado River in Nevada and Arizona.
1936	First publication of *Life* magazine.
1937	Duke of Windsor marries Wallis Simpson on June 3.
1937	Italy withdraws from League of Nations.
1937	Hindenburg disaster.
1938	Orson Welles' radio production of "War of the Worlds" airs on October 31 and causes panic in the United States.
1938	The forty-hour work week is established in the United States.
1938	Howard Hughes circumnavigates the globe in three days.
1939	World War II forces Chanel to close her shop and studio in Paris.

1925 Nellie Taylor Ross becomes the first female governor on December 5.

1925 Miriam Ferguson is elected governor of Texas.

1925 The Charleston becomes a dance craze.

1925 F. Scott Fitzgerald's *The Great Gatsby* is published.

1926 The National Broadcasting Company (NBC) is founded in New York City on November 15.

1926 American *Vogue* compares Chanel's "little black dress" to a Ford.

1926 Ernest Hemingway publishes *The Sun Also Rises*.

1926 The permanent wave is invented by Antonio Buzzacchino.

1927 Charles Lindbergh makes the first solo nonstop flight across the Atlantic in the "Spirit of St. Louis."

1927 Machine Age Exhibition is held in New York.

1927 Schiaparelli designs the first trompe l'oeil pullover sweaters.

1927 The first "talking picture," *The Jazz Singer*, is released.

1927 Josephine Baker becomes a huge star in Paris.

1928 Amelia Earhart is the first woman to fly across the Atlantic on June 17.

1928 The first televisions are for sale in the United States.

1928 Alexander Fleming discovers penicillin.

1929 St. Valentine's Day Massacre occurs in Chicago.

1929 The first Academy Awards ceremony is held on May 16.

1929 Black Friday in New York signals the beginning of the stock market crash on October 24 and the Great Depression, which lasts until about 1941, or the U.S. entrance into World War II.

1929 William Faulkner publishes *The Sound and the Fury*.

1929 Bertrand Russell publishes *Marriage and Morals*.

1929 Estrone, one of the hormones responsible for sexual response in females, is isolated by American and German scientists.

1930 German scientist J. Walter Reppe makes synthetic fabrics from acetylene.

1931 The Empire State Building opens in New York City on May 1 and is proclaimed the tallest building in the world.

1931 Al Capone, the notorious gangster, is jailed for income tax evasion.

1932 Lindbergh baby kidnapped on March 1 and found dead May 12.

1932 "The Star Spangled Banner" is declared the United States national anthem on March 31.

1932 *Letty Lynton* is released starring Joan Crawford, with costumes by Adrian.

1932 Franklin Delano Roosevelt is elected president of the United States on November 8.

1932 Radio City Music Hall opens

1917	The United States joins World War I on the side of the Allies on April 6.
1917	The Immigration Act excludes Asian laborers from entering the United States.
1920	First General Assembly of the League of Nations convenes on January 10.
1920	The Nineteenth Amendment gives American women the right to vote.
1920	Prohibition begins in the United States with the enactment of the Eighteenth Amendment.
1920	Ethelda M. Bleibtrey, an American, wins three medals for women's swimming at the Olympics in Antwerp.
1921	Hitler is elected president of National Socialist German Workers' Party on July 29.
1921	Mussolini declares himself leader of National Fascist Party in Italy on November 7.
1921	Madeleine Vionnet makes her United States debut.
1921	Chanel's "No. 5" perfume is introduced.
1921	Wiener Werstatte opens branch in New York.
1922	James Joyce releases his epic, *Ulysses.*
1922	The first woman, Rebecca Fenton, is appointed to the U.S. Senate on October 3.
1922	Discovery of Tutankhamen's tomb in the Valley of the Kings, Egypt.
1922	Victor Margueritte's novel *La Garconne* is released and helps define the flapper era.
1922	Emily Post publishes her first book, *Etiquette.*
1923	Madeleine Vionnet invents the bias cut.
1923	Sigmund Freud publishes *Das Ich und das Es (The Ego and the Id).*
1923	The first birth control clinic opens in New York.
1924	The Olympic Games open in Paris on July 5.
1924	Chanel designs costumes for the Ballet Russe.
1924	Andre Breton writes the surrealist manifesto.
1924	The first Winter Olympics is held in Chamonix, France.
1925	Exposition des Arts Decoratifs opens in Paris (and included designs by Paul Poiret).
1925	John Thomas Scopes is fined for teaching theory of evolution, and the "Scopes Monkey Trial" follows.
1925	The first national congress of the Klu Klux Klan convenes in Washington, DC.

Chronology of World and Fashion Events, 1900–1949

1900 The World's Fair (Exposition Universelle) is held in Paris.

1901 President William McKinley is assassinated on September 6, and Theodore Roosevelt assumes the presidency.

1901 Marconi sends the first wireless message across the Atlantic Ocean on December 12.

1901 Queen Victoria of England dies on January 22, ending the Victorian Era.

1903 The Wright Brothers make a successful airplane flight at Kitty Hawk, North Carolina, on December 17.

1906 Major earthquake destroys much of San Francisco, California, on April 18.

1906 Paul Poiret introduced the empire waistline into women's fashions.

1907 Pablo Picasso paints *Les Demoiselles d'Avignon*.

1907 Mariano Fortuny creates the "Delphos" gown.

1908 Henry Ford produces the first Model T car on September 27.

1909 William E. B. DuBois leads a group that founds the National Association for the Advancement of Colored People (NAACP) on February 12.

1909 William Howard Taft becomes president on March 4.

1912 The ocean liner *Titanic* sinks on its maiden voyage on April 14.

1913 Woodrow Wilson becomes president of the United States on March 4.

1913 Jantzen introduced the first rib-knit swimsuit, which had the elasticity to allow easy swimming.

1914 The Panama Canal opens under lease to the United States on August 15.

dress with high heels and Brooks Brother suits and adopting ethnic dress, long hair, and beards.

As the final decades of the twentieth century approached, the social consciousness of the 1960s and 1970s was replaced by conspicuous consumption in the 1980s. Instead of reflecting allegiance with a social movement, fashion now reflected one's material worth and station in society. Status symbols were prominently displayed on all apparel, as well as on many household goods. Bigger was better, and indulging in luxury was the message broadcast to all of society.

In response to the excesses of the 1980s, the 1990s appeared almost generic. Most forms of self-expressions in fashions were gone: not so many designer labels nor as much conspicuous consumption. Khakis and white t-shirts became the norm and were considered acceptable dress for almost every occasion. Even the workplace began to dress down, implementing "business casual" and "casual Fridays," instead of the standard suit and tie and dressy outfits for women. Whereas the 1980s screamed self-indulgence, the 1990s quietly and calmly, in an understated manner, closed out the century.

From the Chambre Syndicale de la Couture Parisienne to mass merchandisers, from Nordstrom to Overstock.com, the rapid (and now global) dissemination of fashion information is a potent agent for change in society. Fashion and society are inextricably intertwined, each influencing the other. This book attempts to identify those connections and not just document the fashions of this time but also give context to them. As we progress through the twenty-first century, we will have to wait until enough time has passed to look back and read how fashion influenced twenty-first-century society and how the events of this new century are registered in the fashions we all wear.

We thank our friends, family, and colleagues for their support and encouragement throughout the course of this project. We are grateful for the assistance and reassurance that you each provided.

<div align="right">Amy T. Peterson
Ann T. Kellogg</div>

REFERENCE

Damhorst, M. L., Miller, K. A., and Michelman, S. O. (1999) *The Meanings of Dress.* New York: Fairchild Publications.

historical or current events, art movements, or socio-cultural theories were considered in the development of this book; the scope was limited only to those areas the authors believed directly impacted fashion trends. Nor is this book a comprehensive guide to subculture or alternative fashion movements; the focus is on the mainstream, common fashion trends that were adopted by the majority of Americans.

To guide the reader, a chronology of key historical events and fashion trends is provided at the beginning of each volume. Illustrations of significant fashion trends for both men and women are included to supplement the descriptive text, as does a glossary of fashion terms, which will assist the reader with terminology. An extensive resource guide of numerous articles and books, videos, and films that demonstrate fashion of certain eras, and a substantial listing of authoritative websites, including those for museums and special collections, rounds out the Selected Resources provided.

THE TWENTIETH AND TWENTY-FIRST CENTURIES

The birth of the twentieth century marked the beginning of the new, modern era that was more open, expressive, and progressive than the reserved and sober nineteenth-century Victorian era. Changes in society were rapidly taking place. The telephone, electricity, automobiles, and cameras, at first technological marvels, became commonplace items. Over the course of the century, mass-produced ready-to-wear clothing replaced custom-made hand-tailored clothing, allowing new fashions to be rapidly reproduced and distributed in large volumes simultaneously across the entire country. First store catalogs, and then the Internet, made fashions immediately accessible to individuals in even the most remote parts of the country. After World War II, the economic prosperity experienced by most of the United States resulted in a population shift from urban to suburban, and fashion followed suit with the development of the shopping mall.

The last half of the twentieth century was marked by space exploration, activism, and civil unrest. The tumult of the 1960s witnessed the birth of both space exploration and the Civil Rights Movement. Although the ultra-hip donned vinyl dresses with metallic details, African Americans explored their origins and adopted traditional forms of African dress to express their identity. Middle-class youth became involved in numerous social protest movements against the establishment and, dubbed "hippies," chose to differentiate themselves from their parents by rejecting Jackie-O

Preface

Fashion is influenced by society, and, in turn, fashion influences society. Changes in appearance, however subtle or minimal, reflect changes in society. As society changes and evolves, so does fashion. Fashion is not the exclusive purview of the social elite, nor can it be summarily dismissed as mere vanity. It is much more complex than just wearing the latest styles. We use fashion to express who we are and what we think and to project an image, bolster our confidence, and attract partners. Fashion crosses all strata of society and is tightly interwoven into each individual's identity. Undeniably, fashion "… is an essential part of the human experience" (Damhorst, Miller, and Michelman 1999, p. xi).

Clothing through American History 1900 to the Present examines the relationship between social, cultural, and political developments and fashion in the United States. Volume One discusses the culture, clothing, and fashion in America from 1900 to 1949, and Volume Two discusses the culture, clothing, and fashion in America from 1950 to the present, about midway through 2008 at this writing. Both volumes in this set are structured to provide two levels of information to the reader: first, what people wore and, second, and perhaps more important, why they wore it. In addition to chapters on fashion trends, this work contains chapters specifically dedicated to examining the impact that politics, culture, arts and entertainment, daily life, and family structures have on fashion and how fashion can serve as an impetus for change in society. This set also examines the history of the fashion industry and the communication of fashion information in print, in movies and television, and across the Internet.

Research for this work was conducted through numerous primary and secondary resources on fashion and history, which can be found in the chapter references and in the Resource Guide at the end of each volume, particularly in the "Print and Online Publications" section. Not all

Unnumbered photo essay appears following page 204.

Contents

Library of Congress Cataloging-in-Publication Data

The Greenwood encyclopedia of clothing through American history 1900 to the present /
Amy T. Peterson, general editor [v. 1], Ann T. Kellogg, general editor [v. 2].
 p. cm.
 Includes bibliographical references and index.
 ISBN 978-0-313-35855-5 ((set) : alk. paper)—ISBN 978-0-313-33395-8 ((vol. 1) : alk.
paper)—ISBN 978-0-313-33417-7 ((vol. 2) : alk. paper)
 1. Clothing and dress—United States—History—20th century. I. Peterson, Amy T.
II. Kellogg, Ann T., 1968-
 GT615.G74 2008
 391.0097309′04—dc22 2008024624

British Library Cataloguing in Publication Data is available.

Library of Congress Catalog Card Number: 2008024624
ISBN: 978-0-313-35855-5 (set)
 978-0-313-33395-8 (vol. 1)
 978-0-313-33417-7 (vol. 2)

First published in 2008

Greenwood Press, 88 Post Road West, Westport, CT 06881
An imprint of Greenwood Publishing Group, Inc.
www.greenwood.com

Printed in the United States of America

∞™

The paper used in this book complies with the
Permanent Paper Standard issued by the National
Information Standards Organization (Z39.48-1984).

10 9 8 7 6 5 4 3 2 1

THE GREENWOOD ENCYCLOPEDIA OF

CLOTHING THROUGH AMERICAN HISTORY 1900 TO THE PRESENT

VOLUME 1
1900–1949

Amy T. Peterson, Valerie Hewitt, Heather Vaughan,
Ann T. Kellogg, and Lynn W. Payne

Amy T. Peterson, General Editor

GREENWOOD PRESS
Westport, Connecticut • London

THE GREENWOOD ENCYCLOPEDIA OF

CLOTHING THROUGH AMERICAN HISTORY 1900 TO THE PRESENT